THE EGYPTIAN BOOK OF THE DEAD

The Complete Papyrus of Ani

Translated by E. A. Wallis Budge

Foreword by Dr. Foy Scalf, University of Chicago

CLYDESDALE PRESS

Originally published in 1895 by order of the Trustees of the British Museum.

First Clydesdale Press Edition 2021

Foreword © Skyhorse Publishing

Clydesdale books may be purchased in bulk at special discounts for sales promotion, corporate gifts, fund-raising, or educational purposes. Special editions can also be created to specifications. For details, contact the Special Sales Department, Skyhorse Publishing, 307 West 36th Street, 11th Floor, New York, NY 10018 or info@skyhorsepublishing.com.

Clydesdale Press™ is a pending trademark of Skyhorse Publishing, Inc.®, a Delaware corporation.

Visit our website at www.skyhorsepublishing.com.

10 9 8 7 6

Library of Congress Control Number: 2020930858

Cover design by Kai Texel

Print ISBN: 978-1-945186-65-3
eISBN: 978-1-949846-24-9

Printed in the United States of America

CONTENTS

FOREWORD

INTRODUCTION TO THE SKYHORSE PUBLISHING EDITION

By Dr. Foy Scalf

The Book of the Dead. Immediately evocative, this phrase arouses our imagination and conjures in us ideas of magic, mystery, antiquity, and exoticness. The popularity of the book you hold in your hands—one of the best-selling books in the history of Egyptology, having been in continuous print since its original publication in 1895—can in some way be attributed to its title.[i] Yet this title and the mental images it evokes are very much a legacy of the nineteenth century, deriving from the early years of Egyptology after the discipline had only just been born. After Jean-François Champollion (1790–1832) deciphered the hieroglyphic script in 1822, and thereby founded the modern study of Egyptology, Egyptian religious texts captivated him. In Champollion's grammar and notes, he often referred to what we call the Book of the Dead as the "funerary ritual" (*rituel funéraire*), but he never published a complete

i The translation of the ancient Egyptian Book of the Dead by Sir Ernest Alfred Wallis Budge has appeared in a bewildering array of editions and printings, the unravelling of which requires dedicated scholarship in its own right. Budge's edition of the papyrus was first published in two volumes in 1895. New versions and reprints appeared in 1901, 1909, 1910, 1913, 1920, 1922, 1929, 1960, 1967, 1989, and 1994, as well as numerous other years. The translation was also borrowed and adapted for other work. For example, in 1901, Budge's English translation appeared in Epiphanius Wilson, *Egyptian Literature: Comprising Egyptian Tales, Hymns, Litanies, Invocations, the Book of the Dead, and Cuneiform Writings*, Revised Edition (London: The Colonial Press, 1901), pp. 1–131. The editions were often reformatted so that in one edition the reader finds a hieroglyphic transcription separate from, but on the same page as, the English translation, such as the 1913 edition by G. P. Putnam's Sons published in three volumes consisting of an introduction and commentary in volume one, a hieroglyphic transcription and English translation (not interlinear) with index in volume two, and a facsimile of the papyrus of Ani in volume three. In another edition, that of Kegan Paul, Trench, Trübner & Co. in 1898, the introduction and English translation appeared together in volume one, which included interleaved foldout facsimile plates of the papyrus, the hieroglyphic transcription was contained in volume two, and volume three consisted of a glossary of the Egyptian words. Such editions, therefore, differ from the 1895 printing of the British Museum, reproduced frequently in Dover editions and now here by Skyhorse Publishing, where a hieroglyphic transcription is accompanied by an interlinear English gloss.

translation.[ii] His successor, a Prussian scholar named Karl Richard Lepsius (1810–1884) who carried on the decipherment of Egyptian, produced the first full-length study of what we now call the ancient Egyptian Book of the Dead.[iii] His volume, published in 1842, was called in his native German *Das Todtenbuch der Ägypter*, or "The Book of the Dead of the Egyptians," which may very well derive from an Arabic quip used by villagers who knew of *kutub al-amwāt* "books of the dead" found in nearby tombs.[iv] Thus, this phrase was used because the books were found *with* the dead and not because the books were *about* death. It is from Lepsius's book title that our English counterpart was born when a British Egyptologist named Samuel Birch (1813–1885), who had been one of E. A. Wallis Budge's teachers, first translated it into English in 1867. He hedged his bets by entitling his contribution "The Funerary Ritual or Book of the Dead," thus invoking both Champollion and Lepisus with a single stroke.[v] Once subsequent English publications followed Birch's lead, and with Budge's popular translation embedding the phrase into the public vocabulary, the name "Book of the Dead" has stuck, becoming a common part of scholarly discourse as well as household conversation.

The Book of the Dead is largely a conception of our modern imagination. For the ancient Egyptians, it was not very much like a "book" as defined today. What scholars call the "Book of the Dead" consists of nearly two hundred individual spells—also called chapters—that are found written on any available surface, including famous examples on the walls of Ramses II's

ii Published after his death: Jean-François Champollion, *Graimmaire égyptienne, ou Principes généraux de l'écriture sacrée égyptienne appliquée à la representation de la langue parlée* (Paris: Typ. de Firmin Dido frères, 1836).

iii Karl Richard Lepsius, *Das Todtenbuch der Ägypter nach dem hieroglyphischen Papyrus in Turin* (Leipzig: G. Wigand, 1842). Budge had already discussed this history of translation in his volume *The Mummy: Chapters on Egyptian Funerary Archaeology* (Cambridge: Cambridge University Press, 1893), p. 202, updated and revised in 1925: *The Mummy: A Handbook of Egyptian Funerary Archaeology* (Cambridge: Cambridge University Press, 1925), pp. 236–237.

iv Noted already by Budge in the 1925 edition of *The Mummy*, p. 236, where he notes the Arabic phrase as *kitâb al-mayyitûn* "book of the dead (plural)," as compared to the *kutub al-umwāt* "books of the dead" by Stephen Quirke, *Going Out in Daylight — prt m hrw: The Ancient Egyptian Book of the Dead. Translation, Sources, Meaning* (GHP Egyptology 20; London: Golden House Publications, 2013), p. 1. The differences in the Arabic derive from the morphology of Arabic plurals (*kitâb* is singular "book" and *kutub* is plural "books") and regional dialects (*al-mayyitûn* and *al-amwāt* being synonyms for "the dead (plural)" vs. *al-mayyit* "the dead (singular)" while Quirke's *al-umwāt* may represent an Egyptian dialectical variant). For discussion of the Arabic roots, see Edward William Lane, *An Arabic-English Lexicon*, Part 7: ‎ت-و‎ (Beirut: Librairie du Liban, 1968), p. 2742; and Hans Wehr, *A Dictionary of Modern Written Arabic (Arabic-English)*, edited by J. Milton Cowan, Fourth Edition (Ithaca: Spoken Language Services, Inc., 1994), p. 1091.

v Christian Karl Josias Bunsen, *Egypt's Place in Universal History*, Volume V (London: Longmans, Green, and Co., 1867), pp. 123–333.

tomb, the stelae of the general Kasa, the coffin of the priest Nesbanebdjed, the sarcophagus of Queen Hatshepsut, the mummy cloth of Tuthmosis III, the mask of Tutankhamun, the funerary figurines (often called *ushabtis*) of Amenhotep III, the heart scarab of king Sobekemsaf, and, most notably, the papyrus of Ani. The Egyptians often called these collections the "Spells of Going Out in the Day," explicitly using the plural designation "spells" (*r3.w*), as well as "Book of Going Out in the Day," using the ancient term for a papyrus scroll (*md3.t*). However, this is not a technical title for what we call the Book of the Dead. The Egyptians could use the designation to refer to any composition, and even individual spells could carry the title,[vi] which had the purpose of aiding the transition to life after death, for "going out in the day" refers to the soul's journey out from the tomb at dawn. Therefore, you may find it surprising that, while the Egyptians often labeled what we call the Book of the Dead with the description "Spells of Going Out in the Day," they had no specific title for the compilation.

The copies on papyrus most closely resemble the modern book in physical appearance with their individual papyrus sheets, much like our pages, "bound" together from end to end to form a long scroll of papyrus. Such scrolls could run over 30 meters in length.[vii] However, the so-called Book of the Dead written on these scrolls was not a distinct narrative composition telling a single story. Rather, each scroll contained an idiosyncratic compilation of individual spells. Each manuscript was a unique, handmade object; no two manuscripts are exactly the same. Some manuscripts contain a single spell, while others contain well over one hundred. The order of the spells is flexible, although there is some standardization in the sequencing, especially in the so-called "Saite Recension," a version of the Book of the Dead produced in the Twenty-Fifth and Twenty-Sixth Dynasties around 700 BC. For his translation, Budge used the Papyrus of Ani, a Nineteenth Dynasty papyrus from around 1200 BC. Because Ani's papyrus came from the region near the city of Thebes in the south, and due to how much variation is found in the Book of the Dead manuscripts from the Nineteenth Dynasty (as opposed to the somewhat standardized Saite Recension), Budge applied the term "Theban Recension" to the papyrus of Ani and those like it (as you will see in his introduction to the text). Budge knew well that using the name "Book of the Dead" could be

vi For example, the rubric for spell 125 in one manuscript calls it the "book of going out in the day," while the phrase "spell of going out in the day" was applied to diverse texts, including Book of the Dead spells 15, 64, 66, 68, 71, 72, among others, and had already appeared with the corpus of so-called Coffin Texts in spells 105, 152, 153, 335, 404, 783, 784, etc. The titles have been compiled in Siegfried Schott, *Bücher und Bibliotheken im alten Ägypten* (Wiesbaden: Otto Harrassowitz, 1990), pp. 101 and 167–170.

vii For example, the Greenfield Papyrus is over thirty-seven meters in length. It was published by Budge in *The Greenfield Papyrus in the British Museum: The Funerary Papyrus of Princess Nesitanebtashru, Daughter of Painetchem II and Nesi-Khensu, and Preistess of Amen-Ra at Thebes, about B.C. 970* (London: British Museum, 1912).

misleading. Despite the popularity of his books, many misunderstandings persist because the compilations of spells do not form a book in the typical sense, the Egyptians did not have an exclusive title for them, and they were not about death in the way many people believe.

Reading Budge's translations of the spells demonstrates how variable their content is. Inside the Book of the Dead, the reader finds hymns to gods; a hymn to the sun god Re (spell 15) opens Ani's papyrus (pp. 246–249 in Budge's translation) and a hymn to the underworld god Osiris (spell 185) closes it (pp. 367–368). These two spells bookend the papyrus, perfectly complementing the ancient Egyptian theology of the solar-Osirian cycle. The solar-Osirian cycle refers to the circuit of the sun and its continuity with Osiris, the god of the dead. Each morning the sun is born into the eastern horizon, emerging as the god Khepri, whose name means "he who comes into being." At the height of his powers at noon, the sun takes on its mature manifestation as Re, the king of the gods whose fierce rays both create and destroy. In the evening it becomes Atum, whose name means "the complete one," as he descends into the underworld, which is envisioned in Egyptian mythology as the sky goddess Nut swallowing the sun. In Egyptian cosmology and the mythic episodes told about the god Osiris, Nut is the mother of Osiris. After Re enters Nut, he passes through numerous caverns and gates on his way to the womb of Nut and union with Osiris, who personifies for the Egyptians the power of resurrection. By uniting with Osiris, they merge into a solar-Osirian unity (a union of the gods Re and Osiris), and through Osiris's force of rejuvenation, the sun god regains the ability to be born into the sky again the next morning. With the help of the spells in the Book of the Dead, each ancient Egyptian person wished to join this solar-Osirian cycle after their mortal death, to find a place in the following of the gods, and to live out immortality with the sun. Ani's papyrus, a masterpiece of ancient Egyptian art and literature, physically mimics this cycle with the layout of the spells, thereby ensuring Ani's fellowship with the gods.

In addition to hymns, Book of the Dead spells include a wide range of other genres and topics. A series of transformation spells, based on the concept of *kheper* "coming into being" and the same root word from which the name of the god Khepri derives, promised to turn the dead into various entities symbolic of particular powers, including spell 83 for transforming into a phoenix (p. 339), spell 80 for turning into a god (p. 341), and spell 82 for becoming the god Ptah (pp. 337–338). Many spells make important contributions to Egyptian theology, such as spell 89 for "causing the soul to join with the corpse," which is what happens each night after the sun sets and is the corollary to spell 92, "the spell of opening the tomb for the soul and the shadow, of going out in the day, of having power over the legs"—yet another reference to the theme of the soul leaving the tomb during the daylight hours. The collective purpose of all these spells is the rejuvenation and divinization of the deceased, ensuring the transition into a powerful spirit which the Egyptians called an *akh*; *akh*-spirits became part of the entourage of gods, and they had the power to affect life on earth and intercede on behalf

of both the living and the dead. Book of the Dead spell 1—which occurs in the papyrus of Ani after the introductory hymn to the sun (spell 15), a hymn to Osiris, and the heart scarab spell (spell 30B)—summarizes the collective purpose of the spells in a rubric (section written in red in the original papyrus) as: "Beginning of the spells of going out in the day, of the praises and glorifications of going out and coming back in the necropolis—what is effective in the beautiful west, which are recited on the day of burial and of entering after going out."

To gain an intimate understanding of the Book of the Dead, it is necessary to read its texts and study its images. Outside of a relatively small field of professional scholars and a growing cadre of dedicated amateurs, few will have the time to learn how to read ancient Egyptian. For most people then, a translation is the only option. The translation of Ernest Alfred Wallis Budge (1857–1934), knighted in 1920,[viii] was not the first English translation of the Book of the Dead, but it was certainly the most prominent of its day. It continues to be one of the best-selling translations available. From an early age, Budge had been fascinated with the ancient world, particularly with Assyria and Egypt. As a boy, he learned Egyptian from Samuel Birch, the Keeper of Oriental Antiquities at the British Museum, who also allowed the young Budge access to the library at the museum.[ix] He went on to study at Cambridge and, like his mentor Birch, eventually became Keeper at the British Museum himself from 1894–1924. It was in his capacity as Assistant Keeper that Budge aided the museum in acquiring the now famous papyrus of Ani in 1887. The acquisition remains a scandal to this day, although at the time Budge famously bragged about it, and his promotion to Keeper suggests that his contemporaries at the British Museum appreciated his efforts.

Budge purchased the papyrus while on a trip to Egypt, but by this time his reputation for unscrupulous dealings had long preceded him. Budge and the antiquities dealers were all placed on house arrest while waiting for officials from the antiquities service to inspect what they were doing.[x] While waiting, Budge treated their guards to a sumptuous rooftop meal while hired hands tunneled beneath the building and squirreled away a mass of

viii Supplement to the *London Gazette* 1 January 1920, p. 2.

ix Morris L. Bierbrier, *Who Was Who in Egyptology* (London: Egypt Exploration Society, 2012), pp. 90–91.

x The story is retold by Budge with pride and without regret in his memoir *By Nile and Tigris: A Narrative of Journeys in Egypt and Mesopotamia on Behalf of the British Museum between the Years 1886 and 1913* (London: John Murray, 1920). Numerous critical accounts have been published: Jason Thompson, *Wonderful Things: A History of Egyptology. 2: The Golden Age: 1881–1914* (Cairo: American University in Cairo Press, 2015), pp. 167–169; Donald Reid, *Whose Pharaohs? Archaeology, Museums, and Egyptian National Identity from Napoleon to World War I* (Berkeley: University of California Press, 2002), pp. 181–182; Brian Fagan, *The Rape of the Nile: Tomb Robbers, Tourists, and Archaeologists in Egypt* (Boulder: Westview Press, 2004), pp. 199–203.

antiquities, including the seventy-eight-foot papyrus, which Budge cut into thirty-seven individual sheets to make smuggling it out of the country easier, which he was able to do with collusion from "sympathetic Britons in the army, police, and a shipping company."[xi] Although Budge attempted to defend his actions as necessary to "save" the objects from another fate—perhaps the obscurity of a private collection or worse, given his distrust of the antiquities service—it is clear that he knew exactly what he was doing in circumventing the authorities, dominated at the time by the French. This legacy was largely a result of colonialist policies and imperial conflicts in an Egypt being fought over by the French and British as their empires waxed and waned. Budge and other collectors took the opportunity to fill their coffers.[xii] In the process, and partially as a result, the British Museum today has the finest collection of Book of the Dead manuscripts outside of the Cairo Museum, including the justly acclaimed papyrus of Ani.

The British Museum moved quickly to publicize and popularize their new masterpiece, publishing in 1890 a facsimile edition with an introduction by Birch's successor as Keeper, Peter le Page Renouf.[xiii] Renouf was working on his own translation of the Book of the Dead, but his work was cut short when he was forced into retirement. He was succeeded, against his resolute wishes, by Budge, whom Renouf detested, calling him a "cowardly, mendacious, and dishonorable scoundrel," and accusing him of being a "charlatan and plagiarist."[xiv] Despite Renouf's objections, Budge was appointed to Keeper and immediately went on to produce his own translation of the Book of the Dead, published in 1895, based on the recently acquired papyrus of Ani. Budge's translation has been described ("accurately"

xi Donald Reid, *Whose Pharaohs? Archaeology, Museums, and Egyptian National Identity from Napoleon to World War I* (Berkeley: University of California Press, 2002), p. 182.

xii In the last ten to twenty years, many studies have appeared that provide rich detail and illuminating critique of this history. See Donald Malcolm Reid, *Whose Pharaohs? Archaeology, Museums and Egyptian National Identity from Napoleon to World War I* (Berkeley: University of California Pres, 2002); Donald Malcolm Reid, *Contesting Antiquity in Egypt: Archaeologies, Museums and the Struggle for Identities from World War I to Nasser* (Cairo: American University in Cairo Press, 2015); Elliott Colla, *Conflicted Antiquities: Egyptology, Egyptomania, Egyptian Modernity* (Durham: Duke University Press, 2007); William Carruthers (ed.), *Histories of Egyptology: Interdisciplinary Measures* (Routledge Studies in Egyptology 2; New York: Routledge, 2015); Christina Riggs, *Unwrapping Ancient Egypt* (London: Bloomsbury, 2014).

xiii The 1890 edition by the British Museum contained only a facsimile of the papyrus of Ani (inventory number BM EA 10470). At the time, P. le Page Renouf was Keeper of Egyptian and Assyrian Antiquities prior to Budge taking over in 1894. The facsimile publication itself appeared in a second edition in 1894.

xiv The quotes derive from the private letters of Renouf as quoted in a review by Patricia Usick in *British Museum Studies in Ancient Egypt and Sudan* 5 (2006), pp. 13–16, of the edition of the letters by Kevin J. Cathcart (ed.), *The Letters of Peter le Page Renouf (1822–1897)* (Dublin: University College Dublin Press, 2002–2004).

according to one noted historian) as "virtually unreadable" and "not a good translation."[xv] James Henry Breasted (1865–1935), the first American to hold a PhD in Egyptology and founder of the Oriental Institute in Chicago, was quoted as saying, "... Dr. Budge is so ignorant of the Egyptian language that he cannot translate from it correctly," and that Budge was "... perhaps the most outstanding example of incompetence in the whole range of British official scholarship;" although, in print, Breasted offered a positive review of the work, calling it a "useful book" and "highly recommended to the layman."[xvi]

The merit of Budge's work has often been lost in discussions of his unpopular personality and illicit activities. There is no question that Budge worked extremely fast, being perhaps the most prolific scholar in Egyptological history, but his speed came at the price of careful accuracy and scholarly rigor. His prodigious output has had its benefits; many ancient texts—Egyptian papyri, Coptic manuscripts, and cuneiform tablets—would likely have languished in obscurity for decades, and potentially could lay in obscurity still, without Budge's indefatigable efforts to publish. Yet, it cannot be denied that Budge was not a cutting-edge scholar. In terms of understanding the Egyptian language, Budge lagged far behind the scholars associated with the Berlin school, founded by Adolf Erman (1854–1937), whose students like Kurt Sethe (1869–1934), Alan H. Gardiner (1879–1963), and James Henry Breasted went on to transform the following generations of Egyptology. Budge did not take much notice of their linguistic insights and he employed an antiquated transliteration scheme; as a result, his publications are often full of amateurish blunders made in haste for which contemporary scholars knew better.

Certainly, the content of the Book of the Dead can appear to the uninitiated reader as impenetrable, but the avoidable errors committed by Budge caused friction in the field, as can be seen by the quotes about Budge by his contemporaries. However, there has also been unwarranted confusion about Budge's translation of the Book of the Dead. It is important to understand what you find when you look at his work in the following pages. Most prominently, there is a long section of hieroglyphic transcription with interlinear transliteration and English "translation" found on pages 1–242. In this section, the reader will find many passages that read almost as gibberish, for example: "Not may be repulsed my

xv Jason Thompson, *Wonderful Things: A History of Egyptology. 2: The Golden Age: 1881–1914* (Cairo: American University in Cairo Press, 2015), p. 167, who quoted James Wasserman's "virtually unreadable" comment in the preface to *The Egyptian Book of the Dead: The Book of Going Forth by Day* (San Francisco: Chronicle Books, 1998), p. 9.

xvi The quote about Budge's ignorance is reported in "Archaeological Notes," *Biblia* 8 (1895–1896), p. 176, n. †, and the quote about his incompetence comes from a letter of Breasted quoted in Thompson, *Wonderful Things*, p. 168. Breasted's review appeared in *The Biblical World* 19:3 (1902), pp. 228–229.

hand and arm by the divine chiefs of god any," (page 25) or "Now Yesterday Osiris is, now To-morrow Rā is, on day that of the destruction of his enemies of Neb-er-tcher in it" (page 30). Passages such as these have led to the aforementioned comments about the translation being "virtually unreadable." I have often heard graduate students derisively refer to this as "Budge speak," a reference to the Yoda-like, verb-first word order found in the interlinear "translation." Yet this is not Budge's translation. These interlinear notes are a gloss to the hieroglyphic text. The actual translations, which are absolutely comparable to, and just as comprehensible as, those of his peers, can be found after page 243, where these same passages appear as: "May my hand and my arm not be forced back by the holy ministers of any god," (page 274) and "Yesterday is Osiris, and Tomorrow is Rā, on the day when he shall destroy the enemies of Neb-er-tcher" (page 282).[xvii] Thus, much of the popular derision for "Budge speak" is based on mistaking Budge's glosses for his translations. In fact, if Budge's actual translation is placed side by side with that of Birch (1867) and Raymond Faulkner (1994), it becomes clear that, while unquestionably problematic in certain respects, his translation is within the standards of Egyptological expectation for its time.

Budge Gloss:	"Now Yesterday Osiris is, now To-morrow Rā is, on day that of the destruction of his enemies of Neb-er-tcher in it"
Budge:	"Yesterday is Osiris, and Tomorrow is Rā, on the day when he shall destroy the enemies of Neb-er-tcher"
Birch:	"Yesterday is Osiris, the Morning the Sun; the day on which are strangled the deriders of the Universal Lord"
Faulkner:	"As for yesterday, that is Osiris. As for tomorrow, that is Re on that day in which the foes of the Lord of All were destroyed"

Budge Gloss:	"Not may be repulsed my hand and arm by the divine chiefs of god any"
Budge:	"May my hand and my arm not be forced back by the holy ministers of any god"
Birch:	"My arms have [not] been stopped by the chiefs of the Gods and Goddesses"
Faulkner:	"My hand shall not be thrust aside in the tribunal of all gods"

xvii Compare the translations by Ramond O. Faulkner in *The Egyptian Book of the Dead: The Book of Going Forth by Day* (San Fancisco: Chronicle Books, 1998): "My hand shall not be thrust aside in the tribunal of all gods," (pl. 6) and "As for yesterday, that is Osiris. As for tomorrow, that is Re on that day in which the foes of the Lord of All were destroyed" (pl. 7).

The confusion resulting from the misunderstanding of Budge's glossing is com-pounded by autodidacts and researchers on the fringe who are often looking to confirm their own biases about various topics (be it ancient aliens, lost civilizations, prehistoric cosmonauts, occult mysteries, or psychic revelations) through ancient Egyptian texts in order to lend their theories the authority of antiquity and the imprimatur of Egyptian wisdom. The practice is not new; it had already happened in ancient Egypt, when texts were pseudonymously attributed to earlier eras, and authors writing in Greek and Latin in classical antiquity often considered a visit to Egypt obligatory for any learned men, whether they ever physically stepped foot in Egypt or not. Nonetheless, with his interlinear gloss Budge helped expose the Book of the Dead to wild interpretations by unwittingly implying to many readers that Egyptian grammar was an impenetrable morass to which each interpreter could apply their own rules. Glossing is meant to aid the reader in understanding how the original editor interpreted the various hieroglyphic signs as well as relationships between words. Today, Egyptologists have largely adopted a glossing practice based on what is called the Leipzig Glossing Rules.[xviii] A typical edi-tion of an Egyptian text includes transliteration and translation; transliteration is simply the practice of using roman characters to indicate the sounds of the Egyptian words.[xix] Glosses are generally only added in linguistic work to indicate for non-specialists the grammatical roles of words in the text. Here is a passage from the opening of the papyrus of Ani (spell 15), comparing Budge's treatment with a more modern approach to editing ancient Egyptian texts:

xviii The Leipzig Glossing Rules consist of recommendations for how to label linguistic elements in a way that is mutually understood by language scholars. For the rules, see https://www.eva.mpg. de/lingua/resources/glossing-rules.php. For how these rules have been applied to ancient Egyptian, see Camilla Di Biase-Dyson, Frank Kammerzell, and Daniel A. Werning, "Glossing Ancient Egyptian: Suggestions for Adapting the Leipzig Glossing Rules," *Lingua Aegyptia: Journal of Egyptian Language Studies* 17 (2009), 343–366.

xix The methodology of transliterating ancient Egyptian has gone through several phases over two hundred years of Egyptology. An overview of the early period from Champollion up to the time of Erman can be found in James Teackle Dennis, "The Transliteration of Egyptian," *Journal of the Amer-ican Oriental Society* 24 (1903), 275–281. Two articles from the time were heavily influential: "Zur Umschreibung der Hieroglyphen," *Zeitschrift für ägyptischen Sprache* 27 (1889), 1–14; Adolf Erman, "Die Umschreibung des Ägyptischen," *Zeitschrift für ägyptischen Sprache* 34 (1896), 61–62. A helpful comparative chart showing how different scholars have transliterated the so-called "alphabet" of Egyp-tian hieroglyphs can be found in Carsten Puest, *Egyptian Phonology: An Introduction to the Phonology of a Dead Language* (Monographien zur Ägyptischen Sprache 2; Göttingen: Peust & Gutschmidt Verlag, 1999), 48; and James P. Allen, *Middle Egyptian: An Introduction to the Language and Culture of Hiero-glyphs* (Third Edition; Cambridge: Cambridge University Press, 2014), 17.

Transcription:				
Budge Transliteration:	ḥetep–k	nà	maa-à	neferu-k
Budge Gloss:	Mayest thou be at peace	with me	may I see	thy beauties
Transliteration:	ḥtp=k	n=ỉ	m ꜣꜣ=ỉ	nfr.w=k
Leipzig Gloss:	be peaceful:SBJV=2SG.M	PDAT=1SG.M	see:SBJV=1SG.M	beauty-M.PL=2SG.M
Translation:		May you be welcoming to me so that I may see your beauty.		

 Notice that Budge's glosses are mostly rough English definitions with only the minimum explanation about the grammatical relationships between the words, whereas modern glosses aim to make explicit the linguistic constructions as interpreted by the editor. Budge's antiquated English imitating the King James Bible, featuring the verbal suffix "-st" and the pronouns "thee" and "thou" from early modern English that meant to lend an air of religious grandeur to the work, further conditioned reactions to the text while his very dated transliteration scheme added a layer alienating it from contemporary Egyptology.[xx] It is easy to see how someone could be confused by this convoluted apparatus of glossing and translation. A further confusion for readers of this reprint will be Budge's references to "Plate" followed by a roman numeral. These "plates" refer to the facsimile plates originally published in 1894, reproducing in a revised form the facsimile published by the British Museum in 1890 shortly after acquiring the papyrus of Ani.[xxi] Budge provided a hieroglyphic transcription of the cursive hieroglyphs from the texts on Ani's papyrus, plate by plate, and along with the

xx Erman and the Berlin school had adopted a set of transliteration characters without vowels (since the hieroglyphic script did not indicate vowels) already incorporated by 1889 into the primary Egyptology journal *Zeitschrift für ägyptische Sprache*.

xxi There is even confusion in the title of Budge's book itself across its many editions, since *The Book of the Dead* is listed at the top of the title page in italic print, while *The Papyrus of Ani in the British Museum: The Egyptian Text with Interlinear Transliteration and Translation, a Running Translation, Introduction, Etc.* is given below in non-italic print. Library and books catalogs often list these volumes under different titles or subtitles. Several updates and revisions to this work followed under yet other titles, including the three volume 1898 edition by Kegan Paul, Trench, Trübner & Co. with "The Book of the Dead" at the top of the title page followed by *"The Chapters of Coming Forth by Day: The Egyptian Text according to the Theban Recension in Hieroglyphic Edited from Numerous Papyri, with a Translation, Vocabulary, Etc."* below.

translation at the end of the volume, he offered descriptions of the scenes accompanying the texts. One unfortunate consequence of the many reprints of Budge's translation is the lack of attention paid to the images on the papyrus, which for the ancient Egyptians were certainly as important as the texts—not to mention their striking beauty surely appreciated by today's audience, for the scribes who produced Ani's manuscript were skilled masters.

The caveats above should help the reader situate Budge's translation in its late nineteenth century context as well as provide some guidelines for how to thoughtfully approach and use it. Despite its limitations, Budge's translation is a real classic.[xxii] Hopefully, this introduction will help to clear up some of the confusion associated with "Budge speak" and to redeem, even with its shortcomings, Budge's translation as part of the two-century continuum of Egyptology. For even though Budge wasn't an innovative scholar in his day, and his personality and scruples disturbed many, his English translation of the Book of the Dead is within the norms of his contemporaries. In fact, as Birch was his early mentor, it is likely that he relied heavily on Birch's pioneering efforts to translate the Book of the Dead into English. Birch may have been the first, but it was the enduring popularity of Budge's translation, backed by the British Museum and embellished with the remarkable exquisiteness of Ani's papyrus, that largely helped establish the prevailing legacy of the Book of the Dead.

FOR FURTHER READING

As the previous introduction has suggested, understanding the ancient Egyptian Book of the Dead often includes grappling with a complicated scholarly apparatus. Throw in the century that has passed since Budge's translation, compounded by any associated controversies, and you are left with many troublesome obstacles. In addition to Budge, I would recommend the English translations of T. George Allen,[xxiii] Raymond Faulkner,[xxiv] Stephen

xxii It became a classic in the literal sense when it appeared as part of the Penguin Classics imprint: *The Egyptian Book of the Dead*, translated by E. A. Wallis Budge, with an introduction by John Romer (Penguin Classics; London: Penguin, 2008).

xxiii T. George Allen, *The Book of the Dead or Going Forth by Day: Ideas of the Ancient Egyptians Concerning the Hereafter as Expressed in Their Own Term* (Studies in Ancient Oriental Civilization 37; Chicago: University of Chicago Press, 1974).

xxiv Raymond O. Faulkner, *The Ancient Egyptian Book of the Dead* (New York: The Limited Editions Club, 1972). Faulkner's translation has, like Budge's, been reprinted often, including in a revised reprint from the British Museum in 1985, a Chronicle Books edition in 1998 that included the full facsimile of the papyrus of Ani, and a Barnes & Noble edition in 2005.

Quirke,[xxv] and Paul F. O'Rourke.[xxvi] Two excellent English language catalogs have been recently published to accompany major museum exhibitions: *Book of the Dead: Becoming God in Ancient Egypt* and *Journey through the Afterlife: Book of the Dead*.[xxvii] Each catalog includes interpretive articles written by well-established scholars in addition to individual entries for objects in the exhibition. In conjunction with their exhibit, the British Museum published a set of articles in a special issue of the online journal *British Museum Studies in Ancient Egypt and Sudan* (Issue 15: *The Book of the Dead—Recent Research and New Perspectives*). As a general introduction, the chapter on the Book of the Dead in Erik Hornung's *The Ancient Egyptian Books of the Afterlife* (Ithaca: Cornell University Press, 1999), along with its exceptional annotated bibliography, remains fundamental. For those who wish to delve even deeper, publications on the ancient Egyptian Book of the Dead have multiplied over the last twenty years, partially inspired by the results of the Book of the Dead project out of Bonn and their incredibly helpful database of manuscripts (http:// totenbuch.awk.nrw.de/). Several academic series resulted from this project, including *Handschriften des Altägyptischen Totenbuches, Studien zu Altägyptischen Totentexten, Totenbuchtexte*, and *Totenbuchtexte Supplementa*, the many volumes of which will keep anyone busy for an entire career. These can be supplemented with the *Catalogue of the Books of the Dead in the British Museum*, which at the time of this writing includes four volumes, and the monumental study of Malcolm Mosher Jr., *The Book of the Dead, Saite through Ptolemaic Periods: A Study of Traditions Evident in Versions of Texts and Vignettes* (Prescott: SPBDStudies, 2017–2018), of which six volumes have already appeared.

xxv Stephen Quirke, *Going Out in Daylight – prt m hrw. The Ancient Egyptian Book of the Dead: Translation, Sources, Meanings* (GHP Egyptology 20; London: Golden House Publications, 2013).

xxvi Paul F. O'Rourke, *An Ancient Egyptian Book of the Dead: The Papyrus of Sobekmose* (New York: Thames & Hudson, 2016).

xxvii Foy Scalf (ed.). *Book of the Dead: Becoming God in Ancient Egypt* (Oriental Institute Museum Publications 39; Chicago: Oriental Institute, 2017); John H. Taylor (ed.), *Journey through the Afterlife: Ancient Egyptian Book of the Dead* (Cambridge: Harvard University Press, 2010).

PREFACE.

The Papyrus of Ani, which was acquired by the Trustees of the British Museum in the year 1888, is the largest, the most perfect, the best preserved, and the best illuminated of all the papyri which date from the second half of the XVIIIth dynasty (about B.C. 1500 to 1400). Its rare vignettes, and hymns, and chapters, and its descriptive and introductory rubrics render it of unique importance for the study of the Book of the Dead, and it takes a high place among the authoritative texts of the Theban version of that remarkable work. Although it contains less than one-half of the chapters which are commonly assigned to that version, we may conclude that Ani's exalted official position as Chancellor of the ecclesiastical revenues and endowments of Abydos and Thebes would have ensured a selection of such chapters as would suffice for his spiritual welfare in the future life. We may therefore regard the Papyrus of Ani as typical of the funeral book in vogue among the Theban nobles of his time.

The first edition of the Facsimile of the Papyrus was issued in 1890, and was accompanied by a valuable Introduction by Mr. Le Page Renouf, then Keeper of the Department of Egyptian and Assyrian Antiquities. But, in order to satisfy a widely expressed demand for a translation of the text, the present volume has been prepared to be issued with the second edition of the Facsimile. It contains the hieroglyphic text of the Papyrus with interlinear transliteration and word for word translation, a full description of the vignettes, and a running translation; and in the Introduction an attempt has been made to illustrate from native

Egyptian sources the religious views of the wonderful people who more than five thousand years ago proclaimed the resurrection of a spiritual body and the immortality of the soul.

The passages which supply omissions, and vignettes which contain important variations either in subject matter or arrangement, as well as supplementary texts which appear in the appendixes, have been, as far as possible, drawn from other contemporary papyri in the British Museum.

The second edition of the Facsimile has been executed by Mr. F. C. Price.

<div style="text-align:right">E. A. WALLIS BUDGE.</div>

BRITISH MUSEUM.
 January 25, 1895.

INTRODUCTION.

THE VERSIONS OF THE BOOK OF THE DEAD.

THE history of the great body of religious compositions which form the Book of the Dead of the ancient Egyptians may conveniently be divided into four[1] periods, which are represented by four versions :—

I. The version which was edited by the priests of the college of Annu (the On of the Bible, and the Heliopolis of the Greeks), and which was based upon a series of texts now lost, but which there is evidence to prove had passed through a series of revisions or editions as early as the period of the Vth dynasty. This version was, so far as we know, always written in hieroglyphics, and may be called the Heliopolitan version. It is known from five copies which are inscribed upon the walls of the chambers and passages in the pyramids[2] of kings of the Vth and VIth dynasties at Ṣaḳḳâra;[3] and sections of it are found inscribed upon tombs, sarcophagi, coffins, stelæ and papyri from the XIth dynasty to about A.D. 200.[4]

[1] See Naville, *Todtenbuch* (Einleitung), p. 39.

[2] Hence known as the "pyramid texts."

[3] *I.e.*, Unâs, Tetâ, Pepi I., Mentu-em-sa-f, and Pepi II. Their pyramids were cleared out by MM. Mariette and Maspero during the years 1880–84, and the hieroglyphic texts were published, with a French translation, in *Recueil de Travaux*, t. iii.–xiv., Paris, 1882–93.

[4] In the XIth, XIIth, and XIIIth dynasties many monuments are inscribed with sections of the Unâs text. Thus lines 206–69 are found in hieroglyphics upon the coffin of Amamu (British Museum, No. 6654. See Birch, *Egyptian Texts of the Earliest Period from the Coffin of Amamu*, 1886. Plates XVII.–XX.); ll. 206–14 and 268–84 on the coffin of 𓏺𓎁𓂝𓊨 , Âpâ-ânkh, from Ṣaḳḳâra (see Lepsius, *Denkmäler*, ii., Bl. 99 *b*; Maspero, *Recueil*, t. iii., pp. 200 and 214 ff.); ll. 206–10

II. The Theban version, which was commonly written on papyri in hiero-
 glyphics and was divided into sections or chapters, each of which had
 its distinct title but no definite place in the series. The version was
 much used from the XVIIIth to the XXth dynasty.

III. A version closely allied to the preceding version, which is found written
 on papyri in the hieratic character and also in hieroglyphics. In this
 version, which came into use about the XXth dynasty, the chapters
 have no fixed order.

IV. The so-called Saïte version, in which, at some period anterior probably
 to the XXVIth dynasty, the chapters were arranged in a definite order.
 It is commonly written in hieroglyphics and in hieratic, and it was
 much used from the XXVIth dynasty to the end of the Ptolemaïc
 period.

The earliest inscribed monuments and human remains found in Egypt prove
that the ancient Egyptians took the utmost care to preserve the bodies of their

and 268–89 on the coffin of Ȧntef (see Lepsius, *Denkmäler*, ii., Bl. 145; Maspero, *Recueil*, t. iii.,
pp. 200, 214); line 206 on a coffin of Menthu-ḥetep at Berlin (see Lepsius, *Aelteste Texte*, Bl. 5);
lines 269–94 on the sarcophagus of Ḥeru-ḥetep (see Maspero, *Mémoires*, t. i., p. 144). A section is
found on the walls of the tomb of Queen Neferu (see Maspero, *Recueil*, t. iii., p. 201 ff.; *Mémoires*,
t. i., p. 134); other sections are found on the sarcophagus of ⳼ 𓅓 𓎡𓏤, Ṭaḳā (see Lepsius,
Denkmäler, ii., Bll. 147, 148; Maspero, *Guide au Visiteur*, p. 224, No. 1053; *Mémoires*, t. i., p. 134);
lines 5–8 occur on the stele of Ȧpȧ 𓊵𓏤𓀭 (see Ledrain, *Monuments Égyptiens de la Bibl. Nationale*,
Paris, 1879, foll. 14, 15); lines 166 ff. are found on the stele of Neḥi (see Mariette, *Notice des Mon.
à Boulaq*, p. 190; Maspero, *Recueil*, t. iii., p. 195); and lines 576–83 on the coffin of Sebek-Ȧȧ
𓊹𓏤 ⳼ 𓅓 (see Lepsius, *Aelteste Texte*, Bl. 37; Maspero, *Recueil*, t. iv., p. 68). In the
XVIIIth dynasty line 169 was copied on a wall in the temple of Ḥātshepset at Dêr el-baḥarî (see
Dümichen, *Hist. Inschriften*, Bll. 25–37; Maspero, *Recueil*, t. i., p. 195 ff.); and copies of lines 379–99
occur in the papyri of Mut-ḥetep (British Museum, No. 10,010) and Nefer-uten-f (Paris, No. 3092.
See Naville, *Todtenbuch*, Bd. I., Bl. 197; *Aeg. Zeitschrift*, Bd. XXXII., p. 3; and Naville, Einleitung,
pp. 39, 97). In the XXVIth dynasty we find texts of the Vth dynasty repeated on the walls of the
tomb of Peṭa-Ȧmen-ȧpt, the chief *kher-ḥeb* at Thebes (see Dümichen, *Der Grabpalast des Patuamenap
in der Thebanischen Nekropolis*, Leipzig, 1884–85); and also upon the papyrus written for the lady Sais
⳼ 𓅓 𓏏𓏭, about A.D. 200 (see Devéria, *Catalogue des MSS. Égyptiens*, Paris, 1874, p. 170
No. 3155). Signor Schiaparelli's words are :—"Esso è scritto in ieratico, di un tipo paleografico
"speciale: l' enorme abbondanza di segni espletivi, la frequenza di segni o quasi demotici o quasi
"geroglifici, la sottigliezza di tutti, e l' incertezza con cui sono tracciati, che rivela una mano più abituata
"a scrivere in greco che in egiziano, sono altrettanti caratteri del tipo ieratico del periodo esclusivamente
"romano, a cui il nostro papiro appartiene senza alcun dubbio." *Il Libro dei Funerali*, p. 19. On
Devéria's work in connection with this MS., see Maspero, *Le Rituel du sacrifice Funéraire* (in *Revue de
l'Histoire des Religions*, t. xv., p. 161).

dead by various processes of embalming. The deposit of the body in the tomb was accompanied by ceremonies of a symbolic nature, in the course of which certain compositions comprising prayers, short litanies, etc., having reference to the future life, were recited or chanted by priests and relatives on behalf of the dead. The greatest importance was attached to such compositions, in the belief that their recital would secure for the dead an unhindered passage to God in the next world, would enable him to overcome the opposition of all ghostly foes, would endow his body in the tomb with power to resist corruption, and would ensure him a new life in a glorified body in heaven. At a very remote period certain groups of sections or chapters had already become associated with some of the ceremonies which preceded actual burial, and these eventually became a distinct ritual with clearly defined limits. Side by side, however, with this ritual there seems to have existed another and larger work, which was divided into an indefinite number of sections or chapters comprising chiefly prayers, and which dealt on a larger scale with the welfare of the departed in the next world, and described the state of existence therein and the dangers which must be passed successfully before it could be reached, and was founded generally on the religious dogmas and mythology of the Egyptians. The title of "Book of the Dead" is usually given by Egyptologists to the editions of the larger work which were made in the XVIIIth and following dynasties, but in this Introduction the term is intended to include the general body of texts which have reference to the burial of the dead and to the new life in the world beyond the grave, and which are known to have existed in revised editions and to have been in use among the Egyptians from about B.C. 4500 to the early centuries of the Christian era.

The home, origin, and early history of the collection of ancient religious texts which have descended to us are, at present, unknown, and all working theories regarding them, however strongly supported by apparently well-ascertained facts, must be carefully distinguished as theories only, so long as a single ancient necropolis in Egypt remains unexplored and its inscriptions are untranslated. Whether they were composed by the inhabitants of Egypt, who recorded them in hieroglyphic characters, and who have left the monuments which are the only trustworthy sources of information on the subject, or whether they were brought into Egypt by the early immigrants from the Asiatic continent whence they came, or whether they represent the religious books of the Egyptians incorporated with the funeral texts of some prehistoric dwellers on the banks of the Nile, are all questions which the possible discovery of inscriptions belonging to the first dynasties of the Early Empire can alone decide. The evidence derived from the

enormous mass of new material which we owe to the all-important discoveries of *mastaba* tombs and pyramids by M. Maspero, and to his publication of the early religious texts, proves beyond all doubt that the greater part of the texts comprised in the Book of the Dead are far older than the period of Menà (Menes), the first historical king of Egypt.[1] Certain sections indeed appear to belong to an indefinitely remote and primeval time.

The earliest texts bear within themselves proofs, not only of having been composed, but also of having been revised, or edited, long before the days of king Menà, and judging from many passages in the copies inscribed in hieroglyphics upon the pyramids of Unàs (the last king of the Vth dynasty, about B.C. 3333), and Tetà, Pepi I., Mer-en-Rā, and Pepi II. (kings of the VIth dynasty, about B.C. 3300–3166), it would seem that, even at that remote date, the scribes were perplexed and hardly understood the texts which they had before them.[2] The most moderate estimate makes certain sections of the Book of the Dead as known from these tombs older than three thousand years before Christ. We are in any case justified in estimating the earliest form of the work to be contemporaneous with the foundation of the civilization[3] which we call Egyptian in the valley of

[1] " Les textes des Pyramides nous reportent si loin dans le passé que je n'ai aucun moyen " de les dater que de dire qu'elles étaient déjà vieilles cinq mille ans avant notre ère. Si extraordinaire " que paraisse ce chiffre, il faudra bien nous habituer à le considérer comme représentant une " évaluation à *minima* toutes les fois qu'on voudra rechercher les origines de la religion Égyptienne. " La religion et les textes qui nous la font connaître étaient déjà constitués avant la Ire dynastie : c'est " à nous de nous mettre, pour les comprendre, dans l'état d'esprit où était, il y a plus de sept mille " ans, le peuple qui les a constitués. Bien entendu, je ne parle ici que des systèmes théologiques : si " nous voulions remonter jusqu'à l'origine des éléments qu'ils ont mis en œuvre, il nous faudrait " reculer vers des âges encore plus lointains." Maspero, *La Mythologie Égyptienne* (in *Revue de l'Histoire des Religions*, t. xix., p. 12 ; and in *Études de Mythologie et d'Archéologie Égyptiennes*, t. ii., p. 236). Compare also "dass die einzelnen Texte selbst damals schon einer alten heiligen Litteratur " angehörten, unterliegt keinem Zweifel, sie sind in jeder Hinsicht alterthümlicher als die ältesten " uns erhaltenen Denkmäler. Sie gehören in eine für uns 'vorhistorische' Zeit und man wird ihnen " gewiss kein Unrecht anthun, wenn man sie bis in das vierte Jahrtausend hinein versetzt." Erman, *Das Verhältniss des aegyptischen zu den semitischen Sprachen*, in *Z.D.M.G.*, Bd. XLVI., p. 94.

[2] " Le nombre des prières et des formules dirigées contre les animaux venimeux montre quel " effroi le serpent et le scorpion inspirait aux Égyptiens. Beaucoup d'entre elles sont écrites dans " une langue et avec des combinaisons de signes qui ne paraissent plus avoir été complètement " comprises des scribes qui les copiaient sous Ounas et sous Pepi. Je crois, quant à moi, qu'elles " appartiennent au plus vieux rituel et remontent au delà du règne de Mînî." Maspero, *La Religion Égyptienne* (in *Revue de l'Histoire des Religions*, t. xii., p. 125). See also *Recueil de Travaux*, t. iv., p. 62.

[3] "So sind wir gezwungen, wenigstens die ersten Grundlagen des Buches den Anfängen den " Aegyptischen Civilization beizumessen." See Naville, *Das Aegyptische Todtenbuch* (Einleitung), Berlin, 1886, p. 18.

the Nile.[1] To fix a chronological limit for the arts and civilization of Egypt is absolutely impossible.[2]

The oldest form or edition of the Book of the Dead as we have received it supplies no information whatever as to the period when it was compiled; but a copy of the hieratic text inscribed upon a coffin of Menthu-ḥetep, a queen of the XIth dynasty,[3] about B.C. 2500, made by the late Sir J. G. Wilkinson,[4] informs us that the chapter which, according to the arrangement of Lepsius, bears the number LXIV.,[5] was discovered in the reign of Ḥesep-ti,[6] the fifth king of the Ist dynasty, about B.C. 4266. On this coffin are two copies of the chapter, the one immediately following the other. In the rubric to the first the name of the king during whose reign the chapter is said to have been "found" is given as Menthu-ḥetep, which, as Goodwin first pointed out,[7] is a mistake for Men-kau-Rā,[8] the fourth king of the IVth dynasty, about B.C. 3633;[9] but in the rubric to the second the king's name is given as Ḥesep-ti. Thus it appears that in the period of the XIth dynasty it was believed that the chapter might alternatively be as old as the time of the Ist dynasty. Further, it is given to Ḥesep-ti in papyri of the XXIst dynasty,[10] a period when particular attention was paid to the history of the Book of the Dead; and it thus appears that the Egyptians of the Middle Empire believed the chapter to date from the more

[1] The date of Menȧ, the first king of Egypt, is variously given B.C. 5867 (Champollion), B.C. 5004 (Mariette), B.C 5892 (Lepsius), B.C. 4455 (Brugsch).

[2] See Chabas, *Aeg. Zeitschrift*, 1865, p. 95. On the subject of the Antiquity of Egyptian Civilization generally, see Chabas, *Études sur l'Antiquité Historique d'après les Sources Égyptiennes*, Paris, 1873—Introduction, p. 9.

[3] The name of the queen and her titles are given on p. 7 (margin) thus :—

[4] It was presented to the British Museum in 1834, and is now in the Department of Egyptian and Assyrian Antiquities.

[5] *Todtenbuch*, Bl. 23–25.

[6] [hieroglyphs] the Οὐσαφαΐς υἱός of Manetho.

[7] *Aeg. Zeitschrift*, 1866, p. 54.

[8] See Guieyesse, *Rituel Funéraire Égyptien*, chapitre 64e, Paris, 1876, p. 10, note 2.

[9] The late recension of the Book of the Dead published by Lepsius also gives the king's name as Men-kau-Rā [hieroglyphs] (*Todtenbuch*, Bl. 25, l. 31). In the same recension the CXXXth Chapter is ascribed to the reign of Ḥesep-ti [hieroglyphs] (Bl. 53, l. 28).

[10] Naville, *Todtenbuch* (Einleitung), pp. 33, 139.

remote period. To quote the words of Chabas, the chapter was regarded as
being "very ancient, very mysterious, and very difficult to understand" already
fourteen centuries before our era.[1]

The rubric on the coffin of Queen Menthu-ḥetep, which ascribes the chapter
to Ḥesep-ti, states that "this chapter was found in the foundations beneath the
"ḥennu boat by the foreman of the builders in the time of the king of the
"North and South, Ḥesep-ti, triumphant";[2] the Nebseni papyrus says that
"this chapter was found in the city of Khemennu (Hermopolis) on a block of
"ironstone (?) written in letters of lapis-lazuli, under the feet of the god";[3] and the
Turin papyrus (XXVIth dynasty or later) adds that the name of the finder was
Ḥeru-ṭā-ṭā-f, , the son of Khufu or Cheops,[4] the second king of
the IVth dynasty, about B.C. 3733, who was at the time making a tour of
inspection of the temples. Birch[5] and Naville[6] consider the chapter one of

[1] Chabas, *Voyage d'un Égyptien*, p. 46. According to M. Naville (Einleitung, p. 138), who follows
Chabas's opinion, this chapter is an abridgement of the whole Book of the Dead; and it had, even
though it contained not all the religious doctrine of the Egyptians, a value which was equivalent to the
whole.

[2] . See Goodwin, *Aeg. Zeitschrift*,
1866, p. 55, and compare the reading from the Cairo papyrus of Mes-em-neter given by Naville (*Todten-
buch*, ii., p. 139).

[3] Naville, *Todtenbuch*, Bd. I., Bl. 76, l. 52.

[4] Lepsius, *Todtenbuch*, Bl. 25, l. 31.

[5] "The most remarkable chapter is the 64th It is one of the oldest of all, and is
"attributed, as already stated, to the epoch of king Gaga-Makheru , or Menkheres
"This chapter enjoyed a high reputation till a late period, for it is found on a stone presented to
"General Perofski by the late Emperor Nicholas, which must have come from the tomb of
"Petemenophis,* in the El-Assasif,† and was made during the XXVIth dynasty Some more
"recent compiler of the Hermetic books has evidently paraphrased it for the Ritual of Turin." Bunsen,
Egypt's Place in Universal History, London, 1867, p. 142. The block of stone to which Dr. Birch
refers is described by Golénischeff, *Ermitage Impérial, Inventaire de la Collection Égyptienne*, No. 1101,
pp. 169, 170. M. Maspero thinks it was meant to be a "prétendu fac-similé" of the original slab,
which, according to the rubric, was found in the temple of Thoth, *Revue de l'Histoire des Religions*,
t. xv., p. 299, and *Études de Mythologie*, t. i., p. 368.

[6] *Todtenbuch* (Einleitung), p. 139. Mr. Renouf also holds this opinion, *Trans. Soc. Bibl. Arch.*,
1893, p. 6.

* *I.e.*, , the "chief reader." Many of the inscriptions on whose tomb have been published by
Dümichen, *Der Grabpalast des Patuamenap*; Leipzig, 1884, 1885.

† *I.e.*, Asasîf el-baḥrîyeh, or Asasif of the north, behind Dêr el-baḥarî, on the western bank of the Nile, opposite
Thebes.

the oldest in the Book of the Dead; the former basing his opinion on the rubric, and the latter upon the evidence derived from the contents and character of the text; but Maspero, while admitting the great age of the chapter, does not attach any very great importance to the rubric as fixing any exact date for its composition.[1] Of Ḥeruṭāṭāf the finder of the block of stone, we know from later texts that he was considered to be a learned man, and that his speech was only with difficulty to be understood,[2] and we also know the prominent part which he took as a recognized man of letters in bringing to the court of his father Khufu the sage Ṭeṭṭeṭa.[3] It is then not improbable that Ḥeruṭāṭāf's character for learning may have suggested the connection of his name with the chapter, and possibly as its literary reviser; at all events as early as the period of the Middle Empire tradition associated him with it.

[1] "On explique d'ordinaire cette indication comme une marque d'antiquité extrême; on part de "ce principe que le *Livre des Morts* est de composition relativement moderne, et qu'un scribe égyptien, "nommant un roi des premières dynasties memphites, ne pouvait entendre par là qu'un personnage "d'époque très reculée. Cette explication ne me paraît pas être exacte. En premier lieu, le chapitre "LXIV. se trouve déjà sur des monuments contemporains de la X^e et de la XI^e dynastie, et n'était "certainement pas nouveau au moment où on écrivait les copies les plus vieilles que nous en ayons "aujourd'hui. Lorsqu'on le rédigea sous sa forme actuelle, le règne de Mykérinos, et même celui "d'Housapaïti, ne devaient pas soulever dans l'esprit des indigènes la sensation de l'archaïsme et du "primitif: on avait pour rendre ces idées des expressions plus fortes, qui renvoyaient le lecteur au "siècles des *Serviteurs d'Horus*, à la domination de Rā, aux âges où les dieux régnaient sur l'Égypte." *Revue de l'Histoire des Religions*, t. xv., p. 299.

[2] Chabas, *Voyage*, p. 46; Wiedemann, *Aegyptische Geschichte*, p. 191. In the Brit. Mus. papyrus No. 10,060 (Harris 500), Ḥeruṭāṭāf is mentioned together with I-em-ḥetep as a well known author, and the writer of the dirge says, "I have heard the words of I-em-ḥetep and of Ḥeruṭāṭāf, whose many "and varied writings are said and sung; but now where are their places?" The hieratic text is published with a hieroglyphic transcript by Maspero in *Journal Asiatique*, Sér. VII^ième, t. xv., p. 404 ff., and *Études Égyptiennes*, t. i., p. 173; for English translations, see *Trans. Soc. Bibl. Arch.*, vol. iii., p. 386, and *Records of the Past*, 1st ed., vol. iv., p. 117.

[3] According to the Westcar papyrus, Ḥeruṭāṭāf informed his father Khufu of the existence of a man 110 years old who lived in the town of Ṭeṭṭeṭ-Seneferu: he was able to join to its body again a head that had been cut off, and possessed influence over the lion, and was acquainted with the mysteries of Thoth. By Khufu's command Ḥeruṭāṭāf brought the sage to him by boat, and, on his arrival, the king ordered the head to be struck off from a prisoner that Ṭeṭṭeṭa might fasten it on again. Having excused himself from performing this act upon a man, a goose was brought and its head was cut off and laid on one side of the room and the body was placed on the other. The sage spake certain words of power (𓁹𓃀𓅱𓆓𓏏), whereupon the goose stood up and began to waddle, and the head also began to move towards it; when the head had joined itself again to the body the bird stood up and cackled 𓅱𓃀𓅱𓆓. For the complete hieratic text, transcript and translation, see Erman, *Die Märchen des Papyrus Westcar*, Berlin, 1890, p. 11, plate 6.

Passing from the region of native Egyptian tradition, we touch firm ground with the evidence derived from the monuments of the IInd dynasty. A bas-relief preserved at Aix in Provence mentions Àasen and Ànkef,[1] two of the priests of Senṭ or Senṭà 〔⊞〕, the fifth king of the IInd dynasty, about B.C. 4000; and a stele at Oxford[2] and another in the Egyptian Museum at Gîzeh[3] record the name of a third priest, Sherà ⊏⊐, or Sheri ⊏⊐, a "royal relative". On the stele at Oxford we have represented the deceased and his wife seated, one on each side of an altar 𝖆,[4] which is covered with funeral offerings of pious relatives; above, in perpendicular lines of hieroglyphics in relief, are the names of the objects offered,[5] and below is an inscription which reads,[6] "thousands "of loaves of bread, thousands of vases of ale, thousands of linen garments, "thousands of changes of wearing apparel, and thousands of oxen."[7] Now from this monument it is evident that already in the IInd dynasty a priesthood existed in Egypt which numbered among its members relatives of the royal family, and that a religious system which prescribed as a duty the providing of meat and drink offerings for the dead was also in active operation. The offering of specific objects goes far to prove the existence of a ritual or service wherein their signification would be indicated; the coincidence of these words and the prayer for "thousands of loaves of bread, thousands of vases of "ale," etc., with the promise, "Ànpu-khent-Àmenta shall give thee thy thousands "of loaves of bread, thy thousands of vases of ale, thy thousands of vessels

[1] Wiedemann, *Aegyptische Geschichte*, p. 170. In a maṣṭaba at Ṣaḳḳâra we have a stele of Sheri ⊏⊐ ⦀, a superintendent of the priests of the *ka* 𓅃 ⌐⌐, whereon the cartouches of Senṭ and Per-àb-sen (⊏⊐) both occur. See Mariette and Maspero, *Les Mastaba de l'ancien Empire*, Paris, 1882, p. 92.

[2] See Lepsius, *Auswahl*, Bl. 9.

[3] See Maspero, *Guide du Visiteur au Musée de Boulaq*, 1883, pp. 31, 32, and 213 (No. 1027).

[4] A discussion on the method of depicting this altar on Egyptian monuments by Borchardt may be found in *Aeg. Zeitschrift*, Bd. XXXI., p. 1 (*Die Darstellung innen verzierter Schalen auf aeg. Denkmälern*).

[5] Among others, (1) ⌓⌓, (2) ⊏⊐, (3) ⌓, (4) ⌓; the word incense is written twice, ⌓. Some of these appear in the lists of offerings made for Unàs (l. 147) and for Tetà (ll. 125, 131, 133; see *Recueil de Travaux*, 1884, plate 2).

[6] ⌓⌓⌓⌓⌓⌓⊟.

[7] The sculptor had no room for the ⌓ belonging to ⊟.

" of unguents, thy thousands of changes of apparel, thy thousands of oxen, and
" thy thousands of bullocks," enables us to recognise that ritual in the text
inscribed upon the pyramid of Tetâ in the Vth dynasty, from which the above
promise is taken.[1] Thus the traditional evidence of the text on the coffin of
Menthu-ḥetep and the scene on the monument of Sherâ support one another,
and together they prove beyond a doubt that a form of the Book of the Dead
was in use at least in the period of the earliest dynasties, and that sepulchral
ceremonies connected therewith were duly performed.[2]

With the IVth dynasty we have an increased number of monuments, chiefly
sepulchral, which give details as to the Egyptian sacerdotal system and the funeral
ceremonies which the priests performed.[3] The inscriptions upon the earlier

[1] ⟨hieroglyphs⟩ Tetâ, ll. 388, 389.
(*Recueil*, ed. Maspero, t. v., p. 58.)

[2] The arguments brought forward here in proof of the great antiquity of a religious system in
Egypt are supplemented in a remarkable manner by the inscriptions found in the maṣṭaba of Seker-
khā-baiu ⟨hieroglyphs⟩ at Ṣaḳḳâra. Here we have a man who, like Sherâ, was a "royal relative"
and a priest, but who, unlike him, exercised some of the highest functions of the Egyptian priesthood
in virtue of his title ⟨hieroglyphs⟩ χerp ḥem. (On the ⟨hieroglyphs⟩ * see Max Müller, *Recueil de Travaux*, t. ix.,
p. 166; Brugsch, *Aegyptologie*, p. 218; and Maspero, *Un Manuel de Hiérarchie Égyptienne*, p. 9.)
Among the offerings named in the tomb are the substances ⟨hieroglyphs⟩ and ⟨hieroglyphs⟩ which
are also mentioned on the stele of Sherâ of the IInd dynasty, and in the texts of the VIth dynasty.
But the tomb of Seker-khā-baiu is different from any other known to us, both as regards the form
and cutting of the hieroglyphics, which are in relief, and the way in which they are disposed and
grouped. The style of the whole monument is rude and very primitive, and it cannot be attributed to
any dynasty later than the second, or even to the second itself; it must, therefore, have been built during
the first dynasty, or in the words of MM. Mariette and Maspero, " L'impression générale que l'on reçoit
au premier aspect du tombeau No. 5, est celle d'une extrême antiquité. Rien en effet de ce que nous
sommes habitués à voir dans les autres tombeaux ne se retrouve ici . . . Le monument est
certainement le plus ancien de ceux que nous connaissons dans la plaine de Saqqarah, et il n'y a
pas de raison pour qu'il ne soit pas de la Iʳᵉ Dynastie. " *Les Mastaba de l'ancien Empire;* Paris, 1882,
p. 73. Because there is no incontrovertible proof that this tomb belongs to the Ist dynasty, the
texts on the stele of Sherâ, a monument of a later dynasty, have been adduced as the oldest evidences
of the antiquity of a fixed religious system and literature in Egypt.

[3] Many of the monuments commonly attributed to this dynasty should more correctly be
described as being the work of the IInd dynasty; see Maspero, *Geschichte der Morgenländischen
Völker im Alterthum* (trans. Pietschmann), Leipzig, 1877, p. 56; Wiedemann, *Aegyptische Geschichte*,
p. 170.

* Ptaḥ-shepses bore this title ; see Mariette and Maspero, *Les Mastaba*, p. 113.

monuments prove that many of the priestly officials were still relatives of the royal family, and the tombs of feudal lords, scribes, and others, record a number of their official titles, together with the names of several of their religious festivals. The subsequent increase in the number of the monuments during this period may be due to the natural development of the religion of the time, but it is very probable that the greater security of life and property which had been assured by the vigorous wars of Seneferu,[1] the first king of this dynasty, about B.C. 3766, encouraged men to incur greater expense, and to build larger and better abodes for the dead, and to celebrate the full ritual at the prescribed festivals. In this dynasty the royal dead were honoured with sepulchral monuments of a greater size and magnificence than had ever before been contemplated, and the chapels attached to the pyramids were served by courses of priests whose sole duties consisted in celebrating the services. The fashion of building a pyramid instead of the rectangular flat-roofed maṣṭaba for a royal tomb was revived by Seneferu,[2] who called his pyramid Khā ; and his example was followed by his immediate successors, Khufu (Cheops), Khāf-Rā (Chephren), Men-kau-Rā (Mycerinus), and others.

In the reign of Mycerinus some important work seems to have been undertaken in connection with certain sections of the text of the Book of the Dead, for the rubrics of Chapters XXX B. and CXLVIII.[3] state that these compositions were found inscribed upon " a block of iron (?) of the south in letters of real " lapis-lazuli under the feet of the majesty of the god in the time of the King " of the North and South Men-kau-Rā, by the royal son Ḥeruṭāṭāf, triumphant." That a new impulse should be given to religious observances, and that the revision of existing religious texts should take place in the reign of Mycerinus, was only to be expected if Greek tradition may be believed, for both Herodotus and Diodorus Siculus represent him as a just king, and one who was anxious to efface from the minds of the people the memory of the alleged cruelty of his

[1] He conquered the peoples in the Sinaitic peninsula, and according to a text of a later date he built a wall to keep out the Aamu from Egypt. In the story of Saneha a "pool of Seneferu" is mentioned, which shows that his name was well known on the frontiers of Egypt. See Golénischeff, *Aeg. Zeitschrift*, p. 110 ; Maspero, *Mélanges d'Archéologie*, t. iii., Paris, 1876, p. 71, l. 2 ; Lepsius, *Denkmäler*, ii., 2a.

[2] The building of the pyramid of Mêdûm has usually been attributed to Seneferu, but the excavations made there in 1882 did nothing to clear up the uncertainty which exists on this point; for recent excavations see Petrie, *Medum*, London, 1892, 4to.

[3] For the text see Naville, *Todtenbuch*, Bd. II., Bl. 99 ; Bd. I., Bl. 167.

predecessor by re-opening the temples and by letting every man celebrate his own sacrifices and discharge his own religious duties.[1] His pyramid is the one now known as the "third pyramid of Gîzeh," under which he was buried in a chamber vertically below the apex and 60 feet below the level of the ground. Whether the pyramid was finished or not[2] when the king died, his body was certainly laid in it, and notwithstanding all the attempts made by the Muḥammadan rulers of Egypt[3] to destroy it at the end of the 12th century of our era, it has survived to yield up important facts for the history of the Book of the Dead.

In 1837 Colonel Howard Vyse succeeded in forcing the entrance. On the 29th of July he commenced operations, and on the 1st of August he made his way into the sepulchral chamber, where, however, nothing was found but a rectangular stone sarcophagus[4] without the lid. The large stone slabs of the floor and the linings of the wall had been in many instances removed by thieves in search of treasure. In a lower chamber, connected by a passage with the sepulchral chamber, was found the greater part of the lid of the sarcophagus,[5] together with portions of a wooden coffin, and part of the body of a man, consisting of ribs and vertebræ and the bones of the legs and feet, enveloped

[1] Herodotus, ii., 129, 1 ; Diodorus, i., 64, 9.

[2] According to Diodorus, he died before it was completed (i., 64, 7).

[3] According to ʿAbd el-Laṭîf the Khalif's name was Mâmûn, but M. de Sacy doubted that he was the first to attempt this work ; the authorities on the subject are all given in his *Relation de l'Égypte*, Paris, 1810, p. 215-221. Tradition, as represented in the "Arabian Nights," says that Al-Mâmûn was minded to pull down the Pyramids, and that he expended a mint of money in the attempt; he succeeded, however, only in opening up a small tunnel in one of them, wherein it is said he found treasure to the exact amount of the moneys which he had spent in the work, and neither more nor less. The Arabic writer Idrîsî, who wrote about A.H. 623 (A.D. 1226), states that a few years ago the "Red Pyramid," *i.e.*, that of Mycerinus, was opened on the north side. After passing through various passages a room was reached wherein was found a long blue vessel, quite empty. The opening into this pyramid was effected by people who were in search of treasure ; they worked at it with axes for six months, and they were in great numbers. They found in this basin, after they had broken the covering of it, the decayed remains of a man, but no treasures, excepting some golden tablets inscribed with characters of a language which nobody could understand. Each man's share of these tablets amounted to one hundred dinars (about £50). Other legendary history says that the western pyramid contains thirty chambers of parti-coloured syenite full of precious gems and costly weapons anointed with unguents that they may not rust until the day of the Resurrection. See Howard Vyse, *The Pyramids of Gizeh*, vol. ii., pp. 71, 72 ; and Burton, *The Book of the Thousand Nights and a Night;* 1885, vol. v., p. 105, and vol. x., p. 150.

[4] Vyse, *The Pyramids of Gizeh*, vol. ii., p. 84. A fragment of this sarcophagus is exhibited in the British Museum, First Egyptian Room, Case A, No. 6646.

[5] With considerable difficulty this interesting monument was brought out from the pyramid by Mr. Raven, and having been cased in strong timbers, was sent off to the British Museum. It was

in a coarse woollen cloth of a yellow colour, to which a small quantity of resinous substance and gum adhered.[1] It would therefore seem that, as the sarcophagus could not be removed, the wooden case alone containing the body had been brought into the large apartment for examination. Now, whether the human remains[2] there found are those of Mycerinus or of some one else, as some have suggested, in no way affects the question of the ownership of the coffin, for we know by the hieroglyphic inscription upon it that it was made to hold the mummified body of the king. This inscription, which is arranged in two perpendicular lines down the front of the coffin reads :—[3]

1.

| Ausâr | suten net | Men-kau-Rā | ānχ | t'etta | mes | en | pet | āur |

[Hail] Osiris, { King of the North and South, } Men-kau-Rā, living for ever, born of heaven, conceived of

| Nut | āa | en | Seb | mer - f | peseś - s | mut - k | Nut | ḥer - k |

Nut, heir of Seb, his beloved. Spreadeth she thy mother Nut over thee

embarked at Alexandria in the autumn of 1838, on board a merchant ship, which was supposed to have been lost off Carthagena, as she never was heard of after her departure from Leghorn on the 12th of October in that year, and as some parts of the wreck were picked up near the former port. The sarcophagus is figured by Vyse, *Pyramids*, vol. ii., plate facing p. 84.

[1] As a considerable misapprehension about the finding of these remains has existed, the account of the circumstances under which they were discovered will be of interest. " Sir, by your request, I " send you the particulars of the finding of the bones, mummy-cloth, and parts of the coffin in the " Third Pyramid. In clearing the rubbish out of the large entrance-room, after the men had been " employed there several days and had advanced some distance towards the south-eastern corner, some " bones were first discovered at the bottom of the rubbish ; and the remaining bones and parts of " the coffin were immediately discovered all together. No other parts of the coffin or bones could be " found in the room ; I therefore had the rubbish which had been previously turned out of the same " room carefully re-examined, when several pieces of the coffin and of the mummy-cloth were found ; " but in no other part of the pyramid were any parts of it to be discovered, although every place was " most minutely examined, to make the coffin as complete as possible. There was about three " feet of rubbish on the top of the same ; and from the circumstance of the bones and part of the " coffin being all found together, it appeared as if the coffin had been brought to that spot and there " unpacked.—H. Raven." Vyse, *Pyramids*, vol. ii., p. 86.

[2] They are exhibited in the First Egyptian Room, Case A, and the fragments of the coffin in Wall-Case No. 1 (No. 6647) in the same room.

[3] See Lepsius, *Auswahl*, Taf. 7.

[4] Or *suten bàt;* see Sethe, *Aeg. Zeitschrift*, Bd. XXVIII., p. 125 ; and Bd. XXX., p. 113 ; Max Müller, *Aeg. Zeitschrift*, Bd. XXX., p. 56 ; Renouf, *Proc. Soc. Bibl. Arch.*, 1893, pp. 219, 220 ; and Lefébure, *Aeg. Zeitschrift*, Bd. XXXI., p. 114 ff.

[5] It seems that we should read this god's name *Ḳeb* (see Lefébure, *Aeg. Zeitschrift*, Bd. XXXI., p. 125); for the sake of uniformity the old name is here retained.

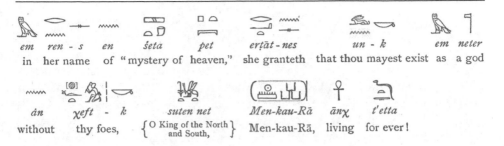

em	ren - s	en	šeta	pet	erṭāt - nes	un - k	em	neter
in	her name	of	"mystery of	heaven,"	she granteth	that thou mayest exist	as	a god

ȧn	χeft - k	suten net	Men-kau-Rā	ānχ	t'etta
without	thy foes,	{ O King of the North and South, }	Men-kau-Rā,	living	for ever!

Now it is to be noted that the passage, " Thy mother Nut spreadeth herself " over thee in her name of 'Mystery of Heaven,' she granteth that thou mayest " be without enemies," occurs in the texts which are inscribed upon the pyramids built by the kings of the VIth dynasty,[1] and thus we have evidence of the use of the same version of one religious text both in the IVth and in the VIth dynasties.[2]

Even if we were to admit that the coffin is a forgery of the XXVIth dynasty, and that the inscription upon it was taken from an edition of the text of the Book of the Dead, still the value of the monument as an evidence of the antiquity of the Book of the Dead is scarcely impaired, for those who added the inscription would certainly have chosen it from a text of the time of Mycerinus.

In the Vth dynasty we have—in an increased number of maṣṭabas and other monuments—evidence of the extension of religious ceremonials, including the

[1] See the texts of Tetȧ and Pepi I. in Maspero, *Recueil de Travaux*, t. v., pp. 20, 38 (ll. 175, 279), and pp. 165, 173 (ll. 60, 103), *etc.*

[2] So far back as 1883, M. Maspero, in lamenting (*Guide du Visiteur de Boulaq*, p. 310) the fact that the Bûlâq Museum possessed only portions of wooden coffins of the Ancient Empire and no complete example, noticed that the coffin of Mycerinus, preserved in the British Museum, had been declared by certain Egyptologists to be a "restoration" of the XXVIth dynasty, rather than the work of the IVth dynasty, in accordance with the inscription upon it; but like Dr. Birch he was of opinion that the coffin certainly belonged to the IVth dynasty, and adduced in support of his views the fact of the existence of portions of a similar coffin of Seker-em-sa-f, a king of the VIth dynasty. Recently, however, an attempt has again been made (*Aeg. Zeitschrift*, Bd. XXX., p. 94 ff.) to prove by the agreement of the variants in the text on the coffin of Mycerinus with those of texts of the XXVIth dynasty, that the Mycerinus text is of this late period, or at all events not earlier than the time of Psammetichus. But it is admitted on all hands that in the XXVIth dynasty the Egyptians resuscitated texts of the first dynasties of the Early Empire, and that they copied the arts and literature of that period as far as possible, and, this being so, the texts on the monuments which have been made the standard of comparison for that on the coffin of Mycerinus may be themselves at fault in their variants. If the text on the cover could be proved to differ as much from an undisputed IVth dynasty text as it does from those even of the VIth dynasty, the philological argument might have some weight; but even this would not get rid of the fact that the cover itself is a genuine relic of the IVth dynasty.

celebration of funeral rites; but a text forming the Book of the Dead as a whole does not occur until the reign of Unâs (B.C. 3333), the last king of the dynasty, who according to the Turin papyrus reigned thirty years. This monarch built on the plain of Ṣaḳḳâra a stone pyramid about sixty-two feet high, each side measuring about two hundred feet at the base. In the time of Perring and Vyse it was surrounded by heaps of broken stone and rubbish, the result of repeated attempts to open it, and with the casing stones, which consisted of compact limestone from the quarries of Ṭura.[1] In February, 1881, M. Maspero began to clear the pyramid, and soon after he succeeded in making an entrance into the innermost chambers, the walls of which were covered with hieroglyphic inscriptions, arranged in perpendicular lines and painted in green.[2] The condition of the interior showed that at some time or other thieves had already succeeded in making an entrance, for the cover of the black basalt sarcophagus of Unâs had been wrenched off and moved near the door of the sarcophagus chamber; the paving stones had been pulled up in the vain attempt to find buried treasure; the mummy had been broken to pieces, and nothing remained of it except the right arm, a tibia, and some fragments of the skull and body. The inscriptions which covered certain walls and corridors in the tomb were afterwards published by M. Maspero.[3] The appearance of the text of Unâs[4] marks an era in the history of the Book of the Dead, and its translation must be regarded as one of the greatest triumphs of Egyptological decipherment, for the want of determinatives in many places in the text, and the archaic spelling of many of the words and passages presented difficulties which were not easily overcome.[5] Here, for the first time, it was shown that the Book of the Dead was no compilation of a comparatively late period in the history of Egyptian civilization, but a work belonging to a very remote antiquity; and it followed naturally that texts which were then known, and which were thought to be themselves original ancient texts, proved to be only versions which had passed through two or more successive revisions.

[1] Vyse, *Pyramids of Gizeh*, p. 51. [2] Maspero, *Recueil de Travaux*, t. iii., p. 178.

[3] See *Recueil de Travaux*, t. iii., pp. 177–224; t. iv., pp. 41–78.

[4] In 1881 Dr. Brugsch described two pyramids of the VIth dynasty inscribed with religious texts similar to those found in the pyramid of Unâs, and translated certain passages (*Aeg. Zeitschrift*, Bd., xix., pp. 1–15); see also Birch in *Trans. Soc. Bibl. Arch.*, 1881, p. 111 ff.

[5] The pyramid which bore among the Arabs the name of *Maṣṭabat el-Far'ûn*, or "Pharaoh's Bench," was excavated by Mariette in 1858, and, because he found the name of Unâs painted on certain blocks of stone, he concluded that it was the tomb of Unâs. M. Maspero's excavations have, as Dr. Lepsius observes (*Aeg. Zeitschrift*, Bd. XIX., p. 15), set the matter right.

Continuing his excavations at Ṣaḳḳâra, M. Maspero opened the pyramid of Tetâ,[1] king of Egypt about B.C. 3300, which Vyse thought[2] had never been entered, and of which, in his day, the masonry on one side only could be seen. Here again it was found that thieves had already been at work, and that they had smashed in pieces walls, floors, and many other parts of the chambers in their frantic search for treasure. As in the case of the pyramid of Unâs, certain chambers, etc., of this tomb were found covered with inscriptions in hieroglyphics, but of a smaller size.[3] A brief examination of the text showed it to be formed of a series of extracts from the Book of the Dead, some of which were identical with those in the pyramid of Unâs. Thus was brought to light a Book of the Dead of the time of the first king[4] of the VIth dynasty.

The pyramid of Pepi I., king of Egypt about B.C. 3233, was next opened.[5] It is situated in the central group at Ṣaḳḳâra, and is commonly known as the pyramid of Shêkh Abu-Manṣûr.[6] Certain chambers and other parts of the tomb were found to be covered with hieroglyphic texts, which not only repeated in part those which had been found in the pyramids of Unâs and Tetâ, but also contained a considerable number of additional sections of the Book of the Dead.[7] In the same neighbourhood M. Maspero cleared out the pyramid of Mer-en-Rā, the fourth king of the VIth dynasty, about B.C. 3200;[8] and the pyramid of Pepi II., the fifth king of the VIth dynasty, about B.C. 3166.[9]

[1] The mummy of the king had been taken out of the sarcophagus through a hole which the thieves had made in it; it was broken by them in pieces, and the only remains of it found by M. Maspero consisted of an arm and shoulder. Parts of the wooden coffin are preserved in the Gîzeh Museum.

[2] *The Pyramids of Gizeh*, vol. iii., p. 39.

[3] They were copied in 1882, and published by M. Maspero in *Recueil de Travaux*, t. v., pp. 1–59.

[4] The broken mummy of this king, together with fragments of its bandages, was found lying on the floor.

[5] See Vyse, *Pyramids of Gizeh*, vol. iii., p. 51.

[6] It had been partially opened by Mariette in May, 1880, but the clearance of sand was not effected until early in 1881.

[7] The full text is given by Maspero in *Recueil de Travaux*, t. v., pp. 157–58, Paris, 1884; t. vii., pp. 145–76, Paris, 1886; and t. viii., pp. 87–120, Paris, 1886.

[8] It was opened early in January, 1880, by Mariette, who seeing that the sarcophagus chamber was inscribed, abandoned his theory that pyramids never contained inscriptions, or that if they did they were not royal tombs. The hieroglyphic texts were published by Maspero in *Recueil de Travaux*, t. ix., pp. 177–91, Paris, 1887; t. x., pp. 1–29, Paris, 1888; and t. xi., pp. 1–31, Paris, 1889. The alabaster vase in the British Museum, No. 4493, came from this pyramid.

[9] This pyramid is a little larger than the others of the period, and is built in steps of small stones; it is commonly called by the Arabs *Haram el-Maṣṭabat*, because it is near the building usually called

Thus we have before the close of the VIth dynasty five copies of a series of texts which formed the Book of the Dead of that period, and an extract from a well-known passage of that work on the wooden coffin of Mycerinus ; we have also seen from a number of maṣṭabas and stelæ that the funeral ceremonies connected with the Book of the Dead were performed certainly in the IInd, and with almost equal certainty in the Ist dynasty. It is easy to show that certain sections of the Book of the Dead of this period were copied and used in the following dynasties down to a period about A.D. 200.

The fact that not only in the pyramids of Unás and Tetá, but also in those of Pepi I. and his immediate successors, we find selected passages, suggests that the Book of the Dead was, even in those early times, so extensive that even a king was fain to make from it a selection only of the passages which suited his individual taste or were considered sufficient to secure his welfare in the next world. In the pyramids of Tetá, Pepi I., Mer-en-Rā and Pepi II. are found many texts which are identical with those employed by their predecessors, and an examination of the inscription of Pepi II. will show that about three-fourths of the whole may be found in the monuments of his ancestors. What principle guided each king in the selection of his texts, or whether the additions in each represent religious developments, it is impossible to say ; but, as the Egyptian religion cannot have remained stationary in every particular, it is probable that some texts reflect the changes in the opinions of the priests upon matters of doctrine.[1] The "Pyramid Texts" prove that each section of the religious books of the Egyptians was originally a separate and independent composition, that it was written with a definite object, and that it might be arranged in any order in a series of similar texts. What preceded or what followed it was never taken into con-

Maṣṭabat el-Farʿûn. See Vyse, *Pyramids*, vol. iii., p. 52. The hieroglyphic texts are published by Maspero in *Recueil de Travaux*, t. xii., pp. 53–95, and pp. 136–95, Paris, 1892 ; and t. xiv., pp. 125–52, Paris, 1892. There is little doubt that this pyramid was broken into more than once in Christian times, and that the early collectors of Egyptian antiquities obtained the beautiful alabaster vases inscribed with the cartouches and titles of Pepi II. from those who had access to the sarcophagus chamber. Among such objects in the British Museum collection, Nos. 4492, 22,559, 22,758 and 22,817 are fine examples.

[1] A development has been observed in the plan of ornamenting the interiors of the pyramids of the Vth and VIth dynasties. In that of Unás about one-quarter of the sarcophagus chamber is covered with architectural decorations, and the hieroglyphics are large, well spaced, and enclosed in broad lines. But as we advance in the VIth dynasty, the space set apart for decorative purposes becomes less, the hieroglyphics are smaller, the lines are crowded, and the inscriptions overflow into the chambers and corridors, which in the Vth dynasty were left blank. See Maspero in *Revue des Religions*, t. xi., p. 124.

sideration by the scribe, although it seems, at times, as if traditions had assigned a sequence to certain texts.

That events of contemporary history were sometimes reflected in the Book of the Dead of the early dynasties is proved by the following. We learn from the inscription upon the tomb of Ḥeru-khuf ⸢𓀀 𓏤 𓏤 𓏤⸣ at Aswân,[1] that this governor of Elephantine was ordered to bring for king Pepi II.[2] a pigmy, ⸢𓂋𓀀𓅓⸣,[3] from the interior of Africa, to dance before the king and amuse him; and he was promised that, if he succeeded in bringing the pigmy alive and in good health, his majesty would confer upon him a higher rank and dignity than that which king Àssà conferred upon his minister Ba-ur-Ṭeṭṭeṭ, who performed this much appreciated service for his master.[4] Now Àssà was the eighth king of the Vth dynasty, and Pepi II. was the fifth king of the VIth dynasty, and between the reigns of these kings there was, according to M. Maspero, an interval of at least sixty-four, but more probably eighty, years. But in the text in the pyramid of Pepi I., which must have been drafted at some period between the reigns of these kings, we have the passage, " Hail thou who [at thy will] makest to
" pass over to the Field of Aaru the soul that is right and true, or dost make ship-
" wreck of it. Rā-meri (i.e., Pepi I.) is right and true in respect of heaven and in
" respect of earth, Pepi is right and true in respect of the island of the earth
" whither he swimmeth and where he arriveth. He who is between the thighs of
" Nut (i.e., Pepi) is the pigmy who danceth [like] the god, and who pleaseth the heart

[1] The full text from this tomb and a discussion on its contents are given by Schiaparelli, *Una tomba egiziana inedita della VI^a dinastia con inscrizioni storiche e geografiche*, in *Atti della R. Accademia dei Lincei*, anno CCLXXXIX., Ser. 4^a, Classe di Scienze Morali, *etc.*, t. x., Rome, 1893, pp. 22–53. This text has been treated by Erman (*Z.D.M.G.*, Bd. XLVI., 1892, p. 574 ff.), who first pointed out the reference to the pigmy in the pyramid texts, and by Maspero in *Revue Critique*, Paris, 1892, p. 366.

[2] See Erman in *Aeg. Zeitschrift*, Bd. XXXI., p. 65 ff.

[3] On the pigmy see Stanley, *Darkest Africa*, vol. i., p. 198; vol. ii., p. 40 f.; Schweinfurth, *Im Herzen von Africa*, Bd. II., Kap. 16, p. 131 ff. That the pigmies paid tribute to the Egyptians is certain from the passage 𓂝𓏤𓀀𓏤𓏤𓏤𓏤𓀀𓅓𓊃𓇾𓏲 "The pigmies came to him from the lands of the south having things of service for his palace"; see Dümichen, *Geschichte des alten Aegyptens*, Berlin, 1887, p. 7.

[4] 𓄿𓏤𓆑𓏤𓀀𓏤𓀁𓏤𓅓𓏤𓂋𓏤𓇾𓏤𓀀𓏤𓇾𓏤𓅓𓏤𓀀𓏤
𓃀𓏤𓄿𓏤𓀀𓏤𓂋𓏤𓏤𓏤𓀀𓏤(𓇳𓏤𓏤𓏤𓇳).

" of the god [Osiris] before his great throne. . . . The two beings who are over
" the throne of the great god proclaim Pepi to be sound and healthy, [therefore]
" Pepi shall sail in the boat to the beautiful field of the great god, and he shall do
" therein that which is done by those to whom veneration is due."[1] Here clearly
we have a reference to the historical fact of the importation of a pigmy from the
regions south of Nubia ; and the idea which seems to have been uppermost in the
mind of him that drafted the text was that as the pigmy pleased the king for
whom he was brought in this world, even so might the dead Pepi please the god
Osiris[2] in the next world. As the pigmy was brought by boat to the king, so
might Pepi be brought by boat to the island wherein the god dwelt ; as the
conditions made by the king were fulfilled by him that brought the pigmy, even so
might the conditions made by Osiris concerning the dead be fulfilled by him that
transported Pepi to his presence. The wording of the passage amply justifies
the assumption that this addition was made to the text after the mission of Assà,
and during the VIth dynasty.[3]

Like other works of a similar nature, however, the pyramid texts afford us no
information as to their authorship. In the later versions of the Book of the
Dead certain chapters[4] are stated to be the work of the god Thoth. They
certainly belong to that class of literature which the Greeks called " Hermetic,"[5]
and it is pretty certain that under some group they were included in the list of the
forty-two works which, according to Clement of Alexandria,[6] constituted the
sacred books of the Egyptians.[7] As Thoth, whom the Greeks called Hermes, is
in Egyptian texts styled " lord of divine books,"[8] " scribe of the company of the
gods,"[9] and " lord of divine speech,"[10] this ascription is well founded. The

[1] For the hieroglyphic text see Maspero, *Recueil de Travaux*, t. vii., pp. 162, 163 ; and t. xi., p. 11.

[2] Pietschmann thinks (*Aeg. Zeitschrift*, Bd. XXXI., p. 73 f.) that the Satyrs, who are referred to
by Diodorus (i., XVIII) as the companions and associates of Osiris in Ethiopia, have their origin in
the pigmies.

[3] The whole question of the pigmy in the text of Pepi I. has been discussed by Maspero in
Recueil de Travaux, t. xiv., p. 186 ff.

[4] Chapp. 30B, 164, 37B and 148. Although these chapters were found at Hermopolis, the city of
Thoth, it does not follow that they were drawn up there.

[5] See Birch, in Bunsen, *Egypt's Place in Universal History*, vol. v., p. 125 ; Naville, *Todtenbuch*
(Einleitung), p. 26.

[6] *Stromata*, VI., 4, 35, ed. Dindorff, t. iii., p. 155.

[7] On the sacred books of the Egyptians see also Iamblichus, *De Mysteriis*, ed. Parthey, Berlin
1857, pp. 260, 261 ; Lepsius, *Chronologie*, p. 45 ff. ; and Brugsch, *Aegyptologie*, p. 149.

pyramid texts are versions of ancient religious compositions which the priests of the college or school of Ȧnnu[1] succeeded in establishing as the authorized version of the Book of the Dead in the first six dynasties. Rā, the local form of the Sun-god, usurps the place occupied by the more ancient form Tmu ; and it would seem that when a dogma had been promulgated by the college of Ȧnnu, it was accepted by the priesthood of all the great cities throughout Egypt. The great influence of the Ȧnnu school of priests even in the time of Unȧs is proved by the following passage from the text in his pyramid : " O God, thy Ȧnnu is " Unȧs ; O God, thy Ȧnnu is Unȧs. O Rā, Ȧnnu is Unȧs, thy Ȧnnu is Unȧs, " O Rā. The mother of Unȧs is Ȧnnu, the father of Unȧs is Ȧnnu ; Unȧs " himself is Ȧnnu, and was born in Ȧnnu."[2] Elsewhere we are told that Unȧs " cometh to the great bull which cometh forth from Ȧnnu,[3] and that he " uttereth words of magical import in Ȧnnu."[4] In Ȧnnu the god Tmu produced the gods Shu and Tefnut,[5] and in Ȧnnu dwelt the great and oldest company of the gods, Tmu, Shu, Tefnut, Seb, Nut, Osiris, Isis, Set and Nephthys.[6] The abode of the blessed in heaven was called[7] Ȧnnu, and it was asserted that the souls of

[1] Ȧnnu, the metropolis of the thirteenth nome of Lower Egypt ; see Brugsch, Dict. Géog., p. 41 ; de Rougé, Géographie Ancienne de la Basse-Égypte, p. 81 ; and Amélineau, La Géographie de l'Égypte à l'Époque Copte, p. 287. Ȧnnu is אֹן, Genesis xli., 45 ; אֹן, Genesis xli., 50 ; אָוֶן Ezekiel xxx., 17 ; and Bêth Shemesh, בֵּית שֶׁמֶשׁ, Jeremiah xliii., 13 ; and the Heliopolis of the Greek writers ('Ηλιούπολις, Strabo, XVII., I., §§ 27, 28 ; Herodotus, II., 3 ; Diodorus, I., 57, 4).

[2] Maspero, Unȧs, ll. 591, 592 ; and compare Pepi I., ll. 690, 691.

[3] See line 596.

[4] (l. 455).

[5] Maspero, Pepi I., l. 465, 466.

[6] The Pyramid of Pepi II., l. 665.

[7] In reading Egyptian religious texts, the existence of the heavenly Ȧnnu, which was to the Egyptians what Jerusalem was to the Jews, and what Mecca still is to the Muḥammadans, must be

the just were there united to their spiritual or glorified bodies, and that they lived there face to face with the deity for all eternity.[1] Judging from the fact that the texts in the tombs of Ḥeru-ḥetep and Neferu, and those inscribed upon the sarcophagus of Ṭaḳà, all of the XIth and XIIth dynasties, differ in extent only and not in character or contents from those of the royal pyramids of Ṣaḳḳâra of the Vth and VIth dynasties, it has been declared that the religion as well as the art of the first Theban empire are nothing but a slavish copy of those of northern Egypt.[2]

The Theban version, which was much used in Upper Egypt from the XVIIIth to the XXth dynasty, was commonly written on papyri in the hieroglyphic character. The text is written in black ink in perpendicular rows of hieroglyphics, which are separated from each other by black lines; the titles of the chapters or sections, and certain parts of the chapters and the rubrics belonging thereto, are written in red ink. A steady development in the illumination of the vignettes is observable in the papyri of this period. At the beginning of the XVIIIth dynasty the vignettes are in black outline, but we see from the papyrus of Hunefer (Brit. Mus. No. 9901), who was an overseer of cattle of Seti I., king of Egypt about B.C. 1370, that the vignettes are painted in reds, greens, yellows, white, and other colours, and that the whole of the text and

remembered. The heavenly Ȧnnu was the capital of the mythological world (see Naville, *Todtenbuch* (Einleitung), p. 27), and was, to the spirits of men, what the earthly Ȧnnu was to their bodies, *i.e.*, the abode of the gods and the centre and source of all divine instruction. Like many other mythological cities, such as Ȧbtu, Tattu, Pe, Tep, Khemennu, *etc.*, the heavenly Ȧnnu had no geographical position.

[1] The importance of Ȧnnu and its gods in the VIth dynasty is well indicated by a prayer from the pyramid of Pepi II. (for the texts see Maspero, *Recueil*, t. x., p. 8, and t. xii., p. 146), which reads:—

"Hail, ye great nine gods who dwell in Ȧnnu, grant ye that Pepi may flourish, and grant ye "that this pyramid of Pepi, this building built for eternity, may flourish, even as the name of the "god Tmu, the chief of the great company of the nine gods, doth flourish. If the name of Shu, "the lord of the celestial shrine in Ȧnnu flourisheth, then Pepi shall flourish, and this his pyramid "shall flourish, and this his work shall endure to all eternity. If the name of Tefnut, the lady of "the terrestrial shrine in Ȧnnu endureth, the name of Pepi shall endure, and this pyramid shall "endure to all eternity. If the name of Seb flourisheth the name of Pepi shall flourish, "and this pyramid shall flourish, and this his work shall endure to all eternity. If the name of "Nut flourisheth in the temple of Shenth in Ȧnnu, the name of Pepi shall flourish, and this "pyramid shall flourish, and this his work shall endure to all eternity. If the name of Osiris "flourisheth in This, the name of Pepi shall flourish, and this pyramid shall flourish, and this his "work shall endure to all eternity. If the name of Osiris Khent-Ȧmenta flourisheth, the name "of Pepi shall flourish, and this pyramid shall flourish, and this his work shall endure to all "eternity. If the name of Set flourisheth in Nubt, the name of Pepi shall flourish, and this "pyramid shall flourish, and this his work shall endure to all eternity."

[2] Maspero, *La Religion Égyptienne d'après les Pyramides de la V^e et de la VI^e dynastie.* (In *Revue des Religions*, t. xii., pp. 138, 139.)

vignettes are enclosed in a red and yellow border. Originally the text was the most important part of the work, and both it and its vignettes were the work of the scribe ; gradually, however, the brilliantly illuminated vignettes were more and more cared for, and when the skill of the scribe failed, the artist was called in. In many fine papyri of the Theban period it is clear that the whole plan of the vignettes of a papyrus was set out by artists, who often failed to leave sufficient space for the texts to which they belonged; in consequence many lines of chapters are often omitted, and the last few lines of some texts are so much crowded as to be almost illegible. The frequent clerical errors also show that while an artist of the greatest skill might be employed on the vignettes, the execution of the text was left to an ignorant or careless scribe. Again, the artist at times arranged his vignettes in wrong order, and it is occasionally evident that neither artist nor scribe understood the matter upon which he was engaged. According to M. Maspero[1] the scribes of the VIth dynasty did not understand the texts which they were drafting, and in the XIXth dynasty the scribe of a papyrus now preserved at Berlin knew or cared so little about the text which he was copying that he transcribed the LXXVIIth Chapter from the wrong end, and apparently never discovered his error although he concluded the chapter with its title.[2] Originally each copy of the Book of the Dead was written to order, but soon the custom obtained of preparing copies with blank spaces in which the name of the purchaser might be inserted ; and many of the errors in spelling and most of the omissions of words are no doubt due to the haste with which such "stock" copies were written by the members of the priestly caste, whose profession it was to copy them.

The papyri upon which copies of the Theban version were written vary in length from about 20 to 90 feet, and in width from 14 to 18 inches ; in the XVIIIth dynasty the layers of the papyrus are of a thicker texture and of a darker colour than in the succeeding dynasties. The art of making great lengths of papyrus of light colour and fine texture attained its highest perfection in the XIXth dynasty. An examination of Theban papyri shows that the work of writing and illuminating a fine copy of the Book of the Dead was frequently distributed between two or more groups of artists and scribes, and that the sections were afterwards joined up into a whole. Occasionally by error two groups of men would transcribe the same chapter ; hence in the papyrus of Ani, Chapter XVIII. occurs twice (see within, p. cxlviii.).

[1] *Recueil de Travaux*, t. iv., p. 62. [2] Naville, *Todtenbuch* (Einleitung), pp. 41–43.

The sections or chapters of the Theban version are a series of separate and distinct compositions, which, like the sections of the pyramid texts, had no fixed order either on coffins or in papyri. Unlike these texts, however, with very few exceptions each composition had a special title and vignette which indicate its purpose. The general selection of the chapters for a papyrus seems to have been left to the individual fancy of the purchaser or scribe, but certain of them were no doubt absolutely necessary for the preservation of the body of the deceased in the tomb, and for the welfare of his soul in its new state of existence. Traditional selections would probably be respected, and recent selections approved by any dominant school of religious thought in Egypt were without doubt accepted.

While in the period of the pyramid texts the various sections were said or sung by priests, probably assisted by some members of the family of the deceased, the welfare of his soul and body being proclaimed for him as an established fact, in the Theban version the hymns and prayers to the gods were put into the mouth of the deceased. As none but the great and wealthy could afford the ceremonies which were performed in the early dynasties, economy was probably the chief cause of this change, which had come about at Thebes as early as the XIIth dynasty. Little by little the ritual portions of the Book of the Dead disappeared, until finally, in the Theban version, the only chapters of this class which remain are the XXIInd, XXIIIrd, CVth, and CLIst.[1] Every chapter and prayer of this version was to be said in the next world, where the words, properly uttered, enabled the deceased to overcome every foe and to attain to the life of the perfected soul which dwelt in a spiritual body in the abode of the blessed.

The common name for the Book of the Dead in the Theban period, and probably also before this date, is 𓂋𓏤𓂻 𓅭 𓉐 𓅓𓏤 *pert em hru*, which words have been variously translated : "manifested in the light," "coming forth from the day," "coming forth by day," "la manifestation au jour," "la manifestation à la lumière," "[Kapitel von] der Erscheinung im Lichte," "Erscheinen am Tage," "[Caput] egrediendi in lucem," *etc.* This name, however, had probably a meaning for the Egyptians which has not yet been rendered in a modern language, and one important idea in connection with the whole work is expressed by another title[2] which calls it "the chapter of making strong (*or* perfect) the *Khu.*"

[1] See Naville, *Todtenbuch* (Einleitung), p. 2c. On the titles "Book of the Dead" and "Ritual Funéraire" which have been given to these texts, see Lepsius, *Todtenbuch*, p. 3 ; De Rougé, *Revue Archéologique*, N.S., t. i., 1860, pp. 69–100.

[2] See Naville, Einleitung, p. 24.

In the Theban version the main principles of the Egyptian religion which were held in the times when the pyramid texts were written are maintained, and the views concerning the eternal existence of the soul remain unaltered. Many passages in the work, however, show that modifications and developments in details have taken place, and much that is not met with in the early dynasties appears, so far as we know, for the first time. The vignettes too are additions to the work; but, although they depict scenes in the life beyond the grave, they do not seem to form a connected series, and it is doubtful if they are arranged on any definite plan. A general idea of the contents of this version may be gathered from the following list of chapters[1] :—

Chapter I. Here begin the Chapters of "Coming forth by day," and of the songs of praise and glorifying,[2] and of coming forth from, and going into, the underworld.[3]

Vignette: The funeral procession from the house of the dead to the tomb.

Chapter Iʙ. The Chapter of making the mummy ⸺ to go into the *ṭuat* ⭑ ,[4] on the day of the burial.[5]

Vignette: Anubis standing by the bier upon which the mummy of the deceased is laid.

Chapter II. [The Chapter of] coming forth by day and of living after death.

Vignette: A man standing, holding a staff Ⲓ.

Chapter III.* Another Chapter like unto it (*i.e.*, like Chapter II).[6]
This Chapter has no vignette.
Chapter IV.* Another Chapter of passing along the way over the earth.
This Chapter has no vignette.

[1] The various chapters of the Book of the Dead were numbered by Lepsius in his edition of the Turin papyrus in 1842. This papyrus, however, is a product of the Ptolemaïc period, and contains a number of chapters which are wanting in the Theban version. For convenience, Lepsius' numbers are retained, and the chapters which belong to the Saïte version are indicated by an asterisk. For the hieroglyphic text see Naville, Einleitung, p. 193 ff.

[2] Another title reads :—" The Chapter of going in to the divine chiefs of Osiris on the day of the burial, and of going in after coming forth." This chapter had to be recited on the day of the burial.

[3] *neter χert*, the commonest name for the tomb.

[4] The Egyptian underworld.

[5] *sam ta*, "the union with the earth."

[6] In some papyri Chapters II. and III. are united and have only one title; see Naville, *Todtenbuch*, Bd. I., Bl. 6.

Chapter V. The Chapter of not allowing the deceased to do work in the underworld.

Vignette : The deceased kneeling on one knee.

Chapter VI. The Chapter of making *ushabtiu* figures do work for a man in the underworld.

Vignette : An *ushabti* figure ⌡.

Chapter VII. The Chapter of passing over the back of Āpep, the evil one.

Vignette : The deceased spearing a serpent.

Chapter VIII. Another Chapter of the *ṭuat*, and of coming forth by day.

Vignette : The deceased kneeling before a ram 𓃝.

Chapter IX. The Chapter of passing through the *ṭuat*.

Vignette : The deceased kneeling before a ram.

Chapter X. (This Chapter is now known as Chapter XLVIII.)

Chapter XI.* The Chapter of coming forth against his enemies in the underworld.

This Chapter has no vignette.

Chapter XII. Another Chapter of going into, and coming forth from, the underworld.

This Chapter has no vignette.

Chapter XIII. The Chapter of going into, and of coming forth, from Āmentet.

This Chapter has no vignette.

Chapter XIV. The Chapter of driving away shame from the heart of the deceased.

This Chapter has no vignette.

Chapter XV. A Hymn of praise to Rā when he riseth in the eastern horizon of heaven.

Vignette : The deceased adoring Rā.

Chapter XVB. 1. A Hymn of praise to Rā when he setteth in the land of life.

Vignette : The deceased adoring Rā.

Chapter XVB. 2. A Hymn of praise to Rā-Harmachis when he setteth in the western horizon of heaven.

Vignette : The deceased adoring Rā.

Chapter XVB. 3. Another hidden Chapter of the *ṭuat*, and of passing through the secret places of the underworld, and of seeing the Disk when he setteth in Āmentet.

Vignette : The god or the deceased spearing a serpent.

Chapter XVIA. [No text : being only a vignette.]

Scene of the worship of the rising sun by mythological beings.

Chapter XVIB. Without title or text.

Vignette : Scene of the worship of the setting sun by mythological beings.

Chapter XVII. Here begin the praises and glorifyings of coming out from, and going into, the underworld in the beautiful Ȧmenta; of coming out by day, and of making transformations and of changing into any form which he pleaseth ; of playing at draughts in the *seḥ* chamber ; and of coming forth in the form of a living soul : to be said by the deceased after his death.

Vignette : The deceased playing at draughts ; the deceased adoring the lion-gods of yesterday and to-day ; the bier of Osiris with Isis and Nephthys at the foot and head respectively ; and a number of mythological beings referred to in the text.

Chapter XVIII. Without title.

Vignette : The deceased adoring the groups of gods belonging to various cities.

Chapter XIX.* The Chapter of the crown (?) of victory.

This Chapter has no vignette.

Chapter XX. Without title.

This Chapter has no vignette.

Chapter XXI.* The Chapter of giving a mouth to a man in the underworld.

This Chapter has no vignette.

Chapter XXII. The Chapter of giving a mouth to the deceased in the underworld.

Vignette : The guardian of the scales touching the mouth of the deceased.

Chapter XXIII. The Chapter of opening the mouth of the deceased in the underworld.

Vignette : The *sem* priest touching the mouth of the deceased with the instrument ⌒.

Chapter XXIV. The Chapter of bringing words of magical power to the deceased in the underworld.

This Chapter has no vignette.

Chapter XXV. The Chapter of causing a man to remember his name in the underworld.

Vignette : A priest holding up 𓊹 before the deceased.

Chapter XXVI. The Chapter of giving a heart to the deceased in the underworld.

Vignette : Anubis holding out a heart to the deceased in the underworld.

Chapter XXVII. The Chapter of not allowing the heart of a man to be taken from him in the underworld.

Vignette: A man tying a heart to the statue of the deceased.[1]

Chapter XXVIII. [The Chapter of] not allowing the heart of a man to be taken from him in the underworld.

Vignette: The deceased with his left hand touching the heart upon his breast, kneeling before a demon holding a knife.

Chapter XXIXA. The Chapter of not carrying away the heart of a man in the underworld.

This Chapter has no vignette.

Chapter XXIXB. Another Chapter of a heart of carnelian.

Vignette: The deceased sitting on a chair before his heart, which rests on a stand ⟨glyph⟩.

Chapter XXXA. The Chapter of not allowing the heart of a man to be driven away from him in the underworld.

Vignette: A heart ⟨glyph⟩.[2]

Chapter XXXB. The Chapter of not allowing the heart of a man to be driven away from him in the underworld.

Vignette: The deceased being weighed against his heart in the balance in the presence of Osiris, " the great god, the prince of eternity."

Chapter XXXI. The Chapter of repulsing the crocodile which cometh to carry the magical words ⟨glyphs⟩ from a man in the underworld.

Vignette: The deceased spearing a crocodile.

Chapter XXXII. [The Chapter of] coming to carry the magical words from a man in the underworld.

This Chapter has no vignette.

Chapter XXXIII. The Chapter of repulsing reptiles of all kinds.

Vignette: The deceased attacking four snakes with a knife in each hand.

Chapter XXXIV. The Chapter of a man not being bitten by a serpent in the hall of the tomb.[3]

This Chapter has no vignette.

Chapter XXXV. The Chapter of not being eaten by worms in the underworld.

[1] Two variants (Naville, *Todtenbuch*, Bd. I., Bl. 38) show the deceased sitting before his heart, and the deceased presenting his heart to a triad of gods.

[2] Or the deceased adoring his heart ⟨glyphs⟩ ; see also Naville, *Todtenbuch*, Bd. I., Bl. 42

[3] ⟨glyphs⟩ *āmiḫat.*

Vignette : Three serpents.

Chapter XXXVI. The Chapter of repulsing the tortoise (￼ *āpśai*).

Vignette : The deceased spearing a beetle.[1]

Chapter XXXVII. The Chapter of repulsing the two *merti* ￼ .

Vignette : Two uræi, which represent the two eyes of Rā.

Chapter XXXVIIIᴀ. The Chapter of living upon the air which is in the underworld.

Vignette : The deceased holding a sail ￼, emblematic of air.

Chapter XXXVIIIʙ. The Chapter of living upon air and of repulsing the two *merti*.

Vignette : The deceased attacking three serpents, a knife in his right hand and a sail in his left.

Chapter XXXIX. The Chapter of repulsing the serpent in the underworld.

Vignette : The deceased spearing a serpent.

Chapter XL. The Chapter of repulsing the eater of the ass.

Vignette : The deceased spearing a serpent which is biting the neck of an ass.

Chapter XLI. The Chapter of doing away with the wounding of the eyes in the underworld.

Vignette : The deceased holding a knife in the right hand and a roll in the left.

Chapter XLII. [The Chapter] of doing away with slaughter in Suten-ḥenen.

Vignette : A man holding a serpent.[2]

Chapter XLIII. The Chapter of not allowing the head of a man to be cut off from him in the underworld.

This Chapter has no vignette.

Chapter XLIV. The Chapter of not dying a second time.

This Chapter has no vignette.

Chapter XLV. The Chapter of not seeing corruption.

This Chapter has no vignette.

Chapter XLVI. The Chapter of not decaying, and of living in the underworld.

This Chapter has no vignette.

Chapter XLVII. The Chapter of not carrying off the place (*or* seat) of the throne from a man in the underworld.

[1] Or the deceased holding a knife and staff and standing before ￼ .

[2] For the variant vignettes see Naville, *Todtenbuch*, Bd. I., Bl. 57.

This Chapter has no vignette.

Chapter XLVIII. [The Chapter of a man coming against] his enemies.

This Chapter has no vignette.

Chapter XLIX.* The Chapter of a man coming forth against his enemies in the underworld.

Vignette : A man standing with a staff in his hand.

Chapter L. The Chapter of not going in to the divine block a second time.

Vignette : A man standing with his back to the block.[1]

Chapter LI. The Chapter of not walking upside down in the underworld.

Vignette : A man standing.

Chapter LII.* The Chapter of not eating filth in the underworld.

This Chapter has no vignette.

Chapter LIII. The Chapter of not allowing a man to eat filth and to drink polluted water in the underworld.

This Chapter has no vignette.

Chapter LIV. The Chapter of giving air in the underworld.

This Chapter has no vignette.

Chapter LV. Another Chapter of giving air.

Vignette : The deceased holding a sail in each hand.[2]

Chapter LVI. The Chapter of snuffing the air in the earth.

Vignette : The deceased kneeling, and holding a sail to his nose.

Chapter LVII. The Chapter of snuffing the air and of gaining the mastery over the waters in the underworld.

Vignette : A man holding a sail, and standing in a running stream.

Chapter LVIII.* The Chapter of snuffing the air and of gaining power over the water which is in the underworld.

Vignette : The deceased holding a sail.

Chapter LIX. The Chapter of snuffing the air and of gaining power over the water which is in the underworld.

Vignette : The deceased standing with his hands extended.

Chapters LX., LXI., LXII. The Chapters of drinking water in the underworld.

[1] Lepsius, *Todtenbuch*, Bl. 21.

[2] A variant vignette of Chapters LV. and XXXVIII. represents the deceased being led into the presence of Osiris by Anubis ; see Naville, *Todtenbuch*, Bd. I., Bl. 68.

Vignettes : The deceased holding a lotus ; the deceased holding his soul in his arms ; and the deceased scooping water into his mouth from a pool.

Chapter LXIIIA. The Chapter of drinking water, and of not being burnt with fire.

Vignette : The deceased drinking water from a stream.

Chapter LXIIIB. The Chapter of not being boiled (or scalded) in the water.

Vignette : The deceased standing by the side of two flames.

Chapter LXIV. The Chapter of coming forth by day in the underworld.

Vignette : The deceased adoring the disk, which stands on the top of a tree.

Chapter LXV. [The Chapter of] coming forth by day, and of gaining the mastery over foes.

Vignette : The deceased adoring Rā.

Chapter LXVI. [The Chapter of] coming forth by day.

This Chapter has no vignette.

Chapter LXVII. The Chapter of opening the doors of the *ṭuat* and of coming forth by day.

This Chapter has no vignette.

Chapter LXVIII. The Chapter of coming forth by day.

Vignette : The deceased kneeling by the side of a tree before a goddess.[1]

Chapter LXIX. Another Chapter.

Chapter LXX. Another Chapter.

Chapter LXXI. The Chapter of coming forth by day.

Vignette : The deceased with both hands raised in adoration kneeling before the goddess Meḥ-urt.[2]

Chapter LXXII. The Chapter of coming forth by day and of passing through the hall of the tomb.

Vignette : The deceased adoring three gods.

Chapter LXXIII. (This Chapter is now known as Chapter IX.)

Chapter LXXIV. The Chapter of lifting up the legs and coming forth upon earth.

Vignette : The deceased standing upright.

Chapter LXXV. The Chapter of travelling to Annu (On), and of receiving an abode there.

[1] For the variant vignettes see Naville, *Todtenbuch*, Bd. I., Bl. 80.

[2] One of the two variant vignettes shows the deceased in the act of adoring Rā , and in the other the deceased kneels before Rā, Thoth, and Osiris ; see Naville, *Todtenbuch*, Bd. I., Bl. 83.

Vignette : The deceased standing before the door of a tomb.

Chapter LXXVI. The Chapter of [a man] changing into whatsoever form he pleaseth.

This Chapter has no vignette.

Chapter LXXVII. The Chapter of changing into a golden hawk.

Vignette : A golden hawk ⟨𓅃⟩.

Chapter LXXVIII. The Chapter of changing into a divine hawk.

Vignette : A hawk.

Chapter LXXIX. The Chapter of being among the company of the gods, and of becoming a prince among the divine powers.

Vignette : The deceased adoring three gods.

Chapter LXXX. The Chapter of changing into a god, and of sending forth light into darkness.

Vignette : A god.

Chapter LXXXIA. The Chapter of changing into a lily.

Vignette : A lily.

Chapter LXXXIB. The Chapter of changing into a lily.

Vignette : The head of the deceased rising out of a lily 𓆸·

Chapter LXXXII. The Chapter of changing into Ptaḥ, of eating cakes, of drinking ale, of unloosing the body, and of living in Ȧnnu (On).

Vignette : The God Ptaḥ in a shrine.

Chapter LXXXIII. The Chapter of changing into a phœnix.

Vignette : A phœnix.

Chapter LXXXIV. The Chapter of changing into a heron.

Vignette : A heron.

Chapter LXXXV. The Chapter of changing into a soul, of not going into the place of punishment : whosoever knoweth it will never perish.

This Chapter has no vignette.

Chapter LXXXVI. The Chapter of changing into a swallow.

Vignette : A swallow.

Chapter LXXXVII. The Chapter of changing into the serpent Sa-ta.

Vignette : A serpent.

Chapter LXXXVIII. The Chapter of changing into a crocodile.

Vignette : A crocodile.

Chapter LXXXIX. The Chapter of making the soul to be united to its body.

Vignette : The soul visiting the body, which lies on a bier.

Chapter XC. The Chapter of giving memory to a man.

Vignette: A jackal.

Chapter XCI. The Chapter of not allowing the soul of a man to be shut in.

Vignette: A soul standing on a pedestal.

Chapter XCII. The Chapter of opening the tomb to the soul and shadow of a man, so that he may come forth and may gain power over his legs

Vignette: The soul of the deceased flying through the door of the tomb.

Chapter XCIII. The Chapter of not sailing to the east in the underworld.

Vignette: The hands of a buckle grasping the deceased by his left arm.

Chapter XCIV. The Chapter of praying for an ink jar and palette.

Vignette: The deceased sitting before a stand, upon which are an ink jar and palette.

Chapter XCV. The Chapter of being near Thoth.

Vignette: The deceased standing before Thoth.

Chapters XCVI., XCVII. The Chapter of being near Thoth, and of giving

.

Vignette: The deceased standing near Thoth.

Chapter XCVIII. [The title of this chapter is incomplete.]

Chapter XCIX. The Chapter of bringing a boat in the underworld.

Vignette: A boat.

Chapter C. The Chapter of making perfect the *khu*, and of making it to enter into the boat of Rā, together with his divine followers.

Vignette: A boat containing a company of gods.

Chapter CI.* The Chapter of protecting the boat of Rā.

Vignette: The deceased in the boat with Rā.

Chapter CII. The Chapter of going into the boat of Rā.

Vignette: The deceased in the boat with Rā.

Chapter CIII. The Chapter of being in the following of Hathor.

Vignette: The deceased standing behind Hathor.

Chapter CIV. The Chapter of sitting among the great gods.

Vignette: The deceased seated between two gods.

Chapter CV. The Chapter of satisfying the *ka* ⊔̣.

Vignette: The deceased burning incense before his *ka*.

Chapter CVI. The Chapter of causing joy each day to a man in Ḥet-ka-Ptaḥ (Memphis).

Vignette: An altar with meat and drink offerings.

Chapter CVII.* The Chapter of going into, and of coming forth from, the

gate of the gods of the west among the followers of the god, and of knowing the souls of Ámentet.

Vignette : Three deities : Rā, Sebek, and Hathor.

Chapter CVIII. The Chapter of knowing the souls of the West.

Vignette : Three deities : Tmu, Sebek, and Hathor.

Chapter CIX. The Chapter of knowing the souls of the East.

Vignette : The deceased making adoration before Rā-Ḥeru-khuti.

Chapter CX. The beginning of the Chapters of the Fields of Peace, and of the Chapters of coming forth by day, and of going into, and of coming forth from, the underworld, and of attaining unto the Fields of Reeds, and of being in the Fields of Peace.

Vignette : The Fields of Peace.

Chapter CXI. (This Chapter is now known as Chapter CVIII.)

Chapter CXII. The Chapter of knowing the souls of Pe.

Vignette : Horus, Mesthȧ, and Ḥāpi.

Chapter CXIII. The Chapter of knowing the souls of Nekhen.

Vignette : Horus, Ṭuamāutef, and Qebḥsennuf.

Chapter CXIV. The Chapter of knowing the souls of Khemennu (Hermopolis).

Vignette : Three ibis-headed gods.

Chapter CXV.* The Chapter of coming forth to heaven, of passing through the hall of the tomb, and of knowing the souls of Ȧnnu.

Vignette : The deceased adoring Thoth, Sau and Tmu.

Chapter CXVI. [The Chapter of] knowing the souls of Ȧnnu.

Vignette : The deceased adoring three ibis-headed gods.

Chapter CXVII. The Chapter of taking a way in Re-stau.

Vignette : The deceased, holding a staff in his hand, ascending the western hills.

Chapter CXVIII. The Chapter of coming forth from Re-stau.

Vignette : The deceased holding a staff in his left hand.

Chapter CXIX. The Chapter of knowing the name of Osiris, and of going into, and of coming forth from, Re-stau.

Vignette : The deceased adoring Osiris.

Chapter CXX. (This Chapter is now known as Chapter XII.)

Chapter CXXI. (This Chapter is now known as Chapter XIII.)

Chapter CXXII.* The Chapter of the deceased going in after coming forth from the underworld.

Vignette : The deceased bowing before his tomb, which is on a hill.

Chapter CXXIII. The Chapter of going into the great house (*i.e.*, tomb).

Vignette : The soul of the deceased standing before a tomb.

Chapter CXXIV. The Chapter of going in to the princes of Osiris.

Vignette : The deceased adoring Mesthà, Ḥāpi, Ṭuamāutef and Qebḥsennuf.

Chapter CXXV. The words which are to be uttered by the deceased when he cometh to the hall of Maāti, which separateth him from his sins, and which maketh him to see God, the Lord of mankind.

Vignette : The hall of Maāti, in which the heart of the deceased is being weighed in a balance in the presence of the great gods.

Chapter CXXVI. [Without title.]

Vignette : A lake of fire, at each corner of which sits an ape.

Chapter CXXVIIA. The book of the praise of the gods of the *qerti*

This Chapter has no vignette.

Chapter CXXVIIB. The Chapter of the words to be spoken on going to the chiefs of Osiris, and of the praise of the gods who are leaders in the *ṭuat*.

This Chapter has no vignette.

Chapter CXXVIII.* The Chapter of praising Osiris.

Vignette : The deceased adoring three deities.

Chapter CXXIX. (This Chapter in now known as Chapter C.)

Chapter CXXX. The Chapter of making perfect the *khu*.

Vignette : The deceased standing between two boats.

Chapter CXXXI.* The Chapter of making a man go into heaven to the side of Rā.

This Chapter has no vignette.

Chapter CXXXII. The Chapter of making a man to go round about to see his house.

Vignette : A man standing before a house or tomb.

Chapter CXXXIII. The Chapter of making perfect the *khu* in the underworld in the presence of the great company of the gods.

Vignette : The deceased adoring Rā, seated in a boat.

Chapter CXXXIV. The Chapter of entering into the boat of Rā, and of being among those who are in his train.

Vignette : The deceased adoring Shu, Tefnut, Seb, Nut, Osiris, Isis, Horus, Hathor.

Chapter CXXXV.* Another Chapter, which is to be recited at the waxing of the moon [each] month.

This Chapter has no vignette.

Chapter CXXXVIA. The Chapter of sailing in the boat of Rā.

Vignette : The deceased standing with hands raised in adoration.

Chapter CXXXVIB. The Chapter of sailing in the great boat of Rā, to pass round the fiery orbit of the sun.

This Chapter has no vignette.

Chapter CXXXVIIA. The Chapter of kindling the fire which is to be made in the underworld.

This Chapter has no vignette.

Chapter CXXXVIIB. The Chapter of the deceased kindling the fire.

Vignette : The deceased seated, kindling a flame.

Chapter CXXXVIII. The Chapter of making the deceased to enter into Abydos.

Vignette : The deceased adoring the standard ⚑.

Chapter CXXXIX. (This Chapter is now known as Chapter CXXIII.)

Chapter CXL.* The Book which is to be recited in the second month of *pert*, when the *utchat* is full in the second month of *pert*.

Vignette : The deceased adoring Ȧnpu, the *utchat*, and Rā.

Chapters CXLI–CXLIII. The Book which is to be recited by a man for his father and for his son at the festivals of Ȧmentet. It will make him perfect before Rā and before the gods, and he shall dwell with them. It shall be recited on the ninth day of the festival.

Vignette : The deceased making offerings before a god.

Chapter CXLIV. The Chapter of going in.

Vignette : Seven pylons.

Chapter CXLVA. [Without title.]

This Chapter has no vignette.

Chapter CXLVB. [The Chapter] of coming forth to the hidden pylons.

This Chapter has no vignette.

Chapter CXLVI. [The Chapter of] knowing the pylons in the house of Osiris in the Field of Ȧaru.

Vignette : A series of pylons guarded each by a god.

Chapter CXLVII. [A Chapter] to be recited by the deceased when he cometh to the first hall of Ȧmentet.

Vignette: A series of doors, each guarded by a god.

Chapter CXLVIII. [The Chapter] of nourishing the *khu* in the underworld, and of removing him from every evil thing.

This Chapter has no vignette.

Chapter CXLIX. [Without title.]

Vignette: The divisions of the other world.

Chapter CL. [Without title.]

Vignette: Certain divisions of the other world.

Chapter CLI. [Without title.]

Vignette: Scene of the mummy chamber.

Chapter CLI*a*. [Chapter] of the hands of Ȧnpu, the dweller in the sepulchral chamber, being upon the lord of life (*i.e.*, the mummy).

Vignette: Anubis standing by the bier of the deceased.

Chapter CLI*b*. The Chapter of the chief of hidden things.

Vignette: A human head.

Chapter CLII. The Chapter of building a house in the earth.

Vignette: The deceased standing by the foundations of his house.

Chapter CLIIIA. The Chapter of coming forth from the net.

Vignette: A net being drawn by a number of men.

CLIIIB. The Chapter of coming forth from the fishing net.

Vignette: Three apes drawing a fishing net.

Chapter CLIV. The Chapter of not allowing the body of a man to decay in the tomb.

This Chapter has no vignette.

Chapter CLV. The Chapter of a Ṭeṭ of gold to be placed on the neck of the *khu*.

Vignette: A Ṭeṭ ⬚.

Chapter CLVI. The Chapter of a buckle of amethyst to be placed on the neck of the *khu*.

Vignette: A Buckle ⬚.

Chapter CLVII*. The Chapter of a vulture of gold to be placed on the neck of the *khu*.

Vignette: A vulture.

Chapter CLVIII.* The Chapter of a collar of gold to be placed on the neck of the *khu*.

Vignette: A collar.

Chapter CLIX.* The Chapter of a sceptre of mother-of-emerald to be placed on the neck of the *khu*.

Vignette: A sceptre ⌇.

Chapter CLX. [The Chapter] of placing a plaque of mother-of-emerald.

Vignette: A plaque.

Chapter CLXI. The Chapter of the opening of the doors of heaven by Thoth, *etc.*

Vignette: Thoth opening four doors.

Chapter CLXII.* The Chapter of causing heat to exist under the head of the *khu*.

Vignette: A cow.

Chapter CLXIII.* The Chapter of not allowing the body of a man to decay in the underworld.

Vignette: Two *utchats*, and a serpent on legs.

Chapter CLXIV.* Another Chapter.

Vignette: A three-headed goddess, winged, standing between two pigmies.

Chapter CLXV.* The Chapter of arriving in port, of not becoming unseen, and of making the body to germinate, and of satisfying it with the water of heaven.

Vignette: The god Min or Āmsu with beetle's body, *etc.*

Chapter CLXVI. The Chapter of the pillow.

Vignette: A pillow.

Chapter CLXVII. The Chapter of bringing the *utchat*.

This Chapter has no vignette.

Chapter CLXVIIIA. [Without title.]

Vignette: The boats of the sun, *etc.*

Chapter CLXVIIIB. [Without title.]

Vignette: Men pouring libations, gods, *etc.*

Chapter CLXIX. The Chapter of setting up the offering chamber.

This Chapter has no vignette.

Chapter CLXX. The Chapter of the roof of the offering chamber.

This Chapter has no vignette.

Chapter CLXXI. The Chapter of tying the *ābu*.

This Chapter has no vignette.

Chapter CLXXII. Here begin the praises which are to be recited in the underworld.

This Chapter has no vignette.

Chapter CLXXIII. Addresses by Horus to his father.

Vignette : The deceased adoring Osiris.

Chapter CLXXIV. The Chapter of causing the *khu* to come forth from the great gate of heaven.

Vignette : The deceased coming forth from a door.

Chapter CLXXV. The Chapter of not dying a second time in the underworld.

Vignette : The deceased adoring an ibis-headed god.

Chapter CLXXVI. The Chapter of not dying a second time in the under-world.

This Chapter has no vignette.

Chapter CLXXVII. The Chapter of raising up the *khu*, and of making the soul to live in the underworld.

This Chapter has no vignette.

Chapter CLXXVIII. The Chapter of raising up the body, of making the eyes to see, of making the ears to hear, of setting firm the head and of giving it its powers.

This Chapter has no vignette.

Chapter CLXXIX. The Chapter of coming forth from yesterday, of coming forth by day, and of praying with the hands.

This Chapter has no vignette.

Chapter CLXXX. The Chapter of coming forth by day, of praising Rā in Amentet, and of ascribing praise unto those who are in the *tuat*.

Vignette : The deceased adoring Rā.

Chapter CLXXXI. The Chapter of going in to the divine chiefs of Osiris who are the leaders in the *tuat*.

Vignette : The deceased adoring Osiris, *etc.*

Chapter CLXXXII. The Book of stablishing the backbone of Osiris, of giving breath to him whose heart is still, and of the repulse of the enemies of Osiris by Thoth.

Vignette : The deceased lying on a bier in a funeral chest, surrounded by various gods.

Chapter CLXXXIII. A hymn of praise to Osiris ; ascribing to him glory, and to Un-nefer adoration.

Vignettes : The deceased, with hands raised in adoration, and the god Thoth.

Chapter CLXXXIV. The Chapter of being with Osiris.

Vignette : The deceased standing by the side of Osiris.

Chapter CLXXXV. The ascription of praise to Osiris, and of adoration to
the everlasting lord.

Vignette : The deceased making adoration to Osiris.

Chapter CLXXXVI. A hymn of praise to Hathor, mistress of Amentet,
and to Meḥ-urt.

Vignette : The deceased approaching the mountain of the dead, from which
appears the goddess Hathor.

The version akin to the Theban was in vogue from the XXth to the XXVIth
dynasty, i.e., about B.C. 1200–550, and was, like the Theban, usually written upon
papyrus. The chapters have no fixed order, and are written in lines in the hieratic
character; the rubrics, catchwords, and certain names, like that of Āpep, are in
red. The vignettes are roughly traced in black outline, and are without ornament;
but at the ends of the best papyri well-painted scenes, in which the deceased is
depicted making adoration to Rā or Horus, are frequently found. The names and
titles of the deceased are written in perpendicular rows of hieroglyphics. The
character of the handwriting changes in different periods : in the papyrus of the
Princess Nesi-Khonsu (about B.C. 1000) it is bold and clear, and much resembles
the handsome style of that found in the great Harris papyrus;[1] but within a
hundred years, apparently, the fine flowing style disappears, and the writing
becomes much smaller and is somewhat cramped; the process of reduction in size
continues until the XXVIth dynasty, about B.C. 550, when the small and coarsely
written characters are frequently difficult to decipher. The papyri upon which
such texts are written vary in length from three to about thirty feet, and in width
from nine to eighteen inches; as we approach the period of the XXVIth dynasty
the texture becomes coarser and the material is darker in colour. The Theban
papyri of this period are lighter in colour than those found in the north of Egypt
and are less brittle ; they certainly suffer less in unrolling.

[1] The Books of the Dead written in the hieroglyphic and hieratic characters which belong to the
period of the rule of the priest-kings of the brotherhood of Āmen form a class by themselves, and have
relatively little in common with the older versions. A remarkable example of this class is the papyrus
of Nesi-Khonsu which M. Maspero published (*Les Momies Royales de Déir el-baharî*, p. 600 f.). The
text is divided into paragraphs, which contain neither prayers nor hymns but a veritable contract
between the god Āmen-Rā and the princess Nesi-Khonsu. After the list of the names and titles of
Āmen-Rā with which it begins follow eleven sections wherein the god declares in legal phraseology that
he hath deified the princess (𓇳𓏏𓈖𓏏𓈖𓏏𓈖𓏏𓈖) in Āmenta and in Neter-
khert ; that he hath deified her soul and her body in order that neither may be destroyed ; that he hath
made her divine like every god and goddess ; and that he hath decreed that whatever is necessary for
her in her new existence shall be done for her, even as it is done for every other god and goddess.

The Saïte and Ptolemaïc version was in vogue from the period of the XXVIth dynasty, about B.C. 550, to probably the end of the rule of the Ptolemies over Egypt. The chapters have a fixed and definite order, and it seems that a careful revision of the whole work was carried out, and that several alterations of an important nature were made in it. A number of chapters which are not found in older papyri appear during this period; but these are not necessarily new inventions, for, as the kings of the XXVIth dynasty are renowned for having revived the arts and sciences and literature of the earliest dynasties, it is quite possible that many or most of the additional chapters are nothing more than new editions of extracts from older works. Many copies of this version were written by scribes who did not understand what they were copying, and omissions of signs, words, and even whole passages are very common; in papyri of the Ptolemaïc period it is impossible to read many passages without the help of texts of earlier periods. The papyri of this period vary in colour from a light to a dark brown, and consist usually of layers composed of strips of the plant measuring about 2 inches in width and 14½ to 16 inches in length. Fine examples of Books of the Dead of this version vary in length from about 24½ feet (B.M. No. 10,479, written for the *utcheb* Ḥeru, the son of the *utcheb* Tcheḥrȧ 𓄿𓏥 ° 𓄿𓏥 𓈖) to 60 feet. Hieroglyphic texts are written in black, in perpendicular rows between rules, and hieratic texts in horizontal lines; both the hieroglyphics and the hieratic characters lack the boldness of the writing of the Theban period, and exhibit the characteristics of a conventional hand. The titles of the chapters, catchwords, the words 𓂋𓏤 which introduce a variant reading, *etc.*, are sometimes written in red. The vignettes are usually traced in black outline, and form a kind of continuous border above the text. In good papyri, however, the scene forming the XVIth Chapter, the scene of the Fields of Peace (Chapter CX.), the Judgment scene (Chapter CXXV.), the vignette of Chapter CXLVIII., the scene forming Chapter CLI. (the sepulchral chamber), and the vignette of Chapter CLXI., fill the whole width of the inscribed portion of the papyrus, and are painted in somewhat crude colours. In some papyri the disk on the head of the hawk of Horus is covered with gold leaf, instead of being painted red as is usual in older papyri. In the Græco-Roman period both texts and vignettes are very carelessly executed, and it is evident that they were written and drawn by ignorant workmen in the quickest and most careless way possible. In this period also certain passages of the text were copied in hieratic and Demotic upon small pieces of papyri which were buried with portions of the bodies of the dead, and upon narrow bandages of coarse linen in which they were swathed.

THE LEGEND OF OSIRIS.

The chief features of the Egyptian religion remained unchanged from the Vth and VIth dynasties down to the period when the Egyptians embraced Christianity, after the preaching of St. Mark the Apostle in Alexandria, A.D. 69, so firmly had the early beliefs taken possession of the Egyptian mind; and the Christians in Egypt, or Copts as they are commonly called, the racial descendants of the ancient Egyptians, seem never to have succeeded in divesting themselves of the superstitious and weird mythological conceptions which they inherited from their heathen ancestors. It is not necessary here to repeat the proofs of this fact which M. Amélineau has brought together,[1] or to adduce evidence from the lives of the saints, martyrs and ascetics; but it is of interest to note in passing that the translators of the New Testament into Coptic rendered the Greek ἄδης by ⲁⲙⲉⲛϯ,[2] amenti, the name which the ancient Egyptians gave to the abode of man after death,[3] and that the Copts peopled it with beings whose prototypes are found on the ancient monuments.

The chief gods mentioned in the pyramid texts are identical with those whose names are given on tomb, coffin and papyrus in the latest dynasties; and if the names of the great cosmic gods, such as Ptaḥ and Khnemu, are of rare occurrence, it should be remembered that the gods of the dead must naturally occupy the chief place in this literature which concerns the dead. Furthermore, we find that the doctrine of eternal life and of the resurrection of a glorified or transformed body, based upon the ancient story of the resurrection of Osiris after a cruel death and horrible mutilation, inflicted by the powers of evil, was the same in all periods, and that the legends of the most ancient times were accepted without material alteration or addition in the texts of the later dynasties.

[1] *Le Christianisme chez les anciens Coptes*, in *Revue des Religions*, t. xiv., Paris, 1886, pp. 308–45.

[2] *I.e.,* 𓊹𓏏𓈗.

[3] See St. Matthew xi., 23; Acts ii., 27, etc.

The story of Osiris is nowhere found in a connected form in Egyptian litera-
ture, but everywhere, and in texts of all periods, the life, sufferings, death and
resurrection of Osiris are accepted as facts universally admitted. Greek writers
have preserved in their works traditions concerning this god, and to Plutarch in
particular we owe an important version of the legend as current in his day. It is
clear that in some points he errs, but this was excusable in dealing with a series of
traditions already some four thousand years old.[1] According to this writer the
goddess Rhea [Nut], the wife of Helios [Rā], was beloved by Kronos [Seb]. When
Helios discovered the intrigue, he cursed his wife and declared that she should
not be delivered of her child in any month or in any year. Then the god Hermes,
who also loved Rhea, played at tables with Selene and won from her the seventieth
part of each day of the year, which, added together, made five whole days. These
he joined to the three hundred and sixty days of which the year then consisted.[2]
Upon the first of these five days was Osiris brought forth ;[3] and at the moment of
his birth a voice was heard to proclaim that the lord of creation was born. In
course of time he became king of Egypt, and devoted himself to civilizing his
subjects and to teaching them the craft of the husbandman ; he established a code
of laws and bade men worship the gods. Having made Egypt peaceful and
flourishing, he set out to instruct the other nations of the world. During his
absence his wife Isis so well ruled the state that Typhon [Set], the evil one, could
do no harm to the realm of Osiris. When Osiris came again, Typhon plotted with
seventy-two comrades, and with Aso, the queen of Ethiopia, to slay him ; and
secretly got the measure of the body of Osiris, and made ready a fair chest, which
was brought into his banqueting hall when Osiris was present together with other
guests. By a ruse Osiris was induced to lie down in the chest, which was imme-
diately closed by Typhon and his fellow conspirators, who conveyed it to the
Tanaitic mouth of the Nile.[4] These things happened on the seventeenth day of

[1] For the text see *De Iside et Osiride*, ed. Didot (Scripta Moralia, t. iii., pp. 429-69), § xii. ff.

[2] The days are called in hieroglyphics ⊙ 𝄞 𓏏 𓎡 | ⌒ , "the five additional days of the
year," ἐπαγόμεναι ἡμέραι πέντε; see Brugsch, *Thesaurus Inscriptionum Aegyptiacarum*, Abt. ii. (*Kalen-
darische Inschriften*), Leipzig, 1883, pp. 479, 480 ; Brugsch, *Aegyptologie*, p. 361 ; Chabas, *Le Calendrier*,
Paris (no date), p. 99 ff.

[3] Osiris was born on the first day, Horus on the second, Set on the third, Isis on the fourth, and
Nephthys on the fifth ; the first, third, and fifth of these days were considered unlucky by the Egyptians.

[4] The mouths of the Nile are discussed and described by Strabo, XVII., i., 18 (ed. Didot, p. 681) ;
and by Diodorus, I., 33, 7 (ed. Didot, p. 26).

the month Hathor,[1] when Osiris was in the twenty-eighth year either of his reign or of his age. The first to know of what had happened were the Pans and Satyrs, who dwelt hard by Panopolis; and finally the news was brought to Isis at Coptos, whereupon she cut off a lock of hair[2] and put on mourning apparel. She then set out in deep grief to find her husband's body, and in the course of her wanderings she discovered that Osiris had been united with her sister Nephthys, and that Anubis, the offspring of the union, had been exposed by his mother as soon as born. Isis tracked him by the help of dogs, and bred him up to be her guard and attendant. Soon after she learned that the chest had been carried by the sea to Byblos, where it had been gently laid by the waves among the branches of a tamarisk tree (ἐρείκῃ τινὶ), which in a very short time had grown to a magnificent size and had enclosed the chest within its trunk. The king of the country, admiring the tree, cut it down and made a pillar for the roof of his house of that part which contained the body of Osiris. When Isis heard of this she went to Byblos, and, gaining admittance to the palace through the report of the royal maidens, she was made nurse to one of the king's sons. Instead of nursing the child in the ordinary way, Isis gave him her finger to suck, and each night she put him into the fire to consume his mortal parts, changing herself the while into a swallow and bemoaning her fate. But the queen once happened to see her son in flames, and cried out, and thus deprived him of immortality. Then Isis told the queen her story and begged for the pillar which supported the roof. This she cut open, and took out the chest and her husband's body,[3] and her lamentations were so terrible that one of the royal children died of fright. She then brought the

[1] In the Calendar in the fourth Sallier papyrus (No. 10,184) this day is marked triply unlucky 𓏤𓏤𓏤, and it is said that great lamentation by Isis and Nephthys took place for Un-nefer (Osiris) thereon. See Chabas, *Le Calendrier*, p. 50. Here we have Plutarch's statement supported by documentary evidence. Some very interesting details concerning the festivals of Osiris in the month Choiak are given by Loret in *Recueil de Travaux*, t. iii., p. 43 ff; t. iv., p. 21 ff.; and t. v., p. 85 ff. The various mysteries which took place thereat are minutely described.

[2] On the cutting of the hair as a sign of mourning, see W. Robertson Smith, *The Religion of the Semites*, p. 395; and for other beliefs about the hair see Tylor, *Primitive Culture*, vol. ii., p. 364, and Fraser, *Golden Bough*, pp. 193-208.

[3] The story continues that Isis then wrapped the pillar in fine linen and anointed it with oil, and restored it to the queen. Plutarch adds that the piece of wood is, to this day, preserved in the temple of Isis, and worshipped by the people of Byblos. Prof. Robertson Smith suggests (*Religion of the Semites*, p. 175) that the rite of draping and anointing a sacred stump supplies the answer to the unsolved question of the nature of the ritual practices connected with the Ashera. That some sort of drapery belonged to the Ashera is clear from 2 Kings xxiii., 7. See also Tylor, *Primitive Culture*, vol. ii., p. 150; and Fraser, *Golden Bough*, vol. i., p. 304 ff.

chest by ship to Egypt, where she opened it and embraced the body of her husband, weeping bitterly. Then she sought her son Horus in Buto, in Lower Egypt, first having hidden the chest in a secret place. But Typhon, one night hunting by the light of the moon, found the chest, and, recognizing the body, tore it into fourteen pieces, which he scattered up and down throughout the land. When Isis heard of this she took a boat made of papyrus [1]—a plant abhorred by crocodiles—and sailing about she gathered the fragments of Osiris's body.[2] Wherever she found one, there she built a tomb. But now Horus had grown up, and being encouraged to the use of arms by Osiris, who returned from the other world, he went out to do battle with Typhon, the murderer of his father. The fight lasted many days, and Typhon was made captive. But Isis, to whom the care of the prisoner was given, so far from aiding her son Horus, set Typhon at liberty. Horus in his rage tore from her head the royal diadem ; but Thoth gave her a helmet in the shape of a cow's head. In two other battles fought between Horus and Typhon, Horus was the victor.[3]

 This is the story of the sufferings and death of Osiris as told by Plutarch. Osiris was the god through whose sufferings and death the Egyptian hoped that his body might rise again in some transformed or glorified shape, and to him who had conquered death and had become the king of the other world the Egyptian appealed in prayer for eternal life through his victory and power. In every funeral inscription known to us, from the pyramid texts down to the roughly-written prayers upon coffins of the Roman period, what is done for Osiris is done also for the deceased, the state and condition of Osiris are the state and condition of

[1] The ark of "bulrushes" was, no doubt, intended to preserve the child Moses from crocodiles.

[2] Μόνον δὲ τῶν μερῶν τοῦ Ὀσίριδος τὴν Ἶσιν οὐχ εὑρεῖν τὸ αἰδοῖον· εὐθὺς γὰρ εἰς τὸν ποταμὸν ῥιφῆναι, καὶ γεύσασθαι τόν τε λεπιδωτὸν αὐτοῦ καὶ τὸν φάγρον καὶ τὸν ὀξύρυγχον. κ.τ.λ. By the festival celebrated by the Egyptians in honour of the model of the lost member of Osiris, we are probably to understand the

public performance of the ceremony of "setting up the Ṭeṭ in Tattu" , which we know took place on the last day of the month Choiak ; see Loret, *Les Fêtes d'Osiris au mois de Khoiak* (*Recueil de Travaux*, t. iv., p. 32, § 87) ; Plutarch, *De Iside*, § xviii.

[3] An account of the battle is also given in the IVth Sallier papyrus, wherein we are told that it took place on the 26th day of the month Thoth. Horus and Set fought in the form of two men, but they afterwards changed themselves into two bears, and they passed three days and three nights in this form. Victory inclined now to one side, and now to the other, and the heart of Isis suffered bitterly. When Horus saw that she loosed the fetters which he had laid upon Set, he became like a "raging panther of the south with fury," and she fled before him ; but he pursued her, and cut off her head, which Thoth transformed by his words of magical power and set upon her body again in the form of that of a cow. In the calendars the 26th day of Thoth was marked triply deadly . See Chabas, *Le Calendrier*, p. 28 ff.

the deceased; in a word, the deceased is identified with Osiris. If Osiris liveth for ever, the deceased will live for ever; if Osiris dieth, then will the deceased perish.[1]

[1] The origin of Plutarch's story of the death of Osiris, and the Egyptian conception of his nature and attributes, may be gathered from the following very remarkable hymn. (The text is given by Ledrain, *Les Monuments Égyptiens de la Bibliothèque Nationale*, Paris, 1879, pll. xxi–xxvii. A French translation of it was published, with notes, by Chabas, in *Revue Archéologique*, Paris, 1857, t. xiv., p. 65 ff.; and an English version was given in *Records of the Past*, 1st series, vol. iv., p. 99 ff. The stele upon which it is found belongs to the early part of the XVIIIth dynasty, by which is meant the period before the reign of Amenophis IV.; this is proved by the fact that the name of the god Åmen has been cut out of it, an act of vandalism which can only have been perpetrated in the fanatical reign of Amenophis IV.) :—

"(1) Hail to thee, Osiris, lord of eternity, king of the gods, thou who hast many names, thou disposer "of created things, thou who hast hidden forms in the temples, thou sacred one, thou KA who "dwellest in Tattu, thou mighty (2) one in Sekhem, thou lord to whom invocations are made in Anti, thou "who art over the offerings in Ånnu, thou lord who makest inquisition in two-fold right and truth, thou "hidden soul, the lord of Qerert, thou who disposest affairs in the city of the White Wall, thou soul of "Rå, thou very body of Rå who restest in (3) Suten-henen, thou to whom adorations are made in the region "of Nårt, thou who makest the soul to rise, thou lord of the Great House in Khemennu, thou mighty "of terror in Shas-hetep, thou lord of eternity, thou chief of Åbtu, thou who sittest upon thy throne in "Ta-tchesert, thou whose name is established in the mouths of (4) men, thou unformed matter of the "world, thou god Tum, thou who providest with food the *ka*'s who are with the company of the gods, "thou perfect *khu* among the *khu*'s, thou provider of the waters of Nu, thou giver of the wind, thou "producer of the wind of the evening from thy nostrils for the satisfaction of thy heart. Thou makest (5) "plants to grow at thy desire, thou givest birth to ; to thee are obedient the stars in the "heights, and thou openest the mighty gates. Thou art the lord to whom hymns of praise are sung "in the southern heaven, and unto thee are adorations paid in the northern heaven. The never setting "stars (6) are before thy face, and they are thy thrones, even as also are those that never rest. An "offering cometh to thee by the command of Seb. The company of the gods adoreth thee, the stars "of the *tuat* bow to the earth in adoration before thee, [all] domains pay homage to thee, and the ends "of the earth offer entreaty and supplication. When those who are among the holy ones (7) see thee "they tremble at thee, and the whole world giveth praise unto thee when it meeteth thy majesty. "Thou art a glorious *sāhu* among the *sāhu*'s, upon thee hath dignity been conferred, thy dominion is "eternal, O thou beautiful Form of the company of the gods; thou gracious one who art beloved "by him that (8) seeth thee. Thou settest thy fear in all the world, and through love for thee all "proclaim thy name before that of all other gods. Unto thee are offerings made by all mankind, "O thou lord to whom commemorations are made, both in heaven and in earth. Many are the "shouts of joy that rise to thee at the Uak* festival, and cries of delight ascend to thee from the "(9) whole world with one voice. Thou art the chief and prince of thy brethren, thou art the prince of "the company of the gods, thou stablishest right and truth everywhere, thou placest thy son upon thy "throne, thou art the object of praise of thy father Seb, and of the love of thy mother Nut. Thou art "exceeding mighty, thou overthrowest those who oppose thee, thou art mighty of hand, and thou "slaughterest thine (10) enemy. Thou settest thy fear in thy foe, thou removest his boundaries, thy "heart is fixed, and thy feet are watchful. Thou art the heir of Seb and the sovereign of all the earth;

* This festival took place on the 17th and 18th days of the month Thoth; see Brugsch, *Kalendarische Inschriften*, p. 235.

Later in the XVIIIth, or early in the XIXth dynasty, we find Osiris called
" the king of eternity, the lord of everlastingness, who traverseth millions of years
" in the duration of his life, the firstborn son of the womb of Nut, begotten of Seb,
" the prince of gods and men, the god of gods, the king of kings, the lord of lords,
" the prince of princes, the governor of the world, from the womb of Nut, whose
" existence is for everlasting,[1] Unnefer of many forms and of many attributes, Tmu
" in Ȧnnu, the lord of Ȧkert,[2] the only one, the lord of the land on each side of the
" celestial Nile."[3]

In the XXVIth dynasty and later there grew up a class of literature repre-

" Seb hath seen thy glorious power, and hath commanded thee to direct the (11) universe for ever and
" ever by thy hand.

" Thou hast made this earth by thy hand, and the waters thereof, and the wind thereof, the herb
" thereof, all the cattle thereof, all the winged fowl thereof, all the fish thereof, all the creeping things
" thereof, and all the four-footed beasts thereof. (12) O thou son of Nut, the whole world is gratified
" when thou ascendest thy father's throne like Rā. Thou shinest in the horizon, thou sendest forth
" thy light into the darkness, thou makest the darkness light with thy double plume, and thou floodest
" the world with light like the (13) Disk at break of day. Thy diadem pierceth heaven and becometh
" a brother unto the stars, O thou form of every god. Thou art gracious in command and in speech,
" thou art the favoured one of the great company of the gods, and thou art the greatly beloved one of
" the lesser company of the gods.

" Thy sister put forth her protecting power for thee, she scattered abroad those who were her
" enemies, (14) she drove back evil hap, she pronounced mighty words of power, she made cunning
" her tongue, and her words failed not. The glorious Isis was perfect in command and in speech,
" and she avenged her brother. She sought him without ceasing, (15) she wandered round and round
" the earth uttering cries of pain, and she rested* not until she had found him. She overshadowed
" him with her feathers, she made wind with her wings, and she uttered cries at the burial of her
" brother. (16) She raised up the prostrate form of him whose heart was still, she took from him of
" his essence, she conceived and brought forth a child,† she suckled it in secret (?) and none knew the
" place thereof; and the arm of the child hath waxed strong in the great house of Seb. (17) The
" company of the gods rejoiceth and is glad at the coming of Osiris's son Horus, and firm of heart and
" triumphant is the son of Isis, the heir of Osiris."‡

[1] For the text see the papyrus of Ani, pl. ii., and pl. xxxvi., l. 2.

[2] *I.e.*, the underworld.

[3] *neb ȧṭebui;* see Ani, pl. xix., l. 9.

* Literally, " she alighted not," ; the whole passage here justifies Plutarch's statement (*De Iside
de Osiride*, 16) concerning Isis : Αὐτὴν δὲ γενομένην χελιδόνα τῇ κίονι περιπίτεσθαι καὶ θρηνεῖν.

† Compare Plutarch, *op. cit.*, § 19: Τὴν δ' Ἰσιν μετὰ τὴν τελευτὴν ἐξ Ὀσίριδος συγγενομένου, τεκεῖν ἠλίτόμηνον καὶ
ἀσθενῆ τοῖς κάτωθεν γυίοις τὸν Ἀρποκράτην.

‡ The remainder of the hymn refers to Horus.

sented by such works as "The Book of Respirations,"[1] "The Lamentations of Isis and Nephthys,"[2] "The Festival Songs of Isis and Nephthys,"[3] "The Litanies of Seker,"[4] and the like, the hymns and prayers of which are addressed to Osiris rather as the god of the dead and type of the resurrection[5] than as the successor of the great cosmic god Tmu-Rā. He is called "the soul that liveth again,"[6] "the being who becometh a child again," "the firstborn son of unformed matter, the lord " of multitudes of aspects and forms, the lord of time and bestower of years, the lord " of life for all eternity."[7] He is the "giver of life from the beginning;"[8] life " springs up to us from his destruction,"[9] and the germ which proceeds from him engenders life in both the dead and the living. [10]

[1] . The text of this work, transcribed into hieroglyphics, was published, with a Latin translation, by Brugsch, under the title, *Sai an Sinsin sive liber Metempsychosis veterum Aegyptiorum*, Berlin, 1851; and an English translation of the same work, but made from a Paris MS., was given by P. J. de Horrack in *Records of the Past*, 1st series, vol., iv., p. 121 ff. See also Birch, *Facsimiles of Two Papyri*, London, 1863, p. 3; Devéria, *Catalogue des MSS. Égyptiens*, Paris, 1874, pp. 130 ff., where several copies of this work are described.

[2] The hieratic text of this work is published with a French translation by P. J. de Horrack, *Les Lamentations d'Isis et de Nephthys*, Paris, 1886.

[3] A hieroglyphic transcript of these works, with an English translation, was given in *Archæologia*, vol. lii., London, 1891.

[4] What Devéria says with reference to the Book of Respirations applies to the whole class: "Toutefois, on remarque dans cet écrit une tendance à la doctrine de la résurrection du corps plus marquée que dans les compositions antérieures" (*Catalogue*, p. 13).

[5] . *Festival Songs*, iv., 33.

[6] . *Ibid.*, viii., 21, ix., 8.

[7] *Litanies of Seker*, col. xviii.

[8] . *Festival Songs*, vi., 1.

[9] . *Ibid.*, iii., 18.

[10] . *Ibid.*, ix., 26.

THE DOCTRINE OF ETERNAL LIFE.

The ideas and beliefs which the Egyptians held in reference to a future existence are not readily to be defined, owing to the many difficulties in translating religious texts and in harmonizing the statements made in different works of different periods. Some confusion of details also seems to have existed in the minds of the Egyptians themselves, which cannot be cleared up until the literature of the subject has been further studied and until more texts have been published. That the Egyptians believed in a future life of some kind is certain; and the doctrine of eternal existence is the leading feature of their religion, and is enunciated with the utmost clearness in all periods. Whether this belief had its origin at Ánnu, the chief city of the worship of the sun-god, is not certain, but is very probable; for already in the pyramid texts we find the idea of everlasting life associated with the sun's existence, and Pepi I. is said to be "the Giver of life, stability, power, health, and all joy of heart, like the Sun, living for ever."[1] The sun rose each day in renewed strength and vigour, and the renewal of youth in a future life was the aim and object of every Egyptian believer. To this end all the religious literature of Egypt was composed. Let us take the following extracts from texts of the VIth dynasty as illustrations :—

1.

ha	Unás	án	śem-nek	ás	met-θ	śem-nek	ánχet
Hail	Unás,	not hast thou gone, behold,	[as] one dead,			thou hast gone	[as] one living

ḥems	ḥer	χenṭ	Áusár
to sit	upon	the throne of	Osiris.[2]

[1] Recueil de Travaux, t. v., p. 167 (l. 65).

[2] Recueil de Travaux, t. iii., p. 201 (l. 206). The context runs "Thy Sceptre ⸽ is in thy hand, and thou givest commands unto the living ones. The *Mekes* and *Nehbet* sceptres are in thy hand, and thou givest commands unto those whose abodes are secret."

2.

Rā-Tem	i-nek	sa-k	i-nek	Unàs	sa-k	pu	en
O Rā-Tum,	cometh to thee	thy son,	cometh to thee	Unàs	thy son	is this	of

t'et-k	en	t'etta
thy body	for	ever.[1]

3.

Tem	sa-k	pu	penen Àusàr	ṭā-nek	set'eb-f	ānχ-f	ānχ-f
O Tum,	thy son	is this	Osiris;	thou hast given	his sustenance	and he liveth;	he liveth,

ānχ	Unàs	pen	àn	mit-f	àn	mit	Unàs	pen
and liveth	Unàs	this;	not	dieth he,	not	dieth	Unàs	this.[2]

4.

ḥetep	Unàs	em	ānχ	em	Àmenta
Setteth	Unàs	in	life	in	Àmenta.[3]

5.

àu	ām-nef	sàa	en	neter	neb	āḥàu	pà	neḥeḥ	t'er-f
He[4] hath eaten	the knowledge	of	god	every,	[his] existence	is for all	eternity		

pà	t'etta	em	sāḥ-f	pen	en	merer-f	àri-f	mest'et'-f
and to everlasting	in	his sāḥ[5]	this;	what	he willeth	he doeth,	[what] he hateth	

àn	àri-nef
not	doth he do.[6]

1 *Recueil de Travaux*, t. iii., p. 208 (ll. 232, 233). 2 *Recueil de Travaux*, t. iii., p. 209 (l. 240).
3 *Ibid.*, t. iv., p. 50 (l. 445). The allusion here is to the setting of the sun.
4 *I.e.*, Unàs. 5 See page lix.
6 *Recueil de Travaux*, t. iv., p. 61 (ll. 520, 521).

6.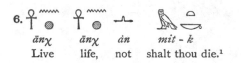

ānχ	ānχ	àn	mit - k
Live	life,	not	shalt thou die.[1]

In the papyrus of Ani the deceased is represented as having come to a place remote and far away, where there is neither air to breathe nor water to drink, but where he holds converse with Tmu. In answer to his question, " How long have I to live ? "[2] the great god of Annu answers :—

àuk	er	ḥeḥ	en	ḥeḥ	āḥā	en	ḥeḥ
Thou shalt exist	for	millions	of	millions of years,	a period	of	millions of years.

In the LXXXIVth Chapter, as given in the same papyrus, the infinite duration of the past and future existence of the soul, as well as its divine nature, is proclaimed by Ani in the words :—

nuk	Śu	paut	ba - à	pu	neter	ba - à	pu	ḥeḥ
I am	Shu [the god] of unformed matter.		My soul	is	God,	my soul	is	eternity.[3]

When the deceased identifies himself with Shu, he makes the period of his existence coeval with that of Tmu-Rā, *i.e.*, he existed before Osiris and the other gods of his company. These two passages prove the identity of the belief in eternal life in the XVIIIth dynasty with that in the Vth and VIth dynasties.

But while we have this evidence of the Egyptian belief in eternal life, we are nowhere told that man's corruptible body will rise again; indeed, the following extracts show that the idea prevailed that the body lay in the earth while the soul or spirit lived in heaven.

1.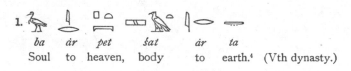

ba	àr	pet	śat	àr	ta
Soul	to	heaven,	body	to	earth.[4] (Vth dynasty.)

[1] *Recueil de Travaux*, t. v., p. 170 (Pepi, l. 85).

[2] Plate XIX., l. 16 (Book of the Dead, Chapter CLXXV.).

[3] Plate XXVIII., l. 15.

[4] *Recueil de Travaux*, t. iv., p. 71 (l. 582).

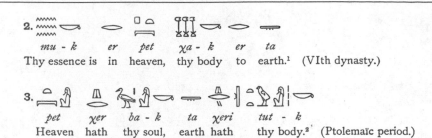

2. mu - k er pet χa - k er ta
Thy essence is in heaven, thy body to earth.[1] (VIth dynasty.)

3. pet χer ba - k ta χeri tut - k
Heaven hath thy soul, earth hath thy body.[2] (Ptolemaïc period.)

There is, however, no doubt that from first to last the Egyptians firmly believed that besides the soul there was some other element of the man that would rise again. The preservation of the corruptible body too was in some way connected with the life in the world to come, and its preservation was necessary to ensure eternal life; otherwise the prayers recited to this end would have been futile, and the time honoured custom of mummifying the dead would have had no meaning. The never ending existence of the soul is asserted in a passage quoted above without reference to Osiris; but the frequent mention of the uniting of his bones, and of the gathering together of his members,[3] and the doing away with all corruption from his body, seems to show that the pious Egyptian connected these things with the resurrection of his own body in some form, and he argued that what had been done for him who was proclaimed to be giver and source of life must be necessary for mortal man.

The physical body of man considered as a whole was called *khat* , a word which seems to be connected with the idea of something which is liable to decay. The word is also applied to the mummified body in the tomb, as we know from the words "My body (*khat*) is buried."[4] Such a body was attributed to the god Osiris;[5] in the CLXIInd Chapter of the Book of the Dead "his great

[1] *Recueil de Travaux*, t. v., p. 45 (l. 304).

[2] Horrack, *Lamentations d Isis et de Nephthys*, Paris, 1866, p. 6.

[3] Already in the pyramid texts we have "Rise up, O thou Tetà! Thou hast received thy head, thou hast knitted together thy bones, thou hast collected thy members." *Recueil de Travaux*, t. v., p. 40 (l. 287).

[4] . Book of the Dead, Chapter LXXXVI., l. 11.

[5] Papyrus of Ani, pl. vii., l. 28, and pl. xix., l. 8.

divine body rested in Ȧnnu." [1] In this respect the god and the deceased were on an equality. As we have seen above, the body neither leaves the tomb nor reappears on earth ; yet its preservation was necessary. Thus the deceased addresses Tmu [2] : " Hail to thee, O my father Osiris, I have come and I have " embalmed this my flesh so that my body may not decay. I am whole, even as my " father Kheperȧ was whole, who is to me the type of that which passeth not away. " Come then, O Form, and give breath unto me, O lord of breath, O thou who art " greater than thy compeers. Stablish thou me, and form thou me, O thou who art " lord of the grave. Grant thou to me to endure for ever, even as thou didst grant " unto thy father Tmu to endure ; and his body neither passed away nor decayed. " I have not done that which is hateful unto thee, nay, I have spoken that which thy " *ka* loveth ; repulse thou me not, and cast thou me not behind thee, O Tmu, to " decay, even as thou doest unto every god and unto every goddess and unto " every beast and creeping thing which perisheth when his soul hath gone forth " from him after his death, and which falleth in pieces after his decay " Homage to thee, O my father Osiris, thy flesh suffered no decay, there were no " worms in thee, thou didst not crumble away, thou didst not wither away, thou " didst not become corruption and worms ; and I myself am Kheperȧ, I shall " possess my flesh for ever and ever, I shall not decay, I shall not crumble away, " I shall not wither away, I shall not become corruption."

But the body does not lie in the tomb inoperative, for by the prayers and ceremonies on the day of burial it is endowed with the power of changing into a *sȧḫu,* or spiritual body. Thus we have such phrases as, " I germinate like the " plants," [3] " My flesh germinateth," [4] " I exist, I exist, I live, I live, I germinate, I " germinate," [5] " thy soul liveth, thy body germinateth by the command of Rȧ

[1] Lepsius, *Todtenbuch,* Bl. 77, l. 7.

[2] This chapter was found inscribed upon one of the linen wrappings of the mummy of Thothmes III., and a copy of the text is given by Naville (*Todtenbuch,* Bd. I., Bl. 179) ; for a later version see Lepsius, *Todtenbuch,* Bl. 75, where many interesting variants occur.

[3] Chapter LXXXIII., 3.

[4] Chapter LXIV., l. 49. (Naville, *Todtenbuch,* Bd. I., Bl. 76.)

[5] Chapter CLIV. (Lepsius, *Todtenbuch,* Bl. 75.)

" himself without diminution, and without defect, like unto Rā for ever and ever."[1]
The word *sāḥu* ⸺ 𓈎𓃀𓄿𓃾, though at times written with the determinative of
a mummy lying on a bier like *khat*, "body," indicates a body which has obtained a
degree of knowledge[2] and power and glory whereby it becomes henceforth lasting
and incorruptible. The body which has become a *sāḥu* has the power of associating
with the soul and of holding converse with it. In this form it can ascend into heaven
and dwell with the gods, and with the *sāḥu* of the gods, and with the souls of the
righteous. In the pyramid texts we have these passages :—

1.

θes - θu	*Tetà*	*pu*	*un - θu*	*āāa*	*peḥ-θà*	*ḥems - k*
Rise up thou	Tetà	this.	Stand up thou	mighty one	being strong.	Sit thou

χent	*neteru*	*àri - k*	*ennu*	*àri*	*en Àusàr*	*em*	*Ḥet - āa*	*àmt*	*Ànnu*
with	the gods,	do thou	that which	did	Osiris	in	the great house	in	Ànnu.

seśep-nek	*sāḥ - k*	*àn*	*t'er*	*reṭ - k*	*em*	*pet*	*àn*
Thou hast received	thy *sāḥ*,	not	shall be fettered	thy foot	in	heaven,	not

χesef - k	*em*	*ta*
shalt thou be turned back	upon	earth.[3]

2.

ànet'	*ḥrà-k*	*Tetà*	*em*	*hru - k*	*pen*	*āḥā - θà*	*χeft*	*Rā*
Hail	to thee,	Tetà,	on	this thy day	[when]	thou art standing	before	Rā [as]

[1] 𓅮𓂋𓏤𓈗𓊵𓏲𓈖𓅂𓏲𓈖𓉐𓏏𓇋𓂝𓄿𓃀𓈗𓏲𓏺. Brugsch, *Liber Metempsychosis*, p. 22.

[2] Compare Coptic ⲥⲁⳍ, "magister."

[3] *Recueil de Travaux*, t. v., p. 36 (l. 271). From line 143 of the same text it would seem that a
man had more than one *sāḥu*, for the words "all thy *sāḥu*," 𓏏𓈎𓈖𓄿𓈎𓈖𓄿𓈎𓈗𓃾,
occur. This may, however, be only a plural of majesty.

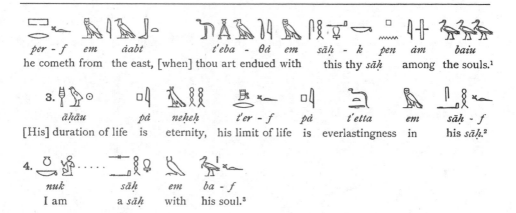

per - f em àabt t'eba - θà em sāḥ - k pen àm baiu
he cometh from the east, [when] thou art endued with this thy sāḥ among the souls.[1]

3. pà neḥeḥ t'er - f pà t'etta em sāḥ - f
āḥāu
[His] duration of life is eternity, his limit of life is everlastingness in his sāḥ.[2]

4. nuk sāḥ em ba - f
 I am a sāḥ with his soul.[3]

In the late edition of the Book of the Dead published by Lepsius the deceased is said to " look upon his body and to rest upon his sāḥu,"[4] and souls are said " to enter into their sāḥu ";[5] and a passage extant both in this and the older Theban edition makes the deceased to receive the sāḥu of the god Osiris.[6] But that Egyptian writers at times confused the khat with the sāḥu is clear from a passage in the Book of Respirations, where it is said, " Hail Osiris, thy name endureth, thy " body is stablished, thy sāḥu germinateth ";[7] in other texts the word "germinate" is applied only to the natural body.

In close connection with the natural and spiritual bodies stood the heart, or rather that part of it which was the seat of the power of life and the fountain of good and evil thoughts. And in addition to the natural and spiritual bodies, man also had an abstract individuality or personality endowed with all his characteristic attributes. This abstract personality had an absolutely independent existence. It could move freely from place to place, separating itself from, or uniting itself to,

[1] *Recueil de Travaux*, t. v., p. 59 (l. 384).

[2] *Ibid.*, t. iv., p. 61 (l. 521).

[3] Book of the Dead, Chapter LXXVIII., l. 14.

[4] . Chapter LXXXIX., l. 6.

[5] *Ibid.*, l. 5.

[6] . Chapter CXXX., l. 38 (ed. Naville).

[7] . See Brugsch, *Liber Metempsychosis*, p. 15.

the body at will, and also enjoying life with the gods in heaven. This was the *ka* ⊔,[1] a word which at times conveys the meanings of its Coptic equivalent ⲕⲱ, and of εἴδωλον, image, genius, double, character, disposition, and mental attributes. The funeral offerings of meat, cakes, ale, wine, unguents, *etc.*, were intended for the *ka*; the scent of the burnt incense was grateful to it. The *ka* dwelt in the man's statue just as the *ka* of a god inhabited the statue of the god. In this respect the *ka* seems to be identical with the *sekhem* ⳼ or image. In the remotest times the tombs had special chambers wherein the *ka* was worshipped and received offerings. The priesthood numbered among its body an order of men who bore the name of "priests of the *ka*" 𝄃⊔, and who performed services in honour of the *ka* in the "*ka* chapel" 𝄃⌂⊔.

In the text of Unás the deceased is said to be "happy with his *ka*"[2] in the next world, and his *ka* is joined unto his body in "the great dwelling";[3] his body

[1] The first scholar who seriously examined the meaning of the word ⊔ was Dr. Birch, who collected several examples of the use and discussed them in his *Mémoire sur une Patère Égyptienne du Musée du Louvre*, Paris, 1858, p. 59 ff. (Extrait du t. xxiv. des *Mémoires de la Société impériale des Antiquaires de France*). Dr. Birch translated the word by être, personne, emblème, divin, génie, principe, esprit. In September, 1878, M. Maspero explained to the Members of the Congress of Lyons the views which he held concerning this word, and which he had for the past five years been teaching in the Collège de France, and said, "le *ka* est une sorte de double de la personne humaine d'une matière moins grossière que la matière dont est formé le corps, mais qu'il fallait nourrir et entretenir comme le corps lui-même; ce double vivait dans le tombeau des offrandes qu'on faisait aux fêtes canoniques, et aujourd'hui encore un grand nombre des génies de la tradition populaire égyptienne ne sont que des *doubles*, devenus démons au moment de la conversion des fellahs au christianisme, puis à l'islamisme." These views were repeated by him at the Sorbonne in February, 1879. See *Comptes Rendus du Congrès provincial des Orientalistes*, Lyons, 1878, t. i., pp. 235–263; *Revue Scientifique de la France et de l'Étranger*, 2ᵉ série, 8ᵉ année, No. 35, March, 1879, pp. 816–820; *Bulletin de l'Association Scientifique de France*, No. 594, 1879, t. xxiii., p. 373–384; Maspero, *Études de Mythologie et d'Archéologie*, t. i., pp. 1, 35, 126. In March, 1879, Mr. Renouf read a paper entitled "On the true sense of an important Egyptian word" (*Trans. Soc. Bibl. Arch.*, vol. vi., London, 1879, pp. 494–508), in which he arrived at conclusions similar to those of M. Maspero; and in September of the same year M. Maspero again treated the subject in *Recueil de Travaux*, t. i., p. 152 f. The various shades of meaning in the word have been discussed subsequently by Brugsch, *Wörterbuch* (Suppl.), pp. 997, 1230; Dümichen, *Der Grabpalast des Patuamenap*, Abt. i., p. 10; Bergmann, *Der Sarkophag des Panehemisis* (in *Jahrbuch der Kunsthistorischen Sammlungen des allerhöchsten Kaiserhauses*, Vienna, 1883, p. 5); Wiedemann, *Die Religion der alten Aegypter*, p. 126.

[2] 𓏏 𓆓 𓆷𓅃 𓈗 ⊔ , l. 472.

[3] ⊔ 𓆷𓅃 𓈗 𓅱 𓂋 ⌂ 𓅃 , l. 482.

having been buried in the lowest chamber, "his *ka* cometh forth to him."[1] Of Pepi I. it is said :—

ȧi	*su*	*ka - k*	*ḥems*	*ka - k*	*ȧm - f*	*ta*	*ḥenā - k*	*ȧt*	*ur*
Washed		is thy *ka*,	sitteth	thy *ka* [and]	it eateth	bread	with thee		unceasingly

en	*t'et*	*t'etta*
	for	ever.[2]

āḥā	*uāb - k*	*uāb*	*ka-k*	*uāb*	*ba - k*	*uāb*	*seχem - k*
	Thou art pure,	thy *ka* is pure,		thy soul is pure,		thy form is pure.[3]	

The *ka*, as we have seen, could eat food, and it was necessary to provide food for it. In the XIIth dynasty and in later periods the gods are entreated to grant meat and drink to the *ka* of the deceased; and it seems as if the Egyptians thought that the future welfare of the spiritual body depended upon the maintenance of a constant supply of sepulchral offerings. When circumstances rendered it impossible to continue the material supply of food, the *ka* fed upon the offerings painted on the walls of the tomb, which were transformed into suitable nourishment by means of the prayers of the living. When there were neither material offerings nor painted similitudes to feed upon, it seems as if the *ka* must have perished; but the texts are not definite on this point.

The following is a specimen of the *ka*'s petition for food written in the XVIIIth dynasty :—

" May the gods grant that I go into and come forth from my tomb, may the
" Majesty refresh its shade, may I drink water from my cistern every day, may all
" my limbs grow, may Ḥāpi give unto me bread and flowers of all kinds in their
" season, may I pass over my estate every day without ceasing, may my soul

[1] ⟨hieroglyphs⟩ , l. 483.

[2] *Recueil de Travaux*, t. v., p. 166, l. 67.

[3] *Ibid.*, l. 112.

" alight upon the branches of the groves which I have planted, may I make myself
" cool beneath my sycamores, may I eat the bread which they provide. May I
" have my mouth that I may speak therewith like the followers of Horus, may I
" come forth to heaven, may I descend to earth, may I never be shut out upon the
" road, may there never be done unto me that which my soul abhorreth, let not my
" soul be imprisoned, but may I be among the venerable and favoured ones, may I
" plough my lands in the Field of Åaru, may I arrive at the Field of Peace, may
" one come out to me with vessels of ale and cakes and bread of the lords of
" eternity, may I receive meat from the altars of the great, I the *ka* of the prophet
" Åmsu."[1]

To that part of man which beyond all doubt was believed to enjoy an eternal
existence in heaven in a state of glory, the Egyptians gave the name *ba* ,
a word which means something like "sublime," "noble," and which has always
hitherto been translated by "soul." The *ba* is not incorporeal, for although it
dwells in the *ka*, and is in some respects, like the heart, the principle of life in man,
still it possesses both substance and form : in form it is depicted as a human-headed
hawk , and in nature and substance it is stated to be exceedingly refined or
ethereal. It revisited the body in the tomb and re-animated it, and conversed with
it ; it could take upon itself any shape that it pleased ; and it had the power of
passing into heaven and of dwelling with the perfected souls there. It was
eternal. As the *ba* was closely associated with the *ka*, it partook of the funeral
offerings, and in one aspect of its existence at least it was liable to decay if not
properly and sufficiently nourished. In the pyramid texts the permanent dwelling-
place of the *ba* or soul is heaven with the gods, whose life it shares :—

1.

sek	*Unås*	*per*	*em*	*hru*	*pen*	*em*	*åru*	*maā*	*en*
Behold	Unås	cometh forth	on	day	this	in	the form	exact	of

ba	*ānχ*
a soul	living.[2]

[1] See *Trans. Soc. Bibl. Arch.*, vol. vi., pp. 307, 308.
[2] *Recueil de Travaux*, t. iv., p. 52 (l. 455).

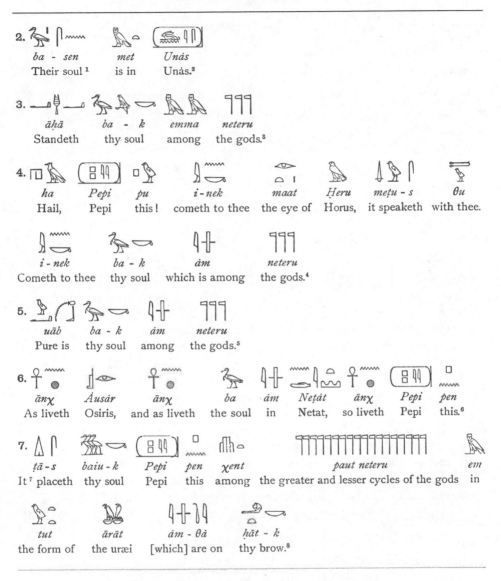

2. *ba - sen* — *met* — *Unás*
Their soul[1] — is in — Unás.[2]

3. *áhá* — *ba - k* — *emma* — *neteru*
Standeth — thy soul — among — the gods.[3]

4. *ha* — *Pepi* — *pu* — *i - nek* — *maat* — *Heru* — *metu - s* — *θu*
Hail, — Pepi — this! — cometh to thee — the eye of — Horus, — it speaketh — with thee.

i - nek — *ba - k* — *àm* — *neteru*
Cometh to thee — thy soul — which is among — the gods.[4]

5. *uáb* — *ba - k* — *àm* — *neteru*
Pure is — thy soul — among — the gods.[5]

6. *ánχ* — *Áusár* — *ánχ* — *ba* — *àm* — *Netát* — *ánχ* — *Pepi* — *pen*
As liveth — Osiris, — and as liveth — the soul — in — Netat, — so liveth — Pepi — this.[6]

7. *tá - s* — *baiu - k* — *Pepi* — *pen* — *χent* — *paut neteru* — *em*
It[7] placeth — thy soul — Pepi — this — among — the greater and lesser cycles of the gods — in

tut — *árát* — *àm - θá* — *hát - k*
the form of — the uræi — [which] are on — thy brow.[8]

[1] *I.e.*, the soul of the gods.
[2] *Recueil de Travaux*, t. iv., p. 61 (l. 522).
[3] *Recueil de Travaux*, t. v., p. 55 (l. 350), and see Pepi I., ll. 19, 20.
[4] *Ibid.*, t. v., p. 160 (l. 13).
[5] *Recueil de Travaux*, t. v., p. 175 (l. 113).
[6] *Ibid.*, t. v., p. 183 (l. 166).
[7] *I.e.*, the Eye of Horus.
[8] *Ibid.*, t. v., p. 184 (l. 167).

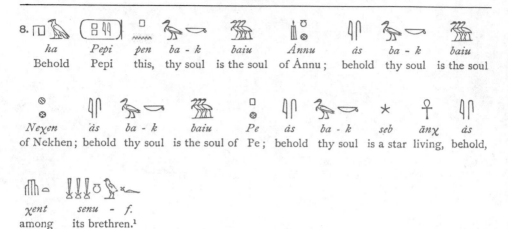

8.

ha	*Pepi*	*pen*	*ba - k*	*baiu*	*Ȧnnu*	*ȧs*	*ba - k*	*baiu*	
Behold	Pepi	this,	thy soul	is the soul	of Ȧnnu;	behold	thy soul	is the soul	

Neχen	*ȧs*	*ba - k*	*baiu*	*Pe*	*ȧs*	*ba - k*	*seb*	*ȧnχ*	*ȧs*
of Nekhen;	behold	thy soul	is the soul of	Pe;	behold	thy soul	is a star	living,	behold,

χent	*senu - f.*
among	its brethren.[1]

In connection with the *ka* and *ba* must be mentioned the *khaïbit* ⌐ or shadow of the man, which the Egyptians regarded as a part of the human economy. It may be compared with the σκιά and *umbra* of the Greeks and Romans. It was supposed to have an entirely independent existence and to be able to separate itself from the body; it was free to move wherever it pleased, and, like the *ka* and *ba*, it partook of the funeral offerings in the tomb, which it visited at will. The mention of the shade, whether of a god or man, in the pyramid texts is unfrequent, and it is not easy to ascertain what views were held concerning it; but from the passage in the text of Unȧs,[2] where it is mentioned together with the souls and spirits and bones of the gods, it is evident that already at that early date its position in relation to man was well defined. From the collection of illustrations which Dr. Birch appended to his paper *On the Shade or Shadow of the Dead*,[3] it is quite clear that in later times at least the shadow was always associated with the soul and was believed to be always near it; and this view is

[1] *Recueil de Travaux*, t. v., p. 184 (l. 168).

[2] *Recueil de Travaux*, t. iv., p. 62 (l. 523).

[3] See *Trans. Soc. Bibl. Arch.*, vol. viii., p. 386–97.

supported by a passage in the XCIInd Chapter of the Book of the Dead,[1] where it is said :—

em	χená	ba - á	sauti	χaibit-á	un	uat
Let not be shut in	my soul,	let not be fettered		my shadow,	let be opened	the way

en	ba - á	en	χaibit-á	maa - f	neter áa
for	my soul	and for	my shadow,	may it see	the great god.

And again, in the LXXXIXth Chapter the deceased says :—

maa - á	ba - á	χaibit-á
May I look upon	my soul	and my shadow.[2]

Another important and apparently eternal part of man was the *khu* 𓐍, which, judging from the meaning of the word, may be defined as a "shining" or translucent, intangible casing or covering of the body, which is frequently depicted in the form of a mummy. For want of a better word *khu* has often been translated "shining one," "glorious," "intelligence," and the like, but in certain cases it may be tolerably well rendered by "spirit." The pyramid texts show us that the *khu*'s of the gods lived in heaven, and thither wended the *khu* of a man as soon as ever the prayers said over the dead body enabled it to do so. Thus it is said, "Unás standeth with the *khu*'s,"[3] and one of the gods is asked to "give him his sceptre among the *khu*'s;"[4] when the souls of the gods enter into Unás, their *khu*'s are with and round about him.[5] To king Tetá it is said :—

[1] Naville, *Todtenbuch*, Bd. I., Bl. 104, ll. 7, 8.

[2] *Ibid.*, Bd. I., Bl. 101.

[3] 𓏤𓎡𓐍𓅜𓐍𓐍𓐍. *Recueil de Travaux*, t. iii., p. 188 (l. 71).

[4] 𓂪𓅜𓐍𓂋𓎡𓅜𓐍𓐍� . *Ibid.*, t. iii., p. 215 (l. 274).

[5] 𓐍𓐍�|𓈗𓏤𓏤. *Ibid.*, t. iv., p. 61 (l. 522).

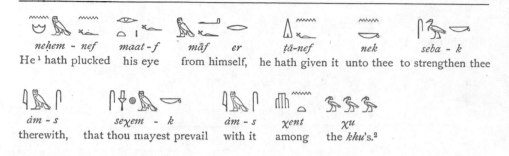

And again, when the god Khent-mennut-f has transported the king to heaven, the god Seb, who rejoices to meet him, is said to give him both hands and welcome him as a brother and to nurse him and to place him among the imperishable *khu's*.[3] In the XCIInd Chapter the deceased is made to pray for the liberation of his soul, shadow, and *khu* from the bondage of the tomb, and for deliverance from those " whose dwellings are hidden, who fetter the souls, who fetter souls and *khu's* " and who shut in the shadows of the dead ";[4] and in the XCIst Chapter[5] is a formula specially prepared to enable the *khu* to pass from the tomb to the domains where Rā and Hathor dwell.

Yet another part of a man was supposed to exist in heaven, to which the Egyptians gave the name *sekhem* ⸢hieroglyphs⸣. The word has been rendered by " power," " form," and the like, but it is very difficult to find any expression which will represent the Egyptian conception of the *sekhem*. It is mentioned in connection with the soul and *khu*, as will be seen from the following passages from the pyramid texts :—

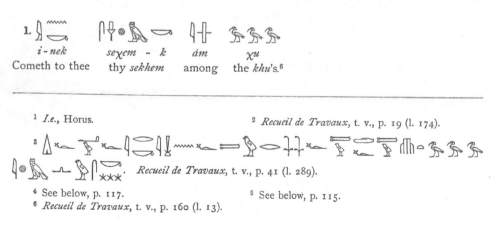

[1] *I.e.*, Horus.

[2] *Recueil de Travaux*, t. v., p. 19 (l. 174).

[3] ⸢hieroglyphs⸣ *Recueil de Travaux*, t. v., p. 41 (l. 289).

[4] See below, p. 117.

[5] See below, p. 115.

[6] *Recueil de Travaux*, t. v., p. 160 (l. 13).

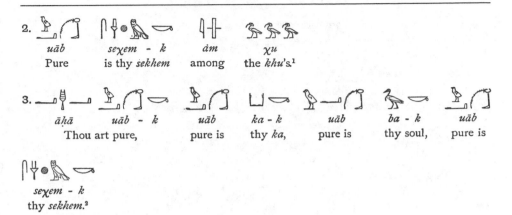

2. *uāb* *seχem - k* *àm* *χu*
 Pure is thy *sekhem* among the *khu's*[1]

3. *āḥā* *uāb - k* *uāb* *ka - k* *uāb* *ba - k* *uāb*
 Thou art pure, pure is thy *ka*, pure is thy soul, pure is

seχem - k
thy *sekhem*.[2]

A name of Rā was ⟨hieroglyphs⟩[3] *sekhem ur*, the "Great Sekhem," and Unàs is identified with him and called :—

seχem ur *seχem* *em* *seχemu*
Great *sekhem*, sekhem among the *sekhemu*.[4]

Finally, the name, ⟨hieroglyphs⟩ *ren*, of a man was believed to exist in heaven, and in the pyramid texts we are told that

nefer *en* *Pepi* *pen* *ḥenā* *ren - f* *ānχ* *Pepi* *pen* *ḥenā* *ka - f*
Happy is Pepi this with his name, liveth Pepi this with his *ka*.[5]

Thus, as we have seen, the whole man consisted of a natural body, a spiritual body, a heart, a double, a soul, a shadow, an intangible ethereal casing or spirit, a form, and a name. All these were, however, bound together inseparably, and the welfare of any single one of them concerned the welfare of all. For the well-being of the spiritual parts it was necessary to preserve from decay the natural body ; and

[1] *Recueil de Travaux*, t. v., p. 175 (l. 113). [2] *Recueil de Travaux*, p. 175, l. 112.
[3] *Ibid.*, t. iv., p. 44, l. 393. [4] *Ibid.*, p. 60, ll. 514, 515.
[5] *Ibid.*, t. v., p. 185, l. 169.

certain passages in the pyramid texts seem to show that a belief in the resurrection cf the natural body existed in the earliest dynasties.[1]

The texts are silent as to the time when the immortal part began its beatified existence ; but it is probable that the Osiris[2] of a man only attained to the full enjoyment of spiritual happiness after the funeral ceremonies had been duly performed and the ritual recited. Comparatively few particulars are known of the manner of life of the soul in heaven, and though a number of interesting facts may be gleaned from the texts of all periods, it is very difficult to harmonize them. This result is due partly to the different views held by different schools of thought in ancient Egypt, and partly to the fact that on some points the Egyptians themselves seem to have had no decided opinions. We depend upon the pyramid texts for our knowledge of their earliest conceptions of a future life.

The life of the Osiris of a man in heaven is at once material and spiritual ; and it seems as if the Egyptians never succeeded in breaking away from their very ancient habit of confusing the things of the body with the things of the soul. They believed in an incorporeal and immortal part of man, the constituent elements of which flew to heaven after death and embalmment; yet the theologians of the VIth dynasty had decided that there was some part of the deceased which could only mount to heaven by means of a ladder. In the pyramid of Tetà it is said, " When Tetà hath purified himself on the borders of this earth where Rā hath " purified himself, he prayeth and setteth up the ladder, and those who dwell in " the great place press Tetà forward with their hands."[3] In the pyramid of Pepi I.

[1] *E.g.,* ⟨hieroglyphs⟩ "This Pepi goeth forth with his flesh." *Recueil de Travaux*, t. v., p. 185, l. 169.

[2] The Osiris consisted of all the spiritual parts of a man gathered together in a form which resembled him exactly. Whatever honour was paid to the mummified body was received by its Osiris, the offerings made to it were accepted by its Osiris, and the amulets laid upon it were made use of by its Osiris for its own protection. The *sāhu*, the *ka*, the *ba*, the *khu*, the *khaibit*, the *sekhem*, and the *ren* were in primeval times separate and independent parts of man's immortal nature; but in the pyramid texts they are welded together, and the dead king Pepi is addressed as " Osiris Pepi." The custom of calling the deceased Osiris continued until the Roman period. On the Osiris of a man, see Wiedemann, *Die Osirianische Unsterblichkeitslehre* (in *Die Religion der alten Aegypter*, p. 128).

[3] ⟨hieroglyphs⟩. Maspero, *Recueil de Travaux*, t. v., p. 7, l. 36.

the king is identified with this ladder : " Isis saith, ' Happy are they who see the
" 'father,' and Nephthys saith, ' They who see the father have rest,' speaking unto
" the father of this Osiris Pepi when he cometh forth unto heaven among the stars
" and among the luminaries which never set. With the uræus on his brow, and his
" book upon both his sides, and magic words at his feet, Pepi goeth forward unto
" his mother Nut, and he entereth therein in his name Ladder."[1] The gods who
preside over this ladder are at one time Rā and Horus, and at another Horus and
Set. In the pyramid of Unâs it is said, " Rā setteth upright the ladder for Osiris,
" and Horus raiseth up the ladder for his father Osiris, when Osiris goeth to [find]
" his soul ; one standeth on the one side, and the other standeth on the other, and
" Unâs is betwixt them. Unâs standeth up and is Horus, he sitteth down and is
" Set."[2] And in the pyramid of Pepi I. we read, " Hail to thee, O Ladder of God,
" hail to thee, O Ladder of Set. Stand up, O Ladder of God, stand up, O Ladder
" of Set, stand up, O Ladder of Horus, whereon Osiris went forth into heaven.
" This Pepi is thy son, this Pepi is Horus, thou hast given birth unto this Pepi even
" as thou hast given birth unto the god who is the lord of the Ladder. Thou hast
" given him the Ladder of God, and thou hast given him the Ladder of Set,
" whereon this Pepi hath gone forth into heaven. Every khu and every god
" stretcheth out his hand unto this Pepi when he cometh forth into heaven by the
" Ladder of God that which he seeth and that which he heareth make him
" wise, and serve as food for him when he cometh forth into heaven by the
" Ladder of God. Pepi riseth up like the uræus which is on the brow of Set, and
" every khu and every god stretcheth out his hand unto Pepi on the Ladder. Pepi
" hath gathered together his bones, he hath collected his flesh, and Pepi hath gone
" straightway into heaven by means of the two fingers of the god who is the Lord
" of the Ladder."[3] Elsewhere we are told that Khonsu and Set " carry the
" Ladder of Pepi, and they set it up."

When the Osiris of a man has entered into heaven as a living soul,[4] he is
regarded as one of those who " have eaten the eye of Horus ";[5] he walks among

[1] *Recueil de Travaux*, t. v., p. 190, ll. 181, 182.
[2] *Ibid.*, t. iv., p. 70, l. 579 ff.
[3] *Études de Mythologie et d'Archéologie*, t. i., p. 344, note 1.

[4] *Recueil de Travaux*, t. v., p. 52 (l. 456).

[5] *Ibid.*, t. iii., p. 165 (l. 169).

the living ones ⳹⳹⳹,[1] he becomes " God, the son of God,"[2] and all the gods of heaven become his brethren.[3] His bones are the gods and goddesses of heaven ;[4] his right side belongs to Horus, and his left side to Set ;[5] the goddess Nut makes him to rise up as a god without an enemy in his name " God ";[6] and God calls him by his name.[7] His face is the face of Åp-uat, his eyes are the great ones among the souls of Ånnu, his nose is Thoth, his mouth is the great lake, his tongue belongs to the boat of right and truth, his teeth are the spirits of Ånnu, his chin is Khert-khent-Sekhem, his backbone is Sema, his shoulders are Set, his breast is Beba,[8] *etc.*; every one of his members is identified with a god. Moreover, his body as a whole is identified with the God of Heaven. For example it is said concerning Unås :—

t'et - k	t'et	ent	Unås	pen	åf - k	åf	en	Unås	pen
Thy body	is the body	of	Unås	this.	Thy flesh	is the flesh	of	Unås	this.

ḳesu - k	ḳesu	Unås	pen	seb - k	ḷseb	Unås	pen
Thy bones	are the bones	of Unås	this.	Thy passage is the passage		of Unås	this.

seb	Unås	pen	seb - k
The passage	of Unås	this is thy passage.[9]	

[1] *Recueil de Travaux*, t. v., p. 183 (l. 166).

[2] *Ibid.*, t. viii., p. 89 (l. 574).

[3] See pyramid of Tetà, (*Recueil*, t. v.), ll. 45, 137, 197, 302.

[4] *Ibid.*, t. iii., p. 202 (l. 209).

[5] *Ibid.*, t. v., p. 23 (l. 198).

[6] *Ibid.*, t. v., p. 38, (l. 279).

[7] *Ibid.*, p. 26 (l. 222) [8] *Ibid.*, t. viii., p. 88 (l. 565 ff.).

[9] *Ibid.*, t. iii., p. 214 (l. 268).

Further, this identification of the deceased with the God of Heaven places him in the position of supreme ruler. For example, we have the prayer that Unàs " may rule the nine gods and complete the company of the nine gods,"[1] and Pepi I., in his progress through heaven, comes upon the double company of the gods, who stretch out their hands, entreating him to come and sit down among them.[2]

Again, the deceased is changed into Horus, the son of Osiris and Isis. It is said of Pepi I., " Behold it is not Pepi who entreateth to see thee in the form in " which thou art 〔hieroglyphs〕, O Osiris, who entreateth to see thee in the " form in which thou art, O Osiris ; but it is thy son who entreateth to see thee in " the form in which thou art, O Osiris, it is Horus who entreateth to see thee in " the form in which thou art " ;[3] and Horus does not place Pepi at the head of the dead, but among the divine gods.[4] Elsewhere we are told that Horus has taken his Eye and given it to Pepi, and that the odour of Pepi's body is the odour of the Eye of Horus.[5] Throughout the pyramid texts the Osiris of the deceased is the son of Tmu, or Tmu-Rā, Shu, Tefnut, Seb, and Nut, the brother of Isis, Nephthys, Set, and Thoth, and the father of Horus ;[6] his hands, arms, belly, back, hips and thighs, and legs are the god Tmu, and his face is Anubis.[7] He is the brother of the moon,[8] he is the child of the star Sothis,[9] he revolves in heaven like Orion 〔hieroglyphs〕 and Sothis 〔hieroglyphs〕,[10] and he rises in his place like a star.[11] The gods, male and

[1] 〔hieroglyphs〕. *Recueil de Travaux*, t. iii., p. 217 (l. 283).

[2] 〔hieroglyphs〕. *Ibid.*, t. vii., p. 150 (l. 263).

[3] *Ibid.*, t. vii., p. 155 (l. 315 f.)

[4] 〔hieroglyphs〕. *Ibid.*, t. v., p. 194 (l. 190).

[5] *Ibid.*, t. vii., p. 169 (l. 457).　　[6] *Ibid.*, t. iii., pp. 209–211.

[7] *Ibid.*, p. 201 (l. 207).

[8] 〔hieroglyphs〕. *Ibid.*, t. v., p. 198 (l. 203).

[9] *Ibid.*, t. iv., p. 44. l. 390.　　[10] *Ibid.*, t. iii., p. 205 (l. 221 f.).

[11] *Ibid.*, t. iv., p. 44 (l. 391).

female, pay homage to him,[1] every being in heaven adores him; and in one interesting passage it is said of Pepi I. that "when he hath come forth into heaven " he will find Rā standing face to face before him, and, having seated himself upon " the shoulders of Rā, Rā will not let him put himself down again upon the ground; " for he knoweth that Pepi is more shining than the shining ones, more perfect " than the perfect, and more stable than the stable ones When Pepi " standeth upon the north of heaven with Rā, he becometh lord of the universe like " unto the king of the gods."[2] To the deceased Horus gives his own *ka*,[3] and also drives away the *ka*'s of the enemies of the deceased from him, and hamstrings his foes.[4] By the divine power thus given to the deceased he brings into subjection the *ka*'s of the gods[5] and other *ka*'s,[6] and he lays his yoke upon the *ka*'s of the triple company of the gods.[7] He also becomes Thoth,[8] the intelligence of the gods, and he judges hearts;[9] and the hearts of those who would take away his food and the breath from his nostrils become the prey of his hands.[10]

The place of the deceased in heaven is by the side of God[11] in the most holy place,[12] and he becomes God and an angel of God;[13] he himself is triumphant,[14]

[1] 𓎡𓂋𓏲𓇋𓈖 (𓉺𓏥) 𓌕 𓏪𓄿𓂡𓅆 𓂝𓂝𓂝. *Recueil de Travaux*, t. v., p. 23 (l. 197).

[2] *Ibid.*, t. v., p. 171 (l. 91 ff.).

[3] 𓎛𓄿𓈖𓎡𓏲𓏺. *Ibid.*, t. v., p. 33 (l. 265).

[4] *Ibid.*, t. v., p. 40 (l. 287).

[5] 𓈖𓃀𓅆𓏭𓌕𓎡𓎡𓎡. *Ibid.*, p. 45 (l. 306).

[6] 𓈖𓅆𓏭(𓈖𓏭)𓎡𓎡. *Ibid.*, t. iv., p. 51 (l. 451); t. iii., p. 208 (l. 234).

[7] *Ibid.*, t. v., p. 46 (l. 307). [8] *Ibid.*, t. vii., p. 168 (l. 452).

[9] *Ibid.*, t. iii., p. 208 (l. 233), 𓎡𓄿𓎺.

[10] *Ibid.*, t. iv., p. 49 (l. 430), 𓎡𓂝𓂋𓎺𓊪𓈖𓏭𓏭𓂡.

[11] 𓂝𓂋𓎡𓉐𓂝𓊋 *un-k ȧr ḳes neter;* *ibid.*, t. iii., p. 202 (l. 209).

[12] 𓇋𓈖 (𓉺𓏥) 𓂝𓊡𓈖𓏏𓂝𓊡𓂋. *Ibid.*, t. v., p. 189 (l. 178).

[13] (𓉺𓏥) 𓂝𓆇𓏏𓆓𓇋𓆇𓎺𓏭𓏴𓏏. *Ibid.*, t. v., p. 187 (l. 175).

[14] 𓌕𓂋𓂝𓊖 *maā-χeru;* *ibid.*, t. v., p. 186 (l. 172). These words are in later times always added after the name of the deceased, and seem to mean something like "he whose voice, or speech,

and his *ka* is triumphant.[1] He sits on a great throne by the side of God.[2] The throne is of iron ornamented with lions' faces and having the hoofs of bulls.[3] He is clothed in the finest raiment, like unto the raiment of those who sit on the throne of living right and truth.[4] He receives the *urerit* crown from the gods,[5] and from the great company of the gods of Ånnu.[6] He thirsts not, nor hungers, nor is sad;[7] he eats the bread of Rā and drinks what he drinks daily,[8] and his bread also is that which is spoken by Seb, and that which comes forth from the mouth of the gods.[9] He eats what the gods eat, he drinks what they drink, he lives as they live, and he dwells where they dwell;[10] all the gods give him their food that he may not die.[11] Not only does he eat and drink of their food, but he wears the

is right and true"; the expression has been rendered by "disant la vérité," "véridique," "juste," "justifié," "vainqueur," "waltend des Wortes," "mächtig der Rede," "vrai de voix," "juste de voix," "victorious," "triumphant," and the like. See on this subject Maspero, *Études de Mythologie et d'Archéologie*, t. i., pp. 93–114; Devéria, *L'Expression Mââ-χerou* (in *Recueil de Travaux*, t. i., p. 10 ff.). A somewhat different view of the signification of maākheru is given by Virey (*Tombeau de Rekhmara*, Paris, 1889, p. 101. Published in *Mémoires publiés par les Membres de la Miss. Arch. Française au Caire*, t. v., fasc. i.). The offerings which were painted on the walls of the tomb were actually enjoyed by the deceased in his new state of being. The Egyptians called them "*per kheru*," that is to say, "*the things which the word or the demand made to appear,*" or "*per ḥru kheru,*" that is to say, "*the things which presented themselves at the word*" or "*at the demand*" of the deceased. The deceased was then called "*maā kheru,*" that is to say, "*he who realizes his word,*" or "*he who realizes while he speaks,*" or "*whose voice or demand realizes,*" or "*whose voice or demand makes true,* or *makes to be really and actually*" that which only appears in painting on the walls of the tomb. M. Amélineau combats this interpretation, and agrees with M. Maspero's rendering of "*juste de voix*"; see *Un Tombeau Égyptien* (in *Revue de l'Histoire des Religions*), t. xxiii., pp. 153, 154. It is possible that *maā-kheru* may mean simply "blessed."

[1] *Recueil de Travaux*, t. v., p. 189 (l. 179).

[2] ⟨hieroglyphs⟩. *Ibid.*, t. iv., p. 58 (l. 494).

[3] ⟨hieroglyphs⟩. *Ibid.*, t. vii., p. 154 (ll. 309, 310).

[4] *Ibid.*, t. v., p. 148 (l. 239). [5] *Ibid.*, t. iv., p. 56 (l. 480).

[6] *Ibid.*, t. v., p. 176 (l. 117). [7] *Ibid.*, t. iii., p. 195 (l. 172).

[8] *Ibid.*, t. v., p. 52 (l. 335).

[9] ⟨hieroglyphs⟩. *Ibid.*, t. iii., p. 208 (l. 234).

[10] *Ibid.*, t. iii., p. 198 (l. 191 f.). [11] *Ibid.*, t. v., p. 164 (l. 56).

apparel which they wear,[1] the white linen and sandals ;[2] he is clothed in white,[3] and " he goeth to the great lake in the midst of the Field of Peace whereon the " great gods sit ; and these great and never failing gods give unto him [to eat] of " the tree of life of which they themselves do eat 〔hieroglyphs〕 " 〔hieroglyphs〕 that he likewise may live."[4] The bread which he eats never decays and his beer never grows stale.[5] He eats of the " bread of eternity " and drinks of the " beer of everlastingness " which the gods eat and drink ;[6] and he nourishes himself upon that bread which the Eye of Horus has shed upon the branches of the olive tree.[7] He suffers neither hunger nor thirst like the gods Shu and Tefnut, for he is filled with the bread of wheat of which Horus himself has eaten ; and the four children of Horus, Ḥāpi, Ṭuamāutef, Qebḥsennuf and Àmset, have appeased the hunger of his belly and the thirst of his lips.[8] He abhors the hunger which he cannot satisfy, and he loathes the thirst which he cannot slake ;[9] but he is delivered from the power of those who would steal away his food.[10] He is washed clean, and his ka is washed clean, and they eat bread together for ever.[11] He is one of the four children of Horus who live on right and truth,[12] and they give him his portion of the food with which they have been so abundantly supplied by the god Seb that they have never yet known what it is to hunger. He goes round about heaven even as they do, and he partakes of their food of figs and wine.[13]

[1] 〔hieroglyphs〕. *Recueil de Travaux*, t. v., p. 190 (l. 180).

[2] 〔hieroglyphs〕 *Ibid.*, t. v., p. 163 (l. 408).

[3] *Ibid.*, t. iv., p. 45 (l. 394). [4] *Ibid.*, t. vii., p. 165 (l. 430).

[5] 〔hieroglyphs〕. *Ibid.*, t. v., p. 41 (l. 288), and t. vii., p. 167 (l. 442).

[6] 〔hieroglyphs〕. *Ibid.*, t. vii., p. 160 (l. 390).

[7] *Ibid.*, t. iii., p. 199 (l. 200). [8] *Ibid.*, t. v., p. 10 (l. 54 ff.).

[9] *Ibid.*, t. iii., p. 199 (l. 195 f.). [10] *Ibid.*, t. iv., p. 48 (l. 429).

[11] *Ibid.*, t. v., p. 167 (l. 66). [12] *Ibid.*, t. viii., p. 106 (l. 673).

[13] 〔hieroglyphs〕. *Ibid.*, t. viii., p 110 (l. 692).

Those who would be hostile to the deceased become thereby foes of the god Tmu, and all injuries inflicted on him are inflicted on that god ;[1] he dwells without fear under the protection of the gods,[2] from whose loins he has come forth.[3] To him "the earth is an abomination, and he will not enter into Seb ; for his soul hath " burst for ever the bonds of his sleep in his house which is upon earth. His " calamities are brought to an end, for Unâs hath been purified with the Eye of " Horus; the calamities of Unâs have been done away by Isis and Nephthys. " Unâs is in heaven, Unâs is in heaven, in the form of air, in the form of air ; he " perisheth not, neither doth anything which is in him perish.[4] He is firmly " stablished in heaven, and he taketh his pure seat in the bows of the bark of " Rā. Those who row Rā up into the heavens row him also, and those who row " Rā beneath the horizon row him also."[5] The life which the deceased leads is said to be generally that of him " who entereth into the west of the sky, and who " cometh forth from the east thereof."[6] In brief, the condition of the blessed is summed up in the following extract from the pyramid of Pepi I. :—[7]

" Hail, Pepi, thou hast come, thou art glorious, and thou hast gotten might like the god " who is seated upon his throne, that is Osiris. Thy soul is with thee in thy body, thy form of " strength is behind thee, thy crown is upon thy head, thy head-dress is upon thy shoulders, " thy face is before thee, and those who sing songs of joy are upon both sides of thee ; those " who follow in the train of God are behind thee, and the divine forms who make God to " come are upon each side of thee. God cometh, and Pepi hath come upon the throne of " Osiris. The shining one who dwelleth in Netat, the divine form that dwelleth in Teni, hath " come. Isis speaketh unto thee, Nephthys holdeth converse with thee, and the shining ones " come unto thee bowing down even to the ground in adoration at thy feet, by reason of the " writing which thou hast, O Pepi, in the region of Saa. Thou comest forth to thy mother " Nut, and she strengtheneth thy arm, and she maketh a way for thee through the sky to the " place where Rā abideth. Thou hast opened the gates of the sky, thou hast opened the " doors of the celestial deep ; thou hast found Rā and he watcheth over thee, he hath taken " thee by thy hand, he hath led thee into the two regions of heaven, and he hath placed thee " on the throne of Osiris. Then hail, O Pepi, for the Eye of Horus came to hold converse " with thee ; thy soul which was among the gods came unto thee ; thy form of power which " was dwelling among the shining ones came unto thee. As a son fighteth for his father, and " as Horus avenged Osiris, even so doth Horus defend Pepi against his enemies. And thou

[1] *Recueil de Travaux*, t. iv., p. 74 (l. 602). [2] *Recueil de Travaux*, t. iv., p. 46 (l. 405).
[3] *Ibid.*, t. iii., p. 202 (l. 209). [4] *Ibid.*, t. iv., p. 51 (l. 447 f.).
[5] *Ibid.*, t. v., p. 53 (l. 340).

[6] *Ibid.*, t. 8, p. 104 (l. 665).

[7] *Ibid.*, t. v., p. 159, (ll. 1–21).

" standest avenged, endowed with all things like unto a god, and equipped with all the forms of
" Osiris upon the throne of Khent-Åmenta. Thou doest that which he doeth among the
" immortal shining ones ; thy soul sitteth upon its throne being provided with thy form, and
" it doeth that which thou doest in the presence of Him that liveth among the living, by
" the command of Rā, the great god. It reapeth the wheat, it cutteth the barley, and it
" giveth it unto thee. Now, therefore, O Pepi, he that hath given unto thee life and all
" power and eternity and the power of speech and thy body is Rā. Thou hast endued
" thyself with the forms of God, and thou hast become magnified thereby before the gods
" who dwell in the Lake. Hail, Pepi, thy soul standeth among the gods and among the
" shining ones, and the fear of thee striketh into their hearts. Hail, Pepi, thou placest thyself
" upon the throne of Him that dwelleth among the living, and it is the writing which thou
" hast [that striketh terror] into their hearts. Thy name shall live upon earth, thy name shall
" flourish upon earth, thou shalt neither perish nor be destroyed for ever and for ever."

Side by side, however, with the passages which speak of the material and
spiritual enjoyments of the deceased, we have others which seem to imply that the
Egyptians believed in a corporeal existence,[1] or at least in the capacity for corporeal
enjoyment, in the future state. This belief may have rested upon the view that
the life in the next world was but a continuation of the life upon earth, which it
resembled closely, or it may have been due to the survival of semi-savage gross
ideas incorporated into the religious texts of the Egyptians. However this may
be, it is quite certain that in the Vth dynasty the deceased king Unàs eats with
his mouth, and exercises other natural functions of the body, and gratifies his
passions.[2] But the most remarkable passage in this connection is one in the

[1] Compare
"O flesh of Tetâ, rot not, decay not, stink not." *Recueil de Travaux*, t. v., p. 55 (l. 347).
" Pepi goeth forth with his flesh "; *ibid.*, t. v., p. 185 (l. 169).
"thy bones shall not be destroyed, and thy flesh
shall not perish "; *ibid.*, p. 55 (l. 353).

[2] Compare the following passages :—

(a)
Ibid., t. iv., p. 76 (ll. 628, 629).

(b)
Ibid., t. v., p. 37 (l. 277).

pyramid of Unâs. Here all creation is represented as being in terror when they see the deceased king rise up as a soul in the form of a god who devours "his "fathers and mothers"; he feeds upon men and also upon gods. He hunts the gods in the fields and snares them; and when they are tied up for slaughter he cuts their throats and disembowels them. He roasts and eats the best of them, but the old gods and goddesses are used for fuel. By eating them he imbibes both their magical powers ⧛ ⊔ , and their *khu*'s 𓅝𓅝𓅝 . He becomes the "great Form, the form among forms, and the god of all the great gods who " exist in visible forms,"[1] and he is at the head of all the *sāhu*, or spiritual bodies in heaven. He carries off the hearts ⟿ ♡♡ of the gods, and devours the wisdom of every god; therefore the duration of his life is everlasting and he lives to all eternity, for the souls of the gods and their *khu*'s are in him. The whole passage reads :—[2]

"(496) The heavens drop water, the stars throb, (497) the archers go round about, the
" (498) bones of Åkeru tremble, and those who are in bondage to them take to flight when
" they see (499) Unâs rise up as a soul, in the form of the god who liveth upon his fathers and
" who maketh food of his (500) mothers. Unâs is the lord of wisdom, and (501) his mother
" knoweth not his name. The gifts of Unâs are in heaven, and he hath become mighty in
" the horizon (502) like unto Tmu, the father that gave him birth, and after Tmu gave him birth
" (503) Unâs became stronger than his father. The *ka*'s of Unâs are behind him, the sole of
" his foot is beneath his feet, his gods are over him, his uræi are [seated] (504) upon his brow,
" the serpent guides of Unâs are in front of him, and the spirit of the flame looketh upon [his]

(c) ... *Ibid.*, t. iii., p. 197 (l. 182 f.).

(d) ... *Ibid.*, t. v., p. 40 (l. 286), and see M. Maspero's note on the same page.

[1] ... Pyramid of Tetâ, l. 327; *ibid.*, t. v., p. 50.

[2] See Maspero, *Recueil*, t. iv., p. 59, t. v., p. 50; and *Revue de l'Histoire des Religions*, t. xii., p. 128.

" soul. The (505) powers of Unás protect him; Unás is a bull in heaven, he directeth his
" steps where he will, he liveth upon the form which (506) each god taketh upon himself, and
" he eateth the flesh of those who come to fill their bellies with the magical charms in the
" Lake of Fire. Unás is (507) equipped with power against the shining spirits thereof, and
" he riseth up in the form of the mighty one, the lord of those who dwell in power (?). Unás
" hath taken his seat with his side turned towards Seb. (508) Unás hath weighed his
" words with the hidden god (?) who hath no name, on the day of hacking in pieces the first-
" born. Unás is the lord of offerings, the untier of the knot, and he himself maketh abundant
' the offerings of meat and drink. (509) Unás devoureth men and liveth upon the gods, he
" is the lord to whom offerings are brought, and he counteth the lists thereof. He that
" cutteth off hairy scalps and dwelleth in the fields hath netted the gods in a snare; (510) he
" that arrangeth his head hath considered them [good] for Unás and hath driven them unto
" him; and the cord-master hath bound them for slaughter. Khonsu the slayer of [his] lords
" hath cut their throats (511) and drawn out their inward parts, for it was he whom Unás
" sent to drive them in; and Shesem hath cut them in pieces and boiled their members in
" his blazing caldrons. (512) Unás hath eaten their magical powers, and he hath swallowed
" their spirits; the great ones among them serve for his meal at daybreak, the lesser serve for
" his meal at eventide, and the least among them serve for his meal in the night. (513) The
" old gods and the old goddesses become fuel for his furnace. The mighty ones in heaven
" shoot out fire under the caldrons which are heaped up with the haunches of the firstborn;
" and he that maketh those who live (514) in heaven to revolve round Unás hath shot into
" the caldrons the haunches of their women; he hath gone round about the two heavens in
" their entirety, and he hath gone round about the two banks of the celestial Nile. Unás is
" the great Form, the Form (515) of forms, and Unás is the chief of the gods in visible forms.
" Whatever he hath found upon his path he hath eaten forthwith, and the magical might of
" Unás is before that of all the (516) *sāhu* who dwell in the horizon. Unás is the firstborn of
" the firstborn. Unás hath gone round thousands and he hath offered oblations unto hundreds;
" he hath manifested his might as the Great Form through Saḥ (Orion) [who is greater] than
" (517) the gods. Unás repeateth his rising in heaven and he is the crown of the lord of the
" horizon. He hath reckoned up the bandlets and the arm-rings, he hath taken possession of
" the hearts of the gods (518). Unás hath eaten the red crown, and he hath swallowed the
" white crown; the food of Unás is the inward parts, and his meat is those who live upon
" (519) magical charms in their hearts. Behold, Unás eateth of that which the red crown
" sendeth forth, he increaseth, and the magical charms of the gods are in his belly; (520) that
" which belongeth to him is not turned back from him. Unás hath eaten the whole of the
" knowledge of every god, and the period of his life is eternity, and the duration of his
" existence is (521) everlastingness, in whatsoever he wisheth to take; whatsoever form he
" hateth he shall not labour in in the horizon for ever and ever and ever. The soul of the
" gods is in Unás, their spirits are with (522) Unás, and the offerings made unto him are
" more than those made unto the gods. The fire of Unás (523) is in their bones, for their
" soul is with Unás, and their shades are with those who belong unto them. (524) Unas hath
" been with the two hidden (?) Kha (?) gods who are without power (?) (525); the
" seat of the heart of Unás is among those who live upon this earth for ever and ever and
" ever."

The notion that, by eating the flesh, or particularly by drinking the blood, of another living being, a man absorbs his nature or life into his own, is one which appears among primitive peoples in many forms. It lies at the root of the wide-spread practice of drinking the fresh blood of enemies—a practice which was familiar to certain tribes of the Arabs before Muḥammad, and which tradition still ascribes to the wild race of Caḫṭân—and also of the habit practised by many savage huntsmen of eating some part (*e.g.*, the liver) of dangerous carnivora, in order that the courage of the animal may pass into them.[1] The flesh and blood of brave men also are, among semi-savage or savage tribes, eaten and drunk to inspire courage.[2] But the idea of hunting, killing, roasting and eating the gods as described above is not apparently common among ancient nations ; the main object of the dead king in doing this was to secure the eternal life which was the peculiar attribute of the gods.

[1] Robertson Smith, *The Religion of the Semites*, p. 295 ; Fraser, *Golden Bough*, vol. ii., p. 86.

[2] The Australian blacks kill a man, cut out his caul-fat, and rub themselves with it, "the belief being that all the qualifications, both physical and mental of the previous owner of the fat, were communicated to him who used it" ; see Fraser, *Golden Bough*, vol. ii., p. 88.

THE EGYPTIANS' IDEAS OF GOD.

To the great and supreme power which made the earth, the heavens, the sea, the sky, men and women, animals, birds, and creeping things, all that is and all that shall be, the Egyptians gave the name *neter* ᵁᵁ ⟍.[1] This word survives in the Coptic ⲛⲟⲩⲧ, but both in the ancient language and in its younger relative the exact meaning of the word is lost. M. Pierret,[2] following de Rougé, connects it with the word ⟍ ᵁ { ⎮ and says that it means "renovation" (renouvellement), but Brugsch[3] renders it by "göttlich," "heilig," "divin," "sacré," and by three Arabic words which mean "divine," "sacred or set apart," and "holy" respectively. By a quotation from the stele of Canopus he shows that in Ptolemaïc times it meant "holy" or "sacred" when applied to the animals of the gods. Mr. Renouf[4] says that "the notion expressed by *nutar* as a noun, and *nutra* as an adjective or verb, must be sought in the Coptic ⲛⲟⲙⲧ, which in the translation of the Bible corresponds to the Greek words δύναμις, ἰσχύς, ἰσχυρός, ἰσχυρόω, 'power,' 'force,' 'strong,' 'fortify,' 'protect,'"[5] and he goes on to show that the word *neter* means "strong" or "mighty." M. Maspero, however, thinks that the Coptic *nomti* has nothing in common with *neter*, the Egyptian word for God, and that the passages quoted by Mr. Renouf in support of his theory can be otherwise explained.[6] His own opinion is that the signification "strong," if it ever existed, is a derived and not an original meaning, and he believes that the word is

[1] Several examples of the different ways in which the word is spelt are given by Maspero, *Notes sur différents points de Grammaire* (in *Mélanges d'Archéologie*, t. ii., Paris, 1873, p. 140).

[2] Pierret, *Essai sur la Mythologie Égyptienne*, Paris, 1879, p. 8.

[3] *Wörterbuch*, p. 825.

[4] *Hibbert Lectures*, p. 95.

[5] A number of examples are given in Tatham, *Lexicon*, Oxford, 1835, pp. 310 806.

[6] *La Mythologie Égyptienne*. t. ii., p. 215.

so old that its first sense is unknown to us. The fact that the Coptic translators of the Bible used the word *nouti* to express the name of the Supreme Being shows that no other word conveyed to their minds their conception of Him, and supports M. Maspero's views on this point. Another definition of the word given by Brugsch makes it to mean "the active power which produces and creates things in " regular recurrence; which bestows new life upon them, and gives back to them " their youthful vigour,"[1] and he adds that the innate conception of the word completely covers the original meaning of the Greek φύσις and the Latin *natura*.

But side by side with *neter*, whatever it may mean, we have mentioned in texts of all ages a number of beings or existences called *neteru* ⌇⌇⌇, or ⌇⌇⌇, or ⌇⌇⌇, or ⌇⌇⌇⌇, or ⌇⌇, or ⌇⌇⌇, or ⌇, which Egyptologists universally translate by the word "gods." Among these must be included the great cosmic powers and the beings who, although held to be supernatural, were yet finite and mortal, and were endowed by the Egyptians with love, hatred, and passions of every sort and kind. The difference between the conceptions of *neter* the one supreme God and the *neteru* is best shown by an appeal to Egyptian texts.

In the pyramid of Unàs it is said to the deceased,

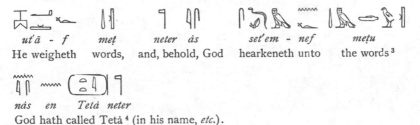

	un - k	àr	ḳes	neter
	Thou existest	at	the side of	God.[2]

In the pyramid of Tetà it is said of the deceased,

ut'à - f	met	neter às	set'em - nef	metu
He weigheth	words,	and, behold, God	hearkeneth unto	the words[3]

nàs	en	Tetà neter
God hath called Tetà[4] (in his name, *etc.*).		

[1] Die thätige Kraft, welche in periodischer Wiederkehr die Dinge erzeugt und erschafft, ihnen neues Leben verleiht und die Jugendfrische zurückgiebt." *Religion und Mythologie*, p. 93.

[2] Maspero, *Recueil de Travaux*, t. iii., p. 202 (l. 209).

[3] *Ibid*, t. v., 27 (ll. 231, 232).

[4] *Ibid.*, p. 26 (l. 223).

In the pyramid of Pepi I. an address to the deceased king says,

seśep - nek	àru	neter	āāa - k	àm	χer	neteru
Thou hast received	the form of	God,	thou hast become great	therewith	before	the gods.[1]

țā	en	mut - k	Nut	un - nek	em neter en	χeft - k	em	ren - k	en neter
Hath placed	thy mother	Nut	thee to be	as	God	to thine enemy	in	thy name	of God.[2]

țua	Pepi	pen	neter
Adoreth	this	Pepi	God.[3]

Pepi	pu	àr	neter	sa	neter
Pepi	this is then	God,	the son of	God.[4]	

All these extracts are from texts of the Vth and VIth dynasties. It may be urged that we might as well translate *neter* by "a god" or "the god," but other evidence of the conception of *neter* at that early date is afforded by the following passages from the Prisse papyrus,[5] which, although belonging at the earliest to the XIth dynasty, contains copies of the Precepts of Kaqemna, written in the reign of Seneferu, a king of the IVth dynasty, and the Precepts of Ptaḥ-ḥetep, written during the reign of Àssà, a king of the Vth dynasty.[6]

[1] *Recueil de Travaux*, t. v., p. 160 (l. 19). [2] *Ibid.*, p. 162 (l. 33).

[3] *Ibid.*, p. 191 (l. 185). [4] *Ibid.*, t. viii., p. 89 (l. 574).

[5] See *Fac-simile d'un papyrus Égyptien en caractères hiératiques*, trouvé à Thèbes, donné à la Bibliothèque royale de Paris et publié par E. Prisse d'Avennes, Paris, 1847, fol. The last translation of the complete work is by Virey, *Études sur le Papyrus Prisse*, Paris, 1887.

[6] M. Amélineau thinks (*La Morale Égyptienne*, p. xi.) that the Prisse papyrus was copied about the period of the XVIIth dynasty and that the works in it only date from the XIIth dynasty; but many Egyptologists assign the composition of the work to the age of Àssà. See Wiedemann, *Aegyptische Geschichte*, p. 201 ; Petrie, *History of Egypt*, p. 81.

1. *àn* *reχ - entu* *χepert* *àrit* *neter*
Not known are the things which will do God.[1]

2. *àm - k* *àri* *her* *em* *reθ* *χesef* *neter*
Thou shalt not cause terror in men and women, [for] is opposed God [thereto].[2]

3. *àu* *àm* *ta* *χer* *seχer* *neter*
The eating of bread is according to the plan of God.[3]

4. *àr* *seka - nek* *ṭer* *em* *seχet* *ṭā* *set* *neter*
If thou art a farmer, labour (?) in the field which hath given God [to thee].[4]

5. *àr* *un - nek* *em* *sa* *àqer* *àri - k* *sa* *en* *smam* *neter*
If thou wouldst be like a wise man, make thou [thy] son to be pleasing unto God.[5]

6. *sehetep* *āqu - k* *em* *χepert nek* *χepert* *en*
Satisfy those who depend on thee, so far as it may be done by thee; it should be done by

ḥesesu *neter*
those favoured of God.[6]

[1] Plate ii., l. 2. [2] Plate iv., line 8.
[3] Plate vii., l. 2. [4] Plate vii., l. 5.
[5] Plate vii., l. 11. [6] Plate xi., l. 1.

7. If, having been of no account, thou hast become great, and if, having been poor, thou hast become rich, when thou art governor of the city be not hard-hearted on account of thy advancement, because

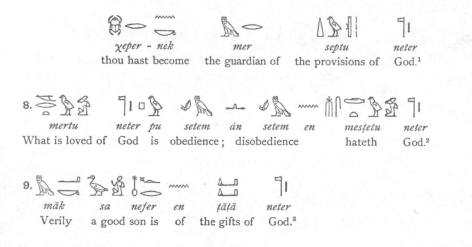

χeper - nek	mer	septu	neter
thou hast become	the guardian of	the provisions of	God.[1]

8.

mertu	neter	pu	setem	àn	setem	en	mesṭetu	neter
What is loved of	God	is	obedience;		disobedience		hateth	God.[2]

9.

māk	sa	nefer	en	ṭātā	neter
Verily	a good son is		of	the gifts of	God.[3]

Passing from the Prisse papyrus, our next source of information is the famous papyrus[4] containing the "Maxims of Ani," which are well known through the labours of de Rougé,[5] Maspero,[6] Chabas[7] and Amélineau.[8] We should speak of them, however, more correctly as the Maxims of Khonsu-ḥetep.[9] The papyrus

[1] Plate xiii., l. 8. [2] Plate xvi., l. 7.

[3] Plate xix., l. 6.

[4] It was found in a box laid upon the floor of the tomb of a Christian monk at Dêr el-Medinet. The text was given by Mariette in *Papyrus Égyptiens du Musée de Boulaq, publiés en fac-simile sous les auspices de S.A. Ismaïl-Pacha, Khédive d'Égypte.*

[5] In the *Moniteur*, 15 Août, 1861 ; and in *Comptes Rendus des séances de l'Académie des Inscriptions et Belles Lettres*, Paris, 1871, pp. 340–50.

[6] In the *Journal de Paris*, 15 Mars, 1871 ; and in the *Academy*, Aug. 1, No. 29, p. 386, 1871.

[7] *L'Égyptologie*, Série I., tt. i., ii., Chalons-sur-Saône and Paris, 4to., 1876–78. This work contains the hieratic text divided into sections for analysis, and accompanied by a hieroglyphic transcript, commentary, *etc.*

[8] *La Morale Égyptienne quinze siècles avant notre ère—Étude sur le Papyrus de Boulaq*, No. 4, Paris, 1892. This work contains a more accurate hieroglyphic transcript of the hieratic text, full translation, *etc.*

[9] Maspero, *Lectures Historiques*, p. 16 ; Amélineau, *op. cit.*, p. ix.

was probably copied about the XXIInd dynasty; but the work itself may date from the XVIIIth. The following are examples of the use of *neter*:—

1.

pa	*neter*	*er*	*seāāauā*	*ren - f*
The	God is for		magnifying	his name.[1]

2.

χennu	*en*	*neter*	*betu - tuf*	*pu*	*sehebu*	*senemeḥu - nek*
The house	of	God	what it hates	is	much speaking.	Pray thou

em	*āb*	*mert*	*āu*	*meṭet - f*	*nebt*	*āmennu*	*āri - f*
with	a loving heart			the petitions of which	all	are in secret.	He will do

χeru - tuk	*setemu - f*	*ā t'eṭ - tuk*	*seśep*	*uṭennu tu-k*
thy business,	he will hear	that which thou sayest	and will accept	thine offerings.[2]

3.

āu	*ṭāu*	*neter - kuā*	*unnu*
Giveth thy	God	existence.[3]	

4.

pa	*neter*	*āput*	*pa*	*maā*
The	God	will judge	the	right.[4]

5.

uṭennu	*neter - ku*	*sau - tu*	*er*	*na*	*betau - tuf*
In offering to	thy God	guard thou	against	the things which	He abominateth.

[1] Amélineau, *La Morale*, p. 13.
[2] *Ibid.*, p. 36.
[3] *Ibid.*, p. 103.
[4] *Ibid.*, p. 138.

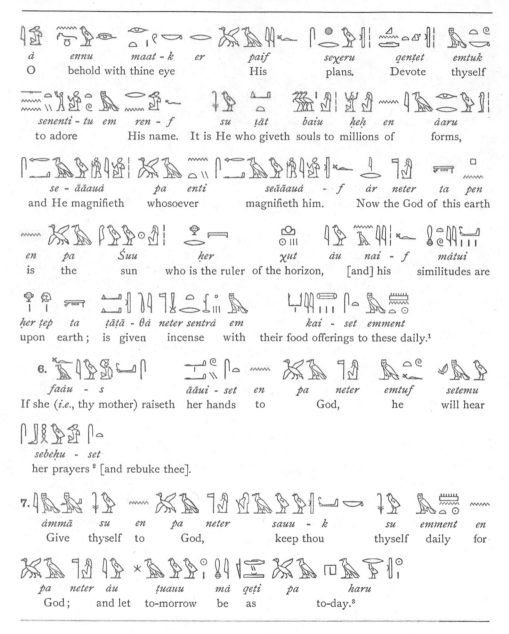

à ennu maat - k er paif seχeru qenṭet emtuk
O behold with thine eye His plans. Devote thyself

senenti - tu em ren - f su ṭāt baiu heḥ en àaru
to adore His name. It is He who giveth souls to millions of forms,

se - āāauà pa enti seāāauà - f àr neter ta pen
and He magnifieth whosoever magnifieth him. Now the God of this earth

en pa Šuu her χut àu nai - f màtui
is the sun who is the ruler of the horizon, [and] his similitudes are

her ṭep ta ṭāṭā - θà neter sentrà em kai - set emment
upon earth; is given incense with their food offerings to these daily.[1]

6. faàu - s àāui - set en pa neter emtuf setemu
If she (*i.e.*, thy mother) raiseth her hands to God, he will hear

sebeḥu - set
her prayers [2] [and rebuke thee].

7. àmmā su en pa neter sauu - k su emment en
Give thyself to God, keep thou thyself daily for

pa neter àu ṭuauu mà qeṭi pa haru
God; and let to-morrow be as to-day.[3]

[1] Amélineau, *La Morale*, p. 141. [2] *Ibid.*, p. 149. [3] *Ibid.*, p. 172.

The passages from the pyramid of Pepi show at once the difference between *neter* as God, and the "gods" *neteru;* the other passages, which might be multiplied almost indefinitely, prove that the Being spoken of is God. The *neteru* or "gods" whom Unás hunted, and snared, and killed, and roasted, and ate, are beings who could die; to them were attributed bodies, souls, *ka*'s, spiritual bodies, *etc.* In a remarkable passage from the CLIVth Chapter of the Book of the Dead (Naville, *Todtenbuch*, Bd. I., Bl. 179, l. 3) the deceased king Thothmes III. prays :—

séseṭ - kuá	emχet - k	Tem	ḫuau	má	ennu	ári - k
Preserve me	behind thee,	O Tmu, from decay		such as	that which	thou workest

er	neter	neb	netert	nebt	er	áut	neb	er	t'etfet	neb
for	god	every,	and goddess	every,	for	animals	all,	for	reptiles	all ;

sebuit - f	per	ba - f	emχet	mit - f	ha - f
for each passeth away	when hath gone forth	his soul	after	his death,	he perisheth

emχet	sebi - f
after	he hath passed away.

Of these mortal gods some curious legends have come down to us; from which the following may be selected as illustrating their inferior position.

THE LEGEND OF RĀ AND ISIS.

Now Isis was a woman who possessed words of power; her heart was wearied with the millions of men, and she chose the millions of the gods, but she esteemed more highly the millions of the *khu*'s. And she meditated in her heart, saying, "Cannot I by means of the "sacred name of God make myself mistress of the earth and become a goddess like unto

" Rā in heaven and upon earth ? " Now, behold, each day Rā entered at the head of his holy mariners and established himself upon the throne of the two horizons. The holy one had grown old, he dribbled at the mouth, his spittle fell upon the earth, and his slobbering dropped upon the ground. And Isis kneaded it with earth in her hand, and formed thereof a sacred serpent in the form of a spear ; she set it not upright before her face, but let it lie upon the ground in the path whereby the great god went forth, according to his heart's desire, into his double kingdom. Now the holy god arose, and the gods who followed him as though he were Pharaoh went with him ; and he came forth according to his daily wont ; and the sacred serpent bit him. The flame of life departed from him, and he who dwelt among the cedars (?) was overcome. The holy god opened his mouth, and the cry of his majesty reached unto heaven. His company of gods said, " What hath happened ? " and his gods exclaimed, " What is it ? " But Rā could not answer, for his jaws trembled and all his members quaked ; the poison spread swiftly through his flesh just as the Nile invadeth all his land. When the great god had stablished his heart, he cried unto those who were in his train, saying, " Come unto me, O ye who have come into being from my " body, ye gods who have come forth from me, make ye known unto Kheperà that a dire " calamity hath fallen upon me. My heart perceiveth it, but my eyes see it not ; my hand " hath not caused it, nor do I know who hath done this unto me. Never have I felt such " pain, neither can sickness cause more woe than this. I am a prince, the son of a prince, " a sacred essence which hath proceded from God. I am a great one, the son of a great one, " and my father planned my name ; I have multitudes of names and multitudes of forms, and " my existence is in every god. I have been proclaimed by the heralds Tmu and Horus, and " my father and my mother uttered my name ; but it hath been hidden within me by him " that begat me, who would not that the words of power of any seer should have " dominion over me. I came forth to look upon that which I had made, I was passing " through the world which I had created, when lo! something stung me, but what I know " not. Is it fire ? Is it water ? My heart is on fire, my flesh quaketh, and trembling " hath seized all my limbs. Let there be brought unto me the children of the gods with " healing words and with lips that know, and with power which reacheth unto heaven." The children of every god came unto him in tears, Isis came with her healing words and with her mouth full of the breath of life, with her enchantments which destroy sickness, and with her words of power which make the dead to live. And she spake, saying, " What hath come " to pass, O holy father? What hath happened? A serpent hath bitten thee, and a thing " which thou hast created hath lifted up his head against thee. Verily it shall be cast " forth by my healing words of power, and I will drive it away from before the sight of thy " sunbeams."

The holy god opened his mouth and said, " I was passing along my path, and I was " going through the two regions of my lands according to my heart's desire, to see that " which I had created, when lo! I was bitten by a serpent which I saw not. Is it fire ? Is it " water ? I am colder than water, I am hotter than fire. All my flesh sweateth, I quake, my " eye hath no strength, I cannot see the sky, and the sweat rusheth to my face even as in the " time of summer." Then said Isis unto Rā, " O tell me thy name, holy father, for whosoever " shall be delivered by thy name shall live." [And Rā said], " I have made the heavens and " the earth, I have ordered the mountains, I have created all that is above them, I have made " the water, I have made to come into being the great and wide sea, I have made the ' Bull of

" his mother,' from whom spring the delights of love. I have made the heavens, I have
" stretched out the two horizons like a curtain, and I have placed the soul of the gods within
" them. I am he who, if he openeth his eyes, doth make the light, and, if he closeth them,
" darkness cometh into being. At his command the Nile riseth, and the gods know not his
" name. I have made the hours, I have created the days, I bring forward the festivals of the
" year, I create the Nile-flood. I make the fire of life, and I provide food in the houses. I
" am Kheperà in the morning, I am Rā at noon, and I am Tmu at even." Meanwhile the
poison was not taken away from his body, but it pierced deeper, and the great god could no
longer walk.

Then said Isis unto Rā, "What thou hast said is not thy name. O tell it unto me,
" and the poison shall depart ; for he shall live whose name shall be revealed." Now the
poison burned like fire, and it was fiercer than the flame and the furnace, and the majesty of
the god said, " I consent that Isis shall search into me, and that my name shall pass from me
" into her." Then the god hid himself from the gods, and his place in the boat of millions
of years was empty. And when the time arrived for the heart of Rā to come forth, Isis
spake unto her son Horus, saying, " The god hath bound himself by an oath to deliver up his
two eyes " (i.e., the sun and moon). Thus was the name of the great god taken from him,
and Isis, the lady of enchantments, said, "Depart, poison, go forth from Rā. O eye of
" Horus, go forth from the god, and shine outside his mouth. It is I who work, it is I who
" make to fall down upon the earth the vanquished poison ; for the name of the great god
" hath been taken away from him. May Rā live ! and may the poison die, may the poison
" die, and may Rā live !" These are the words of Isis, the great goddess, the queen of the
gods, who knew Rā by his own name.[1]

Thus we see that even to the great god Rā were attributed all the weakness
and frailty of mortal man ; and that " gods " and " goddesses " were classed with
beasts and reptiles, which could die and perish. As a result, it seems that the word
" God " should be reserved to express the name of the Creator of the Universe,
and that *neteru*, usually rendered "gods," should be translated by some other word,
but what that word should be it is almost impossible to say.[2]

From the attributes of God set forth in Egyptian texts of all periods, Dr.
Brugsch, de Rougé, and other eminent Egyptologists have come to the opinion that
the dwellers in the Nile valley, from the earliest times, knew and worshipped one
God, nameless, incomprehensible, and eternal. In 1860 de Rougé wrote :—" The

[1] The hieratic text of this story was published by Pleyte and Rossi, *Le Papyrus de Turin*, 1869–
1876, pll. 31–77, and 131–138 ; a French translation of it was published by M. Lefébure, who first
recognized the true character of the composition, in *Aeg. Zeitschrift*, 1883, p. 27 ff ; and a German
translation by Wiedemann is in his collection of " Sonnensagen," *Religion der alten Aegypter*, Münster,
1890, p. 29 ff.

[2] A similar difficulty also exists in Hebrew, for אֱלֹהִים means both God and " gods " ; compare
Psalm lxxxii., 1.

" unity of a supreme and self-existent being, his eternity, his almightiness, and
" external reproduction thereby as God ; the attributing of the creation of the world
" and of all living beings to this supreme God ; the immortality of the soul, com-
" pleted by the dogma of punishments and rewards : such is the sublime and
" persistent base which, notwithstanding all deviations and all mythological em-
" bellishments, must secure for the beliefs of the ancient Egyptians a most
" honourable place among the religions of antiquity."[1] Nine years later he de-
veloped this view, and discussed the difficulty of reconciling the belief in the unity
of God with the polytheism which existed in Egypt from the earliest times, and he
repeated his conviction that the Egyptians believed in a self-existent God who was
One Being, who had created man, and who had endowed him with an immortal
soul.[2] In fact, de Rougé amplifies what Champollion-Figeac (relying upon his
brother's information) wrote in 1839 : " The Egyptian religion is a pure mono-
" theism, which manifested itself externally by a symbolic polytheism."[3] M. Pierret
adopts the view that the texts show us that the Egyptians believed in One infinite
and eternal God who was without a second, and he repeats Champollion's dictum.[4]
But the most recent supporter of the monotheistic theory is Dr. Brugsch, who has
collected a number of striking passages from the texts. From these passages we
may select the following :—

God is one and alone, and none other existeth with Him—God is the One, the One who
hath made all things—God is a spirit, a hidden spirit, the spirit of spirits, the great spirit
of the Egyptians, the divine spirit—God is from the beginning, and He hath been from the
beginning, He hath existed from old and was when nothing else had being. He existed
when nothing else existed, and what existeth He created after He had come into being, He
is the Father of beginnings—God is the eternal One, He is eternal and infinite and endureth
for ever and aye—God is hidden and no man knoweth His form. No man hath been able to
seek out His likeness ; He is hidden to gods and men, and He is a mystery unto His
creatures. No man knoweth how to know Him—His name remaineth hidden ; His name is
a mystery unto His children. His names are innumerable, they are manifold and none
knoweth their number—God is truth and He liveth by truth and He feedeth thereon. He is
the king of truth, and He hath stablished the earth thereupon—God is life and through Him

[1] *Études sur le Rituel Funéraire des Anciens Égyptiens* (in *Revue Archéologique*), Paris, 1860, p. 72.

[2] La croyance à l'Unité du Dieu suprême, à ses attributs de Créateur et de Législateur de l'homme,
qu'il a doué d'une âme immortelle ; voilà les notions primitives enchâssées comme des diamants indes-
tructibles au milieu des superfétations mythologiques accumulées par les siècles qui ont passé sur cette
vieille civilization. See *Conférence sur la Religion des anciens Égyptiens* (in *Annales de Philosophie
Chrétienne*, 5ième Série, t. xx., Paris, 1869, pp. 325-337).

[3] *Égypte*, Paris, 1839, p. 245, col. 1.

[4] *Le Panthéon Égyptien*, Paris, 1881, p. 4.

only man liveth. He giveth life to man, He breatheth the breath of life into his nostrils—God is father and mother, the father of fathers, and the mother of mothers. He begetteth, but was never begotten ; He produceth, but was never produced; He begat himself and produced himself. He createth, but was never created ; He is the maker of his own form, and the fashioner of His own body—God Himself is existence, He endureth without increase or diminution, He multiplieth Himself millions of times, and He is manifold in forms and in members—God hath made the universe, and He hath created all that therein is ; He is the Creator of what is in this world, and of what was, of what is, and of what shall be. He is the Creator of the heavens, and of the earth, and of the deep, and of the water, and of the mountains. God hath stretched out the heavens and founded the earth—What His heart conceived straightway came to pass, and when He hath spoken, it cometh to pass and endureth for ever—God is the father of the gods ; He fashioned men and formed the gods— God is merciful unto those who reverence Him, and He heareth him that calleth upon Him. God knoweth him that acknowledgeth Him, He rewardeth him that serveth Him, and He protecteth him that followeth Him.[1]

Because, however, polytheism existed side by side with monotheism in Egypt, M. Maspero believes that the words "God One" do not mean "One God" in our sense of the words ; and Mr. Renouf thinks that the "Egyptian *nutar* never became a proper name." [2] Whether polytheism grew from monotheism in Egypt, or monotheism from polytheism we will not venture to say, for the evidence of the pyramid texts shows that already in the Vth dynasty monotheism and polytheism were flourishing side by side. The opinion of Tiele is that the religion of Egypt was from the beginning polytheistic, but that it developed in two opposite directions : in the one direction gods were multiplied by the addition of local gods, and in the other the Egyptians drew nearer and nearer to monotheism.[3]

From a number of passages drawn from texts of all periods it is clear that the form in which God made himself manifest to man upon earth was the sun, which the Egyptians called *Rā* ,[4] and that all other gods and goddesses were forms of him. The principal authorities for epithets applied to God and to His visible emblem the sun are the hymns and litanies which are found inscribed upon

[1] Brugsch, *Religion und Mythologie*, pp. 96–99. The whole chapter on the ancient Egyptian conception of God should be read with M. Maspero's comments upon it in *La Mythologie Égyptienne* (*Études de Mythologie*, t. ii., p. 189 ff.).

[2] *Hibbert Lectures*, p. 99.

[3] *Hypothezen omtrent de wording van den Egyptischen Godsdienst* (in *Geschiedenis van den Godsdienst in de Oudheid*, Amsterdam, 1893, p. 25) ; and see Lieblein, *Egyptian Religion*, Leipzig, 1884, p. 10.

[4] See the chapter "Dieu se manifestant par le soleil," in Pierret, *Essai sur la Mythologie Égyptienne*, pp. 18, 19.

the walls of tombs,[1] stelæ, and papyri[2] of the XVIIIth dynasty; and these prove that the Egyptians ascribed the attributes of the Creator to the creature. The religious ideas which we find in these writings in the XVIIIth dynasty are, no doubt, the outcome of the religion of earlier times, for all the evidence now available shows that the Egyptians of the later periods invented comparatively little in the way of religious literature. Where, how, and in what way they succeeded in preserving their most ancient texts, are matters about which little, unfortunately, is known. In course of time we find that the attributes of a certain god in one period are applied to other gods in another; a new god is formed by the fusion of two or more gods; local gods, through the favourable help of political circumstances, or the fortune of war, become almost national gods; and the gods who are the companions of Osiris are endowed by the pious with all the attributes of the great cosmic gods—Rā, Ptaḥ, Khnemu, Kheperà, and the like. Thus the attributes of Rā are bestowed upon Khnemu and Kheperà; the god Horus exists in the aspects of Ḥeru-maati, Ḥeru-khent-àn-maa, Ḥeru-Khuti, Ḥeru-nub, Ḥeru-behuṭet, *etc.*, and the attributes of each are confounded either in periods or localities: Tmu-Rā, and Menthu-Rā, and Åmen-Rā are composed of Tmu and Rā, and Menthu and Rā, and Åmen and Rā respectively, and we have seen from the hymn quoted above (p. lii.) that already in the XVIIIth dynasty the god Osiris had absorbed the attributes which belonged in the earlier dynasties to Rā alone.

Still more remarkable, however, is the progress of the god Åmen in Egyptian theology. In the early empire, *i.e.*, during the first eleven dynasties, this god ranked only as a local god, although his name is as old as the time of Unàs;[3] and

[1] *E.g.*, the litany from the tomb of Seti I., published by Naville, *La Litanie du Soleil*, Leipzig, 1875, p. 13 ff.

[2] *E.g.*, *Hymn to Åmen-Rā*, translated by Goodwin from papyrus No. 17, now preserved in the Gîzeh Museum (see *Les Papyrus Égyptiens du Musée de Boulaq*, ed. Mariette, Paris, 1872, pll. 11–13; *Records of the Past*, vol. i., p. 127 f., and *Trans. Soc. Bibl. Arch.*, vol. ii., p. 250), and by Grébaut, *Hymne à Ammon-Rā*, Paris, 1874); *Hymns to Amen*, translated by Goodwin (see *Records of the Past*, vol. vi., p. 97 f.; *Trans. Soc. Bibl. Arch.*, vol. ii., p. 353), and Chabas (*Mélanges Égyptologiques*, 1870, p. 117); *Hymn to Osiris*, translated by Chabas (*Revue Archéologique*, t. xiv., Paris, 1857, p. 65 ff.), and Goodwin (*Records of the Past*, vol. iv., p. 97 ff.). The various versions of the XVth Chapter of the Book of the Dead, which consists of a series of hymns, are given in the Theban edition by Naville (*Todtenbuch*, Bd. I., Bll. 14–23), and the text of the later Saïte version is discussed and translated by Lefébure, *Traduction comparée des hymnes au Soleil*, Paris, 1868, 4to.

[3] "Åmen and Åment," 𓇳𓊖 𓏏 𓄿 𓈖, are mentioned in l. 558 of the inscription of this king; see Maspero, *Recueil*, t. iv., p. 66.

it is not until the so-called Hyksos have been expelled from Egypt by the Theban kings of the XVIIth dynasty that Åmen, whom the latter had chosen as their great god, and whose worship they had declined to renounce at the bidding of the Hyksos king Åpepi,[1] was acknowledged as the national god of southern Egypt at least. Having by virtue of being the god of the conquerors obtained the position of head of the company of Egyptian gods, he received the attributes of the most ancient gods, and little by little he absorbed the epithets of them all. Thus Åmen became Åmen-Rā, and the glory of the old gods of Ånnu, or Heliopolis, was centred in him who was originally an obscure local god. The worship of Åmen in Egypt was furthered by the priests of the great college of Åmen, which seems to have been established early in the XVIIIth dynasty by the kings who were his devout worshippers. The extract from a papyrus written for the princess Nesi-Khonsu,[2] a member of the priesthood of Åmen, is an example of the exalted language in which his votaries addressed him.

"This is the sacred god, the lord of all the gods, Åmen-Rā, the lord of the throne of the " world, the prince of Åpt,[3] the sacred soul who came into being in the beginning, the great " god who liveth by right and truth, the first ennead which gave birth unto the other two " enneads,[4] the being in whom every god existeth, the One of One,[5] the creator of the things " which came into being when the earth took form in the beginning, whose births are hidden, " whose forms are manifold, and whose growth cannot be known. The sacred Form, beloved, " terrible and mighty in his two risings (?), the lord of space, the mighty one of the form of " Kheperà, who came into existence through Kheperà, the lord of the form of Kheperà; when " he came into being nothing existed except himself. He shone upon the earth from primeval " time [in the form of] the Disk, the prince of light and radiance. He giveth light and " radiance. He giveth light unto all peoples. He saileth over heaven and never resteth, and " on the morrow his vigour is stablished as before; having become old [to-day], he becometh " young again to-morrow. He mastereth the bounds of eternity, he goeth round about heaven, " and entereth into the Ṭuat to illumine the two lands which he hath created. When the " divine (or mighty) God,[6] moulded himself, the heavens and the earth were made by his

[1] The literature relating to the fragment of the Sallier papyrus recording this fact is given by Wiedemann, *Aegyptische Geschichte*, p. 299.

[2] The hieratic text is published, with a hieroglyphic transcript, by Maspero, *Mémoires publiés par les Membres de la Mission Archéologique Française au Caire*, t. i., p. 594 ff., and pll. 25–27.

[3] A district of Thebes on the east bank of the Nile, the modern Karnak.

[4] See within, p. xcvii.

[5] ⛯ ⛯ ℮ 𓀀 .

[6] 𓎛𓏏𓐰𓏤𓏏𓏤 *neter netrà.* M. Maspero translates "dieu exerçant sa fonction de dieu, dieu en activité de service," or "dieu déisant."

" conception.[1] He is the prince of princes, the mightiest of the mighty, he is greater than the
" gods, he is the young bull with sharp pointed horns, and he protecteth the world in his
" great name 'Eternity cometh with its power and bringing therewith the bounds (?) of
" 'everlastingness.' He is the firstborn god, the god who existed from the beginning, the
" governor of the world by reason of his strength, the terrible one of the two lion-gods,[2] the
" aged one, the form of Kheperà which existeth in all the gods, the lion of fearsome glance,
" the governor terrible by reason of his two eyes,[3] the lord who shooteth forth flame [therefrom]
" against his enemies. He is the primeval water which floweth forth in its season to make to
" live all that cometh forth upon his potter's wheel.[4] He is the disk of the Moon, the beauties
" whereof pervade heaven and earth, the untiring and beneficent king, whose will germinateth
" from rising to setting, from whose divine eyes men and women come forth, and from
" whose mouth the gods do come, and [by whom] food and meat and drink are made and
" provided, and [by whom] the things which exist are created. He is the lord of time and he
" traverseth eternity ; he is the aged one who reneweth his youth ; he hath multitudes of eyes
" and myriads of ears ; his rays are the guides of millions of men ; he is the lord of life and
" giveth unto those who love him the whole earth, and they are under the protection of his
" face. When he goeth forth he worketh unopposed, and no man can make of none effect
" that which he hath done. His name is gracious, and the love of him is sweet ; and at the
" dawn all people make supplication unto him through his mighty power and terrible strength,
" and every god lieth in fear of him. He is the young bull that destroyeth the wicked, and
" his strong arm fighteth against his foes. Through him did the earth come into being
" in the beginning. He is the Soul which shineth through his divine eyes,[3] he is the Being
" endowed with power and the maker of all that hath come into being, and he ordered the
" world, and he cannot be known. He is the King who maketh kings to reign, and he directeth
" the world in his course ; gods and goddesses bow down in adoration before his Soul by
" reason of the awful terror which belongeth unto him. He hath gone before and hath
" stablished all that cometh after him, and he made the universe in the beginning by his
" secret counsels. He is the Being who cannot be known, and he is more hidden than all the
" gods. He maketh the Disk to be his vicar, and he himself cannot be known, and he hideth
" himself from that which cometh forth from him. He is a bright flame of fire, mighty in
" splendours, he can be seen only in the form in which he showeth himself, and he can be
" gazed upon only when he manifesteth himself, and that which is in him cannot be under-
" stood. At break of day all peoples make supplication unto him, and when he riseth with
" hues of orange and saffron among the company of the gods he becometh the greatly desired
" one of every god. The god Nu appeareth with the breath of the north wind in this hidden
" god who maketh for untold millions of men the decrees which abide for ever ; his decrees

[1] Literally "his heart," ꝏ àb-f.

[2] I.e., Shu and Tefnut.

[3] I.e., the Sun and the Moon, ut'ati.

[4] nehep ; other examples of the use of this word are given by Brugsch, Wörterbuch
(Suppl., p. 690).

" are gracious and well doing, and they fall not to the ground until they have fulfilled their
" purpose. He giveth long life and multiplieth the years of those who are favoured by him,
" he is the gracious protector of him whom he setteth in his heart, and he is the fashioner of
" eternity and everlastingness. He is the king of the North and of the South, Åmen-Rā, king
" of the gods, the lord of heaven, and of earth and of the waters and of the mountains, with
" whose coming into being the earth began its existence, the mighty one, more princely than
" all the gods of the first company thereof."

With reference to the origin of the gods of the Egyptians much useful
information may be derived from the pyramid texts. From them it would seem
that, in the earliest times, the Egyptians had tried to think out and explain to
themselves the origin of their gods and of their groupings. According to
M. Maspero[1] they reduced everything to one kind of primeval matter which
they believed contained everything in embryo; this matter was water, *Nu*, which
they deified, and everything which arose therefrom was a god. The priests of
Annu at a very early period grouped together the nine greatest gods of Egypt,
forming what is called the *paut neteru* ⟨hieroglyphs⟩ or "company of the gods," or as
it is written in the pyramid texts, *paut āāt* ⟨hieroglyphs⟩, " the great company of
gods"; the texts also show that there was a second group of nine gods called *paut
net'eset* ⟨hieroglyphs⟩, or "lesser company of the gods"; and a third group of
nine gods is also known. When all three *pauts* of gods are addressed they appear
as ⟨hieroglyphs⟩.[2] The great cycle of the gods in Annu
was composed of the gods ·Tmu, Shu, Tefnut, Seb, Nut, Osiris, Isis, Set and
Nephthys; but, though *paut* means " nine," the texts do not always limit a *paut* of
the gods to that number, for sometimes the gods amount to twelve, and sometimes,
even though the number be nine, other gods are substituted for the original gods
of the *paut*. We should naturally expect Rā to stand at the head of the great
paut of the gods; but it must be remembered that the chief local god of Ånnu was
Tmu, and, as the priests of that city revised and edited the pyramid texts known
to us, they naturally substituted their own form of the god Rā, or at best united
him with Rā, and called him Tmu-Rā. In the primeval matter, or water, lived
the god Tmu, and when he rose for the first time, in the form of the sun, he
created the world. Here at once we have Tmu assimilated with Nu. A curious
passage in the pyramid of Pepi I. shows that while as yet there was neither

[1] *La Mythologie Égyptienne* (*Études*, t. ii., p. 237).
[2] See Pyramid of Tetā, l. 307 (Maspero, *Recueil de Travaux*, t. v., p. 46).

heaven nor earth, and when neither gods had been born, nor men created, the god Tmu was the father of human beings,[1] even before death came into the world. The first act of Tmu was to create from his own body the god Shu and the goddess Tefnut ;[2] and afterwards Seb the earth and Nut the sky came into being. These were followed by Osiris and Isis, Set and Nephthys.

Dr. Brugsch's version of the origin of the gods as put forth in his last work on the subject[3] is somewhat different. According to him there was in the beginning neither heaven nor earth, and nothing existed except a boundless primeval mass of water which was shrouded in darkness and which contained within itself the germs or beginnings, male and female, of everything which was to be in the future world. The divine primeval spirit which formed an essential part of the primeval matter felt within itself the desire to begin the work of creation, and its word woke to life the world, the form and shape of which it had already depicted to itself. The first act of creation began with the formation of an egg[4] out of the primeval water, from which broke forth Rā, the immediate cause of all life upon earth. The almighty power of the divine spirit embodied itself in its most brilliant form in the rising sun. When the inert mass of primeval matter felt the desire of the primeval spirit to begin the work of creation, it began to move, and the creatures which were to constitute the future world were formed

[1] *Recueil de Travaux*, t. viii., p. 104 (l. 664). The passage reads :—

mes	Pepi	pen	àn	àtf	Tem	àn	χepert	pet	àn
Gave birth to	Pepi	this		father	Tmu [when] not		was created	heaven,	not

χepert	ta	àn	χepert	reθ	àn	mest	neteru	àn	χepert	met
was created	earth,	not	were created	men,	not	were born	the gods,	not	was created	death.

[2] *Recueil de Travaux*, t. vii., p. 170 (l. 466).

[3] *Religion und Mythologie*, p. 101.

[4] A number of valuable facts concerning the place of the egg in the Egyptian Religion have been collected by Lefébure, *Revue de l' Histoire des Religions*, t. xvi., Paris, 1887, p. 16 ff.

according to the divine intelligence *Maā*. Under the influence of Thoth, or that form of the divine intelligence which created the world by a word, eight elements, four male and four female, arose out of the primeval *Nu*, which possessed the properties of the male and female. These eight elements were called Nu and Nut,[1] Heh and Hehet,[2] Kek and Keket,[3] and Enen and Enenet,[4] or *Khemennu*, the "Eight," and they were considered as primeval fathers and mothers.[5] They are often represented in the forms of four male and four female apes who stand in adoration and greet the rising sun with songs and hymns of praise,[6] but they also appear as male and female human forms with the heads of frogs or serpents.[7] The birth of light from the waters, and of fire from the moist mass of primeval matter, and of Rā from Nu, formed the starting point of all mythological speculations, conjectures, and theories of the Egyptian priests.[8] The light of the sun gave birth to itself out of chaos, and the conception of the future world was depicted in Thoth the divine intelligence ; when Thoth gave the word, what he commanded at once took place by means of Ptaḥ and Khnemu, the visible representatives of the power which turned Thoth's command into deed. Khnemu made the egg of the sun,[9] and Ptaḥ gave to the god of light a finished body.[10] The first *paut* of the gods consisted of Shu, Tefnut, Seb, Nut, Osiris, Isis, Set, Nephthys and Horus, and their governor Tmu or Åtmu.[11]

In a late copy of a work entitled the "Book of knowing the evolutions of Rā," the god Neb-er-tcher, the "lord of the company of the gods," records the story of the creation and of the birth of the gods :—" I am he who evolved himself under " the form of the god Kheperà, I, the evolver of the evolutions evolved myself, " the evolver of all evolutions, after many evolutions and developments which " came forth from my mouth.[12] No heaven existed, and no earth, and no " terrestrial animals or reptiles had come into being. I formed them out of the " inert mass of watery matter, I found no place whereon to stand. . . . , I was " alone, and the gods Shu and Tefnut had not gone forth from me ; there existed

[1] Brugsch, *Religion*, pp. 128, 129.

[2] *Ibid.*, p. 132.

[3] *Ibid.*, p. 140.

[4] *Ibid.*, p. 142.

[5] *Ibid.*, p. 148.

[6] *Ibid.*, pp. 149, 152.

[7] *Ibid.*, p. 158.

[8] *Ibid.*, p. 160.

[9] *Ibid.*, p. 161.

[10] *Ibid.*, p. 163.

[11] *Ibid.*, p. 187.

[12] The variant version says, " I developed myself from the primeval matter which I had made." and adds, " My name is Osiris, , the substance of primeval matter."

" none other who worked with me. I laid the foundations of all things by my will,
" and all things evolved themselves therefrom.¹ I united myself to my shadow,
" and I sent forth Shu and Tefnut out from myself; thus from being one god I
" became three, and Shu and Tefnut gave birth to Nut and Seb, and Nut gave
" birth to Osiris, Horus-Khent-àn-maa, Sut, Isis, and Nephthys, at one birth, one
" after the other, and their children multiply upon this earth." ²

The reader has now before him the main points of the evidence concerning the
Egyptians' notions about God, and the cosmic powers and their phases, and the
anthropomorphic creations with which they peopled the other world, all of which
have been derived from the native literature of ancient Egypt. The different
interpretations which different Egyptologists have placed upon the facts demonstrate
the difficulty of the subject. Speaking generally, the interpreters may be divided
into two classes : those who credit the Egyptians with a number of abstract ideas
about God and the creation of the world and the future life, which are held to be
essentially the product of modern Christian nations ; and those who consider the
mind of the Egyptian as that of a half-savage being to whom occasional glimmerings
of spiritual light were vouchsafed from time to time. All eastern nations have
experienced difficulty in separating spiritual from corporeal conceptions, and the
Egyptian is no exception to the rule ; but if he preserved the gross idea of a
primeval existence with the sublime idea of God which he manifests in writings of
a later date, it seems that this is due more to his reverence for hereditary tradition
than to ignorance. Without attempting to decide questions which have presented
difficulties to the greatest thinkers among Egyptologists, it may safely be said that
the Egyptian whose mind conceived the existence of an unknown, inscrutable,
eternal and infinite God, who was One—whatever the word One may mean here—
and who himself believed in a future life to be spent in a glorified body in heaven,
was not a being whose spiritual needs would be satisfied by a belief in gods who
could eat, and drink, love and hate, and fight and grow old and die. He was
unable to describe the infinite God, himself being finite, and it is not surprising
that he should, in some respects, have made Him in his own image.

¹ The variant version has, "I brought into my own mouth my name as a word of power, and I
straightway came into being."

² The papyrus from which these extracts are taken is in the British Museum, No. 10188. A
hieroglyphic transcript and translation will be found in *Archæologia*, vol. lii., pp. 440–443. For the
passages quoted see Col. 26, l. 22 ; Col. 27, l 5 ; and Col. 28, l. 20 ; Col. 29, l. 6.

THE ABODE OF THE BLESSED.

The gods of the Egyptians dwelt in a heaven with their *ka*'s, and *khu*'s, and shadows, and there they received the blessed dead to dwell with them. This heaven was situated in the sky, which the Egyptians believed to be like an iron ceiling, either flat or vaulted, and to correspond in extent and shape with the earth beneath it. This ceiling was rectangular, and was supported at each corner by a pillar ⌐; in this idea, we have, as M. Maspero has observed, a survival of the roof-tree of very primitive nations. At a very early date the four pillars ⌐⌐⌐⌐, were identified with "the four ancient *khu*'s who dwell in the hair of Horus,"[1] who are also said to be "the four gods who stand by the pillar-sceptres of heaven."[2] These four gods are "children of Horus," 𓀀𓃒𓅆,[3] and their names are Åmset 𓀀𓅆𓂝, Ḥāpi, 𓁷𓊖𓃒𓅆, Ṭuamāutef, ⌐𓃒𓂝, and Qebḥsennuf, 𓀀𓏥𓂝.[4] They were supposed to preside over the four quarters of the world, and subsequently were acknowledged to be the gods of the cardinal points. The Egyptians named the sky or heaven *pet* 𓂝𓏤𓏰. A less primitive view made the heavens in the form of the goddess Nut 𓐰𓏤𓏰, who was represented as a woman with bowed body whose hands and feet rest on the earth 𓍯. In this case the two arms and the two

[1] 𓏤𓏤𓏤 *Recueil de Travaux*, t. iv., p. 55 (l. 473); and compare *Ibid.*, t. v., p. 186 (l. 171).

[2] *Ibid.*, t. v., p. 27 (l. 233).

[3] *Ibid.*, p. 39 (l. 281). [4] *Ibid.*, p. 10 (l. 60)

legs form the four pillars upon which the heavens are supported. Nut, the sky
goddess, was the wife of Seb, the earth god, from whose embrace she was
separated by Shu, the god of the air ; when this separation was effected, earth,
air, and sky came into being. Signor Lanzone has collected a number of illus-
trations of this event from papyri and other documents,[1] wherein we have Seb
lying on the ground, and Shu uplifting Nut with his outstretched hands. The

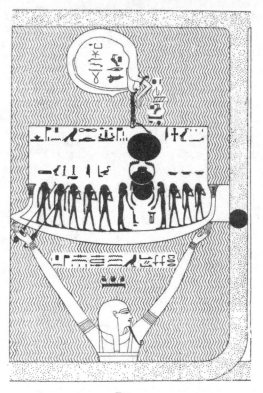

FIG. I.

feet of the goddess rested on the east, and her hands on the west ; this is shown
by the scene wherein Shu is accompanied by two females who have on their
heads 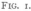 "east" and "west" respectively.[2] The child of the union of Seb
and Nut was the Sun, who was born in the east in the morning, and who made

[1] *Dizionario di Mitologia Egizia*, tavv. 150 ff. [2] *Ibid.*, tav. 158.

his course along his mother's body, until he set in the west in the evening. The
moon followed the sun's course along his mother's body, but sometimes a second
female is represented bowed beneath Nut [1] (Fig. 2), and this is believed to signify
the night sky across which the moon travels. In an interesting picture which
M. Jéquier has published [2] the goddess is depicted lying flat with her arms
stretched out at full length above her head ; on her breast is the disk of the
sun, and on her stomach the moon. Those who believed that the sky was an
iron plane imagined that the stars were a numbers of lamps which were hung
out therefrom, and those who pictured the sky as a goddess studded her body
with stars. One scene makes the morning and evening boats of Rā to sail

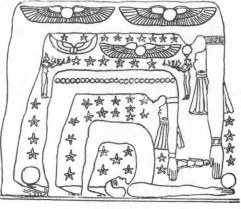

FIG. 2.

along the back of Nut ; [3] another depicts Shu holding up the boat of the sun
wherein is the disk on the horizon ☁.[4] A third from the sarcophagus of Seti I.
represents Nu the god of the primeval water holding up the boat of the sun,
wherein we see the beetle with the solar disk facing it accompanied by Isis and
Nephthys, who stand one on each side ; behind Isis stand the gods Seb, Shu,
Ḥek, Ḥu, and Sa, and behind Nephthys are three deities who represent the
doors through which the god Tmu has made his way to the world.[5]

Within the two bowed female figures which represent the day and the night
sky, and which have been referred to above (Fig. 2), is a third figure which is bent

[1] Lanzone, *op. cit.*, tav. 155. [2] *Le Livre de ce qu'il y a dans l'Hadès*, p. 3.
[3] *Ibid.*, tav. 157. *Ibid.*, tav. 158.
[5] Brugsch, *Religion und Mythologie*, p. 216.

round in a circle ; the space enclosed by it represents according to Dr. Brugsch the _Ṭuat_ ✕⊏⊐[1] or Egyptian underworld, wherein dwelt the gods of the dead and the departed souls. This view is supported by the scene from the sarcophagus of Seti I. (Fig. 1). In the watery space above the bark is the figure of the god bent round in a circle with his toes touching his head, and upon his head stands the goddess Nut with outstretched hands receiving the disk of the sun.[2] In the space enclosed by the body of the god is the legend, " This is Osiris ; his circuit is the Ṭuat."[3] Though nearly all Egyptologists agree about the meaning of the word being "the place of departed souls," yet it has been translated in various ways, different scholars locating the Ṭuat in different parts of creation. Dr. Brugsch and others place it under the earth,[4] others have supposed it to be the space which exists between the arms of Shu and the body of Nut,[5] but the most recent theory put forth is that it was situated neither above nor below the earth, but beyond Egypt to the north, from which it was separated by the mountain range which, as the Egyptians thought, supported the sky.[6] The region of the Ṭuat was a long, mountainous, narrow valley with a river running along it ; starting from the east it made its way to the north, and then taking a circular direction it came back to the east. In the Ṭuat lived all manner of fearful monsters and beasts, and here was the country through which the sun passed during the twelve hours of the night ; according to one view he traversed this region in splendour, and according to another he died and became subject to Osiris the king, god and judge of the kingdom of the departed.

The souls of the dead made their way to their abode in the "other world" by a ladder, according to a very ancient view, or through a gap in the mountains of Abydos called Peḳa ⬚⬚ 𓅿 ⬡ according to another ; but, by whichever way they passed from earth, their destination was a region in the Ṭuat which is called in the pyramid and later texts Sekhet-Àaru,[7] which was situated in the

[1] Brugsch, _op. cit._, p. 211.

[2] The legend reads ⬚⬚⬚ 𓆓 𓈖 𓇳, "This is Nut, she receiveth Rā."

[3] 𓄿 ⬚ 𓂋 𓈖 ✕ ⊏⊐.

[4] _Wörterbuch_, p. 1622.

[5] Lanzone, _Domicile des Esprits_, p. 1 ; _Dizionario_, p. 1292.

[6] Maspero, _La Mythologie Égyptienne_ (_Études_, t. ii., p. 207) ; Jéquier, _Le Livre_, p. 3 The eastern mountain peak was called ⬚⬚ Bakhatet, and the western ⬚⬚ Manu.

[7] _I.e._, the Field of reed plants.

Sekhet-Ḥetep,[1] and was supposed to lie to the north of Egypt. Here dwell Horus and Set, for the fields of Àaru and Ḥetep are their domains,[2] and here enters the deceased with two of the children of Horus on one side of him, and two on the other,[3] and the "two great chiefs who preside over the throne of the great god proclaim eternal life and power for him."[4] Here like the supreme God he is declared to be "one,"[5] and the four children of Horus proclaim his name to Rā. Having gone to the north of the Àaru Field he makes his way to the eastern portion of the *ṭuat*, where according to one legend he becomes like the morning star, near[6] his sister Sothis.[7] Here he lived in the form of the star Sothis, and "the great and little companies of the gods purify him in the Great Bear."[8] The Egyptian theologians, who conceived that a ladder was necessary to enable the soul to ascend to the next world, provided it also with an address which it was to utter when it reached the top. As given in the pyramid of Unàs it reads as follows[9]:—"Hail to thee, O daughter of Àmenta, mistress of Peteru (?) of "heaven, thou gift of Thoth, thou mistress of the two sides of the ladder, open a "way to Unàs, let Unàs pass. Hail to thee, O Nàu, who art [seated] upon the "brink of the Lake of Kha, open thou a way to Unàs, let Unàs pass. Hail to "thee, O thou bull of four horns, thou who hast one horn to the west, and one to "the east, and one to the north, and one to the south, let Unàs pass, for he "is a being from the purified Àmenta, who goeth forth from the country of Baqta. "Hail to thee, O Sekhet-Ḥetep, hail to thee, and to the fields which are in thee, "the fields of Unàs are in thee, for pure offerings are in thee."

[1] *I.e.*, the Field of Peace.

[2] 𓏺𓏺𓏺𓏺𓏺𓏺 *Recueil de Travaux*, t. v., p. 191 (l. 182).

[3] 𓏺𓏺𓏺 *Ibid.*, p. 150 (l. 262).

[4] *Ibid.*, t. vii., p. 163 (l. 402).

[5] 𓏺𓏺 *Ibid.*, t. iv., p. 49 (l. 432).

[6] *Ibid.*, t. v., p. 186 (ll. 80, 172, 177), 𓏺𓏺

[7] *Ibid.*, t. iv., p. 55 (l. 475).

[8] 𓏺𓏺 *Ibid.*, t. iv., p. 68 (l. 567).

[9] *Ibid.*, t. iv., p. 69 (l. 576 ff.).

The souls of the dead could also be commended to the care of the gods above by the gods of Ånnu, and thus we find it said in the pyramid of Unås : "O gods " of the west, O gods of the east, O gods of the south, O gods of the north, ye " four [orders of gods] who embrace the four holy ends of the universe, and " who granted to Osiris to come forth to heaven, and to sail over the celestial " waters thereof with his son Horus by his side to protect him and to make him " to rise like a great god from the celestial deep, say ye to Unås, 'Behold " ' Horus, the son of Osiris, behold Unås, the god of the aged gods, the son of " ' Hathor, behold the seed of Seb, for Osiris hath commanded that Unås shall " ' rise like the second of Horus, and the four *khu*'s who are in Ånnu have " ' written this command to the great gods who are in the celestial waters.' " [1] And again, "When men are buried and receive their thousands of cakes and " thousands of vases of ale upon the table of him that ruleth in Åmenta, that being ' is in sore straits who hath not a written decree : now the decree of Unås is " under the greatest, and not under the little seal." [2]

The plan of the Sekhet-Hetep which we find in the Book of the Dead during the Theban period will be described below, and it is therefore sufficient to say here that the ideas of the happy life which the deceased led had their origin in the pyramid texts, as may be seen from the following passage :—" Unås hath " offered incense unto the great and little companies of the gods, and his mouth " is pure, and the tongue which is therein is pure. O ye judges, ye have taken " Unås unto yourselves, let him eat that which ye eat, let him drink that which " ye drink, let him live upon that which ye live upon, let your seat be his seat, " let his power be your power, let the boat wherein he shall sail be your boat, let " him net birds in Åaru, let him possess running streams in Sekhet-Hetep, and " may he obtain his meat and his drink from you, O ye gods. May the water " of Unås be of the wine which is of Rā, may he revolve in the sky like Rā, " and may he pass over the sky like Thoth." [3]

Of the condition of those who failed to secure a life of beatitude with the gods in the Sekhet-Åaru of the Ṭuat, the pyramid texts say nothing, and it seems as if the doctrine of punishment of the wicked and of the judgment which took place after death is a development characteristic of a later period.

[1] *Recueil de Travaux*, t. iv., p. 69 (ll. 572–75). [2] *Ibid.*, t. iv., p. 71 (l. 583).
[3] *Ibid.*, t. iii. (l. 191–95).

THE GODS OF THE BOOK OF THE DEAD.

The following are the principal gods and goddesses mentioned in the pyramid texts and in the later versions of the Book of the Dead :—

Nu [hieroglyphs] represents the primeval watery mass from which all the gods were evolved, and upon which floats the bark of "millions of years" containing the sun. This god's chief titles are "Father of the gods," [hieroglyphs], and "begetter of the great company of the gods," [hieroglyphs]. He is depicted in the form of a seated deity having upon his head disk and plumes [hieroglyphs].[1]

Nut [hieroglyphs], the female principle of Nu ; she is depicted with the head of a snake surmounted by a disk, or with the head of a cat.[2]

Ptaḥ [hieroglyphs] was associated with the god Khnemu in carrying out at the Creation the mandates of Thoth the divine intelligence ; his name means the "opener," and he was identified by the Greeks with Ἥφαιστος, and by the Latins with Vulcan. He was worshipped at a very early date in Memphis, which is called in Egyptian texts "The House of the Ka of Ptaḥ," [hieroglyphs], and according to Herodotus his temple there was founded by Menà or Menes.[3] He is called the "exceedingly great god, the beginning of being," [hieroglyphs], "the father of fathers and power of powers," [hieroglyphs]; and "he created his form,

[1] Lanzone, *Dizionario*, tav. 166, No. 2. For fuller descriptions of the gods and their titles and attributes see Brugsch, *Religion und Mythologie*, Leipzig, 1884–88 ; Pierret, *Le Panthéon Égyptien*, Paris, 1881 ; Wiedemann, *Die Religion der alten Aegypter*, Münster, 1890 ; Strauss and Corney, *Der altaegyptische Götterglaube*, Heidelberg, 1889. For illustrations of the various forms in which the gods are depicted, see the *Dizionario di Mitologia Egizia*, Turin, 1881 (not yet complete).

[2] Lanzone, *op. cit.*, tavv. 168-71.

[3] Τοῦτο δὲ τοῦ Ἡφαίστου τὸ ἱρὸν ἱδρύσασθαι ἐν αὐτῇ (ii., 99).

and gave birth to his body, and established unending and unvarying right and truth upon the earth." As a solar god he is called "Ptaḥ, the Disk of heaven, who illumineth the world by the fire of his eyes," [hieroglyphs] ; and in the Book of the Dead he is said to have "opened" the mouth of the deceased with the tool [hieroglyph] with which he opened the mouths of the gods.[1] He is depicted in the form of a mummy standing upon *maāt* [hieroglyph], and in his hands he holds a sceptre on the top of which are [hieroglyphs], the emblems of power, life, and stability ; from the back of his neck hangs the *menàt* (see p. 1, note 2).[2] Ptaḥ formed at Memphis the chief member of the triad **Ptaḥ-Sekhet** and **Nefer-Tmu.**

In many texts the god Ptaḥ is often joined to the god **Seker** [hieroglyphs], whose individual attributes it is not easy to describe ; Seker is the Egyptian name of the incarnation of the Apis bull at Memphis. That Seker was a solar god is quite clear, but whether he "closed" the day or the night is not certain. Originally his festival was celebrated in the evening, wherefrom it appears that he represented some form of the night sun ; but in later times the ceremony of drawing the image of the god Seker in the *hennu* boat [hieroglyph] round the sanctuary was performed in the morning at dawn, and thus, united with Ptaḥ, he became the closer of the night and the opener of the day. He is depicted as a mummied body with the head of a hawk, and he sometimes holds in his hands [hieroglyphs], emblems of power, sovereignty, and rule.[3]

Another form of Ptaḥ was **Ptaḥ-Seker-Àusàr** [hieroglyphs], wherein the creator of the world, the sun, and Osiris as the god of the dead, were represented. A large number of *faïence* figures of this triune god are found in graves, and specimens exist in all museums. He is represented as a dwarf standing upon a crocodile, and having a scarabæus upon his head ; the scarab is the emblem of the new life into which the deceased is about to break, the crocodile is the emblem of the darkness of death which has been overcome. According to some the element of Ptaḥ in the triad is the personification of the period of incubation which follows

[1] [hieroglyphs] . Naville, *Todtenbuch*, Bd. I., Bl. 34, ll. 4, 5.

[2] Lanzone, *op. cit.*, tavv. 87–91. [3] Lanzone, *op. cit.*, tav. 368.

death and precedes the entry into eternal life, and the symbols with which he is accompanied explain the character attributed to this god.[1]

The god Ptaḥ is also united with the gods Ḥāpi, Nu and Tanen when he represents various phases of primeval matter.

Khnemu 𓈖𓄿𓈖𓏏 worked with Ptaḥ in carrying out the work of creation ordered by Thoth, and is therefore one of the oldest divinities of Egypt ; his name means " to mould," " to model." His connexion with the primeval water caused him to be regarded as the chief god of the inundation and lord of the cataract at Elephantine. He dwelt in Ȧnnu, but he was lord of Elephantine 𓊨𓏏𓈗, and " the builder of men, the maker of the gods, and the father from the beginning." Elsewhere he is said to be

ȧri	enti-s	qemam	unenet	šā	χeperu	tef
Maker	of things which are,	creator of	what shall be,	the beginning	of beings,	father

tefu	mā	mā
of fathers,	and mother	of mothers.

He supported the heaven upon its four pillars � in the beginning, and earth, air, sea, and sky are his handiwork. He is depicted in the form of a man having a ram's head and horns surmounted by plumes, uræi with disks, *etc. ;* in one hand he holds the sceptre 𓌗 and in the other the emblem of life 𓋹. Occasionally he is hawk-headed, and in one representation he holds the emblem of water 𓈗, in each hand. On a late bas-relief at Philæ we find him seated at a potter's table upon which stands a human being whom he has just fashioned.[2]

Kheperȧ 𓆣𓇳𓏤 was a form of the rising sun, and was both a type of matter which is on the point of passing from inertness into life, and also of the dead body which is about to burst forth into a new life in a glorified form. He is depicted in the form of a man having a beetle for a head, and this insect was his type and emblem among ancient nations, because it was believed to be self-begotten and self-produced ; to this notion we owe the myriads of beetles or

[1] Lanzone, *op. cit.*, p. 244. [2] Lanzone, *op. cit.*, tav. 336, No. 3.

scarabs which are found in tombs of all ages in Egypt, and also in the Greek islands and settlements in the Mediterranean, and in Phœnicia, Syria, and elsewhere. The seat of the god Kheperå was in the boat of the sun, and the pictures which present us with this fact [1] only illustrate an idea which is as old, at least, as the pyramid of Unås, for in this monument it is said of the king :—

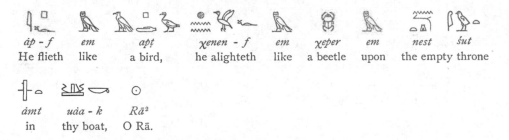

åp - f	*em*	*apt*	*χenen - f*	*em*	*χeper*	*em*	*nest*	*šut*
He flieth	like	a bird,	he alighteth	like	a beetle	upon	the empty throne	

åmt	*uåa - k*	*Rā*[2]
in	thy boat,	O Rā.

In the XVIIIth dynasty Queen Ḥātshepset declared herself to be "the creator of things which came into being like Khepera" [hieroglyphs],[3] and in later times the scribes were exceedingly fond of playing upon the word used as a noun, adjective, verb and proper name.[4]

Tum [hieroglyphs] or Atemu [hieroglyphs] *i.e.*, "the closer," was the great god of Ånnu, and the head of the great company of the gods of that place. It would seem that he usurped the position of Rā in Egyptian mythology, or at any rate that the priests of Ånnu succeeded in causing their local god, either separately or joined with Rā, to be accepted as the leader of the divine group. He represented the evening or night sun, and as such he is called in the XVth chapter of the Book of the Dead "divine god," "self-created," "maker of the gods," "creator of men," " who stretched out the heavens," "the lightener of the *tuat* with his two eyes," *etc.*[5]

[1] Lanzone, *op. cit.*, tav. 330. [2] *Recueil de Travaux*, t. iv., p. 57 (l. 477).

[3] Lepsius, *Denkmäler*, Abth. iii., Bl. 22.

[4] Compare [hieroglyphs]. Maspero, *Mémoires de la Mission*, t. i., p. 595; and in the account of the Creation found in B.M. papyrus No. 10,188, Col. xxvi.,

[hieroglyphs]

[hieroglyphs]

[5] Naville, *Todtenbuch*, Bd. I., Bl. 19, 20.

The "cool breezes of the north wind," for which every dead man prayed, were supposed to proceed from him. He is, as M. Lefébure has pointed out, always depicted in the form of a man; he wears the crowns ⍦ and holds both the sceptre ⎮ and emblem of life ♀. On a mummy case at Turin he is depicted in the boat of the Sun, in company with the god Kheperá; between them are the beetle and sun's disk ⊙.[1] In later times the Egyptians called the feminine form of Tmu Temt ⊂⎮⊙.[2]

Rā ⌒⊙ was the name given to the sun by the Egyptians in a remote antiquity, but the meaning of the word, or the attribute which they ascribed to the sun by it, is unknown. Rā was the visible emblem of God, and was regarded as the god of this earth, to whom offerings and sacrifices were made daily; and when he appeared above the horizon at the creation, time began. In the pyramid texts the soul of the deceased makes its way to where Rā is in heaven, and Rā is entreated to give it a place in the "bark of millions of years" wherein he sails over the sky. The Egyptians attributed to the sun a morning and an evening boat, and in these the god sat accompanied by Kheperá and Tmu, his own forms in the morning and evening respectively. In his daily course he vanquished night and darkness, and mist and cloud disappeared from before his rays; subsequently the Egyptians invented the moral conception of the sun, representing the victory of right over wrong and of truth over falsehood. From a natural point of view the sun was synonymous with movement, and hence typified the life of man; and the setting of the one typified the death of the other. Usually Rā is depicted in human form, sometimes with the head of a hawk, and sometimes without.[3] As early as the time of the pyramid texts we find Rā united with Tmu to form the chief god of Ánnu, and at the same period a female counterpart Rāt ⊙ was assigned to him.[4]

Shu ⎮ ⟆ ⟅, the second member of the company of the gods of Ánnu, was the firstborn son of Rā, Rā-Tmu, or Tum, by the goddess Hathor, the sky, and was the twin brother of Tefnut. He typified the light, he lifted up the sky, Nut, from the earth, Seb, and placed it upon the steps ⌐ which were in Khemennu.

[1] See Lanzone, op. cit., tav. 398.
[2] Ibid., p. 1255.
[3] Ibid., tav. 178.
[4] Pyramid of Unàs, l. 253.

He is usually depicted in the form of a man, who wears upon his head a feather \int, or feathers \iint, and holds in his hand the sceptre $\mathord{\uparrow}$. At other times he appears in the form of a man with upraised arms ; on his head he has the emblem ⟋⟍, and he is often accompanied by $\mathord{\uparrow}\mathord{\uparrow}\mathord{\uparrow}\mathord{\uparrow}$, the four pillars of heaven, *i.e.*, the cardinal points.[1] Among the many *faïence* amulets which are found in tombs are two which have reference to Shu : the little models of steps typify the steps upon which Shu rested the sky in Khemennu ; and the crouching figure of a god supporting the sun's disk symbolizes his act of raising the sun's disk into the space between sky and earth at the time when he separated Nut from Seb.

Tefnut , the third member of the company of the gods of Ȧnnu, was the daughter of Rā, Rā-Tmu, or Tmu, and twin-sister of Shu ; she represented in one form moisture, and in another aspect she seems to personify the power of sunlight. She is depicted in the form of a woman, usually with the head of a lioness surmounted by a disk or uræus, or both ;[2] in *faïence*, however, the twin brother and sister have each a lion's head. In the pyramid texts they play a curious part, Shu being supposed to carry away hunger from the deceased, and Tefnut his thirst.[3]

Seb or **Qeb** , the fourth member of the company of the gods of Ȧnnu, was the son of Shu, husband of Nut, and by her father of Osiris, Isis, Set, and Nephthys. Originally he was the god of the earth, and is called both the "father of the gods" , and the "*erpā* (*i.e.*, the tribal, hereditary head) of the gods." He is depicted in human form, sometimes with a crown upon his head and sceptre $\mathord{\uparrow}$ in his right hand ; and sometimes he has upon his head a goose,[4] which bird was sacred to him. In many places he is called the "great cackler" , and he was supposed to have laid the egg from which the world sprang. Already in the pyramid texts he has become a god of the dead by virtue of representing the earth wherein the deceased was laid.

[1] See Lanzone, *op. cit.*, tav. 385.

[2] See Lanzone, *op. cit.*, tav. 395.

[3] . *Recueil de Travaux*, t. v., p. 10 (l. 61).

[4] See Lanzone, *op. cit.*, tav. 346.

Åusȧr or Osiris �, the sixth member of the company of the gods of Ånnu, was the son of Seb and Nut, and the husband of his sister Isis, the father of "Horus, the son of Isis," and the brother of Set and Nephthys. The version of his sufferings and death by Plutarch has been already described (see p. xlviii.). Whatever may have been the foundation of the legend, it is pretty certain that his character as a god of the dead was well defined long before the versions of the pyramid texts known to us were written, and the only important change which took place in the views of the Egyptians concerning him in later days was the ascription to him of the attributes which in the early dynasties were regarded as belonging only to Rā or to Rā-Tmu. Originally Osiris was a form of the sun-god, and, speaking generally, he may be said to have represented the sun after he had set, and as such was the emblem of the motionless dead ; later texts identify him with the moon. The Egyptians asserted that he was the father of the gods who had given him birth, and, as he was the god both of yesterday and of to-day, he became the type of eternal existence and the symbol of immortality ; as such he usurped not only the attributes of Rā, but those of every other god, and at length he was both the god of the dead and the god of the living. As judge of the dead he was believed to exercise functions similar to those attributed to God. Alone among all the many gods of Egypt, Osiris was chosen as the type of what the deceased hoped to become when, his body having been mummified in the prescribed way, and ceremonies proper to the occasion having been performed and the prayers said, his glorified body should enter into his presence in heaven ; to him as "lord of eternity," by which title as judge of the dead he was commonly addressed, the deceased appealed to make his flesh to germinate and to save his body from decay.[1] The various forms in which Osiris is depicted are too numerous to be described here, but generally speaking he is represented in the form of a mummy wearing a crown and holding in his hands the emblems of sovereignty and power. A very complete series of illustrations of the forms of Osiris is given by Lanzone in his *Dizionario*, tavv. 258–299. The ceremonies connected with the celebration of the events of the sufferings, the death and the resurrection of Osiris occupied a very prominent part in the religious observances of the Egyptians, and it seems as if in the month of Choiak a representation of

[1] Compare [hieroglyphs]. Navi le, *Todtenbuch*, Bd. I., Bl. 179.

them took place in various temples in Egypt; the text of a minute description of them has been published by M. Loret in *Recueil de Travaux*, tom. iii., p. 43 ff., and succeeding volumes. A perusal of this work explains the signification of many of the ceremonies connected with the burial of the dead, the use of amulets, and certain parts of the funeral ritual; and the work in this form being of a late date proves that the doctrine of immortality, gained through the god who was "lord of the heavens and of the earth, of the underworld and of the waters, of the mountains, and of all which the sun goeth round in his course,"[1] had remained unchanged for at least four thousand years of its existence.

Auset or **Isis** ⌓⌣⌇, the seventh member of the company of the gods of Annu, was the wife of Osiris and the mother of Horus; her woes have been described both by Egyptian and Greek writers.[2] Her commonest names are "the great goddess, the divine mother, the mistress of charms or enchantments"; in later times she is called the "mother of the gods," and the "living one." She is usually depicted in the form of a woman, with a head-dress in the shape of a seat ⌇, the hieroglyphic for which forms her name. The animal sacred to her was the cow, hence she sometimes wears upon her head the horns of that animal accompanied by plumes and feathers. In one aspect she is identified with the goddess Selk or Serq, and she then has upon her head a scorpion, the emblem of that goddess;[3] in another aspect she is united to the star Sothis, and then a star ✳ is added to her crown. She is, however, most commonly represented as the mother suckling her child Horus, and figures of her in this aspect, in bronze and *faïence*, exist in thousands. As a nature goddess she is seen standing in the boat of the sun, and she was probably the deity of the dawn.

Ḥeru or **Horus** 🦅, the sun-god, was originally a totally distinct god from Horus, the son of Osiris and Isis, but from the earliest times it seems that the two gods were confounded, and that the attributes of the one were ascribed to the other; the fight which Horus the sun-god waged against night and darkness was also at a very early period identified with the combat between Horus, the son of

[1] �

Chabas, *Un Hymne à Osiris* (in *Revue Arch ologique*, t. xiv., p. 65 ff.); Horrack, *Les Lamentations d'Isis et de Nephthys*, Paris, 1866; *The Festival Songs of Isis and Nephthys* (in *Archæologia*, vol. lii., London, 1891), *etc.*

[3] See Lanzone, *op. cit.*, tav. 306 ff.

Isis, and his brother Set. The visible emblem of the sun-god was at a very early date the hawk 🦅, which was probably the first living thing worshipped by the early Egyptians ; already in the pyramid texts the hawk on a standard 🦅 is used indiscriminately with ⌐ to represent the word "god." The principal forms of Horus the sun-god, which probably represent the sun at various periods of the day and night, are :—Ḥeru-ur 🦅 ('Αρωῆρει), "Horus the Great"; Ḥeru-merti 🦅, "Horus of the two eyes," i.e., of the sun and moon ;[1] Ḥeru-nub 🦅, "the golden Horus"; Ḥeru-khent-khat 🦅 ; Ḥeru-khent-àn-maa 🦅, "Horus dwelling in blindness"; Ḥeru-khuti 🦅, "Horus of the two horizons,"[2] the type of which on earth was the Sphinx; Ḥeru-sam-taui 🦅 "Horus the uniter of the north and south"; Ḥeru-ḥekenu 🦅, "Horus of Ḥeken"; and Ḥeru-beḥuṭet 🦅, "Horus of Beḥuṭet."[3] The cippi of Horus, which became so common at a late period in Egypt, seem to unite the idea of the physical and moral conceptions of Horus the sun-god and of Horus the son of Osiris and Isis.

Horus, the son of Osiris and Isis, 🦅, appears in Egyptian texts usually as Ḥeru-p-khaṛṭ 🦅, or "Horus the child," who afterwards became the "avenger of his father Osiris," and occupied his throne, as we are told in many places in the Book of the Dead. In the pyramid texts the deceased is identified with Ḥeru-p-khaṛṭ, and a reference is made to the fact that the god is always represented with a finger in his mouth.[4] The curious legend which Plutarch relates concerning Harpocrates and the cause of his lameness[5] is probably

[1] A very interesting figure of this god represents him holding his eyes 👁👁 in his hands; see Lanzone, *op. cit.*, p. 618.

[2] *I.e.*, Horus between the mountains of ⌐ Bekhatet and ⌐ Manu, the most easterly and westerly points of the sun's course, and the places where he rose and set.

[3] For figures of these various forms of Horus, see Lanzone, *op. cit.*, tav. 214 ff.

[4] 𓂀 𓃾 𓅿 𓈖 𓏏 𓅆 𓄿 . *Recueil de Travaux*, t. v., p. 44 (l. 301).

[5] Τὴν δ' Ἴσιν μετὰ τὴν τελευτὴν ἐξ Ὀσίριδος συγγενομένου, τεκεῖν ἠλιτόμηνον καὶ ἀσθενῆ τοῖς κάτωθεν γυίοις τὸν Ἁρποκράτην. *De Iside et Osiride*, § xix.

based upon the passage in the history of Osiris and Isis given in a hymn to Osiris of the XVIIIth dynasty.[1]

Set ⌐☐⌐ or Sutekh, the eighth member of the company of the gods of Ȧnnu, was the son of Seb and Nut, and the husband of his sister Nephthys. The worship of this god is exceedingly old, and in the pyramid texts we find that he is often mentioned with Horus and the other gods of the Heliopolitan company in terms of reverence. He was also believed to perform friendly offices for the deceased, and to be a god of the Sekhet-Ȧaru, or abode of the blessed dead. He is usually depicted in human form with the head of an animal which has not yet been identified; in later times the head of the ass was confounded with it, but the figures of the god in bronze which are preserved in the British Museum and elsewhere prove beyond a doubt that the head of Set is that of an animal unknown to us. In the early dynasties he was a beneficent god, and one whose favour was sought after by the living and by the dead, and so late as the XIXth dynasty kings delighted to call themselves "beloved of Set." About the XXIInd dynasty, however, it became the fashion to regard the god as the origin of all evil, and his statues and images were so effectually destroyed that only a few which escaped by accident have come down to us. Originally Set, or Sut, represented the natural night and was the opposite of Horus;[2] that Horus and Set were opposite aspects or forms of the same god is proved by the figure given by Lanzone (*Dizionario*, tav. 37, No. 2), where we see the head of Set and the head of Horus upon one body. The natural opposition of the day and night was at an early period confounded with the battle which took place between Horus, the son of Isis, and Set, wherein Isis intervened, and it seems that the moral idea of the battle of right against wrong[3] became attached to the latter combat, which was undertaken by Horus to avenge his father's murder by Set.

Nebt-ḥet or Nephthys, the last member of the company of the gods of Ȧnnu, was the daughter of Seb and Nut, the sister of Osiris and Isis, and the

[1] . Ledrain, *Monuments Égyptiens*, pl. xxv., ll. 2, 3.

[2] In the pyramid of Unás, l. 190, they are called the ⊂§ || or "two combatants"; and see pyramid of Tetà, l. 69, where we have the spelling ⊂§.

[3] On the personification of evil by Set, see Wiedemann, *Die Religion*, p. 117.

sister and wife of Set. When the sun rose at the creation out of the primeval waters, Nephthys occupied a place in his boat with Isis and other deities; as a nature goddess she either represents the day before sunrise or after sunset, but no portion of the night. She is depicted in the form of a woman, having upon her head the hieroglyphics which form her name, "lady of the house" ⍐. A legend preserved by Plutarch[1] makes her the mother of Ȧnpu or Anubis by Osiris. In Egyptian texts Ȧnpu is called the son of Rā.[2] In religious texts Nephthys is made to be the companion of Isis in all her troubles, and her grief for her brother's death is as great as that of his wife.

Ȧnpu, or Anubis, ⌇, the son of Osiris or Rā, sometimes by Isis and sometimes by Nephthys, seems to represent as a nature god either the darkest part of the twilight or the earliest dawn. He is depicted either in human form with a jackal's head, or as a jackal. In the legend of Osiris and Isis, Anubis played a prominent part in connexion with the dead body of Osiris, and in papyri we see him standing as a guard and protector of the deceased lying upon the bier; in the judgment scene he is found as the guard of the balance, the pointer of which he watches with great diligence. He became the recognized god of the sepulchral chamber, and eventually presided over the whole of the "funeral mountain." He is always regarded as the messenger of Osiris.

Another form of Anubis was the god Ȧp-uat, the ⌇ of the pyramid texts,[3] or "Opener of the ways," who also was depicted in the form of a jackal; and the two gods are often confounded. On sepulchral stelæ and other monuments two jackals are frequently depicted; one of these represents Anubis, and the other Ȧp-uat, and they probably have some connexion with the northern and southern parts of the funereal world. According to M. Maspero the god Anubis led the souls of the dead to the Elysian Fields in the Great Oasis.[4]

Among the primeval gods are two, Hu ⌇ and Sáa ⌇, who are seen in the boat of the sun at the creation. They are the children of Tmu or Tmu-Rā, but the exact part which they play as nature gods has not yet, it seems, been satisfactorily made out. The first mention of them in the pyramid texts records their subjugation by the deceased,[5] but in the Theban Book of the Dead

[1] De Iside et Osiride, § 14. [2] See Lanzone, op. cit., p. 65.
[3] Pyramid of Unâs, l. 187.
[4] See Le Nom antique de la Grande-Oasis (in Journal Asiatique, IXᵉ Série, to i., pp. 233–40).
[5] ⌇. Pyramid of Unâs, l. 439.

they appear among the company of the gods who are present when the soul of the deceased is being weighed in the balance.

Teḥuti or **Thoth** 🦩 represented the divine intelligence which at creation uttered the words that were carried into effect by Ptaḥ and Khnemu. He was self-produced, and was the great god of the earth, air, sea and sky; and he united in himself the attributes of many gods. He was the scribe of the gods, and, as such, he was regarded as the inventor of all the arts and sciences known to the Egyptians; some of his titles are "lord of writing," "master of papyrus," "maker of the palette and the ink-jar," "the mighty speaker," "the sweet-tongued"; and the words and compositions which he recited on behalf of the deceased preserved the latter from the influence of hostile powers and made him invincible in the "other world." He was the god of right and truth, wherein he lived, and whereby he established the world and all that is in it. As the chronologer of heaven and earth, he became the god of the moon; and as the reckoner of time, he obtained his name *Teḥuti, i.e.,* "the measurer"; in these capacities he had the power to grant life for millions of years to the deceased. When the great combat took place between Horus, the son of Isis, and Set, Thoth was present as judge, and he gave to Isis the cow's head in the place of her own which was cut off by Horus in his rage at her inter-ference; having reference to this fact he is called Ap-reḥui 𓄿𓏤𓂝𓄿𓄿, "The judge of the two combatants." One of the Egyptian names for the ibis was 𓏏𓐍𓅝 *Tekh*, and the similarity of the sound of this word to that of Teḥu, the name of the moon as a measurer of time, probably led the Egyptians to depict the god in the form of an ibis, notwithstanding the fact that the dog-headed ape was generally considered to be the animal sacred to him. It has been thought that there were two gods called Thoth, one being a form of Shu; but the attributes belonging to each have not yet been satisfactorily defined. In the monuments and papyri Thoth appears in the form of a man with the head of an ibis, which is sometimes surmounted by the crown 𓋹, or 𓈖, or 𓏥, or by disk and horns 𓇳, or 𓆄, and he holds in his left hand the sceptre 𓌀, and in the right 𓋹; sometimes he is depicted holding his ink-jar 𓏞 and the crescent moon 𓇹, and sometimes he appears in the form of an ape holding a palette full of writing-reeds.[1] Thoth is mentioned in the pyramid texts[2] as the brother of Osiris, but whether he is the

[1] See Lanzone, *op. cit.*, tav. 304, No. 1. [2] *Pyramid of Unâs*, l. 236.

same Thoth who is called the "Lord of Khemennu" and the "Scribe of the gods" is doubtful.

Maāt ⟨hieroglyphs⟩, the wife of Thoth, was the daughter of Rā, and a very ancient goddess; she seems to have assisted Ptaḥ and Khnemu in carrying out rightly the work of creation ordered by Thoth. There is no one word which will exactly describe the Egyptian conception of Maāt both from a physical and from a moral point of view; but the fundamental idea of the word is "straight," and from the Egyptian texts it is clear that *maāt* meant right, true, truth, real, genuine, upright, righteous, just, steadfast, unalterable, etc. Thus already in the Prisse papyrus it is said, "Great is *maāt*, the mighty and unalterable, and it hath never been broken since the time of Osiris,"[1] and Ptaḥ-ḥetep counsels his listener to "make *maāt*, or right and truth, to germinate."[2] The just, upright, and straight man is *maāt* ⟨hieroglyphs⟩, and in a book of moral precepts it is said, "God will judge the right (*maā*)"[3] ⟨hieroglyphs⟩

⟨hieroglyphs⟩.[4] Maāt, the goddess of the unalterable laws of heaven, and the daughter of Rā, is depicted in female form, with the feather ⟨glyph⟩, emblematic of *maāt*, on her head, or with the feather alone for a head, and the sceptre ⟨glyph⟩ in one hand, and ⟨glyph⟩ in the other.[5] In the judgment scene two Maāt goddesses appear; one probably is the personification of physical law, and the other of moral rectitude.

Ḥet-ḥeru, or **Hathor** ⟨hieroglyph⟩, the "house of Horus," was the goddess of the sky wherein Horus the sun-god rose and set. Subsequently a great number of goddesses of the same name were developed from her, and these were identified with Isis, Neith, Iusāset, and many other goddesses whose attributes they absorbed. A group of seven Hathors is also mentioned, and these appear to have partaken of the nature of good fairies. In one form Hathor was the goddess of love, beauty,

[1] Page 17, l. 5, ⟨hieroglyphs⟩

[2] Page 18, l. 1, ⟨hieroglyphs⟩

[3] Amélineau, *La Morale*, p. 138.

[4] The various meanings of *maāt* are illustrated by abundant passages from Egyptian texts by Brugsch, *Wörterbuch* (Suppl.), p. 329.

[5] See Lanzone, *op. cit.* tav. 109.

happiness; and the Greeks identified her with their own Aphrodite. She is often depicted in the form of a woman having disk and horns upon her head, and at times she has the head of a lion surmounted by a uræus. Often she has the form of a cow—the animal sacred to her—and in this form she appears as the goddess of the tomb or Ta-sertet, and she provides meat and drink for the deceased.[1]

Meḥt-urt ⟨hieroglyphs⟩ is the personification of that part of the sky wherein the sun rises, and also of that part of it in which he takes his daily course; she is depicted in the form of a cow, along the body of which the two barks of the sun are seen sailing. Already in the pyramid texts we find the attribute of judge ascribed to Meḥ-urt,[2] and down to a very late date the judgment of the deceased in the hall of double Maāt in the presence of Thoth and the other gods was believed to take place in the abode of Meḥ-urt.[3]

Net or **Neith** ⟨hieroglyphs⟩, or ⟨hieroglyph⟩, "the divine mother, the lady of heaven, the mistress of the gods," was one of the most ancient deities of Egypt, and in the pyramid texts she appears as the mother of Sebek.[4] Like Meḥ-urt she personifies the place in the sky where the sun rises. In one form she was the goddess of the loom and shuttle, and also of the chase; in this aspect she was identified by the Greeks with Athene. She is depicted in the form of a woman, having upon her head the shuttle ⟨hieroglyph⟩ or arrows ⟨hieroglyph⟩, or she wears the crown ⟨hieroglyph⟩ and holds arrows ⟨hieroglyph⟩, a bow ⟨hieroglyph⟩, and a sceptre in her left hand; she also appears in the form of a cow.[5]

Sekhet ⟨hieroglyphs⟩ was in Memphis the wife of Ptaḥ, and the mother of Nefer-Tmu and of **Ī-em-ḥetep**. She was the personification of the burning heat of the sun, and as such was the destroyer of the enemies of Rā and Osiris. When Rā determined to punish mankind with death, because they scoffed at him, he sent Sekhet, his "eye," to perform the work of vengeance; illustrative of this aspect of her is a figure wherein she is depicted with the sun's eye for a head.[6] Usually

[1] A good set of illustrations of this goddess will be found in Lanzone, *op. cit.*, tav. 314 f.

[2] ⟨hieroglyphs⟩ . *Recueil de Travaux,* t. iv., p. 48 (l. 427).

[3] Pleyte, *Chapitres supplémentaires du Livre des Morts* (Chapp. 162, 162,* 163), p. 26.

[4] *Recueil de Travaux*, t. iv., p. 76 (l. 627).

[5] See Lanzone, *op. cit.*, tav. 177.

[6] *Ibid.*, *op. cit.*, tav. 364.

she has the head of a lion surmounted by the sun's disk, round which is a uræus ;
and she generally holds a sceptre ⌠, but sometimes a knife.

Bast ⌠⌡⌐⌑, according to one legend, was the mother of Nefer-Tmu. She
was the personification of the gentle and fructifying heat of the sun, as opposed to
that personified by Sekhet. The cat was sacred to Bast, and the goddess is
usually depicted cat-headed. The most famous seat of her worship was the city of
Bubastis, the modern Tell Basta, in the Delta.

Nefer-Tmu ⌠⌐⌑ was the son either of Sekhet or Bast, and he personified
some form of the sun's heat. He is usually depicted in the form of a man, with a
cluster of lotus flowers upon his head, but sometimes he has the head of a lion ; in
the little *faïence* figures of him which are so common, he stands upon the back of a
lion.[1] He no doubt represents the sun-god in the legend which made him to
burst forth from a lotus, for in the pyramid of Unás the king is said to

χāā	em	Nefer-Tmu	em	seśśen	er	śert	Rā
"Rise	like	Nefer-Tmu	from	the lotus (lily)	to	the nostrils	of Rā,"

and to "come forth on the horizon every day."[2]

Neheb-ka is the name of a goddess who is usually represented
with the head of a serpent, and with whom the deceased identifies himself.

Sebåk , a form of Horus the sun-god, must be distinguished
from Sebåk the companion of Set, the opponent of Osiris; of each of these gods
the crocodile was the sacred animal, and for this reason probably the gods them-
selves were confounded. Sebåk-Rā, the lord of Ombos, is usually depicted in
human form with the head of a crocodile, surmounted by , , or ,
or .[3]

Åmsu ,[4] or **Åmsi** is one of the most ancient gods of Egypt.
He personified the power of generation, or the reproductive force of nature ; he
was the "father of his own mother," and was identified with "Horus the mighty,"
or with Horus the avenger of his father Un-nefer or Osiris. The Greeks identified

[1] See Lanzone, *op. cit.*, tav. 147.
[3] *Ibid., op. cit.*, tav. 353.

[2] *Recueil de Travaux*, iv., t. p. 45 (l. 394).
[4] Also read Min and Khem.

him with the god Pan, and called the chief city where his worship was celebrated Khemmis,[1] after one of his names. He is depicted usually in the form of a man standing upon ⊂⊃; and he has upon his head the plumes ⏅, and holds the flail ⟋ in his right hand, which is raised above his shoulder.[2]

Neb-er-tcher ▽ 𓂋 𓀭, a name which originally implied the "god of the universe," but which was subsequently given to Osiris, and indicated the god after the completed reconstruction of his body, which had been hacked to pieces by Set.

Un-nefer 𓈖𓎡𓏤𓀭, a name of Osiris in his capacity of god and judge of the dead in the underworld. Some make these words to mean the "good being," and others the "beautiful hare."

Ȧsṭennu 𓏤𓈖𓀭 a name given to the god Thoth.

Mert 𓎡𓀭, or Mer-seḳert 𓂋𓎡𓀭, "the lover of silence," is a name of Isis or Hathor as goddess of the underworld. She is depicted in the form of a woman, having a disk and horns upon her head.[3]

Serq or **Selk** 𓊪𓎡𓀭 is a form of the goddess Isis. She is usually depicted in the form of a woman, with a scorpion upon her head; occasionally she appears as a scorpion with a woman's head surmounted by disk and horns.[4]

Ta-urt 𓂝𓄿𓀭, the Thoueris of the Greeks, was identified as the wife of Set or Typhon; she is also known under the names Apt 𓊪𓏏 and Sheput 𓊪𓏏. Her common titles are "mistress of the gods" 𓎟𓏏, and "bearer of the gods" 𓂽𓏤𓏤𓏤. She is depicted in the form of a hippopotamus standing on her hind legs, with distended paunch and hanging breasts, and one of her forefeet rests upon ⍦; sometimes she has the head of a woman, but she always wears the disk, horns, and plumes ⏅.

Uatchit 𓏏𓄿𓀭 was a form of Hathor, and was identified with the appearance of the sky in the north when the sun rose. She is either depicted in the form of a woman, having upon her head the crown of the north 𓋔 and a sceptre 𓏏, around which a serpent is twined, or as a winged uræus wearing the crown of the north.

[1] In Egyptian the town is called Ȧpu 𓊪𓏤𓊖. [2] See Lanzone, *op. cit.*, tav. 332.

[3] *Ibid.*, tav. 124. [4] *Ibid., op. cit.*, tav. 362.

Beb, Bebti, Baba, or **Babu,** 〔hieroglyphs〕, 〔hieroglyphs〕, 〔hieroglyphs〕, 〔hieroglyphs〕, or 〔hieroglyphs〕, mentioned three times in the Book of the Dead, is the "firstborn son of Osiris," and seems to be one of the gods of generation.

Ḥāpi 〔hieroglyphs〕 is the name of the great god of the Nile who was worshipped in Egypt under two forms, *i.e.*, "Ḥāpi of the South," 〔hieroglyphs〕, and "Ḥāpi of the North," 〔hieroglyphs〕; the papyrus was the emblem of the one, and the lotus of the other. From the earliest times the Nile was regarded by the Egyptians as the source of all the prosperity of Egypt, and it was honoured as being the type of the life-giving waters out of the midst of which sprang the gods and all created things. In turn it was identified with all the gods of Egypt, new or old, and its influence was so great upon the minds of the Egyptians that from the earliest days they depicted to themselves a material heaven wherein the Isles of the Blest were laved by the waters of the Nile, and the approach to which was by the way of its stream as it flowed to the north. Others again lived in imagination on the banks of the heavenly Nile, whereon they built cities; and it seems as if the Egyptians never succeeded in conceiving a heaven without a Nile and canals. The Nile is depicted in the form of a man, who wears upon his head a clump of papyrus or lotus flowers; his breasts are those of a woman, indicating fertility. Lanzone reproduces an interesting scene[1] in which the north and south Nile gods are tying a papyrus and a lotus stalk around the emblem of union 〔hieroglyph〕, to indicate the unity of Upper and Lower Egypt, and this emblem 〔hieroglyph〕 is found cut upon the thrones of the kings of Egypt to indicate their sovereignty over the regions traversed by the South and North Niles. It has already been said that Ḥāpi was identified with all the gods in turn, and it follows as a matter of course that the attributes of each were ascribed to him; in one respect, however he is different from them all, for of him it is written :—

〔hiero〕	〔hiero〕	〔hiero〕	〔hiero〕	〔hiero〕	〔hiero〕	〔hiero〕	〔hiero〕	〔hiero〕
àn	*meḥu*	*en*	*àner*	*tut*	*ḥer*	*uaḥ*	*set*	*seχet āārāt*
He cannot be sculptured in		stone;	in the images		on	which men	place	crowns and uræi

〔hiero〕	〔hiero〕	〔hiero〕	〔hiero〕	〔hiero〕	〔hiero〕	〔hiero〕	〔hiero〕	〔hiero〕
àn	*qeṁuḥ*	*entuf*	*àn*	*bakā*	*àn*	*χerpu*	*tuf*	*àn*
he is not made manifest;			service cannot be rendered		nor	offerings made to him;		not

[1] *Dizionario,* tav. 198.

seśeṭ - tu	*em*	*śetau*	*ȧn*	*reχ - tu*	*bu*	*entuf*	*ȧn*
can he be drawn	from	[his] mystery ;	not	can be known	the place	where he is ;	not

qem	*tephet*	*ȧnu* .
is he found	in the painted shrine.[1]	

Here the scribe gave to the Nile the attributes of the great and unknown God its Maker.

In the pyramid texts we find a group of four gods with whom the deceased is closely connected in the "other world"; these are the four "children of Horus", whose names are given in the following order:—**Ḥāpi**, **Tuamāutef**, **Ȧmset**, and **Qebḥsennuf**.[2] The deceased is called their "father."[3] His two arms were identified with Ḥāpi and Ṭuamāutef, and his two legs with Ȧmset and Qebḥsennuf;[4] and when he entered into the Sekhet-Ȧaru they accompanied him as guides, and went in with him two on each side.[5] They took away all hunger and thirst from him,[6] they gave him life in heaven and protected it when given,[7] and they brought to him from the Lake of Khemta the boat of the Eye of Khnemu.[8] In one passage they are called the "four *Khu*'s of Horus", [9] and originally they represented the four pillars which supported the sky, or Horus. Each was supposed to be lord of one of the quarters of the world, and finally became the god of one of the cardinal points. Ḥāpi represented the north, Ṭuamāutef the east, Ȧmset the south, and Qebḥsennuf the west. In the XVIIIth dynasty the Egyptians originated the custom of embalming the intestines of the

[1] For the hieratic text from which this extract is taken see Birch, *Select Papyri*, pll. 20 ff. and 134 ff. ; see also Maspero, *Hymne au Nil, publié et traduit d'après les deux textes du Musée Britannique, Paris*, 1868. 4to.

[2] Pyramid of Unȧs, l. 219 ; Pyramid of Tetȧ, ll. 60, 286 ; Pyramid of Pepi I., ll. 444, 593, *etc.*

[3] Pyramid of Pepi I., l. 593. [4] *Recueil de Travaux*, t. iii., p. 905 (l. 219 f.).

[5] *Ibid.*, t. vii., p. 150 (ll. 261-63). [6] *Ibid.*, t. v., p. 10 (ll. 59 ff.).

[7] *Ibid.*, t. viii., p. 91 (l. 593). [8] *Ibid.*, t. vii., p. 167 (l. 444).

[9] *Ibid.*, t. vii., p. 150 (l. 261).

body separately, and they placed them in four jars, each of which was devoted to the protection of one of the children of Horus, *i.e.*, to the care of one of the gods of the four cardinal points. The god of the north protected the small visceræ, the god of the east the heart and lungs, the god of the south the stomach and large intestines, and the god of the west the liver and gall-bladder. With these four gods four goddesses were associated, viz., Nephthys, Neith, Isis, and Selk or Serq.

Connected with the god Horus are a number of mythological beings called **Ḥeru shesu**[1] (or *shemsu*, as some read it) 𓅃𓏤𓊪𓄿𓄿𓄿, who appear already in the pyramid of Unás in connection with Horus and Set in the ceremony of purifying and "opening the mouth"; and in the pyramid of Pepi I. it is they who wash the king and who recite for him the "Chapter of those who come forth," and the "[Chapter of] those who ascend."[2]

In the judgment scene in the Book of the Dead, grouped round the pan of the balance which contains the heart of the deceased (see Plate III.), are three beings in human form, who bear the names **Shai, Renenet,** and **Meskhenet.**

Shai 𓈙𓄿𓇋𓇋𓀀 is the personification of destiny, and **Renenet** 𓂋𓈖𓈖𓏏𓀀 of fortune; these names are usually found coupled. Shai and Renenet are said to be in the hands of Thoth, the divine intelligence of the gods; and Rameses II. boasts that he himself is "lord of Shai and creator of Renenet."[3] Shai was originally the deity who "decreed" what should happen to a man, and Renenet, as may be seen from the pyramid texts,[4] was the goddess of plenty, good fortune, and the like; subsequently no distinction was made between these deities and the abstract ideas which they represented. In the papyrus of Ani, Shai stands by himself near the pillar of the Balance, and Renenet is accompanied by **Meskhenet**, who appears to be the personification of all the conceptions underlying Shai and Renenet and something else besides. In the story of the children of Rā, as related in the Westcar papyrus, we find the goddess Meskhenet 𓏥𓈖𓏏𓀀 mentioned with Isis, Nephthys, Heqet, and the god Khnemu as assisting at the birth of children.

[1] *Recueil de Travaux*, t. iii., p. 182 (l. 17).

[2] 𓊪—𓏤𓈖𓊪𓅱 ° 𓄿 —𓏏𓈙𓄿𓂋𓊪𓏤 —�ⲟ𓈖𓈖𓊪𓅱 𓏤

𓈖𓈖 ⲟ𓊪𓅃—𓊪𓏤𓈖𓈖 𓊪𓅱 ° , *etc. Ibid.*, t. vii., p. 170 (l. 463).

[3] See Maspero, *Romans et Poésies du Papyrus Harris*, No. 500, Paris, 1879, p. 27.
[4] Pyramid of Unás, l. 564.

Disguised in female forms, the four goddesses go to the house of Rā-user, and, professing to have a knowledge of the art of midwifery, they are admitted to the chamber where the child is about to be born ; Isis stands before the woman, Nephthys behind her, and Heqet accelerates the birth. When the child is born Meskhenet comes and looking upon him says, " A king ; he shall rule throughout this land. May Khnemu give health and strength to his body."[1] The word *meskhenet* is as old as the pyramid times, and seems then to have had the meaning of luck, destiny, *etc.*[2]

The god **Åmen** ⟨hieroglyphs⟩, his wife Mut ⟨hieroglyphs⟩, and their associate Khonsu ⟨hieroglyphs⟩ have nothing whatever to do with the Book of the Dead ; but Åmen, the first member of this great Theban triad, must be mentioned with the other gods, because he was usually identified with one or more of them. The name Åmen means the " hidden one," and the founding of the first shrine of the god recorded in history took place at Thebes during the XIIth dynasty ; from that time until the close of the XVIIth dynasty, Åmen was the chief god of Thebes and nothing more. When, however, the last kings of the XVIIth dynasty had succeeded in expelling the so-called Hyksos and had delivered the country from the yoke of the foreigner, their god assumed an importance hitherto unknown, and his priests endeavoured to make his worship the first in the land. But Åmen was never regarded throughout the entire country as its chief god, although his votaries called him the king of the gods. The conception which the Thebans had of their god as a god of the underworld was modified when they identified him with Rā and called him " Åmen-Rā" ; and, speaking generally, in the time of the XVIIIth dynasty and onwards the god became the personification of the mysterious creating and sustaining power of the universe, which in a material form was typified by the sun. By degrees all the attributes of the old gods of Egypt were ascribed to him, and the titles which among western nations are given to God were added to those pantheistic epithets which Åmen had usurped. The following extracts from a fine hymn[3] will set forth the views of the priesthood of Åmen-Rā concerning their god.

[1] ⟨hieroglyphs⟩ ⟨hieroglyphs⟩. Erman, *Die Märchen des Papyrus Westcar*, Berlin, 1890, Bl. 10, ll. 13, 14.

[2] Compare ⟨hieroglyphs⟩, "the night of thy birth, and the day of thy *meskhenet*" ; see *Recueil de Travaux*, t. vii., p. 161 (l. 397).

[3] See Grébaut, *Hymne à Ammon-Rā*, Paris, 1874 ; and Wiedemann, *Die Religion*, p. 64 ff.

" Adoration to thee, O Åmen-Rā, the bull in Ånnu, the ruler of all the gods,
" the beautiful and beloved god who givest life by means of every kind of food and
" fine cattle.

" Hail to thee, O Åmen-Rā, lord of the world's throne, thou dweller in Thebes,
" thou bull of thy mother that livest in thy field, that extendest thy journeys in the
" land of the south, thou lord of those who dwell in the west, thou governor of Punt,
" thou king of heaven and sovereign of the earth, thou lord of things that exist, thou
" stablisher of creation, thou supporter of the universe. Thou art one in thine attributes
" among the gods, thou beautiful bull of the company of the gods, thou chief of all the
" gods, lord of *Maāt*, father of the gods, creator of men, maker of beasts and cattle, lord
" of all that existeth, maker of the staff of life, creator of the herbs which give life to
" beasts and cattle. Thou art the creator of things celestial and terrestrial, thou
" illuminest the universe The gods cast themselves at thy feet when they perceive
" thee Hymns of praise to thee, O father of the gods, who hast spread out the
" heavens and laid down the earth thou master of eternity and of everlastingness.
" Hail to thee, O Rā, lord of *Maāt*, thou who art hidden in thy shrine, lord of the
" gods. Thou art Kheperå in thy bark, and when thou sendest forth the word the gods
" come into being. Thou art Tmu, the maker of beings which have reason, and, however
" many be their forms, thou givest them life, and thou dost distinguish the shape and
" stature of each from his neighbour. Thou hearest the prayer of the afflicted, and thou
" art gracious unto him that crieth unto thee; thou deliverest the feeble one from the op-
" pressor, and thou judgest between the strong and the weak The Nile riseth at thy
" will. . . . Thou only form, the maker of all that is, One only, the creator of all that shal
" be. Mankind hath come forth from thine eyes, the gods have come into being at thy
" word, thou makest the herbs for the use of beasts and cattle, and the staff of life for the
" need of man. Thou givest life to the fish of the stream and to the fowl of the air, and
" breath unto the germ in the egg ; thou givest life unto the grasshopper, and thou
" makest to live the wild fowl and things that creep and things that fly and everything
" that belongeth thereunto. Thou providest food for the rats in the holes and for the
" birds that sit among the branches thou One, thou only One whose arms are
" many. All men and all creatures adore thee, and praises come unto thee from the
" height of heaven, from earth's widest space, and from the deepest depths of the
" sea thou One, thou only One who hast no second whose names are
" manifold and innumerable."

We have seen above[1] that among other titles the god Åmen was called the " only

One " ⸺⸺, but the addition of the words " who hast no second " ⸺

is remarkable as showing that the Egyptians had already conceived the existence
of a god who had no like or equal, which they hesitated not to proclaim side by
side with their descriptions of his manifestations. Looking at the Egyptian words
in their simple meaning, it is pretty certain that when the Egyptians declared that

[1] See above, p. xcv.

their god was One and that he had no second, they had the same ideas as the Jews and Muḥammadans when they proclaimed their God to be " One "[1] and alone. It has been urged that the Egyptians never advanced to pure monotheism because they never succeeded in freeing themselves from the belief in the existence of other gods, but when they say that a god has " no second," even though they mention other " gods," it is quite evident that like the Jews, they conceived him to be an entirely different being from the existences which, for the want of a better word, or because these possessed superhuman attributes, they named " gods."

The gods above enumerated represent the powers who were the guides and protectors and givers of life and happiness to the deceased in the new life, but from the earliest times it is clear that the Egyptians imagined the existence of other powers who offered opposition to the dead, and who are called in many places his " enemies." Like so many of the ancient gods, these powers were originally certain forces of nature, which were believed to be opposed to those which were regarded as beneficent to man, as for example darkness to light, and night to day; with darkness and night were also associated the powers which contributed in any way to obscure the light of the sun or to prevent his shining. But since the deceased was identified with Horus, or Rā, and his accompanying gods, the enemies of the one became the enemies of the other, and the welfare of the one was the welfare of the other. When the Egyptians personified the beneficent powers of nature, that is to say, their gods, they usually gave to them human forms and conceived them in their own images ; but when they personified the opposing powers they gave to them the shapes of noxious animals and reptiles, such as snakes and scorpions. As time went on, the moral ideas of good and right were attributed to the former, and evil and wickedness to the latter. The first personifications of light and darkness were Horus and Set, and in the combat—the prototype of the subsequent legends of Marduk and Tiamat, Bel and the Dragon, St. George and the Dragon, and many others—which took place between them, the former was always the victor. But, though the deceased was identified with Horus or Rā, the victory which the god gained over Set only benefited the spiritual body which dwelt in heaven, and did not preserve the natural body which lay in the tomb. The principal enemy of the natural body was the worm, and from the earliest times it seems that a huge worm or serpent was chosen by the Egyptians as the type of the powers which were hostile to the dead and also of

[1] אֶחָד, Deut. vi., 4. Compare כִּי יְהֹוָה הוּא הָאֱלֹהִים אֵין עוֹד מִלְבַדּוֹ, Deut. iv., 35 ; and וְאֵין עוֹד זוּלָתִי אֵין אֱלֹהִים, Isaiah xlv., 5.

the foe against whom the Sun-god fought. Already in the pyramid of Unàs a long section of the text contains nothing but formulæ, the recital of which was intended to protect the deceased from various kinds of snakes and worms.[1] These are exceedingly ancient, indeed, they may safely be said to form one of the oldest parts of the funeral literature of the Egyptians, and we find from the later editions of the Book of the Dead and certain Coptic works that the dread of the serpent as the emblem of physical and moral evil existed among the Egyptians in all generations, and that, as will be seen later, the belief in a limbo filled with snakes swayed their minds long after they had been converted to Christianity.

The charms against serpents in the pyramid texts of the Vth and VIth dynasties have their equivalents in the XXXIst and XXXIIIrd Chapters of the Book of the Dead, which are found on coffins of the XIth and XIIth dynasties;[2] and in the XVIIIth dynasty we find vignettes in which the deceased is depicted in the act of spearing a crocodile[3] and of slaughtering serpents.[4] In the Theban and Saïte versions are several small chapters[5] the recital of which drove away reptiles; and of these the most important is the XXXIXth[6] Chapter, which preserved the deceased from the attack of the great serpent Āpep or Apep ⎯⎯ or ⎯⎯, who is depicted with knives stuck in his folds .[7] In the period of the later dynasties a service was performed daily in the temple of Āmen-Rā at Thebes to deliver the Sun-god from the assault of this fiend, and on each occasion it was accompanied by a ceremony in which a waxen figure of Āpep was burnt in the fire; as the wax melted, so the power of Āpep was destroyed.[8] Another name of Āpep was Nāk , who was pierced by the lance of the eye of Horus and made to vomit what he had swallowed.[9]

The judgment scene in the Theban edition of the Book of the Dead reveals the belief in the existence of a tri-formed monster, part crocodile, part lion, and

[1] Maspero, *Recueil de Travaux*, t. iii., p. 226.
[2] Goodwin, *Aeg. Zeitschrift*, 1866, p. 54; see also Lepsius, *Aelteste Texte*, Bl. 35, l. 1 ff.
[3] Naville, *Todtenbuch*, Bd. I., Bl. 44. [4] *Ibid.*, Bd. I., Bl. 46.
[5] *I.e.*, chapp. 32, 34, 35, 36, 37, 38, *etc.*
[6] For the text see Naville, *Todtenbuch*, Bd. I., Bl. 53; and Lepsius, *Todtenbuch*, Bl. 18.
[7] See Lanzone, *Dizionario*, p. 121.
[8] The service for the *Overthrowing of Āpepi* is printed in *Archæologia*, vol. lii., pp. 393–608.
[9] ⎯⎯⎯⎯ Grébaut, *Hymne*, p. 10.

part hippopotamus, whom the Egyptians called Ȧm-mit ⎯⟋⟍🗲⟋🗲⟍🗲|, *i.e.*, "the eater of the Dead," and who lived in Ȧmenta ; her place is by the side of the scales wherein the heart is weighed, and it is clear that such hearts as failed to balance the feather of Maāt were devoured by her. In one papyrus she is depicted crouching by the side of a lake.[1] Other types of evil were the insect Ȧpshai ⟍🗲⟋🗲⟍🗲,[2] confounded in later times with the tortoise [3] ⟍🗲⟋🗲, which dies as Rā lives ;[4] the crocodile Sebȧk, who afterwards became identified with Rā ; the hippopotamus, the ass, *etc.*

The pyramid texts afford scanty information about the fiends and devils with which the later Egyptians peopled certain parts of the Ṭuat, wherein the night sun pursued his course, and where the souls of the dead dwelt ; for this we must turn to the composition entitled the " Book of what is in the Ṭuat," several copies of which have come down to us inscribed upon tombs, coffins, and papyri of the XVIIIth and following dynasties. The Ṭuat was divided into twelve parts, corresponding to the twelve hours of the night ; and this Book professed to afford to the deceased the means whereby he might pass through them successfully. In one of these divisions, which was under the rule of the god Seker, the entrance was guarded by a serpent on four legs with a human head, and within were a serpent with three heads, scorpions,[5] vipers, and winged monsters of terrifying aspect ; a vast desert place was their abode, and seemingly the darkness was so thick there that it might be felt. In other divisions we find serpents spitting fire, lions, crocodile-headed gods, a serpent that devours the dead, a huge crocodile, and many other reptiles of divers shapes and forms.

From the descriptions which accompany the scenes, it is evident that the Ṭuat was regarded by the Egyptians of the XVIIIth dynasty from a moral as well as from a physical point of view.[6] Ȧpep, the emblem of evil, was here punished and overcome, and here dwelt the souls of the wicked and the righteous, who received their punishments or rewards, meted out to them by the decree of Rā and his company of gods. The chief instruments of punishment employed by the gods were fire and beasts which devoured the souls and bodies of the enemies

[1] See below, p. 258. [2] Naville, *Todtenbuch*, Bd. I., Bl. 49.

[3] Lepsius, *Todtenbuch*, Bl. 17.

[4] ⟍🗲⟋🗲⟍🗲. Naville, *Todtenbuch*, Bd. I., Bl. 184.

[5] See Maspero, *Les Hypogées Royaux de Thèbes*, p. 76.

[6] See Lefébure, *Book of Hades* (*Records of the Past*, vol. x., p. 84).

of Rā ; and we may see from the literature of the Copts, or Egyptians who had embraced Christianity, how long the belief in a hell of fire and torturing fiends survived. Thus in the Life of Abba Shenuti,[1] a man is told that the " executioners of Ȧmenti will not show compassion upon thy wretched soul,"[2] and in the history of Pisentios, a Bishop of Coptos in the seventh century of our era, we have a series of details which reflect the Ṭuat of the ancient Egyptians in a remarkable manner. The bishop having taken up his abode in a tomb filled with mummies, causes one of them to tell his history.[3] After saying that his parents were Greeks who worshipped Poseidon, he states that when he was dying already the avenging angels came about him with iron knives and goads as sharp as spears, which they thrust into his sides, while they gnashed their teeth at him ; when he opened his eyes, he saw death in all its manifold forms round about him ; and at that moment angels without mercy (ⲛⲁⲅⲅⲉⲗⲟⲥ ⲛ̄ ⲁⲑⲛⲁⲓ) came and dragged his wretched soul from his body, and tying it to the form of a black horse they bore it away to Amenta (ⲉⲙⲉⲛⲧ = 𓊖). Next, he was delivered over to merciless tormentors, who tortured him in a place where there were multitudes of savage beasts ; and, when he had been cast into the place of outer darkness, he saw a ditch more than two hundred feet deep filled with reptiles, each of which had seven heads, and all their bodies were covered as it were with scorpions. Here also were serpents, the very sight of which terrified the beholder, and to one of them which had teeth like iron stakes was the wretched man given to be devoured ; for five days in each week the serpent crushed him with his teeth, but on the Saturday and Sunday there was respite. Another picture of the torments of Hades is given in the Martyrdom of Macarius of Antioch, wherein the saint, having restored to life a man who had been dead six hours, learned that when he was about to die he was surrounded by fiends, ⲅ̅ⲁⲛⲁⲏⲕⲁⲛⲟⲥ, some of whom had the faces of dragons, ⲛ̄ⲅⲟ ⲛ̄ⲁⲣⲁⲕⲱⲛ, others of lions, ⲛ̄ⲅⲟ ⲛ ⲙ̣ ⲙⲟⲩⲓ, others of crocodiles, ⲛ̄ⲅⲟ ⲛ̄ⲉⲙⲥⲁⲅ, and others of bears, ⲛ̄ⲅⲟ ⲛ̄ⲗⲁⲃⲟⲓ. They tore his soul from his body with great violence, and they fled with it over a mighty river of fire, in which they plunged it to a depth of four hundred cubits ; then they took it out and set it before the Judge of Truth, ⲙ̣ ⲡⲓⲕⲣⲓⲧⲏⲥ ⲙ̣ ⲙⲏⲓ. After hearing the sentence of the Judge the fiends took it to a place of outer darkness where no

[1] See Amélineau, *Monuments pour servir à l'Histoire de l'Égypte Chrétienne*, p. 167.

[2] ⲙ̣ⲓ ⲥⲉⲛⲁⲧⲁⲥⲟ ⲉⲧⲉⲕⲯⲩⲭⲏ ⲛ̄ⲧⲁⲗⲁⲓⲡⲱⲣⲟⲥ ⲛ̄ⲭⲉ ⲛⲓⲁⲏⲙⲙⲱⲣⲓⲥⲧⲏⲥ ⲛ̄ⲧⲉ ⲙⲙⲉⲛⲧ̄.

[3] See Amélineau, *Étude sur le Christianisme en Égypte au Septième Siècle*, Paris, 1887, p. 147.

light came, and they cast it into the cold where there was gnashing of teeth. There it beheld a snake which never slept, ϥⲉⲛⲧ ⲛ̅ ⲁⲧ ⲉⲛⲕⲟⲧ, with a head like that of a crocodile, and which was surrounded by reptiles which cast souls before it to be devoured, ⲉⲣⲉ ⲛⲓϭⲁⲧϥⲓ ⲧⲏⲣⲟⲩ ϩⲁⲧⲟⲧϥ ⲉⲩⲥⲓϯ ⲛ̅ ⲛⲓⲯⲩⲭⲏ ϩⲓⲧϩⲏ ⲙ̅ⲙⲟϥ; when the snake's mouth was full it allowed the other reptiles to eat, and though they rent the soul in pieces it did not die. After this the soul was carried into Amenta for ever, ⲉ̀ⲙⲉⲛϯ ϣⲁ ⲉ̀ⲛⲉϩ.[1] The martyr Macarius suffered in the reign of Diocletian, and the MS. from which the above extract is taken was copied in the year of the Martyrs 634 = A.D. 918. Thus, the old heathen ideas of the Egyptian Ṭuat were applied to the construction of the Coptic Hell.

[1] See Hyvernat, *Les Actes des Martyrs de l'Égypte*, Paris, 1886, pp. 56, 57.

THE PRINCIPAL GEOGRAPHICAL
AND MYTHOLOGICAL PLACES IN THE
BOOK OF THE DEAD.

Abṭu, ⸸ ⫽ ⟞ ≽ ♔ , the Abydos of the Greeks (Strabo, XVII., i., 42), the capital of the eighth nome of Upper Egypt. It was the seat of the worship of Osiris, and from this fact was called Per-Áusár ⬚ 𓏏𓊹, or Busiris, "the house of Osiris"; the Copts gave it the name ⲉⲃⲱⲧ.[1] Egyptian tradition made the sun to end his daily course at Abydos, and to enter into the Ṭuat at this place through a "gap" in the mountains called in Egyptian *peq*, ⬚𓏤𓏏⊗ .[2] These mountains lay near to the town; and in the XIIth dynasty it was believed that the souls of the dead made their way into the other world by the valley which led through them to the great Oasis, where some placed the Elysian Fields.[3]

Ámenta or Ámentet, 𓊽⌒, or 𓊽⌒⌒, was originally the place where the sun set, but subsequently the name was applied to the cemeteries and tombs which were usually built or hewn in the stony plateaus and mountains on the western bank of the Nile. Some believe that Ámenta was, at first, the name of a small district, without either funereal or mythological signification. The Christian Egyptians or Copts used the word Amenti to translate the Greek word Hades, to which they attributed all the ideas which their heathen ancestors had associated with the Ámenta of the Book of the Dead.

Ánnu, 𓉴⊙, the Heliopolis of the Greeks (Herodotus, II., 3, 7, 8, 9, 59, 93; Strabo, XVII., 1, 27 ff.), and the capital of the thirteenth nome of Lower Egypt.

[1] See Amélineau, *La Géographie de l'Égypte à l'Époque Copte*, p. 155.
[2] See Brugsch, *Dict. Géog.*, p. 227.
[3] See Maspero, *Études de Mythologie*, t. i., p. 345.

The Hebrews called it On (Genesis xli., 45, 50; xlvi., 20), Aven (Ezekiel xxx., 17), and Bêth-Shemesh (Jeremiah xliii., 13); this last name is an exact translation of the Egyptian ⌐□○⌐ *per Rā*, "house of the sun," which was also a designation of Ånnu. The Copts have preserved the oldest name of the city under the form ⲱⲛ.[1] A Coptic bishop of this place was present at the Council of Ephesus. The city of Ånnu seems to have become associated with the worship of the sun in prehistoric times. Already in the Vth dynasty its priesthood had succeeded in gaining supremacy for their religious views and beliefs throughout Egypt, and from first to last it maintained its position as the chief seat of theological learning in Egypt. The body of the Aged One, a name of Osiris, reposed in Ånnu, and there dwelt the Eye of Osiris. The deceased made his way to Ånnu, where souls were joined unto bodies in thousands, and where the blessed dead lived on celestial food for ever.

Ån-ruṭf or **Naåruṭf** ⌐ △ ⊗ , △ ⊗, is a section or door of the Ṭuat which lies to the north of Re-stau; the meaning of the word is "it never sprouteth."

Ån-ṭes(?) (see within, p. 323), an unknown locality where , a light tower (?), was adored.

Åpu ⊗, the Panopolis of the Greeks (Πανῶν πόλις, Strabo, XVII., i., 41), the metropolis of the ninth nome of Upper Egypt, and the seat of the worship of the god , whose name is variously read Amsu, Khem, and Min. In ancient days it was famous as the centre for stone cutting and linen weaving, and the latter industry still survives among the modern Coptic population, who, following their ancestors, call their city ϣⲙⲓⲛ, which the Arabs have rendered by Akhmîm.

Åqert , a common name for the abode of the dead.

Bast , more fully Pa-Bast or Per-Bast , the Bubastis of the Greek writers (Herodotus, II., 59, 137, 156, 166; Strabo, XVII., 1, 27), the metropolis of the eighteenth nome of Lower Egypt, and the seat of the worship of Bast, a goddess who was identified with the soul of Isis, *ba en Auset*, . The city is mentioned in the Bible under the form פִּי בֶסֶת (Ezekiel xxx., 17), Pi-beseth,

[1] See Amélineau, *op. cit.*, p. 287.

which the Copts have preserved in their name for the city, ⲡⲟⲩⲃⲁⲥⲧⲓ; the Arabs call the place Tell Basṭa تل بسطه.

Ḥet-benbent ⎡⎤, the name given to many sun-shrines in Egypt, and also to one of the places in the other world where the deceased dwelt.

Ḥet-Ptaḥ-ka ⎡⎤, the sacred name of the city of Memphis, the metropolis of the first nome of Lower Egypt; it means the "House of the *ka* of Ptaḥ," and was probably in use in the period of the Ist dynasty. Other names for Memphis were ⎡⎤ Åneb-ḥet′et, "the city of the white wall"; Men-nefer ⎡⎤; and Khā-nefert ⎡⎤.

Kem-ur ⎡⎤, a name given to the district of the fourth and fifth nomes of Upper Egypt.

Khemennu ⎡⎤, ⎡⎤, *i.e.*, the city of the eight great cosmic gods, the Hermopolis of the Greek writers (Ἑρμοπολιτικὴ φυλακή, Strabo, XVII., 1, 41), and the metropolis of the fifteenth nome of Upper Egypt. The old Egyptian name for the city is preserved in its Coptic and Arabic names, ϣⲙⲟⲩⲛ and Eshmûnên.

Kher-āba ⎡⎤, a very ancient city which was situated on the right bank of the Nile, a little to the south of Annu, near the site of which the "Babylon of Egypt"[1] (the Βαβυλών, φρούριον ἐρυμνόν of Strabo, XVII., 1, 30), was built.

Manu ⎡⎤ or ⎡⎤ is the name given to the region where the sun sets, which was believed to be exactly opposite to the district of Bekha ⎡⎤, where he rose in the east; Manu is a synonym of west, just as Bekha is a synonym of east.[2]

Nekhen ⎡⎤ or ⎡⎤, the name of the shrine of the goddess Nekhebet, which is supposed to have been near to Nekheb, the capital of the third nome of Upper Egypt and the Eileithyiapolis of the Greeks.

Neter-khertet ⎡⎤ or ⎡⎤, a common name for the abode of the dead; it means the "divine subterranean place."

[1] ⲃⲁⲃⲩⲗⲱⲛ ⲛ̄ⲧⲉ ⲭⲏⲙⲓ; see Amélineau, *op. cit.*, p. 75.

[2] See Brugsch, *Dict. Géog.*, pp. 199, 260; Maspero, *Études de Mythologie*, t. i., p. 332; and *Aeg. Zeitschrift*, 1864, pp. 73-76.

Pe ▢, a district of the town of Per-Uatchet ⬚, the Buto of the Greeks (Βοῦτος, Strabo, XVII., i., 18), which was situated in the Delta.

Punt ▢, the tropical district which lay to the south and east of Egypt, and which included probably a part of the Arabian peninsula and the eastern coast of Africa along and south of Somali land.

Re-stau ⬚ or ⬚, a name given to the passages in the tomb which lead from this to the other world ; originally it designated the cemetery of Abydos only, and its god was Osiris.

Sa ⬚, the Saïs of the Greeks (Σάϊς, Strabo, XVII., i., 23), the metropolis of the fifth nome of Lower Egypt, and the seat of the worship of the goddess Neith.

Sekhem ⬚ or ⬚, the Letopolis of the Greeks, and capital of the Letopolites nome (Strabo, XVII., i., 30) ; it was the seat of the worship of Ḥeru-ur ⬚, "Horus the elder," and one of the most important religious centres in Egypt.

Sekhet-Åanru ⬚, the "Field of the *Åanru* plants," was a name originally given to the islands in the Delta where the souls of the dead were supposed to live. Here was the abode of the god Osiris, who bestowed estates in it upon those who had been his followers, and here the beatified dead led a new existence and regaled themselves upon food of every kind, which was given to them in abundance. According to the vignette of the CXth Chapter of the Book of the Dead, the Sekhet-Åanru is the third division of the Sekhet-ḥetepu, or " Fields of Peace," which have been compared with the Elysian Fields of the Greeks.

Set Åmentet ⬚, *i.e.*, "the mountain of the underworld," a common name of the cemetery, which was usually situated in the mountains or desert on the western bank of the Nile.

Suten-ḥenen ⬚, more correctly Ḥenen-su, the metropolis of the twentieth nome of Upper Egypt, called by the Greeks Heracleopolis Magna (Strabo, XVII., i., 35). The Hebrews mention the city (חָנֵס, Isaiah xxx., 4) Hanes as the representative of Upper Egypt, and in Coptic times it was still of considerable size and importance ; the Copts and Arabs have preserved the ancient name of the city under the forms ϩⲛⲏⲥ and اهناس, *Ahnas.*

Ṭanenet ⟨hieroglyphs⟩, a district sacred to the gods Osiris and Ptaḥ; it was probably situated near Memphis.

Ṭa-sert ⟨hieroglyphs⟩ or Ta-tchesertet, a common name for the tomb.

Ṭep ⟨hieroglyphs⟩, a district of the town Per-Uatchet ⟨hieroglyphs⟩, the Buto of the Greeks (Strabo, XVII., i., 18), which was situated in the Delta.

Ṭeṭṭet ⟨hieroglyphs⟩, a name given both to the metropolis[1] of the ninth nome and to the chief city[2] of the sixteenth nome of Lower Egypt.

Ṭuat ⟨hieroglyphs⟩, a common name for the abode of the departed.

[1] *I.e.,* ⟨hieroglyphs⟩ Pa-Åusàr, or Per-Åusàr, the Busiris of the Greeks.

[2] *I.e.,* ⟨hieroglyphs⟩ Ba-neb-Ṭeṭṭet, the Mendes of the Greeks.

FUNERAL CEREMONIES.

In illustration of the ceremonies which accompanied the burial of the dead the reader will find extracts from different texts printed in the *Appendix* on p. 264 ff. To these may be added an extract from the curious ritual which was in vogue in the Vth and VIth dynasties, and which commemorated the ceremonies which were performed for the god Osiris. It is to be noticed how closely the deceased is identified with Osiris, the type of incorruptibility. Osiris takes upon himself "all that is hateful" in the dead : that is, he adopts the burden of his sins ; and the dead is purified by the typical sprinkling of water. While the gods are only accompanied by their *ka's*, the deceased, in right of his identification with a higher power, is accompanied by his Ṭeṭ[1] also, that is, by his Osiris.

Throughout the ceremony, the Eye of Horus,[2] which is represented by various substances, plays a prominent part, for it is that which gives vigour to the heart of the dead and leads him to the god. That portion of the ceremony which was believed to procure the unlocking of the jaws and the opening of the mouth of the deceased, or of the statue which sometimes represented him, was performed after the purification by water and incense had been effected ; and hereby was he enabled to partake of the meat and drink offerings, wherein the friends and relatives also participated, in order that they might cement and seal their mystic unity with the dead and with the god with whom he was identified.[3]

[1] Some fifty years ago, M. Reuvens expressed his belief that the 𓊽 represented the four quarters of the world, and according to M. Maspero it unites in itself the four pillars which support the sky and Osiris, whom they preserve from chaos ; see *Recueil de Travaux*, t. xii., p. 79, note 3 ; and *Études de Mythologie*, t. ii., p. 359.

[2] On the eyes of Horus, see Lefébure, *Le Mythe Osirien—Les Yeux d'Horus*, Paris, 1874 ; and Grébaut, *Les deux yeux du Disque Solaire* (*Recueil de Travaux* t. i., pp. 72, 87, 112–131).

[3] To discuss the origin and development of animal sacrifice among the early Egyptians lies outside the scope of this work. For information on the significance of sacrifice among the Semites, in whose customs many originally Egyptian ideas probably survived, see Robertson Smith, *Religion of the Semites*, p. 294 ff. On the origin of sacrificial acts, see Max Müller, *Natural Religion*, London, 1889, p. 184 ; and E. B. Tylor, *Primitive Culture*, vol. ii., p. 340. Whether the Egyptians regarded the sacrifice of bulls, geese, *etc.*, at the tomb as expiatory offerings, can hardly yet be decided.

Certain formulæ were directed to be repeated four times : a direction which takes us back to the time when the Egyptians first divided the world into four parts, each corresponding to one of the four pillars which held up the sky, that is to say, to one of the four cardinal points, East, South, West, and North, presided over by a special god. The deceased sought to obtain the assistance of each of the four gods of the cardinal points, and to have the right to roam about in his district ; hence the formula was repeated four times. Originally four animals or four geese were sacrificed, one to each god, but subsequently East and North, and West and South were paired, and two bulls (or birds) only were sacrificed, one of which was called the Bull of the North,* and the other the Bull of the South. The custom of four-fold repetition continued to the Ptolemaïc times† and even later.

The priest whose official title was *kher ḥeb*, 𓎔, recited the prayers, and the *sem* or *setem* priest 𓎔 presented the prescribed offerings. The rubrical directions are given on the margin for the sake of clearness.

" O Osiris.‡ all that is hateful in Unàs hath been brought unto thee,[1] and all the evil words which have been spoken in his name. Come, O Thoth, and take them unto Osiris, bring all the evil words which have been spoken and place them in the hollow of thy hand ;[2] thou shalt not escape therefrom, thou shalt not escape therefrom. Whosoever marcheth, marcheth with his *ka*. Horus marcheth with his *ka*, Set marcheth with his *ka*, Thoth marcheth with[3] his *ka*, Sep marcheth with his *ka*, Osiris marcheth with his *ka*, Khent-maati marcheth with his *ka ;* and thy *ṭeṭ* shall march with thy *ka*. Hail, Unàs, the hand of thy *ka* is before thee. Hail, Unàs, the hand of thy *ka* is behind thee. Hail, Unàs, the leg of thy *ka* is before thee. Hail, Unàs, the leg of thy *ka* is behind thee. Osiris Unàs, I have given unto thee the Eye of Horus, and thy face is filled therewith, and the perfume thereof spreadeth over thee. The libations which are poured[4] out by thy son, which are poured out by Horus, are for thee, O Osiris, and they are for thee, O Unàs. I have come, and I have brought unto thee the Eye of Horus that thou mayest refresh thy heart therewith, I have placed it beneath thy feet, and I give unto thee whatsoever hath come forth from thy body that thy heart may not cease to beat through [the want] thereof.[5] Thy voice shall never depart from thee, thy voice shall never depart from thee.

* This subject has been lucidly discussed by Maspero, *Recueil de Travaux*, t. xii., pp. 78, 79.
† See *Archæologia*, vol. lii., p. 453, at the foot.
‡ For the text and French translation, see Maspero, *Recueil de Travaux*, t. iii., p. 179 ff.

"[Here is] unguent, [here is] unguent. Open thy mouth, O Unàs,[1] and taste the taste of the scent which is in the holy habitations. This scent is that which distilleth from Horus, this scent is that which distilleth from Set, and it is that which stablisheth the hearts of the two Horus gods.[2] Thou purifiest thyself with the Ḥeru-shesu;* thou art purified with natron, and Horus is purified with natron; thou art purified with natron, and Set is purified with natron;[3] thou art purified with natron, and Thoth is purified with natron; thou art purified with natron, and Sep is purified with natron; thou art purified with natron, and art established among them, and thy mouth is [as pure] as the mouth of a sucking calf on the day of its birth. Thou art purified with natron, and Horus is purified with natron; thou art purified with natron, and Set is purified with natron;[4] [thou art purified with natron] and Thoth is purified with natron; thou art purified with natron, and Sep is purified with natron; thy ka is purified with natron, and thou art pure, thou art pure, thou art pure, thou art pure. Thou art stablished among the gods thy brethren, thy head is purified for thee with natron, thy bones are washed clean with water, and thou thyself art made perfect with all that belongeth unto thee. O Osiris, I have given unto thee the Eye of Horus, thy face is filled therewith, and the perfume thereof spreadeth over thee.

"Hail, Unàs, thy two jaws are unlocked.[5] Hail, Unàs, the two gods have opened thy mouth.[6] O Unàs, the Eye of Horus hath been given unto thee, and Horus cometh thereunto; it is brought unto thee, and placed in thy mouth.[7] Hail, Unàs, the nipples of the bosom of Horus have been given unto thee, and thou hast taken in thy mouth[8] the breast of thy sister Isis, and the milk which floweth from thy mother is poured into thy mouth.[9]

"Thou hast gotten possession of the two eyes of Horus, the white and the black, thou hast taken them unto thyself and they illumine thy face.[10] The day hath made an offering unto thee in heaven, and the East and the West are at peace with thee; the night hath made an offering[11] unto thee, and the North and the South are at peace with thee. These are the offerings which are brought unto thee, the offerings which thou seest, the offerings which thou hearest, the offerings which are before thee, the offerings which are behind thee, the offerings which are with thee. O Osiris Unàs, the white teeth of Horus are given unto thee that thou mayest fill thy mouth therewith.[12] A royal offering to the ka of Unàs.[13] Osiris Unàs, the Eye of Horus hath been given unto thee, and thou livest, and thou art.[14] O Osiris Unàs, the Eye of Horus which strove with Set hath been

* , "the followers of Horus."

given unto thee, and thou hast lifted it [1] to thy lips, and thy mouth is opened thereby. O Osiris Unàs, thy mouth is opened by that with which thou art filled.[2] O Osiris Unàs, that which hath distilled from thee hath been given unto thee.[3] O Rā, may all the praise which thou receivest in heaven be in praise of Unàs, and may all that belongeth unto thy body belong unto the *ka* of Unàs, and may all that belongeth unto his body belong unto thee.[4] O Unàs, the Eye of Horus hath been given unto thee, that thou mayest be able to taste,[5] and that thou mayest illumine the night. O Unàs, the Eye of Horus hath been given to thee that it may embrace thee.[6] O Unàs, the Eye of Horus which strove with Set hath been given unto thee, in order that the opening of thy mouth may be caused thereby.[7] O Unàs, that which flowed from Osiris hath been given unto thee.[8] O Unàs, the Eye of Horus hath been given unto thee, in order that without the help of iron thy mouth may be set free.[9] O Unàs, the Eye of Horus hath been given unto thee, in order that thy face may be adorned therewith.[10] O Osiris Unàs, the Eye of Horus hath sprinkled oil upon thee.[11] O Osiris Unàs, that which hath been pressed out of thy face hath been given unto thee.[12] O Osiris Unàs, the Eye of Horus hath been given unto thee, in order that it may shave (?) thee.[13] O Osiris Unàs, the Eye of Horus hath been given unto thee, in order that it may anoint thee.[14] O Osiris Unàs, the Eye of Horus hath been given unto thee, in order that it may lead thee unto the gods.[15] O all ye unguents, be ye laid out before your Horus,[16] and make ye him strong. Cause him to gain the mastery over his body, and make his eyes to be opened. May all the shining beings see him, may they hear his name, for the Eye of Horus hath been brought, in order that it may be placed before Osiris Unàs.[17] O Osiris Unàs, the two Eyes of Horus have been laid like paint upon thy face.[18]

"O clothe thyself in peace! Put thou on thy apparel in peace! May Tatet put on [19] apparel in peace! Hail, Eye of Horus, in Tep, in peace! Hail, Eye of Horus, in the houses of Nit, in peace. Receive thou white apparel. O grant that the two lands which rejoiced to do homage unto Horus may do homage unto Set; and grant that the two lands which stood in awe of Set may stand in awe of Unas. Dwell thou with Unàs as his god, open thou a path for him among the shining ones, and stablish thou him among them."

THE PAPYRUS OF ANI.

The papyrus of Ani, 🦅〰️𓏏𓏏𓇯, was found at Thebes, and was purchased by the Trustees of the British Museum in 1888. It measures 78 feet by 1 foot 3 inches, and is the longest known papyrus of the Theban period.[1] It is made up of six distinct lengths of papyrus, which vary in length from 26 feet 9 inches to 5 feet 7 inches. The material is composed of three layers of papyrus supplied by plants which measured in the stalks about $4\frac{1}{2}$ inches in diameter. The several lengths have been joined together with great neatness, and the repairs and insertion of new pieces (see plates 25, 26) have been dexterously made. When first found, the papyrus was of a light colour, similar to that of the papyrus of Hunefer (B.M., No. 9901), but it became darker after it had been unrolled, and certain sections of it have shrunk somewhat.

It contains a number of chapters of the Book of the Dead, nearly all of which are accompanied by vignettes; and at top and bottom is a border of two colours—red and yellow.[2] At the beginning and end of the papyrus spaces of six and eleven inches respectively have been left blank. The inscribed portion is complete, and the loss of the few characters which were damaged in unrolling [3] does not interrupt the text. It was written by three or more scribes; but the uniformity of the execution of the vignettes suggests that fewer artists were employed on the illustrations. The titles of the chapters, rubrics, catchwords, etc., are in red. In some instances the artist has occupied so much space that the

[1] The papyrus of Nebseni, of the XVIIIth dynasty (B.M., No. 9900), measures 76 feet $8\frac{3}{4}$ inches by 13 inches; and the papyrus of Hunefer, of the XIXth dynasty (B.M., No. 9601), 18 feet 10 inches by 1 foot $3\frac{5}{8}$ inches; the Leyden papyrus of Qenna, of the XVIIIth dynasty, measures about 50 feet; and the Dublin papyrus (Da of M. Naville's edition), XVIIIth dynasty, 24 feet 9 inches.

[2] In some sections the border is painted yellow and orange.

[3] See plates 1, 15, 24.

scribe has been obliged to crowd the text (*e.g.*, in plate 11) and at times he has written it on the border (see plates 14, 17). This proves that the vignettes were drawn before the text was written.

All the different sections of the papyrus were not originally written for Ani, for his name has been added in several places [1] by a later hand. As however such additions do not occur in the first section, which measures 16 feet 4 inches in length, it must be concluded that that section was written expressly for him, and that the others were some of those ready-written copies in which blank spaces were left for the insertion of the names of the deceased persons for whom they were purchased. The scribe who filled in Ani's name in these spaces wrote hurriedly, for in Chapter XXXB., line 2 (pl. 15), he left himself no space to write the word "Osiris" in the phrase, "Ani victorious before Osiris" (compare

⟨hieroglyphs⟩, pl. 1, line 5); in Chapter XLIII., lines 1, 2 (pl. 17), he has written it twice; in Chapter IX., l. 1 (pl. 18), he has omitted the determinative

⟨hieroglyph⟩; in Chapter XV., line 2 (pl. 20) he meant to write "Ani, victorious in peace"

⟨hieroglyphs⟩ (pl. 19), but wrote "Ani in triumph" ⟨hieroglyphs⟩;

in Chapter CXXV., line 18 (pl. 30), the word ⟨hieroglyph⟩ is written twice, probably, however, with the view of filling up the line; in Chapter CLI. (pl. 34) the name is written crookedly, and the determinative is omitted; and in Chapters XVIII. (Introduction, pl. 12) and CXXXIV. (pl. 22). the scribe has, in two spaces, omitted to write the name. It seems tolerably certain that all the sections of the papyrus were written about the same time, and that they are the work of scribes of the same school; the variations in the depth of the space occupied by the text and the difference in the colours of the border only show that even the best scribes did not tie themselves to any one plan or method in preparing a copy of the Book of the Dead. The text has many serious errors: by some extraordinary oversight it includes two copies of the XVIIIth Chapter, one with an unusual introduction and the other without introduction; and a large section of the XVIIth Chapter, one of the most important in the whole work, has been entirely omitted. Such mistakes and omissions, however, occur in papyri older than that of Ani, for in the papyrus of Nebseni (B.M., No. 9900), which was written at Memphis early in the XVIIIth dynasty, of Chapters L., LVI., LXIV., CLXXX., two copies each, of

[1] See Chapter XXVI, l. 1 (pl. 15); Chapter XLV., l. 1 (pl. 16); Chapter IX., l. 6 (pl. 18); Chapter CXXXIV., l. 15 (pl. 22); Chapter LXXVIII., l. 1 (pl. 25); Chap. LXXX., l. 1 (pl. 28); Chapter CLXXXV., l. 15 (pl. 36).

Chapters C. and CVI., three copies, and of Chapter XVII. two extracts are given in different parts of the papyrus.[1]

The papyrus of Ani is undated, and no facts are given in it concerning the life of Ani, whereby it would be possible to fix its exact place in the series of the illustrated papyri of the Theban period to which it belongs. His full titles are :—

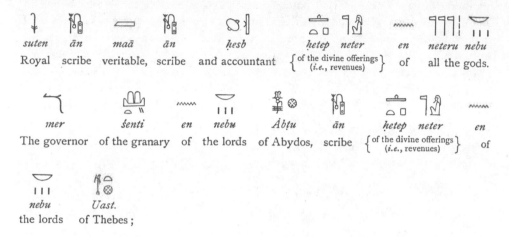

suten	*ān*	*maā*	*ān*	*hesb*	*hetep neter*	*en*	*neteru nebu*	
Royal	scribe	veritable,	scribe	and accountant	{ of the divine offerings (*i.e.*, revenues) }	of	all the gods.	

mer	*śenti*	*en*	*nebu*	*Ȧbṭu*	*ān*	*hetep neter*	*en*	
The governor	of the granary	of	the lords	of Abydos,	scribe	{ of the divine offerings (*i.e.*, revenues) }	of	

nebu	*Uast.*
the lords	of Thebes ;

and he is said to be "beloved of the lord of the North and South" and to "love him" . The name of the king thus referred to cannot be stated. That Ani's rank of "royal scribe"[2] was not titular only is shown by the addition of the word "veritable," and his office of scribe and accountant of all the gods was probably one of the highest which a scribe could hold.[3] His other offices of "governor of the granary of the lords of Abydos," and "scribe of the sacred property of the lords of Thebes," further prove his rank and importance, for Abydos and Thebes were the most ancient and sacred cities of Egypt. Ani's wife Thuthu is described as "the lady of the house, the *qemātet* of Ȧmen" .[4] What the title "lady of the house"

[1] Naville, *Einleitung*, pp. 48–54. [2] See Brugsch, *Aegyptologie*, p. 223.

[3] In the list of the high officers of the priesthood given by Brugsch (*Aegyptologie*, p. 218), we meet with an official whose title is , "the scribe set over the sacred property of the gods"; Ani held a similar appointment.

[4] Plate 19 ; her name is nowhere else mentioned in the papyrus.

means has not yet been decided, but *qemāt* is the title applied to the noble ladies who sang or played on an instrument in the temple of a god.[1] The lady Thuthu belonged to the number of the priestesses of the god Åmen-Rā at Thebes, and she always carries in her hands the sistrum and the instrument *menàt* (⌇, the emblems of her office. Thus Ani and his wife were high ecclesiastical dignitaries connected with the famous confraternity of the priests of Åmen.

An examination of the papyri of the Theban period preserved in the British Museum shows that two distinct classes of Book of the Dead papyri existed in the XVIIIth dynasty. In the first both text and vignettes are traced in black outline,[2] the rubrics, catchwords, *etc.*, alone being in red colour ; in the second the text only is black, the rubrics, *etc.*, being red, and the vignettes beautifully painted in a number of bright colours. To the latter class the papyrus of Ani belongs, but, if the text and vignettes be compared with those found in any other early Theban papyri, it will be seen that it occupies an independent position in all respects. Though agreeing in the main with the papyri of the XVIIIth dynasty in respect of textual readings, the papyrus of Ani has peculiarities in spelling, *etc.*, which are not found in any of them. The handwriting of the first section at least suggests the best period of the XVIIIth dynasty ; but as the scribe forms some of the characters in a way peculiarly his own, the palæographic evidence on this point is not decisive. That the papyrus belongs to the period which produced such documents as the papyrus of Neb-qet,[3] and the papyrus of Qenna,[4] *i.e.*, to some period of the XVIIIth dynasty, is tolerably certain ; and we may assume that it is older than the papyrus of Hunefer, which was written during the reign of Seti I. ; for, though belonging to the same class of highly decorated papyri, the execution of the vignettes is finer and more careful, and the free, bold forms of the hieroglyphics in the better written sections more closely resemble those of the texts inscribed in stone under the greatest kings of the XVIIIth dynasty. The "lord of the two lands," *i.e.*, of Upper and Lower Egypt, or the North and South, mentioned in pl. 4, is probably one of the Thothmes or Åmenḥetep kings, and accordingly we may place the period of our papyrus between 1500 and 1400 years B.C.

[1] In the stele of Canopus, ⸗⌇ is rendered by τὰς ἱερὰς παρθένους; see Brugsch, *Wörterbuch*, p. 1454.

[2] Compare the papyrus of Nebseni (British Museum, No. 9,900).

[3] *Le Papyrus de Neb-Qued*, ed. Devéria, Paris, 1872. M. Pierret, its translator, says, "Il appartient à la plus ancienne époque des exemplaires sur papyrus."

[4] *Papyrus Égyptien Funéraire Hiéroglyphique* (t. ii.), ed. Leemans, Leyden, 1882.

The text may be divided into two parts. The first part contains unusual versions of two hymns to Rā and Osiris, the vignette of the sunrise (Chapter XVIA.), and the Judgment Scene accompanied by texts, some of which occur in no other papyrus. The second part comprises about sixty-two Chapters of the Theban edition of the Book, in the following order:—I., XXII., LXXII., rubric, XVII., CXLVII., CXLVI., XVIII., XXIII., XXIV., XXVI., XXXB., LXI., LIV., XXIX., XXVII., LVIII., LIX., XLIV., XLV., XLVI., L., XCIII., XLIII., LXXXIX., XCI., XCII., LXXIV., VIII., II., IX., CXXXII., X., [XLVIII.], XV., CXXXIII., CXXXIV., XVIII., CXXIV., LXXXVI., LXXVII., LXXVIII., LXXXVII., LXXXVIII. LXXXII., LXXXV., LXXXIII., LXXXIV., LXXXIA., LXXX., CLXXV., CXXV., Introduction and Negative Confession, XLII., CXXV., Rubric, CLV., CLVI., XXIXB., CLXVI., CLI., VI., CX., CXLVIII., CLXXXV., and CLXXXVI. The titles of these Chapters arranged according to the numeration introduced by Lepsius are as follows :—

Chapter I. "Here begin the chapters of 'coming forth by day,' and of the "songs of praise and of glorifying, and of coming forth from and of going into the "glorious Neter-khert in the beautiful Åmenta; to be said on the day of the burial; "going in after coming forth." (See pp. 19, 270 and pll. 5, 6.)

The papyri belonging to the early part of the XVIIth dynasty call this Chapter the "Chapter of going in to the divine chiefs of Osiris," ⌒ ⌒ 〰 🦆 ⌒ ⌒. The large numbers of the men attending the bier and of the weeping women are peculiar to the Ani papyrus.

Chapter II. "The Chapter of coming forth by day and of living after death." (See pp. 120, 321, and pl. 18.)

This Chapter is found only in one other papyrus of the Theban period (British Museum, No. 9964). Another copy of it is inscribed upon a mummy bandage preserved in the Louvre, No. 3097.[1]

Chapter VI.—[See Chapter CLI., of which it forms a part, pp. 233, 362, and pl. 32.] In the papyrus of Nebseni (British Museum, No. 9900) this Chapter stands by itself, and is entitled "Chapter of making the *ushabti* figures to perform work for a man in the Neter-khert," ⌒ 〰 ⌒ 🦅 · .

[1] See Naville, *Einleitung*, p. 103.

Chapter VIII. "The Chapter of passing through Åmenta, and of coming forth by day." (See pp. 119, 320, and pl. 18.)

As a separate composition, this Chapter is found in only two other papyri of the XVIIIth dynasty.[1]

Chapter IX. "The Chapter of coming forth by day, having passed through the tomb." (See pp. 120, 321, and pl. 18.)

The vignette in the papyrus of Ani is similar to that which stands at the head of Chapters VIII. and IX. in other papyri of this period.

Chapter X. [See Chapter XLVIII., pp. 123, 321, and pl. 18.]

Chapter XV. 1. " A hymn of praise to Rā when he riseth in the eastern sky." (See pp. 1, 236, and pl. 1.)

This version is found in no other papyrus.

Chapter XV. 2. " A hymn of praise to Osiris Unnefer, the great god in Abydos,"[2] etc. (See pp. 8, 253, and pl. 2.)

Chapter XV. 3. " A hymn of praise to Rā when he riseth in the eastern sky, " and when he setteth in the [land of] life." (See pp. 123, 322, and pl. 18–21.)

The Litany to Osiris (pl. 19) and the hymn to Rā (pll. 24, 25) which follow are variants of the XVth Chapter, similar to those published by M. Naville.[3]

Chapter XVIA. consists of a vignette only. (See p. 252, and pl. 2.) Strictly speaking, it should form the vignette of the XVth Chapter, or of that part of it which refers to the rising sun. Like many other ancient papyri, the papyrus of Ani has no vignette referring to the sunset.

Chapter XVII. " Here begin the praises and glorifyings of coming out from " and of going into the glorious Neter-khert in the beautiful Åmenta, of coming " forth by day in all the transformations which please him, of playing at draughts, " and of sitting in the Sekh hall, and of coming forth as a living soul." (See pp. 27, 280, and pll. 7–10.)

This is one of the oldest and most important of all the Chapters in the Book of the Dead, and it contains the most complete statements concerning the Egyptian cosmogony as formulated by the college of priests of Heliopolis. The scribe seems to have accidentally omitted a large section.

Chapter XVIII. This Chapter has no title.

[1] *I.e.*, in British Museum papyrus, No. 9964, and in a papyrus in Rome; see Naville, *Einleitung*, p. 118.

[2] This hymn may form no part of the XVth chapter, and may have been inserted after the hymn to Rā on account of Ani's official connection with the ecclesiastical endowments of Abydos.

[3] *Todtenbuch*, Bd. I., Bll. 14–20.

The papyrus of Ani contains two copies of this Chapter. In the first the gods of the localities are grouped separately, and it is preceded by a very rare introduction, in which the An-mut-f and Sa-mer-f priests introduce Ani to the gods, whom he addresses in two speeches. (See p. 71, 301, and pll. 12–14.) In the second the text is not divided into distinct sections, and the gods are not grouped. (See p. 330, and pll. 23–24.)

Chapter XXII. "The Chapter of giving a mouth to Osiris Ani, the scribe " and teller of the holy offerings of all the gods." (See pp. 25, 274, and pl. 6.)

The ceremony of giving a mouth to the deceased was, according to the vignette in the papyrus of Nebseni, performed by the "Guardian of the Balance"

𓀀𓃀𓏤𓏛𓏤𓏪. In the papyrus of Ani there is no vignette, and it is remarkable that this Chapter follows immediately after Chapter I.

Chapter XXIII. "The Chapter of opening the mouth of Osiris, the scribe " Ani." (See pp. 84, 306, and pl. 15.)

Chapter XXIV. "The Chapter of bringing charms unto Osiris Ani in " Neter-khert." (See pp. 85, 306, and pl. 15.)

As with other ancient Theban papyri, the papyrus of Ani gives no vignette.

Chapter XXVI. "The Chapter of giving a heart unto Osiris Ani in Neter- " khert." (See pp. 88, 308, and pl. 15.)

The vignette is probably unique.

Chapter XXVII. "The Chapter of not letting the heart of a man be taken " away from him in Neter-khert." (See pp. 100, 312, and pl. 15.)

The vignette is unusual.

Chapter XXIX. "The Chapter of not letting the heart of a man be taken " away from him in Neter-khert." (See pp. 97, 311, and pl. 15.)

No other copy of this Chapter is at present known.

Chapter XXIXв. "The Chapter of a heart of carnelian." (See pp. 228, 359, and pl. 33.)

Chapter XXXв. "The Chapter of not letting the heart of Osiris Ani be " driven away from him in Neter-khert." (See pp. 11, 90, 258, 309, and pl. 15.)

Chapter XLII. This Chapter is without title (see pp. 213, 353, and pl. 32), but in other ancient papyri it is called "Repulsing of slaughter in Suten-ḥenen"

𓋴𓎛𓂋𓏏𓄿𓏤𓏤.

Chapter XLIII. "The Chapter of not letting the head of a man be cut off " from him in Neter-khert." (See pp. 111, 317, and pl. 17.)

As in other ancient Theban papyri, this Chapter is without vignette.

Chapter XLIV. " The Chapter of not dying a second time in Neter-khert."
(See pp. 105, 315, and pl. 16.)

The vignette is peculiar to the papyrus of Ani.

Chapter XLV. " The Chapter of not suffering corruption in Neter-khert."
(See pp. 106, 315, and pl. 16.)

Only one other copy of the text of this Chapter is known.[1] Among Theban
papyri the vignette is peculiar to the papyrus of Ani.

Chapter XLVI. " The Chapter of not perishing and of becoming alive in
" Neter-khert." (See pp. 107, 316, and pl. 16.)

Only one other copy of the text of this Chapter is known (B.M. No. 9900).
Among Theban papyri the vignette is peculiar to the papyrus of Ani.

Chapter XLVIII. "Another Chapter of one who cometh forth by day
" against his foes in Neter-khert." (See pp. 123, 321, and pl. 18.)

Only one other copy of the text of this Chapter is known (B.M. No. 9900).
Among Theban papyri the vignette is peculiar to the papyrus of Ani.

Chapter L. "The Chapter of not entering in unto the block." (See pp. 108,
316, and pl. 16.)

The text of this Chapter agrees rather with the second version in the papyrus
of Nebseni than with that in B.M. papyrus No. 9964. As the Ani papyrus is of
Theban origin this was to be expected.

Chapter LIV. " The Chapter of giving breath in Neter-khert." (See pp. 94,
310, and pl. 15.)

Only one other copy of this Chapter is known, and it is without
vignette.[2]

Chapter LVIII. " The Chapter of breathing the air, and of having power
" over the water in Neter-khert." (See pp. 103, 314, and pl. 16.)

No other copy of this Chapter is known.

Chapter LIX. " The Chapter of breathing the air, and of having power over
" the water in Neter-khert." (See pp. 104, 315, and pl. 16.)

Only one other copy of this Chapter is known.[2]

Chapter LXI. " The Chapter of not letting the soul of a man be taken away
" from him in Neter-khert." (See pp. 91, 309, and pl. 15.)

The vignette is similar to that in the papyrus of Sutimes, which M. Naville
believes to be no older than the XIXth dynasty.[3]

[1] Naville, *Einleitung*, p. 134. [2] *Ibid.*, p. 136. [3] *Ibid*, p. 100.

Chapter LXXII.—Rubric. (See pp. 26, 275, and pl. 6.)

Chapter LXXIV. "The Chapter of walking with the legs and of coming " forth upon earth." (See pp. 118, 320, and pl. 18.)

Chapter LXXVII. "The Chapter of changing into a golden hawk." (See pp. 152, 332, and pl. 25.)

Chapter LXXVIII. "The Chapter of changing into a divine hawk." (See pp. 154, 333, and pl. 25, 26.)

Chapter LXXX. "The Chapter of changing into the god who giveth light " in the darkness." (See pp. 182, 341, and pl. 28.)

Chapter LXXXIA. "The Chapter of changing into a lotus." (See pp. 181, 340, and pl. 28.)

The pool of water in the vignette is uncommon.

Chapter LXXXII. "The Chapter of changing into Ptaḥ. (See pp. 170, 337, and pl. 27.)

As in other XVIIIth dynasty papyri, this Chapter has a vignette.

Chapter LXXXIII. "The Chapter of changing into a bennu bird" (phœnix?). (See pp. 176, 339, and pl. 27.)

Like other XVIIIth dynasty papyri, this Chapter lacks the addition which is found in the papyrus of Sutimes.

Chapter LXXXIV. "The Chapter of changing into a heron." (See pp. 178, 339, and pl. 28.)

Chapter LXXXV. "The Chapter of changing into the soul of Tmu." (See pp. 172, 338, and pl. 27.)

The vignette to this Chapter is similar to that of the papyrus of Tura, surnamed Nefer-uben-f, of the XVIIIth dynasty.[1]

Chapter LXXXVI. "The Chapter of changing into a swallow." (See pp. 150, 331, and pl. 25.)

Chapter LXXXVII. "The Chapter of changing into Seta." (See pp. 169, 337, and pl. 27.)

Chapter LXXXVIII. "The Chapter of changing into a crocodile." (See pp. 170, 337, and pl. 27.)

Chapter LXXXIX. "The Chapter of causing the soul to be united to its " body in Neter-khert." (See pp. 112, 318, and pl. 17.)

The two incense burners which stand, one at the head and one at the foot of the bier, are peculiar to the papyrus of Ani.

[1] Naville, *Einleitung*, p. 97.

Chapter XCI. "The Chapter of not letting the soul of a man be captive in " Neter-khert." (See pp. 114, 319, and pl. 17.)

Chapter XCII. "The Chapter of opening the tomb to the soul and the " shadow, of coming forth by day, and of getting power over the legs." (See pp. 115, 319, and pl. 17.)

The vignette of this Chapter is unusual and of great interest, for in it Ani's soul accompanies his shadow.

Chapter XCIII. "The Chapter of not letting a man pass over to the east in " Neter-khert." (See pp. 109, 317, and pl. 17.)

The vignette as here given is peculiar to the papyrus of Ani.

Chapter XCIIIA. "Another Chapter." (See pp. 110, 317, and pl. 17.)

Chapter CX. "Here begin the Chapters of the Sekhet-ḥetepu, and the " Chapters of coming forth by day, and of going into and coming out from Neter- " khert, and of arriving in the Sekhet-Àanru, and of being in peace in the great " city wherein are fresh breezes." (See pp. 236, 362, and pl. 34.)

The text is here incomplete.

Chapter CXXIV. "The Chapter of going unto the divine chiefs of Osiris." (See pp. 146, 330, and pl. 24.)

In the vignette we should expect four, instead of three, gods.

Chapter CXXV. "The Chapter of entering into the Hall of double Right " and Truth : a hymn of praise to Osiris." (See pp. 189, 344, and pl. 30.)

The Introduction to this Chapter as found in the papyrus of Ani is not met with elsewhere; the text which usually follows the "Negative Confession" is however omitted. The vignette as here given is peculiar to the papyrus of Ani.

Chapter CXXXII. "The Chapter of making a man to return to see again " his home upon earth." (See pp. 121, 321, and pl. 18.)

Chapter CXXXIII. "[A Chapter] to be said on the day of the month." (See pp. 138, 327, and pl. 21.)

Chapter CXXXIII.—Rubric. (See pp. 142, 328, and pl. 22.)

Chapter CXXXIV. "A hymn of praise to Rā on the day of the month " wherein he saileth in the boat." (See pp. 142, 329, and pl. 22.)

Chapter CXLVI. "The Chapter of renewing the pylons in the House of " Osiris which is in the Sekhet-Àanru." (See pp. 63, 295, and pll. 11, 12.)

Chapter CXLVII. "A Chapter to be said when Ani cometh to the first Ārit." (See pp. 56, 291, and pll. 11, 12.)

Chapter CXLVIII. Without title. See pp. 239, 3 66, and pl. 35.)

Chapter CLI. Scene in the mummy chamber. (See pp. 229, 360, and pll. 33, 34.)

Chapter CLV. "The Chapter of a Ṭeṭ of gold." (See pp. 225, 357, and pl. 33.)

Chapter CLVI. "The Chapter of a Buckle of carnelian." (See pp. 227, 358, and pl. 33.)

Chapter CLXVI. "The Chapter of the Pillow which is placed under the " head." (See pp. 228, 359, and pl. 33.)

Chapter CLXXV. "The Chapter of not dying a second time." (See pp. 184, 341, and pl. 29.)

Only one other much mutilated copy of this most important Chapter is known. In it it is declared that neither men nor gods can conceive what great glory has been laid up for Ani in his existence in the next world, and that his life therein shall be for " millions of millions of years."

Chapter CLXXXV. "A Hymn of Praise to Osiris, the dweller in Ȧmenta, " Un-nefer within Ȧbṭu (Abydos)." (See pp. 241, 367, and pl. 36.)

Chapter CLXXXVI. "A Hymn of praise to Hathor." (See pp. 242, 368. and pl. 37.)

TABLE OF CHAPTERS.

[The Chapters within brackets are not contained in the Papyrus of Ani, but are supplied chiefly from contemporaneous papyri.]

THE BOOK OF THE DEAD.

PLATE I.

1.
ṭua — *Rā* — *χeft* — *uben - f* — *em* — *χut* — *àbtet* — *ent* — *pet*
Adoration — of Rā — when — riseth he — in — horizon — eastern — of — heaven.

àn — *Àusàr* — *àn* — *neter ḥetep* — *en* — *neteru* — *nebu* — *Ani* — 2. *t'eṭ - f*
Behold — Osiris, — the scribe — of the holy offerings — of — the gods — all, — Ani! — Saith he,

ànet' - ḥrà - k — *ì - θà* — *em* — *χeperà* — *χeperà* — *em* — *qemam* — *neteru*
Homage to thee, — who hast come — as — Kheperà, — Kheperà — as — the creator of — the gods.

χāā - k — *uben - k* — 3. *pest* — *mut - k* — *χāā - θà* — *em* — *suten* — *neteru*
Thou risest, — thou shinest, — making bright — thy mother, — crowned — as — king — of the gods,

àri - nek — *mut* — *Nut* — *āāui - s* — *em* — *àrit* — *nini* — 4. *seśep - tu*
doeth to thee — mother — Nut [with] — her two hands — the — act of — worship. — Receiveth thee

Manu — *em* — *ḥetep* — *ḥept - tu* — *Maāt* — *er* — *trà* — *ṭā - f* — *χu*
Manu — with — content, — embraceth thee — Maāt — at — the double season. — May he give — splendour

us — *em* — *maā-χeru* — 5. *pert* — *em* — *ba* — *ānχi* — *er* — *maa*
and power — together with — triumph, — [and] a coming forth — as — a soul — living — to — see

¹ Characters over which a line is printed are, in the papyrus, written in red.

Ḥeru-χuti *en* *ka* *en* *Ausâr* *ân* *Ani* *maā-χeru* *χer* *Ausâr*

{ Horus of the double horizon, } to the *ka* of Osiris, the scribe Ani, triumphant before Osiris.

6. *t'eṭ - f* *à* *neteru nebu nu* *Het-ba* *ut'āu* *pet* *ta* *em*

Saith he, Hail gods all of the Soul Temple, [ye] weighers of heaven [and] earth in

māχait *ṭāṭāu* *ka* *t'efa* *Ta - tu - nen* *uā* *àri* 7.

the balance, givers of food [and] abundance of meat! [Hail] Tatunen, One, maker of

tememu *paut* *neteru* *resi* *meḥtet àmentet* *àbtet*

mankind [and of] the substance of the gods of the south, north, west, [and] east!

àmmā *àau* *en* *Rā* *neb* *pet* *àθi* *ānχ* *ut'a* *senb* 8.

Ascribe praise to Rā, the lord of heaven, the Prince, Life, Strength, Health,

àri *neteru* *ṭua - ten* *su* *em* *àru - f* *nefer* *em* *χāā - f* *em*

Creator of the gods. Adore ye him in his Presence beautiful in his rising in

āṭtet 9. *ṭua - tu* *ḥeru* *ṭua - tu* *χeru*

the *āṭet* boat. Shall worship thee the beings of the heights, shall worship thee { the beings of the depths. }

ân *nek* *Teḥuti* *Maāt* *ment* *rā* *neb* *χeft - k* *erṭāu*

Write for thee Thoth [and] Māat day every. Thine enemy [is] given

10. *en* *set* *Sebàu* *χer* *āāui - f* *qaus* *neḥem* *en*

to the fire, the evil one hath fallen; his arms [are] bound, removed hath

Rā	*reṭ - f*	*mesu*	*beṭeś*	*àn*	*un - sen*
Rā	his legs ;	the sons of	impotent revolt	never [again]	shall they rise up !

ḥet ser	*em*	*heb*	*χeru*	*nehem*	*em*	*àuset*
The House of the Prince [is] in	festival,	the sound of	those that rejoice [is] in	the dwelling		

urt	*neteru*	*em*	*ḥāā*	*maa*	*en*	*sen*	*Rā*	*em*	*χāā-f*
mighty.	The gods [are]	rejoicing [when]	they see	Rā	in	his rising ;			

satetu - f	*ḥer*	*bāḥ*	*taiu*	*uťa*	*hen*	*neter pen*
his beams	flood with light	the countries.	Advanceth	the majesty	of this god	

šeps	*χnem - nef*	*ta*	*en*	*Manu*	*heť*	*ta*	*er*	*mest - f*
venerable, he arriveth [at] the land of	Manu,	[he] illumineth	the earth	at	his birth			

rā	*neb*	*peḥ - nef*	*er*	*ā - f*	*en*	*sef*	*ḥetep - k*	*nà*
every day,	he arriveth	at	his region	of	yesterday.	Mayest thou be at peace with me,		

maa-à	*neferu-k*	*uťa - à*	*ṭep*	*ta*	*ḥu - à*	*āāu*
may I see	thy beauties,	may I advance	upon	the earth,	may I smite	the ass,

beḥen - à	*Sebàu*	*se - ḥetem - nà*	*Āpep*	*em*	*at - f*	*maa-nà*
may I crush	the evil one,	may I destroy	Āpep	at	his moment ;	may I see

¹ The papyrus has

					16.	
ábṭu	*sep - f*	*χeper*	*ànt*	*s*		*ànt*

the *ábṭu* fish [at] his season [of] { revolution, *or* coming into existence, } and the *ànt* fish its, and the *ànt* boat

em	*mer - s*	*maa-nà*	*Ḥeru*	*em*	* àri*	*ḥemu*	*Teḥuti*	*Maāt*

in its pool; may I see Horus as guardian of the rudder [with] Thoth [and] Maāt

				17.				
her	*āāui - f*	*seśep-nà*	*ḥātu*	*em*	*sektet*	*pehuitu*	*em*	*āṭtet*

at his two sides; may I grasp the bows of the *sektet* boat and the stern of the *āṭet* boat.

ṭā - f	[*maa*]	*àθen*	*ṭekek*	*Àḥ*		*àn*	*àbu*	*rā* *neb*

May he grant a view of the disk and a sight of the Moon-god without ceasing every day,

18.				19.				
	per	*ba-à*	*er*	*setut - tu*	*er*	*bu*	*neb*	*merer-f*

and the coming forth of my soul to walk about every place it pleaseth;

20.			21.			22.	
nàstu	*ren - à*		*qem - f*	*em*	*χet*		*uṭeb*

may be proclaimed my name [when] it is found upon the board for offering

	23.					
χet	*ṭātu - nà*	*ḥetepu*	*em-baḥ-à*	*mà*	*śesu*	*Ḥeru*

things, may there be placed for me offerings of food in my presence like the followers of Horus;

¹ In the Leyden Papyrus of the corresponding passage has ; we should then, probably add in the text of Ani after , the words "in revolution." See Naville, *Das aeg. Todtenbuch*, Bl. xiv., ll. 13, 14.

24. *àritu - nà*
may be made for me

25. *àuset em uàa hru t'a* **26.** *neter*
a seat in the boat [on] the day of the going forth of the god;

seśep - à em-baḥ Àusàr em ta **28.** *en maāχeru en ka en*
may I be received into the presence of Osiris in the land of triumph, to the *ka* of

Àusàr Àni
Osiris Ani.

Appendix.

[British Museum Papyrus, No. 10,471.]

ṭua Rā àn suten àn mer menfitu Neχt
Adoration of Rā by the royal scribe, the captain of soldiers, Neχt.

t'eṭ - f ànet' ḥrà-k χu - θà sept Tem Ḥeru - χuti
He saith, Homage to thee, O thou glorious being, dowered. Tmu - Harmachis,

àuk χāāt em χut ent pet à nek em re en
[when] thou risest in the horizon of heaven, a shout of joy to thee from the mouth of

ḥrà - nebu nefer - θà renp - trà - θà em àten em χennu
all peoples. Beautiful one, becoming young at [thy] time in (*or* as) the disk within

ṭeṭ mut - k Ḥet-Ḥeru χāā àrek em àuset nebt àb neb āu
the hand of thy mother Hathor. Rising therefore in place every heart every dilateth

en t'etta iu - nek àterti em kes ṭā - sen à en
for ever. Come to thee the two *àter* with homage, they give a shout of joy at

uben - k	*χāāti*	*em*	*χut*	*ent*	*pet*	*satet - k*		*taui*
thy rising.	[Thou] risest	in	the horizon	of	heaven,	thou sheddest	[upon]	the two lands

māfekt[1]	*Rā*	*pu*	*Ḥeru-χuti*	*pa*	*hun*	*neteri*	*uā*	*ḥeḥ*
emerald light,	Rā,	that is	Harmachis,	the	boy	mighty,	the heir of	eternity,

tut -	*su*	*mes - su*	*t'esef*	*suten*	*ta*	*pen*	*ḥeq*	*ṭuat*
he begot		[and] he gave birth to himself,	the king	of earth	this,	prince	of the underworld,	

her	*set*	*Àuḳert*	*per*	*em*	*māu*	*seta* - *su*
president of the	mountains	of Aukert,	coming forth	from	the water,	drawing himself

em	*Nu*	*ren* - *su*	*ser*	*mestu - f*	*neter*	*ānχ*	*neb*	*mert*
from	Nu,	nursing himself,	increasing	his limbs.	O god	of life,	lord	of love,

ānχ	*ḥrà - nebu*	*pesṭ - k*	*χāā - θà*	*em*	*suten*	*neteru*
live	all peoples [when]	thou shinest,	O crowned	as	the king	of the gods.

àri	*en*	*Nut*	*nini*	*en*	*ḥrà - k*	*ḥept - tu*	*Maāt*	*er*	*trà*	*neb*
Maketh	Nut	homage	to	thee,	embraceth thee	Maāt	at	season	every.	

ḥai - nek	*àmi - χet - k*	*ṭehen* - *sen*	*her*	*ta*	*em*
Sing praises to thee	those who are following thee,	they bow down	upon	the earth	in

[1] Compare — ⟨hieroglyphs⟩. Naville, *Todtenbuch*, I., Bl. xv., l. 13.

χesef - k neb pet neb ta suten maāt neb

meeting thee, the lord of heaven, the lord of earth, the king of righteousness, the lord

ḥeḥ ḥeq t'etta àθi neteru nebu neter ānχ àri ḥeḥ

of eternity, prince of everlasting, ruler of gods all, god of life, maker of eternity,

qemam pet smen su em χennu - s paut neteru em

creator of heaven, is established by him [that] which is within it. The cycle of the gods is in

hennu en uben - k ta em reśtu en maa satet - k

rejoicing at thy rising; the earth is in gladness seeing thy rays;

per pāt em ḥāi er maa neferu - k rā neb t'a - k

come forth the ancestors with cries of joy to see thy beauties day every. Thou goest forth

hert ta rā neb s - ut'a - θà en mut - k Nut nemà - k

over heaven and earth day every strengthened of thy mother Nut. Thou traversest

hert àb - k āu mer en tes-tes χeper em ḥetep

the upper regions, thy heart is dilated with joy, the Pool of Ṭesṭes becometh satisfied.

Sebà χer āāui - f qasu ḥesq en ṭemt

Sebà hath fallen, his two hands are hacked off, cuts asunder the knife

θes - f un en Rā em maā nefer sektet sek - nes peḥ - s

his joints. Liveth Rā in maā beautiful. The sektet boat draweth on, it arriveth.

seta - tu qemāi meḥti āmentet ābtet ḥer ṭua - k pauti ta

Arrive south, north, west, east to praise thee, O substance of the earth,

χeper t'esef senes - tu Åuset ḥenā Nebt-ḥet seχāāi - sen - tu

the creator of himself. Salute thee Isis and Nephthys; they sing songs of joy to thee

em uāa pui āāui - sen em sa ḥa - k śes - tu baiu

in boat that, their hands [are] protecting behind thee. Follow thee the souls

ābta hennu - nek baiu āmenta ḥeq - k neteru nebu seśep - k

of the east, praise thee the souls of the west. Thou rulest gods all, thou receivest

āut āb em χen kerā - k Nåk åsp en set åb - k

expansion of heart within thy shrine. Nak (the fiend) is judged to the fire, thy heart

āu en t'etta åp - tu mut - k Nut en åtef - k Nu

is dilated with joy for ever. Is decreed thy mother Nut to thy father Nu.

PLATE II.

1. ṭua Åusår Un-nefer neter āa ḥer åb Åbtu suten ḥeḥ neb

An adoration of Osiris, Un-nefer, god great within Abydos, king of eternity, lord of

t'etta sebebi ḥeḥ em åḥā - f se ṭep en 2. χat

everlasting, traversing millions of years in the duration of his life, son eldest of the womb of

Nut	*utet*	*en*	*Seb*	*erpāt*	*neb*	*ureret*	*qa*	*ḥet'*
Nut,	engendered	by	Seb	the chief,	lord	of the *ureret* crown,	lofty	of the white crown,

àθi	*neteru*	*reθ*	*seśep - nef*	*ḥeq*	*χu*		*àaut*
prince of	gods	and of men,	he hath received	the crook	[and] flail	and the dignity of	

àtef - f	*āu*	*àb - k*	*enti*	*em*	*Set*	*se - k*	*Ḥeru*	*men*
his fathers.	Gratified [is]	thy heart	which [is]	in	Set, [for]	thy son	Horus [is]	established

ḥer	*nest - k*	*àu - k*	*χāā - θà*	*em*	*neb*	*Ṭeṭṭeṭu*	*em*	*ḥeq*	*àmm*
upon	thy throne.	Thou art	crowned	as	lord	of Tattu [and]	as	ruler	in

Abṭu	*uat' - nek*	*taui*	*em*	*maā - χeru*	*embaḥ*	*ā*
Abydos.	Becomes green [through] thee	the earth	in	triumph	before	the hand of

Neb-er-t'er	*seta - nef*	*enti*	*àn*	*χeper*	*em*	*ren - f*
Neb-er-t'er.	He leadeth in his train { that which existeth [and that which] }		not yet hath become		in	his name

ta ḥer seta - nef	*sek - nef*	*taui*	*em*	*maā - χeru*	*em*	*ren - f*
"Ta - ḥer - seta - nef";	he toweth	the earth	in	triumph	in	his name

pui	*en*	*Seker*	*us - f*	*āu*	*āā senṭ*	*em*	*ren - f*
that	of	"Seker."	Mighty [is] he	exceedingly	and great of terror	in	his name

[1] *I.e.,* ⸻ *Set Àmentet,* "the mountain region on the western bank of the Nile." See Brugsch, *Wörterbuch,* p. 1148.

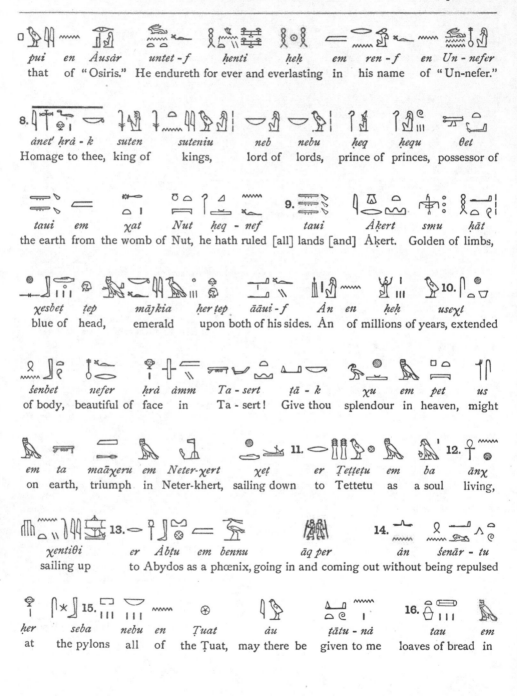

pui en Âusâr untet-f henti heh em ren-f en Un-nefer
that of "Osiris." He endureth for ever and everlasting in his name of "Un-nefer."

8. *ânet' ḥrâ-k suten suteniu neb nebu ḥeq ḥequ θet*
Homage to thee, king of kings, lord of lords, prince of princes, possessor of

taui em χat Nut ḥeq-nef taui Âḳert smu ḥât
the earth from the womb of Nut, he hath ruled [all] lands [and] Âḳert. Golden of limbs,

χesbeṭ ṭep mâjkia her ṭep ââui-f Ân en heh useχt
blue of head, emerald upon both of his sides. Ân of millions of years, extended

šenbet nefer ḥrâ âmm Ta-sert ṭâ-k χu em pet us
of body, beautiful of face in Ta-sert! Give thou splendour in heaven, might

em ta maâχeru em Neter-χert χeṭ er Ṭeṭṭeṭu em ba ânχ
on earth, triumph in Neter-khert, sailing down to Tettetu as a soul living,

χentiθi er Âbṭu em bennu âq per ân šenâr-tu
sailing up to Abydos as a phœnix, going in and coming out without being repulsed

ḥer seba nebu en Ṭuat âu ṭâtu-nâ tau em
at the pylons all of the Ṭuat, may there be given to me loaves of bread in

17.
pa　　qebḥ　　　　　ḥetepu　em Ȧnnu　seḥ　men　em　Seχet-Ȧrui,
the house of coolness, [and] offerings　in Ȧnnu, a field enduring in　Sekhet-Arui,

19.　　　　　　　　　　　　　　　　　　　　　　20.
[per]　　beti　　ȧm - f　　en　ka　en　Ȧusȧr　ȧn　Ani
and wheat [and] barley　in it,—　to the　ka　of　Osiris,　scribe　Ani!

PLATE III.

1.　　　　　　　　　　　　2.　　　　　　　　　　3.
ṭeṭ　ȧn　Ȧusȧr　ȧn　　Ani.　　　ṭet - f　　ȧb-ȧ　en　mut - ȧ
Speech　by　Osiris,　scribe　Ani.　　Saith he : My heart　　my mother,

4.　　　　　　　　5.　　　　　　　　　　　　　　　　　　6.
sep sen　ḥȧti - ȧ　en　χeperu - [ȧ]　　　　em　　ȧḥȧ　er - ȧ　em
twice.　My heart of　my coming into being. [May there] not [be] resistance to me　in

7.　　　　　　　　　　　　　　　　　　8.
meter　　　　　em　χesef　er - ȧ　　em　　　　ṭaṭ'at
judgment ;　[may there] not　be repulse　to me　on the part of　the divine chiefs ;

em　arit　req - k　er - ȧ　embaḥ　　　ȧri　mȧχait
[may they] not　make　thy separation　from me　in the presence of the possessor of the scales.

entek　ka - ȧ　ȧm　χat - ȧ　　χnem　seut'a　　ȧt - ȧ
Thou art　my ka　within　my body　[which] formeth　and strengtheneth　my limbs.

11.　　　　　　　　　　　　　　　　12.
per - nek　er　bu　nefer　　ḥen (?)　ȧ　ȧm　　em
Mayest thou come forth to the place of happiness [to which] advance　I　there. [May] not

[1] An interesting variant of this passage occurs on the leather roll, British Museum No. 10,473 ; it runs :—

seχer	ren - à	en	šenit	13.		em	t'et	ḳer	er - à	14.
make to stink	my name	the	Shenit;		[may there] not	be spoken	lies	against me		

erma	15.	neter	neferui	nefer	setem-k
near the		god.	Good, good is it	for thee to hear	

[Above the head of Anubis.]

t'et	àn	àm	ut	àmmā	ḥrà	pa	ut'ā	maāt
Saith	he	that is in	the tomb:	Graciously grant,	O		weigher of	righteousness,

.	en	māχait	er	āḥāu - s	
		the balance	to	stablish it.	

¹ In the papyrus of Hunefer (British Museum No. 9901) this chapter ends with the words, "the Shenit, in the presence of the great god, lord of Amenta," but in several others, all of a later date, the chapter has here the words :—

šenit	àriu	reθ	em	āḥāu	nefer - en - n
the Shenit	who make	men and women	to be	in stability.	Pleasant [is it] for us

nefer - en	setem	āu	àb	en	ut'ā	t'etu
pleasant [is it]	to hear	gladness	of heart	at	the weighing	of words.

Here follows the petition, "let not lies be spoken (⟨glyphs⟩ equals ⟨glyph⟩) against me near the great god, in the presence of the great god, lord of Amenta," and the chapter ends with,

māk	θenθ - k	un - θà	em	maāχeru
"Verily	how great wilt thou be	rising up	in	triumph!"

² Compare the legend in the papyrus of Ånhai (British Museum No. 10,472) :—

Appendix.

[From a Papyrus at Parma (Naville, *Todtenbuch*, Bd. II., Bl. 99).]

1. *t'eṭu her χeper en meḥf mesbeb em smu ānt - f*
To be said over a scarab of green stone encircled with *smu* metal, [with] its ring (?)

2. *em het' erṭāu en χu er χeχ - f qementu re pen em*
of silver, [and] placed upon the dead person at his neck. Was found chapter this in

χemennu χer reṭ en hen en neter pen - s her tebt
Hermopolis under the feet of the majesty of god this. It [was inscribed] upon a slab

3. *en bât qemāu em ān neter t'esef em ha hen*
of iron of the south in the writing of the god himself in the time of the majesty

4. *en suten net Men-kau-Rā maāχeru àn suten se Ḥeru - ṭāṭā - f*
of the { king of the North } Men-kau-Rā, triumphant, by the royal son, Ḥeru - ṭāṭā - f;
 { and South, }

5. *qem su em ua - f er àrit sàpt em er - pau*
[he] found it in his going to make an inspection in the temples.

[From a Papyrus at Paris (Naville, *Todtenbuch*, Bd. I., Bl. 167, ll. 14–27).]

àr	*χert*	*reχ*	*re*	*pen*	*semaāχeru - f*	*pu*	*ṭep*	*ta*	*em*
When is	known	chapter	this	it maketh a man to triumph		upon	earth [and] in		

neter χert	*àu - f*	*àri - f*	*àrit*	*ānχu*	*em*	*ket*	*pu*	*χert*
the under-world.	He performeth		works [and he] liveth		upon	things after the manner		

āāạt	*ent*	*neter*	*qem-entu*	*re*	*pen*	*em*	*χemennu*	*her*	*teb*	*ent*
great		of the god.	Was found	chapter	this	in	Hermopolis	upon	a slab	of

bàa	*qemāt*	*ān*	*em*	*χesbeṭ*	*maā*	*χer*	*reṭui*	*hen*
iron	of the south	inscribed with	lapis-lazuli	real	under the two feet of the majesty			

en	*neter*	*pen*	*em*	*hau*	*hen*	*en*	*suten net*	*Men-kau-Rā,*	*àn*
of	god	this	in	the time of	the majesty of the	{ king of the North and South, }	Men-kau-Rā,	by	

suten	*se*	*Ḥeru-ṭāṭā-f*	*maāχeru*	*qem - nef*	*su*	*em*	*menmen - f*	*er*	*àrit*
the royal son	Ḥeru-ṭāṭā-f,		triumphant!	He found	it	in	his journeying	to make	

sàpti	*em*	*er - pau*	*àu*	*neχtu*	*henā - f*	*her*	*seṭebḥ - nef*
an inspection	in	the temples.	Was	strength	with him	to	make him diligent

su	*em*	*sesai*	*àn - nef*	*su*	*em*	*bàau*	*en*	*suten*
in	understanding [it].	He brought	it	as	a marvellous thing	to	the king	

χeft	maa - f	entet	śetau	pu	āāa	àn	maa
when	he saw	that	a mystery	it was	great,		unseen [and]

àn	petrà	séseṭ - entu	re	pen	ābu		turà
unbeheld.	Shall be recited	chapter	this	by a person purified [and] washed,		[one who]	

àn	àm	ātu	mehit	às	tu	àri -	nek	χeper	en
hath not	eaten	animal flesh	[or] fish.	Behold	thou shalt	make		a scarab	of

meh - f	en	qeṭu - s	āb	em	χennu	àb	en
green stone	with its	rim (?)	plated [with gold and placed]	within	the heart of		

se	àrit - nef	àp - re	mesu	em	ānta
a person ;	it will perform for him	the " opening of the mouth,"	anointed	with ānt unguent.	

PLATE III.—(*continued*).

16. 17. 18.

Teṭ	àn	Tehuti	àp maā	en	paut	neteru	āat	enti	embah
Saith	Thoth	the righteous judge	of the cycle of the gods	great	who are	in the presence of			

[1] Compare [hieroglyphs], Naville, *Todtenbuch*, Bd. II., Bl. 99.

[2] In British Museum papyrus No. 9901, the speech of Thoth reads :—

māk - à	her	metru	ren	en	Àusàr	suten ān	Hunefer	àu	àb - f
Verily I	am	justifying	the name	of	Osiris	the royal scribe	Hunefer.		His heart

pert	her	māχa	bu	qem - nef	t'ai
hath come forth	upon	the Scale,	not	hath he been found	an evil doer.

Ảusȧr	*setem-ten*	*t'etet*	*pen*	*em*	*un*	*maȧ*	*ảu*	*ut'ȧ*	*en*	*ȧb*	*en*
Osiris:	Hear ye	decision	this.	In	very	truth	is	weighed		the heart of	

Ảusȧr	*ảu*	*ba - f*	*ȧḥȧ*	*em*	*meter*	*er - f*	*sep - f*	*maȧ*	*her*
Osiris,	is	his soul	standing	as	a witness	for him;	his sentence	is right	upon

mȧχaȧt	*ur*	*ȧn*	*qem - entu*	*betta - f*	*neb*	*ȧn*	*χeb - f*
the scales	great.	Not	hath been found	wickedness [in] him	any;	not	hath he wasted

šebu	*em*	*er - pau*	*ȧn*	*ḥet' - f*	*ȧrit*	*ȧn*
food offerings	in the	temples;	not	hath he done harm	in deed;	not

šem - f	*χer*	*re - f*	*nekau*	*t'er*	*un - nef*	*ṭep*	*ta*
hath he let go	with	his mouth	evil things	whilst	he was	upon	earth.

t'eṭ	*ȧn paut*	*neteru*	*ȧȧ*	*en*	*Teḥuti*	*ȧm*	*χemennu*	*....*	*en*	*set*
Saith	the cycle of the gods	great	to	Thoth	[dwelling] in Hermopolis:		Decreed is		it	

enen	*pert*	*em*	*re - k*	*maȧ*	*met*		*Ảusȧr*	*ȧn*
that which	cometh forth	from	thy mouth.	True [and] righteous [is]			Osiris,	the scribe

¹ The variants are

Ani	maāχeru	àn	beta - f	àn	seχer - f	χer - n
Ani	triumphant.	Not	hath he sinned,	not	hath he done evil	in respect of us.

àn	erṭāt	seχem	Āmemet	àm - f	àmmā	ṭā-tu - nef
Let not	be allowed	to prevail	Amemet	over him.	Let there be	given to him

sennu	pert	embaḥ	Àusàr	seḥ	men	em	seχet - ḥetepu
cakes,	and a coming forth	in the presence of Osiris,		and a field abiding	in		Sekhet-ḥetepu

mà	šesu	Ḥeru
like	the followers of	Horus.

PLATE IV.

t'eṭ	àn	Ḥeru	se	Àuset	ī - nà	χer - k	Un-nefer	àn-nà-
Saith	Horus	the son of Isis:			I have come	to thee,	Un-nefer,	[and] I have brought

nek	Àusàr	Ani	àb - f	maā	pert	em	māχait	àn
to thee	Osiris	Ani.	His heart	is right	coming forth	from	the balance,	not

beta - f	χer	neter	neb	netert	neb	ut'ā	en	su	Teḥuti	em
sinned hath it	against	god	any	[or] goddess	any.	Hath weighed		it	Thoth	according to

àn	t'eṭ	en	paut	neteru	er - f	met	maāt	ur
the decree	uttered	by	the cycle of the gods		unto him;	[it is] true	[and] righteous	very.

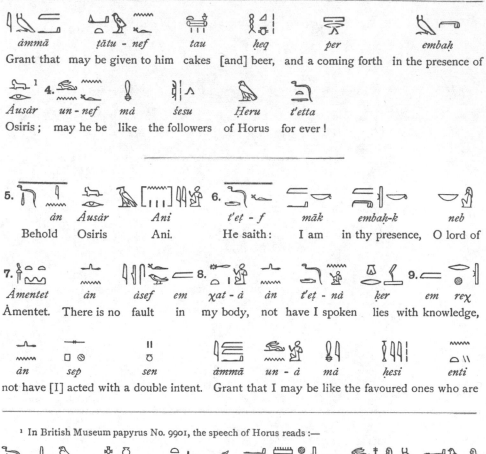

âmmâ	ṭâtu - nef	tau	ḥeq	per	embaḥ
Grant that	may be given to him	cakes	[and] beer,	and a coming forth	in the presence of

Àusâr	un - nef	mâ	śesu	Ḥeru	t'etta
Osiris;	may he be	like	the followers	of Horus	for ever!

5.	ân	Àusâr	Ani	t'eṭ - f	6.	mâk	embaḥ-k	neb
	Behold	Osiris	Ani.		He saith:	I am	in thy presence,	O lord of

7.	Àmentet	ân	àsef	em	χat - à	8.	ân	t'eṭ - nâ	ḳer	em	reχ	9.
	Àmentet.	There is no	fault	in	my body,		not	have I spoken	lies	with	knowledge,	

ân	sep	sen	âmmâ	un - à	mâ	ḥesi	enti
not have [I] acted	with	a double intent.	Grant that	I may be	like	the favoured ones	who are

[1] In British Museum papyrus No. 9901, the speech of Horus reads :—

t'eṭ	ân	Ḥeru	neṭ'	tef - f	uâ	menχ	en	Un-nefer	mâkuâ
Saith	Horus	the avenger	of his father,	heir	veritable		of	Un-nefer:	I am come

her	bes - nek	Àusâr	Hu-nefer	àu - f	sàp	mâ	mâχa	àu	pa
to	lead to thee	Osiris	Hu-nefer.	He hath been	judged	in	the scales,		the

teχ	hui	er	àuset-f
weight of the balance	resteth (?)	upon	its place.

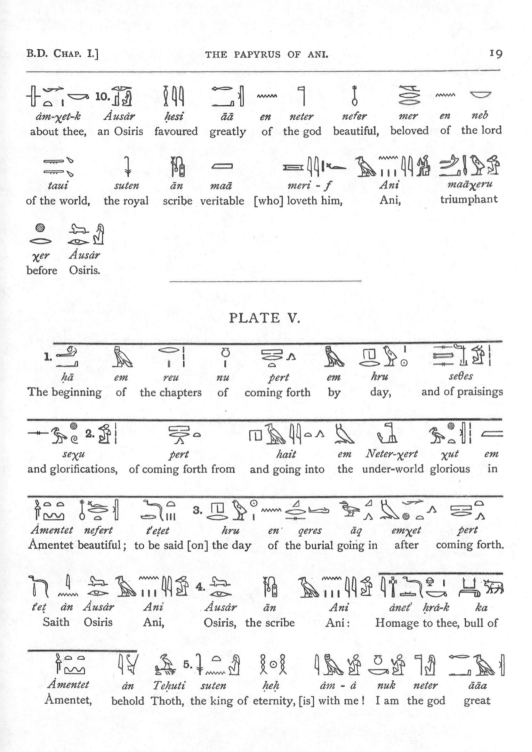

àm-χet-k Åusàr ḥesi āā en neter nefer mer en neb
about thee, an Osiris favoured greatly of the god beautiful, beloved of the lord

taui suten ān maā meri - f Ani maāχeru
of the world, the royal scribe veritable [who] loveth him, Ani, triumphant

χer Åusàr
before Osiris.

PLATE V.

1. ḥā em reu nu pert em hru seθes
The beginning of the chapters of coming forth by day, and of praisings

seχu 2. pert hait em Neter-χert χut em
and glorifications, of coming forth from and going into the under-world glorious in

Åmentet nefert t'eṭet hru en' qeres āq emχet pert
Åmentet beautiful; to be said [on] the day of the burial going in after coming forth.

t'eṭ àn Åusàr Ani 4. Åusàr ān Ani ànet' ḥrà-k ka
Saith Osiris Ani, Osiris, the scribe Ani: Homage to thee, bull of

Åmentet àn Tehuti suten 5. heh àm - à nuk neter āāa
Åmentet, behold Thoth, the king of eternity, [is] with me! I am the god great

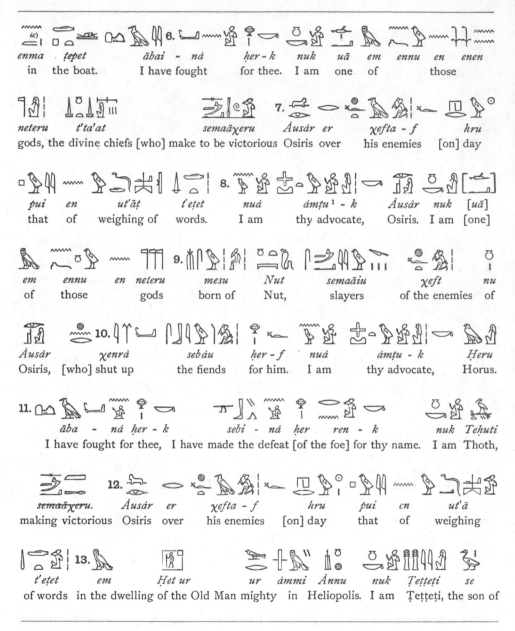

enma *ṭepet* *ābai - nà* *her - k* *nuk* *uā* *em* *ennu* *en* *enen*
in the boat. I have fought for thee. I am one of those

neteru *t'ta'at* *semaāχeru* *Àusàr er* *χefta - f* *hru*
gods, the divine chiefs [who] make to be victorious Osiris over his enemies [on] day

pui *en* *ut'āṭ* *t'eṭet* *nuà* *àmṭu¹ - k* *Àusàr* *nuk* *[uā]*
that of weighing of words. I am thy advocate, Osiris. I am [one]

em *ennu* *en* *neteru* *mesu* *Nut* *semaāiu* *χeft* *nu*
of those gods born of Nut, slayers of the enemies of

Àusàr *χenrà* *sebàu* *her - f* *nuà* *àmṭu - k* *Ḥeru*
Osiris, [who] shut up the fiends for him. I am thy advocate, Horus.

11. *āba - nà her - k* *sebi - nà her ren - k* *nuk Teḥuti*
 I have fought for thee, I have made the defeat [of the foe] for thy name. I am Thoth,

 12. *Àusàr* *er* *χefta - f* *hru* *pui* *cn* *ut'à*
semaāχeru.
making victorious Osiris over his enemies [on] day that of weighing

t'eṭet *em* *Ḥet ur* *ur* *àmmi Ànnu* *nuk* *Teṭṭeṭi* *se*
of words in the dwelling of the Old Man mighty in Heliopolis. I am Teṭṭeṭi, the son of

¹ Or *temṭu;* see Brugsch, *Wörterbuch* (Suppl.), p. 76.

14. *Ṭeṭṭeṭi*; *āu* *àm - à* *em* *Ṭeṭṭeṭu* *mesi - à* *em* 15. *Ṭeṭṭeṭu* *un - à* *ḥenā*

Tetteti; I was conceived in Tettetu, I was born in Tettetu. I am with

ḥai *àakebit* 16. *Àusàr em* *Reχtet* *semaāχeru*

the weepers { and the women [who] wail for } Osiris in the double land of(?) Rekhtet, { making to be victorious }

Àusàr *er* *χefta - f* 17. *set* *Rā Teḥuti* *semaāχeru* *Àusàr* *er*

Osiris over his enemies. Ordered it Rā Thoth to make victorious Osiris over

χefta - f *tu* 18. *àri - nà* *Teḥuti* *un - à* *ḥenā* *Ḥeru* *hru*

his enemies; what was ordered did for me Thoth. I am with Horus [on] the day

hebs 19. *Teśteś* *un* *tephetu* *en* *àāu* *urṭ*

of clothing Teshtesh, opening the storehouses of washing the still

àb 20. *seś* *re* *en* *seśit* *em* *Re - stau* *un - à* *ḥenā* *Ḥeru*

of heart, unbolting the door of concealed things in Re - stau. I am with Horus

21. *em* *neṭ* *qāḥ* *pui* *àbi* *en* *Àusàr* *àmmi* *Seχem*.

protecting shoulder that left of Osiris in Sekhem.

22. *āq - à* *peru - à* *em* *ammu* *hru* *ṭer*

I go in [and] I come out from the flames [on] the day of destroying

¹ The variants are ⟨glyphs⟩, ⟨glyphs⟩ (British Museum papyrus No. 9964) = ⟨glyphs⟩ ⟨glyphs⟩ of Lepsius, *Todtenbuch*, Bl. L., l. 5. See Birch, *Aeg. Zeitschrift*, 1869, p. 115.

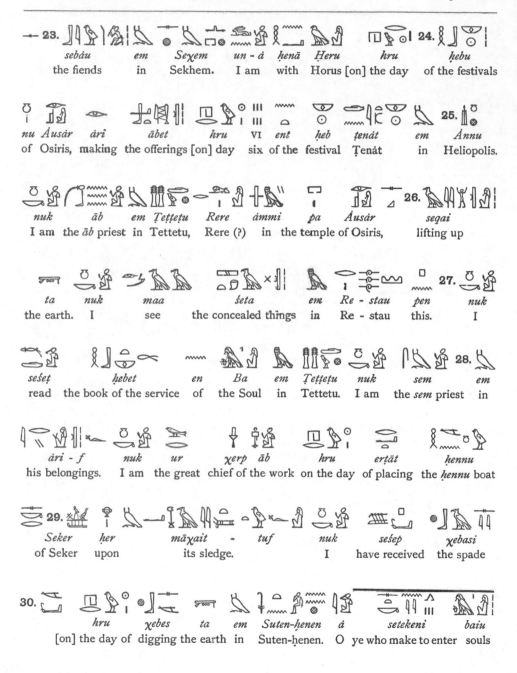

23. sebâu em Seχem un - à henâ Heru hru 24. hebu
the fiends in Sekhem. I am with Horus [on] the day of the festivals

nu Âusàr àri ābet hru VI ent heb tenât 25. em Ânnu
of Osiris, making the offerings [on] day six of the festival Tenât in Heliopolis.

nuk āb em Tettetu Rere àmmi pa Âusàr 26. seqai
I am the āb priest in Tettetu, Rere (?) in the temple of Osiris, lifting up

ta nuk maa šeta em Re - stau pen 27. nuk
the earth. I see the concealed things in Re - stau this. I

seseṭ ḥebet en Ba em Tettetu nuk sem 28. em
read the book of the service of the Soul in Tettetu. I am the sem priest in

àri - f nuk ur χerp āb hru ertât hennu
his belongings. I am the great chief of the work on the day of placing the hennu boat

29. Seker her māχait - tuf nuk sesep χebasi
of Seker upon its sledge. I have received the spade

30. hru χebes ta em Suten-ḥenen à setekeni baiu
[on] the day of digging the earth in Suten-henen. O ye who make to enter souls

PLATE VI.

31.

menχu em pa Àusàr seteken - ten ba àqer en Àusàr

perfected in the house of Osiris, may ye make to enter the soul perfect of Osiris,

32.

àn Ani maāχeru ḥenā - ten er pa Àusàr setem - f ten

the scribe Ani, victorious, with you into the house of Osiris. May he hear [as] ye [hear];

33.

maa - f mà maa - ten āḥā - f mà āḥā-ten ḥems - f mà

may he see as ye see; may he stand as ye stand; may he sit as

34.

ḥems - ten à ṭāṭāiu tau ḥeq en baiu menχu em

ye sit. O givers of cakes [and] beer to souls perfected in

35.

pa Àusàr ṭā - ten tau ḥeq er trāui en ba en Àusàr

the house of Osiris, give ye cakes [and] beer at the double season to the soul of Osiris

36.

Ani maāχeru χer neteru nebu Àbṭu maāχeru ḥenā - ten

Ani, victorious before the gods all of Abydos, victorious with you.

37.

à uniu uat àpui mātennu en baiu

O openers of the way [and] openers of the roads to souls

38.

menχu em pa en Àusàr un àref - ten - nef uat

perfected in the house of Osiris, open therefore ye to him the way,

¹ We must read ⟨hieroglyphs⟩.

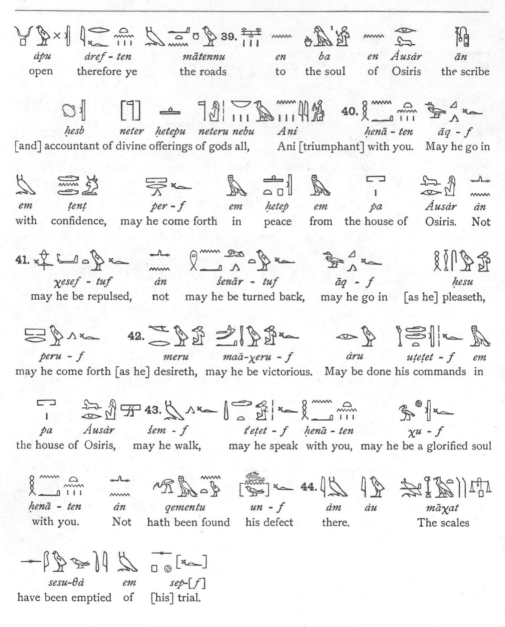

àpu	àref - ten	màtennu	39.	en	ba	en	Àusàr	àn
open	therefore ye	the roads		to	the soul	of	Osiris	the scribe

ḥesb	neter	ḥetepu	neteru nebu	Ani	40.	ḥenā - ten	àq - f
[and] accountant	of divine	offerings	of gods all,	Ani [triumphant]		with you.	May he go in

em	ṭenṭ	per - f	em	ḥetep	em	pa	Àusàr	àn
with	confidence,	may he come forth	in	peace	from	the house of	Osiris.	Not

41.	χesef - tuf	àn	šenār - tuf	àq - f	ḥesu
	may he be repulsed,	not	may he be turned back,	may he go in	[as he] pleaseth,

peru - f	42.	meru	maā-χeru - f	àru	uṭeṭet - f	em
may he come forth [as he] desireth,		may he be victorious.		May be done	his commands	in

pa	Àusàr	šem - f	43.	t'eṭet - f	ḥenā - ten	χu - f
the house of	Osiris,	may he walk,		may he speak	with you,	may he be a glorified soul

ḥenā - ten	àn	qementu	un - f	àm	àu	44.	māχat
with you.	Not	hath been found	his defect	there.			The scales

sesu-θà	em	sep-[f]
have been emptied	of	[his] trial.

Re	en	ertāt	re	en	1. Ausār	ān	ḥesb	neter	ḥetepu	neteru
Chapter	of giving	a mouth to			Osiris, scribe [and]	accountant	of divine offerings			of the gods

nebu	Ani	maāχeru - nef	em	Neter-χert
all,	Ani ;	may be he victorious	in	the underworld.

T'eṭṭu	àu - à	2. uben - kuà	em	suḥt	àmt	ta	śeta	àu
To be said :	I	rise	out of	the egg	in	the land	hidden.	May

3. erṭāu - nà	re - à	t'eṭu - à	àm - f	embaḥ	neter	āā	neb
be given to me	my mouth,	may I speak	with it	before	the god	great	the lord

4. ṭuat	àn	χesef - tu	ā - à	em	t'at'at	en neter neb
of the underworld.	Not	may be repulsed	my hand and arm	by	the divine chiefs	of god any.

nuk	Ausār	neb	5. Re - stau	peseś	Ausār	ān	Ani	maāχeru
I am	Osiris	lord of	Re - stau,	shareth	Osiris,	the scribe	Ani,	triumphant,

em	ennu	enti	6. ṭep - f (sic)	χet	ī - nà	er	merer	àb - à
with	that	being who	[is upon] the top (sic)	of the steps.	I have come	at	the wish	of my heart

em	Śe	nesert	āχem - nà	7. ànet' - ḥrà - k	neb	seśep	χenti
from	the Pool	of double Fire,	I have quenched [it].	Homage to thee,	lord	of radiance,	at the head

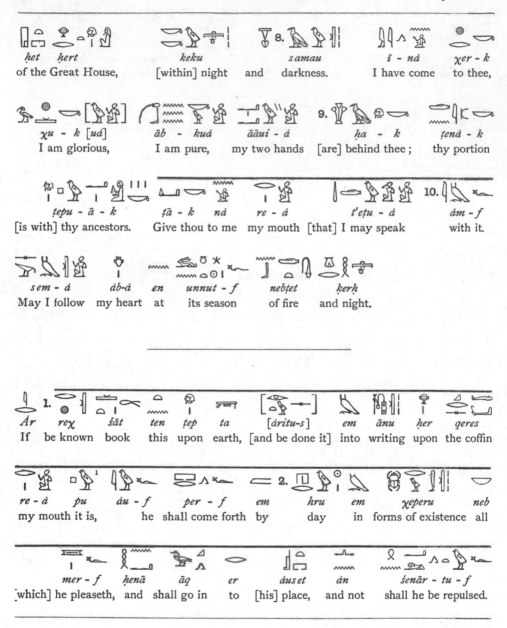

het	*ḥert*	*keku*	*samau*	*ī - nå*	*χer - k*
of the Great House,		[within] night	and darkness.	I have come	to thee,

χu - k [uå]	*āb - kuå*	*āāui - å*	*ḥa - k*	*ṭenå - k*
I am glorious,	I am pure,	my two hands	[are] behind thee ;	thy portion

ṭepu - ā - k	*ṭā - k nå*	*re - å*	*t'eṭu - å*	*åm - f*
[is with] thy ancestors.	Give thou to me	my mouth	[that] I may speak	with it.

sem - å	*åb-å*	*en*	*unnut - f*	*nebṭet*	*ḳerḥ*
May I follow	my heart	at	its season	of fire	and night.

1.
Ȧr	*reχ*	*śåt*	*ten*	*ṭep*	*ta*	*[åritu-s]*	*em*	*ānu*	*ḥer*	*ḳeres*
If	be known	book	this	upon	earth,	[and be done it]	into	writing	upon	the coffin

2.
re - å	*pu*	*åu - f*	*per - f*	*em*	*ḥru*	*em*	*χeperu*	*neb*
my mouth it is,		he	shall come forth	by	day	in	forms of existence	all

mer - f	*ḥenā*	*āq*	*er*	*åuset*	*ån*	*śenår - tu - f*
[which] he pleaseth,	and	shall go in	to	[his] place,	and not	shall he be repulsed.

¹ Read ⏝ ▢ *re pen*, "this chapter"?

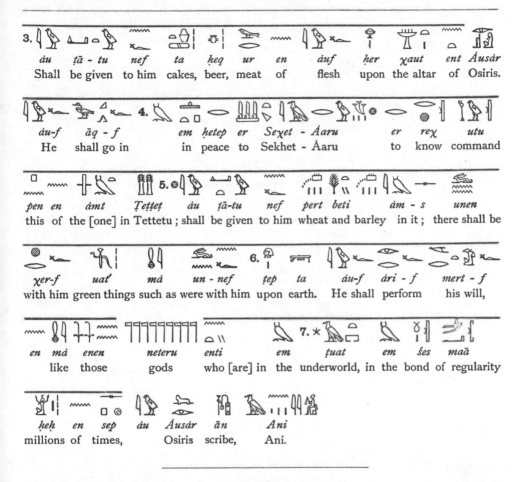

3. àu · ţā-tu · nef · ta · ḥeq · ur · en · àuf · ḥer · χaut · ent · Àusàr
Shall · be given · to him · cakes, · beer, · meat · of · flesh · upon · the altar · of Osiris.

àu-f · āq-f · 4. · em ḥetep · er · Seχet-Àaru · er · reχ · utu
He · shall go in · in peace · to · Sekhet-Àaru · to · know · command

pen en · àmt · Ţeţţeţ · 5. àu · ţā-tu · nef · pert beti · àm-s · unen
this of · the [one] in · Tettetu; · shall · be given · to him · wheat and barley · in it; · there shall be

χer-f · uaţ · mà · un-nef · 6. ţep · ta · àu-f · àri-f · mert-f
with him · green things · such as · were with him · upon · earth. · He shall · perform · his will,

en · mà · enen · neteru · enti · em · 7. ţuat · em · śes · maā
like · those · gods · who [are] · in · the underworld, · in the · bond of regularity

ḥeḥ · en · sep · àu · Àusàr · ān · Ani
millions of · times, · Osiris · scribe, · Ani.

PLATE VII.

1. Ḥā · em · seθes · seχu · pert · hait · em
The beginnings · of the · praisings · [and] glorifications, · of coming out · and going · into

Neter-χert · χut · em · Àmentet · nefert · 2. pert · em · hru · em
Neter-khert · glorious · in · Amentet · the beautiful, · of coming out · by · day · in

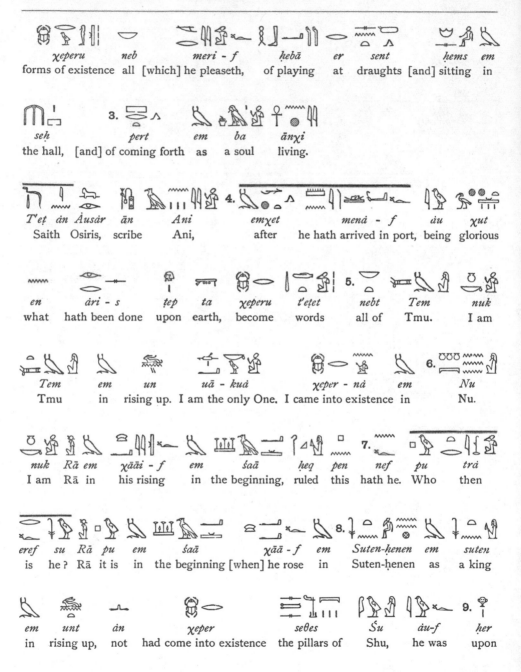

χeperu	neb	meri - f	ḥebā	er	sent	ḥems	em
forms of existence	all	[which] he pleaseth,	of playing	at	draughts	[and] sitting	in

3.

seḥ		pert	em	ba	ānχi
the hall,	[and]	of coming forth	as	a soul	living.

4.

T'eṭ	àn	Àusàr	àn	Ani		emχet	menà - f	àu	χut
Saith	Osiris,		scribe	Ani,		after	he hath arrived in port,	being	glorious

5.

en	àri - s	ṭep	ta	χeperu	t'eṭet	nebt	Tem	nuk
what	hath been done	upon	earth,	become	words	all of	Tmu.	I am

6.

Tem	em	un	uà - kuà	χeper - nà	em	Nu
Tmu	in	rising up.	I am the only One.	I came into existence	in	Nu.

7.

nuk	Rā em	χāài - f	em	śaā	ḥeq	pen	nef	pu	trà
I am	Rā in	his rising	in	the beginning,	ruled	this	hath he.	Who	then

8.

eref	su	Rā pu	em	śaā	χāā - f	em	Suten-ḥenen	em	suten
is	he?	Rā it is	in	the beginning	[when] he rose	in	Suten-ḥenen	as	a king

9.

em	unt	àn	χeper	seθes	Śu	àu-f	ḥer
in	rising up,	not	had come into existence	the pillars of	Shu,	he was	upon

qaqa	en	ámi	χemennu.	nuk	neter	āā	χeper
the height	of	him who is in	Khemennu.	I am	the god	great	[who] came into

t'esef	Nu	pu	qemam	ren - f	paut
existence by himself,	Nu	that is,	[who] created	his name	"paut

neteru	em	neter	pu	trá	eref	su	Rā	pu	qemam
neteru"	as	god.	Who	then		is he ?	Rā	it is	the creator

ren	en	āt - f	χeper	enen	pu	em	neteru
of the name[s]	of his limbs ;	have come into	existence	these	in the	form of	the gods

ámi	χet	Rā	nuk	áti	χesef - f	em	neteru
who are in the train of	Rā.		I am	without	repulse is he	among	the gods.

pu	trá	eref	su	Tem	pu	ámi	áten - f
Who	then		is he ?	Tmu	it is	in	his disk ;

ki	t'et	Rā	pu	em	uben - f	em	χut	ábti	ent	pet
otherwise said,		Rā	it is	in	his rising	in	the horizon	eastern	of	heaven.

nuk	sef	reχ	-	kuá	tuau	pu	trá	eref	su
I am	Yesterday,			I know	To-morrow.	Who	then		is he ?

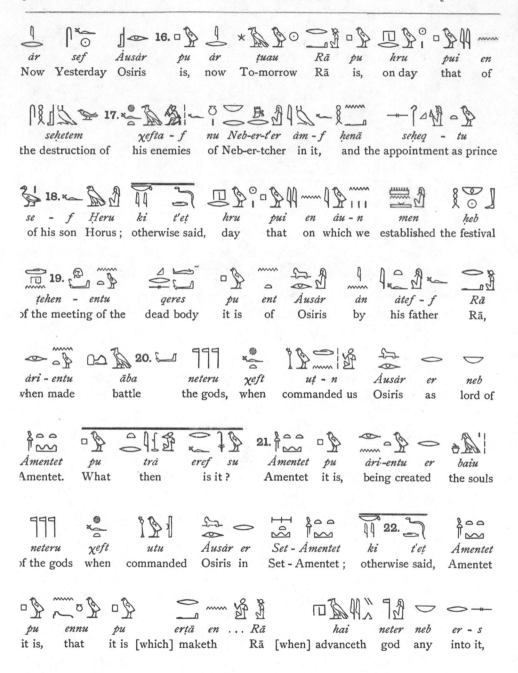

år	*sef*	*Åusàr*	16. *pu*	*år*	*ṭuau*	*Rā*	*pu*	*hru*	*pui*	*en*
Now	Yesterday	Osiris	is,	now	To-morrow	Rā	is,	on day	that	of

seḥetem	17. *χefta - f*	*nu Neb-er-t'er*	*àm - f*	*ḥenā*	*seḥeq - tu*
the destruction of	his enemies	of Neb-er-tcher	in it,	and the appointment as prince	

18. *se - f*	*Ḥeru*	*ki*	*t'eṭ*	*hru*	*pui*	*en àu - n*	*men*	*ḥeb*
of his son	Horus;	otherwise said,	day	that	on which we	established	the festival	

19. *ṭehen - entu*	*qeres*	*pu*	*ent*	*Åusàr*	*àn*	*àtef - f*	*Rā*	
of the meeting of the	dead body	it is	of	Osiris	by	his father	Rā,	

àri - entu	*āba*	20. *neteru*	*χeft*	*uṭ - n*	*Åusàr*	*er*	*neb*
when made	battle	the gods,	when	commanded us	Osiris	as	lord of

Åmentet	*pu*	*trà*	*eref*	*su*	21. *Åmentet*	*pu*	*àri-entu*	*er*	*baiu*
Åmentet.	What	then		is it ?	Amentet	it is,	being created	the souls	

neteru	*χeft*	*utu*	*Åusàr er*	*Set - Åmentet*	*ki*	22. *t'eṭ*	*Åmentet*
of the gods	when	commanded	Osiris in	Set - Amentet ;	otherwise said,	Amentet	

pu	*ennu*	*pu*	*erṭā en*	... *Rā*	*hai*	*neter*	*neb*	*er - s*
it is,	that	it is [which] maketh	Rā	[when] advanceth	god	any	into it,	

23.

āḥā	āba - nef	ḥer - s	àuà	reχ - kuà	neter	pui
[he] standeth	[and] he fighteth	for it.	I	know	god	that

24.

enti	àm - s	pu	trà	eref	su	Àusàr	pu	ki	t'eṭ	Rā
who [is]	in it.	Who	then		is he?	Osiris	it is;	otherwise said,		Rā

25.

ren - f	ḥennu	pu	en	Rā	nek - f	àm - f	t'es-f
[is] his name,	[or] the phallus	it is	of	Rā	when he uniteth	with	himself.

26.

nuk	bennu	pui	enti	em	Ànnu	nuk	àri	sàpu
I am	bennu	that	which [is]	in	Heliopolis.	I am	the keeper	of the book

en	enti		unen	pu	trà	eref	su
of that	which is, and of that which shall be.		Who		then		is he?

27.

Àusàr	pu	ki	t'eṭ	χat-f	pu	ki	t'eṭ	àr
Osiris	it is;	otherwise said,		his dead body	it is;	otherwise said,		

28.

setat - f	àr	en	enti	unen	χat	pu
his excrements.			{ Now that which is, and that which shall be }		is his dead body;	

29.

ki	t'eṭ	en	er	neḥeḥ	pu	ḥenā	t'etta	àr	neḥeḥ	pu
otherwise said,				Eternity	it is	and Everlastingness,			Eternity	is

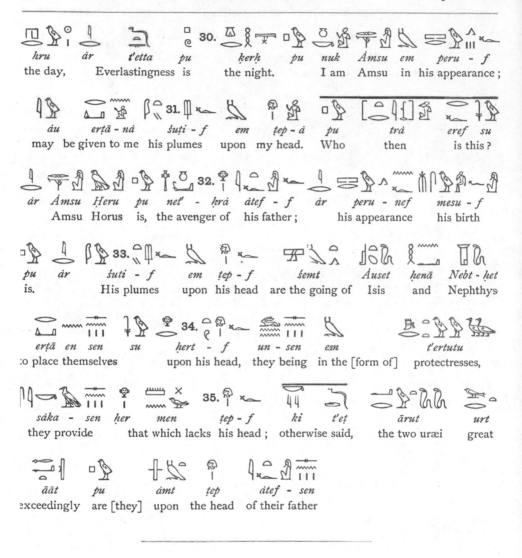

hru àr t'etta pu ḳerḥ pu nuk Ȧmsu em peru - f
the day, Everlastingness is the night. I am Amsu in his appearance;

àu erṭā - nà śuti - f em ṭep - à pu trà eref su
may be given to me his plumes upon my head. Who then is this?

àr Ȧmsu Ḥeru pu neṭ' - ḥrà àtef - f àr peru - nef mesu - f
 Amsu Horus is, the avenger of his father; his appearance his birth

pu àr śuti - f em ṭep - f śemt Auset henā Nebt - ḥet
is, His plumes upon his head are the going of Isis and Nephthys

erṭā en sen su ḥert - f un - sen em t'ertutu
:o place themselves upon his head, they being in the [form of] protectresses,

sȧka - sen her men ṭep - f ḳi t'eṭ ārut urt
they provide that which lacks his head; otherwise said, the two uræi great

āāt pu àmt ṭep àtef - sen
exceedingly are [they] upon the head of their father

PLATE VIII.

36. Tem ḳi t'eṭ en maa - f pu śuti - f em ṭep - f
 Tmu; otherwise said, his two eyes are his plumes upon his head

		37.							
unen	Àusàr	àn	ḥetep	neteru	nebu	Ani		em	maāχeru
Riseth up	Osiris,	the scribe	of offerings	of gods	all,	Ani,		in	triumph

				38.							
em ta - f	ì - nef	em	nut - f	pu	trà	eref	su	χut			
in his land,	he cometh	into	his city.	What	then		is it?	The horizon			

				39.				
pu	ent	àtef - f	Tem	ṭer - à	àut - à	χersek - à		
it is	of	his father	Tmu.	I have made an end	of my failings,	I have removed		

			40.				
ṭut - à	pu	trà	eref su	sàṭ - tu	χapaa		
my defects.	What	then	is it?	The cutting off	the corruptible matter		

				41.				
pu	en Àusàr	àn	Ani	maāχeru	χer	neteru	nebu	seḥerà - tu
it is	of Osiris	the scribe	Ani,	triumphant	before	gods	all.	Driven away

				42.				
ṭut	neb	àri - f	pu	trà	eref	su	àb	
are the defects	all	which belong to him.	What	then		is it?	The purification	

				43.			
pu	em	hru	en	mes - tuf	àbu - à	em	seš - ui - à
it is	on	the day	of	his birth.	I am purified	in	my double nest

					44.			
āàt	urt	enti	em	Suten-ḥenen,	hru	pui	en	àbetet
great	exceedingly	which [is]	in	Suten-ḥenen,	[on] day	that	of	offerings of

					45.				
reχit	en	neter	pui	āà	enti	àm - s	pu	trà	eref su
the people	to	god	that	great	who [is]	in it.	What	then	is it?

ḥeḥ *ren* *en* *uā* *uat'* *urȧ* *ren* *en* *ki*
"Millions of years" [is] the name of the one, "Green Lake" [is] the name of the other;

śe *pu* *en* *ḥesmen* *ḥenā* *śe* *pu* *en* *Māāāat* *ki*
a pool it is of natron, and a pool it is of nitre; otherwise

t'eṭ *semu* *ḥeḥ* *ren* *en* *uā* *uat'* *urȧ*
said, " Traverser of millions of years " [is] the name of the one, "Green Lake" [is]

48. *ren* *en* *ki* *ki* *t'eṭ* *utet* *ḥeḥ* *ren*
the name of the other; otherwise said, " Begetter of millions of years " [is] the name

en *uā* *uat'* *urȧ* *ren* *en* *ki* 49. *ȧr* *χert* *neter* *āā*
of the one, "Green Lake" [is] the name of the other. As concerning the god great

enti *ȧm-s* *Rā* *pu* *t'esef* *śem-nā* *ḥer* *uat* *reχ-nā*
who [is] in it, Rā it is himself. I pass over the way, I know

ṭep *em* *Śe-Maāat* 51. *pu* *trȧ* *eref* *su* *ȧr*
the heads (?) of She-Maāta. What then is it?

Re-stau *pu* *ṭuaut* *pu* 52. *rest* *Naȧrutf* *sebaut*
Re-stau it is the underworld south of Naarutf, the door

meḥti *en* *āat* *ȧr* *χert* 53. *Śe-maāat* *Ȧbṭu* *pu*
north of the tomb. As concerning She-Maāat Abydos it is;

ki	t'eṭ	uat	pu	śemt	en	54.	ȧtef - f	Tem
otherwise said,		the road	it is [which]	travelleth			his father	Tmu

ḥer - s	χeft	ut'a - f	er	Seχet -	Ȧaru	pu	55.	mest
over it	when	he goeth	to	Sekhet -	Aaru,	[which]		produceth

t'efaui	en	neteru	ḥa	kerȧ	56.	ȧr	χert	sebat
the tchefa food	of	the gods	behind	the shrine.		Now		the Gate

pu	sert	seba	pu	en	seḃes	Śu	57.	ȧr	seba	meḥti
Sert		the gate	is	of	the pillars	of Shu,			the gate	northern

en	ṭuat	pu	ki	t'eṭ	ȧȧui	rei	pui
of	the underworld	it is ;	otherwise said,		the two leaves	of door	that

58.	ut'a	en	Temu	ḥer - f	χeft	ut'a - f	χut	ȧbti
	goeth		Tmu	through it	when	he goeth forth	from the horizon	eastern

ent	pet	59.	ȧmiu - baḥ	ȧmmā - nȧ	ȧȧui - ten	nuk
of	heaven.		O ye gods who are in the presence,	grant to me	your two arms.	I am

neter	pui	60.	en	χeper - nȧ	ȧm - ten	pu	trȧ	eref	su
god	that,			I shall come into existence	among you.	What	then	is it ?	

senf	pu	61.	per	em	ḥenenu	en	Rā	emχet
The drops of blood	it is [which]		come forth	from	the phallus	of	Rā	after

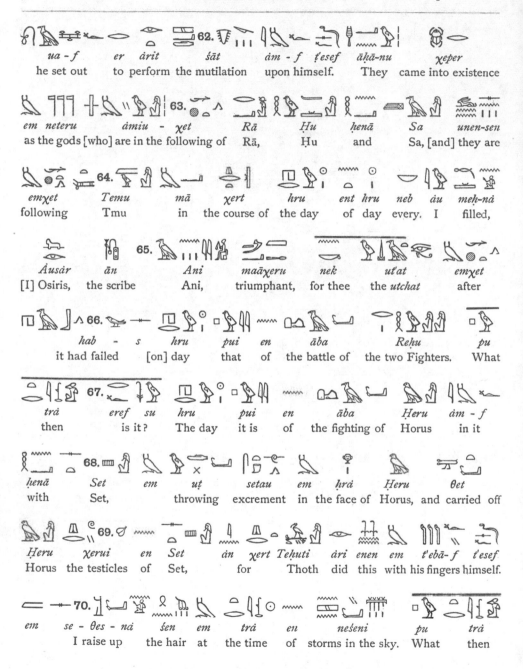

ua - f	*er*	*àrit*	*šāt*	*àm - f*	*ṭesef*	*āḥā-nu*	*χeper*
he set out	to perform	the mutilation		upon himself.		They	came into existence

em neteru	*àmiu - χet*	*Rā*	*Ḥu*	*ḥenā*	*Sa*	*unen-sen*
as the gods [who] are in the following of		Rā,	Ḥu	and	Sa, [and] they are	

emχet	*Temu*	*mā*	*χert*	*hru*	*ent hru*	*neb*	*àu*	*meh-nà*
following	Tmu	in	the course of	the day	of day	every.	I	filled,

Àusàr	*àn*	*Ani*	*maāχeru*	*nek*	*ut'at*	*emχet*
[I] Osiris,	the scribe	Ani,	triumphant,	for thee	the *utchat*	after

hab - s		*hru*	*pui*	*en*	*āba*	*Reḥu*	*pu*
it had failed		[on] day	that	of	the battle of	the two Fighters.	What

trà	*eref*	*su*	*hru*	*pui*	*en*	*āba*	*Ḥeru*	*àm - f*
then	is it?		The day	it is	of	the fighting of	Horus	in it

ḥenā	*Set*	*em*	*uṭ*	*setau*	*em*	*ḥrà*	*Ḥeru*	*θet*
with	Set,		throwing	excrement	in	the face of	Horus,	and carried off

Ḥeru	*χerui*	*en*	*Set*	*àn*	*χert*	*Teḥuti*	*àri*	*enen*	*em*	*t'ebā-f*	*t'esef*
Horus	the testicles	of	Set,	for		Thoth	did	this	with	his fingers	himself.

em	*se - θes - nà*	*šen*	*em*	*trà*	*en*	*neśeni*	*pu*	*trà*
	I raise up	the hair	at	the time	of	storms in the sky.	What	then

eref	su	maat	pu	åmt	en	Rā	em	neśeni - s	eref
is it ?		Eye	it is	the right	of	Rā	in	its raging	against him

emχet
after

PLATE IX.

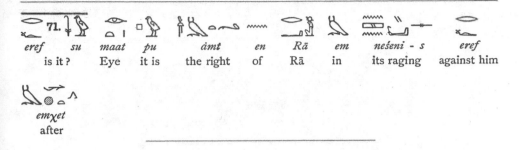

	habi - f		su	àn	Tehuti	θes	śeni	àm	àn - nef - s	en
	he hath made it to depart, [and]				Thoth	raiseth up	the hair	there,	and he bringeth it	

	ānχ	ut'a	senb	àn	beka	en	neb	ki	t'eṭ
[i.e., the eye]	living,	healthy	and sound,	without	defect	to [its] lord ;		otherwise said,	

unen	maat	pu	em	mer - s	em	unen - s	her	remi	en
it is	the eye		when	it is sick,	when	it is		weeping	for

sen - f	āḥā	àref	àn	Tehuti	er	pesaḳ	nes	àu
its fellow ;	standeth up then			Thoth	to	wash	it.	

maa - nà	Rā	mes	em	sef	er	χepṭet	en
I see	Rā	born	of	yesterday	from	the hind-quarters	of

Meḥ-urt	ut'a - f	ut'a - à	θes rer	pu	trà	eref su
Meḥ-urt ;	his strength [is] my strength, and conversely.			What	then	is it ?

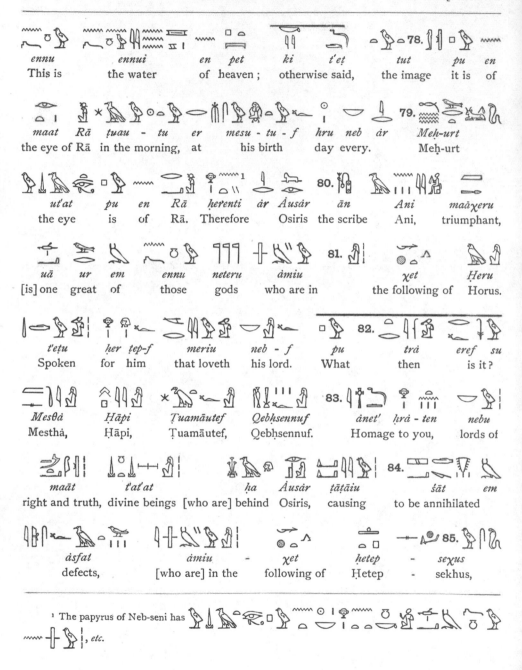

| ennu | ennui | en | pet | ki | t'eṭ | tut | pu | en |
| This is | the water | of | heaven; | otherwise said, | | the image | it is | of |

| maat | Rā | ṭuau - tu | er | mesu - tu - f | hru neb | àr | Meḥ-urt |
| the eye of Rā | | in the morning, | at | his birth | day every. | | Meḥ-urt |

| ut'at | pu | en | Rā | ḥerenti | àr | Àusàr | ān | Ani | maàχeru |
| the eye | is | of | Rā. | Therefore | | Osiris | the scribe | Ani, | triumphant, |

| uā | ur | em | ennu | neteru | àmiu | χet | Ḥeru |
| [is] one | great | of | those | gods | who are in | the following of | Horus. |

| t'eṭu | ḥer ṭep-f | meriu | neb - f | pu | trà | eref su |
| Spoken | for him | that loveth | his lord. | What | then | is it? |

| Mesthà | Ḥāpi | Ṭuamāutef | Qebḥsennuf | ànet' ḥrà - ten | nebu |
| Mesthà, | Ḥāpi, | Ṭuamāutef, | Qebḥsennuf. | Homage to you, | lords of |

| maāt | t'at'at | ḥa | Àusàr | ṭāṭāiu | śāt | em |
| right and truth, | divine beings | [who are] behind | Osiris, | causing | to be annihilated | |

| àsfat | àmiu - | χet | ḥetep - | seχus |
| defects, | [who are] in the | following of | Ḥetep - | sekhus, |

¹ The papyrus of Neb-seni has <image> , etc.

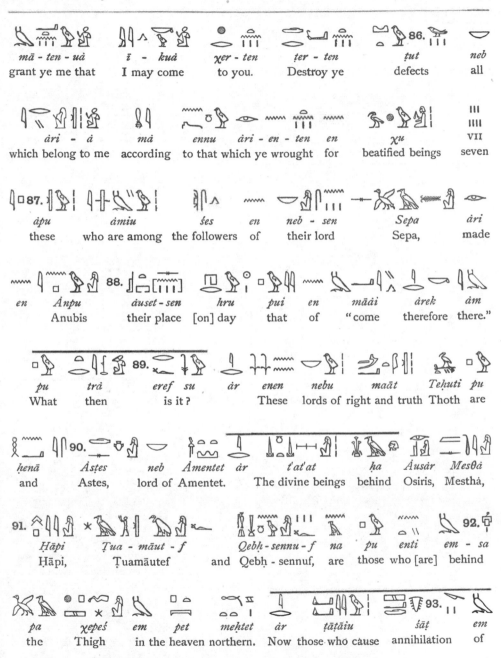

mā - ten - uā	ī - kuā	χer - ten	ṭer - ten	ṭut	86.	neb
grant ye me that	I may come	to you.	Destroy ye	defects		all

ári - á	mā	ennu	ári - en - ten	en	χu	VII
which belong to me	according	to that which ye wrought		for	beatified beings	seven

87. ápu	ámiu	šes	en	neb - sen	Sepa	ári
these	who are among	the followers	of	their lord	Sepa,	made

en	Ánpu	88. áuset - sen	hru	pui	en	māái	árek	ám
Anubis		their place	[on] day	that	of	"come	therefore	there."

pu	trā	89. eref su	ár	enen	nebu	maāt	Teḥuti	pu
What	then	is it ?		These	lords of right and truth		Thoth	are

henā	Ásṭes	90. neb	Ámentet	ár	t'at'at	ḥa	Áusár	Mesθá
and	Astes,	lord of Amentet.		The divine beings		behind	Osiris,	Mesthá,

91. Ḥāpi	Ṭua - māut - f	Qebḥ - sennu - f	na	pu	enti	em - sa	92.
Ḥāpi,	Ṭuamāutef	and Qebḥ - sennuf,		are	those who [are]	behind	

pa	χepeš	em	pet	meḥtet	ár	ṭāṭáiu	šāṭ	93.	em
the	Thigh	in the heaven	northern.		Now those who cause		annihilation		of

àsfet	àmu	-	χet	Hetep	-	seχius		Sebek
defects	and are in		the following of	Hetep	-	sekhius	94.	Sebek

pu	àmi	māa	àr	Hetep	-	seχius	maat	pu	ent	Rā
are	in the	waters.	Now	Hetep	-	sekhius	the eye	is	of	95. Rā;

ki	t'et	nesert	unen - s	em - χet	Àusàr	her		samt
otherwise	said,	the flame	it is	following	Osiris	to		96. burn up

baiu	nu	χefta - f	àr	χert	tut	neb	àri
the souls	of	his enemies.	As	concerning	the defects	all	which belong to

Àusàr	ān	neter hetepu	en	neteru nebu	Ani	maāχeru	t'er
97. Osiris,	scribe of	divine offerings	of	all the gods,	Ani,	triumphant,	since

hai - f		em	χat	en	mut - [f]	(sic)	àr	χert
98. he went forth		from	the womb	of	[his] mother.		As	concerning

χu	àpu	VII	Mesθà	Hāpi	Tuamāutef		Qebhsennuf
the beatified beings,	those	99. seven,	Mesthà,	Hāpi,	Tuamāutef,		Qebhsennuf,

Maa - àtef - f	χeri - beq - f	Heru - χenti - maa	ertāt - sen
100. Maa - atef - f,	Kheri - beq - f,	Heru - Khenti - maa,	101. placed then

àn	Ànpu	em	sau	qeres	ent	Àusàr	ki	t'et	em	sa
àn.	Anubis	as	protectors	of the dead body	of	Osiris;	otherwise	said,	102.	behind

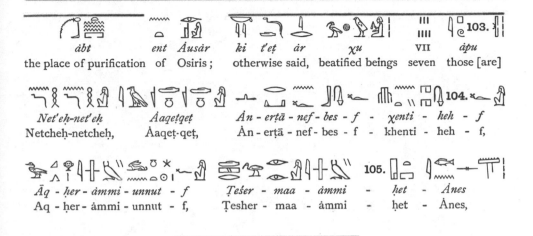

àbt	*ent*	*Àusàr*	*ki t'et*	*àr*	*χu*	VII	*àpu*
the place of purification	of	Osiris;	otherwise said,		beatified beings	seven	those [are]

Net'eḥ-net'eḥ	*Àaqetqet*	*Àn-ertā-nef-bes-f-χenti-heh-f*	
Netcheḥ-netcheḥ,	Àaqet-qet,	Àn-ertā-nef-bes-f-khenti-heh-f,	

Āq-ḥer-àmmi-unnut-f		*Ṭeśer-maa-àmmi-ḥet-Ànes*		
Aq-ḥer-àmmi-unnut-f,		Ṭesher-maa-àmmi-ḥet-Ànes,		

PLATE X.

Ubes-ḥrà-per-em-χetχet	*Maa-em-kerḥ-àn-nef-em-hru*
Ubes-ḥrà-per-em-khetkhet,	Maa-em-kerḥ-àn-nef-em-hru.

àr	*ḥeri*	*t'at'at*	*en*	*na*	*en*	*àruṭ-f*	*Heru*	*net'*	*ḥrà*
Now the chief of	the divine beings of		those		of	his hall	is Horus,	the avenger of	

àtef-f	*àr*	*χert*	*hru*	*pef*	*māi*	*àrek*	*àm*	*t'et* *Àusàr* *pu*
his father.	As concerning		day	that	of "Come	then	there,"	the saying to Osiris it is

en	*Rā*	*māài*	*àrek*	*àm*	*maa-tu set*	*à er Àmentet*	*nuk*
by	Rā	"Come	then	there";	see, decreed is it	for me in Amentet.	I am

ba-f	*ḥer-àb*	*T'afi*	*pu*	*trà*	*eref*	*su* *Àusàr* *pu*
his soul	within the two	Tchafi.	What	then	is it?	Osiris it is [when]

111. *āq - f er Ṭeṭṭetu qem - nef ba àm en Rā āḥā en ḥept*
he goeth in to Tattu, and findeth he the soul there of Rā, embraceth [one]

112. *en ki àm āḥā enu χeper em baiu ḥer-àb T'afi.*[1]
the other there, and come into existence souls within the two Tchafi.[1]

àr χer T'afi, Ḥeru pu net' ḥrà tef - f henā
As concerning the two Tchafi, Horus it is, the avenger of his father, and **17.**

Ḥeru - em χent-en-maa ki t'eṭ àr ba - f ḥer-àb T'afi
Horus - em - khent-en-maa; otherwise said, his double soul within the Tchafi

ba pu en Rā ba pu en Àusàr ba pu en àm Śu
the soul is of Rā, the soul is of Osiris, the soul is which [is] in Shu, **18.**

ba pu en àm Tefnut ba - f pui en àmu Ṭeṭṭet
the soul is which [is] in Tefnut, his double soul [is] that which [is] in Tattu.

nuk màu pui peśeni àśeṭ erma - f em Ànnu
I am cat that fighting (?) by the persea tree near him in Heliopolis, **19.**

ḳerḥ pui en ḥetem χefta nu Neb-er-t'er àm - f peti trà
[on] night that of destroying the enemies of Neb-er-tcher in it. What then

[1] The following text within brackets has been accidentally omitted by the scribe of the Ani papyrus, and is here supplied from that of Nebseni (B.M. 9900).

[2] Papyrus, Plate xiv., l. 16.

eref	su		māu	pui	t'a	Rā	pu	20.	t'esef	t'ettu - nef	māu	em
is	it?		Cat	that	male	Rā	is		himself,	and called is he	"Cat"	by

t'et	Sa	eref	māu	su	em	enen		āri - nef	χeper
the word of	Sa	about him,	"Like [is] he		unto	that [which] he hath made,"		and became	

ren - f	pu	en	māu	ki	t'et	unen	21.	Śu	pu	her	ārit
his name			"Cat";	otherwise said,				Shu	it is in	making over	

āmt	en	Seb	en Āusār	ār	χer	pesen	āset
the property of	Seb		to Osiris.	As concerning	the fighting (?)	by the persea tree	

·erma - f	em	Ānnu	un	mesu	beteset	pu	her	maā
near him	in	Ānnu,		the children of	impotent revolt	it is	when is done	justice

22. her	āri	en	sen	ār	χert	kerh	pef	en	āba - ā
for what they have done.				Now	concerning	night	that	of	battle,

āq - sen	pu	em	ābti	pet	āhā	en	ā	en	āba
[when] they enter it is into the eastern part of the sky, there straightway taketh place a battle									

em	pet	em	ta	er	t'er -f	à	àm	suht -f	23.	pest
in heaven [and]	on the earth	to its whole extent.		Hail	in	his egg,		shining		

¹ This restoration is certain, for traces of the characters in red still remain on the papyrus.

em	àten - f	uben	em	χut - f	nub	her	bà
from	his disk,	rising	from	his horizon,	glittering	above	sky

àti	sen - f	em	neteru	seqtet	her	seθesu	Śu	tàtà
without	his second	among	the gods,	sailing	over	the pillars of	Shu,	giving

nifu	em	heh	en	re - f	sehet	taui	em	χu - f
winds	of	fire	of	his mouth,	making bright	the two earths	with	his radiance,

nehem - k	Neb-seni	neb	àmaχ	mà	neter	pui	śeta
deliver thou	Nebseni,	the lord of devotion,	from	god	that	secret	

àru	unen	ành - f	em	ààui	màχa	kerh
of form,	being	his two eyebrows	like unto	the two arms	of the scales,	on night

pfi	en	hesebt	àuaa	peti trà eref su	Àn - à - f
that	of the reckoning of the destroying goddess.	Who then is it?	Àn - à - f		

26. pu	àr	χert	kerh	pef	en	hesebt	àuaa	kerh
it is.	As concerning	night	that	of	the reckoning of the destroying goddess,	the night		

pu	en	nesert	en	χerit	tàtà	serhu	em
it is	of	the burning up	of	the enemies,	and of causing	the destruction	of

àsfet	er	nemmet - f	27. tent	baiu	peti trà
the wicked	at	his block,	[and] of the slaughter	of souls.	Who then

¹ Supplied from Naville, Todtenbuch, Bd. II., Bl. 60.

eref su Nemu pu sàti pu en Ausâr ki t'et
is it? Nemu it is the slaughterer of Osiris; otherwise said,

Āpep pu un-nef em tep en uā χer maāt
Āpep it is, [when] he riseth up with one head having [upon it] Maāt;

28. ki t'et Heru pu un - nef em tepui unen uā χer
 otherwise said, Horus is it [when] he riseth up with two heads, one having

maāt ki χer àsfet tātā - f àsfet en àri - s
Maāt, the other having wickedness. He giveth wickedness to the worker thereof,

maāt en ses χer - s 29. ki t'et Heru pu
[and] Maāt to [him] that followeth after it; otherwise said, Horus is it

āā χent χem ki t'et Tehuti pu ki t'et
the great, president of Sekhem; otherwise said, Thoth it is; otherwise said,

Nefer-Tmu pu Septu χesef χet en χefta nu Neb - er - t'er
Nefer-Tmu it is [or] Septu, thwarting the business of the enemies of Neb - er - tcher,

nehem - k [1]mā ennu en àru setau àmenhi
deliver thou from those watchers who bring slaughtering knives,

septu t'ebā meru hesq àmu - χet 31. Ausâr
and are provided with fingers cruel, and slay those who are in the following of Osiris,

[1] Here follows the name Nebseni, *etc.*

enen	seχem - sen	âm - â	enen	hai - â	er	ketut - sen
not	may they prevail	over me,	not	may I fall under		their knives.

peti trà	eref	su	Ånpu	pu	Heru	pu	em	χent - en - maa
What then	is it?		Anubis	it is, [and]	Horus	it is	as	Khent - en - maa;

ki	t'et	t'at'at	pu	χesefet	χet	en	sen
otherwise	said,	the divine chiefs	it is,	the repulsers of	the affairs	of	their;

ki	t'et	ur	en	śeniu	en	seχem
otherwise said,		the princes (?)	of	the *sheniu* chamber.	Not	may overcome

33.

tes - sen	em	enen	hai - â	er	ketut - sen
knives their,[1]	not	may fall I	under	their instruments of torture,

34.

her entet	tuâ	reχ - kuâ	ren	âri	reχ - kuâ	mât'et
because	I,	I know	name	their,	[and] I know	oppressor

tui	âm - sen	en	pa	Åusàr	satet	em	maat
that,	[who is] among them	in	the house of	Osiris,	shooting light	from	[his] eye,

en	maa	entuf	rer	en	pet	em	nes	en	re - f
not	seen [is] he.		He goeth round		heaven	within	the flame	of	his mouth,

35.

semà	Hāpi	[en]	maa - entuf	nuk	ut'a	tep	ta	χer
commanding	the Nile,	[not]	being himself seen.	I am	strong	upon	earth	before

[1] Here follow the titles of Nebseni.

Rā	menā - ȧ	nefer	χer	Ȧusȧr	enen	ȧb - θen	ȧm - ȧ
Rā,	may my arrival [be]	happy	before	Osiris.	Not may	your offerings [be]	against me

enen em	heru	āχu - sen	her entet	tuȧ	em	śes	en
those which [are] upon	their altars,		because	I am	among	the followers of	

Neb - er - t′er	er	ān	en	χeperu	āχa - ȧ	em
Neb - er - tcher	according	to the writings	to	Kheperu.	I fly	as

bȧk	nekek - nȧ	em	smen	sek - ȧ	heh	mȧ	Neheb - kau
a hawk,	I cackle	as	a goose,	I kill	always	like	Neheb - kau.

peti trȧ	set	ennu	pu	en	heru	āχu - sen	tut
What then [is] it?	Those	it is which [are]		upon	their altars,	the image	

pu	en	maat	Rā	henā	tut	en	maat	Heru	ȧ	Rā	Tem
it is	of	the eye of	Rā	and	the image	of	the eye of	Horus.	O	Rā -	Tmu,

neb	het āat	ȧθi	ānχ	ut′a	senb	neteru	nebu	nehem - k
the lord of the Great House,	Prince,	life,	strength,	health,	of gods	all,	deliver thou[1]	

mȧ	neter	pui	enti	hrȧ - f	em	θesem	ȧnhui - f	em
from	god	that	whose face is	in [the form of]	a dog,	[and] his eyebrows	like	

reθ	ānχ - f	em	χerit	ȧri	qeb	tui	en	śe
[those of] men,	he liveth	upon	the enemy,	watching	bight	that	of	the lake

[1] Here follows the name of Nebseni, etc.

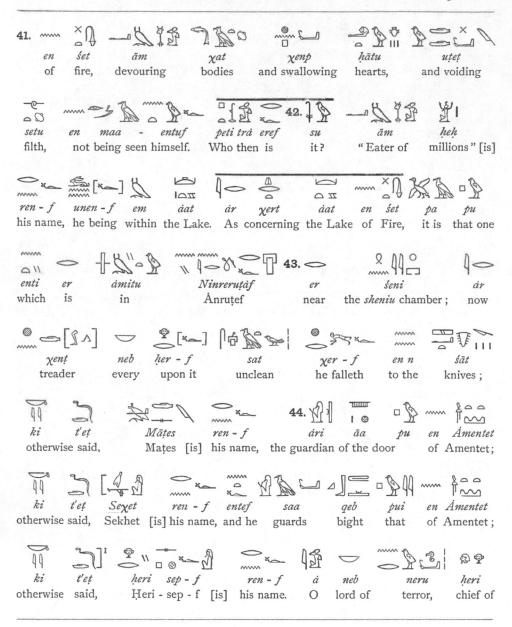

41. en śet ām χat χenp ḥātu uṭeṭ
of fire, devouring bodies and swallowing hearts, and voiding

setu en maa - entuf peti trä eref su ām heḥ
filth, not being seen himself. Who then is it ? " Eater of millions " [is]

ren - f unen - f em àat àr χert àat en śet pa pu
his name, he being within the Lake. As concerning the Lake of Fire, it is that one

enti er àmitu Ninreruṭàf er śeni àr
which is in Ànruṭef near the sheniu chamber ; now

χenṭ neb ḥer - f sat χer - f en n śāt
treader every upon it unclean he falleth to the knives ;

44. ki t'eṭ Māṭes ren - f àri āa pu en Amentet
otherwise said, Maṭes [is] his name, the guardian of the door of Amentet;

ki t'eṭ Seχet ren - f entef saa qeb pui en Àmentet
otherwise said, Sekhet [is] his name, and he guards bight that of Amentet;

ki t'eṭ ḥeri sep - f ren - f à neb neru ḥeri
otherwise said, Ḥeri - sep - f [is] his name. O lord of terror, chief of

¹ Added from Naville, *Todtenbuch*, Bd. II., Bl. 64.

taui *neb* *ṭeśert* *uaṭ* 45. *nemmetu* *ānχ* *em*

the two lands, lord of ruddiness, making ready the block of slaughter, living upon

besku *peti* *trȧ* *eref* *su* *saa* *qeb* *pui* *en*

entrails. Who then is it? The guardian of bight that of

46. *Ȧmentet* *peti trȧ* *eref* *su* *ḥāti* *pu* *en* *Ȧusȧr* *entef* *ȧm*

Amenta. What then is it? The heart it is of Osiris, it is the devourer of

śāt *nebt* *erṭāi - nef* *ureret* *āut ȧb* *em*

slaughtered things all. Hath been given to him the *ureret* crown [with]dilatation of heart as

χent *Suten-ḥenen* *peti trȧ* 47. *eref* *su* *ȧr* *erṭāi - nef*

president of Suten-ḥenen. What then is it? Now there hath been given to him

ureret *āut ȧb* *em* *χent* *Suten-ḥenen* *Ȧusȧr* *pu*

the *ureret* crown [with] dilatation of heart as president of Suten-ḥenen. Osiris it is,

uṭeṭ - f *ḥeqt* *em* *neteru* *hru pef* *en* *samat* *taui*

he was commanded to rule among the gods [on] day that of the union of the two earths

48. *em baḥ* *ā* *Neb - er - ṭer* *peti trȧ* *eref* *su* *ȧr* *uṭeṭ - nef*

before Neb - er - tcher. What then is it? Now he that was commanded

ḥeqt *em* *neteru* *Ḥeru* *pu* *se* *Ȧuset* *seḥeq* *em ȧuset*

to rule among the gods Horus is, son of Isis, [who] was appointed to rule in the seat

¹ Plate XV. of the Nebseni papyrus begins with this word.

49.

tef - f	Ausâr	âr	hru	pef	samat	taui	temt
of his father	Osiris.	Now	day	that	of the union	of the two earths,	the gathering

taui	pu	er	qeres	Ausâr	ba	ānχ	âmi
of the two earths	it is	at	the sarcophagus of	Osiris,	the soul	living	in

50.

Suten-ḥenen	ṭāṭā	ka	ṭer	âsfeta	sem - nef
Suten-ḥenen,	the giver of	food,	the annihilator of	sins,	he guideth [along]

uat	ḥeḥ	peti trä	eref	su	Rā	pu	t'esef	nehem - k	χer
the road of	eternity.	What then	is	it?	Rā	it is	himself.	Deliver thou[1] ...	before

51.

neter	āa	pui	t'ai	baiu	nesbu	āua	ānχ
great god	that		the carrier away	of souls,	the devourer of	dirt,	living

em	ḥuait	saa	keku	âmi	senket	senṭu - f
upon	garbage,	the guardian of	darkness [living] in		light,	fear him

52.

âmu	beḳ	peti trä	eref	su]
those [who are] in	misery.	Who then	is	it?]

âr	χert	baiu	her-âb	Tafi	mā	neter	pui	t'ai
As	concerning	the souls	within	the Tchafi,	with	god	that	who seizeth

113.

ba	nesbu	ḥātu	ānχ	em	ḥuau	âri
the soul,	and eateth	hearts	and liveth	upon	the entrails,	the guardian

114.

[1] Here follows the name of Nebseni. [2] Papyrus of Ani, Plate X., line 7.

keku — *ami* — *Sekeri* — *seṇt - nef* — *amiu*

of the darkness [who is] within the *seker* boat ; fear him those who live in

115. *beḳa* — *pu* — *trà* — *eref* — *su* — *Suti* — *pu* — *ki* — *t'eṭ*

defects. What then is it ? Suti it is ; otherwise said,

smam — *ur* — *ba* — *en* — *Seb* — *à* — *χeperà* — *her-àb*

Smam - ur 116. the soul of Seb. Hail, Kheperà within

uàa - f — *paut* — *t'et - f* — *nehem - k* — *Ausàr*

his boat, the double cycle of the gods [is] his body, deliver thou Osiris

117. *Ani* — *maàχeru* — *mà* — *ennu* — *pu* — *àri* — *sàpu*

Ani, triumphant, from those watchers who give judgment, [who]

erṭà — *en* — *sen* — *Neb - er - t'er* — *er* — *χu - nef* — *er* — *àrit* — *satu*

have been placed by Neb - er - tcher to protect him and to perform the fettering of

χefta - f — *ṭàṭàiu* — *šàṭ* — *em* — *àati* — *enti*

his enemies, [who] make slaughter in 119. the slaughter houses, there is no

per — *em* — *saut - sen* — *àn* — *habi - sen* — *ṭes - sen*

coming forth from their restraint. Not may they send knives their

àm - à — *àn* — *àq - à* — *er* — *àati - sen* — *àn* — *urṭ - nà*

into me, 120. not may I enter into their slaughter houses, not may I stay

[1] The papyrus of Nebseni ha ⬚ Set.

121.

em	χennu	samatu - sen	àn	àritu - nà	χet	em
within	their chambers of torture,	not	have been done by me	things	of	

ennu	but	neteru	her-enti	nuk	àb	her [àb] mesqet
those which	hate	the gods,	because	I am	pure	within the Mesqet.

122.

àn - nef	mesi	em	θehent	àmt	Tanenet
Have been brought to him	cakes	of	saffron	within	Tanenet.

123.

pu	trà	eref	su	χeperà	her-àb	uàa - f	Rā	pu	t'esef
Who then	is	it?	Kheperà	within	his boat,	Rā	it is	himself.	

124.

àr	ennu	en	àri	sàpu	bentet	pu	Àuset	pu
Now	those		guardians	who give judgment	the apes	are	Isis	

125.

Nebt-ḥet	pu	àr	ennu	en butu	neteru	hesu	pu	ḳer
[and] Nephthys.	Now those things which hate the gods	wickedness	are [and]	falsehood.				

àr	seś	āḅt	her-àb	mesqet	Ànpu	pu	àuf
Now	the passer of the purification chamber	within	the Mesqet	Anubis	is,	he is	

126.

em sa	āftet	entet	χer	màχatu	ent Àusàr	àr	ertāit - nef
behind	the chest	which holdeth the intestines of Osiris.	He to whom have been given				

127.

mesit	em	θehent	àmt	Tanenet	Àusàr	pu	ki
cakes	of	saffron	in	Tanenet	Osiris	is;	otherwise

t'eṭ	ȧr	mesit	em	θeḥent	128.	ȧmu	Tanenet
said,		the cakes	of	saffron		in	Tanenet

pet	pu	ta	pu	ki	t'eṭ	gengen	Śu	ent	ta	pu
heaven [and] earth are;				otherwise said,		the strengthener	Shu	of the two earths is		

129.	em	Suten-ḥenen	ȧr	mesit	em	θeḥent	maat	Ḥeru	pu
	in	Suten-ḥenen.	Now	the cakes	of	saffron	the eye of	Horus	are,

ȧr	Tanenet	130.	samat	pu	ent	Ȧusȧr	(sic)	qeṭ	pa - k
now	Tanenet		the burial place	is	of	Osiris.		Hath built	thy house

Tmu	sent	ḥet - k	Rereθȧ	peḥ	en	131.	rert	turȧ
Tmu,	hath founded	thy habitation	Rereθà,	arrive			drugs,	purifieth

Ḥeru	neterti	Set	θes-χer	ȧ - nef	em	ta	pen	θet - nef
Horus,	strengtheneth	Set, and vice versâ.		Cometh he	into	earth	this,	he hath taken it

em	reṭ - f	132.	Ȧusȧr	ȧn	Ani	maȧχeru	χer	Ȧusȧr	entef
with	his two feet,		Osiris, the scribe		Ani,	triumphant	before	Osiris.	He is

Tmu	ȧu - f	em	nut - k	ḥa - k	133.	Rehu	ḥet'	re
Tmu,	he is	in	thy town.	Turn thou back,		Reḥu,	shining of	mouth

peṭes	ṭep¹	ḥem	en	peḥti - f	ki	t'eṭ	ḥem
moveable of	head,	turn thou back	from	his strength;	otherwise said,		turn back from

1 This is the reading of the Nebseni Papyrus, and of many others.

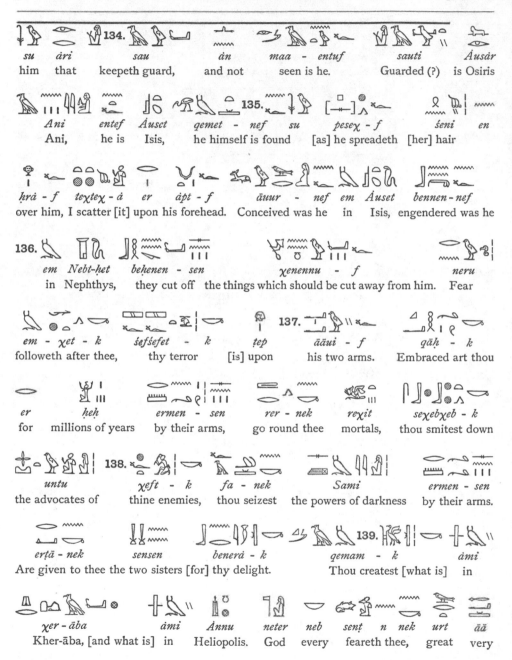

su	àri	sau	134.	àn	maa - entuf	sauti	Ausàr
him	that	keepeth guard,		and not	seen is he.	Guarded (?)	is Osiris

Ani	entef	Àuset	qemet - nef	su	135. pesex - f	seni	en
Ani,	he is	Isis,	he himself is found		[as] he spreadeth	[her] hair	

hrà - f	textex - à	er	àpt - f	àuur - nef	em	Auset	bennen - nef
over him,	I scatter [it]	upon his forehead.	Conceived was he	in	Isis,	engendered was he	

136.

em	Nebt-het	behenen - sen	xenennu - f	neru
in	Nephthys,	they cut off	the things which should be cut away from him.	Fear

em - xet - k	šefšefet - k	tep	137. ààui - f	qàh - k
followeth after thee,	thy terror	[is] upon	his two arms.	Embraced art thou

er	heh	ermen - sen	rer - nek	rexit	sexebxeb - k
for	millions of years	by their arms,	go round thee	mortals,	thou smitest down

untu	138. xeft - k	fa - nek	Sami	ermen - sen
the advocates of	thine enemies,	thou seizest	the powers of darkness	by their arms.

ertà - nek	sensen	benerà - k	qemam - k	139. àmi
Are given to thee	the two sisters	[for] thy delight.	Thou createst [what is]	in

xer - àba	àmi	Annu	neter	neb	sent	n	nek	urt	àà
Kher-àba,	[and what is] in	Heliopolis.	God	every	feareth thee,			great	very

			140.				
šefšeft - k	*neter*	*neb*	*mā*	*seḥurà*	*su*	*satet*	
and terrible art thou.	God	every	of him that curseth	him	shooting arrows........		

ānχ - k	*er*	*meri - k*	*entek*	*Uatit*	*nebt*	*àmmu*
Thou livest	according to thy will,	thou art	Uatchit,	the lady	of flame.	

141.

àri - sen - nek	*ānṭ*	*àm - sen*	*pu*	*trà*	*eref*	*su*
Those who rise up against thee	evil [cometh] among them.	What then	is	it?		

		142.			
šeta	*àru*	*ṭàṭā* *menḥu*	*ren*	*en*	*ḥat*
"Hidden of	forms,	given by Menḥu" [is]	the name	of	the sarcophagus.

maatu - f	*her*	*à*	*ren*	*en*	*qeràu*	*ki* *t'eṭ*
"He seeth [what is] upon [his] hand" is	the name of	the shrine;	otherwise said,			

143.

ren	*en*	*nemmet*	*àr*	*sa*	*het'*	*re*	*pest* *ṭep*
it is the name	of	the block.	Now	the	shining	of mouth [and]	moveable of head

						144.		
ḥenen	*pu*	*en* *Àusàr*	*ki*	*t'eṭ*	*ḥenen*	*pu*	*en* *Rā*	*àr*
the phallus	is	of Osiris;	otherwise said,	the phallus	it is	of Rā.	Now	

pesteχ - nek	*šen - k*	*teχteχ - à*	*en*	*er*	*àpt-[f]*	*unen* *Àuset*	*pu*	*her*
thou spreadest	thy hair,	I scatter it	upon	his forehead,	Isis	it is [who]		

¹ We should probably add some word like "thou avengest."

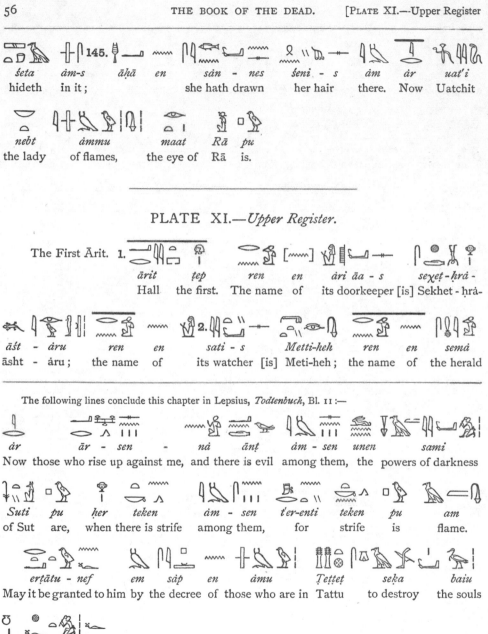

śeta	*àm-s*	*āḥā*	*en*	*sàn - nes*	*śeni - s*	*àm*	*àr*	*uat'i*
hideth	in it;			she hath drawn	her hair	there.	Now	Uatchit

nebt	*àmmu*	*maat*	*Rā*	*pu*
the lady	of flames,	the eye of	Rā	is.

PLATE XI.—*Upper Register.*

The First Ārit. **1.**

àrit	*ṭep*	*ren*	*en*	*àri āa - s*	*seχeṭ - ḥrà -*
Hall	the first.	The name	of	its doorkeeper [is]	Sekhet - hrà-

āśt - àru	*ren*	*en*	*sati - s*	*Metti-heh*	*ren*	*en*	*semà*
āsht - àru;	the name	of	its watcher [is]	Meti-heh;	the name	of	the herald

The following lines conclude this chapter in Lepsius, *Todtenbuch*, Bl. 11 :—

àr	*ār - sen*	*-*	*nà*	*ànṭ*	*àm - sen*	*unen*	*sami*
Now	those who rise up against me,		and there is evil	among them,	the powers of darkness		

Suti	*pu*	*her*	*teken*	*àm - sen*	*ṭer-enti*	*teken*	*pu*	*am*
of Sut	are,	when there is strife	among them,	for	strife	is	flame.	

erṭàtu - nef	*em*	*sàp*	*en*	*àmu*	*Ṭeṭṭeṭ*	*seḳa*	*baiu*
May it be granted to him	by the decree	of	those who are in	Tattu	to destroy	the souls	

nu	*χefti - ṭ*
of	his enemies!

âm - s	Ha -	χeru	t'eṭtu	ân	Ani	maāχeru	χeft	sper	er
in it [is]	Ha -	kheru.	Saith		Ani	triumphant	when	coming	to

ārit	ṭept	nuk	ur	âri	seśep -f	ī - nå		χer-k	Åusår
hall	the first:	I am	the mighty one	making	his light.	I have come		to thee,	Osiris.

ṭua - å	tu	āb	er	ertu - k		sta	âm - k	ârit
I adore	thee,	purified	from	thy foul emanations.		Lead on,	do not thou	make

ren	en	Re - stau	eref	ånet' - hrå - k	Åusår	em	seχem - k	em
the name	of	Re-stau	to him.	Homage to thee,	Osiris,	in	thy might,	in

user - k	em	Re - stau	θes - tu	seχem - k	Åusår	em	Åbṭu
thy strength	in	Re-stau.	Rise thou up,	conquer thou,	O Osiris	in	Abydos.

rer - k	pet	χent - k	tu	χeft	Rā	maa - nek	reχit
Thou goest round	heaven,	thou sailest		in the presence of	Rā,	thou seest	the rekhit

neb	å	rer	en	Rā	âm - s	māk	t'eṭ - å	Åusår	nuk	såh
all.	Hail,	revolveth		Rā	in it!	Verily	I say,	Osiris,	I am	a ruler

neter	t'eṭ - nå	χeper	ân	χesef	er - å	her - s	em	åneb
divine,	I say	let it be that	there is no repulse		to me	at it,	at	its wall

- f	t'ābet	åp	uat	em	Re - stau	senet'em
of	burning coals.	[I] have opened	the way	in	Re - stau,	easing

¹ Read �container⌟. ² The papyrus has ⌟.

16.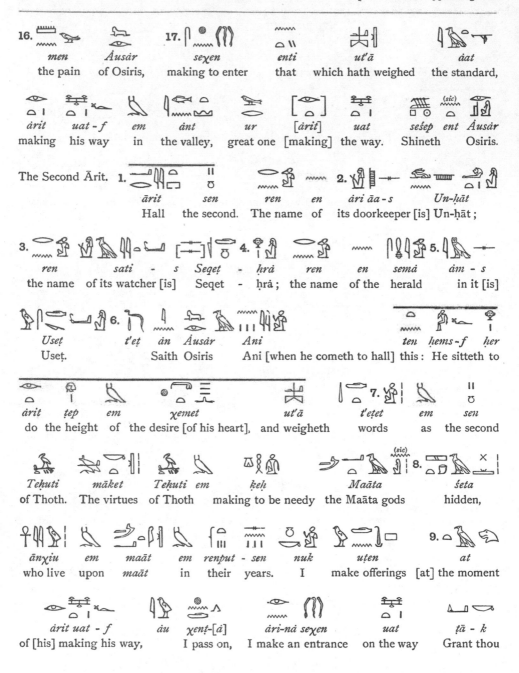

men — Áusár — seχen — enti — ut'á — àat
the pain — of Osiris, — making to enter — that — which hath weighed — the standard,

àrit — uat - f — em — ànt — ur — [àrit] — uat — seśep — ent — Áusár
making — his way — in — the valley, — great one — [making] — the way. — Shineth — Osiris.

The Second Ārit. **1.** ārit — sen — ren — en — àri áa - s — Un-ḥát
Hall — the second. — The name of — its doorkeeper [is] Un-ḥāt;

3. ren — sati - s — Seqet - ḥrà — **4.** ren — en — semá — **5.** àm - s
the name — of its watcher [is] — Seqet - ḥrà; — the name — of the — herald — in it [is]

Useṭ — **6.** t'eṭ — àn — Áusár — Ani — ten — ḥems - f — ḥer
Useṭ. — Saith — Osiris — Ani [when he cometh to hall] this: He sitteth to

àrit — ṭep — em — χemet — ut'á — **7.** t'eṭet — em — sen
do — the height — of — the desire [of his heart], — and weigheth — words — as — the second

Teḥuti — màket — Teḥuti — em — keh — Maāta — **8.** śeta
of Thoth. — The virtues — of Thoth — making to be needy — the Maāta gods — hidden,

ānχiu — em — maāt — em — renput - sen — nuk — uṭen — **9.** at
who live — upon — maāt — in — their years. — I — make offerings — [at] the moment

àrit uat - f — àu — χenṭ-[à] — àri-nà seχen — uat — ṭā - k
of [his] making his way, — I pass on, — I make an entrance — on the way — Grant thou

ses̄ - ā	seṡeṭ - ā		maa	Rā	mā	ariu	ḥeṭepu.
that I may pass,	that [I] may accomplish		the sight of	Rā	with	those who make	offerings.

The Third Ārit. 1.

ārit	χemt	ren	en	ari āa - s	Qeq - ḥauatu -
Hall	the third.	The name	of	its doorkeeper [is]	Qeq - ḥauatu -

3. ent - peḥui	ren	en	sati - s	Se - res - ḥrà	5. ren
ent - peḥui ;	the name	of	its watcher [is]	Se - res - ḥrà ;	the name

en	semā	àm - s	Āaa	t'eṭ	àn Àusàr	Ani	nuk	6. ṡeta
of	the herald	in it [is]	Āaa	Saith	Osiris	Ani :	I am	hidden in

ḳeb	àp	Reḥui	ī - nà	ṭer - à	ṭut	her
the great deep,	O judge	of the Reḥui,	I have come	and I have destroyed	the defects	for

Àusàr	nuk	unχ	at - f (sic)	7.	per	em	urert
Osiris.	I am	binding up	his standard	[which]	cometh forth	from	the crown.

semenχ - nà	χet	em	Àbṭu	àp - nà	uat	em	Re-stau
I have established	things	in	Abydos,	I have opened	the way	in	Re-stau,

8. se - net'em - nà	ment	em Àusàr	seχeχ	àat - f	àri - nà
I have eased	the pain	in Osiris,	[I] have made to balance	his standard,	I have made

uat	seṡep - f	em	Re - stau	**The Fourth Ārit.** 1.	ārit	àft	ren
the way.	He shineth	in	Re - stau.		Hall	the fourth.	The name

2. *en* *àri àa - s* *χesef ḥrà - àśt - χeru* 3. *ren en* 4. *sati*
of its doorkeeper [is] Khesef - ḥrà - àśt - kheru; the name of [its] watcher [is]

Se-res - ṭepu 5. *ren en* *semà àm - s* 6. *χesef - Aṭ* *t'eṭ àn*
Seres - tepu; the name of the herald in it [is] Khesef - Aṭ. Saith

Àusàr *àn* *Ani* *maàχeru* *nuk* *ka* 7. *se* *t'erit*
Osiris, the scribe Ani, triumphant: I am the bull, the son of the ancestress

ent *Àusàr* *mā - ten* *meter - nef* *àtef - f* *neb*
of Osiris. Grant ye that may give evidence for him his father, the lord of

8. *àmmu - f* *ut'ā - nà* *beḳasu* *àm* *àu* *àn - nà - f*
his divine companions(?), { I have weighed in judgment } the guilty there. I have brought him

ànχ 9. *er* *fent - f* *en* *t'etta* *nuk* *se* *Àusàr* *àri - nà* *uat*
life to his nostril for ever. I am the son of Osiris, I have made the way,

seś - à *àm* *em* *Neter-χert* The Fifth Ārit. 1. *àrit* *ṭuat* *ren* 2. *en*
I have passed there into Neter-khert. Hall the fifth. The name of

àri àa - s *ànχ - f* *em* *fent* 3. *ren* *en* *sati - s*
ts doorkeeper [is] Ānkh - f - em - fent; the name of its watcher [is]

4. *Śabu* *ren en* 5. *semà àm - s* *Ṭeb - ḥrà - keha* 6.
Shabu; the name of the herald in it [is] Ṭeb - ḥrà - keha -

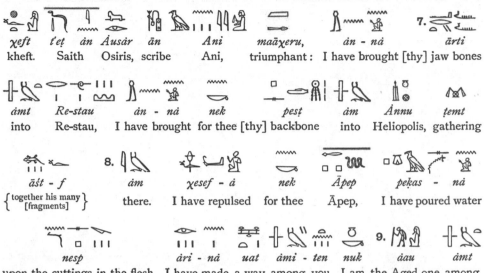

χeft	t'et	àn	Àusàr	àn	Ani	maāχeru,	àn - nà	ārti
kheft.	Saith	Osiris,	scribe		Ani,	triumphant:	I have brought [thy]	jaw bones

àmt	Re-stau	àn - nà	nek	pest	àm	Ānnu	temt
into	Re-stau,	I have brought	for thee	[thy] backbone	into	Heliopolis,	gathering

āst - f	àm	χesef - à	nek	Āpep	peḳas - nà
{together his many [fragments]}	there.	I have repulsed	for thee	Āpep,	I have poured water

nesp		àri - nà	uat	àmi - ten	nuk	àau	àmt
upon the cuttings in the flesh.		I have made	a way	among you,	I am	the Aged one	among

PLATE XII.

neteru	àri - à	āb	en	Àusàr	net'	en	su	em	maāχeru
the gods,	I have made	the offering	of	Osiris.	Triumphed hath		he	with	victory,

temt	qesu - f	saqa	āt - f	The Sixth Ārit. 1.	ārit
gathering together	his bones,	collecting	his limbs.		Hall the

saset	ren	en	àri āa-s	Àtek - tau - kehaq - χeru	ren	en
sixth.	The name	of	its doorkeeper [is]	Àtek - tau - kehaq - kheru;	the name	of

sati - s	Àn - ḥrà	ren	en	semā	àm - s	Ātes -
its watcher [is]	Àn - ḥrà;	the name	of	the herald	in it [is]	Ātes -

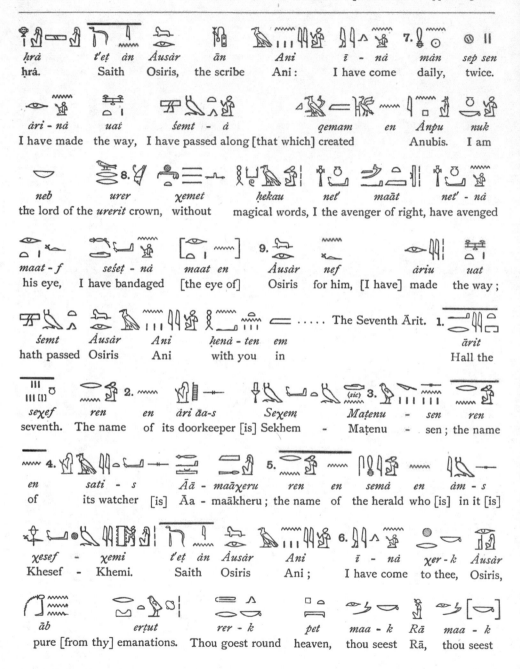

ḥrȧ | *t'eṭ* | *ȧn* | *Ȧusȧr* | *ȧn* | *Ani* | *ī - nȧ* | *mȧn* | *sep sen* 7.
ḥrȧ. | Saith | Osiris, | the scribe | Ani: | | I have come | daily, | twice.

ȧri - nȧ | *uaṭ* | *šemt - ȧ* | *qemam* | *en* | *Ȧnpu* | *nuk*
I have made | the way, | I have passed along [that which] created | | Anubis. | I am

neb | *urer* | *χemet* 8. | *ḥekau* | *neṭ* | *maȧt* | *neṭ' - nȧ*
the lord of the *urerit* crown, | without | magical words, | I the avenger of right, have avenged

maat - f | *seśeṭ - nȧ* | *maat en* | *Ȧusȧr* 9. | *nef* | *ȧriu* | *uat*
his eye, | I have bandaged | [the eye of] | Osiris | for him, | [I have] made | the way;

šemt | *Ȧusȧr* | *Ani* | *ḥenȧ - ten* | *em* | …… The Seventh Ārit. 1. | *ȧrit*
hath passed | Osiris | Ani | with you | in | | Hall the

seχef | *ren* 2. | *en* | *ȧri ȧa-s* | *Seχem* | *Maṭenu - sen* 3. (sic) | *ren*
seventh. | The name | of | its doorkeeper [is] | Sekhem - | Maṭenu - sen; | the name

en 4. | *sati - s* | *Āȧ - maȧχeru* | *ren* 5. | *en* | *semȧ* | *en* | *ȧm - s*
of | its watcher | [is] Āa - maākheru; | the name | of | the herald who [is] in it [is]

χesef - χemi | *t'eṭ* | *ȧn* | *Ȧusȧr* | *Ani* | *ī - nȧ* 6. | *χer - k* | *Ȧusȧr*
Khesef - Khemi. | Saith | Osiris | Ani; | | I have come | to thee, | Osiris,

ȧb | *erṭut* | *rer - k* | *pet* | *maa - k* | *Rā* | *maa - k*
pure [from thy] emanations. | Thou goest round | heaven, | thou seest | Rā, | thou seest

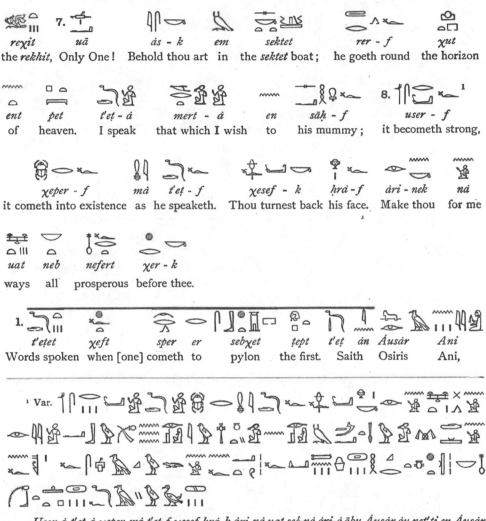

reχit	uā	ás - k	em	sektet	rer - f	χut
the *rekhit*,	Only One!	Behold thou art	in	the *sektet* boat;	he goeth round	the horizon

ent	pet	t'eṭ - á	mert - á	en	sāḥ - f	user - f
of	heaven.	I speak	that which I wish	to	his mummy;	it becometh strong,

χeper - f	mà	t'eṭ - f	χesef - k	ḥrà-f	àri - nek	nà
it cometh into existence	as	he speaketh.	Thou turnest back	his face.	Make thou	for me

uat	neb	nefert	χer - k
ways	all	prosperous	before thee.

t'eṭet	χeft	sper	er	sebχet	ṭept	t'eṭ	àn	Àusàr	Ani
Words spoken	when [one] cometh	to		pylon	the first.	Saith		Osiris	Ani,

¹ Var.

User-à t'eṭ-à χeper mà t'eṭ-f χesef ḥrà-k àri-nà uat seš-nà àri-à ābu Àusàr àu neṭ'ti en Àusàr em maātχeru ṭemṭ-nà nef qesu-f saqu-nà nef àt-f ṭā-θen tau ḥeqt χet neb nefer àbt ḥeṭepet t'efaiu.

"I become strong, I speak, coming into being according to what he hath said, turning back thy face. I make the way, I pass over it. I make the purification of Osiris. I avenge Osiris victoriously. I collect for him his bones, I gather together for him his members. Grant ye cakes, and ale, and all good and pure things, and offerings of *tchefaiu* food." Naville, *Todtenbuch*, Bd. I., Bl. 166.

maāχeru	*nebt*	*setau*	*qat*	*sebti*	*ḥert*	*nebt*	
triumphant:	Lady of	terrors,	lofty of	walls,	sovereign lady,	mistress of	

χebχebet	*t'ettu*	*χesef*	*neśeni*	*neḥem*	*uai*
destruction,	[disposer] of	words,	which repulse	destroyers,	delivering from	destruction

en	*ī*	*ren*	*en*	*āri*	*āa* - *s*		*Neruit*
{ the traveller along [the way]. }	The name	of		its doorkeeper	[is]		Neruit.

t'etet	*χeft*	*sper*	*er*	*sebχet*	*sen*	*t'et*	*ān*	*Àusàr*	*ān*
Words spoken	when [one] cometh	to		pylon	the second.	Saith	Osiris, scribe		

Ani	*maāχeru*	*neb[t]*	*pet*	*ḥent*	*taui*	*nesbit*
Ani,	triumphant:	Lady of	heaven,	mistress of	the world,	devourer,

nebt	*tememet*	*tennut*	*er*	*bu*	*nebu*	*ren*	*en*
lady of	mortals;	how much greater [is she]	than	all peoples!	The name	of	

āri	*āāau* - *s*	*Mes-Ptaḥ*	*pu*	*t'etet*	*χeft*	*sper*
the keeper of	its door	Mes-Ptaḥ	is.	Words spoken	when [one] cometh	

er	*sebχet*	*χemt*	*ent*	*pa*	*Àusàr*	*ān*	*ān*	*Ani*
to	pylon	the third	of	the house	of Osiris.	Saith	the scribe	Ani,

¹ Read ‿ ⬭ 𓀁 *sert.*

² *I.e.,* [hieroglyphs] . See Naville, *Todtenbuch,*
Bd. II., Bl. 370.

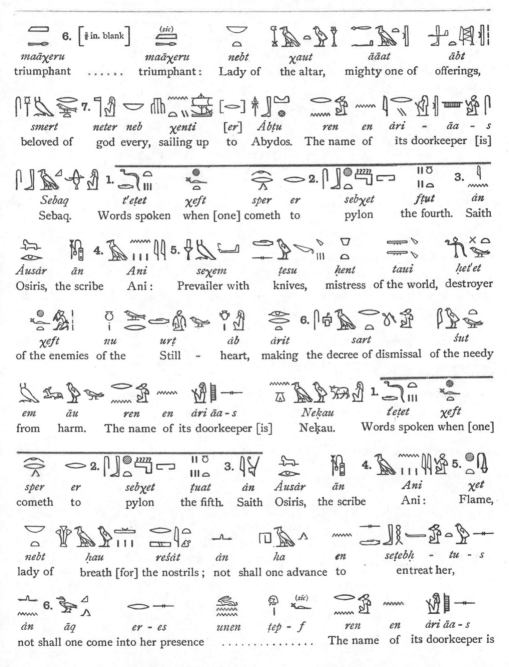

6. [¾ in. blank] (sic)

maāχeru maāχeru nebt χaut āāat ābt
triumphant triumphant: Lady of the altar, mighty one of offerings,

7.

smert neter neb χenti [er] Ábṭu ren en àri - āa - s
beloved of god every, sailing up to Abydos. The name of its doorkeeper [is]

1. **2.** **3.**

Sebaq. t'eṭet χeft sper er sebχet fṭut àn
Sebaq. Words spoken when [one] cometh to pylon the fourth. Saith

4. **5.**

Áusàr ān Ani seχem ṭesu ḥent taui ḥeṭet
Osiris, the scribe Ani: Prevailer with knives, mistress of the world, destroyer

6.

χeft nu urṭ àb àrit sart śut
of the enemies of the Still - heart, making the decree of dismissal of the needy

1.

em àu ren en àri āa - s Neḳau ṭeṭet χeft
from harm. The name of its doorkeeper [is] Neḳau. Words spoken when [one]

2. **3.** **4.** **5.**

sper er sebχet ṭuat àn Áusàr ān Ani χet
cometh to pylon the fifth. Saith Osiris, the scribe Ani: Flame,

nebt ḥau reśàt àn ha en seṭebḥ - tu - s
lady of breath [for] the nostrils; not shall one advance to entreat her,

6. (sic)

àn āq er - es unen ṭep - f ren en àri āa - s
not shall one come into her presence The name of its doorkeeper is

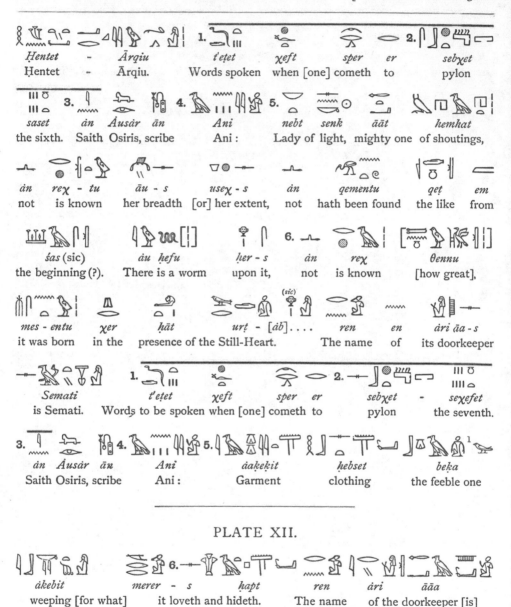

Ḥentet — Ārqiu. t'eṭet χeft sper er sebχet
Ḥentet — Ārqiu. Words spoken when [one] cometh to pylon

saset àn Àusàr àn Ani nebt senk āāt hemhat
the sixth. Saith Osiris, scribe Ani: Lady of light, mighty one of shoutings,

àn reχ - tu āu - s useχ - s àn qementu qeṭ em
not is known her breadth [or] her extent, not hath been found the like from

śas (sic) àu ḥefu ḥer - s àn reχ θennu
the beginning (?). There is a worm upon it, not is known [how great],

mes - entu χer ḥāt urṭ - [àb].... ren en àri āa - s
it was born in the presence of the Still-Heart. The name of its doorkeeper

Semati t'eṭet χeft sper er sebχet - seχefet
is Semati. Words to be spoken when [one] cometh to pylon the seventh.

àn Àusàr àn Ani àaḳeḳit ḥebset beḳa
Saith Osiris, scribe Ani: Garment clothing the feeble one

PLATE XII.

àkebit merer - s ḥapt ren àri āāa
weeping [for what] it loveth and hideth. The name of the doorkeeper [is]

¹ Var.

Sâkti - f. t'etet χeft sper er sebχet χemennet àn
Sâkti - f. Words to be spoken when [one] cometh to pylon the eighth. Saith

Àusâr ân Ani maāχeru rekehet bes āχem t'aft
Osiris scribe Ani, triumphant: Fire blazing, [not to be] quenched the flame,

septet pāt χaāt tet smammet àtet net'net'
provided with flames, far-reaching of hand, slaying not to be gainsaid,

àt seś her - s en sent nāhi - s ren en àri āa-s
not may one pass over it through fear of the hurt thereof. The name of its doorkeeper

χu-t'et-f t'etet χeft sper er sebχet paut àn
[is] Khu-tchet-f. Words to be spoken when [one] cometh to pylon the ninth. Saith

Àusâr Ani àm hāt neb user hereret àb
Osiris Ani: [The one who is] at the front, lady of strength, who quieteth the heart of

mesat neb - s χet 300 + 50 em teben satet em
Mesat (?) her lord, measures three hundred and fifty in circuit, clothed with

uat' qemāu θest bes hebset bek
mother-of-emerald of the south, raising up the divine figure, clothing the feeble one,

¹ Var.

qeq	nebt	ḥrä	neb	ren	en	àri āa-s	Àri-su t'esef	1. t'eṭeṭ
food (?)	face	every.	The name	of	its doorkeeper is	Àri-su-tchesef.	Words to be spoken

χeft	sper	er	sebχet	2. meḥt met	àn	Àusàr	3. Ani	
when	[one]	cometh	to	pylon	the tenth.	Saith	Osiris	Ani:

4. qat - χeru	5. neheset	tenàut	setebḥ	neru
High of voice,	raising	cries [in those who]	make entreaty,	fearful one

en	šefšeft - s	àn	6. senṭ - nes	enti	em	χennu - s	ren
in	her terror,	not	feareth she	whosoever	is	within it.	The name

en	àri āa - s	Seχen - ur
of	its doorkeeper is	Sekhen - ur.

Appendix.

[The following text of the speeches of the deceased at Pylons XI.–XXI. is taken from Naville, *Todtenbuch*, Bd. I., Bl. 161, 162.]

sebχet	meḥt met uā	nemt	ṭesu	uṭebt	sebà	her
Pylon	the eleventh.	Repeater of	slaughter,	burner of	fiends,	terrible is

nes	sebχet	nebt	àrit	àhehi	hru	en	àχeχut	àu - s	χer
she [at]	pylons	all,	making	rejoicing	on the day	of	darkness.	She is	holding

¹ Var.

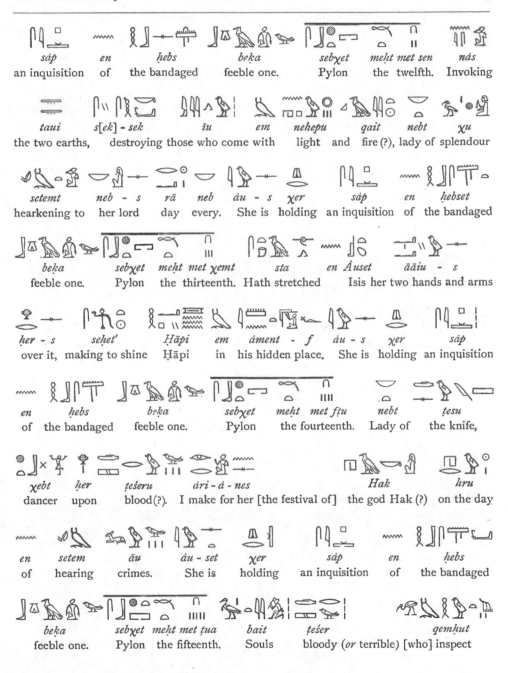

sâp	*en*	*ḥebs*	*beḳa*	*sebχet*	*meḥt met sen*	*nâs*
an inquisition	of	the bandaged	feeble one.	Pylon	the twelfth.	Invoking

taui	*s[ek] - sek*	*îu*	*em*	*neḥepu*	*qait*	*nebt*	*χu*
the two earths,	destroying those who come with		light	and	fire (?),	lady of	splendour

setemt	*neb - s*	*râ*	*neb*	*âu - s*	*χer*	*sâp*	*en*	*ḥebset*
hearkening to	her lord	day	every.	She is	holding	an inquisition	of	the bandaged

beḳa	*sebχet*	*meḥt met χemt*	*sta*	*en Âuset*	*ââiu - s*
feeble one.	Pylon	the thirteenth.	Hath stretched	Isis	her two hands and arms

ḥer - s	*seḥet'*	*Ḥâpi*	*em*	*âment - f*	*âu - s*	*χer*	*sâp*
over it,	making to shine	Ḥâpi	in	his hidden place.	She is	holding	an inquisition

en	*ḥebs*	*beḳa*	*sebχet*	*meḥt met ftu*	*nebt*	*ṭesu*
of	the bandaged	feeble one.	Pylon	the fourteenth.	Lady of	the knife,

χebt	*ḥer*	*ṭeśeru*	*âri - â - nes*	*Hak*	*hru*
dancer	upon	blood(?).	I make for her [the festival of]	the god Hak (?)	on the day

en	*setem*	*âu*	*âu - set*	*χer*	*sâp*	*en*	*ḥebs*
of	hearing	crimes.	She is	holding	an inquisition	of	the bandaged

beḳa	*sebχet meḥt met ṭua*	*bait*	*ṭeśer*	*qemḥut*
feeble one.	Pylon the fifteenth.	Souls	bloody (*or* terrible) [who] inspect	

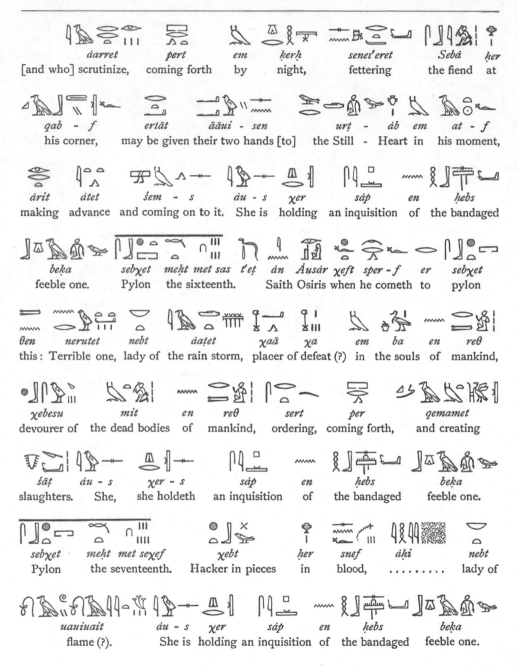

àarret	*pert*	*em*	*ḳerḥ*	*senet'eret*	*Sebä*	*her*
[and who] scrutinize,	coming forth	by	night,	fettering	the fiend	at

qab - f	*eriāt*	*āāui - sen*	*urṭ - àb*	*em*	*at - f*
his corner,	may be given	their two hands [to]	the Still - Heart	in	his moment,

àrit	*àtet*	*šem - s*	*àu - s*	*χer*	*sàp*	*en*	*ḥebs*
making	advance	and coming on to it.	She is	holding	an inquisition	of	the bandaged

beḳa	*sebχet*	*meḥt met sas t'eṭ*	*àn Àusàr χeft sper - f*	*er*	*sebχet*
feeble one.	Pylon	the sixteenth.	Saith Osiris when he cometh to		pylon

θen	*nerutet*	*nebt*	*àaṭet*	*χaā*	*χa*	*em*	*ba*	*en*	*reθ*
this:	Terrible one,	lady of	the rain storm,	placer of defeat (?)		in	the souls	of	mankind,

χebesu	*mit*	*en*	*reθ*	*sert*	*per*	*qemamet*
devourer of	the dead bodies	of	mankind,	ordering,	coming forth,	and creating

šāṭ	*àu - s*	*χer - s*	*sàp*	*en*	*ḥebs*	*beḳa*
slaughters.	She,	she holdeth	an inquisition	of	the bandaged	feeble one.

sebχet	*meḥt met seχef*	*χebt*	*her*	*snef*	*àḥi*	*nebt*
Pylon	the seventeenth.	Hacker in pieces	in	blood,	lady of

uauiuait	*àu - s*	*χer*	*sàp*	*en*	*ḥebs*	*beḳa*
flame (?).	She is	holding	an inquisition	of	the bandaged	feeble one.

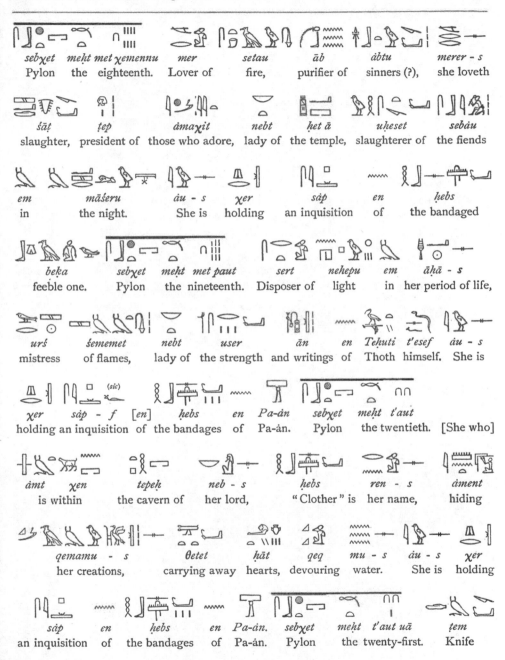

sebχet	meḥt	met χemennu	mer	setau	āb	ȧbtu	merer - s
Pylon	the	eighteenth.	Lover of	fire,	purifier of	sinners (?),	she loveth

šāṭ	ṭep	ȧmaχit	nebt	ḥet ā	uḥeset	sebȧu
slaughter,	president of	those who adore,	lady of	the temple,	slaughterer of	the fiends

em	māśeru	ȧu - s	χer	sȧp	en	ḥebs
in	the night.	She is	holding	an inquisition	of	the bandaged

beḳa	sebχet	meḥt	met paut	sert	neḥepu	em	āḥā - s
feeble one.	Pylon	the	nineteenth.	Disposer of	light	in	her period of life,

urś	šememet	nebt	user	ān	en	Teḥuti	t'esef	ȧu - s
mistress	of flames,	lady of	the strength	and writings of		Thoth	himself.	She is

χer	sȧp - f	[en]	ḥebs	en	Pa-ȧn.	sebχet	meḥt	t'aut
holding	an inquisition	of	the bandages	of	Pa-ȧn.	Pylon	the	twentieth. [She who]

ȧmt	χen	tepeḥ	neb - s	ḥebs	ren - s	ȧment
is within		the cavern of	her lord,	"Clother" is	her name,	hiding

qemamu - s	θetet	ḥāt	qeq	mu - s	ȧu - s	χer
her creations,	carrying away	hearts,	devouring	water.	She is	holding

sȧp	en	ḥebs	en	Pa-ȧn.	sebχet	meḥt	t'aut uā	ṭem
an inquisition	of	the bandages	of	Pa-ȧn.	Pylon	the	twenty-first.	Knife

[ṭe]sia	er	t'eṭu	ȧri	ḥemen	hai
cutting	when is uttered [its name],		making the slaughter (?)	[of those who]	advance

nebȧu - s	ȧu - s	χer	seχeru	ȧmen
to her flames.	She is	possessing	schemes	hidden.

1.

t'eṭ	ȧn	Ȧn-māut-f	t'eṭ-f	ī-[ȧ]	χer	ten	t'aṭ'aṭ	āāt
Speaketh		Ȧn-māut-f.	He saith:	[I have] come	to	you,	O divine chiefs,	mighty

			2.			
ȧmu	pet	ta	Neter-χert	ȧn - nȧ - ten		Ȧusȧr
[who are] in	heaven,	earth	and the nether-world,	I have brought to you		Osiris

Ani	ȧn	beta - f	χer	neteru	nebu	ȧmmā	un - f
Ani;	not	hath he sinned	against	gods	any.	Grant	that he may be

ḥenā - ten	hru	neb
with you	day	every.

1.

ṭua	Ȧusȧr	neb	Re-stau	paut	neteru	āāt	ȧmi
An adoration of	Osiris,	lord of	Re-stau,	[and] of the cycle of the gods		great	[which is] in

					2.			
Neter-χert	ȧn	Ȧusȧr	ān	Ani	t'eṭ-f	ȧnet'-ḥrȧ-k		χent
Neter-χert.		Osiris, the scribe		Ani,	he saith:	Homage to thee,		president of

Ȧmentet	Un-nefer	ḥer-ȧb	Ȧbṭu	ī-[ȧ]	χer - k	ȧb-ȧ	χer
Amentet,	Un-nefer	within	Abydos!	I have	come to thee,	and my heart	possesseth

3. *maāt* *àn* *àsf* *em* *χat - à* *àn* *t'eṭ-[à]* *ḳer* *em* *reχ*

right and truth. Not is there sin in my body, not have I spoken lies with knowledge,

àn *àri - à* *sep* *sen* *ṭā - k* *nà* *tau* 4. *per*

not have I acted with a motive double. Grant thou to me cakes, and a coming forth

embaḥ *her* *χaut* *nebu* *maāt* *ì* *āq*

in the presence at the altar of the lords of right and truth, a going in and a coming out

em *Neter-χert* *àn* *śentu* *ba-à* *[maa]* *àθen* *tekeḳ*

from Neter-khert, not being driven away my soul from the sight of the disk, the sight of

5. *àḥ* *t'etta* *sep sen*

the moon for ever: twice.

1. *t'eṭ* *àn* *Se - mer - f* *t'eṭ - f* *ì - χer - ten* *t'at'at* *àmu*

Speaketh Se - mer - f. He saith : [I have] come to you, O divine chiefs [who are] in

Re - stau *àn - nà - ten* *Àusàr* 2. *Ani* *àmmā* *tau* *mu*

Re - stau. I have brought to you Osiris Ani. Grant cakes, water,

nifu *. seḥ* *em* *Seχet - ḥetepet* *mà* *śesu* *Ḥeru*

wind, an estate in Sekhet - ḥetep as [to] the followers of Horus.

1. ✶ *ṭua* *Àusàr* *neb* *t'etta* *t'at'at* *nebu* *Re-stau*

An adoration of Osiris lord of everlastingness, [and of] the divine beings lords of Re-stau.

àn	*Àusàr*	*[àn Ani]*	*t'et - f*	*ànet'-ḥrà-k*	*suten*	*Neter-χert,*	
	Osiris	[scribe Ani]	he saith :	Homage to thee,	king of	the nether-world,	

heq	*nu*	*Àkert*	*ì-[à]*	*χer - k*	*reχ-k[uà]*	*seχeru - k*	*àper-k[uà]*
prince	of	Akert,	[I have] come	to thee,	I know	thy plans,	I am provided

em	*àru - k*	*en*	*ṭuat*	*ṭà - k - nà*	*àuset*	*em*	*Neter-χert*
with	thy forms	in	the nether-world.	Grant thou to me	a place	in	the nether-world

erma	*nebu*	*maāt*	*seḥ - à*	*men*	*em*	*seχet-ḥetepu*	
near	the lords	of right and truth,	my estate may	it be permanent	in	Sekhet-ḥetep,	

seśep	*sennu*	*embaḥ - k*	
[may I] receive	cakes	before thee.	

PLATE XIII.

[1. *à*	*Teḥuti*	*semaāχeru*	*Àusàr er*	*χefta - f*	*semaāχeru*	*Àusàr er*		
Hail	Thoth,	making victorious	Osiris over	his enemies,	make victorious	Osiris over		

χefta - f	*mà*	*semaāχeru*	*Àusàr er*	*χefta-f*	*embaḥ*	*t'at'at*	
his enemies,	as thou madest victorious	Osiris over	his enemies	before	the divine beings		

àmt	*Rā*	*àmt*	*Àusàr*	*àmt*	*Ànnu*	*kerḥ*	*en*	*χet*
[who are] with	Rā	and with	Osiris	in	Heliopolis,	[on] the night	of	the things

¹ Papyrus, ⟨glyph⟩.

χaui	ḳerḥ	pui	en	āba - ā	en	ȧrit	saut
of the night,	night	that	of	battle	and	of making	the fettering

sebȧu	hru	pu	en	ḥetem - tu	χefta	nu	Neb-er-t'er
of the Sebau,	day	that	of	destroying	the enemies	of	Neb-er-tcher.

§ A. 1.

ȧr	t'at'at	āāt	ȧmt	Ȧnnu	Tmu	pu	Śu	pu
The divine chiefs	great	in	Heliopolis are	Temu,		Shu,		

Tefnut	pu	ȧr	2. saiu	sebȧu	ḥetem - entu
Tefnut.		Now	the fettering	of the Sebau	the destruction

sami	Set	pu	em	nem	3. qen - tuf	ȧ	Teḥuti
of the fiends	of Set	is	the second time	he wrought evil.	Hail	Thoth,	

semaāχeru	Ȧusȧr	er	χefta - f	semaāχeru	Ȧusȧr	Ani
making victorious	Osiris	against	his enemies,	make to triumph	Osiris	Ani

4. Ani	er	χefta - f	em	t'at'at	āāt	ȧmt
Ani (sic)	against	his enemies	before	the divine beings	great [who are] in	

Ṭeṭṭetu	ḳerḥ	pui	en	seāḥā	ṭeṭ	em	Ṭeṭṭetu
Tattu [on]	night	that	of	making to stand up	the Tet	in	Tattu.

[1] The passage in brackets is supplied from Naville, *Todtenbuch*, Bd. I., Bl. 31.

[2] Var. ḥait.

[3] In many papyri the order of this and of the following sections is changed.

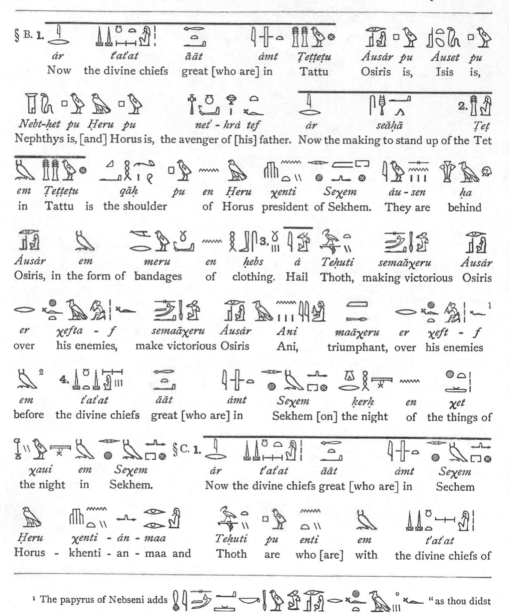

§ B. 1.

ȧr	t'at'at	āāt	ȧmt	Ṭeṭṭetu	Ȧusȧr pu	Ȧuset pu
Now	the divine chiefs	great [who are] in		Tattu	Osiris is,	Isis is,

Nebt-ḥet pu Ḥeru pu	net' - ḥrȧ tef	ȧr	seāḥā	2. Ṭeṭ
Nephthys is, [and] Horus is,	the avenger of [his] father.	Now	the making to stand up of the Tet	

em	Ṭeṭṭetu	qāḥ	pu	en	Ḥeru	χenti	Seχem	ȧu - sen	ḥa
in	Tattu	is	the shoulder	of	Horus	president	of Sekhem.	They are	behind

Ȧusȧr	em	meru	en	ḥebs	ȧ	Teḥuti	semaāχeru	Ȧusȧr
Osiris,	in the form of	bandages	of	clothing.	Hail	Thoth,	making victorious	Osiris

er	χefta - f	semaāχeru Ȧusȧr	Ani	maāχeru	er	χeft - f
over	his enemies,	make victorious Osiris	Ani,	triumphant,	over	his enemies[1]

em	4. t'at'at	āāt	ȧmt	Seχem	ḳerḥ	en	χet
before	the divine chiefs	great [who are] in		Sekhem	[on] the night	of	the things of

χaui	em	Seχem	§ C. 1. ȧr	t'at'at	āāt	ȧmt	Seχem
the night	in	Sekhem.	Now the divine chiefs		great [who are] in		Sechem

Ḥeru	χenti - ȧn - maa	Teḥuti	pu	enti	em	t'at'at
Horus -	khenti - an - maa	and Thoth	are	who [are]	with	the divine chiefs of

[1] The papyrus of Nebseni adds ⟨hieroglyphs⟩ "as thou didst make Osiris to triumph over his enemies."

[2] Var. ⟨hieroglyphs⟩ embaḥ, "before."

Naârereṭef. 2. âr kerḥ pui en χet χaut
Naârerutf. Now night that of the things of the night

 heṭ' ta pu er qeres Âusâr â Teḥuti
of the festival the daybreak is at the sarcophagus of Osiris. Hail Thoth,

semaāχeru Âusâr 3. er χefta - f semaāχeru Âusâr ân
making to triumph Osiris over his enemies, make to triumph Osiris, the scribe

Ani er χeft - f em t'at'at āāt àmt Pet Ṭept
Ani, over his enemies before the divine chiefs great in Pet and Tept

4. kerḥ pui en se-āḥā āāiui en Ḥeru
[on] night that of setting up the columns of Horus [and of]

smen - tu nef āuāt em χet tef - f Âusâr § D. 1. âr
making him to be established heir of the things of his father Osiris. Now

t'at'at āāt àm Pet Ṭept Ḥeru pu Âuset pu Mesθà pu
the divine chiefs great in Pet and Tept Horus is, Isis is, Mesthà is, [and]

Ḥāpi pu âr seāḥā āāiui en 2. Ḥeru ṭeṭ Set pu
Ḥāpi is. Now the setting up of the pillars of Horus the saying of Set is

en àmu - χet seāḥā āāiui eres à Teḥuti semaāχeru
to [his] followers, "Set up columns upon it." Hail Thoth, making to triumph

¹ The variants are [hieroglyphs], [hieroglyphs], and [hieroglyphs].

Áusâr er χefta - f semaāχeru Áusâr ān Ani maāχeru
Osiris over his enemies, make to triumph Osiris, the scribe Ani, (triumphant

nef er χefta - f em t'at'at āāt àmt Taiu (?)- reχit
is he) over his enemies before the divine chiefs great in Taiu (?)- Rekhit [on]

4. kerḥ pui en st'er Áuset res - tu her àrit kabit
night that of the lying down of Isis watching to make lamentation

her sen - s Áusâr § E. 1. àr t'at'at āāt àmt Taiu(?)-reχit Áuset
for her brother Osiris. Now the divine chiefs great in Taiu(?)-Rekhit Isis

pu Ḥeru pu Mesθà pu à Teḥuti semaāχeru Áusâr er
is, Horus is, and Mesthà is. Hail Thoth, making to triumph Osiris over

χefta - f semaāχeru Áusâr ān Ani maāχeru em ḥetep
his enemies, make to triumph Osiris, the scribe Ani, triumphant in peace!

er χefta - f em t'at'at āāt àmt Àbṭu kerḥ
over his enemies before the divine chiefs great in Abydos [on] night

pui en Haker em tennu mitu em sàpt
that of Haker, at the separation of the dead, at the judgment

4. χu em χeper àhabu em Teni
of good spirits, at the coming into existence of cries of joy in Teni.

PLATE XIV.

F. 1.
àr	t'at'at	āāt	àmt	Abṭu	Àusàr	pu	Àuset	pu
Now	the divine chiefs	great	in	Abydos	Osiris	is,	Isis	is, and

Ap-uati	pu	à	Teḥuti	smaāχeru	Àusàr	er	χefta - f
Ȧp-uat	is.	Hail	Thoth,	making to triumph	Osiris	over	his enemies,

semaāχeru	Àusàr	ān	hesb	ḥetep	neter	en	neteru nebu
make to triumph	Osiris,	the scribe,	the accountant	of the divine offerings	of	gods	all,

Ani	er	χefta - f	em	t'at'at	àput
Ani,	over	his enemies	before	the divine chiefs [who]	judge

mitu	ḳerḥ	pui	en	àrit	sàpt	menta	sen
the dead	on	night	that	of	making	the judgment	of those who are annihilated.

§ G. 1.
àr	t'at'at	āāt	àmt	àp	mitu	Teḥuti	pu
Now	the divine chiefs	great	in	the judgment	of the dead	Thoth	is,

[1] Var.
em	t'at'at	àmt	mitu	ḳerḥ	pui	en	àrit
"before	the divine beings	among	the dead	[on] night	that	of	making

sàpt	menta - set
judgment	annihilated are they."

See Naville, *Todtenbuch*, Bd. II., Bl. 79.

[2] Var. àm uat mita, "in the way of the dead."

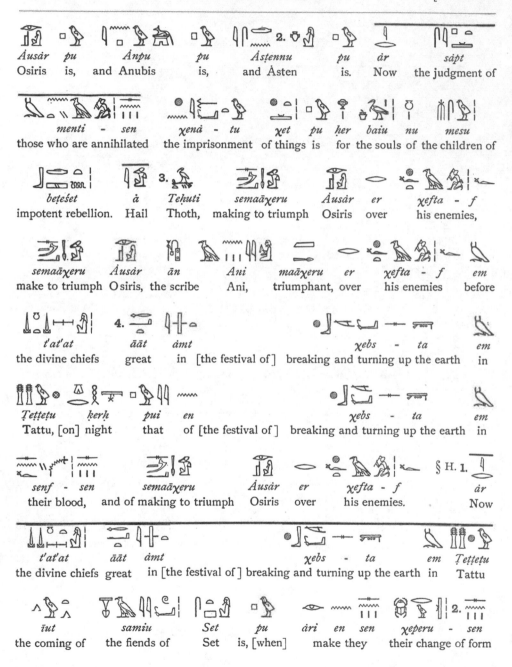

Àusâr pu Ànpu pu Àstennu pu âr sâpt
Osiris is, and Anubis is, and Àsten is. Now the judgment of

menti - sen χenà - tu χet pu ḥer baiu nu mesu
those who are annihilated the imprisonment of things is for the souls of the children of

beṭeṣet à Teḥuti semaāχeru Àusâr er χefta - f
impotent rebellion. Hail Thoth, making to triumph Osiris over his enemies,

semaāχeru Àusâr ân Ani maāχeru er χefta - f em
make to triumph Osiris, the scribe Ani, triumphant, over his enemies before

t'at'at āāt àmt χebs - ta em
the divine chiefs great in [the festival of] breaking and turning up the earth in

Ṭeṭṭeṭu kerḥ pui en χebs - ta em
Tattu, [on] night that of [the festival of] breaking and turning up the earth in

senf - sen semaāχeru Àusâr er χefta - f § H. 1. âr
their blood, and of making to triumph Osiris over his enemies. Now

t'at'at āāt àmt χebs - ta em Ṭeṭṭeṭu
the divine chiefs great in [the festival of] breaking and turning up the earth in Tattu

îut samiu Set pu àri en sen χeperu - sen
the coming of the fiends of Set is, [when] make they their change of form

em　āut　āḥā　en　sen　sefet　embaḥ　ā　neteru　āpu
into　animals,　they　are slain　in the presence of　gods　those,

en　t'erā - entu　senf - u　haï　ām - sen　erṭāu - entu
and　being smitten down　their blood　floweth　among them ;　are granted these things

em　sāpt　en　āmu　Ṭeṭṭeṭu　ā　Teḥuti　semaāχeru　Ausār
by　the judgment　of　those who are in　Tattu.　Hail　Thoth,　making to triumph　Osiris

er　χefta - f　semaāχeru　Ausār　Ani　er　χefta - f
over　his enemies,　make to triumph　Osiris　Ani　over　his enemies

em　t'at'at　āāt　āmt　Naārereṭef　ḳerḥ　pui　en
before　the divine chiefs　great　in　Naārereṭef　[on]　night　that　of

§ I. I.

seśeta　āru　ār　t'at'at　āāt　āmt　Naārereṭef
making secret　the forms.　Now the divine chiefs great　in　Naārereṭef

Rā　pu　Ausār　pu　Śu　pu　Bebi　pu　ār　ḳerḥ　pui　en
Rā　is,　Osiris　is,　Shu　is,　and Bebi　is.　Now　night　that　of

2.

seśeta　āru　unentu　her　ḳeres　χepeś
making secret　the forms　is the presence　at　the sarcophagus　[of] the thigh,

[1] Var. *ābu.*

[2] Var. *āā āru,* "Mighty one of forms."

[3] The papyrus of Nebseni adds *t'at'a,* "head."

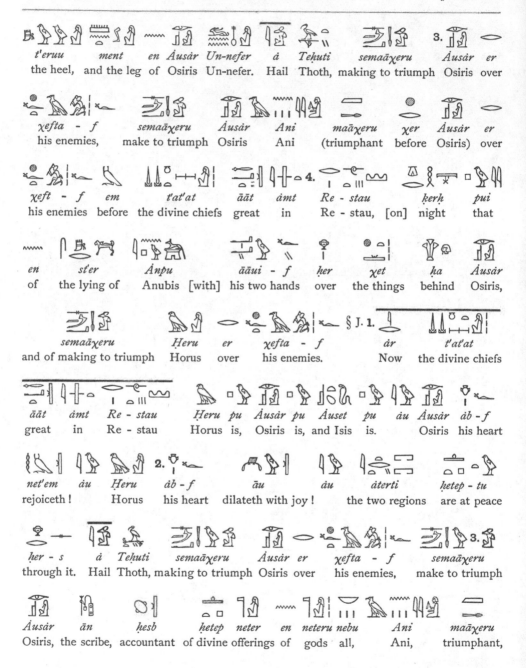

t'eruu ment en Åusår Un-nefer å Tehuti semaāχeru Åusår er
the heel, and the leg of Osiris Un-nefer. Hail Thoth, making to triumph Osiris over

χefta - f semaāχeru Åusår Ani maāχeru χer Åusår er
his enemies, make to triumph Osiris Ani (triumphant) before Osiris) over

χeft - f em t'at'at āāt åmt Re - stau kerh pui
his enemies before the divine chiefs great in Re - stau, [on] night that

en st'er Ånpu āāui - f her χet ha Åusår
of the lying of Anubis [with] his two hands over the things behind Osiris,

semaāχeru Heru er χefta - f år t'at'at
and of making to triumph Horus over his enemies. Now the divine chiefs

āāt åmt Re - stau Heru pu Åusår pu Åuset pu åu Åusår åb - f
great in Re - stau Horus is, Osiris is, and Isis is. Osiris his heart

net'em åu Heru åb - f āu åu återti hetep - tu
rejoiceth! Horus his heart dilateth with joy! the two regions are at peace

her - s å Tehuti semaāχeru Åusår er χefta - f semaāχeru
through it. Hail Thoth, making to triumph Osiris over his enemies, make to triumph

Åusår ān hesb hetep neter en neteru nebu Ani maāχeru
Osiris, the scribe, accountant of divine offerings of gods all, Ani, triumphant,

er	χefta - f	em	t'at'at	4. āāt	met	åmt	Rā	åmt	Åusår
over	his enemies	before	the divine chiefs	great	ten	with	Rā,	with	Osiris,

åmt	neter	neb	netert	nebt	embaḥ	ā	Neb-er-t'er	ṭer - f
with	god	every,	goddess	every,	before		Neb-er-tcher;	he hath destroyed

5. χefta - f	ṭer - f	ṭut	nebt	årt - f	t'eṭṭu	re
his enemies,	he hath destroyed	evil	all	belonging to him.	If be said	chapter

pen	āb	per	pu	em	hru	em - χet	menå
this,	the pure [one]	cometh forth	by		day,	after	death, [and he maketh]

tut	ṭāṭā	åb - f	år	χer	seseṭṭu	re	pen	neb
the form	[which] would give	his heart.	Now	if	be recited	chapter	this	all

her - f	ut'a	pu	åri - nef	ṭep	taiu	åu - f	per - f	em	χet
over him,	strong	it	maketh him	upon	earth;	he will come forth		from	fire

nebt	ån	rer	su	χet	neb	ṭut	nebt	åri - f
every,	not	shall encompass	him	thing	any	or evil	any	which appertaineth to him

ses	maāt	heḥ	sep
with unbroken regularity		millions of times.	

PLATE XV.

1.
re — *un* — *re* — *en* — *Áusár* — *án* — *Ani* — *t'etá* — *un*

Chapter of opening the mouth of Osiris, the scribe Ani. To be said : Be opened

re - á — *án* — *Ptah* — *uáu* — *netu* — *sep sen* — *áru* — *re - á* — *án*

my mouth by Ptah, untied the bandages, twice, which are upon my mouth by

2.
neter — *nut - á* — *í* — *áref* — *Tehuti* — *meh* — *áper* — *em* — *hekau*

the god of my town. Come then, Thoth, filled with [and] provided with charms,

uáu — *netu* — *sep sen* — *en* — *Set* — *sau* — *re - á* — *xesef - tu*

untie the bandages, twice, of Set [which] fetter my mouth ; repulsing

3.

Tem — *uten - nef* — *sen - f* — *sai* — *set*

Tmu shoots them he at those who would fetter [me with] them.

un — *re - á* — *ápu* — *re - á* — *án* — *Su* — *em* — *nut(?)-f* — *tui*

Be opened my mouth, be unclosed my mouth by Shu with weapon his that

4.

ent — *báat* — *en* — *pet* — *enti* — *áp - nef* — *re* — *en* — *neteru* — *ám - s*

of iron of heaven he opened the mouth of the gods with it.

¹ Var. "may he shoot them at that which guardeth my mouth" (No. 10,471, plate 8) ; (No. 10,477, plate 5).

nuk	Seχet	ḥems - á	ḥer	ḳes	ámt	urt	āāt	ent	pet	nuk
I am	Sekhet,	I sit	upon	side	west		great	of	heaven.	I am

Saḥu	urt	ḥer - áb	baiu	Ánnu	ár	ḥeka
Sah	the great	in the midst of	the souls of	Heliopolis.	As concerning	charms

neb	t'etet	neb	t'eṭu	er - á	sut	āḥā	neteru	er - sen
all	and words	all	spoken	against me	these,	may resist	the gods	them,

paut	neteru	ṭemṭiu
and the cycle of	the gods	all.

1. ṛe	en	án	ḥeka	en	Áusár	Ani	2. nuk	Tem -	χeperá
Chapter	of	bringing	charms	to	Osiris	Ani:	I am	Tmu -	Khepera

χeper	t'esef	ḥer	uárt	mut - f	ertáu	unśu
[who] produced	himself	upon	the leg	of his mother.	Are made	wolves

en	ámi	Nu	behennu	en	ámiu	t'at'at
those who are in	Nu,	and	hyænas	those who are among		the divine chiefs.

ást	ṭemṭ - ná	ḥekau	pen	entef	χer	se	entef	χer - f
Behold I collect		charm	{ this [from every place where] }	it is,	from	the person	with whom it is,	

betennu	er	θesem	χaχ	er	śuit	à	ánen	máχent
quicker	than	greyhounds,	fleeter	than	light.	Hail	bringer	of the boat

ent	*Rā*	*ruṭ*	*āqi - k*	*em*	*meḥit*	*em*	*χent - k*
of	Rā,	strong [are]	{ thy sail and rudder ropes }	in	the wind	as	thou sailest

er	*Śe - nesert*	*em*	*neter-χert*	*àsk*	*ṭemṭ - nek*	*ḥekau*	*pen*
over	the Lake of Fire	in	the underworld.	Behold	thou collectest	charm	this

em	*bu*	*neb*	*enti*	*f*	*àm*	*χer*	*se*	*enti*	*f*	*χer - f*	*betenu*
from	place	every	in which	it [is]	there,	from	the person	with whom	it [is],	quicker	

er	*θesemu*	*χaχt*	*er*	*śuit*	*àrit*	*χeperu*	*em*	*ertu*
than	greyhounds,	swifter	than	light,	making	forms of existence	from	the thigh(?)

¹ The end of this chapter according to the Nebseni papyrus is as follows :—

ki	*t'eṭ*	*χaχ*	*er*	*Śu*	*en*	*ertā*	*em*	*qemam*	*neteru*
otherwise	said,	swifter	than	Shu	who	maketh	the	creation of	the gods

em	*sekerà*	*en*	*ertātu*	*beḳu*	*en*	*ertā*	*serefu*	*ṭepu*
from [*or* in]	silence,	who	maketh them	powerless,	who	giveth	heat to	the heads

en	*neteru*	*àsθ*	*ertā - nà*	*en*	*ḥekau*	*pen*	*em*	*bu*	*neb*
of	the gods.	Behold	is given to me		charm	this	from	place	every

enti - f	*àm*	*χer*	*se*	*enti - f*	*χer - f*	*beten*	*er*	*θesem*
in which it is,		from	person	with whom it	is,	quicker	than	a greyhound,

χaχ	*er*	*śuit*
fleeter	than	light.

6.

mut	*em*	*qemam - tu*	*neteru*	*em*	*sekeru*	*erṭā - entu*
of the mother,		creating	the gods	from	silence,	giving

mut	*seref*	*en*	*neteru*	*àstu*	*erṭā - nā*	*ḥekau*	*àpen*
the mother (?)	heat	to	the gods.	Behold	is given to me	charm	this

χer	*enti - f*	7. *betennu*	*er*	*θesemu*	*χaχ*	*er*	*šuit*
from	where it is	quicker	than	greyhounds,	fleeter	than	light;

ki	*t'eṭ*	*χaχ*	*er*	*šuit*
otherwise	said,	fleeter	than	a shadow (?).

Appendix.[1]

1. *Re*	*en*	*erṭāt*	*seχau*	2. *ren - f*	*em*	*Neter-χert*	*erṭā - nā*
Chapter of		{ making [the] deceased] }	to remember	his name	in the netherworld.		May be given to me

ren - à	*em*	*pa*	*ur*	*seχa-à*	*ren - à*	*em*	*pa*
my name	in the	Great	Double House,	may I remember	my name	in the	House

neser	3. *kerḥ*	*pui*	*en*	*àp*	*renput en*	*tennut*
of Fire	[in] night	that	of	computing	years	[and] telling the number of

àbeṭ	*nuk*	*àmi*	*pui*	*ḥems - à*	*ḥer*	*kes*	*àbti*	*en*
the months.	I am	with	that Divine Being, and	I sit	at	the side	east	of

[1] The text of this chapter is taken from the papyrus of Nebseni (Brit. Mus., No. 9900).

pet	*neter*	*neb*	*temu - f*	*em sa - à*	*t'eṭ - à*	*ren - f*	*em - χet*
heaven.	God	any	advanceth he	behind me,	I declare	his name	immediately.

1. *Re en erṭāt àb en Àusàr Ani nef em Neter-χert* **2.**

Chapter of giving the heart to Osiris Ani to him in the netherworld. [Ani saith:]

àb - à	*nà*	*em*	*pa*	*àbu*	*ḥāti - à*	*nà*	*em*	*pa*	*ḥātu*
May my heart be to me		in the	House	of hearts,	my heart [be]	to me	in the	House	of hearts.

àu - nà	*àb - à*	*ḥetep - f*	*àm - à*	*àn*	*àmu - à*	*śetā*	*ent Àusàr*
May be to me	my heart,	may it rest	in me, [or]		I shall not eat	the cakes	of Osiris

ḥer	*ḳes*	*àbti*	*en*	*aḳi*	**3.** *χuχet*	*em*	*χeṭ - k*
on the	side	east	of	the Lake of Flowers.	A boat	in	thy going down [the Nile],

χenti - k	*àn*	*ha - à*	*er*	*χuṭet*	*àmi - k*	*àu - nà*
and in thy sailing up,	nor	shall I advance	to	the boat	with thee.	May be to me

re - à	**4.** *t'eṭu - à*	*àm - f*	*reṭ - à*	*er*	*śemt*
my mouth	[that] I may speak	with it,	my two legs	to	walk,

āāui - à	*er*	*seχer*	*χeft - à*	*un - nà*	*āa*	*en*
my two hands and arms	to	overthrow	my enemy.	Be opened to me	the doors	of

pet	**5.** *seśu - nà*	*seb*	*erpāt*	*neteru*	*ārtit - f*	*er - à*
heaven,	may unbolt for me	Seb	the chief	of the gods	his two jaws	for me,

un - f maa-à šetentet tunu - f 6. ret - à

may he open my two eyes [which are] blinded, may he make to stretch out my feet

qerfi serut en Ånpu masti - à

which are fastened together, may make strong Anubis my legs

θesu er - à tunu - à 7. Seχet netert unen-à em

to rise up for myself. Maketh me to rise Sekhet the goddess [that] I may be in

pet àri utu - nà em Ḥet-Ptaḥ-ka reχ - à em

heaven, being done what I command in the House of the Ka of Ptaḥ. I know

àb - à seχem - à em 8. ḥāti - à seχem - à em

my heart, I have gained power over my heart, I have gained power over

āāui - à seχem - à em ret - à seχem - à

my two hands and arms, I have gained power over my feet, I have gained the power

em àrit merert ka - à àn 9. χenà - tu ba - à [er]

to do what pleaseth my Ka. Not shall be imprisoned my soul [with]

χat - à [ḥer] sebau nu Åmentet em āq - à em hetep

my body [at] the gates of Amenta, at my entrance in peace

pert em hetep

and coming forth in peace!

1.

Re	*en*	*tem*	*erṭāt*	*χesef - tu*	*àb*	*en*	*Àusàr*	*àn*
Chapter	of	not	allowing	to be driven away	the heart	of	Osiris,	the scribe

ḥeteρ	*neter*	*en*	*neteru*	*nebu*	*Ani*	*maāχeru*	*χer - nef*	*em*
of the divine offerings	of	gods	all	Ani,	triumphant,	from him	in	

Neter-χert	*t'eṭ - f*	*àb - à*	*en*	*mut - à*	*sep sen*	*ḥāti - à*	*en*
the netherworld.	He saith:	My heart		my mother;	twice.	My heart,	

3.

χeρeru - à	*em*	*āḥā*	*er - à*	*em*	*meteru*	*em*
my coming into existence.	Not	be there resistance	to me	in	the judgment,	not

χesef	*er - à*	*em*	*t'at'at*	*em*	*àrit*	*reqi - k*	*er - à*
be there repulse	to me	by	the divine chiefs,	not	make	thy separation	from me

embaḥ	*àri*	*māχait*	*entek*	*ka - à*	*àmi*	*χat - à*
in the presence	of the keeper	of the scales.	Thou art	my double	within	my body

4.

χnem	*seut'a*	*āt - à*	*per - nek*	*er*	*bu*	*nefer*
forming and making strong	my limbs.		Mayest thou come forth	to	the place of	happiness

ḥen - n	*àm*	*em*	*seχenś*	*ren - à*	*en*	*śenit*
[to which] we advance	there.	Not	may make to stink	my name	the	Shenit

àriu	*reθ*	*em*	*āḥā*
who make	men [to be] in	stability.	

[1] For the additions see above, p. 12.

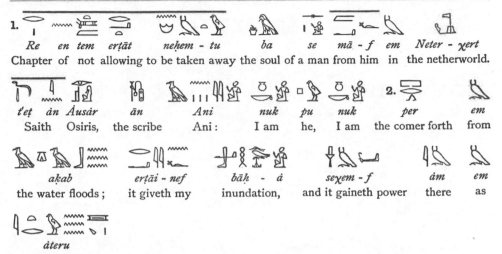

1. *Re en tem erṭāt neḥem - tu ba se mā - f em Neter - χert*
Chapter of not allowing to be taken away the soul of a man from him in the netherworld.

t'eṭ àn Àusàr ān Ani nuk pu nuk per em
Saith Osiris, the scribe Ani : I am he, I am the comer forth from

aḳab erṭāi - nef bāḥ - à seχem - f àm em
the water floods ; it giveth my inundation, and it gaineth power there as

àteru
the river [Nile].

Appendix.

Re en surà em Neter-χert 1. *nuk pu nuk per*
Chapter of drinking water in the underworld. I am he, I am the comer forth

em 2. Seb erṭāi - nef bāḥ seχem - f àm - f
from Seb. Hath been given to him the inundation, he hath obtained power in it

em Ḥāpi nuk un - nà āāu 3. pet seneś - nà
as Ḥāpi. I, I open the two doors of heaven ; are opened to me

āāu qebḥ àn Tehuti àn Ḥāpi pu en
the two doors of the water floods by Thoth [and] by Ḥāpi who the two sons(?) are of

[1] This text is from Naville, *Todtenbuch*, Bd. I., Bl. 72.

4. *pet* *urt* *em* *nehepu* *t̄ā - ten* *seχem - ȧ* *em* *mu* *mȧ*

heaven, mighty of splendours. Grant ye that I may gain power over the water even as

āua *Set* *χerui - f* *nesru* *pu* *nesen* *taui*

conquered Set his enemies on day (?) that of terrifying the world.

5.

seb - nȧ *uru* *qāḥ* *ȧm* *qāḥ* *mȧ* *seb - sen* *neter*

I have passed by the great ones shoulder against shoulder as they have passed by god

pui *āa* *χu* 6. *āper* *χemt* *ren - f* *ȧu* *seb - nȧ*

that great, splendid, provided, unknown [is] his name. I have passed by

ur *qāḥ* *un - nȧ* *urt* *en Ȧusȧr* *senes - nȧ*

the mighty one of the shoulder, I have opened the flood of Osiris, I have passed through 7.

qebḥ *Teḥuti - Ḥāpi - Tem* *neb* *χut* *em ren - f* *pui* *en Teḥuti*

the flood Thoth - Ḥāpi - Tmu, lord of the horizon, in his name that of " Thoth

pens *ta* 8. *seχem - ȧ* *em* *mu* *mȧ* *āua* *Set*

cleaver of the earth." I have gained power in the water as conquered Set

χeru - f *nuk* *t'a* *pet* *nuk* *Rā* *nuk* *Ru* (?) *nuk*

his enemies. I have sailed over heaven. I am Rā, I am the Lion-God, I am

sema *ȧu* *ȧm - nȧ* 9. *χepes* *ȧu* *t̄a - nȧ* *āuā*

the young bull, I have eaten the thigh, I have seized the flesh,

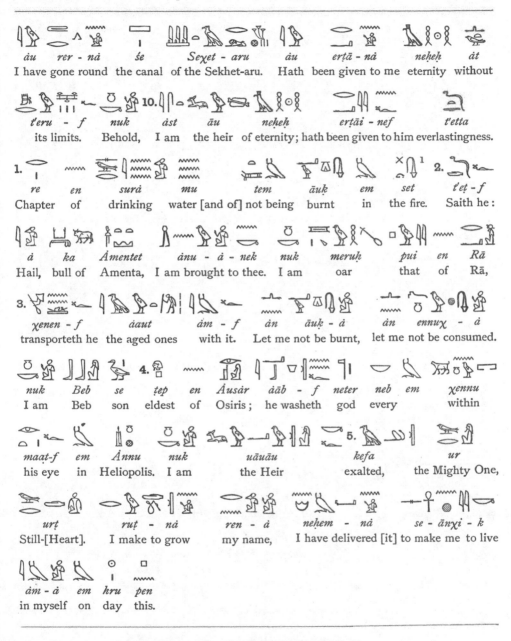

àu rer - nà še Seχet - aru àu erṭā - nà neḥeḥ àt
I have gone round the canal of the Sekhet-aru. Hath been given to me eternity without

t'eru - f nuk àst āu neḥeḥ erṭāi - nef t'etta
its limits. Behold, I am the heir of eternity; hath been given to him everlastingness.

1. re en surà mu tem āuk em set t'eṭ - f 2.
Chapter of drinking water [and of] not being burnt in the fire. Saith he:

à ka Àmentet ànu - à - nek nuk meruḥ pui en Rā
Hail, bull of Amenta, I am brought to thee. I am oar that of Rā,

3. χenen - f àaut àm - f àn āuḳ - à àn ennuχ - à
transporteth he the aged ones with it. Let me not be burnt, let me not be consumed.

nuk Beb se ṭep en Àusàr àāb - f neter neb em χennu
I am Beb son eldest of Osiris; he washeth god every within

maaṭ-f em Ànnu nuk uāuāu kefa ur
his eye in Heliopolis. I am the Heir exalted, the Mighty One,

urṭ ruṭ - nà ren - à neḥem - nà se - ānχi - k
Still-[Heart]. I make to grow my name, I have delivered [it] to make me to live

àm - à em hru pen
in myself on day this.

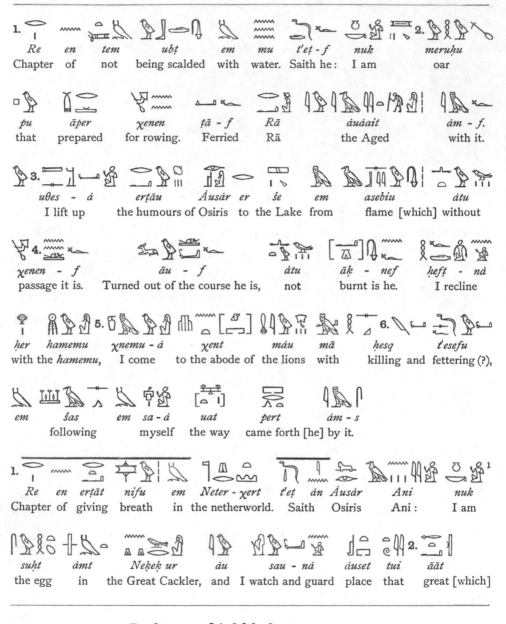

1.

Re	en	tem	ubṭ	em	mu	t'eṭ - f	nuk	2. meruḥu
Chapter	of	not	being scalded	with	water.	Saith he:	I am	oar

pu	āper	χenen	ṭā - f	Rā	àuàait	àm - f.
that	prepared	for rowing.	Ferried	Rā	the Aged	with it.

3.

uθes - à	erṭāu	Àusàr	er	še	em	asebiu	àtu
I lift up	the humours of Osiris		to the Lake	from		flame [which]	without

4.

χenen - f	āu - f	àtu	āḳ - nef	ḥeft - nà
passage it is.	Turned out of the course he is,	not	burnt is he.	I recline

her	hamemu	5. χnemu - à	χent	màu	mà	ḥesq	6. t'esefu
with the hamemu,		I come	to the abode of	the lions	with	killing and	fettering (?),

em	šas	em	sa - à	uat	pert	àm - s
	following		myself	the way	came forth [he] by it.	

1.

Re	en	erṭàt	nifu	em	Neter - χert	t'eṭ	àn	Àusàr	Ani	nuk [1]
Chapter	of	giving	breath	in	the netherworld.	Saith		Osiris	Ani:	I am

suḥt	àmt	Neḳeḳ ur	àu	sau - nà	àuset	tui	2. āàt
the egg	in	the Great Cackler,	and	I watch and guard	place	that	great [which]

¹ Var. [hieroglyphs] "I am Ruruθà, the egg."

àpt	Seb	er	ta	ānχ - à	ānχ - s	neχeχt - à	ānχ - à
proclaimed	Seb	upon	earth.	I live and it liveth;		I grow strong,	I live,

sesen - à	nifu	nuk	utā	aāb	rer - nà	ḥa
I smell	the air.	I am	Utcha -	aāb,	and I go round	behind

en	suḥt - f	beka - nà	at	ur	peḥti	Set	à
his egg,		I have destroyed (?) the moment of the great of strength,				Set.	Hail

neṭ'em	taui	àmi	t'efa	àmi	χesba	sau - ten
{thou who makest pleasant}	the world	with	tchefa food,	[dweller] in	the blue,	watch ye

er	àmi	seśet - f	neχen	per - f	er	ten
over [him that is] in		his nest,	the babe	he cometh forth	to	you.

Appendix.

1.
ki	re	en	erṭāt	nifu	nuk	sab - sabu	nuk	2. Śu
Another	chapter	of	giving	breath.	I am	Sab - sabu.	I am	Shu.

àthu	nifu	em-baḥ	àu	χu	er	t'eru	pet	er
[I] draw in	the air	in the presence	of	the glorious god	at	the limits of	heaven,	at

[1] Var. "I guard that great thing [with which] Seb has made an opening in the earth."

[2] The text is from Naville, *Todtenbuch*, Bd. I., Bl. 67.

t'eru	*ta*	*er*	*t'eru*	*Śu*	*en*	*bàu*	*àu*	*ertàu*	*nifu*
the limits of	earth,	at	the limits	Shu	of	the sky (?).	I	give	breath

en	*enen*	*unnu*
to	those [who are]	children.

1.
Re	*en*	*sesenet*	*nifu*	*emmā*	*ta*	*t'et̠ - f*	*à Tmu*	*t̠ā - k - nà*
Chapter	of	smelling	the air	in	the earth.	Saith he :	O Tmu,	grant thou to me

nifu	*pui*	*net'em*	*àmi*	*śert - k*
breath	that	sweet	in	thy two nostrils.

3.
nuk	*seχen*	*àuset*	*tui*
I	embrace	seat (?)	that

urt	*ḥer-àb*	*Unnu*	*saa - nà*
great	within	Hermopolis.	I guard

4.
suḥt	*tui*	*neḳeḳ*	*ur*
egg	that	of the	Great Cackler.

rut̠-à	*rut̠-s*	*θes rer*	*ānχ-à ānχ-s*	*sen - à*	*nifu*	*sesen - s*	*nifu.*
I grow,	it groweth,	and *vice versâ*;	I live, it liveth ;	I smell	the air,	it smelleth	the air.

1.
Re	*en*	*temt*	*ertāt*	*neḥemtu*	*àb*	*en*	*se*	*mā - f*	*em*
Chapter	of	not	allowing	to be taken away	the heart	of	a person	from him	in

¹ A variant adds :—

un	*re - à*	*petrà - à*	*em*	*maa - à*
"[I] open	my mouth,	I see	with	my eyes."

² The text is from the Nebseni papyrus.

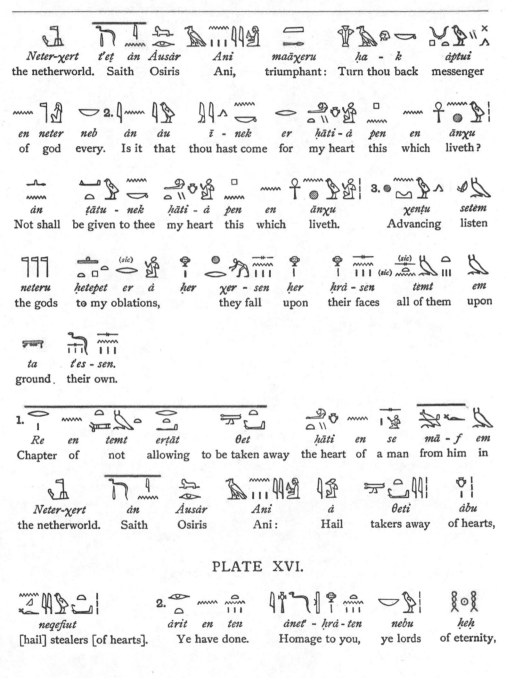

Neter-χert	*t'eṭ*	*àn*	*Àusàr*	*Ani*	*maāχeru*	*ḥa - k*	*àptui*	
the netherworld.	Saith	Osiris		Ani,	triumphant:	Turn thou back	messenger	

en neter	*neb*	*àn*	*àu*	*ī - nek*	*er*	*ḥàti - à*	*pen*	*en*	*ānχu*
of god	every.	Is it	that	thou hast come	for	my heart	this	which	liveth?

àn	*ṭàtu - nek*	*ḥàti - à*	*pen*	*en*	*ānχu*	*χenṭu*	*setèm*
Not shall	be given to thee	my heart	this	which	liveth.	Advancing	listen

neteru	*ḥetepet*	*er*	*à*	*her*	*χer - sen*	*her*	*ḥrà - sen*	*temt*	*em*
the gods	to my oblations,				they fall	upon	their faces	all of them	upon

ta	*t'es - sen.*	
ground .	their own.	

1. *Re*	*en*	*temt*	*erṭàt*	*Θet*	*ḥàti*	*en*	*se*	*mā - f*	*em*
Chapter	of	not	allowing	to be taken away	the heart	of	a man	from him	in

Neter-χert	*àn*	*Àusàr*	*Ani*	*à*	*Θeti*	*àbu*
the netherworld.	Saith	Osiris	Ani:	Hail	takers away	of hearts,

PLATE XVI.

neqefiut	2. *àrit*	*en*	*ten*	*ànet' - ḥrà - ten*	*nebu*	*ḥeḥ*
[hail] stealers [of hearts].	Ye have done.			Homage to you,	ye lords	of eternity,

χeri *t'etta* *em* *θet* *àb* *pen* *en* *Àusàr* *Ani* *em*

possessors of everlastingness, do not take away heart this of Osiris Ani with

t'ebā - ten *ḥāti - f* *pen* *àm* *nen* *seχeperu - ten* *t'etet*

your fingers, and his heart this thither. Not make ye to come into existence words

ṭut *er - f* *ḥerentet* *àri* *àb* *pen* *en* *Àusàr* *Àni* *en* *àb*

evil against it because belongeth heart this to Osiris Ani, heart

pen *en* *āā* *rennu* *ur* *t'etet - f* *en* *āt - f*

this of the great of names, the mighty one, his words are in his limbs,

heb - f *àb - f* *χenti* *χat - f* *mat* *àb - f* *er* *neteru*

goeth forth his heart to inhabit his body. Pleasant [is] his heart to the gods,

àb *en* *Àusàr* *Ani* *maāχeru-nef* *seχem - f* *àm - f* *àn*

the heart of Osiris Ani, victorious is he, he hath gained power over it, not

t'eṭ - f *àrit-nef* *entef* *seχem* *em* *āt - f* *t'esef*

hath he said [what] hath been done to it. He hath gained power over his limbs his own,

setem - nef *àb - f* *entef* *neb - k* *àuk* *em* *χat - f* *àn*

hath obeyed him his heart, he is· thy lord, thou art in his body, not

req - k *nuk* *ututeṭ* *setem - k* *nà*

mayest thou fall away. I have commanded that thou shouldst be obedient to me [in]

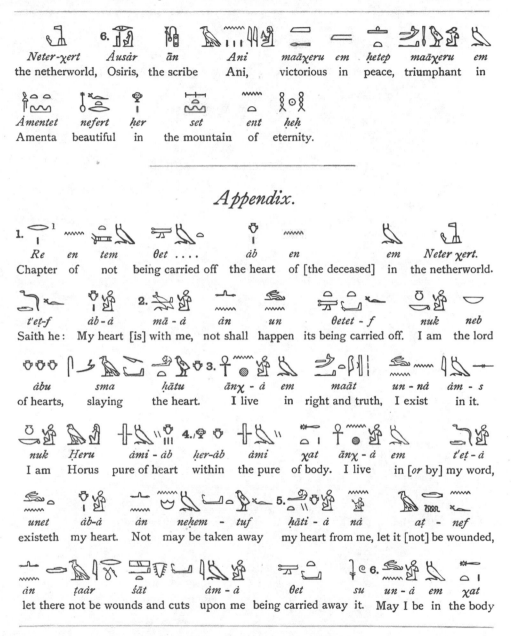

Neter-χert Àusàr ān Ani, maāχeru em ḥetep maāχeru em
the netherworld, Osiris, the scribe Ani, victorious in peace, triumphant in

Àmentet nefert ḥer set ent ḥeḥ
Amenta beautiful in the mountain of eternity.

Appendix.

1. Re en tem θet àb en em Neter χert.
Chapter of not being carried off the heart of [the deceased] in the netherworld.

t'eṭ-f àb-à mā-à àn un θetet-f nuk neb
Saith he: My heart [is] with me, not shall happen its being carried off. I am the lord

àbu sma ḥātu ānχ-à em maāt un-nà àm-s
of hearts, slaying the heart. I live in right and truth, I exist in it.

nuk Ḥeru àmi-àb ḥer-àb àmi χat ānχ-à em t'eṭ-à
I am Horus pure of heart within the pure of body. I live in [or by] my word,

unet àb-à àn nehem-tuf ḥāti-à nà aṭ-nef
existeth my heart. Not may be taken away my heart from me, let it [not] be wounded,

àn ṭaàr śāt àm-à θet su un-à em χat
let there not be wounds and cuts upon me being carried away it. May I be in the body

¹ The text is from Naville, *Todtenbuch*, Bd. I., Bl. 40.

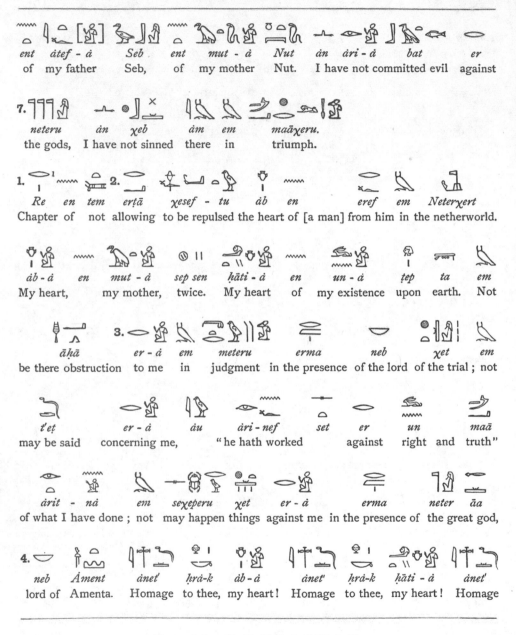

ent àtef - à Seb, ent mut - à Nut. àn àri - à bat er
of my father Seb, of my mother Nut. I have not committed evil against

7. neteru àn χeb àm em maāχeru.
the gods, I have not sinned there in triumph.

1. Re en tem erṭā χesef - tu àb en eref em Neterχert
Chapter of not allowing to be repulsed the heart of [a man] from him in the netherworld.

àb - à en mut - à sep sen ḥāti - à en un - à ṭep ta em
My heart, my mother, twice. My heart of my existence upon earth. Not

āḥā er - à em meteru erma neb χet em
be there obstruction to me in judgment in the presence of the lord of the trial ; not

t'eṭ er - à àu àri - nef set er un maā
may be said concerning me, "he hath worked against right and truth"

àrit - nà em seχeperu χet er - à erma neter āa
of what I have done ; not may happen things against me in the presence of the great god,

4. neb Àment ànet' ḥrà-k àb - à ànet' ḥrà-k ḥāti - à ànet'
lord of Amenta. Homage to thee, my heart ! Homage to thee, my heart ! Homage

¹ The text is from Naville, *Todtenbuch*, Bd. I., Bl. 42.

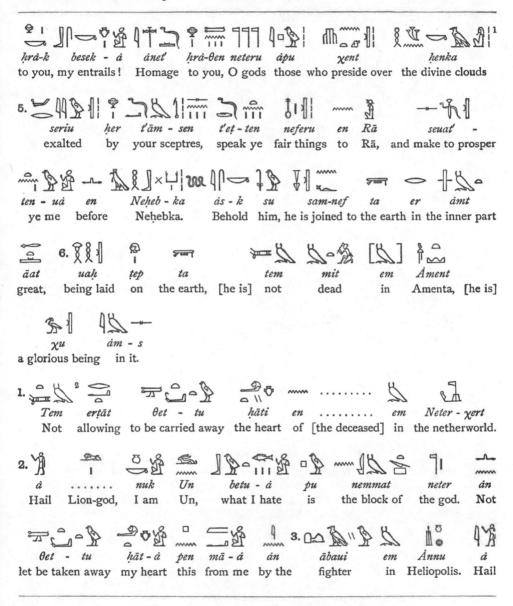

ḥrā-k besek - à ànet' ḥrā-θen neteru àpu χent henka
to you, my entrails! Homage to you, O gods those who preside over the divine clouds

5.
seriu her t'ām - sen t'eṭ - ten neferu en Rā, seuat' -
exalted by your sceptres, speak ye fair things to Rā, and make to prosper

ten - uà en Neḥeb - ka às - k su sam-nef ta er àmt
ye me before Nehebka. Behold him, he is joined to the earth in the inner part

āat 6. uaḥ ṭep ta tem mit em Àment
great, being laid on the earth, [he is] not dead in Amenta, [he is]

χu àm - s
a glorious being in it.

1. Tem ertāt θet - tu ḥāti en em Neter - χert
Not allowing to be carried away the heart of [the deceased] in the netherworld.

2. à nuk Un betu - à pu nemmat neter àn
Hail Lion-god, I am Un, what I hate is the block of the god. Not

θet - tu ḥāt - à pen mā - à àn 3. ābaui em Ànnu à
let be taken away my heart this from me by the fighter in Heliopolis. Hail

1 Var. ḥenksiu, i.e., clouds like hair.
2 The text is from Naville, *Todtenbuch*, Bd. I., Bl. 39.

seṭi en Âusâr maa - nef Set à âni em - sa ḥu
bandager of Osiris, he hath seen Set! Hail returning one from after the smiting of

su ḫerḫert hems 4. ḥâti pen rem - f su t'esef em - baḥ
Him [and his] destruction. Sitteth heart this, weepeth it itself before

Âusâr ḫet - f mā - f ṭebḥ - nef mā - f âu erṭā - nà nef
Osiris; its staff [is] with it, it prayeth [for it] from him, may be given to me for it,

âu sâp - nà nef śetatu âb em ḥet
may be decreed to me for it the hidden things of the heart in the temple of

Useḫ - ḥrà âu ḫenp - nef śā em re ḫemennu àn
the god Usekh-ḥrà, may be granted to it food from the mouth of the Eight(?). Not

θet - tu ḥâti - à pen nuk seḫent en ten âuset-f ennuḥu
let be taken my heart this. I make you to inhabit its place, linking

ḥât er - f em 6. Seḫet - ḥetepu renput user er bu neb ust
hearts to it (?) in Sekhet hetepu, years of vigour in places all mighty,

nehem kau at - k em ḫefā - k ḥer peḥti - k âu
carrying away food [at] thy moment with thy fist according to thy strength. Is

ḥât pen her erṭāt ḳennu en 7. Tem sem - f er tephetu
heart this placed upon the altars of Tmu, he leadeth to the dens

Set	ertā-nef	nà	su	ḥāt-à	àri	en	àb-f	t'at'at	àmt
of Set,	he hath given	to me		my heart,	hath done		its will	the divine chiefs	in

Neter - χert	χenṭ	ḥebs	qemt - en - sen	pu
the nether-world.	The leg	and the bandages	[when] they find	[them]

qeres - en - sen
they bury [them].

1.	Re	en	seset	nifu	seχem	em	mu	em	Neter - χert
	Chapter	of	breathing	the air	and having power	over	the water	in	the nether-world.

t'eṭ	àn	Àusàr	Ani	un - nà	[ni]	mā	trà	tu	entek
Saith		Osiris	Ani :	Open to me!		Who	then art thou?		Thou

sebi	χeper - nek	2. ten	nuk	uā	àm	ten	nimā	enti
journey	makest	what?	I am	one	of	you.	Who is that	who is

ḥenā - k	Merti	pu	ruà - k	eref	ṭep	mā	ṭep	em	3. teken
with thee?	It is Merti.		Separate thou	from him,	head	from	head,	in	entering

Mesqen	ṭā - f	ṭa - à	er	ḥet	ent	qem - ḥràu
the Mesqen.	He granteth	that I may travel	to	the temple	of	{ the gods who have found [their] faces. }

saq	baiu	ren	en	4. māχenti - à	neśi	śen
"Assember of souls" [is]		the name	of	my boat ;	"Making to stand the hair" [is]	

ren	en	useru	sert	ren	en	mat'abet
the name	of	the oars;	"Goad" [is]	the name	of	the hold;

semet	āga	ren	en	hemi	mātet	setut
"Making straight for the middle" [is]	the name	of	the rudder;	likewise		

qeres - k - tu	em	sun	er	erṭāi - ten - nā	māherā	en
...............	in	the lake.		Grant ye to me	a vessel	of

ārtet	śens	pasi	ṭeni (sic)	ur	en	āuf	em	het
milk,	cakes,	loaves,	cups of drink,	and meat	of	flesh	in	the temple

ent	Ànpu	àr	reχ	re	pen	àu - f	āq - f	emχet
of	Anubis.	If	be known	chapter	this	he	entereth	after

pert	em	neter - χert	ent
coming forth	from	the netherworld.	

Re	en	seset	nifu	seχem	em	mu	em	Neter-χert
Chapter	of	smelling	the air	and obtaining power	over	the waters	in	the netherworld

ṭeṭ	àn	Àusàr	Ani	à	nehet	tui	ent	Nut	ṭāt - nà	em
Saith	Osiris	Ani:		Hail	sycamore	that	of	Nut,	grant to me	of

mu (?)	nifu	àmt	nuk	seχen	àuset	tui	ḥer-àbt	Unnu
the water	and air	[which are] in thee.	I	embrace	seat	that	within	Hermopolis

àu	*sau - nà*	*suḥt*	*tui*	*ent*	*neḳeḳ*	*ur*	*ruṭ - s*
I watch and guard		egg	that	of	the Cackler	great ;	it groweth,

ruṭ - à	*ānχ - s*	*ānχ - à*	*seset - s*	*nifu*	*seset - à*	*nifu*	*Àusàr*
I grow ;	it liveth,	I live ;	it smelleth	air,	I smell	air, [I]	the Osiris

Ani	*em*	*maāχeru*
Ani	in	triumph.

Re	*en*	*temt*	*mit*	*em*	*nem*	*em*	*Neter-χert*	*t'eṭ*	*àn*	*Àusàr*
Chapter	of	not	dying	a second time	in	the netherworld.	Saith	Osiris,		

Ani	*unu*	*tephet - à*	*seṗ sen*	*χer*	*χu*
Ani :	Is opened	my hiding-place,	twice.	Hath fallen	light

em	*χennu*	*kekui*	*seru - à*	*maat*	*Ḥeru*	*renen - nuà*
within	the darkness.	Hath arranged me	the eye of	Horus,	hath nursed me	

Àp - uati	*àmen - nuà*	*emmā - ten*	*àu χemu*	*seku*
the god Àp-uat.	I have hidden	myself	with you,	O never setting stars.

àu àṗt(?) à	*em*	*Rā*	*àu ḥrà - à*	*un*	*àu ḥàti - à*	*her àuset - f*
[My] brow [is like that]	of	Rā,	is my face	open,	is my heart	upon its seat,

ṭeṗ	*re - à*	*reχ - [à]*	*nuk*	*Rā*	*māket*	*su*	*t'esef*	*àn*	*χem - à - tu*
I utter words,	[I] know.		I am	Rā	verily	he	himself.	Not	am I made of no effect,

àn	àua - à - tu	ànχ - nek	tef - k	se	Nut	nuk	se - k
not	is violence done to me.	Liveth for thee	thy father,		O son of Nut.	I am	thy son

ur	maa - [à]		śeta - k	àuà	χāā - kuà	em	suten
eldest,	[I] see		thy hidden things.	I,	I am diademed	as	king

neteru	àn	mit - à	em - nem	em	Neter-χert
of the gods,	not	die I	a second time	in	the netherworld.[1]

1.

Re	en	temt	ḥua	em	Neter-χert	t'eṭ	àn	Àusàr	Ani
Chapter	of	not	decaying	in	the netherworld.		Saith	Osiris	Ani :

[1] Compare chapters 175 and 176 ; chapter 176 reads :—

bet - à	pu	ta	en	àbtet	àn	àq - à	er	χebt
[What] I hate	is	the land	of	the east.	M.y I never enter		into	the cavern,

àn	àritu - nà	χet	em	ennu	bet	neteru	ḥerentet	nuk
may never be done to me	things	of		those [which] hate	the gods,		because	I

às	śes	āb	ḥer - àb	mesqet	ertā - n - nef	Neb - er - t'er	χu - f
behold	pass	pure	within	the Mesqet.	May give to him	Neb-er-tcher	his splendours

ḥru	pef	en	sam	taui	embaḥ - ā	neb	χet	àr	reχ
on day	that	of	uniting	the two earths	before	the lord	of things.	If	be known

re	pen	un - nef	em		χu	àger	em	Neter - χert
chapter	this,	he is	in the condition of		a spirit	perfect	in	the netherworld.

(See Naville, *Todtenbuch*, Bd. I., Bl. 200, chap. 176.)

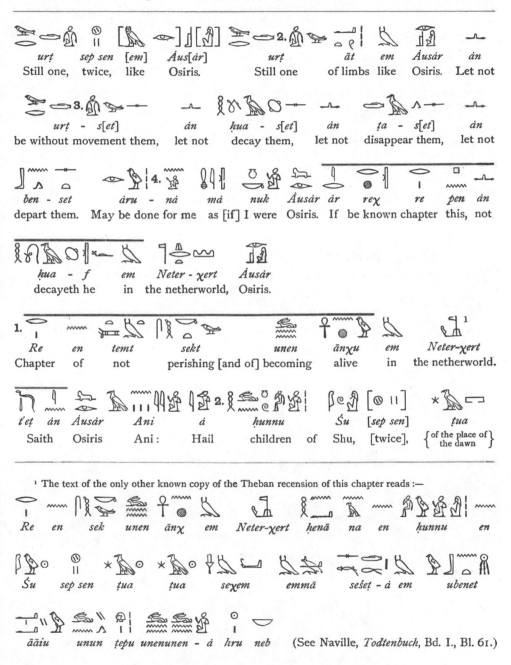

urṭ	sep sen	[em]	Áus[ár]	urṭ	āt	em	Áusár	án
Still one,	twice,	like	Osiris.	Still one	of limbs	like	Osiris.	Let not

urṭ - s[et]	án	ḥua - s[et]	án	ṭa - s[et]	án
be without movement them,	let not	decay them,	let not	disappear them,	let not

ben - set	áru - ná	má	nuk	Áusár	ár	reχ	re	pen	án
depart them.	May be done for me	as [if]	I were	Osiris.	If	be known	chapter	this,	not

ḥua - f	em	Neter - χert	Áusár
decayeth he	in	the netherworld,	Osiris.

1.

Re	en	temt	sekt	unen	ānχu	em	Neter-χert
Chapter	of	not	perishing [and of]	becoming	alive	in	the netherworld.

t'eṭ	án	Áusár	Ani	á	ḥunnu	Śu	[sep sen]	ṭua
Saith	Osiris	Ani :	Hail	children	of	Shu,	[twice],	{ of the place of the dawn }

[1] The text of the only other known copy of the Theban recension of this chapter reads :—

Re	en	sek	unen	ānχ	em	Neter-χert	ḥená	na	en	ḥunnu	en

Śu	sep sen	ṭua	ṭua	seχem	emmá	seśeṭ - á em	ubenet

ááiu	unun	ṭepu unenunen - á	ḥru	neb	(See Naville, *Todtenbuch*, Bd. I., Bl. 61.)

seχem	*em*	*seśet - f*	*em*	*hamemet*	*un - nå*
who have possession	of	his diadem	in	the form of *hamemet*;	may I rise up,

unun	*Àusàr*
may I travel [like] Osiris.	

1.

Re	*en*	*temt*	*àq*	*er*	*nemmat*	*t'eṭ*	*àn*	*Àusàr*	*Ani*	*àu*
Chapter	of	not	entering	to	the block.	Saith		Osiris	Ani :	

θesu - nå	*ḥa - à*	*em*	*pet*	*àri*	*ta*	*àn*	*Rā*
{ Bindeth up for me [the vertebræ] }	of my neck and back	in	heaven	the guardian of	the earth,		Rā.

2.

erṭāt	*hru*	*en*	*sment*	*θesu - à*	*er*	*eneniu*
It hath been granted	on the day	of	establishing	my rising up	from	weakness

ḥer	*ment*	*ḥru*	*pfi*	3.	*ent*	*ḥesq*	*samet*	*àu*
upon [my] two legs,		on day	that		of	cutting off	the hair.	Hath

θes	*θest*	*ḥa - à*	*àn*	*Set*	*paut*	*neteru*	*em*
bound up	the vertebræ	of my neck and back		Set	and the cycle	of the gods	in

4.

user - s	*ṭepi*	*àn*	*χeper*	*χennu*	*seut'a - ten - à*
their strength	pristine ;	not	may happen	their separation.	Make strong ye [me]

em	*sema*	*àtef - à*	*nuk*	5.	*θet*	*taui*	*θesu*
against	the slayer of	my father.	I		obtain power over	the two earths.	Hath bound up

θest - à	àn	Nut	maa	sep - s	ṭepi	maat	maāt
my vertebræ		Nut,	seeing	time their	first,		seeing [them] in meet order,

àn	mes	neteru	aśemu	nuk	Penti	àu - à
[as when] not	were born	the gods	in visible forms.	I am	Penti.	I am

em	āuā	neteru	āāa	Àusàr	àn	Ani	maāχeru
{ in the condition of being }	the heir	of the gods	great,	[I], Osiris	the scribe	Ani,	triumphant !

1.

Re	en	temt	erṭàt	t'a - tu	se	er	àbtet	em	Neter-χert
Chapter	of	not	allowing	to pass	a man	to	the east	in	the netherworld.

t'eṭ	àn	Àusàr	Ani	à	hennu
Saith	Osiris	Ani :	Hail	phallus	

PLATE XVII.

2.

nui	en Rā	ennuṭ	heṭ' - f	χennu	χeper	χet
that	of Rā,	advancing	he destroyeth	opposition.	Come into existence	things

enennu	em	heh	em	Bàbu	user - à	àm	er
inert	during	millions of years	from	the god Baba.	I am stronger	by [it] than	

3.

useru	seχem - à	àm	er	seχemu	àr	àn
the strong,	I have power	by [it]	more than	the mighty.	So then	

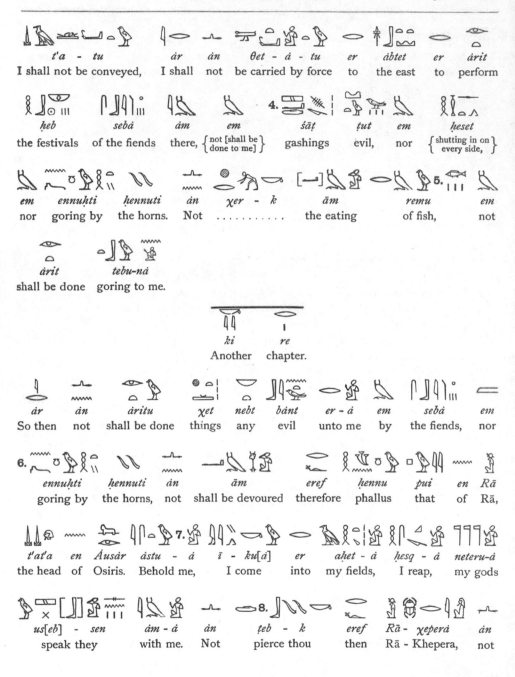

t'a - tu — I shall not be conveyed, àr — I shall àn — not θet - à - tu — be carried by force er — to àbtet — the east er — to àrit — perform

ḥeb — the festivals sebà — of the fiends àm — there, em — { not [shall be done to me] } 4. šàṭ — gashings ṭut — evil, em — nor ḥeset — { shutting in on every side, }

em — nor ennuḥti — goring by ḥennuti — the horns. àn — Not χer - k — àm — the eating remu — of fish, 5. em — not

àrit — shall be done tebu-nà — goring to me.

ki — Another re — chapter.

àr — So then àn — not àritu — shall be done χet — things nebt — any bànt — evil er - à — unto me em — by sebà — the fiends, em — nor

6. ennuḥti — goring by ḥennuti — the horns, àn — not àm — shall be devoured eref — therefore ḥennu — phallus pui — that en — of Rā — Rā,

t'aṭ'a — the head en — of Àusàr — Osiris. àstu - à — Behold me, 7. ì - ku[à] — I come er — into aḥet - à — my fields, ḥesq - à — I reap, neteru-à — my gods

us[eb] - sen — speak they àm - à — with me. àn — Not ṭeb - k — pierce thou eref — then 8. Rā - χeperà — Rā - Khepera, àn — not

χeper	ka	eref	benentu	em	maat	Tmu	àn
shall come into being	in very truth		sickness	in	the eye	of Tmu,	not

ḥetem - f	àn	āau - à - tu	àn	t'a - à - tu	er
shall it be destroyed.	Not	let be made an end of me,	not	let be conveyed me	to

àbtet	er	àrit	ḥeb	sebà	àm - à	ṭut	àn	àritu
the east	to	perform	the festivals	of the fiends [hostile] to me ;		evil,	not let be made	

| 10. | | | | | | | |

šāṭ	àm - à	ṭut	àn	t'ait - à	er	àbtet	Àusàr
gashings	in me	evil ;	not	am I conveyed	to	the east,	Osiris

àn	ḥesb	ḥetep	neter	en	neteru	nebu	Ani	maāχeru
the scribe,	accountant	of the divine offerings		of	gods	all	Ani,	triumphant

maāχeru	nefer	neb	àmaχ
with victory	happy,	lord of	reverence.

1.	Re	en	tem	erṭāt	šāṭ	ṭep	se	mā - f	em	Neter - χert
	Chapter of		not	allowing	to be cut off	the head	of a man	from him	in	the underworld.

t'eṭ	àn	Àusàr	Ani	2. Ani	nuk	ur	se
Saith		Osiris	Ani	(sic):	I am	the Great One,	son of

ur	nesert	se	nesert	3. erṭāi - nef	ṭep - f	em - χet
the Great One,	Fire,	son	of the Fire !	Was given to him	his head	after

šāṭ - tuf *àn* *neḥem - tu* *ṭep* *en* *Àusàr* *mā - f* *àn*
it was cut off; not was carried away the head of Osiris from him, not

neḥem - tu *ṭep* *en* *Àusàr* 4. *Ani* *mā - f* *àu - à*
shall be carried away the head of Osiris Ani from him. I have

θesu - kuà *maā - kuà* *renpà - ku[à]* *nuk*
bound up my limbs, I have made myself whole and sound, I have become young, I am

Àusàr *pu* *neb* *ḥeḥ*
Osiris lord of eternity!

1. *re* *en* *erṭāt* *ṭemà* *ba* *χat - f* *em* *Neter-χert* *t'eṭ* *àn*
Chapter of causing to be united a soul to its body in the netherworld. Saith

Àusàr *Ani* *à* *Ànnitu* *à* *peḥ - reri* *pu*
Osiris Ani: Hail god Annitu! Hail runner

2. *àmi* *seḥ - f* *neter āa* *ṭā - k* *itu - nà* *ba - à* *em* *bu*
dwelling in his hall! O great god, grant thou that may come to me my soul from place

neb *enti - f* *àm* *àr* *ut'efau* *ànen - tu - nà* *ba - à*
any which is it there. If [there be] delay bring thou to me my soul

em *bu* *neb* *enti - f* *àm* *qem - k* *maat* *Ḥeru* *āḥā - θà* *erek*
from place any which is it there. [If] thou findest [me], O eye of Horus, support [me] thou

mà *nefai* ... *Àusàra* *en* *sť er* *en* *sť eru* *Àusàr*
like those beings who are like Osiris, not lie down [they], not let lie down Osiris

Ani *maàχeru* *maàχeru* *em* *Ánnu* *ta* *em* *χa* *en*
Ani, triumphant, triumphant, in Heliopolis, the land wherein [are] thousands of

ṭemà *àu - f* *θet - nà* *ba - à* *χu - à* *maàχeru - à*
unions. Hath he carried away from me my soul, my intelligence [and] my triumph

henà - f *em* *bu* *neb* *enti - f* *àm* *ennu* *erek* *àri* *pet*
with him into place every which is it there. Seeth therefore the guardian of heaven

en *ba - à* *àr* *uť efau* *erṭà - nek* *maa* *ba - à*
my soul. If [there be] delay, grant thou to see my soul

χat - à *qem - k* *maat* *Ḥeru* *āḥā - θà erek* *mà*
my body. [If] thou find [me], O eye of Horus, support [me] then like

nefai *à* *neteru* *setau* *em* *uàa* *en* *neb*
{ those beings who are like unto Osiris. } Hail gods who row in the boat of the lord

ḥeḥ *àniu* *ḥert* *en* *ṭuat* *seḥeriu* *uat*
of millions of years, who lead [it] above the underworld, who make it to pass over the ways

en *Nu* *setekeniu* *baiu* *er* *sàḥu* *āāui - ten* *meḥ* *χer*
of Nu, who make to enter the souls into the mummies, your hands [are] filled with

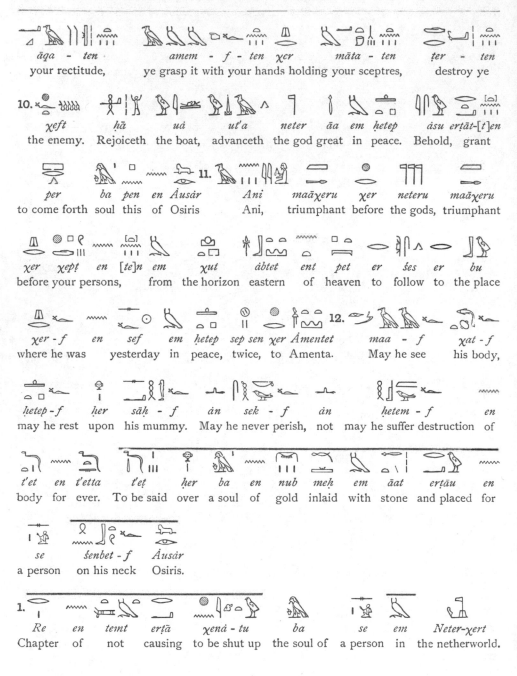

āqa	-	ten		amem	-	f	-	ten	χer	māta	-	ten		ṭer	-	ten
your rectitude,				ye grasp it with your hands						holding your sceptres,				destroy ye		

10.

χeft	hā	uȧ	utȧ	neter	āa	em	ḥetep	ȧsu erṭāt-[t]en
the enemy.	Rejoiceth	the boat,	advanceth	the god	great	in	peace.	Behold, grant

per	ba	pen	en	Ȧusȧr	**11.**	Ani	maāχeru	χer	neteru	maāχeru
to come forth	soul	this	of	Osiris		Ani,	triumphant	before	the gods,	triumphant

χer	χeρṭ	en	[te]n	em	χut	ȧbtet	ent	pet	er	šes	er	bu
before	your persons,			from	the horizon	eastern	of	heaven	to	follow	to	the place

χer	-	f	en	sef	em	ḥetep	sep sen	χer	Ȧmentet	**12.**	maa	-	f	χat	-	f
where he was			yesterday		in	peace,	twice,	to	Amenta.		May he see			his body,		

ḥetep	-	f	ḥer	sāḥ	-	f	ȧn	sek	-	f	ȧn	ḥetem	-	f	en
may he rest			upon	his mummy.			May he never perish,				not	may he suffer destruction			of

t'et	en	t'etta	t'eṭ	ḥer	ba	en	nub	meḥ	em	āat	erṭāu	en
body	for	ever.	To be said	over	a soul	of	gold	inlaid	with	stone	and placed	for

se	šenbet	-	f	Ȧusȧr
a person	on his neck			Osiris.

1.

Re	en	temt	erṭā	χenȧ	-	tu	ba	se	em	Neter-χert
Chapter	of	not	causing	to be shut up			the soul of	a person	in	the netherworld.

t'eṭ	àn	Àusàr	Ani	à	qa	ṭuau - f - tu	ur
Saith	Osiris	Ani :	Hail	exalted One,		the One who is adored,	mighty

2.

baiu	ba	āā	šefšeft	ṭāṭā	neru - f	en	neteru	χāā
of soul,	ram,	mighty	of terror,	causing	fear of himself	in	the gods,	diademed

her	nest - f	urt	àri - f	uat	en	χu	en	ba	en
upon	his throne	mighty.	He maketh	the way	for	the intelligence,	for	the soul	of

3.

Àusàr	Ani	àu - à	àper - k[uà]	nuk	χu	àper	àri - nà
Osiris	Ani.	I am	provided,	I am	an intelligence	provided,	I have made

4.

uat	er	bu	enti	Rā	Het Heru	àm	àr	reχ	re	pen
the way	to	the place	in which	Rā	[and] Hathor	are there.	If	be known	chapter	this

àu - f	χeper-f	em	χu	āper	em	Neter-χert	àn	χenà - tuf
he	becometh	as	an intelligence provided	in	the netherworld,	not	is he shut out	

her	sebχet	neb	en	Àmentet	em	āq	per	nu
at	door	any	in	Àmenta	in	entering in	and coming out	of the sky.

1.

Re	en	un	àsi	en	ba	en	χaibit	pert	em
Chapter	of	opening	the tomb	to	the soul	and to	the shadow,	of coming forth	by

hru	seχem	em	reṭui	t'eṭ	àn	Àusàr	ān	Ani
day,	and of gaining power	over	the legs.	Saith		Osiris,	the scribe	Ani,

2.

maāχeru	unt	un - θȧ	χetem	χetem - θȧ	sṭer
triumphant :	The place of restraint	is opened,	that which is shut	is shut,	prostrate ;

unt	unθȧ	en	ba-ȧ	ȧmi - s	maat	Ḥeru
the place of restraint	is opened	to	my soul	dwelling in it.	The eye of	Horus

3.

seśeṭu - ȧ	sment	χakeru	em	ȧpt	Rā	peṭ
I have bound,	establishing	splendours	on	the forehead of	Rā ;	are stretched out

nemmat	un	mast	ȧri - nȧ	uat	pu	āāa	ȧuf - ȧ
the steps,	are lifted up	the thighs.	I have made	way	that	great,	my members

4.

ruṭ	nuk	Ḥeru	neṭ	tef - f	ȧn	ureret
are vigorous.	I am	Horus,	the avenger	of his father.	[I] bring	the *ureret* crown

em	meṭ - f	un	uat	en	baiu	ȧu	ba - ȧ	f	maa - f
upon	its staff.	Opened [is]	the way	of	souls.	My	soul	(*sic*)	seeth it

PLATE XVIII.

neter	āa	em -	χennu	uȧa	en	Rā	hru	baiu	ȧu
the god	great		within	the boat	of	Rā	[on] the day of	souls.	Is

6.

ba - ȧ	ȧu	em	ḥāt	emmā	ȧp	renput	māȧ	seśeṭ - nȧ
my soul		in	the front	among	those who	reckon years.	Come,	hath delivered for me

ba - á maat Ḥeru en [s]men χakeru - á em ȧpt
my soul the eye of Horus, [which] establisheth my (sic) splendours on the forehead of

Rā ȧχeχu er ḥrȧu-sen ȧmu ȧt Ȧusȧr ȧn
Rā and rays of light upon the faces of those who are in the limbs of Osiris. Not

χenȧ - ten ba - ȧ ȧn saa - ten χaibit-ȧ un uat
shut ye in my soul, not fetter ye my shade, be there open a way

en ba - ȧ en χaibit-ȧ maa - f neter āa em - χennu
for my soul, and for my shade, may it see the god great within

kerȧ hru ȧp baiu nem - f t'eṭet en Ȧusȧr en
the shrine on the day of the judgment of souls, may it repeat the words of Osiris. The

śetau ȧuset sau ȧt Ȧusȧr sau baiu
beings hidden of dwellings, fetterers of the limbs of Osiris, fetterers of the souls, and

χu χetemi her χaibit mitmitu ȧriu ṭut er - ȧ ȧn
of the khu, who shut in the shade of the dead, who can do evil to me, not

ȧrit - sen ṭut er - ȧ ȧsebi uat nȧ en ȧbu - k
may they do evil to me, turning away [their] path from me! Thy heart is

ḥenȧ - k ba - ȧ χu - ȧ āper en sem - sen - tu
with thee. May my soul and my khu be provided against passage their.

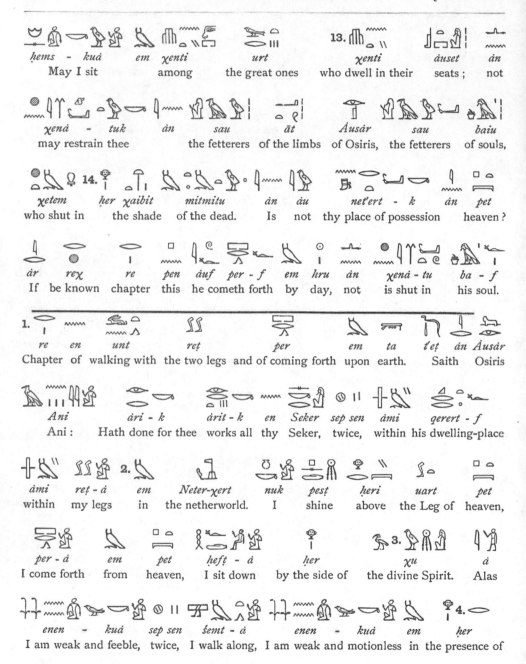

ḥems - kuȧ em χenti urt χenti ȧuset ȧn
May I sit among the great ones who dwell in their seats ; not

χenȧ - tuk ȧn sau ȧt Ȧusȧr sau baiu
may restrain thee the fetterers of the limbs of Osiris, the fetterers of souls,

χetem her χaibit mitmitu ȧn ȧu net'ert - k ȧn pet
who shut in the shade of the dead. Is not thy place of possession heaven ?

ȧr reχ re pen ȧuf per - f em hru ȧn χenȧ - tu ba - f
If be known chapter this he cometh forth by day, not is shut in his soul.

re en unt reṭ per em ta t'eṭ ȧn Ȧusȧr
Chapter of walking with the two legs and of coming forth upon earth. Saith Osiris

Ani ȧri - k ȧrit - k en Seker seṗ sen ȧmi qerert - f
Ani : Hath done for thee works all thy Seker, twice, within his dwelling-place

ȧmi reṭ - ȧ em Neter-χert nuk pesṭ heri uart pet
within my legs in the netherworld. I shine above the Leg of heaven,

per - ȧ em pet heft - ȧ her χu ȧ
I come forth from heaven, I sit down by the side of the divine Spirit. Alas

enen - kuȧ seṗ sen šemt - ȧ enen - kuȧ em her
I am weak and feeble, twice, I walk along, I am weak and motionless in the presence of

àbeḥ	*t'a*	*[re] sen*	*em*	*Neter - χert*	*Àusàr*	*àn*	*Ani,*	
the teeth,	gnasheth	mouth their	in	the netherworld,	Osiris,	scribe	Ani,	

maāχeru	*em*	*ḥetep*
triumphant	in	peace.

1.
re	*en*	*āba*	*Àmentet*	*pert*	*em hru t'eṭ*	*àn Àusàr*	
Chapter	of	passing through	Amenta	[and of coming forth]	by day.	Saith Osiris	

Ani	*unu*	*unnu*	*χetem*	*ṭep....*	*2.* *Teḥuti*	*àger*	*maat*
Ani:	Opened	is Unnu,	shut [is]	the head of	Thoth,	perfect is	the eye of

Ḥeru	*seśeṭu - à*	*maat*	*Ḥeru · χu*	*χakeru*	*.... em*	*àpt*
Horus.	I have delivered	the eye of	Horus	shining with splendours	on the forehead of

Rā	*àtef*	*neteru*	*nuk Àusàr*	*pui*	*enen*	*[àm] Àmentet*	*reχ*
Rā,	the father of	the gods,	[I am] Osiris	that	same	dwelling in Amenta.	Knoweth

en Àusàr	*hru - f*	*tem - f*	*unen àm àn*	*unen - à*	*àm*	*4.* *nuk*	
Osiris	his day,	not did he	exist there, not	shall exist I	there,	I am	

àāḥ	*àmi*	*neteru*	*àn*	*tem - à*	*āḥā*	*àrek*	*Ḥeru*
the moon	among	the gods,	not	come to an end I.	Stand up	then,	Horus,

àp - f - tu	*emmā*	*neteru*
he hath counted thee	among	the gods.

1.

Re *en* *pert* *em* *hru* *ānχ* *emχet* *mit* *t'et̮* *ȧn* *Ȧusȧr*
Chapter of coming forth by day [and] of living after death. Saith Osiris

Ani *ȧ* *uā* *uben* *em* *ȧȧḥ* 2. *ȧ* *uā* *pest̮* *em*
Ani: Hail only One, shining from the moon, hail only One, shining from

ȧȧḥ *pert* *Ȧusȧr* *Ani* *pen* *em* *āśt - k* *tui*
the moon. Let come forth Osiris Ani this among thy multitudes those

3. *ȧreruti* *uāu* *su* *ȧmui* *em* *χu* *unu - nef*
outside; let be established him among the shining ones; let be opened to him

t̮uat *ȧsk* *Ȧusȧr* *Ȧusȧr* 4. *Ani* (sic) *pert* *em* *hru* *er*
the underworld. Behold Osiris, Osiris Ani shall come forth by day to

ȧrit *mert - f* *t̮ep* *'ta* *emmā* *ānχiu*
do his will upon earth among the living.

1.

Re *pert* *em* *hru* *emχet* *āba* *ȧmmehet* *t'et̮* *ȧn*
Chapter of coming forth by day after having traversed the tomb. Saith [Osiris]

Ani *ȧ* *ba* *āa* *śeft* 2. *māk - ȧ* *ī - kuȧ*
Ani: Hail Soul, mighty of valour! Verily I am here. I have come,

maa - ȧ - tu *āba - ȧ* *t̮uat* *maa - ȧ* 3. *ȧtef-f*
I see thee, I have traversed the netherworld, I have seen [my] father

Àusàr seḥeri - à kekiu nuk meri - f ì - nà maa - à

Osiris, I have dispelled the night. I am his beloved. I have come that I may see

4. *àtef ... - à Àusàr ḥesq - à àb pen en Suti àri χet er*

 my father Osiris. I have stabbed this heart of Set, performing things for

*àtef - à Àusàr * 5. *un - nà uat neb àm pet àm ta nuk se*

my father Osiris. I have opened to me way every in heaven, in earth. I am a son

*meri àtef - f Àusàr * 6. *sàḥ - kuà χu - kuà*

loving his father Osiris. I have become a prince, I have become glorious,

àper - kuà à neter neb χu neb àri - nà

I am provided with what is necessary. Hail god every, shining being every, make for me

uat Àusàr àn Ani maàχeru

a way, the Osiris, the scribe Ani, triumphant.

1. *Re en erṭàt rer su se er maa pa - f ṭep ta*

Chapter of making to return a man himself to see his house upon earth.

*t'eṭ àn Àusàr Ani pen nuk - * 2. *per em peṭ àu*

Saith Osiris Ani this: I am the Lion-god coming forth with strides. I have

satet - nà àu seṭeṭefu - nà sep sen nuk maat Ḥeru seś - nà

shot arrows, I have wounded [the prey]; twice I am the eye of Horus, I have opened

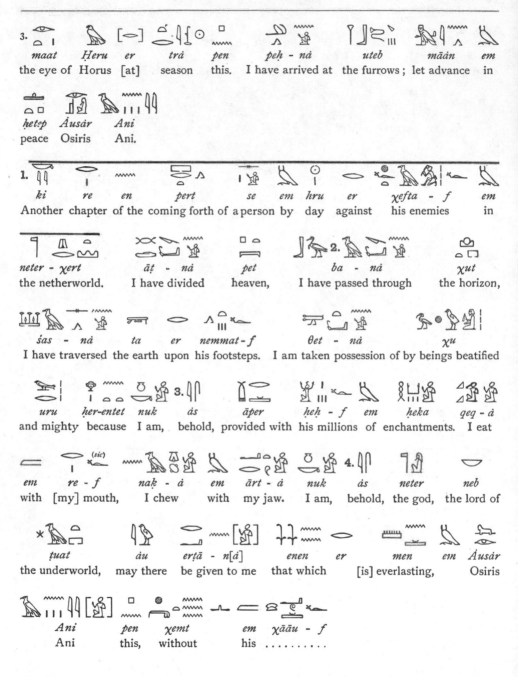

3.

maat	Ḥeru	er	trà	pen	peḥ - nà	uteb	mā̀n	em
the eye of	Horus	[at]	season	this.	I have arrived at	the furrows;	let advance	in

ḥetep	Àusàr	Ani
peace	Osiris	Ani.

1.

ki	re	en	pert	se	em	hru	er	χefta - f	em
Another	chapter	of the	coming forth of	a person	by	day	against	his enemies	in

neter - χert	àṭ - nà	pet	ba - nà 2.	χut
the netherworld.	I have divided	heaven,	I have passed through	the horizon,

śas - nà	ta	er	nemmat - f	θet - nà	χu
I have traversed	the earth	upon	his footsteps.	I am taken possession of by	beings beatified

uru	her-entet	nuk	às	àper	heḥ - f	em	heka	qeq - à
and mighty	because	I am,	behold,	provided with	his millions	of	enchantments.	I eat

em	re - f	nak - à	em	àrt - à	nuk	às 4.	neter	neb
with	[my] mouth,	I chew	with	my jaw.	I am,	behold,	the god,	the lord of

ṭuat	àu	erṭà - n[à]	enen	er	men	em	Àusàr
the underworld,	may there	be given to me	that which	[is] everlasting,			Osiris

Ani	pen	χemt	em	χā̀u - f
Ani	this,	without	his

1. *ṭua* / *Rā* / *em* / *uben - f* / *em* / *χut* / *er* / *χeper* / *ḥetep - f* / *em*
An adoration of / Rā / in / his rising / in / the horizon, / when / becometh / his setting / in

ānχ / *t'eṭ* / *ȧn* / *Ausȧr* / *ȧn* / *Ani* / *ȧneṭ' - ḥrȧ - k* / 2. *Rā* / *em*
life. / Saith / Osiris, / the scribe / Ani: / Homage to thee, / Rā / in

PLATE XIX.

uben - f / *Tem Ḥeru χuti* / *ṭua - tu* / *neferu-k* / *em* / *maa-ȧ*
his rising, / Tmu-Harmachis. / Adored art thou [when] / thy beauties are / in / my two eyes,

χeper / *χu* / *her* / *śenbet* / *ut'a - k* / *em* / *ḥetep - k* / *em*
and are [thy] / shining rays / upon / [my] body. / Thou goest forth / in / peace / thy / in

sektet / *ȧb - k* / *āu* / *em* / *maāu* / *em* / *āṭtet* / *ȧb - s*
the *sektet* boat, / thy heart / is gratified / by the / winds / in / the *āṭet* boat; / its heart

net' em / *nemȧ - [k]* / *hert* / *em* / *ḥetepiu* / *seχer* / *χefta - k*
is glad. / Thou stridest / over heaven / in / peace, / are overthrown / thy enemies;

5. *hennu - nek* / *ȧuχemu* / *urṭu* / *ṭua - tu*
sing hymns of praise to thee / the stars / which never rest, / praise thee

ȧuχemu / *seku* / 6. *ḥetep* / *em* / *χut* / *ent* / *Manu* / *nefer-θȧ* / *em*
the stars that never set / [as] settest [thou] / in / the horizon / of / Manu, / beautiful one / in

àterti (?) neb ānχ-θà ṭeṭṭeṭ em neb - à ànet'-ḥrà-k Rā em
{ the two halves of the sky, } the lord living and established as my lord. Homage to thee, Rā at

uben - k 7. Tem em ḥetep - k nefer uben - k pest - k ḥer
thy rising, Tmu at thy setting beautiful. Thou risest, thou shinest over

pest mut - k χāà - θà em suten neteru 8. àri en Nut nini
the back of thy mother, O crowned as king of the gods. Maketh Nut homage

en ḥrà - k ḥept - tu Maāt er tràui nemà - k
to thy face, embraceth thee Maāt at the double season. Thou stridest

ḥert àb - k āu mer Ṭes Ṭes 9. χeper em ḥetepu Sebàu
over heaven, thy heart is glad, the Lake of Testes becometh at peace. The Fiend

χer āāui - f aqesau seḥeq en ṭemt θeset - f
hath fallen, his two arms and hands are cut off, hath severed the knife his sinews.

unen Rā em maāt 10. nefer sektet sek - nes peḥ su
Is Rā in winds fair, the sektet boat draweth on it, he arriveth

setau tu qemāiu meḥtaiu àmentaiu àbtetiu ḥer
being towed along. [The gods of] the south, north, west [and] east are for

ṭua - k 11. pautti χeperu uṭ χeru ta
praising thee, the double Paut of forms of existence; sending forth the word the earth

bāh　　*em*　　*seker*　　*uā*　　*χeper*　　*ámtu*　　*pet*　　*ȧn*
is inundated　with　silence.　O only One,　existing　in　heaven　[when]　not

χeper　　*set*　　*tu*　　12. *peḥreru*(?) *neb*　*uā*　*ȧri*
had come into existence　the earth　and the mountains,　runner,　lord,　only One,　maker of

unenet　　*nub - nef*　　*nes*　　*paut*　　*neteru*　　*χenp*
things which exist,　he hath formed　the tongue　of the cycle　of the gods,　drawing out

enti　　*em*　　*mu*　　*per - k*　　*ȧm - f*　*her*　　*nept*　　*ent*
that which is 'in　the waters　thou comest forth　in it　upon　the inundated land　of the

Set　　*Ḥeru*　　13. *tepȧ - ȧ*　　*nifu*　　*per*　　*em*　　*fent-k*　　*meḥit*
Lake of　Horus.　I smell　the air　coming forth　from　thy nose,　and the wind

pert　　*em*　　*mut - k*　　*seχu - k*　　*χu - ȧ*　　*neteri - k*
coming forth　from　thy mother.　Make thou glorious my beatified being,　make strong thou

Ȧusȧr　　*ba - ȧ*　　*tua - tu*　　*ḥetep*　*neb*　*neteru*　　*seqa - tu*　　*em*
Osiris　my soul.　Adored art thou [in] peace,　O lord　of the gods,　thou art exalted　by

bȧit - k　　*satu - k*　　*satu*　*her*　*śenbet - ȧ*　*mȧ ḥru*
reason of thy wondrous things.　Shine thou [with thy] beams　upon　my body　daily,

15. *Ȧusȧr*　*ȧn*　*ḥesb*　*ḥetep*　*neter*　*en*　*neteru nebu*　*mer*　*śenti*
Osiris, scribe and accountant of　divine offerings of　gods all,　superintendent of the granary

en	nebu	Ábṭu	suten	ān	maā	meri - f	Ani	maāχeru
of	the lords	of Abydos,	royal	scribe	veritable	loving him,	Ani,	triumphant

em	ḥetep
in	peace !

1.

	ṭuau	Áusàr	neb	t'etta	Unnefer	Ḥeru	-	χuti	āst
	Adoration of	Osiris, the lord of eternity,			Un-nefer,	Horus of the double horizon,			many

χeperu	āā	àru	2.	Ptaḥ	Sekri	Tmu	em	Ánnu
of forms of existence,	mighty	of shapes,		Ptaḥ - Socharis - Tmu			in	Heliopolis,

neb	śeθit	χnem - f	Ḥet-ka-Ptaḥ	neteru	pu	sem
lord of	the hidden house,	he hath created	Memphis	and the gods,		guide of

3.	ṭuat	χu - sen - tu	ḥetep-k	em	Nut	ḥepti - θ	Áuset
	the underworld,	they glorify thee	when thou settest	in	Nut	Embraceth thee	Isis

em	ḥetep	seḥeru - s	t'ai	em	re	uat - k	ṭā - nek
in	peace,	driveth away she	the fiends	from	the mouth	of thy paths.	Thou givest

hrà - k	er	Ámentet	seḥet' - k	taiu	em	smu	st'eriu
thy face	upon	Amenta,	thou makest bright	the world [as] with		smu metal ;	the dead

āḥā	er	maa - nek	tepà - sen	meḥu	maa-sen	hrà - k	mà	uben
rise up	to	see thee ;	they breathe	the airs,	they see	thy face	as	riseth up

àten	*em*	*χut - f*	*àb - sen*	*hetep*	*her*	*maa - nek*	*entek*
the disk	in	his horizon;	their hearts	are at peace	by reason of	seeing thee,	thou art

heh	*t'etta*

eternity and everlastingness.

1.

ànet' hrà - k	*χabes*	*em Àn*	*hamemet*	*em*	*χer-āba,*
Homage to thee, [lord of] starry deities	in	Àn, [and of] the celestial beings		in	Kher-āba,

Unti	*χu*	*er*	*neteru*	*šeta*	*àmt*	*Ànnu*
[thou] god Unti,	glorious more	than	the gods	hidden	in	Heliopolis.

2.

ànet' hrà - k	*Àn*	*em*	*Àn-ṭes*	*Ḥeru*	*em*	*χuti*	*peṭ nemmat*
Homage to thee,	Àn	in	Àntes (?),	Horus	in	the double horizon,	long of step,

					3.	
t'a - f	*hert*	*entef*	*Ḥeru - χuti*		*ànet' hrà - k*	*ba*
he passeth forth	over heaven;	he is	Horus of the double horizon.		Homage to thee,	Soul

pu	*en*	*heh*	*Bai*	*àmi*	*Ṭeṭṭeṭu*	*Un-nefer*	*se*
of	everlastingness,		Soul (*or* Ram-god) dwelling in	Tattu,	Un-nefer,	son of	

				4.			
Nut	*entef*	*neb*	*Àkert*	*ànet' hrà - k*	*em*	*heq - k*	*Ṭeṭṭu*
Nut;	he is	lord of	Aḳert.	Homage to thee	in	thy dominion over	Tattu,

urert	*men*	*em*	*ṭep - k*	*entek*	*uā*	*àri*	*māket - f*
the *urert* crown	is established	upon	thy head;	thou art	the One,	maker	of his strength,

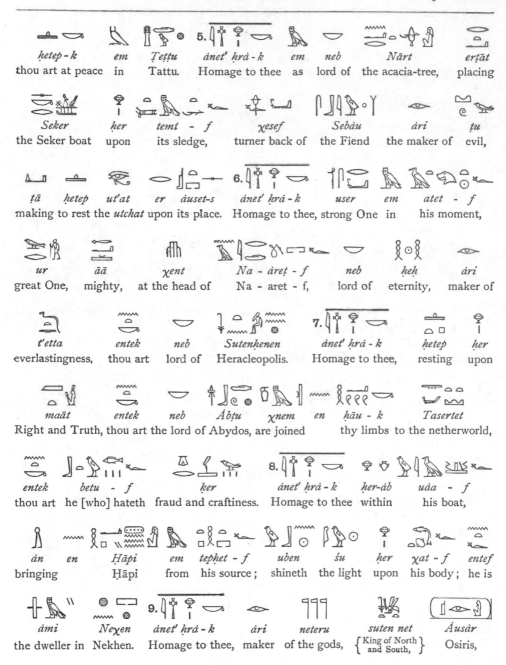

ḥetep - k　*em*　*Teṭṭu*　*ȧnet' ḥrȧ - k*　*em*　*neb*　*Nārt*　*erṭāt*
thou art at peace in Tattu. Homage to thee as lord of the acacia-tree, placing

Seker　*her*　*temt - f*　*χesef*　*Sebȧu*　*ȧri*　*ṭu*
the Seker boat upon its sledge, turner back of the Fiend the maker of evil,

ṭā　*ḥetep*　*ut'at*　*er*　*ȧuset-s*　*ȧnet' ḥrȧ - k*　*user*　*em*　*atet - f*
making to rest the *utchat* upon its place. Homage to thee, strong One in his moment,

ur　*āā*　*χent*　*Na - ȧreṭ - f*　*neb*　*ḥeḥ*　*ȧri*
great One, mighty, at the head of Na - aret - f, lord of eternity, maker of

t'etta　*entek*　*neb*　*Sutenḥenen*　*ȧnet' ḥrȧ - k*　*ḥetep*　*her*
everlastingness, thou art lord of Heracleopolis. Homage to thee, resting upon

maāt　*entek*　*neb*　*Ȧbṭu*　*χnem*　*en*　*ḥāu - k*　*Tasertet*
Right and Truth, thou art the lord of Abydos, are joined thy limbs to the netherworld,

entek　*betu - f*　*ḳer*　*ȧnet' ḥrȧ - k*　*her-ȧb*　*uȧa - f*
thou art he [who] hateth fraud and craftiness. Homage to thee within his boat,

ȧn　*en*　*Ḥāpi*　*em*　*tephet - f*　*uben*　*śu*　*her*　*χat - f*　*entef*
bringing Ḥāpi from his source; shineth the light upon his body; he is

ȧmi　*Neχen*　*ȧnet' ḥrȧ - k*　*ȧri*　*neteru*　*suten net*　*Ȧusȧr*
the dweller in Nekhen. Homage to thee, maker of the gods, { King of North and South, } Osiris,

maāχeru	ker	taiu	em	sep - f	menχ	entef	pu	neb	ȧteb
triumphant,	master of	worlds	in	his seasons	gracious,	he	is	the lord of	the world.

10.

ṭā - k - nȧ	uat	seś - ȧ	em	ḥetep	nuk	āq	ȧn	t'eṭ - ȧ
Grant thou to me	a way	that I may pass	in	peace.	I am	just and true,	I have	not spoken

ker	em	reχ - ȧ	ȧn	ȧri - ȧ	sep sen
lies	to	my knowledge,	not	have I acted	with a motive second.

PLATE XX.

1.

ṭua - ṭuau	Rā	χeft	uben - f	em	χut	ȧbtet	ent
An adoration of	Rā	when	he riseth	in	the horizon	eastern	of

pet	ḥā en	ȧmu - χet - f	**2.**	ȧ	Ȧusȧr	Ani	em	maāχeru
heaven.	Rejoice	those who are in his train.		Hail	Osiris	Ani	in	triumph,

t'eṭ - f	ȧ	ȧten	pui	neb	satetu	uben	em	χut	hru
saith he :	Hail	Disk	that,	lord	of rays,	rising	in	the horizon	day

neb	pest - k	em	ḥrȧ	en	Ȧusȧr	Ani	em maāχeru	ṭua - f
every ;	do thou shine	upon	the face	of	Osiris	Ani,	in triumph.	He adoreth

tu	em	ṭuait	**4.**	se - ḥetep - f	tu	māśeru
thee	at	daybreak,		he maketh to rest thee with praise		at eventide.

¹ For a similar text see Lepsius, *Todtenbuch*, Bl. iv.

per *ba* *en* *Åusår* *Ani* *maāχeru* *henā - k* *er* *pet*

May come forth the soul of Osiris, Ani, victorious with thee into heaven,

utu - f *em* *Māāṭet* *menå - f* *em* *Sektet*

may he go forth in the *Māāṭet* boat, may he come into port in the *Sektet* boat,

åbeχ - f *em* *åχemu - urṭ* *em* *pet* *Åusår* *Ani*,

may he go in among the stars which set in heaven. Osiris, Ani,

ḥetep-θå *maāχeru* *t'eṭ - f* *suaś - f* *neb - f* *neb*

being at peace and in triumph, saith he, adoreth he his lord, the lord of

ḥeḥ *ånet' - ḥrå - k* *Ḥeru - χuti* *χeperå* *pu*

eternity, [saying]: Homage to thee, Horus of the two horizons, Kheperå that is, [who]

χeper *t'esef* *neferiu* *uben - k* *em* *χut* *se - ḥet' - k*

created himself; doubly beautiful [is] thy rising in the horizon, thou shinest upon

taiu *em* *satu - k* *neteru* *nebu* *em* *ḥāāui*

the two lands with thy beams. Gods all are in rejoicing [when]

maa - s[en] *tu* *em* *suten* *en* *pet* *Nebt-Unnut* *men - θå*

they see thee in the condition of king of heaven. Nebt-Unnut is placed

em *ṭep - k* *qemāt - s* *meḥt - s* *em* *åpt - k*

upon thy head; her portion of the south [and] her portion of the north [are] on thy forehead;

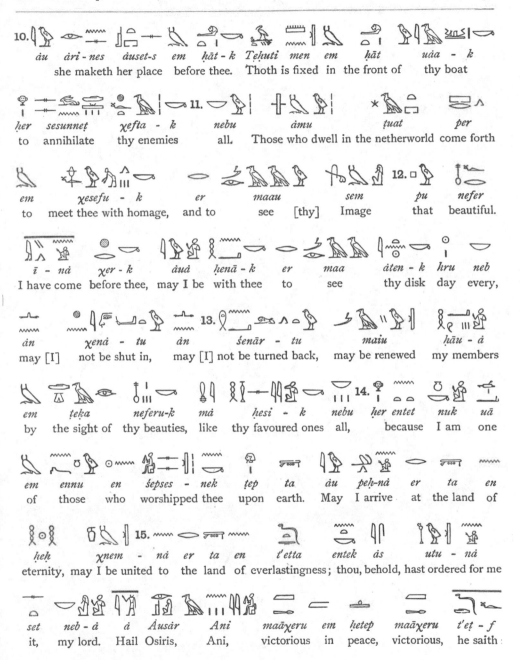

10.
àu　àri - nes　àuset-s　em　ḥāt - k　Teḥuti　men　em　ḥāt　uāa - k
she maketh her place　before thee.　Thoth is fixed　in　the front of　thy boat

ḥer　sesunneṭ　χefta - k　11. nebu　àmu　ṭuat　per
to　annihilate　thy enemies　all.　Those who dwell in the netherworld come forth

em　χesefu - k　er　maau　sem　12. pu　nefer
to　meet thee with homage,　and to　see　[thy]　Image　that　beautiful.

ī - nà　χer - k　àuà　ḥenā - k　er　maa　àten - k　ḥru　neb
I have come　before thee,　may I be　with thee　to　see　thy disk　day　every,

àn　χenà - tu　àn　13. śenār - tu　maiu　ḥāu - à
may [I]　not be shut in,　may [I] not be turned back,　may be renewed　my members

em　ṭeḵa　neferu-ḵ　mà　ḥesi - ḵ　nebu　14. ḥer entet　nuk　uā
by　the sight of　thy beauties,　like　thy favoured ones　all,　because　I am　one

em　ennu　en　śepses - nek　ṭep　ta　àu　peḥ-nà　er　ta　en
of　those　who　worshipped thee　upon　earth.　May I arrive　at　the land　of

ḥeḥ　χnem - nà　er　ta　en　15. t'etta　entek　às　utu - nà
eternity,　may I be united to　the land of everlastingness;　thou, behold, hast ordered for me

set　neb - à　à　Ausàr　Ani　maāχeru　em　ḥetep　maāχeru　t'eṭ - f
it,　my lord.　Hail Osiris,　Ani,　victorious　in　peace,　victorious,　he saith :

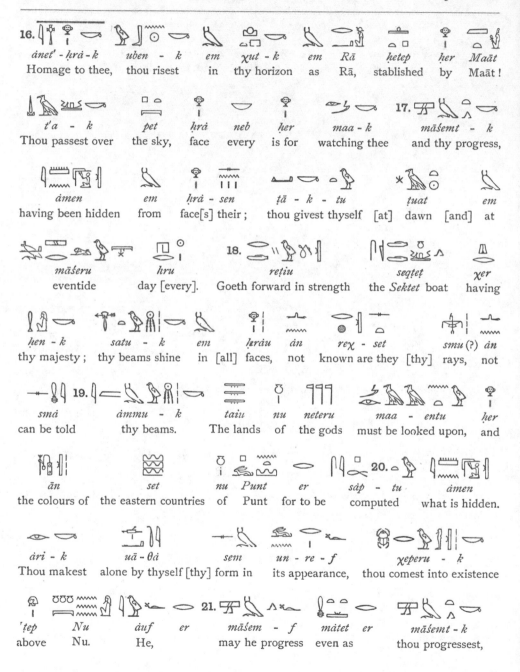

16. ȧnet' - ḥrȧ - k uben - k em χut - k em Rā ḥetep her Maāt
Homage to thee, thou risest in thy horizon as Rā, stablished by Maāt !

t'a - k pet ḥrȧ neb her maa - k 17. māsemt - k
Thou passest over the sky, face every is for watching thee and thy progress,

ȧmen em ḥrȧ - sen ṭā - k - tu ṭuat em
having been hidden from face[s] their; thou givest thyself [at] dawn [and] at

māseru hru 18. reṭiu seqṭeṭ χer
eventide day [every]. Goeth forward in strength the Sektet boat having

ḥen - k satu - k em ḥrāu ȧn reχ - set smu (?) ȧn
thy majesty; thy beams shine in [all] faces, not known are they [thy] rays, not

smȧ 19. ȧmmu - k taiu nu neteru maa - entu her
can be told thy beams. The lands of the gods must be looked upon, and

ān set nu Punt er sȧp - tu 20. ȧmen
the colours of the eastern countries of Punt for to be computed what is hidden.

ȧri - k uā - θȧ sem un - re - f χeperu - k
Thou makest alone by thyself [thy] form in its appearance, thou comest into existence

'ṭep Nu 21. ȧuf er māsem - f mȧtet er māsemt - k
above Nu. He, may he progress even as thou progressest,

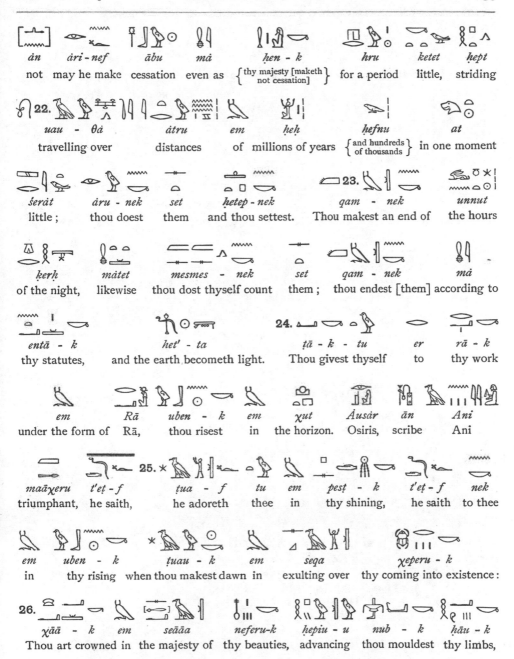

ân	âri - nef	âbu	mâ	ḥen - k	hru	ketet	ḥept
not	may he make	cessation	even as	{ thy majesty [maketh not cessation] }	for a period	little,	striding

22.

uau - θā	âtru	em	ḥeḥ	ḥefnu	at
travelling over	distances	of	millions of years	{ and hundreds of thousands }	in one moment

šerât	âru - nek	set	ḥetep - nek	qam - nek	unnut
little ;	thou doest	them	and thou settest.	Thou makest an end of	the hours

23.

kerḥ	mâtet	mesmes - nek	set	qam - nek	mâ
of the night,	likewise	thou dost thyself count	them ;	thou endest [them]	according to

entā - k	ḥet' - ta	ṭā - k - tu	er	rā - k
thy statutes,	and the earth becometh light.	Thou givest thyself	to	thy work

24.

em	Rā	uben - k	em	χut	Âusâr	ân	Ani
under the form of	Rā,	thou risest	in	the horizon.	Osiris,	scribe	Ani

25.

maāχeru	t'eṭ - f	ṭua - f	tu	em	pesṭ - k	t'eṭ - f	nek
triumphant,	he saith,	he adoreth	thee	in	thy shining,	he saith	to thee

em	uben - k	ṭuau - k	em	seqa	χeperu - k
in	thy rising	when thou makest dawn	in	exulting over	thy coming into existence :

26.

χāā - k	em	seāāa	neferu-k	ḥepiu - u	nub - k	ḥāu - k
Thou art crowned in	the majesty of	thy beauties,	advancing	thou mouldest	thy limbs,	

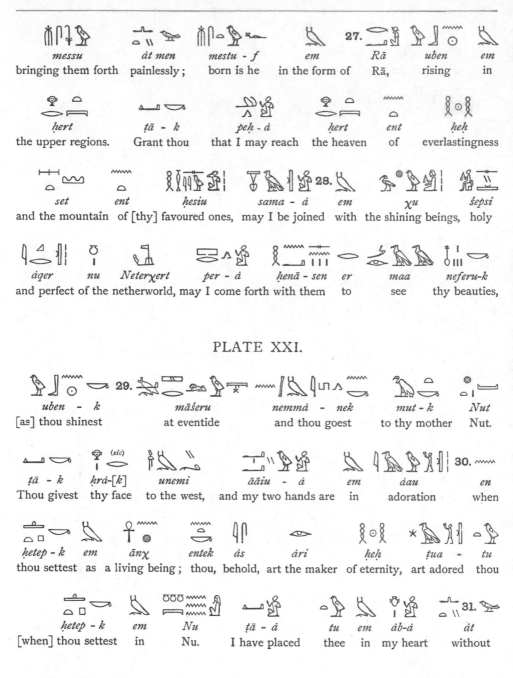

messu	àt men	mestu - f	em	27. Rā	uben	em
bringing them forth	painlessly;	born is he	in the form of	Rā,	rising	in

hert	ṭā - k	peḥ - à	hert	ent	heh
the upper regions.	Grant thou	that I may reach	the heaven	of	everlastingness

set	ent	hesiu	sama - à	em	28. χu	šepsi
and the mountain	of [thy] favoured ones,	may I be joined		with	the shining beings,	holy

àqer	nu	Neterχert	per - à	henā - sen	er	maa	neferu-k
and perfect	of the netherworld,	may I come forth	with them	to	see	thy beauties,	

PLATE XXI.

uben - k	māśeru	nemmà - nek	29. mut - k	Nut
[as] thou shinest	at eventide	and thou goest	to thy mother	Nut.

ṭā - k	ḥrà-[k]	unemi	āāiu - à	em	àau	30. en
Thou givest	thy face (sic)	to the west,	and my two hands are	in	adoration	when

hetep - k	em	ānχ	entek	às	àri	heh	ṭua - tu
thou settest	as	a living being;	thou,	behold,	art the maker	of eternity,	art adored thou

hetep - k	em	Nu	ṭā - à	tu	em	àb-à	31. àt
[when] thou settest	in	Nu.	I have placed	thee	in	my heart	without

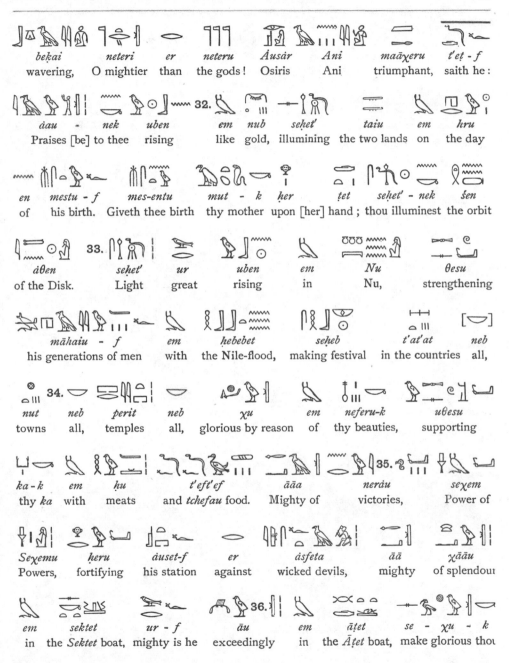

beḳai	neteri	er	neteru	Àusàr	Ani	maāχeru	t'eṭ - f
wavering,	O mightier	than	the gods!	Osiris	Ani	triumphant,	saith he :

àau -	nek	uben	em	nub	seḥeṭ'	taiu	em	hru
Praises [be] to thee	rising		like	gold,	illumining	the two lands	on	the day

en	mestu - f	mes-entu	mut - k	her	ṭet	seḥeṭ' - nek	šen
of	his birth.	Giveth thee birth	thy mother	upon [her] hand ;	thou illuminest the orbit		

àθen	seḥeṭ'	ur	uben	em	Nu	θesu
of the Disk.	Light	great	rising	in	Nu,	strengthening

māhaiu - f	em	ḥebebet	seḥeb	t'aṭ'aṭ	neb
his generations of men	with	the Nile-flood,	making festival	in the countries	all,

nut	neb	perit	neb	χu	em	neferu-k	uθesu
towns	all,	temples	all,	glorious by reason	of	thy beauties,	supporting

ka - k	em	ḥu	t'eft'ef	āāa	neràu	seχem
thy ka	with	meats	and tchefau food.	Mighty of	victories,	Power of

Seχemu	ḥeru	àuset-f	er	àsfeta	āā	χāāu
Powers,	fortifying	his station	against	wicked devils,	mighty	of splendour

em	sektet	ur - f	àu	em	āṭet	se - χu - k
in	the Sektet boat,	mighty is he	exceedingly	in	the Āṭet boat,	make glorious thou

Àusàr *Ani* *em maāχeru em* *Neterχert* *ṭā - k* *un - nef* *er*
Osiris Ani with victory in the netherworld, grant thou that he may be in the

Àmentet 37. *śu* *em* *ṭut* *māk* *ḥa - k* *àsfet*
netherworld empty of sins, I pray thee put behind thee [his] faults.

ṭā - kuà *em* *àmχι* 38. *χer* *χu* *χnem - f*
Grant that I may be among the venerated beings with the shining ones, may he join

baiu *em* *Ta-sertet* *seqṭeṭ - f* *em* *Seχet - Àaru* 39.
the souls [which are] in the Ta-sertet, may he journey into the Sekhet - Àaru

ḥer enti sa *utu* *em* *āut* *àn Àusàr* *ān* *Ani* *maāχeru*
through the decree with joy of heart. O Osiris, the scribe Ani, triumphant,

40. *peri - k* *er* *pet* *t'ai - k* *bàt* *sensen - k*
thou shalt come forth into heaven, thou shalt pass over the sky, thou shalt be associated

emmā *sebu* *àritu - nek* 41. *ḥekennu* *em* *uàa* *nàs - tuk*
with the stars, shall be made to thee praises in the boat, thou shalt be hymned

em *āṭet* 42. *ṭeḳai - k* *Rā* *em* *χennu* *en* *kerà - f*
in the *Āṭet* boat; thou shalt see Rā within shrine his,

seḥeṭep - k *àθen - f* *hru* *neb* *maa - nek* 43. *ànt* *em*
thou shalt set with his disk day every, thou shalt see the *ànt* fish in

χeperȧ - s her bābāt ent māfekt maa - nek ȧbṭu
its coming into existence upon the water of turquoise, thou shalt see the *abṭu* fish

sep - f χeper ṭutu χer χeft ser - nef
[in] his season. May it happen that the Evil One shall fall when he setteth in order

ḥeseq - nȧ ṭemu θesu - nef unen Rā em maāu
destruction for me, let be cut asunder his vertebræ. Is Rā in winds

nefer sek en sektet peḥ su qet Rā em
good, draweth onward the *sektet* boat and arriveth it, the sailors of Rā are in

ḥāāiu Nebt - ānχ ȧb - s netem seχer χeft en
rejoicing. Nebt - ānkh her heart is glad, [for] fallen hath the enemy of

neb - s maa - nek Ḥeru her neferu Ṭeḥuti Maāt her
her lord. Thou shalt see Horus in the place of look out and Thoth and Maāt at

āāiu - f neteru nebu em ḥāāu maa en sen
his two sides. Gods all are in rejoicing [when] they see

Rā iu em ḥetep er seānχ ȧbu en χu ȧn Ȧusȧr
Rā coming in peace to make to live the hearts of the shining ones ; Osiris

ān ḥetep neter en nebu Uast Ani maāχeru ḥenā - sen
the scribe of the divine offerings of the lords of Thebes Ani, triumphant, with them.

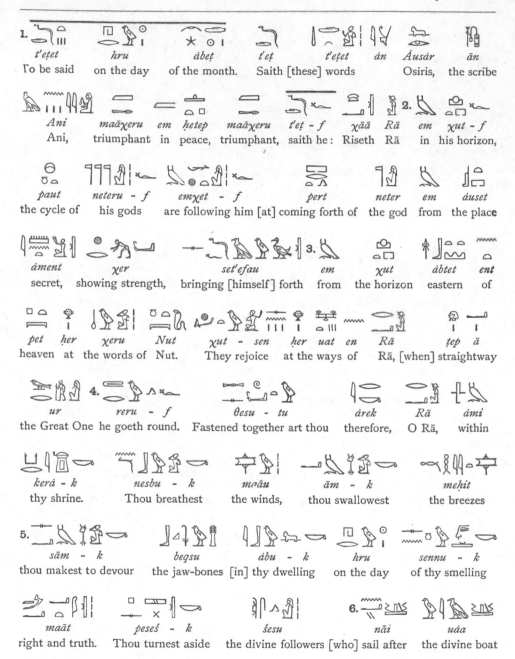

1. *t'eṭet* / *hru* / *ábeṭ* / *t'eṭ* / *t'eṭet* / *án* / *Ausár* / *án*

To be said / on the day / of the month. / Saith [these] words / Osiris, / the scribe

Ani / *maāχeru* / *em* / *ḥeṭep* / *maāχeru* / *t'eṭ - f* / *χāā* / *Rā* / *em* / *χut - f* 2.

Ani, / triumphant / in / peace, / triumphant, / saith he: / Riseth / Rā / in / his horizon,

paut / *neteru - f* / *emχet - f* / *pert* / *neter* / *em* / *áuset*

the cycle of / his gods / are following him [at] coming forth of / the god / from / the place

áment / *χer* / *set'efau* / *em* / *χut* / *ábtet* / *ent* 3.

secret, / showing strength, / bringing [himself] forth / from / the horizon / eastern / of

pet / *her* / *χeru* / *Nut* / *χut - sen* / *her* / *uat* / *en* / *Rā* / *ṭep* / *ā*

heaven / at / the words of / Nut. / They rejoice / at / the ways of / Rā, [when] straightway

ur / *reru - f* 4. / *θesu - tu* / *árek* / *Rā* / *ámi*

the Great One / he goeth round. / Fastened together art thou / therefore, / O Rā, / within

kerá - k / *nesbu - k* / *mᶜáu* / *ám - k* / *meḥit*

thy shrine. / Thou breathest / the winds, / thou swallowest / the breezes

5. *sām - k* / *beqsu* / *ábu - k* / *hru* / *sennu - k*

thou makest to devour / the jaw-bones / [in] thy dwelling / on the day / of thy smelling

maāt / *peseś - k* / *śesu* / *nái* / *uáa* 6.

right and truth. / Thou turnest aside / the divine followers [who] sail after / the divine boat

er nemnem uru ḥer χeru - k ȧp - k qesu - k
to come back [to] the mighty beings at thy word. Thou numberest thy bones,

saaq - k āt - k 7. ṭā - k ḥrȧ - k er Amentet nefert
thou gatherest together thy limbs; thou givest thy face towards Amenta the beautiful,

ūit - k ȧm matu - θȧ hru neb tut ȧs pui en nub
comest thou there being renewed day every. Image, behold, that of gold,

χer samau ȧtennu en pet χer seṭau
having the splendours of the disk of heaven, possessing terror;

rer - k maui - θȧ hru neb ȧ ḥai em χut
thou goest round, being renewed thyself day every. Hail, rejoicing in the horizon

hai (sic) em ennuḥ - k neteru ȧmu pet
shouts of joy in thy towing ropes! May the gods who are in heaven [when]

maa en sen 10. Ȧusȧr Ani em maāχeru ṭāu - nef ȧaiu
they see Osiris Ani in triumph give to him praises

mȧ Rā Ȧusȧr ān Ani ur 11. t'ār
like Rā. May Osiris the scribe Ani be the prince distinguished by

urertu ȧp peseḥ - f Ȧusȧr
the *urertu* crown; and may be apportioned his meat and drink offerings of Osiris

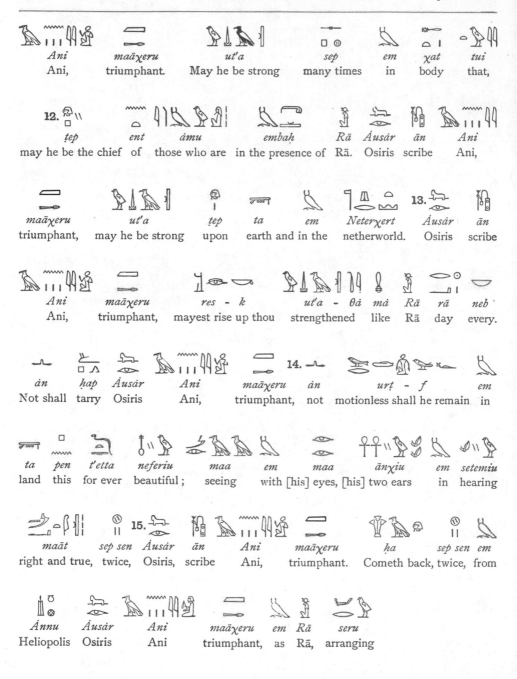

Ani	maāχeru	ut'a	sep	em	χat	tui
Ani,	triumphant.	May he be strong	many times	in	body	that,

12. ṭep	ent	àmu	embaḥ	Rā	Àusàr	ān	Ani
may he be the chief	of	those who are	in the presence of	Rā.	Osiris	scribe	Ani,

maāχeru	ut'a	ṭep	ta	em	Neterχert	13. Àusàr	ān
triumphant,	may he be strong	upon	earth and in the		netherworld.	Osiris	scribe

Ani	maāχeru	res - k	ut'a - θà mà	Rā	rā	neb
Ani,	triumphant,	mayest rise up thou	strengthened like	Rā	day	every.

àn	ḥap	Àusàr	Ani	maāχeru	àn	14. urṭ - f	em
Not shall	tarry	Osiris	Ani,	triumphant,	not	motionless shall he remain	in

ta	pen	t'etta	neferiu	maa	em	maa	ānχiu	em	setemiu
land	this	for ever	beautiful;	seeing	with [his] eyes,		[his] two ears	in	hearing

maāt	sep sen	15. Àusàr	ān	Ani	maāχeru	ḥa	sep sen em
right and true,	twice,	Osiris,	scribe	Ani,	triumphant.	Cometh back,	twice, from

Ànnu	Àusàr	Ani	maāχeru	em Rā	seru
Heliopolis	Osiris	Ani	triumphant,	as Rā,	arranging

PLATE XXII.

16. *ḥeptu* the oars *em* among *śesu* the followers *Nu* of Nu. *àn* Not *t'eṭ* hath *en* said *Àusàr* Osiris *Ani* Ani,

maāχeru triumphant, *maa - nef* what he hath seen, *àn* not **17.** *nem* hath repeated *[setemet - nef]* [what he hath heard] *Àusàr* Osiris *em* in

pa the house *śetau* which is concealed. *hai* Hail, *hennu* shouts of gladness *en* to *Àusàr* Osiris *Ani* Ani,

maāχeru triumphant. **18.** *neter* The divine *ḥā* body *en* of *Rā* Rā *em* is in *uàa* the divine boat *Nu* of Nu *emmā* together with

ḥetep satisfaction *ka* of the double *en neter* of the god *em* according to *mereret - f* his will, *Àusàr* Osiris **19.** *Ani* Ani,

maāχeru triumphant *em ḥetep* in peace, *maāχeru* triumphant *em* as *Ḥeru* Horus, *āāa* mighty of *χeperu* forms of existence. *t'eṭ* Say [these]

t'eṭet words *ḥer* over **20.** *uàa* a boat *en* of *meḥ* cubits *seχef* seven *em* in *āu - f* its length, *àru* made *em* in *śe* colour

uat'u green, *ḥer* for *t'at'at* the divine chiefs. *àri* Make *pet* a heaven *ent* of *sebu* stars **21.** *seāb - θà* washed *turà - θà* and purified

em	ḥesmen	em	neter senθer	àst	ari - nek	tut	en	Rā
with	natron [and] with		incense.	Behold,	thou must make	a figure	of	Rā

her	meḥtet	nematu	em	χenti	ertā - θa	em	ḥāt
upon a stone plaque		new	with	yellow colour, and it shall be placed	in	front of	

uàa	pen	àst	àri - nek	tut	en	χu	pen
boat	this.	Behold,	thou must make	a figure	of	deceased	this [whom]

meriu - k	seàqer - f	em	uàa	pen	seqtet - f
thou wishest	to make perfect in strength	in	boat	this;	make it to travel

em	uàa	en	Rā	maa - su	Rā	àm - f	t'esef
in	the divine boat	of	Rā,	will look upon him	Rā	in it	himself.

àm - k	maat	her ḥrà - nebu	àpu	her ḥāu - k	t'esek	em
Do not thou	show [it] to	anyone	except thyself		thine own,	or

tef - k	se - k	saa - sen	her	ḥrà - sen	maa - entuf
thy father [or] thy son,	and let keep guard them	over	their faces,	he will be seen	

em	Neterχert	em	àptu	en	Rā
in	the netherworld	as	a messenger	of	Rā.

1.	ṭua	Rā	hru	àbeṭ	nā	uàa
	Adoration of	Rā [on]	the day	of the month	[whereon he] saileth	in the boat.

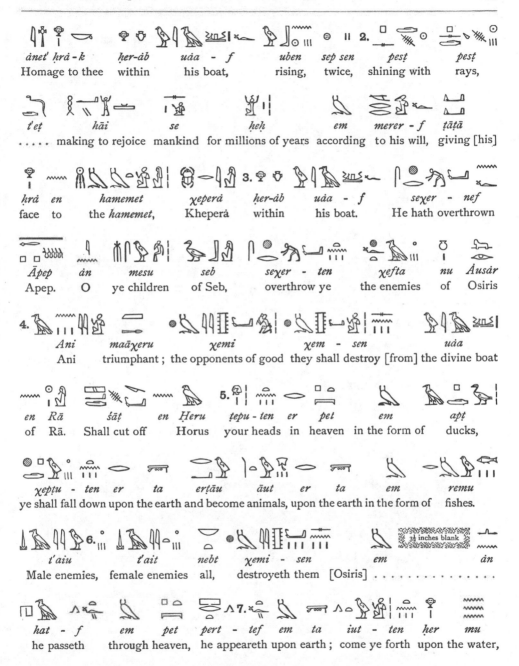

ànet' ḥrà - k *her-àb* *uàa - f* *uben* *sep sen* *pest* *pest*
Homage to thee within his boat, rising, twice, shining with rays,

t'et *hāi* *se* *heḥ* *em* *merer - f* *tātā*
. making to rejoice mankind for millions of years according to his will, giving [his]

ḥrà *en* *hamemet* *χeperà* *her-àb* *uàa - f* *seχer - nef*
face to the *hamemet*, Kheperà within his boat. He hath overthrown

Āpep *àn* *mesu* *seb* *seχer - ten* *χefta* *nu* *Àusàr*
Apep. O ye children of Seb, overthrow ye the enemies of Osiris

Ani *maāχeru* *χemi* *χem - sen* *uàa*
Ani triumphant; the opponents of good they shall destroy [from] the divine boat

en Rā *sāt* *en Ḥeru* *tepu - ten* *er* *pet* *em* *apt*
of Rā. Shall cut off Horus your heads in heaven in the form of ducks,

χeptu - ten *er* *ta* *ertàu* *àut* *er* *ta* *em* *remu*
ye shall fall down upon the earth and become animals, upon the earth in the form of fishes.

t'aiu *t'ait* *nebt* *χemi - sen* *em* *àn*
Male enemies, female enemies all, destroyeth them [Osiris]

hat - f *em* *pet* *pert - tef* *em* *ta* *iut - ten* *ḥer* *mu*
he passeth through heaven, he appeareth upon earth; come ye forth upon the water,

śas - ten em āb sebu ḥeseq en sen Ṭehuti
pass ye along in front of the starry deities, and slaughtereth them Thoth.

8. *seχer per em Ȧnreti ker āten en Ȧusȧr*
..... coming forth from Ȧnreti. Is silent and becometh the substitute Osiris,

ān Ani nek erṭā ȧs ten pu neter pen ur śāṭ
the scribe Ani Behold ye then god this great of slaughter,

9. *āāa śefśeft āb - f em snef - ten benānān - f*
mighty of terror, he washeth in your blood, he batheth

em ṭeśe[r]u - ten χemi - ten sen **10.** *em Ȧusȧr ān Ani*
in your gore. Destroyeth them Osiris the scribe Ani

em uȧa neb - f Rā Ḥeru Ȧusȧr Ani maāχeru
from the boat of his lord Rā Horus. Osiris Ani, triumphant,

ānχ āb mes en su mut - f Ȧuset renen en su **12.** *Nebt-ḥet*
living of heart, giveth birth to him his mother Isis, nurseth him Nephthys,

mā ȧrit en sen en Ḥeru χesef samait Suti
even as did they for Horus the repeller of the fiends of Sut;

maa en sen urertu **13.** *men - θȧ em ṭep-f χer en sen*
they saw the *urertu* crown stablished upon his head, and they fell down

her	*hrā-sen*	*χu*	*ās*	*ret* *neteru*	*mitu*			
upon	their faces.	O shining beings,	behold,	ye men,	gods,	damned ones, [when]			

maa	*en*	*sen*	*Àusàr*	*Ani*	*maāχeru*	*em*	*Ḥeru*	*àuf*	*em*
they see			Osiris	Ani,	triumphant	as	Horus,	he	being

15. *ḥes* *urertu* *χer - ten* *her* *hrà - ten* *maāχeru*
adored [through] the *urertu* crown, fall ye down upon your faces. Victorious

àn *Àusàr* *Ani* **16.** *maāχeru* *er* *χefta - f* *em* *pet* *heri*
is Osiris Ani, triumphant, over his enemies in the heaven above,

em *pet* *χeri* *em* *t'at'at* **17.** *ent neter neb* *ent* *netert* *nebt*
in the heaven beneath, with the divine chiefs of god every [and] of goddess every.

t'eṭ *ḥer* *bàk* *āā* *āḥā* *ḥet'et* *em* *tep - f* *Tem* **18.** *Śu*
Say over a hawk great standing with the white crown upon his head, Tmu, Shu,

Tefnut *Seb* *Nut* *Àusàr* *Àuset* *Nebt-ḥet* *ānu* *em* *χenti* *her*
Tefnut, Seb, Nut, Osiris, Isis, Nephthys, write with yellow colour upon

19. *meḥtet* *ent* *maut* *erṭàu* *em* *uàa* *pen* *ḥenā* *tut* *en*
a plaque of newness, and place in boat this with a figure of

(sic)

20. *χu* *pen* *urḥu* *ḥekennu* *erṭàu* *en* *sen* *neter senθer* *ḥer*
dead person this anointed with unguents. Let them place incense upon

				21.			
set	aptu	aśert	tua	Rā	pu		nā
the fire,	and ducks	to be roasted.	An act of praise	of Rā	is it	[when]	arriveth

uáa - f	pu	unen	ári - f	si -	henā	Rā	er	bu	neb
his boat	this		with	Rā	to	place	every	

	22.							
seqtet - f	ám	behen	χefta	nu	Rā	pu	em	unen maā
saileth he	there;	slaughtered	the enemies	of	Rā	are	in	very truth.

árit	hru	sas	ent	heb	re	en	seqtet
To be done	on day	sixth	of	the festival;	the chapter	of	the sektet boat.

PLATE XXIV.[2]

1.									
Re	en	hai	er	t'at'at	Áusár	t'et	án	Áusár	án
Chapter	of	going	to	the divine chiefs of	Osiris.		Saith	Osiris	the scribe

						2.		
Ani	maāχeru	áu	qet - ná	ba - á	χent		em	Tettetu
Ani,	triumphant:	Hath	builded for me	my soul	a dwelling-place		in	Tattu,

uat'et - [á]	em Pe	seka - ná	aht	em	áru - á	
I have become vigorous in	Pe.	I have ploughed	the fields	in	my forms of existence,	

[1] Var. ⟨hieroglyphs⟩ erţā un áru-nef su pu henā Rā hru neb, "This being done it will make him be with Rā every day." See Naville, *Todtenbuch*, Bd. I., p. 346.

[2] The whole of Plate XXIII. and a part of Plate XXIV. contain a duplicate copy of Chapter XVIII.

áu mama - á em Ámsu her - s betu - á sep sen án
is my palm tree as the god Amsu over them. My abominations, twice, not

qeq - á betu - á betu - á pu hes án qeq - á su
do I eat; my abominations those which I abominate are filth, not do I eat it.

hetepau kau en áu xemu ám - f án
[There are] food offerings and meat [for those] who are not destroyed by it. Not

ári - á nef em ááiu - á án xent - á her - f em tebt - á
do I raise myself to it with my two arms, not do I walk thereupon with my sandals,

her-enti tau - á em beti het'et heqt - á em át teser ent
because my bread is of grains white, my beer is of the grains red of

Hāpi án sektet átet án - n[á] set qeq - á
Hāpi. Indeed the sektet boat and the átet boat bring to [me] them, and I eat

set xeri semamu áu - á rex - kuá ermennu
them under the trees [of which] I, I know the branches

neferu áx árit - ná sexu - á het'et ám sebes - uá
beautiful. How I make myself glorious with the white crown there, I lift up

árāut á ári āa en sehetep taiu án - ná
the uræi! Hail, guardian of the door, who giveth peace to the world, bring to me

ennu	en	ári	ḥetepet	ṭā - k	fa - á	seṭu
those	who	make	offerings.	Grant thou	that I may lift	the earth,

un - nā	χu	ermennu	χer	paut
that may open to me	the beings of splendour [their] arms,	that may speak	the cycle	

11.

neteru	t'eṭu	hamemet	ḥenā Åusår	Ani	**12.** semu
of the gods	the words of	the *hamemet*	with Osiris	Ani.	May lead [him]

ḥātu	neteru	seru - f	em	pet	emmā
the hearts of	the gods,	may they make him powerful	in	heaven	among

13.

āχemiu	ár	neter neb	netert	nebt	t'at - f	åu	er
the gods who have visible forms.	Now	god every,	and goddess	every	he passeth	are	for

ári	Åusår	ån	Ani	maāχeru	ṭep	renpit	ānχ	em
making	Osiris	the scribe	Ani,	triumphant,	at the beginning of	the year,	living	upon

14.

ḥātu	qeq	su	ḥer	pert	em	åbt	såp - tuf	en
hearts,	eating	them	at	the coming forth	from	the east;	judged is he	by

ṭepu - ā	Rā	såp - tuf	en	ṭepu - ā	seśep	**15.** χu
the ancestors of	Rā,	judged is he	by	the ancestors of	Light.	[He is] a shining being

ḥebsu	pet	emmā	uru	åu	χert	Åusår	ån
clothed [in]	heaven	among	the mighty ones.	The provisions of		Osiris	the scribe

Ani *maāχeru* * àmmā* *tau* 16. *ḥeqt* *àri* *re - ten* *āq - nā*
Ani, triumphant, are among the cakes and beer [made] for your mouths. I go in

her *àten* *pert - nā* *her* *Àḥui* *t'eṭu - nā* *śesu* 17.
through the Disk, I come out through the god Àḥui. I speak with the followers

neteru *t'eṭu - nā* *àten* *t'eṭu - nā* *hamemet* *ṭā - f*
of the gods, I speak with the Disk, I speak with the *hamemet*; he granteth

neru - à *em* *kekiu* *samau* *em* *χennu* *Meḥ - urt* 18.
me to be victorious in the blackness of the night within Meḥ - urt,

erma *ṭehen - f* *às* *kuà* *henā* *Àusàr* *temamu - à* 19.
near his forehead. Behold I am with Osiris, [and] I proclaim

temamu - f *emmā* *uru* *t'eṭ - f* *nā* *t'eṭu*
what he announceth among the mighty ones. He speaketh to me the words

reθ *setem - à* *nem - à* *nef* *t'eṭu* *neteru* *ī - nā* *Àusàr* 20.
of men, I listen and I repeat to him the words of the gods. I come Osiris

Ani *maāχeru* *ḥetep* *em* *āper* *sàri - nek*
Ani triumphant in peace as one endowed [with all things]. { Thou raisest up } { [right and truth] }

mertu - f *nuk* *χu* *āper* *er* *χu* *nebu* 21.
for those who love them. I am a shining being endowed more than shining beings all.

PLATE XXV.

1. *ḥā* — *em* — *re* — *en* — *àrit* — *χeperu* — *àrit* — *χeperu*

The beginning of the chapters of making transformations. Making the transformation

em — *ment* — *t'eṭ* — *àn* — *Àusàr* — *Ani* — *maāχeru* — *nuk* — *ment*

into a swallow (*or* dove). Saith Osiris Ani, triumphant: I am a swallow,

ment — *tefi* — *ḥet'et'et* — *set* — *Rā* — *à* — *neteru* — *net'emui* — *set*

swallow that the scorpion, the daughter of Rā. Hail ye gods, sweet [is] your

ten — *sep sen* — *à* — *nesert* — *pert* — *em* — *χut* — *à* — *enti* — *em*

smell, twice. Hail flame coming forth from the horizon. Hail thou who art in

nut — *àn - nà* — *sau* — *qeb - f* — *àm* — *àmmā - nà* — *āāui - k*

the town. May lead me the guardian of his corner there. O grant to me thy two hands

urś - nà — *em* — *àa* — *nesert* — *māsem - nà* — *em* — *àpt*

that I may pass the time in the Island of flame. I have travelled with an order,

ì - nà — *χer* — *smà - s* — *un - nà* — *χet* — *t'eṭ - à* — *maa - nà*

I have come having its report, may one open to me. How shall I tell what I have seen

àm — *àu-à* — *em* — *Ḥeru* — *χerp* — *en* — *uàa* — *ertāu - nef* — *nest*

there? I was like Horus, the prince of the divine boat, was given to him the throne

en	tef - f	àu	Sut	pef	se	Nut	χer	ànt	àri - nef
of	his father,	and	Sut	that	son	of Nut	possessed	the calamity [which]	he had made

eref	àu	sàp - nà	enti	em	Seχem	qàḥ - à
for himself.		Give judgment upon me	being	in	Sekhem. I stretched out	

āāui - à	her	Àusàr	māśem - nà	er	sàp	ī - nà	er	t'eṭ
my two arms	to	Osiris,	I passed on	to	judgment.	I have come	to	say:

àmmā	seś - à	smà - à	àptu	nuk	āq	àp
Grant that	I may pass	[that] I may report	[my] message.	I	enter	being judged,

per	tennu	her	seb	pui	[en]	Neb-er-t'er	āb - nuà
coming out	distinguished	at	door	that	[of]	Neb-er-tcher.	I am pure

her	uārt	tui	āāat	ṭer - à	ṭut - à
at	place of passage	that	great,	I have destroyed	my defects,

χersek - à	àsfet - à	χersek - nà	ṭut	àri - à
I have made an end	of my wickednesses,	I have annihilated	the faults	which belong to me,

au - à	āb - kuà	neteri - kuà	àri ā	àri - nà	uat	nuk
I myself	am pure,	I am mighty.	O doorkeepers,	I have made	the way.	I am

màtet - ten	per - à	em	hru	māśem-à	her	uārt-à
like unto you,	I have come forth	by	day.	I have walked	upon	my two legs,

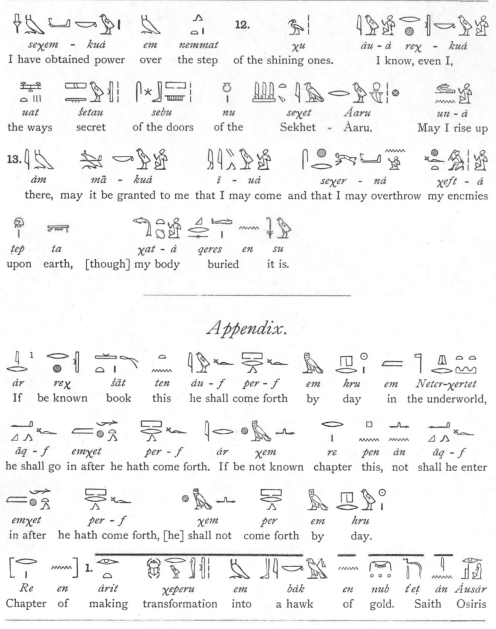

seχem - kuȧ em nemmat 12. χu ȧu - ȧ reχ - kuȧ

I have obtained power over the step of the shining ones. I know, even I,

uat śetau sebu nu seχet Ȧaru un - ȧ

the ways secret of the doors of the Sekhet - Ȧaru. May I rise up

13. ȧm mȧ - kuȧ ī - uȧ seχer - nȧ χeft - ȧ

there, may it be granted to me that I may come and that I may overthrow my enemies

ṭep ta χat - ȧ qeres en su

upon earth, [though] my body buried it is.

Appendix.

ȧr reχ śȧt ten ȧu - f per - f em hru em Neter-χertet

If be known book this he shall come forth by day in the underworld,

ȧq - f emχet per - f ȧr χem re pen ȧn ȧq - f

he shall go in after he hath come forth. If be not known chapter this, not shall he enter

emχet per - f χem per em hru

in after he hath come forth, [he] shall not come forth by day.

Re en ȧrit χeperu em bȧk en nub t'et ȧn Ȧusȧr

Chapter of making transformation into a hawk of gold. Saith Osiris

¹ The text is from Lepsius, *Todtenbuch*, Bl. 32.

2. *Ani* — *Ani* — *àu - à* — *χāā - kuà* — *em* — *seśeṭet* — *em*

Ani — Ani (*sic*). — May I — rise, even I, — in — the *seshet* chamber — like

bàk — *en* — *nub* — **3.** *per* — *em* — *suḥt - f* — *pa - nà* — *χenen - nà*

a hawk — of — gold — coming forth — from — his egg. — May I fly, — may I alight

em — *bàk* — *en* — *meḥ* — **4.** *seχef* — *her* — *pesṭ - f* — *ṭenḥ - f* — *em*

like — a hawk — of — cubits — seven — at — his back, — his two wings — being of

uaṭ'u — *qemāt* — *per - nà* — *em* — *sektet* — **5.** *àu*

mother-of-emerald — of the south. — May I come forth — from — the *sektet* boat,

àn - nà — *àb - à* — *em* — *ṭu* — *àbtet* — *χenen - nà* — *em*

may be brought to me — my heart — from — the mountain — of the east; — may I alight — on

āṭet — *àu* — *àn - nà* — *àmu* — **6.** *paut - sen* — *em*

the *āṭet* boat [and] — and — may be brought to me — those — who are in their cycles — with

kesu - sen — *àu - à* — *χāā - kuà* — *ṭemṭ - kuà* — **7.** *em*

bowings their. — May — I rise, even I, — may I gather myself together — like

bàk — *nefer* — *en* — *nub* — *ṭep* — *bennu* — *āq* — *Rā* — *er*

a hawk — beautiful — of — gold — [with] the head — of a phœnix, — entering to — Rā —

àmi — *ṭef - à*[1] — *hems - à* — *er* — *àmitu* — **8.** *neteru* — *àpu* — *uru* — *en*

.............. — May I sit down — among — gods — those — the great ones of

[1] Read [hieroglyphs] "daily to hear his words."

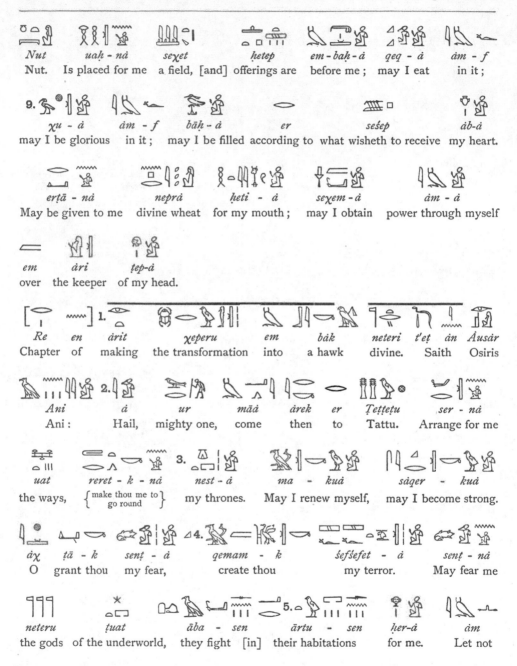

Nut. Is placed for me a field, [and] offerings are before me; may I eat in it;

9. may I be glorious in it; may I be filled according to what wisheth to receive my heart.

May be given to me divine wheat for my mouth; may I obtain power through myself

over the keeper of my head.

Chapter of making the transformation into a hawk divine. Saith Osiris

Ani: Hail, mighty one, come then to Tattu. Arrange for me

the ways, { make thou me to go round } my thrones. May I renew myself, may I become strong.

O grant thou my fear, create thou my terror. May fear me

the gods of the underworld, they fight [in] their habitations for me. Let not

The transliterations appearing above the English:

Nut | uah - nà | seχet | ḥetep | em-baḥ-à | qeq - à | àm - f

χu - à | àm - f | bàḥ-à | er | seśep | àb-à

erṭa - nà | neprà | ḥeti - à | seχem-à | àm - à

em | àri | ṭep-à

Re | en | àrit | χeperu | em | bàk | neteri | t'eṭ | àn | Ausàr

Ani | à | ur | màá | àrek | er | Ṭeṭṭeṭu | ser - nà

uat | reret - k - nà | nest - à | ma - kuà | sàqer - kuà

àχ | ṭà - k | senṭ - à | qemam - k | śefśefet - à | senṭ - nà

neteru | ṭuat | àba - sen | àrtu - sen | ḥer-à | àm

tekem (sic) - *tuá* *ári* *neken* - *à* *afu* - *à* *em* *pa*
come near me [him] that would do harm to me, may I walk (?) through the house

kekiu *kef* - *à* *baka* *àmen* *eref*
of darkness, may I clothe myself the feeble one, [and] hide ; therefore

ári *mà* *àn* *sen* *neteru* *setemiu* *χeru* *χepiu* *entia* *em*
doing even as they. O ye gods who hear speech, ye chiefs who are among

śesu *en Àusàr* *ker* *àr* - *ten* *neteru* *t'etu* *neter* *henà* - *à*
the followers of Osiris, be silent therefore ye. O gods, speaketh the god with me,

setem - *f* *maàt* *t'et* - *nà* *nef* *t'etu* - *nà* *àrek Àusàr* *tá* - *k*
he heareth right and true, [what] I speak to him, speak for me then, Osiris. Grant thou

uteb *perert* *em* *re* - *k* *er* - *à* *maa* - *à* *àru* - *k*
the revolution coming forth from thy mouth in respect of me, may I see thy forms

t'esek *seqet* - *à* *baiu* - *k* *tá* - *k* *per* - *à* *seχem* - *à*
thy own, may I understand thy soul. Grant thou that I may come forth, { and that I may obtain power }

em *ret* - *à* *un* - *à* *àm* *mà* *Neb* - *er* - *t'er* *heri* *nest* - *f* *sent* - *nà*
over my legs. May I be there like Neb-er-tcher upon his throne. May fear me

neteru *tuat* *àba* - *sen* *àrtu* - *sen* *her* - *à* *tá* - *k* *ennut* *er* - *à*
the gods of the *tuat*, may they fight at their gates for me. Grant thou that I may pass along

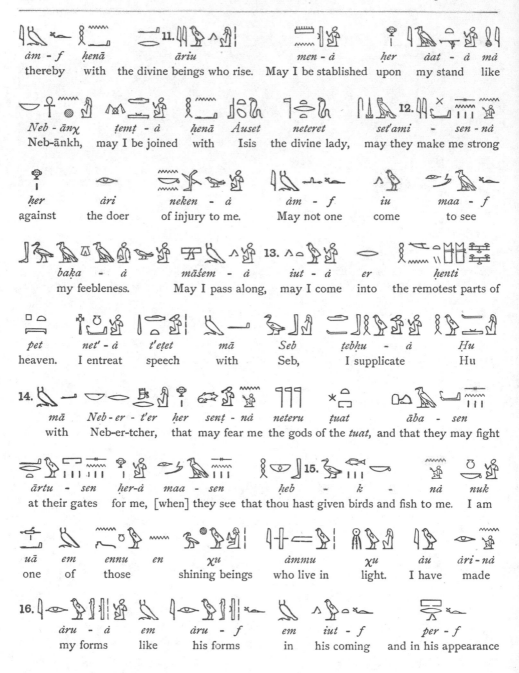

àm - f ḥenā àriu men - à her àat - à mā
thereby with the divine beings who rise. May I be stablished upon my stand like

Neb - ānχ, ṭemṭ - à ḥenā Àuset neteret seʿami - sen - nà
Neb-ānkh, may I be joined with Isis the divine lady, may they make me strong

ḥer àri neken - à àm - f iu maa - f
against the doer of injury to me. May not one come to see

baḳa - à māsem - à iut - à er ḥenti
my feebleness. May I pass along, may I come into the remotest parts of

pet net' - à t'eṭet mā Seb ṭebḥu - à Ḥu
heaven. I entreat speech with Seb, I supplicate Hu

mā Neb - er - t'er her senṭ - nà neteru ṭuat āba - sen
with Neb-er-tcher, that may fear me the gods of the tuat, and that they may fight

àrtu - sen her-à maa - sen ḥeb - k - nà nuk
at their gates for me, [when] they see that thou hast given birds and fish to me. I am

uā em ennu en χu àmmu χu àu àri - nà
one of those shining beings who live in light. I have made

àru - à em àru - f em iut - f per - f
my forms like his forms in his coming and in his appearance

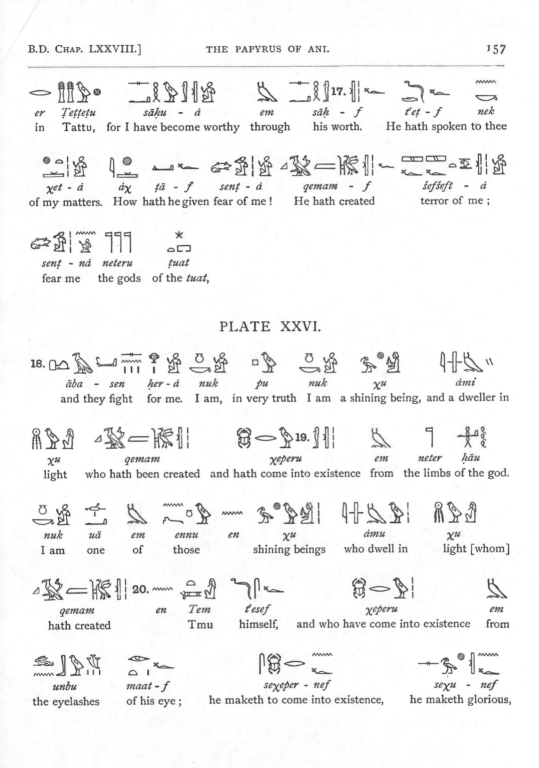

er Ṭeṭṭeṭu sāḥu - ȧ em sāḥ - f t'eṭ - f nek
in Tattu, for I have become worthy through his worth. He hath spoken to thee

χet - ȧ ȧχ ṭā - f senṭ - ȧ qemam - f šefšeft - ȧ
of my matters. How hath he given fear of me ! He hath created terror of me ;

senṭ - nȧ neteru ṭuat
fear me the gods of the *tuat*,

PLATE XXVI.

18. āba - sen ḥer - ȧ nuk pu nuk χu ȧmi
and they fight for me. I am, in very truth I am a shining being, and a dweller in

χu qemam χeperu em neter ḥāu
light who hath been created and hath come into existence from the limbs of the god.

nuk uā em ennu en χu ȧmu χu
I am one of those shining beings who dwell in light [whom]

qemam en Tem t'esef χeperu em
hath created Tmu himself, and who have come into existence from

unbu maat - f seχeper - nef seχu - nef
the eyelashes of his eye ; he maketh to come into existence, he maketh glorious,

teni - f — *ḥrāu-sen* — *em* — *unen-sen* — *ḥenā - f* — **21.** *àstu* — *su*

he maketh to be distinguished — their faces [when] they exist — with him. — Behold — him

uāu — *em* — *Nu* — *ser - sen* — *s....* — *per - f* — *em*

the Only One — in — Nu! — They do homage to him — [as] — he cometh forth — from

χut — *tā - sen* — *senṭ - f* — *en* — *neteru* — **22.** *χu*

the horizon, — and they set — the fear of him — in — the gods — and the shining beings

χeperu — *ḥenā - f* — *nuk* — *uā* — *em* — *fentu*

who have come into existence — with him. — I am — the One — among — the worms

qemam — *en* — *maat* — *neb* — *uā* — *àstu* — *àn*

which created — the eye of — the lord, — the Only One. — Behold — not

χeper — *en* — *Àuset* — *mest* — *Ḥeru* — *àu - à* — *seruṭ - à*

{having come into existence} — Isis, [not] being born Horus, — I had become strong and flourished,

àu-à — *seneχeχ - à* — *teni - kuà* — **24.** *er* — *àmu*

I had grown old, — I was greater — than — those who were among

χu — *χeperu* — *ḥenā - f* — *àu - à* — *χāā - kuà* — *em*

the shining beings who came into existence with him, — and, — even I arose — in the form of

bàk — **25.** *neteri* — *sāḥ - nuà* — *Ḥeru* — *em* — *ba - f*

a hawk — divine, — and made me worthy of honour — Horus — as — his soul

er	θet	χet - f	en	Àusàr	er	ţuat	àuf	t'eţ	en
to	take possession	of the things	of	Osiris	in	the *tuat*.	He	hath spoken	the

Rereti (?)	er - à	her ţep	àri	het	en
26.
| Double Lion-god | to me, | the chief of | that which appertaineth to | the house | of |

nemmes	àmi	tephet - f	hem - k	àr (sic)	heru	pet
the *nemmes* crown	which is in	his hiding place :	Get thee back	to	the heights of heaven,	

mà emmà	às - tu - θà	sàh - θà em	χeperu - k	en	Heru
27.
| inasmuch as | thou, behold, hast become worthy in | thy forms | through Horus, |

àn	nemmes	er - ek	t'eţu	àrek	er	t'eru	nu
28.
| not | is the *nemmes* | for thee, | speech is | to thee | to | the limits | of |

pet	nuk	àri	θetet	χet	Heru	en Àusàr er	ţuat
heaven.	I am the guardian,	taketh possession	of the things	Horus	of Osiris in	the *tuat*.	

àu	nem - nà	en	Heru	em	t'eţ	en	nà	àtef - f	Àusàr	em
29.
| Crieth out to me | Horus | what had said to me | his father | Osiris | in |

renput	em	hru	qeres	tà - k - nà	nemmes
years	on the	day	of the sepulture [of Osiris].	I give to thee by myself	the *nemmes*

àn	Rereti	er - à	màśem - k	iut - k
30.
| of the Double Lion-god [which is] to me, that thou mayest pass onward and thou mayest come |

her	uat	pet	maa-tu	ammu	t'eru	χut
over	the way	of heaven;	may see thee	those who are in	the limits of	the horizon,

sent-nek	neteru	tuat	31. aba-sen	artu-sen	her-k
may fear thee	the gods	of the tuat,	they fight at	their doors	for thee.

Åuhet	aru	au	χebχeb	her	t'etu	neteru	nebu
Auhet	belongeth to them.	Have	fallen	before [my] words	the gods	the lords of	

32. t'er	ariu	kerå	neb	uā	å	ån
boundaries (?),	the guardians	of the shrine	of the lord,	the Only one.	Hail,	the

qa	her	teb-f	er-å	sesetu-nef	nemmes
exalted one	upon	his chest	is for me,	he hath bound on [for me]	the nemmes crown,

33.	Rereti	Åahet	åri-nå	uat	åu-å
hath decreed	the double Lion-god,	Åahet	hath made for me	a way.	I,

qa-kuå	sesetu	en	Rereti	nemmes	er-å
I am exalted,	hath bound	on	the Double Lion-god	the nemmes crown	for me,

34. tåi-nå	temamit-å	semen-nef-nå	åb-å	em
hath been given to me	my hair;	he hath established for me	my heart	through

åat-f	em	usert-f	urti	ån	35. χer-å	her
his back	and through	his might	great (?),	not	shall I fall	through

										36.
Šu	*nuk*	*Ḥetep*	*neb*	*ārāti*	*uašti*	*nuk*	*reχ*	*χu*	*àu*	
Shu.	I am	Ḥetep,	lord	of the uræi	adored.	I	know	Khu,	is	

nifu - f	*em*	*χat - à*	*àn*	*χesef - uà*	*ka*	*neśeni*	*ī - nà*
his breath	in	my body.	Not	shall I be repulsed by	the bull	of terror,	I shall come

			37.				
màn	*em*	*per*	*Rereti*	*per - nà*	*àm - f*	*er*	*per*
daily	into	the house of the Double Lion-god,	I shall come forth	from it	into the house		

				38.	
Àuset	*maa - nà*	*seru*	*śetau*	*sem - kuà*	*er*
of Isis,	I shall see	the holy things	hidden,	I shall pass through	

seru	*àmennu*	*maa - nà*	*enti*	*àm*	*àu*	*t'eṭ - à*	*t'er*
the holy rites	hidden,	I shall see	what is	there,	shall	my words	complete

			39.				
āāau	*Šu*	*χesef - sen*	*at*	*nuk*	*pu*	*Ḥeru*	*àmi*
the majesty of	Shu,	they shall repulse	the moment.	I am		Horus,	the dweller in

χu - f	*seχem - à*	*em*	*seśeṭ - f*	*seχem - à*
his splendours.	I have gained possession	of	his tiara,	I have gained possession

40.						
em	*em* (sic) *seśepu - f*	*māśem - à*	*er*	*henti*	*pet*	*àu*
of	his rays of light,	I have travelled	over	the uttermost parts of	heaven.	Is

						41.				
Ḥeru	*her*	*àuset - f*	*àu*	*Ḥeru*	*her*	*nest - f*	*àu*	*ḥrà - à*	*em*	*bàk*
Horus	upon	his throne.	Is	Horus	upon	his seat.	Is	my face	like that of	a hawk

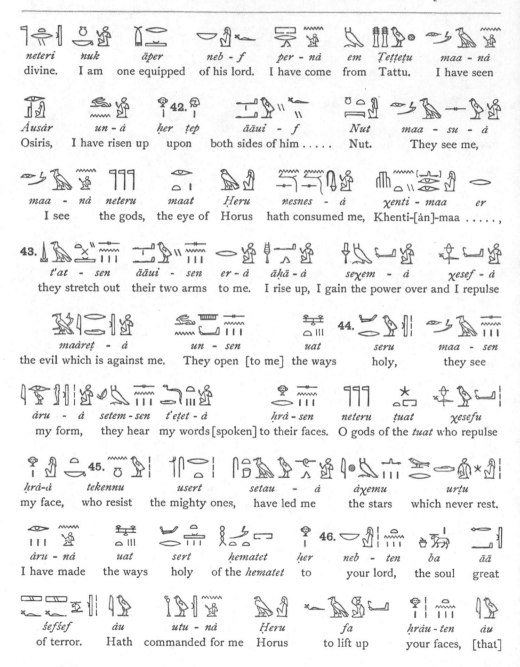

neteri	*nuk*	*āper*	*neb - f*	*per - nà*	*em*	*Ṭeṭṭeṭu*	*maa - nà*
divine.	I am	one equipped	of his lord.	I have come	from	Tattu.	I have seen

Àusâr	*un - à*	*her ṭep* 42.	*āāui - f*	*Nut*	*maa - su - à*
Osiris,	I have risen up	upon	both sides of him	Nut.	They see me,

maa - nà	*neteru*	*maat*	*Ḥeru*	*nesnes - à*	*χenti - maa*	*er*
I see	the gods,	the eye of	Horus	hath consumed me,	Khenti-[àn]-maa ,

43.

t'at - sen	*āāui - sen*	*er - à*	*āḥā - à*	*seχem - à*	*χesef - à*
they stretch out	their two arms	to me.	I rise up,	I gain the power over	and I repulse

maàreṭ - à	*un - sen*	*uat* 44.	*seru*	*maa - sen*
the evil which is against me.	They open [to me]	the ways	holy,	they see

àru - à	*setem - sen*	*t'eṭet - à*	*ḥrà - sen*	*neteru* *ṭuat*	*χesefu*
my form,	they hear	my words [spoken]	to their faces.	O gods of the *tuat*	who repulse

45.

ḥrà-à	*tekennu*	*usert*	*setau - à*	*àχemu*	*urṭu*
my face,	who resist	the mighty ones,	have led me	the stars	which never rest.

				46.			
àru - nà	*uat*	*sert*	*ḥematet*	*ḥer*	*neb - ten*	*ba*	*āā*
I have made	the ways	holy	of the *ḥematet*	to	your lord,	the soul	great

šefšef	*àu*	*utu - nà*	*Ḥeru*	*fa*	*ḥràu - ten*	*àu*
of terror.	Hath	commanded for me	Horus	to lift up	your faces,	[that]

ṭekai - ten - uȧ ȧu - ȧ χāā - kuȧ em bȧk neteri
ye may see me. I have risen like a hawk divine,

sāh - nuȧ Ḥeru em ba - f er θet
hath distinguished me Horus like his soul to take possession of

χet - f en Ȧusȧr er ṭuat ȧri - nȧ uat śas - ȧ peḥ - ȧ
things his of Osiris in the tuat. I have made the way, I have travelled, I have arrived

χentia tephetu - sen ȧru ḥet Ȧusȧr t'eṭ - ȧ en sen
at those who live in their caverns guarding the house of Osiris. I speak to them of

useru - f ṭā - ȧ reχ - sen neru - f sepṭ ḥenti
his power, I make them to know the fearful power of him provided with horns

er Sut reχ - sen enti θet - nef ḥu θet - nef
against Sut. They know who hath carried off the divine food which had brought

seχemiu Tem seua nefer nȧs ȧn sen em neteru ṭuat
the power of Tmu. A coming happy they have proclaimed the gods of the tuat

er - ȧ s - teni en sen en ren - sen χenta tephetu - sen
for me. They have magnified their names, those who live in their caverns

ȧru ḥet Ȧusȧr mā - ten - kuȧ ȧ - kuȧ χer ten
guarding the house of Osiris. Grant ye to me that I may come to you.

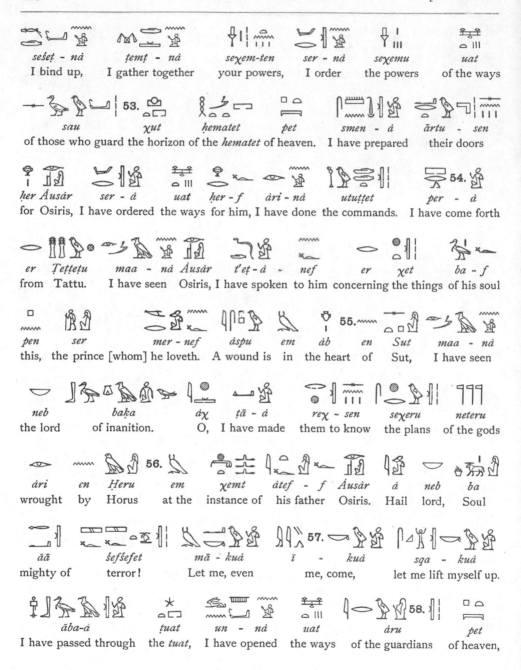

seṣeṭ - nà ṭemṭ - nà seχem-ten ser - nà seχemu uat
I bind up, I gather together your powers, I order the powers of the ways

53. sau χut hematet pet smen - à ārtu - sen
of those who guard the horizon of the hematet of heaven. I have prepared their doors

her Àusàr ser - à uat her - f àri - nà ututṭet per - à
for Osiris, I have ordered the ways for him, I have done the commands. I have come forth

er Ṭeṭṭeṭu maa - nà Àusàr t'eṭ-à - nef er χet ba - f
from Tattu. I have seen Osiris, I have spoken to him concerning the things of his soul

pen ser mer - nef àspu em àb en Sut maa - nà
this, the prince [whom] he loveth. A wound is in the heart of Sut, I have seen

neb baka àχ ṭā - à reχ - sen seχeru neteru
the lord of inanition. O, I have made them to know the plans of the gods

àri en Ḥeru em χemt àtef - f Àusàr à neb ba
wrought by Horus at the instance of his father Osiris. Hail lord, Soul

āā ṣefṣefet mā - kuà ī - kuà sqa - kuà
mighty of terror! Let me, even me, come, let me lift myself up.

āba-à ṭuat un - nà uat àru pet
I have passed through the tuat, I have opened the ways of the guardians of heaven,

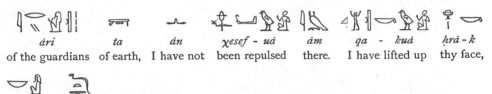

àri	*ta*	*àn*	*χesef - uà*	*àm*	*qa - kuà*	*ḥrà - k*	
of the guardians	of earth,	I have not	been repulsed	there.	I have lifted up	thy face,	

neb	*t'etta*
O lord	of eternity.

Appendix.

In the Paris papyrus, from which the text of the LXXVIIIth chapter is taken by Naville,[1] the chapter ends with the following :—

qa - θà	*ḥer*	*àuset - k*	*Àusàr*	*setem - k*	*nefert*	*Àusàr*	*uat'*
Thou art exalted	upon	thy throne,	Osiris.	Thou hearest	joyful things,	Osiris.	Vigorous is

peḥ - k	*Àusàr*	*θes - tu - nek*	*ṭep - k*	*Àusàr*	*smen - tu - nek*	*àpt (?)-k*
thy strength,	Osiris.	Bound to thee is	thy head,	Osiris.	Established is for thee	thy brow,

Àusàr	*net'em*	*àb - k*	*neḥ - k*	*men*	*àu*	*en*	*śenit - k*
Osiris.	Joyful is thy heart.	Be thou pleased to establish	gladness	for	thy ministers.		

àu - k	*men - θà em*	*ka*	*Àmenta*	*se - k*	*Ḥeru*	*χāā*	*ḥer nest - k*
Thou art	established as	bull of	Àmenta,	thy son	Horus·	is crowned	on thy throne,

ānχ	*neb*	*χeri - f*	*se - k*	*ṭā - f*	*ḥeḥ*	*senṭ - nef*
all life [is]	with him.	Thy son	to him are given	millions of years,	the fear of him is for	

ḥeḥ	*senṭ - nef*	*paut*	*neteru*	*ba - k*	*ṭā - nef*
millions of years;	fear him	the cycle of the gods.	Thy soul	to it is given	

[1] *Todtenbuch*, Bd. I., Bl. 89.

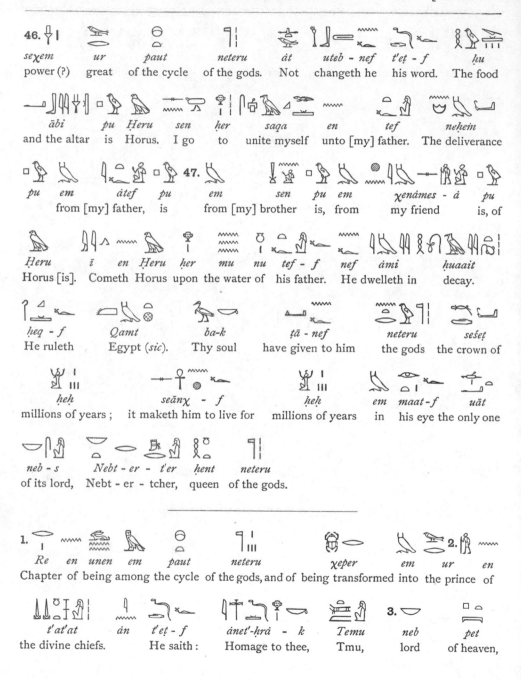

46.
seχem — *ur* — *paut* — *neteru* — *àt* — *uteb - nef* — *t'eṭ - f* — *ḥu*
power (?) great of the cycle of the gods. Not changeth he his word. The food

ābi — *pu* — *Ḥeru* — *sen* — *her* — *saqa* — *en* — *tef* — *neḥem*
and the altar is Horus. I go to unite myself unto [my] father. The deliverance

pu — *em* — *àtef* — *pu* — *em* — 47. — *sen* — *pu* — *em* — *χenàmes - à* — *pu*
from [my] father, is from [my] brother is, from my friend is, of

Ḥeru — *ī* — *en* — *Ḥeru* — *her* — *mu* — *nu* — *tef - f* — *nef* — *àmi* — *ḥuaait*
Horus [is]. Cometh Horus upon the water of his father. He dwelleth in decay.

ḥeq - f — *Qamt* — *ba-k* — *ṭā - nef* — *neteru* — *seṣeṭ*
He ruleth Egypt (sic). Thy soul have given to him the gods the crown of

heḥ — *seānχ - f* — *heḥ* — *em* — *maat - f* — *uàt*
millions of years; it maketh him to live for millions of years in his eye the only one

neb - s — *Nebt - er - t'er* — *hent* — *neteru*
of its lord, Nebt - er - tcher, queen of the gods.

1.
Re — *en* — *unen* — *em* — *paut* — *neteru* — *χeper* — *em* — *ur* — *en* 2.
Chapter of being among the cycle of the gods, and of being transformed into the prince of

t'at'at — *àn* — *t'eṭ - f* — *ànet'-ḥrà - k* — *Temu* — *neb* — *pet* 3.
the divine chiefs. He saith : Homage to thee, Tmu, lord of heaven,

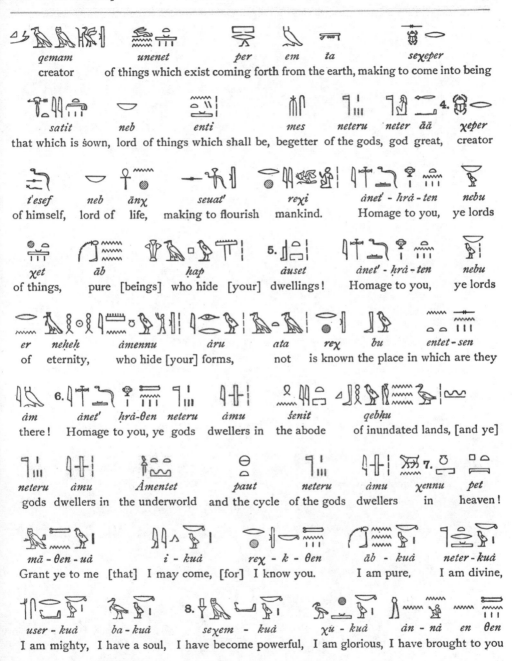

qemam unenet per em ta sexeper
creator of things which exist coming forth from the earth, making to come into being

satit neb enti mes neteru neter āā xeper
that which is sown, lord of things which shall be, begetter of the gods, god great, creator

t'esef neb ānx seuat' rexi ānet'-hrā-ten nebu
of himself, lord of life, making to flourish mankind. Homage to you, ye lords

xet āb hap āuset ānet'-hrā-ten nebu
of things, pure [beings] who hide [your] dwellings! Homage to you, ye lords

er neheh āmennu āru ata rex bu entet-sen
of eternity, who hide [your] forms, not is known the place in which are they

ām ānet' hrā-θen neteru āmu senit qebhu
there! Homage to you, ye gods dwellers in the abode of inundated lands, [and ye]

neteru āmu Āmentet paut neteru āmu xennu pet
gods dwellers in the underworld and the cycle of the gods dwellers in heaven!

mā-θen-uā i-kuā rex-k-θen āb-kuā neter-kuā
Grant ye to me [that] I may come, [for] I know you. I am pure, I am divine,

user-kuā ba-kuā sexem-kuā xu-kuā ān-nā en θen
I am mighty, I have a soul, I have become powerful, I am glorious, I have brought to you

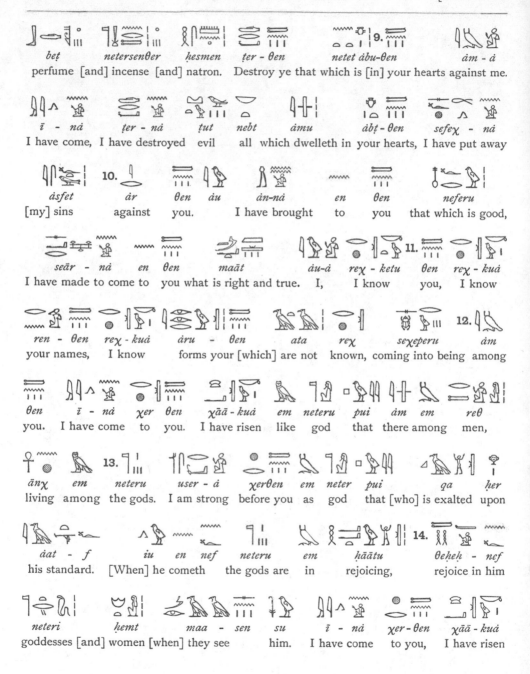

beṭ	netersenθer	ḥesmen	ṭer - θen	netet àbu-θen	9.	àm - à
perfume [and]	incense [and]	natron.	Destroy ye	that which is [in]	your hearts	against me.

ī - nà	ṭer - nà	ṭut	nebt	àmu	àbṭ - θen	sefeχ - nà
I have come,	I have destroyed	evil	all	which dwelleth in	your hearts,	I have put away

àsfet	10.	àr	θen	àu	àn-nà	en	θen	neferu
[my] sins		against	you.		I have brought	to	you	that which is good,

seàr - nà	en	θen	maāt	àu-à	reχ - ketu	11.	θen	reχ - kuà
I have made to come to	you		what is right and true.	I,	I know		you,	I know

ren - θen	reχ - kuà	àru - θen	ata	reχ	seχeperu	12.	àm
your names,	I know	forms your [which]	are not	known,	coming into being		among

θen	ī - nà	χer	θen	χāā - kuà	em	neteru	pui	àm	em	reθ
you.	I have come	to	you.	I have risen	like	god	that	there among		men,

ānχ	em	neteru	13.	user - à	χerθen	em	neter	pui	qa	her
living	among	the gods.		I am strong	before you	as	god	that [who] is exalted		upon

àat - f	iu	en	nef	neteru	em	ḥāātu	14.	θeḥeḥ - nef
his standard.	[When] he cometh		the gods are	in		rejoicing,		rejoice in him

neteri	ḥemt	maa - sen	su	ī - nà	χer-θen	χāā - kuà
goddesses [and]	women	[when] they see	him.	I have come	to you,	I have risen

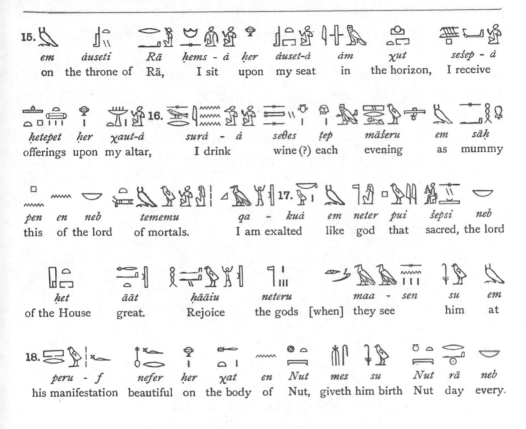

15.

em	àuseti	Rā	ḥems - à	ḥer	àuset-à	àm	χut	seṡep - à
on	the throne of	Rā,	I sit	upon	my seat	in	the horizon,	I receive

ḥetepet	ḥer	χaut-à	16.	surà - à	seθes	ṭep	māṡeru	em	sāḥ
offerings	upon	my altar,		I drink	wine (?)	each	evening	as	mummy

pen	en	neb	tememu	qa - kuà	17.	em	neter	pui	ṡepsi	neb
this	of the lord	of mortals.		I am exalted		like	god	that	sacred,	the lord

ḥet	āāt	ḥāāiu	neteru	maa - sen	su	em
of the House	great.	Rejoice	the gods	[when] they see	him	at

18.

peru - f	nefer	ḥer	χat	en	Nut	mes	su	Nut	rā	neb
his manifestation	beautiful	on	the body	of	Nut,	giveth him birth		Nut	day	every.

PLATE XXVII.

1.

àrit	χeperu	em	Seta	t'eṭ	àn	Àusàr	Ani
[Chapter of] making	the transformation	into	Seta.	Saith		Osiris	Ani,

2.

maāχeru	nuk	Se-ta	āu	renpit	st'er	mes	rā	neb
triumphant :	I am	Seta	extended	of years.	[I] lie down,	[I am] born	day	every,

nuk	Se-en-ta	àmmi	t'eru	ta	st'er - à	mes - kuà
I am	Se-ta	the dweller in	the limits of	the earth.	I lie down,	I am born,

ma - kuà	renp - kuà	rā	neb
I renew myself,	I become young	day	every.

àrit	χeperu	em	sebåk	t'et	àn	Àusàr	Ani
[Chapter of] making	the transformation into		a crocodile.		Saith	Osiris	Ani,

maāχeru	nuk	emsuḥ	ḥer-àb	neru - f	nuk	emsuḥ	àn - nà
triumphant :	I am	the crocodile	within	his terrors,	I am	the crocodile god,	I bring

em	āuaui	nuk	remu	āā	em	Qemui	nuk
	destruction.	I am	the Fish	great	in	Qemui,	I am

neb	kesenu	em	Seχem	Àusàr	Ani	neb	kesenu
the lord	of homage	in	Sekhem, [and]	Osiris	Ani	is the lord	of homage

em	Seχem
in	Sekhem.

àrit	χeperu	em	Ptaḥ	t'et	àn	Àusàr	Ani	àu
[Chapter of] making	the transformation	into	Ptaḥ.		Saith	Osiris	Ani :	[I]

àm	tau	surà - nà	ḥeqt	unχ - kuà	pa - nà
eat	bread,	I drink	beer,	I put on raiment.	I fly

¹ Variant [hieroglyphs], sept-kuà, "I am equipped."

em	bâk	neqeq-nà	em	smen	χenen-nà	em	pefa
like	a hawk,	I cackle	like	a goose,	I alight	upon	the way

erma	àat	heb	Ur	but	sep sen	àn
near the funereal mountain	on the festival of	the Great One.	What is evil	doubly	not have	

qeq-à	pu	ḥesu	àn	qeq-à	su	betu	ka-à	àn
I eaten,	what is foul	not have I swallowed it.	What abominateth	my ka	not hath			

āq-f	er	χat-à	ānχ-kuà	eref	emmā	reχ-sen	neteru
entered it	into	my body.	I live	then	according to	what know	the gods

χu	ānχ-à	seχem-à	em	tau-sen	seχem-à	qeq-à
glorious.	I live	and I obtain power	from	their bread,	I obtain power	[as] I eat

su	χer	semam	àm	Ḥet-ḥert	ḥent-à	àri-à	āabet	àri-à
it	beneath	the foliage of	the tree of	Hathor	my lady.	I make	an offering,	I make

tau	em	Ṭeṭṭeṭu	uaḥit	em	Ànnu	unχ-à	ṭaàu
[an offering of] bread	in	Tattu	and oblations	in	Ànnu.	I array myself	in the covering of

Mātait	āḥā-à	ḥems-à	er	bu	merer	àb-à	àm
Matait.	I stand up	and I sit down	wherever	desireth	my heart	there.	

ṭep-à	em	Rā	temṭ-à	em	Temu	àftu
My head is like [that of] Rā,	I have gathered myself together	like	Tmu.	The four quarters		

Rā　　　āu　　　ent　　　ta　　　per - à　　　nes - à　　　　em　Ptaḥ　ḥetit - à

of Rā [are] the extent of the earth. I come forth. My tongue is　of　Ptaḥ,　my throat is

em Ḥet - ḥert　　seχa - à　　　t'eṭet　　　Temu　en　àtef - à　em　re - à

of　　Hathor.　I make mention　of the words of　Tmu,　my father, with my mouth.

sek - f　　　ḥent　　　ḥemt　　Seb　　seṭ　　　ṭepu　her - f

He constraineth　the servant (?)　the wife of　Seb.　Are broken down　heads　to him,

senṭ　eref　　àm　　nem - tu　　　ànnu　　em　　neχtu

terror is to him　there.　Are recited　hymns of praise　at　[my] acts of strength,

àp - tuà　　āuā　　neb　　　ta　　en　Seb　　neḥep

I am accounted　the heir　of the lord　of the earth, of　Seb,　the protector.

qebḥ　　Seb　　ṭā - f - nà　　χāāu - f　　uaḥ - nà　　ammu

Giveth water　Seb,　he giveth to me　his risings.　Bow down to me　those who are in

Ȧnnu　ṭep - sen　　nuk　　ka - sen　　　user　　　at　er　　at

Annu　their heads.　I am　their bull,　becoming strong　moment　by　moment,

nek - à　　seχem - à　　em　　ḥeḥ

I copulate,　I have gained strength　for　millions of years.

àrit　　χeperu　　em　　ba　　Tem　t'eṭ　àn Ȧusàr　ān

[Chapter of] making　the transformation　into the Soul of Tmu.　Saith　Osiris the scribe

Ani maāχeru àn āq - à er χebenu àn sek - à

Ani, triumphant: I have not gone into the house of destruction, { I have not come to an end, }

àn reχ - à su nuk Rā per em Nu ba pu neter

I have not known it. I am Rā coming forth from Nu, the soul that is divine,

qemam hāu - f betu - à àsfet àn maa - à su

the creator of his members. Abomination to me is sin, not do I look upon it,

en kai - à em maāt ānχ - à àm - s nuk Ḥu

not do I cry against right and truth, I live in it. I am Ḥu.

àt sek - f em ren - à pui en ba χeper-nà t'es-à

Never doth he fail in my name that of Soul. I have created myself

henā Nu em ren-[à] pu en χeperà χeper-nà àm - sen (sic)

with Nu in my name of Kheperà; I come into being in it

em Rā nuk neb seśep

in the form of Rā. I am the lord of light.

Appendix.

betu - à menà àn āq - à er χebt Ṭuaa nuk

What I hate is burial, not let me enter into the cavern of Tuaa. I

[1] The text is from Naville, *Todtenbuch*, Bd. I., Bl. 97.

ṭāṭā χut en Ȧusȧr se-ḥetep ȧb en ȧmu χet
ascribe glory to Osiris, [and] pacify the heart of those who dwell among things,

mert ṭāṭā-sen senṭ-ȧ qemam-sen šefšeft-ȧ en
the divine friends, give they fear of me, create they terror of me in

ȧmu qeb-sen ȧs kuȧ qa-kuȧ her ȧat-ȧ
those who are in their corners. Behold me, I am exalted upon my standard

7. *Nu her ȧuset ȧpt-ȧ nuk Nu ȧn χemi-ȧ*
Nu, upon the place adjudged to me. I am Nu, not shall overthrow me

ȧru ȧsfet nuk uru paut ba-ȧ pu neteru
those who do evil. I am the eldest born of unformed matter, my soul is the gods,

baiu en neḥeḥ nuk qemam keku ȧru ȧuset-f
[who are] the souls of eternity. I am the creator of darkness making his place

t'eru ḥeri ı̄-nȧ ba-ȧ āā her uat ȧauu
in the confines of the sky. I come, my soul advanceth over the way of the aged ones.

ȧri-nȧ keku em t'eru ḥeri mer-ȧ peḥ t'eru-sen
I make darkness in the confines of the sky, if I wish [I] arrive at their boundaries.

māšem-ȧ her reṭ-ȧ χerp-ȧ t'a bȧ ȧriu
I walk upon my legs, I am strong sailing over the sky, working.

seṡet - à	keku	fentut	àmen	seḥer - à	nemmat-à	er
I fetter with bands	the darkness and	the Worms	hidden.	I extend	my steps	to

neb	àui	ba - à	pu	ba	t'et - à	pu	àrātu	er
the lord	of two-fold strength.	My soul	is,	the soul of	my body	is	the uræus,	

tut - à	pu	neḥeḥ	neb	renput	ḥeq	pu	t'etta	nuk	qa
my form (?) is		for ever,	the lord	of years,	the prince		of eternity.	I am	the exalted one

neb	ta	bu - à	ḥun - à	em	nut	àr - à
and the lord	of the earth.	I am exalted (?).	I become young	in	the towns,	I grow young

em	seχet - à	ren - à	pu	àn	sek	en	ren - à	nuk	ba
in	my province,	my name	is	"Not	setteth		my name."	I am	the soul,

qemam	Nu	àri	àuset - f	em	Neter-χert	àn	maa
the creator	of Nu,	making	his seat	in	the underworld.	Not	is seen

seṡ - à	àn	seṭ - tu	suḥt - à	nuk	neb	ḥeḥ	àri - nà
my nest,	not	is cracked	my egg.	I am	lord of	millions of years.	I make

seṡ - à	em	t'eru	ḥeri	haa - à	er	ta	Seb
my nest	in	the limits	of the sky,	I descend	to	the earth	of Seb,

ṭer - à	ṭut - à	maa - à	àtef - à	neb	Māṡ	sen	t'et - f
I destroy	my defects.	I see	my father	the lord	of Māsh,	breatheth	his body

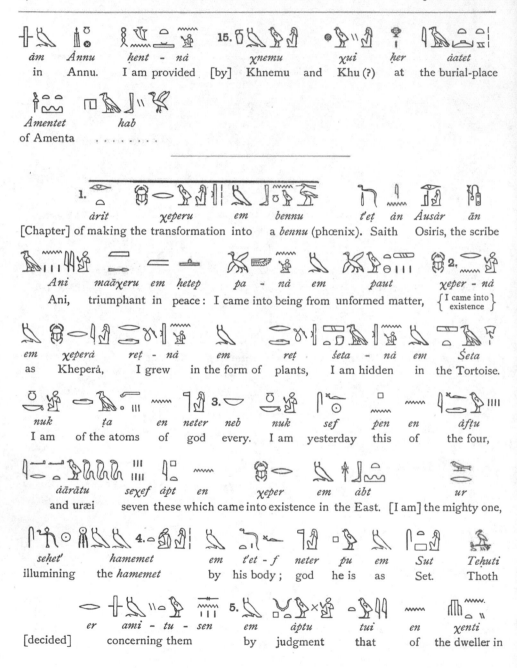

âm Ânnu hent - nà χnemu χui her àatet
in Annu. I am provided [by] Khnemu and Khu (?) at the burial-place

Âmentet hab
of Amenta

1. àrit χeperu em bennu t'et àn Ausàr ân
[Chapter] of making the transformation into a *bennu* (phœnix). Saith Osiris, the scribe

Ani maāχeru em ḥetep pa - nà em paut χeper - nà
Ani, triumphant in peace: I came into being from unformed matter, { I came into existence }

em χeperà reṭ - nà em reṭ śeta - nà em Śeta
as Kheperà, I grew in the form of plants, I am hidden in the Tortoise.

nuk ṭa en neter neb nuk sef pen en àfṭu
I am of the atoms of god every. I am yesterday this of the four,

ààrātu seχef àpt en χeper em àbt ur
and uræi seven these which came into existence in the East. [I am] the mighty one,

seḥeṭ hamemet em t'et - f neter pu em Sut Teḥuti
illumining the *hamemet* by his body; god he is as Set. Thoth

er ami - tu - sen em àptu tui en χenti
[decided] concerning them by judgment that of the dweller in

Seχem	*henā*	*baiu*	*Ānnu*	*ennui*	*er*	*ámmi - tu - sen*
Sekhem	together with the spirits of	Annu.		Sailing		among them

ī - nā	*χāā - kuȧ*	*χu - kuȧ*	*user - kuȧ*	*neteri - kuȧ*
I have come,	I am crowned,	I am glorious,	I am mighty,	I am strong

emmā	*neteru*	*nuk*	*χensu*	*tenten*	*nebu*
among	the gods.	I am	Khensu	repulsing	all.

Appendix.

re	*pen*	*āb*	*pert*	*em hru emχet*	*menȧ - f*
[If be known] chapter	this	the purified one	shall come forth by day	after	his burial,

ȧrit	*χeperu*	*em*	*tȧtȧ*	*āb - f*	*unen*	*em*
and shall make	the transformations	according to	the wish	of his heart,	[and] shall be	among

śes	*en*	*Un-nefer*	*ḥetep*	*em*	*śau*	*en*	*Ȧusȧr*
the servants	of	Un-nefer,	and shall be satisfied	with	the food	of	Osiris

perχeru	*maa*	*ȧθen*	*t'au*	*pu*	*tep*	*ta*	*χer*	*Rā*
and sepulchral meals,	and shall see	the Disk,	and shall go forth			over the earth	with	Rā,

¹ See Naville, *Todtenbuch*, Bd. II., Bl. 185.

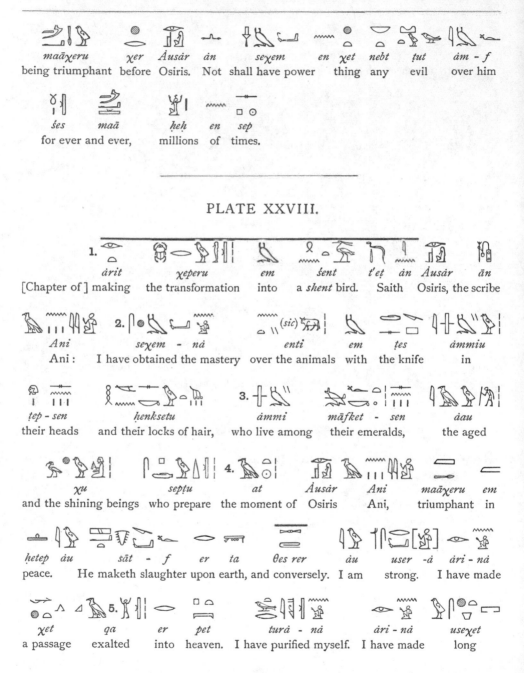

maāχeru	χer	Àusàr	àn	seχem	en	χet	nebt	ṭut	àm - f
being triumphant	before	Osiris.	Not	shall have power		thing	any	evil	over him

šes	maā	ḥeḥ	en	seṗ
for ever and ever,		millions	of	times.

PLATE XXVIII.

1.

àrit	χeperu	em	šent	t'eṭ	àn	Àusàr	àn
[Chapter of] making	the transformation	into	a *shent* bird.	Saith		Osiris, the scribe	

Ani	seχem - nà	enti	em	ṭes	àmmiu
Ani:	I have obtained the mastery	over the animals	with	the knife	in

ṭeṗ - sen	ḥenksetu	**3.** àmmi	māfket - sen	àau
their heads	and their locks of hair,	who live among	their emeralds,	the aged

χu	seṗṭu	**4.** at	Àusàr	Ani	maāχeru	em
and the shining beings	who prepare	the moment of	Osiris	Ani,	triumphant	in

ḥeteṗ	àu	sāt - f	er	ta	θes rer	àu	user -à	àri - nà
peace.	He maketh slaughter upon earth, and conversely.					I am	strong.	I have made

χet	qa	**5.** er	pet	turà - nà	àri - nà	useχet
a passage	exalted	into	heaven.	I have purified myself.	I have made	long

en	*nemmat-à*	*er*	*nut-à*	*ḳeru*	*māšem* - *à*	*sepu*	*ṭā* - *tu*
my footsteps		to	my town,	possessing	my going	to Sepu (?).	I have placed

		em	*Unnu*	*χaāā* - *nà*	*neteru*	*her*	*uat* - *sen*
	[the being who is]	in	Unnu,	I have set	the gods	upon	their ways,

χu - *nuà*	*peru*	-	*àmu*	*kerà* - *sen*	*reχ* - *à*
I have made glorious	the temples		of those who live in	their shrines.	I know

ennu	*Nut*	*reχ* - *à*	*Ta* - *tu* - *enen*	*reχ* - *à*	*Ṭeśer*	*sta* - *nà*
Nut,		I know	Tatunen,	I know	Tesher,	I have brought along

ābu - *sen*	*reχ* - *à*	*Ḥeka*	*setem* - *à*	*t'eṭet* - *f*	*nuk*	*mas*	*ṭeśer*
their horns.	I know	Ḥeka,	I hear	his words.	I am	the calf	red

enti	*em*	*ānu*	*t'eṭ*	*àn*	*neteru*	*χeft*	*setem* - *sen*	*sefeχ*	*ḥrà* - *n*
which is	in	the writings.	The		gods say	when	they hear:	Let us abase	our faces,

ît - *f*	*χer* - *à*	*àu*	*nehepu*	*em*	*χemt* - *ten*	*sepu* - *à*	*em*	*χat* - *à*
let him come	to me ;		there is light	without you.		My seasons are in		my body.

àn	*t'eṭ* - *à*	*em*	*àuset*	*maāt*	*màn*	*ḥāpepet*	*maāt*
I do not speak [evil]		in	the place	of right and truth,	every day	advancing in	right and truth,

ḥer	*ànḥu* - *s* (sic)	*χaui*	*χenti*	*er*	*seḥeb*	*st'er*
being shrouded in		darkness,	sailing	to	keep the festival of	the dead one,

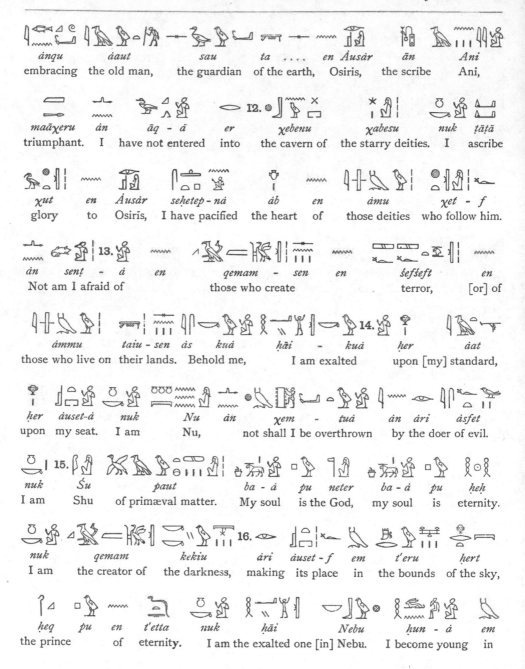

ànqu	àaut	sau	ta	en Àusàr	àn	Ani
embracing	the old man,	the guardian	of the earth,	Osiris,	the scribe	Ani,

maāχeru	àn	āq - ă	er	χebenu	χabesu	nuk	ṭāṭā
triumphant.	I	have not entered	into	the cavern of	the starry deities.	I	ascribe

χut	en	Àusàr	seḥetep - nă	àb	en	àmu	χet - f
glory	to	Osiris,	I have pacified	the heart	of	those deities	who follow him.

àn	senṭ - ă	en	qemam - sen	en	šefšeft	en
Not am I afraid of		those who create		terror,		[or] of

àmmu	taiu - sen	às	kuà	ḥài - kuà	her	àat
those who live on	their lands.	Behold me,		I am exalted	upon [my] standard,	

her	àuset-à	nuk	Nu	àn	χem - tuà	àn àri	àsfet
upon	my seat.	I am	Nu,		not shall I be overthrown	by the doer	of evil.

nuk	Śu	paut	ba - à	pu	neter	ba - à	pu	ḥeḥ
I am	Shu	of primæval matter.	My soul	is the God,		my soul	is	eternity.

nuk	qemam	kekiu	àri	àuset - f	em	t'eru	ḥert
I am	the creator of	the darkness,	making	its place	in	the bounds	of the sky,

ḥeq	pu	en	t'etta	nuk	ḥài	Nebu	ḥun - à	em
the prince		of	eternity.	I am the exalted one [in] Nebu.		I become young	in	

17.

nut	àatu - à	em	seχet-à	ren - à	àn	sek,
the town,	I become young	in	my province.	My name	is ' Not	setting.'

18.

ren - à ba	qemam	en	Nu	àri	àuset - f	em	Neterχert
My name is Soul,	creator	of	Nu,	making	his seat	in	the underworld.

àn	maa - entu	seś à	àn	set - tu - nà	suḥt	nuk	neb
Not	is seen	my nest,	not	cracked have I [my] egg.		I am	the lord of

19.

ḥeḥ	àri - nà	seśu - à	em	t'eru	ḥert
millions of years.	I have made	my nest	on	the borders	of the sky.

ḥa - à	er	ta	en	Seb	ter - [à]	tut - à	maa - nà
I come down	to	the earth	of	Seb.	I destroy	my defects.	I see

20.

àtef - à	em	neb	Śàutet	àr	Àusàr	[Ani]	t'et - f
my father	as	the lord of	Shautet.	As concerning	Osiris	[Ani]	his body

àmmi	Ànnu,	ḥenti	en	àmu	χui	ḥer	àat
is in	Ànnu,	ordered	by	those who are with	Khui	at	the burial place of

Àmentet	ḥeb
Amenta,	a messenger (?)

1.

àrit	χeperu	em	seśeni	t'et	àn	Àusàr	Ani
[Chapter of] making	the transformation	into	a lotus.	Saith		Osiris	Ani:

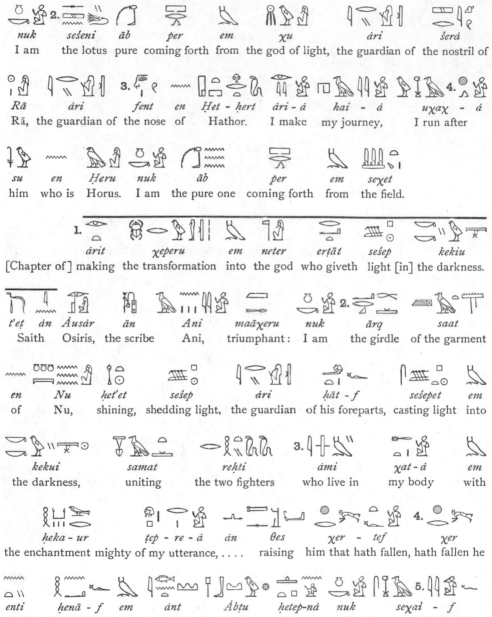

2. nuk · seśeni · āb · per · em · χu · àri · śerà
I am · the lotus · pure · coming forth · from · the god of light, · the guardian · of the nostril of

Rā · àri · fent · en · Ḥet - ḥert · àri - à · hai - à · **3.** uχaχ - à
Rā, · the guardian · of the nose · of · Hathor. · I make · my journey, · **4.** I run after

su · en · Ḥeru · nuk · āb · per · em · seχet
him · who is · Horus. · I am · the pure one · coming forth · from · the field.

1. àrit · χeperu · em · neter · erṭāt · seśep · kekiu
[Chapter of] making · the transformation · into · the god · who giveth · light [in] · the darkness.

t'eṭ · àn · Àusàr · ân · Ani · maāχeru · nuk · **2.** ārq · saat
Saith · Osiris, · the scribe · Ani, · triumphant: · I am · the girdle · of the garment

en · Nu · ḥet'et · seśep · àri · ḥāt - f · seśepet · em
of · Nu, · shining, · shedding light, · the guardian · of his foreparts, · casting light · into

kekui · samat · reḥti · **3.** àmi · χat - à · em
the darkness, · uniting · the two fighters · who live in · my body · with

ḥeka - ur · ṭep - re - à · àn · θes · χer - tef · **4.** χer
the enchantment · mighty of my utterance, · raising · him that hath fallen, · hath fallen he

enti · ḥenā - f · em · ànt · Àbṭu · ḥetep-nà · nuk · seχaì - f · **5.**
who [was] with him · in · the valley of · Abydos. · I rest. · I · have remembered him.

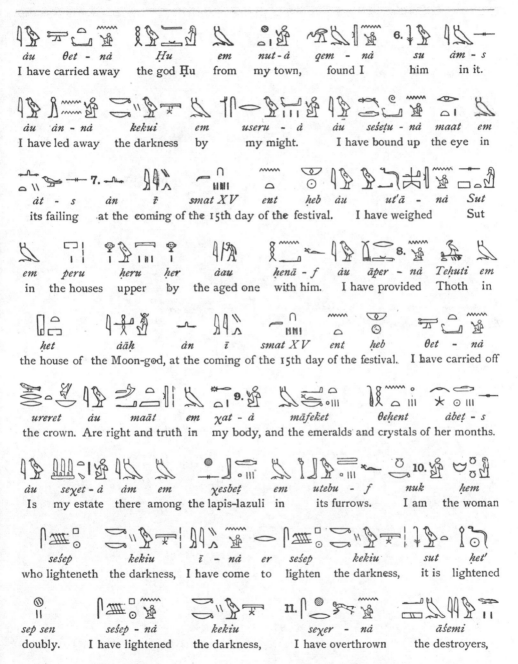

						6.		
àu	*θet - nà*	*Ḥu*	*em*	*nut - à*	*qem - nà*		*su*	*àm - s*
I have carried away		the god Ḥu	from	my town,	found I		him	in it.

àu	*àn - nà*	*kekui*	*em*	*useru - à*	*àu*	*seṣeṭu - nà*	*maat*	*em*
I have led away		the darkness	by	my might.	I have bound up		the eye	in

		7.						
àt - s	*àn*	*ī*	*smat XV*	*ent*	*ḥeb*	*àu*	*ut'à - nà*	*Sut*
its failing	at the coming of the 15th day of the				festival.	I have weighed		Sut

						8.			
em	*peru*	*ḥeru*	*ḥer*	*àau*	*ḥenā - f*	*àu*	*āper - nà*	*Teḥuti*	*em*
in	the houses	upper	by	the aged one	with him.	I have provided		Thoth	in

het	*āāḥ*	*àn*	*ī*	*smat XV*	*ent*	*ḥeb*	*θet - nà*
the house of	the Moon-god, at the coming of the 15th day of the festival.						I have carried off

				9.				
ureret	*àu*	*maāt*	*em*	*χat - à*	*māfeket*	*θeḥent*	*àbet - s*	
the crown.	Are right and truth in			my body,	and the emeralds	and crystals	of her months.	

							10.	
àu	*seχet - à*	*àm*	*em*	*χesbeṭ*	*em*	*utebu - f*	*nuk*	*ḥem*
Is	my estate	there	among the lapis-lazuli	in		its furrows.	I am	the woman

seśep	*kekiu*	*ī - nà*	*er*	*seśep*	*kekiu*	*sut*	*het'*
who lighteneth	the darkness,	I have come	to	lighten	the darkness,	it is	lightened

			11.	
sep sen	*seśep - nà*	*kekiu*	*seχer - nà*	*āśemi*
doubly.	I have lightened	the darkness,	I have overthrown	the destroyers,

ṭua - nà	àmu	kekiu	se - āḥā - nà	12. àakebi
I have adored	those who are in	the darkness.	I have made to stand	those who weep,

àmennu	ḥrāu-sen	bakai - sen	maa - sen	uà	àr	ten
who hid	their faces,	who had sunk down.	They looked	upon me then	

nuk	ḥem	àn	erṭai - à	er	setem - ten	ḥer - s
I am	a woman.	Not	have I caused	that	ye should hear	concerning her.

PLATE XXIX.

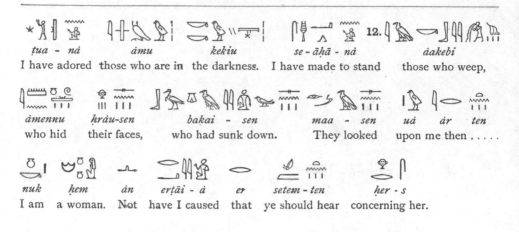

1. re	en	tem	met	em	nem	t'eṭ	àn	Ausàr	Ani
Chapter	of	not	dying	a second time.		Saith		Osiris	Ani,

maāχeru	à	Teḥuti	àsset	pu	χepert	set	em	mesu	Nut
triumphant:	Hail	Thoth,	what	is that which hath happened			to	the children of	Nut?

3. àri - en - sen	χeruiu	àu	seśeṭu - en - sen	χennu	àri - en - sen
They have done	battle,		they have supported	strife,	they have done

àsfet	qemam - en - sen	sebàu	àri - en - sen	śāt
evil,	they have created	the fiends,	they have made	slaughter,

qemam - en - sen	sautu	àu	ḳert	àru - en - sen	āā
they have created	troubles;		but surely they have worked the mighty		

6.
er	net'es	em	àrit - sen	nebt	tā	àrek	āā	Tehuti	si
against	the weak	in	deeds their	all.	Grant	then	might of	Thoth		what hath decreed

7.
Tem	àn	maa - nek	àsfet	àn	uχet - k		sehu
Tmu.	Not	seest thou	evil,	not	art thou enraged		[when they] confuse

8.
renput-sen	setekennu	àbet - sen	t'erenti	àru - en - sen	het'
their years,	and go in among	their months,	because	they have done	iniquity

àment	em	àrit - nek	neb	nuk	mesθà - k	Tehuti
secret	in	what [they] have done against thee all.	I am	thy pallet, O Thoth,		

9.
se - āri - nà	nek	pes - k	àn	nu - à	emmā	ennu	en
I have brought	to thee	thy ink-jar.	Not	am I	among	those	who [work]

het'	àment - sen	àn	àritu	het'	àm - à
iniquity	in their secret [places],	not	may be done	iniquity	to me.

10.
t'et àn Àusàr	Ani	Ani	à	Tem	àsset	pu
Saith Osiris	Ani,	Ani (sic):	Hail	Tmu!	What	is [this to which]

śas-à	er	set	àu	kert	àn	mu	set	àn	nìfu	set	met' - θà
I have come	into	it?	But	surely	without	water	it is,	without	air	it is,	deep

11.
sep sen	kektu - θà	sep sen	heh - θà	sep sen	ānχ - θà	àm - s	em
doubly,	darkened	doubly,	remote	doubly.	He who liveth	in it [is] in	

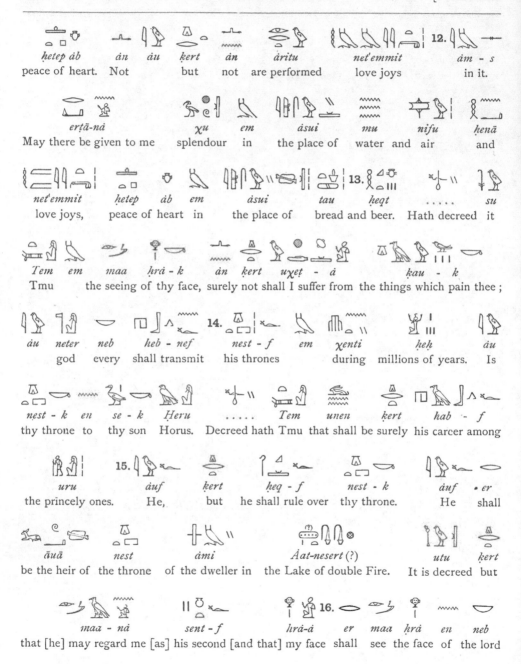

ḥetep áb àn àu ḳert àn àritu neťemmit 12. àm - s
peace of heart. Not but not are performed love joys in it.

erṭā-nà χu em àsui mu nifu ḥenā
May there be given to me splendour in the place of water and air and

neťemmit ḥetep áb em àsui tau ḥeḳt 13. su
love joys, peace of heart in the place of bread and beer. Hath decreed it

Tem em maa ḥrà - k àn ḳert uχeṭ - à ḳau - k
Tmu the seeing of thy face, surely not shall I suffer from the things which pain thee ;

àu neter neb heb - nef 14. nest - f em χenti ḥeḥ àu
god every shall transmit his thrones during millions of years. Is

nest - k en se - k Ḥeru Tem unen ḳert hab - f
thy throne to thy son Horus. Decreed hath Tmu that shall be surely his career among

uru 15. àuf ḳert ḥeḳ - f nest - k àuf • er
the princely ones. He, but he shall rule over thy throne. He shall

āuā nest àmi Àat-nesert (?) utu ḳert
be the heir of the throne of the dweller in the Lake of double Fire. It is decreed but

maa - nà sent - f ḥrà-à er 16. maa ḥrà en neb
that [he] may regard me [as] his second [and that] my face shall see the face of the lord

Tem àsset pu āḥā em ānχ àuk er
Tmu. What then is [my] duration in life? It is decreed that thou art for

ḥeḥ en ḥeḥ āḥā en ḥeḥ àu erṭā - nà
millions of years of millions of years, a duration of millions of years. I have granted

hab - f uru àu - à ḳert er heṭ⁴ àrit - nà nebt
that he may pass on to the princely ones. I am but doing away with what I did all

àu ta pen er ī em Nu em huhu mà ṭepi - f
when earth this was coming from Nu out of the watery abyss like unto its former

ā nuk seṗ ḥenā Àusàr àri - nà χeperu - à em keteχu
state. I am fate and Osiris. I have made my transformations into other

ḥeftu àn reχ - sen reθ àn maa-sen neteru neferui
serpents. Not know they mankind, not can perceive they the gods the double beauty

àri - nà en Àusàr teni er neteru nebu àu erṭā - nà nef
[which] I have made for Osiris; greater [is he] than gods all. I have granted to him

set àu ḳert se - f Heru em āuā her nest - f
[to rule] in the underworld. But his son Horus [is] as [his] heir upon his throne

àmi Àat-nesert (?) àu àri - nà ḳeri àuset - f en uàa
within the Lake of double Fire. I have made but his seat in the boat

en	ḥeḥ	àu	Ḥeru	men	ḥer	sereχ - f	en	mertu
of	millions of years.	Is	Horus	established	upon	his throne	with [his]	friends

ḳer	mennu - f	ḳert	hab	ba	en	Sut
and possessing	his remains.	But	hath departed	the soul	of	Sut,

tennu	er neteru nebu	àu	erṭà - nà	satu
greater	than the gods all [to Åmenta].	May it be granted to me		to bind

ba - f	àmi	uàa	en	mer - f	senṭ	neter	ḥàu
his soul	in	the boat of the sun	at	his will		fear	divine members.

à	àtef - à	Àusàr	àri - k	nà	àri en nek	àtef - k	Rà
O	my father	Osiris,	hast done thou	for me	what did for thee	thy father	Rà.

uaḥ-à	ṭep	ta	ḳer - à	nest - à	senb	àu - à
May I abide	upon	earth,	may I possess	my throne,	may be strong	my heir,

ruṭ	àsi - à	mertu - à	pu	ṭep	ta	erṭàt
may make green	my tomb	my friends	who are	upon	earth.	May be given

χeft - à	em	neḳàtu	Selq	ḥer	ḳasu - sen	nuk	se - k
my enemies	over to	the destruction of	Selq	for	their fettering.	I am	thy son.

àtef - à	Rà	àri - k nà	ennu	en	ànχ	uťa	senb	àu
My father is	Rà.	Thou hast made for me	this same		life,	strength,	health.	Is

Ḥeru	men - θ	her	sereχ - f	ṭā - k	ī - ut	āḥā - ȧ	pui
Horus	established	upon	his throne.	Grant thou	the course of	my life	may be that

en	sebt	er	ȧmaχ
of	advancing	to	a state of being venerated.

PLATE XXX.

1.

Re	en	āq	er	useχt	maāti	ṭua	Ȧusȧr
Chapter	of	entering	into	the Hall of	Double Maāti.	A hymn of praise to	Osiris

χenti	Ȧmentet	t'eṭ	ȧn	Ȧusȧr	ān	Ani	maāχeru	ī - nȧ
the dweller in	Ȧmentet.	Saith	Osiris,	the scribe	Ani,	triumphant:	I have come	

āa	er	maa	neferu - k	āāui - ȧ	em	ȧau	en
advancing to	see	thy beauties.	My two hands are [held up] in	acclamation of			

ren - k	maā	ī - nȧ	āa	ȧn	χeper	āś	ȧn
thy name	righteous,	I have come advancing.	Not hath come into existence	the āsh tree,	not		

3.

mest	śenṭet	ȧn	qemau	setu	ȧser
hath been produced	the shenṭ tree,	not	hath created	the ground	the ȧser plants.

ȧr	āq - ȧ	er	ȧuset	śeta	ȧu	t'eṭet - ȧ	ḥenā	Sut
Now I have entered	into	the place of hidden things.			I have spoken	with	Sut,	

χenem - ȧ *teken* *ȧm - ȧ* *ḥebs* *ḥrȧ - f* *χeru* *ḥer*
my friend (?) hath entered to me, clothing his face, falling down upon

χet *šeta* *ȧu - f* 5. *ȧq - f* *er* *per* *Ȧusȧr* *ȧu - f*
the things which are hidden. He, he hath entered into the house of Osiris, he,

maa - f *šeta* *enti* *ȧm - f* *ȧu* *t'at'at* *ent* *sebχit*
he hath seen the hidden things which [are] in it. Are the divine chiefs of the pylons

em *χu* *t'et* *ȧn* 6. *Ȧnpu* *en* *ḳesui - f*
in the form of beatified spirits. Hath spoken Anubis on both sides of him

χeru *se* *ȧu'* *em* *Ta - merȧ* *ȧuf* *reχu* *uat - n*
with the word of a man [at his] coming from Ta - merȧ. He knoweth our paths

ṭemȧ - n *ḥetep - kuȧ* 7. *sensen-ȧ* *sti - f* *em* *uȧ* *ȧm - ten*
[and] our towns. Offerings are made to me, I smell his smell as one of you.

t'et - f *nȧ* *nuk Ȧusȧr* *ȧn* *Ani* *maȧχeru* *em ḥetep* *maȧχeru*
Saith he to me : I am Osiris the scribe Ȧni, triumphant in peace, triumphant !

8. *ī - nȧ* *ȧa* *er* *maa* *neteru* *ȧȧaiu* *ȧnχ - ȧ* *em*
I have come advancing to see the gods great, and I live upon

ḥetepet *ȧmu* *kau - sen* *un - nȧ* *er* *t'eru* 9. *ba* *neb*
the offerings which eat their doubles. I have been to the borders of the Ram, lord of

Ṭeṭṭeṭ ṭā - f per - å em bennu er t'eṭeṭ - å
Tattu. He granted that I might come forth as a *bennu* bird, that I might speak·

un - nå em åtru uṭen - å em neter sentrå
I have been in the water of the river. I have made offerings with incense.

sem - å em shenṭet en ẖerṭu un - nå em Åbṭu
I have made my way by the *shenṭ* tree of the children (?). I have been in Abydos

em Per - Satet åu semeḥ - nå uå en ẖefta åuå
in the Temple of Satet. I have submerged the boat of [my] enemies. I,

t'a - kuå er Se em neshemet maa - nå sāhu
I have sailed forth upon the Lake in the *neshem* boat. I have seen the noble ones of

Qem - ur un - nå em Ṭeṭṭu sekeru - nå
Qem - ur. I have been in Tattu, and I have brought myself to silence.

ṭā - nå seẖem neter em reṭ - f un - nå em Per - ṭep - ṭu - f
I have placed the image of the god upon his two feet. I have been with Per - ṭep - ṭu - f

maa - nå ẖenti neter ḥet (?) åuå āq - kuå er
and I have seen the dweller in the divine abode. I, I have entered into

Per - Åusår kefa - nå åfnetu en enti åm auå
Per - Åusår, and I have draped myself in the apparel of him who is there. I,

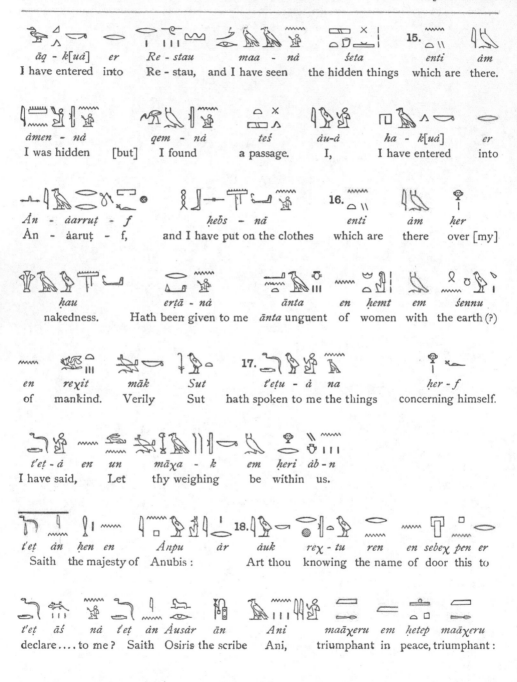

āq - k[uȧ] er Re - stau maa - nȧ śeta 15. enti ȧm
I have entered into Re - stau, and I have seen the hidden things which are there.

ȧmen - nȧ [but] qem - nȧ teś ȧu-ȧ ha - k[uȧ] er
I was hidden [but] I found a passage. I, I have entered into

Ȧn - ȧarruṭ - f, ḥebs - nȧ 16. enti ȧm ḥer
Ȧn - ȧaruṭ - f, and I have put on the clothes which are there over [my]

ḥau ertā - nȧ ānta en ḥemt em śennu
nakedness. Hath been given to me ānta unguent of women with the earth (?)

en reχit māk Sut 17. t'eṭu - ȧ na ḥer - f
of mankind. Verily Sut hath spoken to me the things concerning himself.

t'eṭ - ȧ en un māχa - k em ḥeri ȧb - n
I have said, Let thy weighing be within us.

t'eṭ ȧn ḥen en Ȧnpu ȧr ȧuk 18. reχ - tu ren en sebeχ pen er
Saith the majesty of Anubis: Art thou knowing the name of door this to

t'eṭ āś nȧ t'eṭ ȧn Ȧusȧr ān Ani maāχeru em ḥetep maāχeru
declare....to me? Saith Osiris the scribe Ani, triumphant in peace, triumphant:

RETURNING TO PLATE XXIX.

19.

pen	χer - sek	Śu	ren	en	20. sebeχ pen	t'et	àn	ḥen en
this.	"Driver away of	Shu" is the name		of	this door.	Saith		the majesty of

21.

Ȧnpu	àr	àuk	reχ - tu	ren	en	setem	22. ḥeri
Anubis :	Art thou		knowing	the name	of	the leaf	upper

setem	χeri	neb	maāt	23. ḥeri	tep	ret - f	àn	ren	en
and the leaf	lower?	"Lord of	right	upon		his two feet" is		the name	of

24.

setemet	ḥeri	neb	peḥti	θesu	menmenet	25. seś	àrek
the leaf	upper ;	"Lord of	might,	disposer of	{ cattle " [is the name of the leaf lower] }.	Pass	then,

26.

tuk	reχtu	Ȧusàr	àn	ḥesb	27. ḥetep	neter	en	neteru
thou	knowest,	O Osiris,	the scribe	accountant	of the divine offerings	of	the gods	

28.

nebu	Uast	Ani	maāχeru	neb	àmaχ
all	of Thebes,	Ani	triumphant,	lord	of veneration.

Appendix.[1]

1.

t'etet	χeft	sper	er	useχt	ten	ent	Maāti	peχχa
To be said	when	one cometh	to	hall	this	of	double Maāti,	of separating [one]

[1] For the text, see Naville, *Todtenbuch*, Bd. I., Bl. 133.

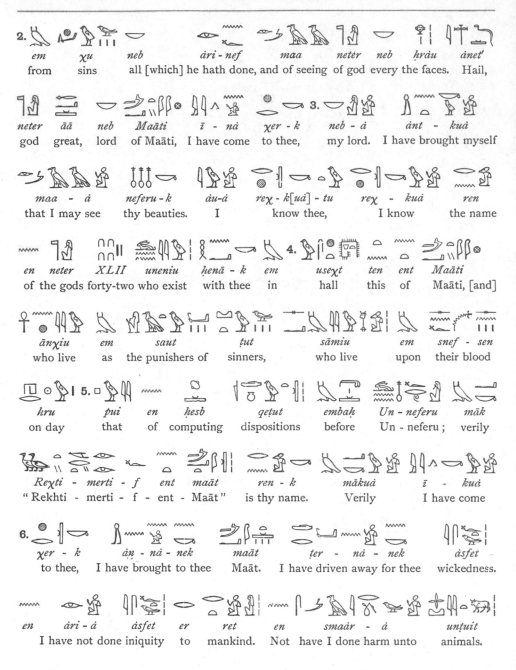

2.
em | χu | neb | ári - nef | maa | netèr | neb | hràu | ànet'
from | sins | all [which] he hath done, and of seeing of god every the faces. Hail,

neter | ǎǎ | neb | Maāti | ī - nà | χer - k | neb - à | 3. | ànt - kuà
god | great, | lord | of Maāti, | I have come | to thee, | my lord. | | I have brought myself

maa - à | neferu - k | àu-à | reχ - k[uà] - tu | reχ - kuà | ren
that I may see | thy beauties. | I | know thee, | I know | the name

en | neter | XLII | uneniu | henā - k | em | useχt | ten | ent | Maāti
of the gods forty-two who exist | with thee | in | hall | this | of | Maāti, [and]

ānχiu | em | saut | ṭut | sāmiu | em | snef - sen
who live | as | the punishers of | sinners, | who live | upon | their blood

hru | pui | en | hesb | 5. | qeṭut | embah | Un - neferu | māk
on day | that | of | computing | | dispositions | before | Un - neferu; | verily

Reχti - merti - f | ent | maāt | ren - k | mākuà | ī - kuà
"Rekhti - merti - f - ent - Maāt" | is thy name. | Verily | I have come

6.
χer - k | àn - nà - nek | maāt | ṭer - nà - nek | àsfet
to thee, | I have brought to thee | Maāt. | I have driven away for thee | wickedness.

en | àri - à | àsfet | er | ret | en | smaàr - à | unṭuit
I have not done iniquity | to | mankind. | Not | have I done harm unto | animals.

en	àri - à	āuit	em	àuset	maāt	en	reχ - à	netet
Not	have I done	wickedness	in	the place of	Maāt.	Not	have I known	evil.

en	àri - à	bu - ţu		en	àri - à	ţep	hru	neb
Not	have I acted	wickedly.		Not	have I done	each	day and every	

bak	em	ḥeru	àrit - nà	en	sper	ren - à	er	uàa
works	above	what I should do.	Not hath come forth	my name	to	the boat of		

χerp	en	saat - à	neter	en	nem - à	en
the Prince.	Not	have I despised	God.	Not	have I caused misery.	Not

nemḥ - à	en	àri - à	but	neter	en	sàţu - à
have I caused affliction.	Not have I done what is abominable to God.	Not	have I caused harm			

ḥen	en	ḥer-ţep - f	en	smer - à	en
to be done to the servant	by	his chief.	Not have I caused pain.	Not	

serem - à	en	smam - à	en	utu - à	en	smam - à
have I made to weep.	Not	have I killed.	Not have I made the order for killing for me.			

en	àri - à	ment ḥrà - nebu	en	χeb - à	śebu	em
Not	have I done	harm to mankind.	Not	have I taken aught	of the oblations	in

re - peru	en	ḥeţ' - à	paut	neteru	en	neḥem - à
the temples.	Not	have I purloined	the cakes	of the gods.	Not	have I carried off

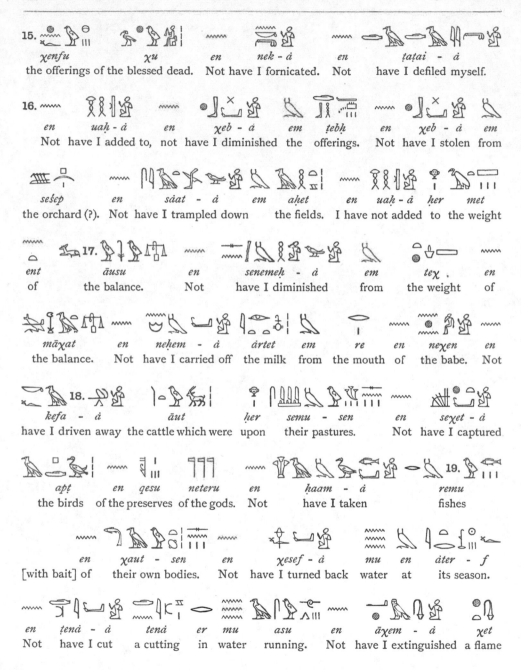

15. *xenfu* *xu* *en* *nek - à* *en* *tatai - à*
the offerings of the blessed dead. Not have I fornicated. Not have I defiled myself.

16. *en* *uah - à* *en* *xeb - à* *em* *tebh* *en* *xeb - à* *em*
Not have I added to, not have I diminished the offerings. Not have I stolen from

sesep *en* *sàat - à* *em* *ahet* *en* *uah - à* *her* *met*
the orchard (?). Not have I trampled down the fields. I have not added to the weight

ent *àusu* *en* *senemeh - à* *em* *tex* *en*
of the balance. Not have I diminished from the weight of

màxat *en* *nehem - à* *àrtet* *em* *re* *en* *nexen* *en*
the balance. Not have I carried off the milk from the mouth of the babe. Not

18. *kefa - à* *àut* *her* *semu - sen* *en* *sexet - à*
have I driven away the cattle which were upon their pastures. Not have I captured

apt *en* *qesu* *neteru* *en* *haam - à* 19. *remu*
the birds of the preserves of the gods. Not have I taken fishes

en *xaut - sen* *en* *xesef - à* *mu* *en* *àter - f*
[with bait] of their own bodies. Not have I turned back water at its season.

en *tenà - à* *tenà* *er* *mu* *asu* *en* *àxem - à* *xet*
Not have I cut a cutting in water running. Not have I extinguished a flame

20.

em	at - s	en	teh - à	sesu	her	setepet	en
at	its hour.	Not	have I violated	the times	for	the chosen offerings.	Not

śenā - à	menmenet	neter	χet	en	χesef - à	neter	em
have I driven back	the cattle of	divine	things.	I have not repulsed	God	in	

peru - f	àuà	21. āb - kuà	sep	ftu	āb - à	āb
his manifestations.	I, even I, am pure.	Times	four.	I am pure [with] the purity of		

bennu	pu	āā	enti	em	Suten-ḥenen	her entet	nuk	às	fenṭ	pu
bennu	that	great	which is	in	Suten-ḥenen,	because	I am,	behold,	nose	that

22.

en	neb	nifu	seānχ	reχit	nebt	hru	pui	en
of	the lord	of winds	making to live	mortals	all	on day	that	of

meḥ	uťat	em	Ánnu	em	àbeṭ sen	pert
filling	the utchat	in	Heliopolis,	in	month second	of the season of coming forth

ārqi	23. embaḥ	en	neb	ta	pen	nuk	maa	meḥ
to the end,	before	the lord	of this earth.	I	see	the filling of		

uťat	em	Ánnu	enen	χeper	buṭu	er - à	em	ta
the utchat	in	Heliopolis.	Not	let be done	evil	to me	in	land

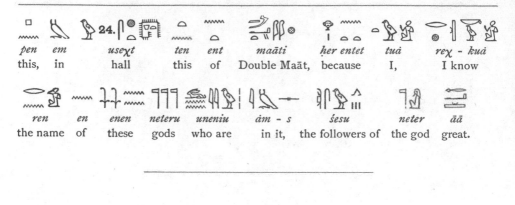

pen	*em*	*usext*	*ten*	*ent*	*maāti*	*her entet*	*tuå*	*rex - kuå*
this,	in	hall	this	of	Double Maāt,	because	I,	I know

ren	*en*	*enen*	*neteru*	*uneniu*	*åm - s*	*śesu*	*neter*	*āā*
the name	of	these	gods	who are	in it,	the followers of	the god	great.

PLATE XXXI.

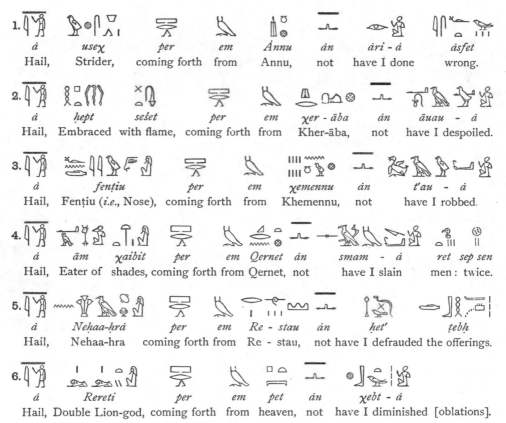

1.
å	*usex*	*per*	*em*	*Ånnu*	*ån*	*åri - å*	*åsfet*	
Hail,	Strider,	coming forth	from	Annu,	not	have I done	wrong.	

2.
å	*ḥept seśet*	*per*	*em*	*xer - āba*	*ån*	*āuau - å*	
Hail,	Embraced with flame,	coming forth	from	Kher-āba,	not	have I despoiled.	

3.
å	*fenṭiu*	*per*	*em*	*xemennu*	*ån*	*t'au - å*	
Hail,	Fenṭiu (*i.e.*, Nose),	coming forth	from	Khemennu,	not	have I robbed.	

4.
å	*ām*	*xaibit*	*per*	*em*	*Qernet*	*ån*	*smam - å*	*ret sep sen*
Hail,	Eater of	shades,	coming forth	from	Qernet,	not	have I slain	men : twice.

5.
å	*Nehaa-ḥrå*	*per*	*em*	*Re - stau*	*ån*	*het' ṭebḥ*	
Hail,	Nehaa-hra	coming forth from	Re - stau,	not	have I defrauded the offerings.		

6.
å	*Rereti*	*per*	*em*	*pet*	*ån*	*xebt - å*	
Hail,	Double Lion-god,	coming forth	from	heaven,	not	have I diminished [oblations].	

7.

à maa-f em χet per em Saut àn t'a - à

Hail, Whose two eyes are of fire, coming forth from Saut, not have I despoiled

χet neter 8. à nebàt per em χetχet àn t'et - à

the things of the god. Hail, Flame, coming forth in going back, not have I spoken

ker 9. à set qesu per em Suten - henen àn

lies. Hail, Breaker of bones, coming forth from Suten - henen, not

nehem-à àmmet 10. à utu neser per em

have I carried off food. Hail, Shooter forth of flame, coming forth from

Het-ka-Ptah àn kenà - à 11. à Qererti per em Àmentet àn

Memphis, not have I afflicted [any]. Hail, Qererti, coming forth from Amentet, not

nek-à en nek - à 12. à hrà - f ha - f per em tephet - f

have I committed fornication. Hail, whose face is behind him, coming forth from his cavern,

àn θerem - à 13. à Basti per em śetat àn

not have I made to weep. Hail, Bast, coming forth from the secret place, not

àm àb - à 14. à ta reț per em àχeχ àn

have I eaten my heart. Hail, Blazing legs, coming forth from the darkness, not

teh - à 15. à àm snef per em nemmat àn

have I transgressed. Hail, Eater of blood, coming forth from the block, not

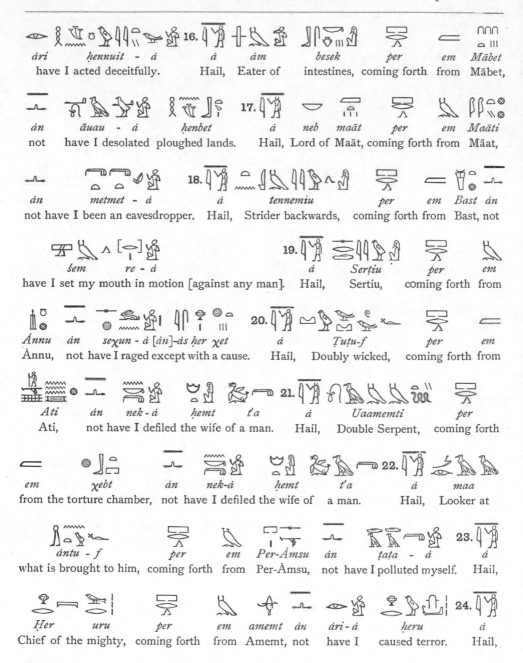

àri hennuit - à à àm besek per em Mābet
have I acted deceitfully. Hail, Eater of intestines, coming forth from Mābet,

àn āuau - à henbet à neb maāt per em Maāti
not have I desolated ploughed lands. Hail, Lord of Maāt, coming forth from Māat,

àn metmet - à à tennemiu per em Bast àn
not have I been an eavesdropper. Hail, Strider backwards, coming forth from Bast, not

šem re - à à Serṭiu per em
have I set my mouth in motion [against any man]. Hail, Sertiu, coming forth from

Ànnu àn seχun - à [àn]-às her χet à Ṭuṭu-f per em
Ànnu, not have I raged except with a cause. Hail, Doubly wicked, coming forth from

Ati àn nek - à hemt t'a à Uaamemti per
Ati, not have I defiled the wife of a man. Hail, Double Serpent, coming forth

em χebt àn nek-à hemt t'a à maa
from the torture chamber, not have I defiled the wife of a man. Hail, Looker at

àntu - f per em Per-Àmsu àn ṭaṭa - à à
what is brought to him, coming forth from Per-Àmsu, not have I polluted myself. Hail,

Ḥer uru per em amemt àn àri - à heru à
Chief of the mighty, coming forth from Amemt, not have I caused terror. Hail,

χemiu *pert* *em* *Ḳesiu* *àn* *teḥ - à* 25. *à*
Khemiu, coming forth from Kesiu, not have I committed offence. Hail,

Seśeṭ - χeru *per* *em* *Urit* *àn* *ta - à*
Disposer of speech, coming forth from Urit, not have I inflamed myself with rage.

26. *à* *Neχennu* *per* *em* *Uab* *àn* *seχa - à ḥrà - à* *ḥer t'eṭet*
Hail, Babe, coming forth from Uab, not have I made deaf myself to the words of

maāt 27. *à* *Kennememti* *per* *em* *Kennemmet* *àn* *śent - à*
right and truth. Hail, Kennememti, coming forth from Kennemmet, not have I caused grief.

28. *à* *Àn* *ḥetep - f* *per* *em* *Sau* *àn* *per - ā*
Hail, Bringer of his offering, coming forth from Sais, not have I acted insolently.

29. *à* *Serà - χeru* *per* *em* *Unàset* *àn* *χennu - à*
Hail, Disposer of speech, coming forth from Unàset, not have I stirred up strife.

30. *à* *Neb ḥràu* *per* *em* *Neṭ'fet* *àn* *asta - àb - à*
Hail, Lord of faces, coming forth from Netchefet, not have I judged hastily.

31. *à* *Seχeriu* *per* *em* *Uten* *àn* *semetmet - à*
Hail, Sekheriu, coming forth from Uten, not have I been an eavesdropper.

32. *à* *Neb àbui* *per* *em* *Sauti* *àn* *āś χeru - à*
Hail, Lord of two horns, coming forth from Sais, not have I multiplied my words

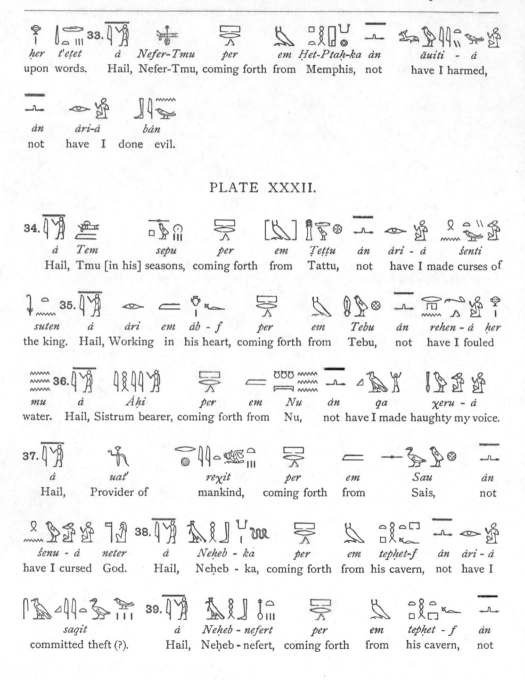

33. *her* *t'etet* upon words. *à* Hail, *Nefer-Tmu*, Nefer-Tmu, *per* coming forth *em Ḥet-Ptaḥ-ka* from Memphis, *àn* not *āuiti - à* have I harmed,

àn not *àri-à* have I *bàn* done evil.

PLATE XXXII.

34. *à* Hail, *Tem* Tmu [in his] *sepu* seasons, *per* coming forth *em* from *Ṭeṭṭu* Tattu, *àn* not *àri - à* have I made *šenti* curses of

35. *suten* the king. *à* Hail, *àri* Working *em àb - f* in his heart, *per* coming forth *em* from *Tebu* Tebu, *àn* not *rehen - à* have I fouled *her*

36. *mu* water. *à* Hail, *Aḥi* Sistrum bearer, *per* coming forth *em* from *Nu* Nu, *àn* not *qa* have I made *χeru - à* haughty my voice.

37. *à* Hail, *uat'* Provider of *reχit* mankind, *per* coming forth *em* from *Sau* Sais, *àn* not

38. *šenu - à* have I cursed *neter* God. *à* Hail, *Neḥeb - ka* Neheb - ka, *per* coming forth *em* from *tephet-f* his cavern, *àn* not *àri - à* have I

39. *saqit* committed theft (?). *à* Hail, *Neḥeb - nefert* Neheb - nefert, *per* coming forth *em* from *tephet - f* his cavern, *àn* not

ḥet' *pautti* *neteru* *à* 40. *Set'eser-ṭep* *per*

have I defrauded the offerings of the gods. Hail, Arranger of [his] head, coming forth

em *kerà* *àn* *neḥem - à* *χenf* *er* *χu*

from [his] shrine, not have I carried away offerings from the beatified ones.

41. *à* *Àn* *ā - f* *per* *em* *Maāt* *àn* *neḥem-à* *χenf*

Hail, Bringer of his arm, coming forth from { the double town of Maāt, } not have I carried off the food

neχen *àn* *seqasat - à* *neter* *nut-à* 42. *à* *Ḥet' àbeḥu*

of the infant, not have I sinned against the god of the town. Hail, White-teeth,

per *em* *Ta - śe* *àn* *semam - à* *àḥ* *neteri*

coming forth from Ta-she, not have I slaughtered the cattle divine.

Appendix.[1]

2. *ànet'* *ḥràu-θen* *neteru* *àpu* 3. *àu - à* *reχ - kuà - ten* *reχ - kuà*

Homage to you, O gods these! I, even I know you. I know

ren - ten *enen* *χer - à* *en* 4. *śāt - ten* *enen* *sàr - ten*

your names. Do not cast me down to your slaughtering knives, do not bring forward ye

bà[n] - à *en* *neter pen* *enti* *θen* *emχet - f* 5. *enen* *īu - tu* *sep - à*

my wickedness before god this whom ye follow him, let not come my moment

[1] For the text see Naville, *Todtenbuch*, Bd. I., Bll. 137, 138.

her - ten	*t'et - ten*	*maāt*	*er - ā*	*em - baḥ*	*ā*	6.	*Neb-er-t'er*	*her entet*
before you.	Declare ye	right and truth	for me	before	the hand of		Neb-er-tcher,	because

àri - nà	*maāt*	*em*	*Ta-merà*	*en*	*šen - à*	*neter*	*en*
I have done	right and truth	in	Ta-mera.	Not	have I cursed	God,	not

īu	*sep - à*	*ànet'*	*ḥràu-ten*	*neteru*	*àm*	*useχt - θen*	*ent*
hath come my moment.		Homage	to you,	O gods,	who live in	your hall	of

7. *Maāti*	*at*	*ḳer*	*em*	*χat - sen*	*ānχiu*	*em*	*maāt*
right and truth,	without	evil	in	their bodies,	who live	in	right and truth

em Ànnu	*sāmiu*	*em*	*ḥaut - sen*	*embaḥ*	8. *Ḥeru*	*àm*
in Annu,	who consume		their entrails	in the presence of	Horus	in

àten - f	*neḥem - ten - uà*	*mā*	*Baabi*	*ānχ*	*em*	*beseku*
his disk,	deliver ye me	from	Baabi,	who liveth	upon	the intestines

seru	*hru*	*pui*	*en*	*àpt*	*āāt*	*mā - ten*	9. *ì - kuà*	*χer - ten*
of princes,	on day	that	of	the judgment	great	by you;	I have come	to you.

enen	*àsfet - à*	*enen*	*χebent - à*	*en*	*tu - à*	*enen*
Not	have I committed faults,	not	have I sinned,	not	have I done evil,	not

meteru - à	*enen*	*àri - nà*	*χet*	*eref*	*ānχ - à*	*em*
have I borne false witness,	not	let be done to me	anything	therefore.	I live	in

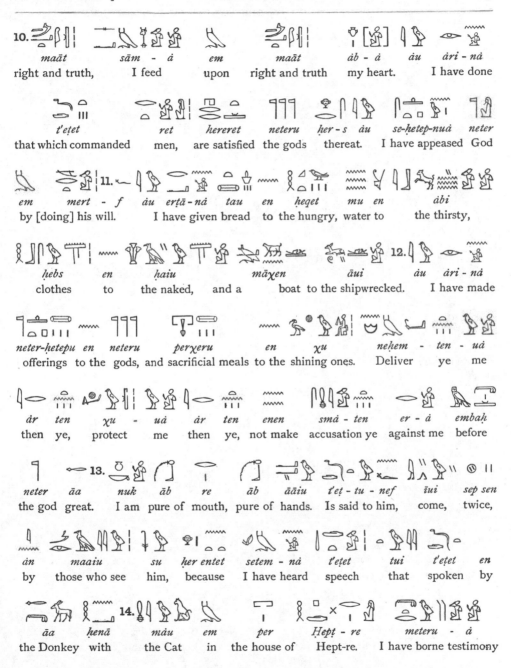

10.
maāt	*sām - ā*	*em*	*maāt*	*āb - ā*	*āu*	*ari - nā*
right and truth,	I feed	upon	right and truth	my heart.		I have done

t'etet	*ret*	*hereret*	*neteru*	*her - s*	*āu*	*se-ḥetep-nuā*	*neter*
that which commanded	men,	are satisfied	the gods	thereat.		I have appeased	God

em	*mert - f*	11. *āu ertā - nā*	*tau*	*en*	*ḥeqet*	*mu*	*en*	*ābi*
by [doing] his will.		I have given	bread	to the hungry,		water to		the thirsty,

ḥebs	*en*	*ḥaiu*	*māχen*	*āui*	12. *āu*	*ari - nā*
clothes	to	the naked,	and a	boat to the shipwrecked.		I have made

neter-ḥetepu en	*neteru*	*perχeru*	*en*	*χu*	*nehem - ten - uā*
offerings to the gods,	and sacrificial meals		to the	shining ones.	Deliver ye me

ār	*ten*	*χu - uā*	*ār*	*ten*	*enen*	*smā - ten*	*er - ā*	*embaḥ*
then ye,	protect	me	then	ye,	not make	accusation ye	against me	before

neter	*āa*	13. *nuk*	*āb*	*re*	*āb*	*āāiu*	*t'eṭ - tu - nef*	*īui*	*sep sen*
the god	great.	I am	pure of	mouth,	pure of hands.		Is said to him,	come,	twice,

ān	*maaiu*	*su*	*ḥer entet*	*setem - nā*	*t'etet*	*tui*	*t'etet*	*en*
by	those who see	him,	because	I have heard	speech	that	spoken	by

āa	*ḥenā*	14. *māu*	*em*	*per*	*Ḥept - re*	*meteru - ā*
the Donkey	with	the Cat	in	the house of	Ḥept-re.	I have borne testimony

em her - f ṭā - f tentu àu maa - nà peseš àseśeṭ

before him, he hath given the decision. I have seen the division of the persea trees

15. *em χennu Re-stau nuk semiu - à embaḥ neteru*

within Re-stau. I, I offer up prayers in the presence of the gods

reχ χert χat - sen ī - nà āa er semetert

knowing what concerneth their persons. I have come advancing to make a declaration of

maāt er erṭāt āusu er āḥāu - f em χennu

right and truth, to place the balance upon its supports within

ḳaàu à qa her àat - f neb atefu

the amaranthine bushes. Hail exalted upon his standard, lord of the *atef* crown,

àri ren - f em neb nifu neḥem - kuà mā naik

máking his name as the lord of winds, deliver me from thy

en àputat uṭeṭiu θemesu seχeperiu àṭerit

messengers who make to happen dire deeds, who make to arise calamities,

18. *àt t'amet ent ḥràu-sen her entet àri - nà maāt*

without covering upon their faces, because I have done right and truth.

neb maāt āb - kuà ḥāti - à em ābu peḥi - à

O lord of right and truth, I am pure, my breast is washed, my hinder parts

19. turà her-àb-à em seṣeṭit maāt enen āt
are cleansed, my interior [hath been] in the pool of right and truth, without a member

àm - à ṣu āb - nà em seṣeṭit reset ḥetep - nà em
in me lacking. I have been purified in the pool southern, I have rested in

Ḥemt meḥtet em seχet senehemu **20.** ābet qeti
Hemet, to the north of the field of the grasshoppers; bathe the divine sailors

àm - s em unnut kerḥ en senāā àb en neteru em - χet
in it, at the season of night to gratify (?) the heart of the gods after

seṣ-à her-s em **21.** kerḥ em hru ṭāu ĭut - f àn - sen
I have passed over it by night and by day. They grant his coming, they say

er - à nimā trà tu àn - sen er - à pu trà ren - k
to me. Who then art thou? say they to me. What then is thy name?

àn - sen er - à nuk ruṭ χeri en **22.** ḥait àmi baaq
say they to me. I grow among the flowers dwelling in the olive tree is

ren - à seṣ-nek her mā àn - sen er - à seṣ-nà her nut
my name. Pass on thou forthwith, say they unto me. I have passed by the town

meḥtet baat peti trà maa - nek àm χenṭ **23.** pu ḥenā mesṭet
north of the bushes. What then didst thou see there? The leg and the thigh.

peti trá	án-k	en	sen	àu	maa - nà	àhehi	em	ennu	taiu
What then	didst thou say	to	them?		I saw	rejoicing	in	those	lands

Fenχu	peti trá	erṭāt - sen	nek	24. besu	pu	en	seśet
of the Fenkhu.	What then	did give they	to thee?	A flame	it was	of	fire,

henā	uat'	en	θehent	peti trá	àri - nek	eres	àu	qeres - nà
together with a tablet		of	crystal.	What then	didst thou do therewith?			I buried

set	her	uteb	en	maāti	em	χet	χaui	peti trá
it	by	the place	of	Maāti	with	the things	of the night.	What then

25. qem - nek	àm	her	uteb	en	maāti	uas	pu	en	ṭes
didst thou find	there	by	the place	of	Maāti?	A sceptre	of		flint (?) ;

àu	seśet - nek	su	pe trá àref	su	uas	pu	en	ṭes	erṭā
maketh to prevail thee it.			What then is [the name of]	the sceptre	of			flint?	Giver of

nifu	ren - f	peti trá	àref	àri - nek	er	pa	besu	en
winds, is its name.		What then	therefore didst thou do with		the		flame	of

seśet	henā	pa	uat'	en	θehent	26. em-χet	qeres - k	set
fire and with		the	tablet	of	crystal	after	thou didst bury	it?

àu	hatu - nà	her - s	àu	seśeṭ - nà	set	àu	27. āχem - nà	seśet
I uttered words		over it,		I adjured	it,	and	I extinguished	the fire,

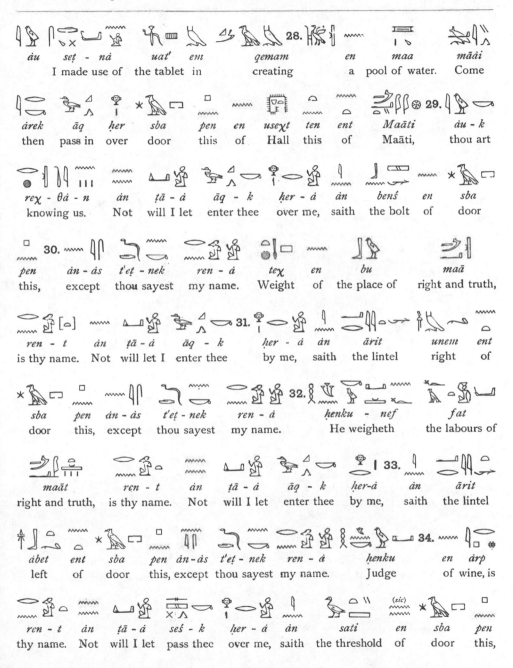

àu seṭ - nà uat' em qemam 28. en maa māài
I made use of the tablet in creating a pool of water. Come

àrek āq her sba pen en useχt ten ent Maāti àu - k
then pass in over door this of Hall this of Maāti, thou art

reχ - θà - n àn ṭā - à āq - k her - à àn benś en sba
knowing us. Not will I let enter thee over me, saith the bolt of door

30. pen àn - às t'eṭ - nek ren - à teχ en bu maā
this, except thou sayest my name. Weight of the place of right and truth,

ren - t àn ṭā - à āq - k 31. her - à àn ārit unem ent
is thy name. Not will let I enter thee by me, saith the lintel right of

sba pen àn - às t'eṭ - nek ren - à 32. henku - nef fat
door this, except thou sayest my name. He weigheth the labours of

maāt ren - t àn ṭā - à āq - k her-à àn 33. ārit
right and truth, is thy name. Not will I let enter thee by me, saith the lintel

àbet ent sba pen àn-às t'eṭ - nek ren - à henku en àrp
left of door this, except thou sayest my name. Judge of wine, is 34.

ren - t àn ṭā - à seś - k her - à àn sati en sba pen
thy name. Not will I let pass thee over me, saith the threshold of door this,

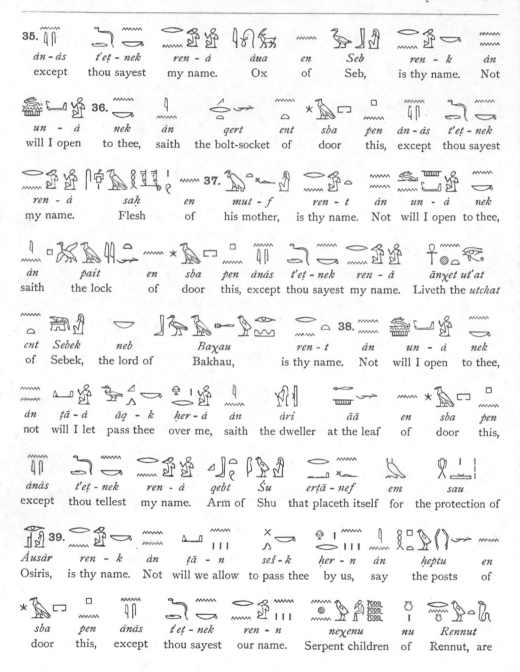

35. *àn-às* *t'et-nek* *ren-à* *àua* *en* *Seb* *ren-k* *àn*
except thou sayest my name. Ox of Seb, is thy name. Not

36. *un-à* *nek* *àn* *qert* *ent* *sba* *pen* *àn-às* *t'et-nek*
will I open to thee, saith the bolt-socket of door this, except thou sayest

37. *ren-à* *sah* *en* *mut-f* *ren-t* *àn* *un-à* *nek*
my name. Flesh of his mother, is thy name. Not will I open to thee,

àn *pait* *en* *sba* *pen* *ànàs* *t'et-nek* *ren-à* *ànχet ut'at*
saith the lock of door this, except thou sayest my name. Liveth the *utchat*

38. *ent* *Sebek* *neb* *Baχau* *ren-t* *àn* *un-à* *nek*
of Sebek, the lord of Bakhau, is thy name. Not will I open to thee,

àn *tā-à* *āq-k* *her-à* *àn* *ari* *āā* *en* *sba* *pen*
not will I let pass thee over me, saith the dweller at the leaf of door this,

ànàs *t'et-nek* *ren-à* *qebt* *Śu* *ertā-nef* *em* *sau*
except thou tellest my name. Arm of Shu that placeth itself for the protection of

39. *Àusàr* *ren-k* *àn* *tā-n* *seś-k* *her-n* *àn* *heptu* *en*
Osiris, is thy name. Not will we allow to pass thee by us, say the posts of

sba *pen* *ànàs* *t'et-nek* *ren-n* *neχenu* *nu* *Rennut*
door this, except thou sayest our name. Serpent children of Rennut, are

ren - ten	àu - k	reχ - θà - n	40.	seś	àrek	her - n	àn	χent - k
your names.	Thou knowest us,			pass	then	by us.	Not	shalt tread thou

her - à	àn	seti	en	useχt	ten	ànàs	t'eṭ - k	ren - à
upon me,	saith	the floor	of	hall	this,	except	thou sayest	my name.

her	mā	àref	àu - à	ḳert	āb - kuà	her entet	àn	41.	reχ - n
.			I am	silent,	I am pure,	because	not		do we know

reṭ - k	χenṭ - k	her - n	àm - sen	t'eṭ	àrek	nà	set	besu
thy two legs	thou treadest	upon us	with them;	tell	then	to me	them.	Traveller

embaḥ	Àmsu	ren	en	reṭ - à	unemi	un pet	ent	Nebt-ḥet
before	Amsu,	is the name	of	my leg	right.	Grief	of	Nephthys,

ren	en	42.	reṭ - à	àbi	χenṭ	àrek	her - n	àu - k
is the name	of		my leg	left.	Tread	then	upon us,	thou

reχ - θà - n	àn	semà - à	tu	àn	àri	āā	en	useχt	θen
knowest us.	Not	will I question thee,		saith	the guardian	of the door	of	hall	this,

àn - às	t'eṭ - nek	ren - à	sa	àbu	43.	t'ār	χat	ren - k
except	thou sayest	my name.	Discerner of	hearts,		searcher of	reins,	is thy name.

semà - à	tu	àref	nimā	en	neter	àmi	unnut - f	t'eṭ - k	set
I will question thee		then.	Who	is	the god	dwelling in	his hour?	Speak thou	it.

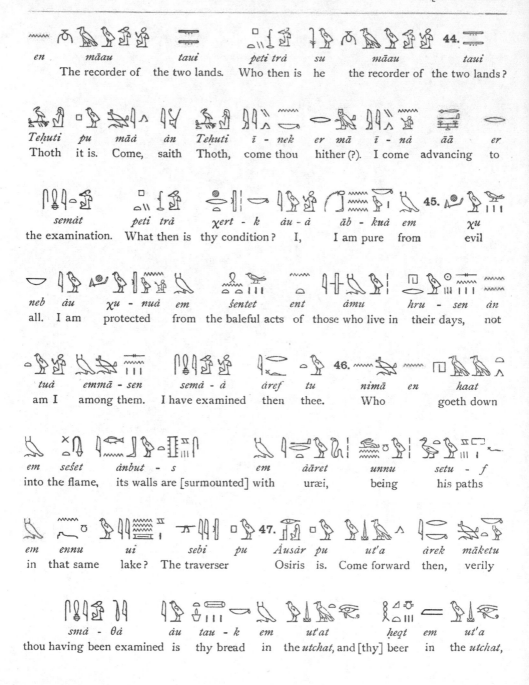

en	māau	taui	peti trà	su	māau	taui 44.
The recorder of	the two lands.		Who then is	he	the recorder of	the two lands?

Teḥuti	pu	māā	àn	Teḥuti	ī - nek	er mā	ī - nà	āā	er
Thoth	it is.	Come,	saith	Thoth,	come thou	hither (?).	I come	advancing	to

semàt	peti trà	χert - k	àu - à	āb - kuà	em	χu 45.
the examination.	What then is	thy condition?	I,	I am pure	from	evil

neb	àu	χu - nuà	em	šentet	ent	àmu	hru - sen	àn
all.	I am	protected	from	the baleful acts	of	those who live in	their days,	not

tuà	emmā - sen	semā - à	àref	tu	nimā	en	haat 46.
am I	among them.	I have examined	then	thee.	Who		goeth down

em	seśet	ànbut - s	em	āāret	unnu	setu - f
into the flame,		its walls are [surmounted] with		uræi,	being	his paths

em	ennu	ui	sebi	pu	Àusàr pu	ut'a	àrek	māketu 47.
in	that same	lake?	The traverser		Osiris is.	Come forward	then,	verily

smà - θà	àu	tau - k	em	ut'at	ḥeqt	em	ut'a
thou having been examined is		thy bread	in	the utchat,	and [thy] beer	in	the utchat,

àu	per - tu	nek	χeru	ṭep	ta	em	ut'a
are	brought out	to thee	. sepulchral offerings	upon	earth	from	the *utchat*.

......	su	er - ȧ
Hath decreed it	he	for me.

1.	àu	śen	en Àusàr	Ani	maāχeru	em	Nu	2. àu	hrȧ
	Is	the hair	of Osiris	Ani,	triumphant,	of	Nu.	Is	the face

en Àusàr	ān	Ani	maāχeru	em	Rā	3. àu	maa	en Àusàr
of Osiris, the scribe	Ani,	triumphant,	of	Rā.	Are	the eyes	of Osiris	

Ani	maāχeru	em	Ḥet–Ḥert	4. àu	mest'er	en	Àusàr	Ani
Ani,	triumphant,	of	Hathor.	Are	the ears	of	Osiris	Ani,

maāχeru	em	Àp-uat	àu	seput	en	Àusàr	Ani	maāχeru
triumphant,	of	Ap-uat.·	Are	the lips	of	Osiris	Ani,	triumphant,

em	Ànpu	àu	àbehu	en Àusàr	Ani	maāχeru	em	Serqet
of	Anubis.	Are	the teeth	of Osiris	Ani,	triumphant,	of	Serqet.

7.	àu	neḥeṭu (sic) en	Àusàr	Ani	maāχeru	em	Àuset	8. àu
	Is	the neck of	Osiris	Ani,	triumphant,	of	Isis.	Are

āāui	en	Àusàr	Ani	maāχeru	em	Ba	neb	Ṭeṭṭu
the two hands of	Osiris	Ani,	triumphant,	of	the Ram	the lord	of [Tattu].	

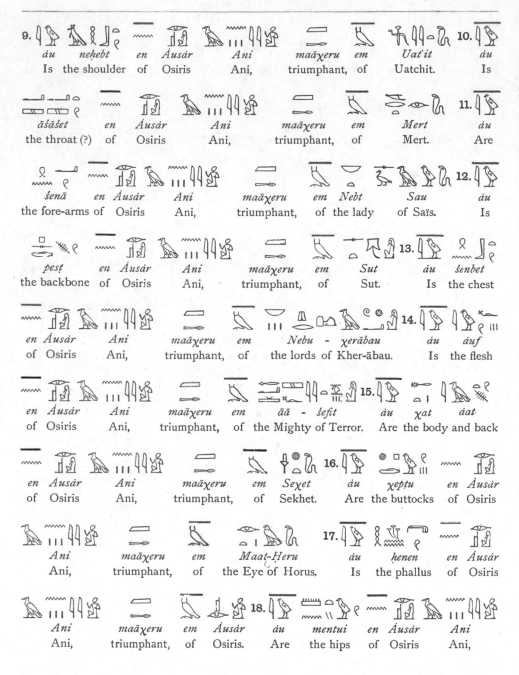

9. àu nehebt en Àusàr Ani maāχeru em Uat'it
Is the shoulder of Osiris Ani, triumphant, of Uatchit.

10. àu àśāśet en Àusàr Ani maāχeru em Mert
Is the throat (?) of Osiris Ani, triumphant, of Mert.

11. àu śenā en Àusàr Ani maāχeru em Nebt Sau
Are the fore-arms of Osiris Ani, triumphant, of the lady of Saïs.

12. àu peśt en Àusàr Ani maāχeru em Sut
Is the backbone of Osiris Ani, triumphant, of Sut.

13. àu śenbet en Àusàr Ani maāχeru em Nebu - χerābau
Is the chest of Osiris Ani, triumphant, of the lords of Kher-ābau.

14. àu àuf en Àusàr Ani maāχeru em āā - śefit
Is the flesh of Osiris Ani, triumphant, of the Mighty of Terror.

15. àu χat àat en Àusàr Ani maāχeru em Seχet
Are the body and back of Osiris Ani, triumphant, of Sekhet.

16. àu χeptu en Àusàr Ani maāχeru em Maat-Heru
Are the buttocks of Osiris Ani, triumphant, of the Eye of Horus.

17. àu henen en Àusàr Ani maāχeru em Àusàr
Is the phallus of Osiris Ani, triumphant, of Osiris.

18. àu mentui en Àusàr Ani
Are the hips of Osiris Ani,

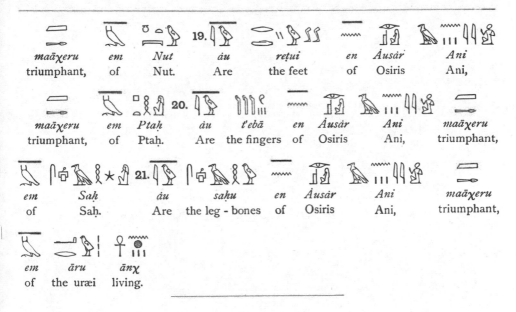

maāχeru	*em*	*Nut*	**19.** *àu*	*reṭui*	*en*	*Àusàr*	*Ani*	
triumphant,	of	Nut.	Are	the feet	of	Osiris	Ani,	

maāχeru	*em*	*Ptaḥ*	**20.** *àu*	*t'ebā*	*en*	*Àusàr*	*Ani*	*maāχeru*
triumphant,	of	Ptaḥ.	Are	the fingers	of	Osiris	Ani,	triumphant,

em	*Sah*	**21.** *àu*	*sahu*	*en*	*Àusàr*	*Ani*		*maāχeru*
of	Saḥ.	Are	the leg - bones	of	Osiris	Ani,		triumphant,

em	*āru*	*ānχ*
of	the uræi	living.

Appendix.

1.	*χesef*	*śāt*	*em*	*Suten-ḥenen*	*àn*	*ta*	*en*	*χet*
	[Chapter of] driving	back slaughter	in	Suten-ḥenen.	Saith [Osiris]:	Land	of	the sceptre!

2. *het'et*	*en*	*tut*	*àat*	*nuk*	*χi*	*sep*	*ftu*	*à*
White crown	of	the statue!	Divine standard!	I am	the Child.	Times	four.	Hail

Àb - urt	*àu*	*t'eṭ - nek*	*en*	*màn*	*àper*	**3.** *het'et*	*em*	*reχ - nek*
goddess Aburt!		Thou sayest		daily:	Is provided	the block	as thou knowest.	

àu - ì - nek	*er*	*suàs*	*ur*	*nuk*	*men*	*ḥeset*
Thou hast come	to	decay, [thou] great one.		I	establish	those who praise me.

¹ For the text see Naville, *Todtenbuch*, Bd. I., Bl. 56.

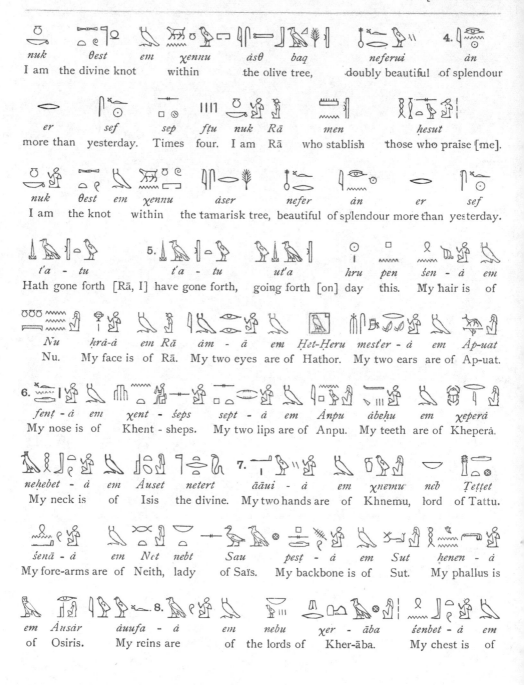

nuk θest em χennu àsθ baq neferui àn 4.
I am the divine knot within the olive tree, doubly beautiful of splendour

er sef sep ftu nuk Rā men hesut
more than yesterday. Times four. I am Rā who stablish those who praise [me].

nuk θest em χennu àser nefer àn er sef
I am the knot within the tamarisk tree, beautiful of splendour more than yesterday.

t'a - tu 5. t'a - tu ut'a hru pen śen - à em
Hath gone forth [Rā, I] have gone forth, going forth [on] day this. My hair is of

Nu ḥrà-à em Rā àm - à em Ḥet-Ḥeru mest'er - à em Àp-uat
Nu. My face is of Rā. My two eyes are of Hathor. My two ears are of Ap-uat.

6. fenṭ - à em χent - śeps sept - à em Ànpu àbeḥu em χeperà
My nose is of Khent - sheps. My two lips are of Anpu. My teeth are of Kheperà.

nehebet - à em Àuset netert àāui - à em χnemu neb Ṭeṭṭet
My neck is of Isis the divine. My two hands are of Khnemu, lord of Tattu.

śenā - à em Net nebt Sau peśṭ - à em Sut henen - à
My fore-arms are of Neith, lady of Saïs. My backbone is of Sut. My phallus is

em Àusàr 8. àuufa - à em nebu χer - āba śenbet - à em
of Osiris. My reins are of the lords of Kher-āba. My chest is of

Āa - šefšefet àu χat - à àat - à em Seχet χept - à
the Mighty of terror. Are my belly [and] my back of Sekhet. My buttocks are

em maat Ḥeru ment - à seset - à em Nut àu reṭi - à em
of the eye of Horus. My hips and legs are of Nut. Are my feet of

Ptaḥ àu t'ebā-à àu sah - à em ārātu ānχiu àn āt
Ptaḥ. Are my fingers, are my leg-bones of the uræi living. Not a member

àm - à šut em neter àu Tehuti em sau àuf - à tem nuk
in me is without a god. Thoth is protecting my flesh entirely. I am

Rā en hru neb àn χefā - tuà her āāui - à àn t'a - tuà
Rā day every. Not shall I be seized by my arms, not shall I be carried away

her ṭeṭ - à àn àri reθ neteru χu mitu pāt nebt
by my hand, not shall do men, gods, shining ones, the dead, ancient ones any,

12. *reχit nebt hamemet nebt āua neb àm - à nuk*
 mortal any, hamemet any, harm any unto me. I

per ut'a χem ren - f nuk sef maa heh en
come forth, advancing, unknown is his name. I am yesterday. Seer of millions of

13. *renpit ren - à seb sep sen em uat Ḥeru sàp nuk*
 years, is my name, travelling, twice, along the way of Horus the Judge. I am

neb *t'etta* *ḥui - à* *aui - à* *nuk* *neb* *urert* *nuk* *àm*
the lord of eternity, I feel, I perceive. I am the lord of the crown. I am in

ut'at 14. *suḥti - à* *sep sen* *erṭā - nà* *ānχ - sen* *nuk*
the *utchat* [and in] my egg, twice. It is granted to me to live [with] them. I am

àm *ut'at* *em* *āχant* *àu - à* *em* *māket - s* *per - nà*
in the *utchat* in [its] closing. I exist by its strength. I come forth [and]

uben - nà 15. *āq - nà* *ānχ - à* *nuk* *àm* *ut'at* *àuset - à*
I shine ; I go in [and] I come to life. I am in the *utchat*. My seat is

em *nest - à* *ḥems - à* *em* *t'esert* *χer - s* *nuk* *Ḥeru* *χent*
on my throne. I sit in the pupil of the eye by it. I am Horus traversing

ḥeḥ 16. *utu - nà* *nest - à* *ḥeq - à* *s* *em* *re-[à]* *t'eṭet* *ker*
{ millions of years. } I have commanded my seat, I rule it by [my] mouth ; speaking and silent

āqa - uà *māk* *àru - à* *seχeṭ* *nuk* *Unen* 17.
I maintain an exact balance. Verily my forms are inverted. I am the god Unen,

trà *em* *trà* *χert - f* *àm - f* *uā* *em* *uā* *rer - f*
season from season, what is his is in him. [I am] One [coming] from One. He revolveth.

nuk *àmi* *ut'at* *àn* *χet - à* *ṭu* *χennu* *àn* 18.
I am in the *utchat*. Not are my things evil [or] hostile, not

su	er - ȧ	ȧp	sba	em	pet	nuk	ḥeq	nest	ȧp
are they against me.	[I] open	the door	in	heaven.	I	rule [upon]	the throne,	opening	

mestu	em ḥru pen	ȧn	χi	ḥu	her	māten	en	sef
births	on day this.	[I am] not	the child	walking	upon	the road	of yesterday,	

nuk	ḥru	pen	reθ	em	reθ	nuk	pu	māki - ten	en
I am	day	this	for peoples	upon	peoples.	I it is who	make strong you	for	

ḥeḥ	ȧn	ȧu	unna	ni	peta	en	ta	resu
millions of years.	If ye	are	in	heaven,	or	in earth,	in the south,	

mā	meḥta	mā	ȧmenta	mā	ȧbta	senṭ - ȧ	ten (sic) em
or in the north,	or in the	west,	or in the east,	my fear is in		

χat - θen	nuk	āb	em	maat - f	ȧn	mit - ȧ	em	nem
your bodies.	I am	the pure one	in	his eye,	not	shall I die	a second time.	

at - ȧ	em	χat - θen	ȧru - ȧ	em	χent - ȧ	nuk	ȧn	reχeχ - f
My moment is in	your bodies,	my forms	are in	my habitation,	I am he who is not known,			

ṭeśeriu	ḥrȧ - sen	er - ȧ	nuk	unf	ȧn	qem	trȧ
the rosy-faced beings are	with me.	I am	the Unveiled.	Not	is found	a season	

χer	ȧri - f	er - ȧ	pet	ten	ta	ten
wherein	he made	for me	heaven,	enlarging the bounds of	the earth,	and making great

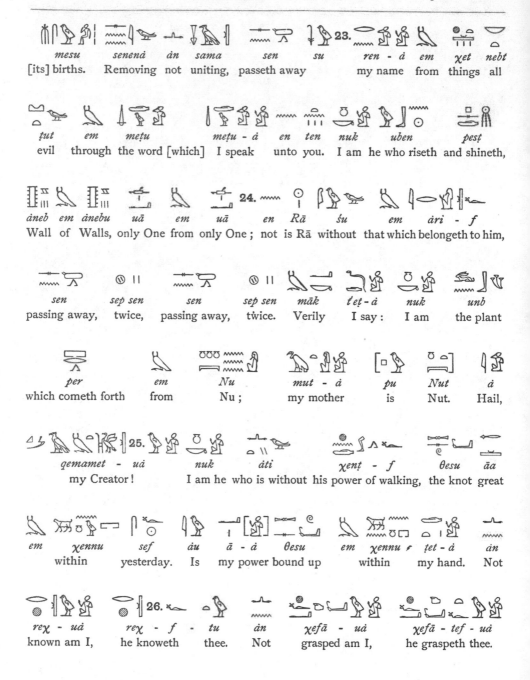

| *mesu* | *senenå* | *ån* | *sama* | *sen* | *su* | **23.** | *ren - å* | *em* | *χet* | *nebt* |
| [its] births. | Removing | not | uniting, | passeth away | | | my name | from | things | all |

| *ṭut* | *em* | *meṭu* | *meṭu - å* | *en* | *ten* | *nuk* | *uben* | *pesṭ* |
| evil | through | the word | [which] I speak | | unto you. | I am | he who riseth | and shineth, |

| *åneb* | *em* | *ånebu* | *uå* | *em* | *uå* | **24.** | *en* | *Rå* | *śu* | *em* | *åri - f* |
| Wall | of | Walls, | only One | from | only One ; | | not is | Rå | without | | that which belongeth to him, |

| *sen* | *sep sen* | *sen* | *sep sen* | *māk* | *ṭeṭ - å* | *nuk* | *unb* |
| passing away, | twice, | passing away, | twice. | Verily | I say : | I am | the plant |

| *per* | *em* | *Nu* | *mut - å* | *pu* | *Nut* | *å* |
| which cometh forth | from | Nu ; | my mother | is | Nut. | Hail, |

| *qemamet - uå* | **25.** | *nuk* | *åti* | *χenṭ - f* | *θesu* | *āa* |
| my Creator ! | | I am he who is without his power of walking, | | | the knot | great |

| *em* | *χennu* | *sef* | *åu* | *ā - å* | *θesu* | *em* | *χennu ʄ* | *ṭet - å* | *ån* |
| within | yesterday. | Is | my power bound up | | | within | | my hand. | Not |

| *reχ - uå,* | *reχ - f - tu* | **26.** | *ån* | *χefā - uå,* | *χefā - tef - uå.* |
| known am I, | he knoweth thee. | | Not | grasped am I, | he graspeth thee. |

suḥt	sep sen	nuk	Ḥeru	χenti	heḥ	heḥ	er
Egg,	twice.	I am	Horus	dwelling for	millions of years,	[his] flame is	upon

ḥrȧu-θen	aśiu	27.	ȧb - sen	ṭet	ḥeq - nȧ	nest - ȧ	sen - ȧ
your faces,	burning		[in] their hearts		I command	my throne.	I advance

trȧ	pen	uȧt	ȧp - nȧ	ȧu	uȧu - kuȧ	em	ṭu	nebt
at season	this.	The ways	I have opened,		I have turned myself away	from	evil	all.

nuk	qefṭennu	28.	en	nub	šep χemt	t'ebȧ sen	ȧn	reṭui - f
I am	the ape		of	gold	of three palms	and two fingers,	exist not	his legs,

ȧn	ȧȧiu - f	χent	Ḥet - Ptaḥ	ut'a - ȧ	ut'a
exist not	his arms,	dwelling in	the temple of Ptaḥ.	I go forth	in the going of

qefṭennu	en	29.	nub	šep χemt	t'ebȧ sen	ȧu	[reṭui] - f
the ape	of		gold of	three palms	and two fingers,	exist not	his legs,

ȧn	ȧȧui - f	χent	Ḥet - Ptaḥ	t'eṭ meṭu	pen
exist not	his arms,	dwelling in	the temple of Ptaḥ.	Being said	this [chapter]

ȧba - k	ṭer - k
thou shalt open a way,	and shalt go in.

PLATE XXXIII.

àn	*Àusàr*	*Ani*	*maāχeru*	*unχ - f*		*ḥebs*	*θàb*
See	Osiris	Ani,	triumphant,	girt about is he with raiment,			shod

em	*tebtu*	*ḥet'eti*	*urḥu*	*em*	*ṭept*	*ent*	*ānta*
with	sandals	white,	anointed	with	the finest oil	of	*ānta* unguent.

uṭenθ - nef	*ka*	*uat'*	*neter sentrà*	*re*	*ḥetepi*	*ḥeq*
Have been offered to him a bull,	vegetables,	incense,	ducks,	offerings of flowers, beer,		

¹ A less corrupt text of lines 1–4 reads as follows (See Naville, *Todtenbuch*, Bd. II., Bl. 332):—

àrit	*mà*	*χeper*	*àbet*	*ent*	*Maāti*	*t'eṭ*	*se*	*re*	*pen*
To be done	as	one cometh to the	Hall	of	Maāti.	Shall say	a man	chapter	this

āb	*turà*	*unχ - nef*	*ḥebs*	*en*	*ṭept*	*tebu*	*em*
cleansed,	purified.	He shall be girt about with	garments	of	the finest quality,	shod	with

ḥet'eti		*mestemu*	*em*	*mestemt*	*urḥ*	*em*	*ṭept*
white	sandals, [the eyes]	smeared	with	eye-paint,	anointed	with	the finest

ent	*ānta*	*uṭen - nef*	*ka*	*uat'*	*apṭ*	*neter sentrà*	
of	*ānta* unguent.	Must be offered unto him	a bull,	vegetables, ducks,		incense,	

tau	*ḥeqt*	*semu*	*às*	*àri - nek*	*sem*	*pen*	*em*	*ān*
cakes,	beer,	herbs.	Behold	thou must make	picture	this	in	writing, *etc.*

semu	*ȧst*	*ȧri - nek*	*sem*	*ḥetepet*	*ȧn*
and vegetables.	Behold	thou must make	the image of a table of offerings,		in writing

her	*setu*	*āb*	*em*	*χenti*	*āb*	*sekertu*	*em*	*aḥet*	*enti*
upon	a tile	pure,	with	colour	pure, [and]	bury [it]	in	a field	which

5.

ȧn	*χenṭ*	*en*	*šaȧa*	*her - s*	*ȧr*	*ȧrit*	*šāt*	*ten*
not hath trodden			a pig	upon it.	If	be made	writing	this

6.

her - f	*un - nef*	*uaṭ*	*mesten* (sic) *nu*	*mest - f*	*uaṭ*	
upon it	he shall rise,	and shall flourish	the children of	children his,	[as] flourisheth	

7.

Rā	*ȧn*	*ḥettau*	*un - nef*	*em seṣeṭ* (sic) *ȧb*	*en*	*suten*	*em*
Rā	without	intermission ;	he shall be	in of heart	of	the king	among

šeni - f	*ȧu ṭāu - f*	*šensen* (sic)	*ṭes*	*ur*	*en*
his chiefs ;	shall be given to him	cakes,	and vessels of water,	and joints	of

[1] Var. ⟨hieroglyphs⟩ , ⟨hieroglyphs⟩ .

[2] Var. ⟨hieroglyphs⟩ "pigs and donkeys."

[3] Var. ⟨hieroglyphs⟩ "satisfying the heart of the king and of his nobles."

[4] Var. ⟨hieroglyphs⟩ *ṭātu-nef ṣenset ṭes pa-sen,* "shall be given to him bread, vessels of drink, cakes."

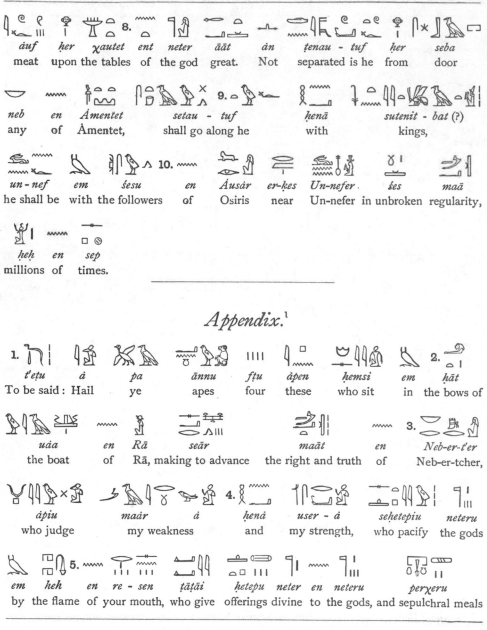

àuf her χautet ent neter ààt àn ţenau - tuf her seba
meat upon the tables of the god great. Not separated is he from door

neb en Amentet setau - tuf ḥenā sutenit - bat (?)
any of Àmentet, shall go along he with kings,

un - nef em śesu en Àusàr er-ḳes Un-nefer śes maā
he shall be with the followers of Osiris near Un-nefer in unbroken regularity,

ḥeḥ en sep
millions of times.

Appendix.[1]

t'eţu à pa ànnu fţu àpen ḥemsi em ḥàt
To be said: Hail ye apes four these who sit in the bows of

uàa en Rā seàr maāt en Neb-er-t'er
the boat of Rā, making to advance the right and truth of Neb-er-tcher,

àpiu maàr à ḥenà user - à seḥetepiu neteru
who judge my weakness and my strength, who pacify the gods

em ḥeḥ en re - sen ţàţài ḥetepu neter en neteru perχeru
by the flame of your mouth, who give offerings divine to the gods, and sepulchral meals

[1] See Naville, *Todtenbuch*, Bd. I., Bl. 140.

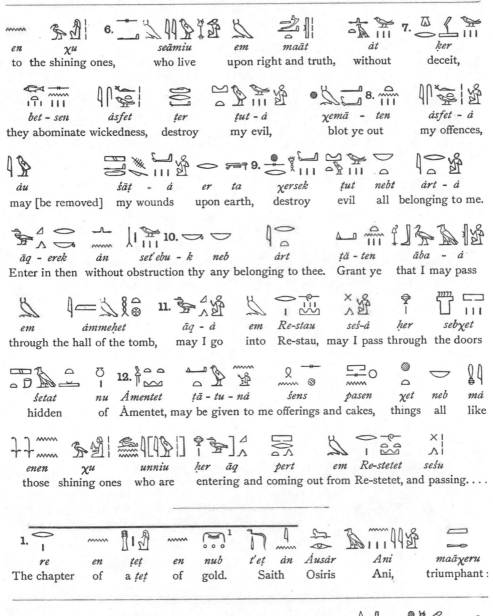

en	χu	seāmiu	em	maāt	àt	ḳer	
to	the shining ones,	who live	upon right and truth,		without	deceit,	

bet - sen	àsfet	ṭer	ṭut - à	χemā - ten	àsfet - à
they abominate	wickedness,	destroy	my evil,	blot ye out	my offences,

àu	śāṭ - à	er	ta	χersek	ṭut	nebt	àrt - à
may [be removed]	my wounds	upon	earth,	destroy	evil	all	belonging to me.

āq - erek	àn	set'ebu - k	neb	àrt	ṭā - ten	āba - à
Enter in then	without obstruction	thy	any	belonging to thee.	Grant ye	that I may pass

em	àmmeḥet	āq - à	em	Re-stau	seś-à	her	sebχet
through the hall of the tomb,		may I go	into	Re-stau,	may I pass through		the doors

śetat	nu	Àmentet	ṭā - tu - nà	śens	pasen	χet	neb	mà
hidden	of	Àmentet, may be given to me	offerings	and cakes,	things	all	like	

enen	χu	unniu	ḥer	āq	pert	em	Re-stetet	seśu
those	shining ones	who are	entering and coming out		from Re-stetet, and passing. . . .			

re	en	ṭeṭ	en	nub	t'eṭ	àn	Àusàr	Ani	maāχeru
The chapter	of	a ṭeṭ	of	gold.	Saith	Osiris	Ani,	triumphant :	

¹ The variants (Naville, *Todtenbuch*, Bd. II., Bl. 437) add the words,

ṭāṭā er χeχ en χu, " to be placed on the neck of the shining one."

uben - k nek urtu - ȧb pest - k nek urtu - ȧb
Thou risest for thyself, O still heart, thou shinest for thyself, O still heart.

ṭȧ - k - tu her ḳes - k ȧt - nȧ ȧn-nȧ nek ṭeṭ en nub
Place thou thyself upon thy side. I have come and I have brought to thee a *ṭeṭ* of gold,

ḥȧ - k ȧm - f [1]
rejoice thou in it.

[1] The text of the Nebseni papyrus reads (Naville, *Todtenbuch*, Bd. I., Bl. 180) :—

"Thou hast thy backbone, O still heart! Thou hast thy sinews, O still heart! They are at thy side. I have given moisture unto thee. Verily I have brought to thee the Ṭeṭ, rejoice thou in it." The rubric reads :—

t'eṭṭu re pen her ṭeṭ en nub menχu her χati en nehet
Shall be said chapter this over a *ṭeṭ* of gold laid upon a body of sycamore wood,

χebu em ȧnu nu ȧnχȧm erṭau er χeχ en χu pen
washed in water of ȧnkham flowers, and placed on the neck of shining one this.

ȧu - f ȧq her sebau nu Ȧmentet emχet meṭu - f
He shall enter through the doors of the underworld after his speech

em ȧu χeru ȧu - f ṭȧ - f su her ḳes - f enen
........ words. He shall place himself upon his side this

ȧmu - χet Ȧusȧr
among the followers of Osiris.

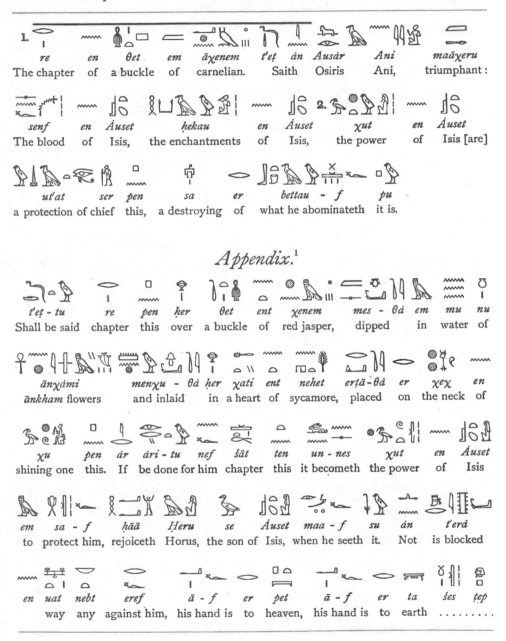

1.
re	en	θet	em	ắχenem	t'eṭ	án	Ausár	Ani	maắχeru
The chapter	of	a buckle	of	carnelian.	Saith		Osiris	Ani,	triumphant :

senf	en	Áuset	hekau	en	Áuset	2. χut	en	Áuset
The blood	of	Isis,	the enchantments	of	Isis,	the power	of	Isis [are]

uťat	ser	pen	sa	er	bettau - f	pu
a protection of chief	this,	a destroying	of	what he abominateth	it is.	

Appendix.[1]

t'eṭ - tu	re	pen	her	θet	ent	χenem	mes - θà	em	mu	nu
Shall be said	chapter	this	over	a buckle	of	red jasper,	dipped	in	water of	

ānχàmi	menχu - θà her χati	ent	nehet	erṭā-θà	er	χeχ	en
ānkham flowers	and inlaid	in a heart of	sycamore,	placed	on	the neck of	

χu	pen	àr	àri - tu	nef	śāt	ten	un - nes	χut	en	Áuset
shining one	this.	If	be done for him	chapter	this	it becometh	the power	of	Isis	

em	sa - f	hāā	Heru	se	Áuset	maa - f	su	àn	ťerà
to	protect him,	rejoiceth	Horus,	the son of Isis,	when he seeth it.	Not	is blocked		

en	uat	nebt	eref	ā - f	er	pet	ā - f	er	ta	śes	ṭep
way	any	against him,	his hand is	to	heaven,	his hand is	to	earth		

[1] See Maspero, *Mémoire sur quelques papyrus du Louvre*, Paris, 1875, p. 9 f.

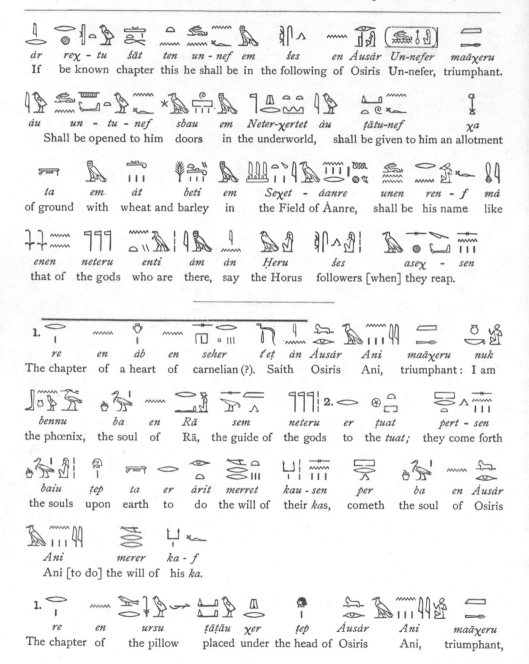

àr reχ - tu šāt ten un - nef em šes en Àusàr Un-nefer maāχeru
If be known chapter this he shall be in the following of Osiris Un-nefer, triumphant.

àu un - tu - nef sbau em Neter-χertet àu ṭàtu-nef χa
Shall be opened to him doors in the underworld, shall be given to him an allotment

ta em àt beti em Seχet - àanre unen ren - f mà
of ground with wheat and barley in the Field of Àanre, shall be his name like

enen neteru enti àm àn Ḥeru šes aseχ - sen
that of the gods who are there, say the Horus followers [when] they reap.

1. re en àb en seher t'eṭ àn Àusàr Ani maāχeru nuk
The chapter of a heart of carnelian (?). Saith Osiris Ani, triumphant: I am

bennu ba en Rā sem neteru er ṭuat 2. pert - sen
the phœnix, the soul of Rā, the guide of the gods to the tuat; they come forth

baiu ṭep ta er àrit merret kau - sen per ba en Àusàr
the souls upon earth to do the will of their kas, cometh the soul of Osiris

Ani merer ka - f
Ani [to do] the will of his ka.

1. re en ursu ṭàṭàu χer ṭep Àusàr Ani maāχeru
The chapter of the pillow placed under the head of Osiris Ani, triumphant,

er	*seres - θ*	*mennu*	*st'er*	*Àusàr*	*seres - k*	*ṭep - k*	*er*	
to	remove	disasters from	the dead body of	Osiris.	Lift thou up	thy head	into	

χut	*θesu - à nek*	*maāχeru*	*seχer*	*en Ptaḥ*
the horizon.	I have fastened together thee [in]	triumph.	Hath overthrown	Ptaḥ

χeftat - f - k	*àu*	*χefta - f*	*χer*	*àn*	*un - sen*	*Àusàr*
enemies his and thine.	Are	enemies his	fallen,	not	shall they rise up,	O Osiris.

I. 1.

t'eṭ	*àn Àuset*	*ì - à*	*un - à*	*em*	*sa - k*	*ḥun - nà - k*	2.
Saith	Isis :	I have come	that I may be		thy protector.	I waft to thee	

nifu	*er*	*feṭ (sic)-k*	*meḥit - u*	*en*	*šeràui - k*	*pert*	*em*
winds	to	thy nose,	[and] the north winds	to	thy nostrils	coming forth	from

3. ∧

Temu	*seq - [nà]*	*nek*	*ḥeti - k*	*erṭà - nà*	*un - nek*	*em*
Tem.	I have collected for thee	thy lungs.	I have granted	that thou mightest be	as	

4.

neter	*χefta - k*	*χer*	*χer tebt - k*	*semaāχeru - k*	*em*
a god.	Thine enemies	have fallen	under thy feet,	thou hast been made to triumph	in

5.　6.

7.

Nut	*user-tu*	*mà*	*neteru*
Nut,	being powerful	with	the gods.

Appendix.[1]

t'eṭ ȧn Ȧnpu ȧm ut χent neter ḥet erṭā - nef
Saith Anubis dwelling in place of the funeral, chief of the divine house, he placeth

āāui - f ḥer neb ānχ ṭeb - nef su em ȧrt - f
his two hands upon the lord of life, he supplieth him with what belongeth to him:

ȧneṭ' ḥrȧ - k nefer neb maa - tu uṭ'at θesu en Ptaḥ-seker
Hail to thee, fair one, O lord ! Seen by the *utchat*, bound up by Ptaḥ-Seker,

seqa en Ȧnpu erṭātu erṭā en nef Śu seθes - tu
gathered together by Anpu, Shu, lifted up

ḥer nefer ḥeq t'etta maat - k nek maat - k unemt em
with the fair one, the prince of eternity. Thine eyes are to thee. Thy eye right is in

sektet maat - k ȧbt em āṭet ȧu ȧnḥui - k em
the *sektet* boat ; thy eye left is in the *ātet* boat. Are thine eyebrows in

maa nefer embaḥ paut neteru ȧu ȧpt - k em sau en
sight fair before the cycle of the gods. Is thy brow (?) in the protection of

Ȧnpu ȧu mākḥa - k nefer χer bȧk śepsi ȧu
Anubis. Is the back of thy head in fair state with the hawk sacred. Are

[1] See Naville, *Todtenbuch*, Bd. I., Bl. 174.

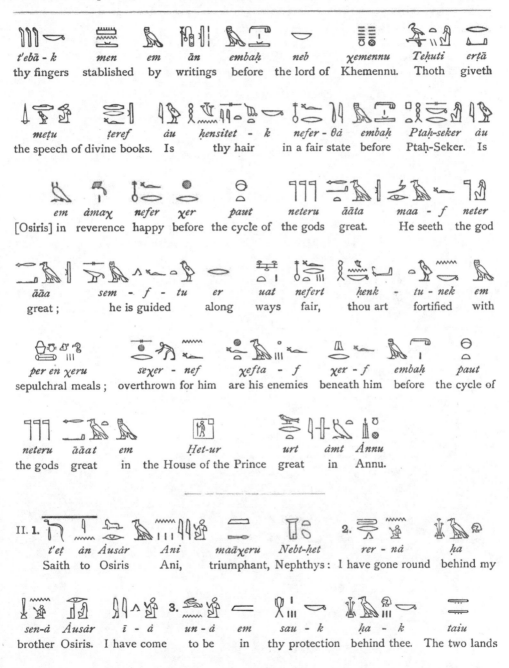

t'ebā - k	men	em	ān	embaḥ	neb	χemennu	Teḥuti	erṭā
thy fingers	stablished	by	writings	before	the lord of	Khemennu.	Thoth	giveth

meṭu	ṭeref	àu	ḥensitet - k	nefer - θà	embaḥ	Ptaḥ-seker	àu
the speech of divine books.	Is		thy hair	in a fair state	before	Ptaḥ-Seker.	Is

em	àmaχ	nefer	χer	paut	neteru	āāta	maa - f	neter
[Osiris] in	reverence	happy	before	the cycle of	the gods	great.	He seeth	the god

āāa	sem - f - tu	er	uat	nefert	ḥenk - tu - nek	em
great ;	he is guided	along	ways	fair,	thou art fortified	with

per en χeru	seχer - nef	χefta - f	χer - f	embaḥ	paut
sepulchral meals ;	overthrown for him	are his enemies	beneath him	before	the cycle of

neteru	āāat	em	Ḥet-ur	urt	àmt	Ànnu
the gods	great	in	the House of the Prince	great	in	Annu.

II. 1.

t'eṭ	àn	Àusàr	Ani	maāχeru	Nebt-ḥet	rer - nà	ḥa
Saith	to	Osiris	Ani,	triumphant,	Nephthys :	I have gone round	behind my

2.

sen-à	Àusàr	ī - à	un - à	em	sau - k	ḥa - k	taiu
brother	Osiris.	I have come	to be	in	thy protection	behind thee.	The two lands

3.

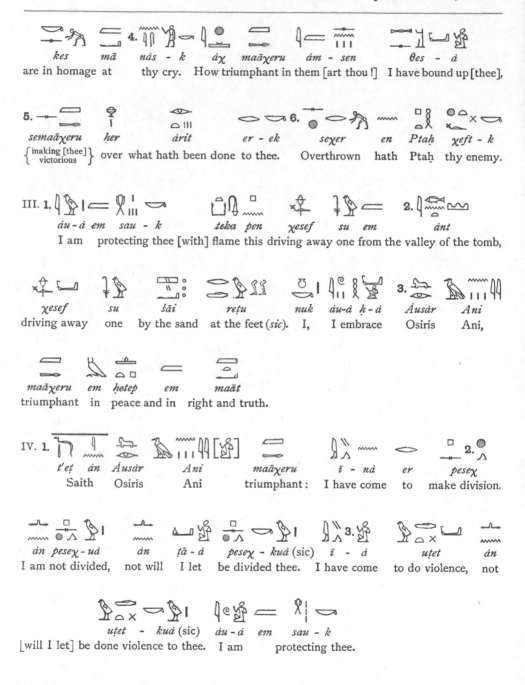

kes mā nàs - k àχ maāχeru àm - sen θes - à
are in homage at thy cry. How triumphant in them [art thou!] I have bound up [thee],

5. semaāχeru her àrit er - ek 6. seχer en Ptaḥ χeft - k
{ making [thee] victorious } over what hath been done to thee. Overthrown hath Ptaḥ thy enemy.

III. 1. àu-à em sau - k teka pen χesef su em 2. ànt
I am protecting thee [with] flame this driving away one from the valley of the tomb,

χesef su šāi reṭu nuk àu-à ḥ-à 3. Ausàr Ani
driving away one by the sand at the feet (sic). I, I embrace Osiris Ani,

maāχeru em ḥeteþ em maāt
triumphant in peace and in right and truth.

IV. 1. t'eṭ àn Ausàr Ani maāχeru ì - nà er 2. peseχ
Saith Osiris Ani triumphant: I have come to make division.

àn peseχ - uà àn ṭā - à peseχ - kuà (sic) 3. ì - à uṭet àn
I am not divided, not will I let be divided thee. I have come to do violence, not

uṭet - kuà (sic) àu-à em sau - k
[will I let] be done violence to thee. I am protecting thee.

V. 1.

ṭua Rā χeft uben - f em χuti ent ȧbtet ent pet ȧn

Adoration to Rā when he riseth in the horizon of the east of heaven by

Ȧusȧr Ani maȧχeru

Osiris Ani, triumphant.

VI. 1.

ṭua Rā χeft ḥetep - f em χuti ȧmentet ent pet ȧn Ȧusȧr

Adoration to Rā when he setteth in the horizon western of heaven. Saith Osiris

3.

Ani maȧχeru em ḥetep em Neter χert nuk ba ȧqer

Ani, triumphant in peace in the underworld: I am a soul perfect.

VII. 1.

t'eṭ ȧn Ȧusȧr Ani em maȧχeru nuk ba ȧqer ȧmu

Saith Osiris Ani in triumph: I am a soul perfect in

3.

suḥt pen ent ȧbṭ nuk mȧi āāt ȧmi em ȧuset

divine egg this of the ȧbtu fish. I am the Cat great dwelling in the seat of

maāt ent uben Śu ȧm - f

right and truth where riseth Shu in it.

VIII. 1.

seḥet' Ȧusȧr Ani maȧχeru ȧ śabti ȧpen ȧr

The overseer Osiris Ani, triumphant. Hail *shabti* figure this, if

ȧpt ȧr ḥeseb er ȧrit kat nebt ȧrt

be decreed [Osiris], if he be adjudged, to do labours any [which] are to be done

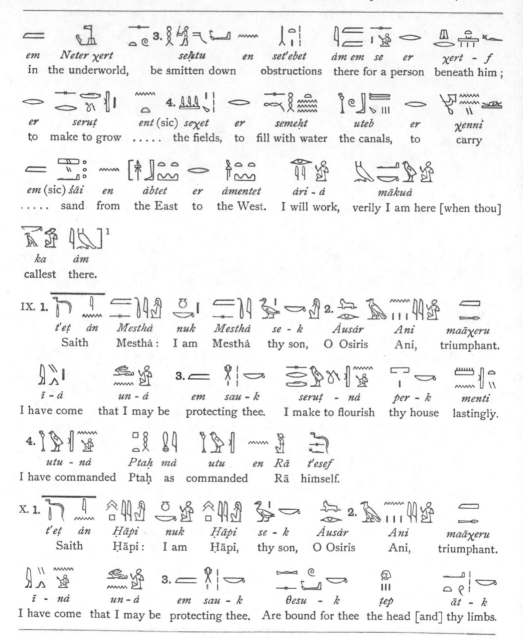

em	Neter χert		seḫtu	en	set'ebet	àm em	se	er	χert - ƒ
in	the underworld,	be smitten down		obstructions	there for a person			beneath him ;	

er	seruṭ		ent (sic) seχet	er	semeḫt	uteb	er	χenni
to	make to grow	the fields,	to	fill with water	the canals,	to	carry

em (sic) śāi	en	àbtet	er	àmentet	àri - à	mākuà
..... sand	from	the East	to	the West.	I will work,	verily I am here [when thou]

ka	àm
callest	there.

IX. 1.

t'eṭ	àn	Mesthà	nuk	Mesthà	se - k	Àusàr	Ani	maāχeru
Saith		Mesthà :	I am	Mesthà	thy son,	O Osiris	Ani,	triumphant.

ī - à		un - à	em	sau - k	seruṭ - nà	per - k	menti
I have come	that I may be	protecting thee.		I make to flourish	thy house	lastingly.	

utu - nà	Ptaḥ mà	utu	en Rā	t'esef
I have commanded	Ptaḥ as	commanded	Rā	himself.

X. 1.

t'eṭ	àn	Ḥāpi	nuk	Ḥāpi	se - k	Àusàr	Ani	maāχeru
Saith		Ḥāpi :	I am	Ḥāpi,	thy son,	O Osiris	Ani,	triumphant.

ī - nà		un - à	em	sau - k	θesu - k	ṭep	āt - k
I have come	that I may be	protecting thee.		Are bound for thee	the head [and] thy limbs.		

The words in brackets are supplied from Naville, *Todtenbuch*, Bd. II., Bl. 430.

ḥui - nek 4. *χefta - f* (sic) - *k* *χer - k* *erṭā-nā* *nek*
[I] have smitten down for thee thine enemies beneath thee. I have given to thee

ṭep *t'etta* *sep sen* 5. *Ảusảr* *Ani* *maȧχeru* *em* *ḥetep*
the head for ever, twice, O Osiris Ani, triumphant in peace.

XI. 1. *t'eṭ* *ȧn* *Ṭuamāutef* *nuk* *se - k* *Ḥeru* *meriu - k* 2. *ỉ - nā*
Saith Ṭuamāutef: I am thy son Horus thy beloved. I have come

net'ti *tef - ȧ* *Ảusȧr* *mā* *ȧri* *neken - f* 3. *ṭā-ȧ* *su* (sic) *χer*
to avenge my father Osiris from the doer of evil to him. I have set him under

reṭ - k *t'etta* *sep sen* *men* *sep sen* 4. *Ảusȧr* *Ani* *em maāχeruti* *ḥetep*
thy feet for ever, twice, everlastingly, twice, O Osiris Ani, triumphant in peace.

XII. 1. *t'eṭ* *ȧn* *Qebḥ-sennuf* *nuk* *se - k* *Ảusȧr* 2. *Ani* *maāχeru*
Saith Qebḥ-sennuf: I am thy son, O Osiris Ani, triumphant.

ỉ - a *un - ȧ* *em* 3. *sau - k* *ṭemṭ - ȧ* *qesu - k*
I have come that I may be protecting thee. I have collected thy bones.

saq - ȧ - k 4. *āt - k* *ȧn Ảusȧr* *pui* *āāa* 5. *enti* *em*
I have gathered together for thee thy members. Osiris that great who is in

ȧuset *maāt* *enti* *amiu* *ken*
the place of right and truth, who

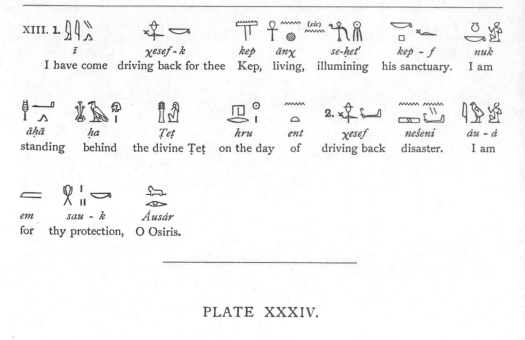

XIII. 1. *ī* — *χesef-k* — *kep*, *ānχ*, *se-ḥet'* — *kep-f* — *nuk*

I have come driving back for thee Kep, living, illumining his sanctuary. I am

āḥā *ḥa* *Ṭeṭ* *hru* *ent* 2. *χesef* *neśeni* *àu-à*

standing behind the divine Ṭeṭ on the day of driving back disaster. I am

em *sau-k* *Àusàr*

for thy protection, O Osiris.

PLATE XXXIV.

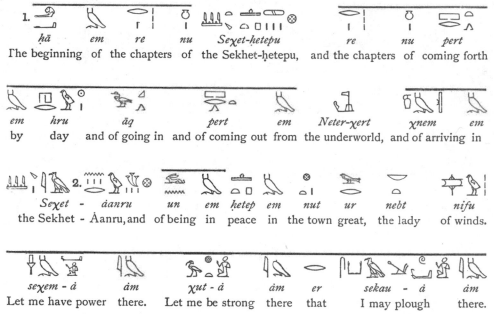

1. *ḥā* *em* *re* *nu* *Seχet-ḥetepu*, *re* *nu* *pert*

The beginning of the chapters of the Sekhet-ḥetepu, and the chapters of coming forth

em *hru* *āq* *pert* *em* *Neter-χert* *χnem* *em*

by day and of going in and of coming out from the underworld, and of arriving in

Seχet - àanru, and *un* *em* *ḥetep* *em* *nut* *ur* *nebt* *nifu*

the Sekhet - Àanru, and of being in peace in the town great, the lady of winds.

seχem - à *àm* *χut - à* *àm* *er* *sekau - à* *àm*

Let me have power there. Let me be strong there that I may plough there.

asχ - à	àm	qeq - à	àm	surà - à	àm	em
Let me reap	there.	Let me eat	there.	Let me drink	there	as

àrit	àrit	neb	ṭep	ta
they are done	all	upon	earth.	

t'eṭ	àn	Àusàr	Ani		maāχeru	entek	θet	Ḥeru
Saith	Osiris	Ani,		Ani (sic) triumphant :	Hath carried away	Horus		

àn	Sut	maa	em	qeṭ	er	Seχet - ḥetepet	peseśet
Set	to look upon	the building (?)	in	the Field of Hetepet,	distributing		

nifu	her	ba	en	hru - f	àm	suḥt	neḥem - f
winds	upon the divine soul in	his day	in	the divine Egg..	He hath delivered		

χennu	χat	en	Ḥeru	nuk	seśet - à	su	em	āt
the interior	of the body	of	Horus	I,	even I have crowned him	in	the house of	

Śu	àu	āt	χabesu (?)-f	nuk	às	ḥetep	em	sepu - f
Shu.	The House of	his stars	I	behold	repose	in	his seasons (?).	

sem - f	meḥt	en	paut	neteru	semsu - f
He hath passed through	the Meḥt district	of	the cycle of the gods,	his aged ones.	

[1] The Nebseni papyrus adds, ⸻ nehep àm, "Let me make love there."

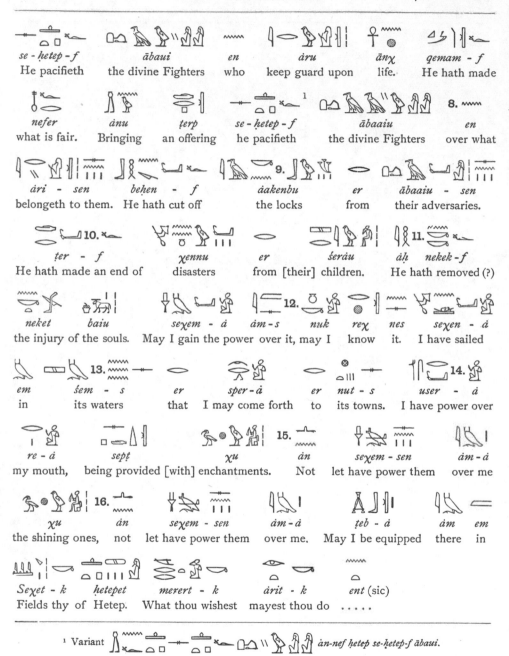

se - ḥetep - f	ābaui	en	àru	ānχ	qemam - f
He pacifieth	the divine Fighters	who	keep guard upon	life.	He hath made

nefer	ànu	ṭerp	se - ḥetep - f	ābaaiu	8.
what is fair.	Bringing	an offering	he pacifieth	the divine Fighters	en over what

àri - sen	beḥen - f	àakenbu	er	9. ābaaiu - sen
belongeth to them.	He hath cut off	the locks	from	their adversaries.

ṭer - f	χennu	er	šeràu	11. àḥ nekek - f
He hath made an end of	disasters	from [their] children.		He hath removed (?)

neket	baiu	seχem - à	àm - s	nuk	reχ	nes	seχen - à
the injury of the souls.		May I gain the power over it,	may I	know	it.		I have sailed

em	šem - s	er	sper - à	er	nut - s	user - à
in	its waters	that	I may come forth	to	its towns.	I have power over

re - à	sepṭ	χu	àn	seχem - sen	àm - à
my mouth,	being provided [with] enchantments.		Not	let have power them	over me

χu	àn	seχem - sen	àm - à	ṭeb - à	àm	em
the shining ones,	not	let have power them	over me.	May I be equipped	there	in

Seχet - k	ḥetepet	merert - k	àrit - k	ent (sic)
Fields thy of	Hetep.	What thou wishest	mayest thou do

¹ Variant 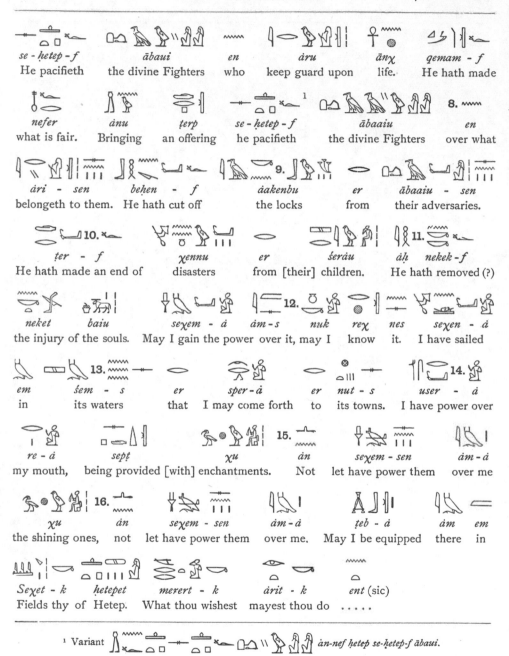 àn-nef ḥetep se-ḥetep-f ābaui.

PLATE XXXV.

1. *t'eṭ àn Àusàr Ani maāχeru àneṭ'-ḥrä-k em enti neb*
Saith Osiris Ani, triumphant: Homage to thee who art the lord,

neb maāt uāu neb ḥeh àrit t'etta
the lord of right and truth, the One, the lord of eternity, the maker of everlastingness,

ì - nà χer - k neb Rā seuaṭ' - kuà en neb kauit
I have come to thee, O [my lord] Rā. I have made food offerings to the lord of the cows

seχef ḥenā (sic) ka àri ṭāṭāiu tau ḥeqt en
seven together with the bull belonging thereto. O ye who give cakes and ale to

χut ṭā - ten en ba - à ḥenà - ten χeper-f χer
the shining ones, grant ye to my soul [to be] with you. May he come into being upon

peχṭ - ten un - nef mà uā àm - ten er neḥeḥ ḥenā t'etta
your thighs. May he be like one of you for ever and for ever.

χut - f em Àmentat nefert àn Àusàr Ani maāχeru
May he be glorious in Amenta the beautiful, Osiris Ani, triumphant.

PLATE XXXVI.

à seχem nefer ḥemi nefer en pet meḥtet à rer
Hail, power beautiful, rudder beautiful of heaven north. Hail, revolver of

pet sem taui ḥemi nefer en pet àmentet à χu
heaven, pilot of the two earths, rudder beautiful of heaven west. Hail, shining one,

her ṭept ḥet àšemu ḥemi nefer en pet àbtet à
above the temple of the gods in visible forms, rudder beautiful of heaven east. Hail,

χenti her ṭept ḥet šài ḥemi nefer en pet resi à neteru
dweller above the temple of sand, rudder beautiful of heaven south. Hail, ye gods,

ḥeri ta semu ṭuat à neteru mutet ḥeri
above the earth, pilots of the underworld. Hail, ye gods, mothers, who are above

ta em Neter-χert em per Àusàr sep sen à neteru semu
the earth, who are in the underworld, and in the house of Osiris, twice. Hail, ye gods, pilots

Ta - sert ḥeru ta semu ṭuat à šesu Rā
of Tasert, who are above the earth, pilots of the underworld. Hail, followers of Rā,

àmi - χet Àusàr
who are in the train of Osiris.

1. *ṭua* *Ausār* *χenti* *Amentet* *Un-nefer* *her-āb* *Ābṭu* *ān* *Ausār*

A hymn of praise to Osiris, dweller in Amentet, Un-nefer, within Abydos. Osiris

Ani *maāχeru* *t'eṭ - f* *ā* *neb - ā* *sebebi* 2. *heh* *unt - f*

Ani, triumphant, saith he: Hail, my lord, traversing eternity, his existence

er *t'etta* *neb* *nebu* *suten* *suteniu* *āθi* *neter* *neteru* 3. *uneniu* (sic)

being for ever, lord of lords, king of kings, prince, god of the gods who live

mā ten *sen* *χer - k* *em neteru* *pui* *reθ* *āri - kuā*

with you they, [I have come] to thee gods men. Make thou for me

āuset *sen* *χenti* *Neter-χert* 4. *senemeḥ - sen* *tut* *en* *ka - k* 5. *enti*

a seat [with] them in the underworld, they adore the images of thy *ka*, who are

em *ī* *en* *heh* *en* 6. *heh* *pehu* 7. *meni*

among those who come for millions of millions of years. Arriving, coming into port

ār - kuā *enti* *em* *χat* 8. *her* *sen* *nek* *ān* 9. *χeper* *āsq* *em*

. which is in the body Not may arise delay in

Ta-merā 10. *sen* *em* *āmā - k* 11. *ī - sen* *nek* *tem*

Ta-Mera their Grant thou that they may come to thee all [of them]

uru	mà	ketet	ṭā - f	āq	per	em	Neter-χert	àn
great	as well as little.		May he grant	entrance	and exit	in	the underworld,	without

šentu	her	seba	en	ṭuat	en	ka	en	Ausàr	Ani
repulse	at	the gates	of	the underworld	to	the ka	of	Osiris	Ani.

PLATE XXXVII.

Ḥet-ḥert	nebt	Àmentet	àmt	Urt	nebt	Ta-sert	maat	Rā	àmt
Hathor,	lady of	Amentet,	dweller in	Urt,	lady of	Ta-sert,	the eye of	Rā,	dweller in

ḥāt - f	ḥrà	nefert	em	uàa	en	heḥ	àuset	ḥetep	en	àri
his brow,	face	beautiful	in	the boat	of	millions of years.	The seat	of peace	for	doing

maāt	em	χennut	en	ḥesiu	ta	set er	àri
what is right and true		among (?)	the	favoured ones to make	

nešet	urt	er	t'a	pa	maāti
the bark of the sun	great	to	sail forth	the	right and truth.

TRANSLATION.

THE BOOK OF THE DEAD.

PLATE I.

Vignette: The scribe Ani ⟨hieroglyphs⟩, standing with hands raised in adoration before a table of offerings consisting of haunches of beef ⟨hieroglyph⟩, loaves of bread and cakes ⟨hieroglyph⟩, ⟨hieroglyph⟩, ⟨hieroglyph⟩, vases of wine and oil ⟨hieroglyph⟩, ⟨hieroglyph⟩, fruits, lotus ⟨hieroglyph⟩, ⟨hieroglyph⟩, and other flowers. He wears a fringed white and saffron-coloured linen garment; and has a wig, necklace, and bracelets. Behind him stands his wife "Osiris, the lady of the house, the lady of the choir of Amen, Thuthu,"[1] similarly robed and holding a sistrum ⟨hieroglyph⟩ and a vine (?)-branch in her right hand, and a *menât* ⟨hieroglyph⟩ in her left.[2]

[1] ⟨hieroglyphs⟩, see Plate XIX.

[2] The *menât*, which is often called "the counterpoise of a collar," consists of a disk, with a handle attached, and a cord. It was an object which was usually offered to the gods, with the sistrum; it was presented to guests at a feast by their host; and it was held by priestesses at religious festivals. It was either worn on the neck or carried in the left hand; and it was an emblem which brought joy to the bearer. Interesting examples of the pendent *menât* in the British Museum are No. 17,166, inscribed, ⟨hieroglyphs⟩, "Beautiful god, lord of the two lands, maker of things, King of the North and South, Khnem-âb-Rā, son of the Sun, Âāḥmes (Amāsis), beloved of Hathor, lady of sycamore trees"; and No. 13,950 * in faïence; and Nos. 8172, 8173, and 20,607 in hard stone. No. 18,109 is the disk of a *menât* in faïence, inscribed, ⟨hieroglyphs⟩ ⟨hieroglyphs⟩, "Hathor, lady of the town of Ânithâ." No. 20,760 is a disk and handle in bronze, the disk having, in hollow work, the figure of a cow, sacred to Hathor, and the handle, the upper part of which is in the form of the head of Hathor, having a sistrum. On the one side is the prenomen of Amenophis III. ⟨cartouche⟩, and on the other is ⟨hieroglyphs⟩, "Hathor, lady of the sycamore." The meaning and use of the *menât* is discussed by Lefébure in *Le Menât et le Nom de l'eunuque* (*Proc. Soc. Bibl. Arch.*, 1891, pp. 333–349).

* A duplicate is in the Louvre; see Perrot and Chipiez, *Histoire de l'Art, l'Égypte*, p. 821, No. 550.

Text: [Chapter XV.] (1)[1] A HYMN OF PRAISE TO RĀ WHEN HE RISETH IN THE EASTERN PART OF HEAVEN. Behold Osiris Ani the scribe who recordeth the holy offerings of all the gods, (2) who saith: " Homage to thee, O thou who hast come as " Khepera,[2] Khepera, the creator of the gods. Thou risest, thou shinest, (3) making " bright thy mother [Nut], crowned king of the gods. [Thy] mother Nut [3] " doeth homage unto thee with both her hands. (4) The land of Manu [4] " receiveth thee with content, and the goddess Maāt [5] embraceth thee at the two " seasons. May he give splendour, and power, and triumph, and (5) a coming-forth " [*i.e.*, resurrection] as a living soul to see Horus of the two horizons [6] to the

[1] The numbers in parentheses indicate the lines of the papyrus.

[2] The god Khepera is usually represented with a beetle for a head ; and the scarab, or beetle, was sacred to him. The name means "to become, to turn, to roll," and the abstract noun *kheperu* ⌂⌂⌂ may be rendered by "becomings," or "evolutions." The god was self-created, and was the father of all the other gods ; men and women sprang from the tears which fell from his eyes ; and the animal and vegetable worlds owed their existence to him. Khepera is a phase of Tmu, the night-sun, at the twelfth hour of the night, when he "becomes" the rising sun or Harmachis (*i.e.*, Horus in the horizon). He is also described as "Khepera in the morning, Rā at mid-day, and Tmu in the evening." See Lanzone, *Dizionario*, p. 927 ff. ; Grébaut, *Hymne à Ammon-Rā*, p. 164, note 2 ; Pierret, *Panthéon*, pp. 74, 75 ; Lefébure, *Traduction Comparée des Hymnes au Soleil*, p. 39 ; De Rougé, *Inscription d'Ahmès*, p. 110 ; *Archaeologia*, vol. 52, p. 541 ff. ; Wiedemann, *Die Religion der Alten Aegypter*, p. 17 ; Brugsch, *Religion und Mythologie*, p. 245, *etc.*

[3] The goddess Nut represented the sky, and perhaps also the exact place where the sun rose. She was the wife of Seb, the Earth-god, and gave birth to Isis, Osiris, and other gods. One of her commonest titles is "mother of the gods." She is depicted as a woman bearing a vase �?? upon her head, and some-times wears the disk and horns usually characteristic of Isis and Hathor. She was the daughter and mother of Rā. See Lanzone, *Dizionario*, p. 392 ; Pierret, *Panthéon*, pp. 34, 36 ; Brugsch, *Religion und Mythologie*, pp. 603–610.

[4] Manu is the name given to the mountains on the western bank of the Nile, opposite Thebes, wherein was situated ⌂⌂⌂ *ṭu Manu*, "the mountain of Manu," the chief site of rock-hewn tombs. See Brugsch, *Dict. Géog.*, p. 259.

[5] Maāt, "daughter of the Sun, and queen of the gods," is the personification of righteousness and truth and justice. In many papyri she is represented as leading the deceased into the Hall of Double Maāt, where his heart is to be weighed against her emblem. She usually wears the feather ⌂, emblematic of Truth, and is called the "lady of heaven": see Lanzone, *Dizionario*, p. 276 (and tav. 109, where the twin-goddesses Maāt are shown) ; Pierret, *Panthéon*, p. 201. She is sometimes represented blind-fold : see Wiedemann, *Religion der alten Aegypter*, p. 78. For figures of the goddess in bronze and stone, see Nos. 380, 383, 386, 11,109, and 11,114 in the British Museum.

[6] *Ḥeru-khuti*, *i.e.*, "Horus of the two horizons," the Harmachis of the Greeks, is the day-sun from his rising in the eastern horizon to his setting in the western horizon ; for the various forms in which he is represented, see Lanzone, *Dizionario*, tav. 129. Strictly speaking, he is the rising sun, and is one of the most important forms of Horus. As god of mid-day and evening he is called Rā-Harmachis and Tmu-Harmachis respectively. The sphinx at Gîzeh was dedicated to him.

" *ka* [1] of Osiris,[2] the scribe Ani, triumphant [3] before Osiris, (6) who saith : Hail
" all ye gods of the Temple of the Soul,[4] who weigh heaven and earth in the
" balance, and who provide food and abundance of meat. Hail Tatunen,[5] One,
" (7) creator of mankind and of the substance of the gods of the south and of the
" north, of the west and of the east. Ascribe [ye] praise unto Rā, the lord of
" heaven, the (8) Prince, Life, Health, and Strength, the Creator of the gods, and
" adore ye him in his beautiful Presence as he riseth in the *ātet* [6] boat. (9) They
" who dwell in the heights and they who dwell in the depths worship thee.
" Thoth [7] and Maāt both are thy recorders. Thine enemy [8] is given to the (10)
" fire, the evil one hath fallen ; his arms are bound, and his legs hath Rā taken
" from him. The children of (11) impotent revolt shall never rise up again.

[1] According to the Egyptian belief man consisted of a body ⟨hiero⟩ *χa*, a soul ⟨hiero⟩ *ba*, an intelligence
⟨hiero⟩ *χu*, and ⟨hiero⟩ a *ka*. The word *ka* means "image," the Greek εἴδωλον (compare Coptic ⲔⲰ,
Peyron, *Lexicon*, p. 61). The *ka* seems to have been the "ghost," as we should say, of a man,
and it has been defined as his abstract personality, to which, after death, the Egyptians gave a material
form. It was a subordinate part of the human being during life, but after death it became active ;
and to it the offerings brought to the tomb by the relatives of the dead were dedicated. It was
believed that it returned to the body and had a share in its re-vivification. See Birch, *Mémoire sur une
patère Égyptienne* (in *Trans. Soc. Imp. des Antiquaires de France*, 1858 ; Chabas, *Papyrus Magique*,
pp. 28, 29 ; Maspero, *Étude sur quelques peintures*, p. 191 ff. ; *Trans. Soc. Bibl. Arch.*, vol. vi., p. 494 ff. ;
Brugsch, *Aegyptologie*, p. 181 ; Wiedemann, *Religion der alten Aegypter*, p. 126 f.).

[2] The deceased is always identified with Osiris, or the sun which has set, the judge and god of the
dead. As the sun sets in the west and rises again in the east, so the dead man is laid in his tomb on
the western bank of the Nile, and after being acquitted in the Hall of Judgment, proceeds to the east to
begin a new existence.

[3] *maāχeru* or *maātχeru*. On this word, see Naville, *Litanie du Soleil*, p. 74 ; Devéria, *L'Expression
Mââ-χerou* (in *Recueil de Travaux*, tom. i., p. 10 ff.).

[4] Compare ⟨hiero⟩, and ⟨hiero⟩, Brugsch, *Dict. Géog.*, pp. 185, 186.

[5] Tatunen, or Tenen ⟨hiero⟩, was, like Seb with whom he was identified, the god of the earth ;
his name is often joined to that of Ptah, and he is then described as the creator of gods and men, and
the maker of the egg of the sun and of the moon. See Lanzone, *Dizionario*, p. 1259 ; Wiedemann,
Religion, p. 74 ; Pierret, *Panthéon*, p. 6 ; and Naville, *La Litanie du Soleil*, pp. 118, 119, and
plate xxiv., l. 3. This god was, in one aspect, a destroyer of created things ; compare ⟨hiero⟩
⟨hiero⟩, Naville, *op. cit.*, p. 89.

[6] A name for the boat of the evening sun.

[7] See *infra*, p. 257, note 2.

[8] The enemy of Rā was darkness and night, or any cloud which obscured the light of the sun.
The darkness personified was Āpep, Nāk, *etc.*, and his attendant fiends were the *mesu betesh*, or
'children of unsuccessful revolt."

" The House of the Prince [1] keepeth festival, and the sound of those who rejoice
" is in the (12) mighty dwelling. The gods are glad [when] they see Rā in his
" rising; his beams flood the world with light. (13) The majesty of the god, who
" is to be feared, setteth forth and cometh unto the land of Manu; he maketh
" bright the earth at his birth each day; he cometh unto the place where he was
" yesterday. (14) O mayest thou be at peace with me; may I behold thy
" beauties; may I advance upon the earth; may I smite the Ass; may I crush
" (15) the evil one; may I destroy Apep [2] in his hour [3]; may I see the *àbṭu* [4]
" fish at the time of his creation, and the *ànt* fish in his creation, and the (16)
" *ànt* [4] boat in its lake. May I see Horus in charge of the rudder, with Thoth

[1] , more fully , " the great house of the old man," *i.e.*, the great temple of
Rā at Heliopolis: see Brugsch, *Dict. Géog.*, p. 153.

[2] Āpep, the serpent, personifying darkness, which Horus or the rising sun must conquer before he
can re-appear in the East.

[3] Compare the following scenes which represent Āpep in the form of a serpent and crocodile and
ass being pierced by the deceased.

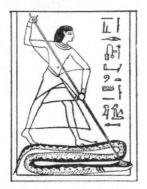
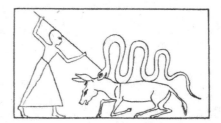
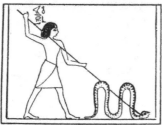
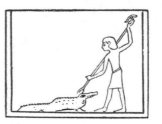

[4] The *àbṭu* and the *ànt* fishes are sometimes depicted on coffins swimming at the bows of the
boat of the sun.

"and Maāt beside him; may I grasp the bows of the (17) *sektet*[1] boat, and the
"stern of the *ātet* boat.　May he grant unto the *ka* of Osiris Ani to behold the
"disk of the Sun and to see the Moon-god without ceasing, every day; and
"may my soul (18) come forth and walk hither and thither and whithersoever it
"pleaseth.　May my name be proclaimed when it is found upon the board of the
"table of (22) offerings; may offerings be made unto me in my (24) presence, even
"as they are made unto the followers of Horus; may there be prepared for me a
"seat in the boat of the Sun on the day of the going forth of the (26) god; and
"may I be received into the presence of Osiris in the land (28) of triumph!"

Appendix : The following versions of this chapter are taken from : I. Naville,
Todtenbuch, Bd. I., Pl. xiv.; II. Naville, *Todtenbuch*, Bd. I., Pl. xv.; III. *British
Museum Papyrus* No. 9901 ; and IV. *British Museum Papyrus* No. 10,471.

I. (1) A HYMN OF PRAISE TO RĀ WHEN HE RISETH IN THE EASTERN PART
OF HEAVEN.　Behold Osiris, Qenna the merchant, (2) who saith: "Homage to thee,
"in thy rising thou Tmu in thy crowns of beauty.　Thou risest, thou risest, thou Rā
"shinest, (3) thou shinest, at dawn of day.　Thou art crowned like unto the king of
"the gods, and the goddess Shuti doeth homage unto thee.　(4) The company
"of the gods praise thee from the double-dwelling.　Thou goest forth over the
"upper air and thy heart is filled with gladness.　(5) The *sektet* boat draweth
"onward as [Rā] cometh to the haven in the *ātet* boat with fair winds.　Rā
"rejoiceth, Rā rejoiceth.　(6) Thy father is Nu, thy mother is Nut, and thou art crowned
"as Rā-Harmachis.　Thy sacred boat advanceth in peace.　Thy foe hath been cast
"down and his (7) head hath been cut off; the heart of the Lady of life rejoiceth in that
"the enemy of her lord hath been overthrown.　The mariners of Rā have content of
"heart and Annu rejoiceth."
　　　(8) The merchant Qenna saith : "I have come to thee, O Lord of the gods,
"Tmu-Harmachis, who passest over the earth (9) I know that by which thou
"dost live.　Grant that I may be like unto one of those who are thy favoured (10) ones
"[among the followers] of the great god.　May my name be proclaimed, may it be
"found, may it be lastingly renewed with (11) The oars are lifted into the *sektet*
"boat, and the sacred boat cometh in peace.　(12) May I see Rā when he appeareth in
"the sky at dawn, and when his enemies have fallen at the block.　(13) May I behold
"[Horus] guiding the rudder and steering with [his] two hands.　(14) May I
"see the *ābṭu* fish at the moment of his creation ; and may I see the *ant* fish when he
"maketh himself manifest at creation, and the *ant* boat upon its lake.　O thou Only
"One, O thou Mighty One, thou Growing One, (15) who dost never wax faint, and

[1] A name of the boat of the rising sun.

" from whom power cannot be taken, the devoted (17) servant of
" the lord of Abṭu."

　　The merchant Qenna saith: (18)"Homage to thee Ḥeru-Khuti-Tmu, Ḥeru-Khepera,
" mighty hawk, who dost cause the body [of man] to make merry, beautiful of face by
" reason of thy two great plumes. Thou (19) wakest up in beauty at the dawn, when
" the company of the gods and mortals sing songs of joy unto thee ; hymns of
" praise are offered unto thee at eventide. The (20) starry deities also adore thee. O thou
" firstborn, who dost lie without movement, (21) arise ; thy mother showeth loving-
" kindness unto thee every day. Rā liveth and the fiend Nák is dead; thou dost endure
" for ever, and the (22) fiend hath fallen.

　　" Thou sailest over the sky with life and strength. The goddess Neḥebka is in
" (23) the *āṭet* boat ; the sacred boat rejoiceth. Thy heart is glad and thy brow is
" wreathed with the twin serpents."

　　II. (1) A Hymn of Praise to Rā when he riseth in the Eastern
part of Heaven. Behold Osiris, Qenna the merchant, triumphant, who saith : (2)
" Homage to thee, O thou who risest in Nu, and who at thy birth dost make the world
" bright with light; all the company of the gods (3) sing hymns of praise unto thee. The
" beings who minister unto Osiris cherish him as King of the North and of the South, the
" beautiful and beloved man-child. When (4) he riseth, mortals live. The nations rejoice
" in him, and the Spirits of Annu sing unto him songs of joy. The Spirits of the towns of
" Pe and Nekhen (5) exalt him, the apes of dawn adore him, and all beasts and cattle
" praise (6) him with one accord. The goddess Sebá overthroweth thine enemies, there-
" fore rejoice (7) within thy boat; and thy mariners are content thereat. Thou hast arrived
" in the *āṭet* boat, and thy heart swelleth with joy. O Lord of the gods, when thou
" (8) dost create them, they ascribe praises unto thee. The azure goddess Nut doth
" compass thee on every side, and the god Nu floodeth thee with his rays of light.
" (9) O cast thou thy light upon me and let me see thy beauties, me, the (10) Osiris
" Qenna the merchant, triumphant! When thou goest forth over the earth I will sing
" praises unto thy fair (11) face. Thou risest in the horizon of heaven, and [thy] disk is
" adored [when] it resteth upon the mountain to give life unto the world."

　　Saith Qenna the merchant, triumphant : (12) " Thou risest, thou risest, coming forth
" from the god Nu. Thou dost become young again and art the same as thou wert
" yesterday, O mighty youth who hast created thyself. Not my hand. (13)
" Thou hast come with thy splendours, and thou hast made heaven and earth bright with
" thy rays of pure emerald light. The land of Punt is (14) established for the perfumes
" which thou smellest with thy nostrils. (15) Thou risest, O thou marvellous Being, in
" heaven, the twin serpents are placed upon thy brow, and thou art lord of the world and
" the inhabitants (16) thereof; [the company] of the gods and Qenna the merchant,
" triumphant, adore thee."

　　III. (1, 2) A Hymn of Praise to Rā when he riseth in the Eastern
part of Heaven. (3) Behold Osiris Hunefer, triumphant, who saith : " Homage to
" thee, O thou who art Rā when thou (4) risest and Tmu when thou settest. Thou
" risest, thou risest ; thou shinest, (5) thou shinest, thou who art crowned king of the

" gods.　Thou art the lord of heaven, [thou art] the lord of earth, [thou art] the creator
" of those who dwell in the heights (6) and of those who dwell in the depths.　[Thou
" art] the One god who came into (7) being in the beginning of time.　Thou didst create
" the earth, (8) thou didst fashion man, thou didst make the watery abyss of the sky,
" thou didst form Hapi [the Nile], and thou art the maker of streams and of the
" (9) great deep, and thou givest life to all that is therein.　Thou hast knit (10) together
" the mountains, thou has made mankind and the beasts of the field, thou hast created
" the heavens and the earth.　Worshipped be thou whom the goddess Maāt embraceth
" at morn and at eve.　Thou dost travel across the (11) sky with heart swelling with
" joy ; the Lake of Testes is at peace.　The fiend Nāk hath fallen and his two arms are
" cut off.　The *sektet* boat receiveth fair winds, and the heart of him that is in his shrine
" rejoiceth.　Thou (12) art crowned with a heavenly form, the Only one, provided [with all
" things].　Rā cometh forth from Nu in triumph.　O thou mighty youth, thou everlasting
" son, self-begotten, who didst give thyself birth, (13) O thou mighty One, of myriad
" forms and aspects, king of the world, Prince of Annu, lord of eternity and ruler of the
" everlasting, the company of the gods rejoice when thou risest and when thou sailest
" (14) across the sky, O thou who art exalted in the *sektet* boat.　Homage to thee,
" O Amen-Rā, thou who dost rest upon Maāt, thou who passest over the heaven, and
" every face seeth thee.　Thou dost wax great as thy (15) Majesty doth advance, and
" thy rays are upon all faces.　Thou art unknown and canst not be searched out
" his fellow except thyself ; thou art (16) the Only One [Men] praise thee in
" thy name [Rā], and they swear by thee, for thou art lord over them.　Thou hast heard
" (17) with thine ears and thou hast seen with thine eyes.　Millions of years have gone
" over the world ; I cannot tell the number of them, through which thou hast passed.
" Thy heart hath decreed a day of happiness in thy name [of Rā].　Thou dost pass over
" (18) and travellest through untold spaces of millions and hundreds of thousands of
" years ; thou settest out in peace, and thou steerest thy way across the watery abyss to
" the place which thou lovest ; this thou doest in one (19) little moment of time, and
" thou dost sink down and makest an end of the hours."

　　　Osiris, the governor of the palace of the lord of the two lands (*i.e.*, Seti I.), Hunefer,
triumphant, saith : (20) " Hail my lord, thou that passest through eternity and whose
" being is everlasting.　Hail thou Disk, lord of beams of light, thou risest and thou
" makest all mankind to live.　Grant thou that I may behold thee at dawn each day."

　　　IV.　A HYMN OF PRAISE TO RĀ by Nekht, the royal scribe, captain of soldiers,
who saith : " Homage to thee, O thou glorious Being, thou who art provided [with all
" things].　O Tmu-Ḥeru-khuti, when thou risest in the horizon of heaven, a cry of joy
" cometh out of the mouth of all peoples.　O thou beautiful Being, thou dost renew
" thyself in thy season in the form of the Disk within thy mother Hathor ; therefore in
" every place every heart swelleth with joy at thy rising, for ever.　The eastern and the
" western parts of heaven come to thee with homage, and give forth sounds of joy at thy
" rising.　O Rā, thou who art Ḥeru-khuti (Harmachis), the mighty man-child, the heir of
" eternity, self-begotten and self-born, king of earth, prince of the netherworld, governor
" of the mountains of Åuḳert (*i.e.*, the netherworld), thou dost rise in the horizon of
" heaven and sheddest upon the world beams of emerald light ; thou art born from the

"water, thou art sprung from Nu, who fostereth thee and ordereth thy members.　O thou
"who art crowned king of the gods, god of life, lord of love, all the nations live when
"thou dost shine.　The goddess Nut doeth homage unto thee, and the goddess
"Maāt embraceth thee at all times.　They who are in thy following sing unto thee with
"joy and bow down to the earth when they meet thee, the god of heaven, the lord of
"earth, the king of right and truth, the god of eternity, the everlasting ruler, the prince
"of all the gods, the god of life, the creator of eternity, the maker of heaven by whom
"is established all that therein is.　The company of the gods rejoice at thy rising, the
"earth is glad when it beholdeth thy rays ; the peoples that have been long dead come
"forth with cries of joy to see thy beauties.　Thou goest forth over heaven and earth,
"made strong each day by thy mother Nut.　Thou passest through the uppermost
"heaven, thy heart swelleth with joy; and the Lake of Testes is content thereat.
"The Enemy hath fallen, his arms are hewn off, the knife hath cut asunder his joints.
"Rā liveth in Maā[1] the beautiful.　The *sektet* boat draweth on and cometh into port ;
"the south, the north, the west and the east turn to praise thee, O thou unformed substance
"of the earth, who didst create thyself.　Isis and Nephthys salute thee, they sing unto thee
"in thy boat hymns of joy, they shield thee with their hands.　The souls of the East
"follow thee, the souls of the West praise thee.　Thou art the ruler of all gods and thou
"hast joy of heart within thy shrine ; for the Serpent Nȧk is condemned to the fire, and
"thy heart shall be joyful for ever.　Thy mother Nut is adjudged to thy father Nu."

PLATE II.

Vignette I. :　The disk of the Sun ⊙, supported by a pair of arms (|),
proceeding from the *ānkh* ☥, the sign of life, which in turn is supported by a *tet* ∯,
the emblem of the East and of the god Osiris.　The *tet* stands upon the horizon
◠.　On each side of the disk are three dog-headed apes, spirits of the Dawn,
their arms raised in adoration of the disk.　On the right hand side of the *tet* is the
goddess Nephthys 〔⌂𝄐〕, and on the left is Isis 〔⌂𝄐〕; each goddess raising her
hands in adoration of the *tet*, and kneeling upon the emblem *aāt* ▱, or hemi-
sphere.　Above is the sky ▱.　This vignette belongs properly to the hymn to
the rising sun.[2]

[1] Maā, unvarying and unalterable Law.

[2] Compare the vignette from British Museum papyrus No. 9901.　(Fig. 1.)

In some papyri the apes are four (Naville, *Das Aeg. Todtenbuch*, Bd. I., Bl. 26), or seven (Naville,
op. cit., Bd. I., Bl. 21) in number.

In the vignette which usually accompanies the hymn to the setting sun (Fig. 2), but which does not
occur in the present papyrus, a hawk wearing on his head a disk encircled by a serpent, *i.e.*, Rā-Harmachis

Text: (1) [Hymn to Osiris.] "Glory be to Osiris Un-nefer, the great god
"within Abydos, king of eternity, lord of the everlasting, who passeth through
"millions of years in his existence. Eldest son of the womb (2) of Nut,
"engendered by Seb the Erpāt,[1] lord of the crowns of the North and South, lord
"of the lofty white crown. As Prince of gods and of men (3) he hath received the
"crook and the flail and the dignity of his divine fathers.[2] Let thy heart which is

, takes the place of the disk and ⟨*symbol*⟩ (*e.g.*, British Museum papyri Nos. 9901 (Naville, *op. cit.*, Bd. I.,
Bl. 21,), and 10,472); and the *ṭeṭ* is represented by the stand ⟨*symbol*⟩ (Naville, *op. cit.*, Bd. I., Bl. 22), on one
side of which are three hawk-headed deities, and on the other three jackal-headed deities (see Lanzone,
Dizionario, pp. 56, 57.). Beneath are Isis and Nephthys kneeling in adoration before two lion-gods,
which represent yesterday and to-morrow. An interesting variant of the latter vignette occurs in British
Museum papyrus No. 10,472, which was made for the lady Anhai, a singer in the temple of Amen at
Thebes, about B.C. 1000, where, in addition to the apes and figures of the goddesses (the titles of Isis
being ⟨*hieroglyphs*⟩, and those of Nephthys ⟨*hieroglyphs*⟩), there
are represented, on each side (1) the winged *utchat* ⟨*symbol*⟩ with pendent uræus ⟨*symbol*⟩ and *shen* ⟨*symbol*⟩ (emble-
matic of the sun's circuit) and feather ⟨*symbol*⟩; (2) a man, prostrate, adoring the disk; (3) four men, upright,
with both hands raised in adoration; and (4) a human-headed bird ⟨*symbol*⟩, emblematic of the soul of
the deceased lady, standing upon a pylon.

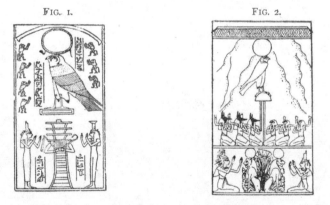

Fig. 1. Fig. 2.

[1] The word ⟨*hieroglyphs*⟩ *er-pāt* is composed of ⟨*symbol*⟩ *er* "chief" and ⟨*symbol*⟩ *pāt* a "clan," "tribe," or
"family"; Seb, then, was the prince of the family of the gods. *Erpāt* is a very ancient word, and was
probably in use in Egypt before *suten*, the common word for "king." For a discussion on this point see
Maspero, *Un Manuel de Hiérarchie Égyptienne*, p. 15 ff.; Brugsch, *Aegyptologie*, p. 210.

[2] Osiris, the night sun, was the son of Rā, and the father and son of Horus. He is always repre-
sented as a mummy holding in his hands the sceptre ⟨*symbol*⟩, crook ⟨*symbol*⟩, and flail ⟨*symbol*⟩. See Lanzone, *Dizio-
nario*, p. 690 ff.; Wiedemann, *Religion*, p. 123 ff.; Brugsch, *Religion und Mythologie*, p. 611 ff.

" in the mountain of Amenta be content, for thy son Horus is stablished upon thy
" throne.　(4) Thou art crowned lord of Tattu[1] and ruler in Abṭu.[2]　Through thee
" the world waxeth green (5) in triumph before the might of Neb-er-tcher.[3]　He
" leadeth in his train that which is and that which is not yet, in his name (6)
" Ta-her-seta-nef;[4]　he toweth along the earth in triumph in his name Seker.[5]
" He is (7) exceeding mighty and most terrible in his name Osiris.　He
" endureth for ever and for ever in his name Un-nefer.[6]　(8) Homage
" to thee, King of kings, Lord of lords, Prince of princes, who from
" the womb of Nut hast possessed the world (9) and hast ruled all lands
" and Akert.[7]　Thy body is of gold, thy head is of azure, and emerald light
" encircleth thee.　O An[8] of millions of years, (10) all-pervading with thy body and

[1] The name Ṭeṭṭeṭ or Tattu was borne by two towns in Lower Egypt : Busiris, the metropolis of
the 9th nome, and Mendes, the metropolis of the 16th nome.　See Brugsch, *Dict. Géog.*, p. 978, and
De Rougé, *Géographie Ancienne de la Basse Égypte*, p. 58.

[2] Both Busiris and Abydos claimed to be the resting place of the body of Osiris.

[3] A name of Osiris when his scattered limbs had been brought together and built up again into a
body by Isis and Nephthys : see Lanzone, *Dizionario*, p. 714.　The name means "lord of entirety."

[4] *I.e.*, The one who draws the world.

[5] Seker is, like Ptah, Osiris, and Tenen, a form of the night sun.　At the festival of this god, the
Hennu boat, , a symbol of the god Seker of Memphis, was drawn round the sanctuary
at dawn at the moment when the sun casts its golden rays upon the earth.　For a list of Seker's shrines,
see Lanzone, *Dizionario*, pp. 1117–1119.　See also Wiedemann, *Religion*, p. 75; Pierret, *Panthéon*, p. 66.

[6] A name of Osiris which, as an important name, is written at times in a cartouche, *e.g.*,

, and 　It is usually explained to mean "the Good Being," although

it has been suggested　(*Proc. Soc. Bibl. Arch.*, 1886) that "beautiful hare" is its signifi-
cation.

[7] A general term for a necropolis.　Akert is the country of which Osiris was the prince; and it is
mentioned as connected with *Stat* and *Neter-khert*, each of which is a name
of the great necropolis on the western bank of the Nile.　See Brugsch, *Dict. Géog.*, p. 75; Lepsius,
Todtenbuch, chap. 165, l. 6; Naville, *La Litanie du Soleil*, p. 98.

[8] An or Ani, a name or form of Rā, the Sun-god (compare
"Ani at the head of the cycle of the gods," Grébaut, *Hymne*, p. 22), and also of Osiris.　Ani is also
identified with the Moon-god; compare

" beautiful in countenance in Ta-sert.[1]　Grant thou to the *ka* of Osiris, the scribe
" Ani, splendour in heaven and might upon earth and triumph in Neter-khert;[1]　and
" that I may sail down to (11) Tattu like a living soul and up to (13) Abṭu like a
" *bennu* (phœnix); and that I may go in and come out without repulse at (15) the
" pylons of the Tuat.[1]　May there be given unto (16) me loaves of bread in the
" house of coolness, and (17) offerings of food in Annu, (18) and a homestead for
" ever in Sekhet-Aru[2] with wheat and barley (20) therefor."

PLATE III.

Vignette: Scene of the weighing of the Heart of the Dead. Ani
and his wife enter the Hall of Double Law or Truth, wherein the heart ♡,
emblematical of the conscience, is to be weighed in the balance against the feather
∫, emblematical of law.　Above, twelve gods, each holding a sceptre ⎮, are seated
upon thrones before a table of offerings of fruit, flowers, etc.　Their names are :—
Harmachis, " the great god within his boat ";
Tmu; Shu; Tefnut, " lady of heaven "; Seb;
Nut, " lady of Heaven "; Isis; Nephthys; Horus, " the
great god"; Hathor, " lady of Amenta"; Ḥu; and
Sa.　Upon the beam of the scales sits the dog-headed ape [3] which was associated

.* " Hail, Ani, thou shinest upon us from heaven
every day.　May we never cease to behold thy rays!　Thoth protecteth thee and maketh thy soul to
stand up in the *māāṭ* boat in thy name of Moon."　For the identification of Ani with Horus, see
Naville, *La Litanie du Soleil*, p. 99, note 10.　The god Ani is also addressed as "Eye of Horus" by the
deceased in the 89th chapter of the Book of the Dead, which refers to the "uniting of a soul to its
body in the underworld."

[1] A name of the underworld.

[2] Or *Seχet-Anru*, a division of the *Seχet-ḥetepu* (see Plate XXXV.), the Elysian fields wherein the
souls of the blessed were supposed to reap and sow.

[3] In British Museum papyrus No. 9901 the goddess Maāt is seated on the centre of the beam of
the balance.　The double Maāt goddesses are at times represented standing beside the balance to
watch the result of the weighing, and at the same time Maāt is also placed in the scale to be
weighed against the heart of the deceased (Fig. 1) (see Naville, *Todtenbuch*, Bd. I., Bl. 136, *Pa.*).　In the

* For the hieratic text, see De Horrack, *Lamentations d'Isis et de Nephthys*, p. 4, ll. 1-3.

with Thoth,[1] the scribe of the gods. The god Anubis, jackal-headed, tests the tongue of the balance, the suspending bracket of which is in the form of the feather ⌠. The inscription above the head of Anubis reads :—" He who is in the tomb saith, ' I pray thee, O weigher of righteousness, to guide (?) the balance that it may be stablished.' " On the left of the balance, facing Anubis, stands Ani's " Luck" or " Destiny," *Shai* 𓅓𓏏𓀀, and above is the object called *mesχen* 𓎛, which has been described[2] as " a cubit with human head," and which is supposed to be connected with the place of birth. Behind these stand the goddesses Meskhenet 𓅓𓈖𓏏 and Renenet 𓂋𓈖𓏏𓃀 : Meskhenet[3]

papyrus of Qenna the head of Anubis is on the beam, and the ape, wearing disk and crescent, is seated upon a pylon-shaped pedestal beside the balance (Fig. 2). Another vignette shows Horus holding Maât in his hand, weighing the heart in the presence of the Maât goddesses, and Anubis, holding the deceased by the hand, presents the heart to Osiris while Isis and Nephthys in the form of apes sit near (Fig. 3).

FIG. 1. FIG. 2.

FIG. 3.

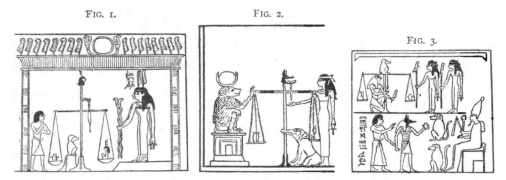

[1] In the papyrus of Sutimes (Naville, *Todtenbuch*, Bd. I., Bl. 43) the ape is called 𓏴𓏌𓎡 *neb χemennu ut'a maā*, "Lord of Khemennu, just weigher"; and in British Museum papyrus No. 9900, " Thoth, lord of the scales."

[2] Birch, in Bunsen's *Egypt's Place*, vol. v., p. 259. In the papyrus of Ânhai (British Museum, No. 10,472) there is a *meskhen* on each side of the upright of the balance : one is called Shai and the other Renen.

[3] Four goddesses bore the name of Meskhen, and they were supposed to assist the resurrection of Osiris ; they were associated with Tefnut, Nut, Isis, and Nephthys (see Lepsius, *Denkmäler*, iv., Bl. 59 *a*; and Mariette, *Dendérah*, iv., pl. 74 *a*). Each wore upon her head the object 𓋃, which is said by some to represent the blossoms of palm trees (Lanzone, *Dizionario*, p. 329). Examples of this as an amulet, in hard stone, in the British Museum, are Nos. 8158, 8159, 8161, 20,618, and, in porcelain, No. 15,963.

presiding over the birth-chamber, and Renenet[1] probably superintending the rearing of children. Behind the *meskhen* is the soul of Ani in the form of a human-headed bird standing on a pylon. On the right of the balance, behind Anubis, stands Thoth,[2] the scribe of the gods, with his reed-pen and palette[3] containing black and red ink, with which to record the result of the trial. Behind Thoth stands the female monster Āmām[4] ⸺, the "Devourer," or Ām-mit ⸺, "the eater of the Dead."

[1] The name of this goddess is probably connected with the word *renen*, "to suckle." M. Pierret identifies her with the goddess of that name who presided over harvests, and is described as the "lady of the offerings of all the gods" (*Panthéon*, p. 61), having a snake's head, which in some instances is surmounted by the disk, horns and feathers of the goddess Hathor (see Lanzone, *Dizionario*, tav. 188, No. 2).

[2] Thoth was the personification of intelligence. He was self-created and self-existent, and was the "heart of Rā." He invented writing, letters, the arts and sciences, and he was skilled in astronomy and mathematics. Among his many titles are "lord of Law," "maker of Law," and "begetter of Law." He justified Osiris against his enemies, and he wrote the story of the fight between Horus, the son of Osiris, and Set. As "lord of Law" he presides over the trial of the heart of the dead, and, as being the justifier of the god Osiris against his enemies, he is represented in funereal scenes as the justifier also of the dead before Osiris (see Lanzone, *Dizionario*, p. 1264 ff., and tav. ccciv., No. 1; Pierret, *Panthéon*, pp. 10–14; and Brugsch, *Religion und Mythologie*, p. 439 ff.). Brugsch connects the name Teḥuti (Thoth) with the old Egyptian word *teḥu*, "ibis," and he believes that it means the "being who is like an ibis." The word *teχ* also means "to measure," "to compute," "to weigh"; and as this god is called "the counter of the heavens and the stars, and of all that therein is," the connexion of the name Thoth with *teχ* is evident. Bronze and *faïence* figures of the god represent him with the head of an ibis, and holding an *utchat* in his hands (see Nos. 481, 490 *a*, and 11,385 in the British Museum). The *utchat*, or eye of the sun, has reference to the belief that Thoth brought back each morning the light of the sun which had been removed during the night.

[3] The palettes of the Egyptian scribe were rectangular, and were made of wood, stone, basalt, ivory (see Nos. 5512*a*, 5513, 5525*a*, and 12,779, etc., in the British Museum). They measure from 10 to 17 inches in length, and from 2 to 3 inches in width. They usually contain two round cavities to hold red and black ink, and a groove to hold the reed-pens. The inscriptions on them, which usually have reference to Thoth, are cut, or written in ink, or inlaid in colour; the name of the owner of the palette is generally added. The colours with which the Egyptians wrote were made of vegetable substances, coloured earths, and preparations of copper.

[4] She is also called "Devourer of Amenta" (*i.e.*, the underworld), and Shai (see Lanzone, *Dizionario*, p. 129). In the British Museum papyrus No. 9901 she is described as—

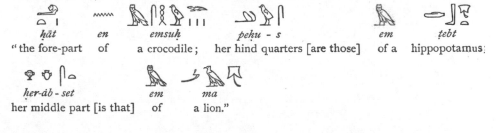

ḥāt	en	emsuḥ	peḥu - s	em	ṭebt
"the fore-part	of	a crocodile;	her hind quarters [are those]	of a	hippopotamus;

her-āb - set	em	ma
her middle part [is that]	of	a lion."

Text: [Chapter XXXB.] Osiris, the scribe Ani, saith:[1] "My heart my mother,
" my heart my mother, my heart my coming into being! May there be nothing to
"resist me at [my] judgment; may there be no opposition to me from the *Tchatcha;*[2]
" may there be no parting of thee from me in the presence of him who keepeth the
" scales! Thou art my *ka* within my body [which] knitteth[3] and strengtheneth my
" limbs. Mayest thou come forth to the place of happiness to which[4] I am advancing.
" May the *Shenit*[5] not cause my name to stink, and may no lies be spoken against
" me in the presence of the god![6] Good is it for thee to hear."[7]

Thoth, the righteous judge of the great company of the gods who are in the
presence of the god Osiris, saith: " Hear ye this judgment. The heart of Osiris
" hath in very truth been weighed, and his soul hath stood as a witness for him;
" it hath been found true by trial in the Great Balance. There hath not been
" found any wickedness in him; he hath not wasted the offerings in the temples;
" he hath not done harm by his deeds; and he uttered no evil reports while he
" was upon earth."

The great company of the gods reply to Thoth dwelling in Khemennu: " That
" which cometh forth from thy mouth hath been ordained. Osiris, the scribe

The Devourer usually stands near the balance instead of behind Thoth; but there is one papyrus
quoted by Naville, (*Todtenbuch*, Bd. I., Bl. 136) in which she is shown crouching beside the lake of
fire in the infernal regions.

[1] Ani's speech forms the text of Chapter XXXB. as numbered by M. Naville (*Todtenbuch*, Bd. I., Bl. 43).

[2] The four gods of the cardinal points, Mesthâ, Ḥāpi, Tuamāutef, and Qebḥsennuf (see Naville,
Todtenbuch Einleitung, p. 164).

[3] Some copies read, "Thou art my *ka* within my body, the god Khnemu (*i.e.*, "Moulder") who
uniteth (*or* formeth) and strengtheneth my limbs." Khnemu was called " builder of men, maker of the
gods, the father from the beginning; creator of things which are," etc.

[4] British Museum papyrus No. 9901 has " place of happiness to which thou goest with me."

[5] A class of divine beings.

[6] *I.e.*, " the great god, lord of Amenta."

[7] This sentence appears to be unfinished; see the Egyptian text, p. 12.

" Ani, triumphant, is holy and righteous. He hath not sinned, neither hath he done " evil against us. Let it not be given to the devourer Āmemet to prevail over him. " Meat-offerings and entrance into the presence of the god Osiris shall be granted " unto him, together with a homestead for ever in Sekhet-hetepu, as unto the " followers of Horus."

PLATE IV.

Vignette : Ani, found just, is led into the presence of Osiris. On the left the hawk-headed god Horus, the son of Isis, wearing the double crown of the North and the South, takes Ani by the hand and leads him forward towards " Osiris, the lord of eternity " 𓁹𓊨 *Ausàr neb t'etta*, who is enthroned on the right within a shrine in the form of a funereal chest. The god wears the *atef* crown with plumes; a *menat* (see p. 245, note 2) hangs from the back of his neck; and he holds in his hands the crook 𓋹, sceptre 𓌅, and flail 𓏏, emblems of sovereignty and dominion. He is wrapped in bandages ornamented with scale-work. The side of his throne is painted to resemble the doors of the tomb. Behind him stand Nephthys on his right hand and Isis on his left. Facing him, and standing on a lotus flower, are the four " children of Horus (*or* Osiris)," or gods of the cardinal points. The first, Mestha, has the head of a man; the second, Ḥāpi, the head of an ape; the third, Ṭuamāutef, the head of a jackal; and the fourth, Qebḥsennuf, the head of a hawk. Suspended near the lotus is an object which is usually called a panther's skin,[1] but is more probably a bullock's hide.

The roof of the shrine is supported on pillars with lotus capitals, and is surmounted by a figure of Horus-Sept or Horus-Seker and rows of uræi.

In the centre Ani kneels before the god upon a reed mat, raising his right hand in adoration, and holding in his left hand the *kherp* sceptre 𓌆. He wears a whitened wig surmounted by a " cone," the signification of which is unknown. Round his neck is a deep collar of precious stones. Near him stands a table of offerings of meat, fruit, flowers, etc., and in the compartments above are a number of vessels for wine, beer, oil, wax, etc., together with bread, cakes, ducks, a wreath, and single flowers.

[1] On the bullock's hide, in which the deceased, or the person who represented him, was supposed to wrap himself, see Virey, *Tombeau de Rekhmara*, p. 50, and plate 26, lower register.

Appendix: The shrine is in some instances represented in the shape of a pylon, the cornice of which is ornamented either with uræi 〈glyph〉, or with the disk of the sun and feathers, emblematic of Maāt, 〈glyph〉. It usually rests upon a base made in the shape of a cubit, 〈glyph〉. The throne upon which Osiris sits is placed upon reed mats (British Museum papyrus No. 10,471), or upon the cubit-shaped base, or in a pool of water, from which springs a lotus flower with buds and having the four gods of the cardinal points (see British Museum papyrus No. 9901) standing upon it. In some of the

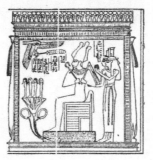

oldest papyri the body of Osiris is painted white, and he stands upright. Isis is described as "great lady, divine mother," and Nephthys as "the mistress of the underworld." In British Museum papyrus No. 10,471 the scene of the presentation of the deceased to Osiris is unusual and of interest. On the right the scribe Nekht 〈glyph〉 and his wife Thuàu 〈glyph〉 stand with both hands raised in adoration of Osiris. Behind them, upon a cubit-shaped base, is a house with four windows in its upper half, and upon the roof two triangular projections similar to those which admit air into modern houses in the East. Before the door are a sycamore (?) tree and a palm tree, with clusters of fruit; on the left is the god Osiris on his throne, and behind him stands "Maāt, mistress of the two countries, daughter of Rā," above whom are two outstretched female arms proceeding from a mountain and holding a disk between the hands. In the centre, between Osiris and the deceased, is a pool of water with three sycamore (?) trees on each side, and at each corner a palm tree bearing clusters of dates; and from it there springs a vine laden with bunches of grapes.

In British Museum papyrus No. 10,472 the god seated in the shrine wears the crown of the god Tanen 〈glyph〉, and is called "Ptaḥ-Seker-Àusàr, within the hidden place, great god, lord of Ta-sert, king of eternity, prince of the everlasting."

Text: Saith Horus, the son of Isis: "I have come unto thee, O Unnefer, and "I have brought the Osiris Ani unto thee. His heart is [found] righteous coming "forth from the balance, and it hath not sinned against god or goddess. Thoth "hath weighed it according to the decree uttered unto him by the company

" of the gods ; and it is very true and righteous.　Grant him cakes and ale ;
" and let him enter into the presence of Osiris ; and may he be like unto the
" followers of Horus for ever."

　　Behold, Osiris Ani saith :　" O Lord of Amentet (the underworld), I am in thy
" presence.　There is no sin in me, I have not lied wittingly, nor have I done
" aught with a false heart.　Grant that I may be like unto those favoured ones
" who are round about thee, and that I may be an Osiris, greatly favoured of the
" beautiful god and beloved of the lord of the world, [I] the royal scribe indeed,
" who loveth him, Ani, triumphant before the god Osiris."

　　Appendix:　The usual title of this chapter [XXXB.] is, " Chapter of not
allowing the heart of [the deceased] to be driven away from him in the underworld."[1]　It
is an address by the deceased to his own heart, which he calls his *ka* or " double " within
his body.　It should be accompanied by a vignette of the trial of the heart in which
the heart is weighed against the dead man himself, as in the ancient Nebseni papyrus.

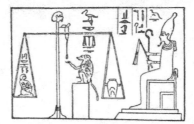

In the Ani papyrus, however, it will be observed that the heart is being weighed against
the feather of the Law, Maät, a scene which often accompanies Chapter CXXV.

　　Interesting variants of the vignettes of Chapter XXXB. are given by Naville
(*Todtenbuch*, Bd. I., Bl. 43), where we find the deceased addressing either his heart placed
on a stand ⚖, or a beetle, or a heart to which are attached the antennæ of a beetle.　In
certain papyri this chapter is followed by a rubric :—" [This chapter is] to be said over a
" scarab[2] of green stone encircled with *smu* metal, and [having] a ring of silver, which
" is to be placed upon the neck of the dead.　This chapter was found in Khemennu,[3]

[1] ⟨hieroglyphs⟩ ⟨hieroglyphs⟩

[2] Chapter XXXA. is never found inscribed upon scarabs.

[3] *I.e.*, Hermopolis Magna, the metropolis of Un ⟨hieroglyph⟩, the 15th nome of Upper Egypt, the city
called ⲅⲙⲉⲛⲟⲩⲛ ⟨hieroglyph⟩ by the Copts, and Eshmûnên, الاشمونين‎, by the Arabs.　It was the abode of the
" eight" (*xemennu*) great primeval gods, and of Thoth, the scribe of the gods.　(See Meyer and
Dümichen, *Geschichte des alten Ägyptens*, p. 185.)

"written upon a slab of steel of the South, in the writing of the god himself, under
"the feet of the majesty of the god, in the time of the majesty of Men-kau-Ra,[1] the
"king of the North and of the South, triumphant, by the royal son Ḥeru-ṭāṭā-f,[2] who
"found it while he was journeying to inspect the temples."[3]

The scarabs which are found in the mummies, or lying upon the breast just above
the position of the heart, form an interesting section of every large Egyptian collection.
In the British Museum series every important type of the funereal scarab is represented.
They are made of green basalt, green granite (Nos. 7894 and 15,497), white limestone
(Nos. 7917, 7927, 15,508), light green marble (No. 7905), black stone (Nos. 7907, 7909,
7913), blue paste (Nos. 7904, 14,549), blue glass (No. 22,872), and purple, blue, or
green glazed *faïence* (Nos. 7868, 7869). They vary in size from 5 inches to 2 inches
in length. On the hard stone examples the text of the Chapter of the Heart, more
or less complete, is usually cut on the base in outline ; but it is sometimes traced in
red ink (No. 7915), or in gold (No. 15,518). Incuse hieroglyphics are sometimes
filled with gold (No. 7881). The name of the person with whom the scarab was
buried usually precedes the text of the Chapter of the Heart ; but in many
instances blank spaces are found left without insertion of the name—a proof that
these amulets were bought ready-made. The base however is often quite plain
(Nos. 7965, 7966), or figures of Osiris, Isis, and Nephthys occupy the place of the
usual inscription (Nos. 15,500, 15,507). The backs of scarabs are generally quite
plain, but we find examples inscribed with figures of the boat of the Sun 𓇳,
Osiris, with flail and crook 𓀭, the *bennu* bird 𓅣, and the *u'tat* 𓂀 (No. 7883), Rā
and Osiris (No. 15,507), and the *bennu* bird with the inscription 𓎟𓏏𓄣𓈖𓇳
neteri āb en Rā, "the mighty heart of Rā" (No. 7878). A finehard, green stone scarab
of the Greek or Roman period has upon the back the figures of four Greek deities
(No. 7966). In rare instances, the beetles have a human face (Nos. 7876, 15,516) or
head (No. 7999). Carefully made scarabs have usually a band of gold across and down
the back where the wings join : an example of the late period (No. 7977) has the whole
of the back gilded. The scarab was set in a gold oval ring, at one end of which was
a smaller ring for suspension from the neck or for attachment to the bandages of the
mummy (No. 15,504). The green glazed *faïence* scarab of Thothmes III. (No. 18,190)
was suspended by a gold chain from a bronze torque. A thick gold wire to fit the neck
is attached to No. 24,401. The base of the scarab is sometimes in the form of a heart
(Nos. 7917, 7925). A remarkable example of this variety is No. 7925, in which are

[1] The fifth king of the IVth dynasty.

[2] This prince is said to have been a very learned man, whose speech was difficult to be understood
see Wiedemann, *Aeg. Geschichte.*, *p.* 191).

[3] For the hieroglyphic text, see pp. 13–15. This rubric was published by Birch, *Aeg. Zeitschrift*,
). 54 ; and by Rosellini, *Breve Notizia interno un frammento di Papiro funebre Egizio essistente nel
lucale museo di Parma ;* Parma, 1839, 8vo.

the emblems of "life," ☥, "stability," 𝍲, and "protection," ⚱, engraved on the upper part of the base. Across the back of this scarab is :—

[hieroglyphs]
[hieroglyphs] ;[1]

On the right wing:— [hieroglyphs] ; and on the left :—

[hieroglyphs] .[2]

A highly polished, fine green basalt scarab with human face (No. 7876) is set in a gold base, upon the face and edges of which are cut part of the Chapter of the Heart. At a period subsequent to the XXIInd dynasty inscribed funereal scarabs in marble, paste, etc., were set in pylon-shaped pectorals made of Egyptian porcelain, glazed blue, green, or yellow, which were sewed to the mummy bandages over the heart. On such pectorals the boat of the Sun is either traced in colours or worked in relief, and the scarab is placed so as to appear to be carried in the boat ; on the left stands Isis, and on the right Nephthys (Nos. 7857, 7864, 7866).

PLATES V. AND VI.

Vignettes : The funereal procession to the tomb ; running the length of the two plates. In the centre of Plate V. the mummy of the dead man is seen lying in a chest or shrine mounted on a boat with runners, which is drawn by oxen. In the boat, at the head and foot of the mummy, are two small models of Nephthys and Isis. By the side kneels Ani's wife Thuthu, lamenting. In front of the boat is the *Sem* priest burning incense in a censer,[3] and pouring out a libation from a vase ᵠ ; he wears his characteristic dress, a panther's skin. Eight mourners follow, one of whom has his hair whitened. In the rear a sepulchral ark or chest,[4] surmounted by a figure of Anubis [hieroglyph] and ornamented with [hieroglyph], emblems of "protection" and "stability," is drawn on a sledge by four attendants, and is followed by two others. By their side walk other attendants carrying Ani's palette, boxes, chair, couch, staff, etc.

In Plate VI. the procession is continued up to the tomb. In the centre is a

1 "Thou goest forth over heaven in three-fold peace [in] thy *sektet* boat ; when thou showest thy face thee."

2 "He giveth to thee thine eyes to see therewith, and thine ears [to hear therewith]."

3 For a bronze censer similar in shape, see No. 5296 *a*, Fourth Egyptian Room.

4 It is similar in shape to the chests which held the four jars containing the mummied intestines of the deceased. For examples of them see Nos. 8543*a*, 8543*b* in the Third Egyptian Room.

group of wailing women, followed by attendants carrying on yokes boxes of flowers, vases of unguents, etc. In the right centre are a cow with her calf, chairs of painted wood with flowers upon them, and an attendant with shaven head, carrying a haunch ◠◡, newly cut, for the funereal feast. The group on the right is performing the last rites. Before the door of the tomb stands the mummy of Ani to receive the final honours ; behind him, embracing him, stands Anubis, the god of the tomb ; and at his feet, in front, kneels Thuthu to take a last farewell of her husband's body. Before a table of offerings stand two priests : the *Sem* priest, who wears a panther's skin, holding in his right hand a libation vase, and in his left a censer ; and a priest holding in his right hand an instrument[1] with which he is about to touch the mouth and eyes of the mummy, and in his left the instrument ◠◠ for " opening the mouth." Behind or beside them on the ground, in a row, lie the instruments employed in the ceremony of " opening the mouth,"[2] etc., the *mes𝑥et* instrument ◠◡, the sepulchral box ▥, the boxes of purification ▤ ▭, the bandlet ⌡, the libation vases ▽▽▽, the ostrich feather ⌡, and the instruments called *Seb-ur*, *Ṭemānu* or *Ṭun-tet* ◠◠, and the *Pesh-en-kef* ⪤. The *Kher-ḥeb* priest stands behind reading the service of the dead from a papyrus.

Appendix : In the papyrus of Hunefer a slab or stele with rounded top ⌂ is placed by the door of the tomb (Fig. 1, p. 265). In the upper part of it the deceased is shown adoring Osiris, and below is the legend,[3] " Hail, Osiris, the chief of Amenta, the lord of eternity,

[1] This instrument is called ▱⌁⌁ *ur ḥekau*, and is made of a sinuous piece of wood, one end of which is in the form of a ram's head surmounted by a uræus (Fig. 1).

[2] In the Neb-seni papyrus the " Guardian of the Scale " opens the mouth of the deceased (Fig. 2).

FIG. 1. FIG. 2.

[3]

" spreading out in everlastingness, lord of adorations, chief of the company of his gods ;
" and hail, Anubis [dweller] in the tomb, great god, chief of the holy dwelling. May they
"grant that I may go into and come out from the underworld, that I may follow Osiris in
" all his festivals at the beginning of the year, that I may receive cakes, and that I may
" go forth into the presence of [Osiris]; I, the double (*ka*) of Osiris, the greatly
" favoured of his god, Hu-nefer." In the upper register of this section of the papyrus is
the text of the " Chapter of opening the mouth of the statue of Osiris." The complete
scene, including this stele and vignette, appears in the tomb of Pe-ta-Amen-Apt. In the
vignette of the first chapter of the Book of the Dead in the papyrus of Neb-qet[1] the
soul of the deceased is represented descending the steps of the tomb to carry food to its
mummy in the underground chamber (Fig. 2).

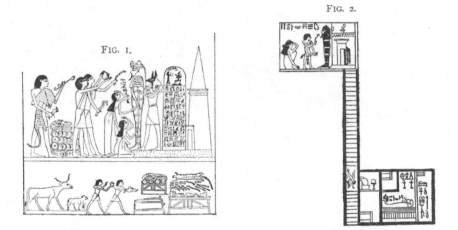

FIG. 2.

FIG. 1.

The ceremonies[2] which took place at the door of the tomb in an Egyptian funeral
are of considerable interest. The priest called *Kher-ḥeb*, holding the *Sem* priest by the
arm, gives directions for the slaughter of " a bull of the South." The slaughterer, standing
on the bull, cuts off a fore-leg (Fig. 3) and takes out the heart. A woman, called the
Tcherâuur, who personifies Isis, then whispers in the deceased's ear, " Behold, thy lips are
set in order for thee, so that thy mouth may be opened." Next, an antelope[3] and a duck[4]

[1] Devéria and Pierret, *Papyrus Funéraire de Neb-set*, plate 3.
[2] The following description of them is based upon the chapters on this subject in Dümichen,
Der Grabpalast des Patuamenap, Abth. 11, plates 1 ff., pp. 3 ff.

[3] 〰𓏤 𓂝𓂝 𓃻 *âri.*

[4] 𓊹 𓈖𓈖𓈖𓂝 𓅭 *smennu.*

are brought by order of the *Kher-ḥeb*, and their heads are cut off.[1] The *Kher-ḥeb* then addresses the *Sem* priest: "I have seized them for thee, I have brought unto thee thine " enemies. His hands bring his head [as] his gift. I have slain them for thee, O Tmu ; " let not his enemies rise up against this god." The slaughterer then presents the thigh to the *Kher-ḥeb*, and the heart to an official whose title was *Smer*, ⌐⌐⌐, and all three then "place the thigh and the heart upon the ground before this god " (*i.e.,* Osiris). The *Kher-ḥeb* then says to the deceased, represented by his mummy or statue: "I have

FIG 3.

" brought unto thee the thigh (Fig. 4) as the Eye of Horus. I have brought unto thee " the heart ; let there be no rising up against this god. I have brought unto thee the " antelope, his head is cut off ; I have brought unto thee the duck, his head is cut off." Here the sacrifice ends.

FIG. 4. FIG. 5. FIG. 6.

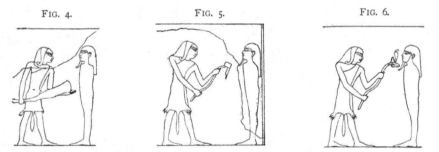

The next part of the ceremony, *i.e.,* "the opening of the mouth and eyes," is performed by the *Sem* priest, who addresses the deceased : "I have come to embrace " thee, I am thy son Horus, I have pressed thy mouth ; I am thy son, I love thee. His " mother beats her breast and weeps for him, and those who are in chains with him (*i.e.,* " Isis and Nephthys) beat their breasts. Thy mouth was closed, but I have set in order for

[1] The slaughter of the antelope and duck typified the destruction of the enemies of the deceased ; for, when Horus destroyed the enemies of his father Osiris, " he cut off their heads [which took] the " form of ducks in the sky, making them to fall headlong to the ground in the form of antelopes, and " into the water in the form of fishes." For the text, see Schiaparelli, *Il Libro dei Funerali degli Antichi Egiziani* (in *Atti della R. Accademia dei Lincei ;* Rome, 1883 and 1890), p. 94 ; Naville, *Todtenbuch*, chap. 134.

" thee thy mouth[1] and thy teeth." The *Kher-ḥeb* next calls on the *Sem* priest four times :
" O *Sem*, take the *Seb-ur*[2] (Fig. 5) and open the mouth and the eyes"; and while the *Sem*
priest is performing the ceremony the *Kher-ḥeb* continues : " Thy mouth was closed, but
" I have set in order for thee thy mouth and thy teeth. I open for thee thy mouth, I
" open for thee thy two eyes. I have opened for thee thy mouth with the instrument of
" Anubis. I have opened thy mouth with the instrument of Anubis, with the iron tool
" with which the mouths of the gods were opened. Horus, open the mouth, Horus, open
" the mouth. Horus hath opened the mouth of the dead, as he whilom opened the mouth
" of Osiris, with the iron which came forth from Set, with the iron tool (Fig. 6) with which
" he opened the mouths of the gods. He hath opened thy mouth with it. The dead
" shall walk and shall speak, and his body shall [be] with the great company of the gods
" in the Great House of the Aged one in Annu, and he shall receive there the *ureret* crown
" from Horus, the lord of mankind." The *Kher-ḥeb* next says : ." Let the *Ami-Khent*
" priest (Fig. 7) stand behind him (*i.e.*, the deceased), and say, ' My father, my father,' four
" times." The eldest son of the deceased then stands behind the deceased, and in his

FIG. 7.

FIG. 8.

name the *Kher-ḥeb* says : " His mother beateth her breast and weepeth for him, and
" those who are in chains with him also beat their breasts." Another priest, called
Am-Khent-Heru, takes up the same position and says : " Isis goeth unto Horus, who
" embraceth his father." A priestly official belonging to the *mesenti* class then goes
behind the deceased, and the *Sem*, *Smer* and *Kher-ḥeb* priests stand in front, and the *Sem*
priest and the *Kher-ḥeb*, personifying Horus and Sut, respectively cry : " I am Horus,
" I am Sut ; I will not let thee illumine the head of my father." The *Sem* priest
then leaves the *Ka*-chapel and returns, leading in the *Se-mer-f*, *i.e.*, " the son who loveth
" him "; whereupon the *Kher-ḥeb* says : " O Sem, let the *Se-mer-f* come into the tomb in
" order that he may see the god." The *Sem* priest holding him by the arm then leads
forward the *Se-mer-f*, who addresses the deceased : " I have come, I have brought

[1] See Schiaparelli, *Il Libro dei Funerali degli Antichi Egiziani ;* Maspero, *Le Rituel du Sacrifice
Funéraire* (in *Revue de L'Histoire des Religions*, 1887, p. 159 ff.).

[2] ⚹ 𓏤𓏤𓏤. For a complete list of these instruments, see Schiaparelli, *Il Libro dei Funerali
degli Antichi Egiziani*, p. 109.

" unto thee thy son who loveth thee ; he shall open for thee thy mouth and thine eyes."
(Fig. 8). A tomb-official, *Ȧm-ȧs*, then takes up his position behind the deceased, and the
Se-mer-f and the *Kher-ḥeb* stand in front ; the *Kher-ḥeb* repeating four times: " The
" *Se-mer-f* openeth the mouth and the two eyes of the deceased, first with a needle[1] of
" iron, then with a rod of *smu* metal "; the *Ȧm-ȧs* addressing the deceased : " Behold the
" *Se-mer-f*"; and the *Kher-ḥeb* saying, in the name of the *Se-mer-f* : "I have pressed for thee
" thy mouth, even as thy father pressed it in the name of Seker. Hail, Horus hath
" pressed thy mouth for thee, he hath opened thine eyes for thee ; Horus hath opened
" thy mouth for thee, he hath opened for thee thine eyes ; they are firmly stablished.
" Thy mouth was closed ; I have ordered thy mouth and thy teeth for thee in their true
" order. Thou hast [again] opened thy mouth ; Horus hath opened thy mouth. I have
" stablished thy mouth firmly. Horus hath opened for thee thy mouth, Horus hath
" opened for thee thy two eyes." The *Kher-ḥeb* then speaks on behalf of the *Sem*
priest : " Thy mouth was closed up. I have ordered aright for thee thy mouth and thy
" teeth. Thy mouth is firmly stablished. Thy mouth was tightly closed. His mouth
" is firmly stablished, and [his] two eyes are firmly stablished." The *Sem* priest next
presents to the deceased (Fig. 9) a cone-shaped offering Ⱌ,[2] and at the same time the
Kher-ḥeb says : " Open the mouth and the two eyes, open the mouth and the two eyes.
Thou hadst tightly closed thy mouth, thou hast [again] opened thy two eyes." Then the
Kher-ḥeb says, on behalf of the *Smer* (Fig. 10) priest who stands behind the deceased :

| FIG. 9. | FIG. 10. | FIG. 11. |

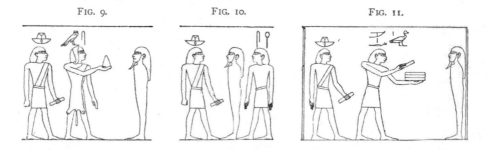

" One cometh unto thee for thy purification." Next the *Se-mer-f* comes forward with
four boxes (Fig. 11) in his hands, and the *Kher-ḥeb* says : " O *se-mer-f*, take the four
" boxes of purification, press the mouth and the two eyes, and open the mouth and
" the two eyes with each of them four times, and say, ' Thy mouth and thy two
" eyes are firmly stablished, and they are restored aright,' and say also, ' I have
" firmly pressed thy mouth, I have opened thy mouth, I have opened thy two eyes
" by means of the four boxes of purification.'" The *Sem* priest then approaches

[1] 𓎡𓏏𓊛𓊪 *t'ettef.*

[2] A large collection of such offerings is exhibited in the Third Egyptian Room.

" the deceased (Fig. 12) with the instrument ⲩ,[1] and the *Kher-ḥeb* at the same time
says: " O *Sem* priest, lay the *pesh-en-kef* upon his mouth, and say, ' I have stablished
" for thee thy two jaw-bones in thy face which was divided into two parts.' " The
Sem priest next makes an offering of grapes (Fig. 13), the *Kher-ḥeb* saying: " O *Sem*
" priest, place the grapes upon his mouth and say, ' He bringeth to thee the eye
" of Horus, he graspeth it ; do thou also grasp it.' " After an ostrich feather has
been offered (Fig. 14) by the *Sem* priest, and a number of the ceremonies described
above have been repeated, and other animals slaughtered, the *Kher-ḥeb* addresses
the *Sem* priest, and says: " Take the instrument *Ṭun-tet*[2] (thrice) and open the
" mouth and the eyes " (four times). He then continues: " O *Sem* priest, take the iron
" instrument of Anubis, *Ṭun-tet* (thrice). Open the mouth and the two eyes (four
" times), and say, ' I open for thee thy mouth with the iron instrument of Anubis with
" which he opened the mouths of the gods. Horus openeth the mouth, Horus openeth

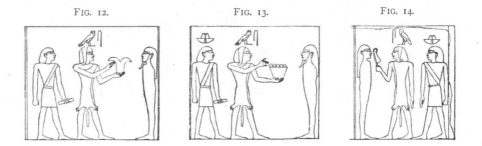

Fig. 12. Fig. 13. Fig. 14.

" the mouth, Horus openeth the mouth with the iron which cometh forth from Set,
" wherewith he hath opened the mouth of Osiris. With the iron tool (*meskhet*) where-
" with he opened the mouths of the gods doth he open the mouth. He [the deceased]
" shall go in and he shall speak [again], and his body shall dwell with the company of the
" great gods in Annu, wherein he hath received the *ureret* crown from Horus, lord of
" men. Hail, Horus openeth thy mouth and thy two eyes with the instrument *Seb-ur*
" or *Temān*,[3] with the instrument *Ṭun-tet* of the Opener of the Roads (*i.e.*, Anubis)
" wherewith he opened the mouth of all the gods of the North. Horus the Great[4]
" cometh to embrace thee. I, thy son who loveth thee, have opened thy mouth and thy
" two eyes. His mother beateth her breast in grief while she embraceth him, and the
" two sisters (*i.e.*, Isis and Nephthys), who are one, strike themselves in grief. All the
" gods open thy mouth according to the book of the service.' " The *Kher-ḥeb* next
instructs the *Sem* priest to clothe the mummy or statue of the deceased with the *nemes*[1]

[1] It is called *Pesh-en-kef* ⬚ ~~~ ⟶ ⲩ. See Dümichen, *Der Grabpalast des Patuamenap*,
Abth. 1, pp. 18, 19.

[2] ⬚ | ⬚. [3] ✶ ⬚ 𓏏 ~~~ ⬚. [4] Ḥeru-ur, the Heroeris of the Greeks.

band or fillet (Fig. 15), and to say: "Lo! the *nemes* fillet, the *nemes* fillet, which cometh as
" the light, which cometh as the light; it cometh as the eye of Horus, the brilliant; it
" cometh forth from Nekheb. The gods were bound therewith; bound round is thy
" face with it in its name of *Ḥetch* (*i.e.*, light, or brilliance), coming forth from Nekheb.
" All that could do harm to thee upon earth is destroyed." The *Sem* priest, holding a
vase of ointment in his left hand, and smearing the mouth with his fore-finger (Fig. 16),
says: " I have anointed thy face with ointment, I have anointed thine eyes. I have painted
" thine eye with *uatch* and with *mestchem.* May no ill-luck happen through the
" dethronement of his two eyes in his body, even as no evil fortune came to Horus
" through the overthrow of his eye in his body. Thy two eyes are decked therewith
" in its name of *Uatch,* which maketh thee to give forth fragrance, in its name of
" Sweet-smelling." A number of scented unguents and perfumes are brought forward,
and at the presentation of each a short sentence is recited by the *Kher-ḥeb* having
reference to the final triumph of the deceased in the underworld and to the help
which the great gods will render to him.

Fig. 15. Fig. 16.

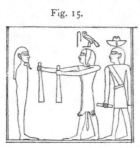 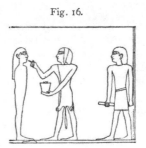

Text: [Chapter I.]² (1) HERE BEGIN THE CHAPTERS OF COMING FORTH
BY DAY,³ AND OF THE SONGS OF PRAISE⁴ AND (2) GLORIFYING,⁴ AND OF COMING
FORTH FROM AND GOING INTO THE GLORIOUS NETER-KHERT IN THE BEAUTIFUL

¹ 〔hieroglyphs〕

² The text accompanying Plates 5 and 6 represents Chapter I., Chapter XXII., and the Rubric of
Chapter LXXII., of Lepsius's numeration.

³ In Egyptian *Per em hru.* This title has been translated and explained in various ways, as *e.g.*,
"Coming forth from [*or* as] the Day" (Birch, in Bunsen's *Egypt's Place*, vol. v., p. 161); "The
departure from the day" (Birch, *Papyrus of Nas-khem*, p. 3); "Sortir du jour" (Devéria, *Catalogue;*
1874, p. 49); "Sortir du jour" (Naville, *Einleitung*, p. 23); "Sortie de la journée" (Pierret,
Le Papyrus de Neb-Qed; 1872, p. 2); "Ausgang bei Tage" (Brugsch, *Aegyptologie*, p. 155).
Another fairly common title for the Book of the Dead is "Chapter of making perfect the blessed
dead" (see Naville, *Einleitung*, pp. 24, 25).

⁴ For other examples of the use of the words *settes* and *seχu*, see Brugsch, *Wörterbuch*, pp. 133,
1165.

Amenta; to be said on (3) the day of the burial: going in after coming forth.
Osiris Ani, (4) Osiris, the scribe Ani, saith: "Homage to thee, O bull of Amenta,
"Thoth the (5) king of eternity is with me. I am the great god in[1] the boat of
"the Sun; I have (6) fought for thee. I am one of the gods, those holy princes[2]
"who make Osiris (7) to be victorious over his enemies on the day of weighing of
"words.[3] (8) I am thy mediator, O Osiris. I am [one] of the gods (9) born of
"Nut, those who slay the foes of Osiris (10) and hold for him in bondage the fiend
"Sebau. I am thy mediator, O Horus. (11) I have fought for thee, I have put to flight
"the enemy for thy name's sake. I am Thoth, who have made (12) Osiris victorious
"over his enemies on the day of weighing of words in the (13) great House of
"the mighty Ancient One in Annu.[4] I am Tetteti,[5] the son of Tetteti; I was
"(14) conceived in Tattu, I was born in (15) Tattu.[6] I am with those who weep
"and with the women who bewail (16) Osiris in the double land (?) of Rechtet;[7]
"and I make Osiris to be victorious over his enemies. (17) Rā commanded[8] Thoth
"to make Osiris victorious over his enemies; and that which was (18) bidden for
"me Thoth did. I am with Horus on the day of the clothing of (19) Teshtesh[9]
"and of the opening of the storehouses of water for the purification of the god
"whose heart moveth not, and (20) of the unbolting of the door of concealed things
"in Re-stau.[10] I am with Horus who (21) guardeth the left shoulder of Osiris in

[1] The papyrus of Ani reads ⌇, as do Pf, Pj, Pk, and Pl. See Naville, *Todtenbuch*, Bd. I., Bl. 2, p. 2.

[2] *I.e.*, Mesthâ, Ḥāpi, Ṭuamāutef, Qebḥsennuf, the gods of the cardinal points.

[3] Compare the use of דְּבַר in 2 Samuel, iii. 13.

[4] A name of the temple of Rā in Heliopolis. See Brugsch, *Dict. Géog.*, p. 153.

[5] *I.e.*, the god of Ṭeṭṭeṭu, or Busiris, a town which was believed to contain the body of Osiris.

[6] See Brugsch, *Dict. Géog.*, p. 978.

[7] The reading 𓂀 *Reχtet* is given by British Museum papyrus No. 9964. See also Brugsch, *Dict. Géog.*, p. 392.

[8] The translation here follows the variant reading given by Pierret, 𓀀𓏤 *utu en Rā er semaāχeru Àusâr.* See *Aeg. Zeitschrift*, 1869, p. 139; and *Le Livre des Morts*, p. 10.

[9] A name of Osiris. See Lanzone, *Dizionario*, p. 1262.

[10] *I.e.*, "the door of the passages of the tomb." A picture of Re-stau 𓏤 is given on Plate VIII.

"Sekhem,[1] and I (22) go into and come out from the divine flames [2] on the day of
"the destruction (23) of the fiends in Sekhem. I am with Horus on the day of
"the (24) festivals of Osiris, making the offerings on the sixth day of the festival,[3]
"[and on] the Ṭenat [4] festival in (25) Annu. I am a priest in Tattu,[5] Rere (?) in
"the temple of Osiris,[6] [on the day of] casting up (26) the earth.[7] I see the
"things which are concealed in Re-stau. (27) I read from the book of the festival
"of the Soul [which is] in Tattu.[8] I am the *Sem* [9] priest (28), and I perform his
"course. I am the great chief of the work [10] on the day of the placing of the *hennu*

[1] Sekhem is the metropolis of , or *Khens*, the Greek Letopolites, the 2nd nome of Lower
Egypt; it is the ⲟⲧϣⲉⲗⲗ, or Ⲃⲟⲧϣⲉⲗⲗ of the Coptic writers, and was situated about twenty-
five miles north of Memphis. According to a text at Edfu, the neck of Osiris, *māχaq*, was
preserved there. The god Horus, under the form of a lion, was worshipped at Sekhem. See Brugsch,
Aeg. Zeitschrift, 1879, pp. 33–36; Brugsch, *Dict. Géog.*, p. 738; and De Rougé, *Géographie Ancienne*,
p. 8.

[2] The chief variants are (see Naville,
Todtenbuch, Bd. II., Bl. 8.) On this passage see Devéria, *Aeg. Zeitschrift*, 1870, p. 60.

[3] *I.e.*, the day of the festival of Osiris who is called "Lord of the Festival of the Sixth Day." A
list of the festivals of the month is given by Brugsch, *Matériaux pour servir à la reconstruction du
Calendrier*; Leipzig, 1864, plate iv.

[4] *I.e.*, the festival on the 7th day of the month. See Brugsch, *op. cit.*, plate iv.

[5] Var. *Ṭāṭāu.*

[6] The reading of the text is not usual. British Museum papyrus No. 9901 has, after *Tattu*,
,
and according to this text we should read, "I am a priest in Tattu, exalting him that is upon the steps
(Pierret, "degrés de l'initiation"); I am a prophet in Abtu on the day of casting up the earth."

[7] According to Devéria (*Aeg. Zeitschrift*, 1870, p. 61), "casting up the earth" means the day of
digging the grave.

[8] Var. "The Ram, lord of Tattu," *i.e.*, Osiris.

[9] Or *setem* , a priest of Ptah at Memphis.

[10] *ur χerp āb* (or *ḥem*), the name of the chief priest of Ptah at Memphis (see Brugsch,
Wörterbuch, Supp., p. 392; and Brugsch, *Aegyptologie*, p. 218). The position of this official is
described by Maspero, *Un Manuel de Hiérarchie Égyptienne*, p. 53. The title was in use in the
earliest times (see De Rougé, *Six Premières Dynasties*, pp. 110, 111).

" boat of Seker (29) upon its sledge.[1] I have grasped the spade [2] (30) on the day of
" digging the ground in Suten-ḥenen.[3] O ye who make (31) perfected souls to
" enter into the Hall of Osiris, may ye cause the perfected soul of Osiris, the scribe
" (32) Ani, victorious [in the Hall of Double Truth], to enter with you into the
" house of Osiris. May he hear as ye hear; may he (33) see as ye see; may
" he stand as ye stand; may he sit as (34) ye sit![4]

" O ye who give bread and ale to perfected souls in the Hall of (35)
Osiris, give ye bread and ale at the two seasons to the soul of Osiris Ani,
" who is (36) victorious before all the gods of Abṭu, and who is victorious with
" you.

" (37) O ye who open the way and lay open the paths to perfected souls
" in the Hall of (38) Osiris, open ye the way and lay open the paths (39) to the
" soul of Osiris, the scribe and steward of all the divine offerings, Ani (40)
" [who is triumphant] with you. May he enter in with a bold heart and
" may he come forth in peace from the house of Osiris. May he not (41)
" be rejected, may he not be turned back, may he enter in [as he] pleaseth,
" may he come forth [as he] (42) desireth, and may he be victorious. May
" his bidding be done in the house of Osiris; may he (43) walk, and may
" he speak with you, and may he be a glorified soul along with you.[5] He hath
" not been found wanting (44) there,[6] and the Balance is rid of [his] trial."[6]

Appendix : After the First Chapter M. Naville has printed in his
Todtenbuch the text of a composition which also refers to the funeral, and which
he has designated Chapter I B. It is entitled " Chapter of making the

[1] The day of the festival of Seker was celebrated in the various sanctuaries of Egypt at dawn, " at
the moment when the sun casts its golden rays upon the earth." The *ḥennu* boat was drawn round the
sanctuary (see Lanzone, *Dizionario*, pp. 1117–1119.). The Serapeum was called ⌐⌐ ✕ 𓏤 ⊙ *Pa-ḥennu.*

[2] M. Pierret renders, " Je reçois l'office de laboureur," but the variants given by M. Naville
(𓂀 𓏤𓏤𓏤 ⊐) show that some digging instrument is intended.

[3] *I.e.*, 𓉐𓏤 𓏏 𓈖𓈖𓈖⊙ *Ḥet-suten-ḥenen*, the Heracleopolis Magna of the Greeks, the ϩⲛⲏⲥ of
the Copts, and اهناس of the Arabs. See Brugsch, *Dict. Géog.*, p. 601.

[4] British Museum papyrus No. 9901 adds, " in the Temple of Osiris."

[5] *I.e.*, in the Hall of Double Truth.

[6] For a translation of the remainder of the chapter according to the Saïtic recension, see Pierret,
Le Livre des Morts, pp. 7, 8.

mummy to go into the underworld on the day of the funeral." The text is, however, mutilated in places; and the following version has been made by the help of the two copies of the text published by Pleyte, *Chapitres Supplémentaires au Livre des Morts*, p. 182 ff.; and by Birch, *Proc. Soc. Bibl. Arch.*, 1885, p. 84 f.

[Chapter IB.] "Homage to thee,[1] O thou who livest in Set-Sert of Amenta. Osiris "the scribe Nekht-Amen, triumphant, knoweth thy name. Deliver thou him from the "worms which are in Re-stau, and which feed upon the bodies of men and drink their "blood. Osiris, the favoured one of his divine city, the royal scribe Nekht-Åmen, "triumphant, is known unto you [ye worms] and he knoweth your names. This is the "first bidding of Osiris, the Lord of All, who hath completed all his hidden works: 'Give "thou breath [unto them] who fear those who are in the Bight of the Stream of Amenta.' "He hath ordered the plans of His throne is placed within the "darkness, and there is given unto him glory in Re-stau. O god of light, come thou "down unto me and swallow up the worms which are in Amenta. The great god who "dwelleth within Tattu, whom he seeth not, heareth his prayers. They who are in "affliction fear him [the god] who cometh forth with the sentence at the sacred block. "Osiris, the royal scribe Nekht-Åmen, cometh with the decree of the Lord of All, and "Horus hath taken possession of his throne for him. He cometh with tidings; [may he "enter in] according to his word and may he see Ånnu. The nobles have stood up "on the ground before him, and the scribes magnify him. The princes bind his "swathings, and make festivals for him in Annu. For him hath heaven been led "captive; he hath seized the inheritance of the earth in his grasp. Neither heaven nor "earth can be taken away from him, for, behold, he is Rā, the first-born of the gods. "His mother suckleth him, she giveth her breast from the sky."

[*Rubric.*] The words of this chapter are to be said after [the deceased] is laid to rest in Amenta, etc.

Text: [Chapter XXII.][2] (1) CHAPTER OF GIVING A MOUTH (2) TO OSIRIS ANI, THE SCRIBE AND TELLER OF THE HOLY OFFERINGS OF ALL THE GODS. MAY HE BE VICTORIOUS IN NETER-KHERT! (3) "I rise out of the egg in the hidden land. May "my mouth be given (4) unto me that I may speak with it before the great god, the "lord of the underworld. (5) May my hand and my arm not be forced back by the "holy (6) ministers of any god. I am Osiris, the lord of the mouth of the tomb; "and Osiris, the victorious scribe Ani, hath a portion [3] with him (7) who is upon the

[1] The god addressed is Anubis, who in the vignette is shown standing by the bier.

[2] The Nebseni papyrus here has a vignette in which the "Guardian of the Balance" is shown touching the mouth of the deceased. In other instances the deceased touches his own mouth.

[3] The Nebseni papyrus has: "Osiris, lord of Re-stau, is the being who is on the top of the steps," . The Ani papyrus incorrectly reads "his top."

"top of the steps.　According to the desire of my heart, I have come from the
"Pool of Fire,[1] and I have quenched it.　(8) Homage to thee,[2] O thou lord of
"brightness, thou who art at the head[3] of the Great House, and who dwellest in
"night (9) and in thick darkness; I have come unto thee.　I am glorious, I am
"pure; my arms (10) support thee.　Thy portion shall be with those who have
"gone before.　O grant unto me my mouth that I may speak (11) therewith; and
"that I may follow my heart when it passeth through the fire and darkness."[4]

[*Rubric of Chapter* LXXII.]　(1). If this writing be (2) known [by the
deceased] upon earth, and this chapter be done into writing upon [his] coffin, he
shall come forth by (3) day in all the forms of existence which he desireth, and
he shall enter into [his] place and shall not be rejected.　(4) Bread and ale and
meat shall be given unto Osiris, the scribe Ani, upon the altar of Osiris.　He
shall (5) enter into the Fields of Aaru in peace, to learn the bidding of him who
dwelleth in Tattu; (6) there shall wheat and barley be given unto him; there
shall he flourish as he did upon (7) earth; and he shall do whatsoever pleaseth
him, even as [do] the gods who are in the underworld, (8) for everlasting millions
of ages, world without end.

Appendix:　The text of Chapter LXXII. does not occur in the Papyrus of
Ani.　It is given by M. Naville (see *Todtenbuch*, I., Bl. 84) from a papyrus in the
Louvre.　In the vignettes which accompany it, the deceased is represented as
adoring three gods, who are either standing in a shrine or are seated upon it.　In
other instances, the deceased stands by a sepulchral chest or outside a pylon
with hands raised in adoration.　The following is a translation of the Louvre
text :—

　　(1) CHAPTER OF COMING FORTH BY DAY AND OF PASSING THROUGH THE
ÂMMAḤET.　(2) " Homage to you, O ye lords of *kas*, ye lords of right and truth,
" infallible, who shall endure for ever and shall exist through countless ages, grant
" that (3) I may enter into your [presence].　I, even I, am pure and holy, and I have
" gotten power over the spells which are mine.　Judgment (4) hath been passed

[1] A variant gives the reading ⬚⬚⬚ (Naville, *Todtenbuch*, Bd. II., Bl. 84).　For the
situation of the pool, see Brugsch, *Dict. Géog.*, p. 359.

[2] The following lines of text form the XXIst chapter of the Saïte recension of the Book of the
Dead.　See Lepsius, *Todtenbuch*, plate xiv.; and Pierret, *Le Livre des Morts*, p. 91.

[3] Compare ⬚⬚⬚.

[4] The chapter which Lepsius has numbered XXIII., as being most closely connected with the
XXIInd chapter, and which refers to the opening of the mouth of the deceased, follows on Plate XV.

" upon me in my glorified form. Deliver ye me from the crocodile which is in the place
" of the lords of right and truth. Grant ye unto me (5) my mouth that I may speak
" therewith. May offerings be made unto me in your presence, for I know you and
" I know your names, and I know (6) the name of the great god. Grant ye abundance
" of food for his nostrils. The god Rekem passeth through the western horizon of
" heaven. He (7) travelleth on, and I travel on ; he goeth forth, and I go forth.
" Let me not be destroyed in the place Mesqet ; let not the Fiend get the mastery
" over me ; let me not be driven back from your gates ; (8) let not your doors
" be shut against me ; for I have [eaten] bread in Pe and I have drunken ale in Tepu.
" If my arms be fettered in the (9) holy habitation, may my father Tmu stablish for
" me my mansion in the place above [this] earth where there are wheat and barley in
" abundance which cannot be told. May feasts be made for me there, for my soul and
" for my (10) body. Grant me even offerings of the dead, bread, and ale, and wine, oxen,
" and ducks, linen bandages and incense, wax, and all the good and fair and pure things
" whereby the gods do live. May I rise again in all the forms which (11) I desire
" without fail and for ever. May I sail up and down through the fields of Aaru ; may
" I come thither in peace ; for I am the double Lion-god."

PLATES VII.–X.

Vignette : The vignette of these plates, forming one composition, runs along
the top of the text. The subjects are :—

Plate VII. 1. Ani and his wife in the *seḥ* hall;[1] he is moving a piece on a
draught-board [2] (to illustrate lines 3 and 4 of the text).

2. The souls of Ani and his wife standing upon a pylon-shaped building.
The hieroglyphics by the side of Ani's soul read ☥ 𓀀 ～～～ 𓂀 *ba en Àusàr*, "the
soul of Osiris."

[1] In the papyrus of Hunefer the first scene in this vignette is composed of 𓊪 Amenta, and the
signs ⚱ and ⬭, emblematic of food and drink. On each side is a figure of the deceased, but
that on the left faces to the left and that on the right faces to the right. (1) Compare also the variant
from the papyrus of Mut-em-uaa. (2)

(1) (2)

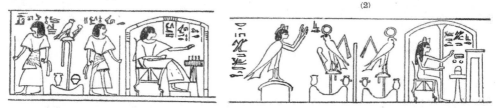

[2] See page 281, note 1.

3. A table of offerings, upon which are laid a libation vase ⵞ, plants, and lotus flowers ⵚ.[1]

4. Two lions seated back to back and supporting the horizon ⵔ, over which extends the sky ⵕ. The lion on the right is called ⵖ *Sef, i.e.,* "Yesterday," and that on the left ⵘ *Tuau, i.e.,* "Tomorrow" (to illustrate lines 13–16).

5. The *bennu* bird ⵙ,[2] and a table of offerings (to illustrate lines 26–30).

6. The mummy of Ani lying on a bier ⵚ within a funereal shrine ⵛ; at the head and foot are Nephthys and Isis in the form of hawks ⵜ, ⵝ. Beneath the bier are vases painted to imitate variegated marble or glass,[3] a funereal box, Ani's palette, etc.[4]

Plate VIII. 1.[5] The god Ḥeḥ ⵞⵙ, "Millions of years," wearing the emblem of "years" ⵠ upon his head, and holding a similar object in his right hand; he is

[1] In many papyri a figure of the deceased, kneeling in adoration before the lions supporting the horizon, takes the place of the table of offerings. Here the artist probably intended to represent the souls of Ani and his wife making these offerings to the lion-gods.

[2] The name of the sanctuary in which the *bennu* bird was worshipped was Het-bennu . Greek writers called this bird the phœnix, and the Egyptians considered it as a symbol of Osiris. In a text quoted by Brugsch (*Wörterbuch*, p. 397), it is said to have created itself. The *bennu* was also worshipped at Diospolis Parva in Upper Egypt; and it was asserted that the thigh of Osiris was preserved in one of its sanctuaries, and his phallus in another.

[3] For examples of such vases see Nos. 4875, 4879, 4887, 9529, in the Fourth Egyptian Room.

[4] In many papyri the soul of the deceased in the form of a human-headed bird is seen hovering over the dead body. (Fig. 1.)

[5] The papyrus of Ani omits the two uræi which are referred to in lines 33–36. According to the papyrus of Hunefer (British Museum papyrus No. 9901) they represent the North and the South. (Fig. 2.)

FIG. 1.

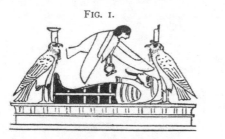

FIG. 2.

kneeling and extends his left hand over a pool (?) in which is an eye 👁 (to illustrate line 46).

2. The god 🏺 *Uatch-ura*, "Great Green Water," with each hand extended over a pool; that under his right hand is called 🔡 *She en ḥesmen*, "Pool of Natron," and that under his left hand 🔡 ○ ▭ *She en Māāāat*, "Pool of Nitre *or* Salt" (to illustrate lines 47–50).

3. A pylon with doors, called 🔡 *Re-stau*, "Gate of the funereal passages" (to illustrate lines 56–58).

4. The *utchat* facing to the left 👁 above a pylon (to illustrate line 73).

5. The cow 🔡 (Fig. 1) *Meḥurt maat Rā*, "Meḥurt, the eye of Rā," with a flail ⋀, and having on her head a disk and horns ☿ and round her neck the collar ◒ and *menàt* 🎗 (to illustrate lines 75–79).[1]

6. A funereal chest 📦, from which emerge the head of Rā, and his two arms and hands, each holding the emblem of life ⚶. The chest, which is called 📦 *àat Àbṭu*, "the district of Abydos," or the "burial place of the East," has upon its side figures of the four children of

[1] In the papyrus of Hunefer (British Museum papyrus No. 9901) the god Thoth is represented offering the *utchat* to the *Meḥurt* cow. (Fig. 2.)

FIG. 2.

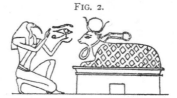

Horus who protect the intestines of Osiris or the deceased. On the right stand
⋇ 🐾 Ṭuamāutef and ▦ Qebḥsennuf, and on the left ▱
Mestḣȧ and 🐦 Ḥāpi (to illustrate lines 82, 83).

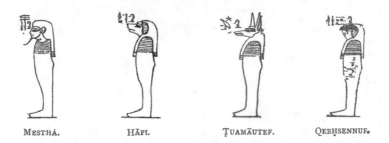

| MESTḢȦ. | HĀPI. | ṬUAMĀUTEF. | QEBḤSENNUF. |

Plate IX. 1. Figures of three gods who, together with Mestḣȧ, Ḥāpi,
Ṭuamāutef, and Qebḥsennuf, are the "seven shining ones" referred to
in line 99. Their names are:— ⌣ [⌣] Maa-ȧtef-f, 🔲
Kheri-beq-f, and 🐦 Ḥeru-khent-maati.

2. The god 𓏺 Anpu (Anubis), jackal-headed.

3. Figures of seven gods, whose names are ⌣ Netchehnetcheh,
🦅 Ȧaqetqet, ⌣ Khenti-heh-f,[1]
╈ Ȧmi-unnut-f,[2] ⌣ Tesher-maa,[3]
𓏏 Bes-maa-em-kerḥ,[4] and 𓏤 An-
em-hru[5] (to illustrate lines 99–106).

4. The soul of Rā 🦅, and the soul of Osiris in
the form of a human-headed bird 🦅 wearing the
crown ⌀, conversing in Tattu 𓊽𓊽: a scene of very rare occurrence, and
illustrating lines 111, 112.

[1] *I.e.*, "He dwelleth in his flame." [2] *I.e.*, "He who is in his hour."

[3] *I.e.*, "Red of both eyes." [4] *I.e.*, "Flame seeing in the night."

[5] *I.e.*, "Bringing by day."

Plate X. 1. The Cat, *i.e.*, the Sun, which dwelleth by the persea tree in Heliopolis, cutting off the head of the serpent Āpepi, emblematic of his enemies.[1]

2. Three seated deities holding knives. They are probably Sau, Horus of Sekhem, and Nefer-Tmu.

3. Ani and his wife Thuthu, who holds a sistrum 𓏣, kneeling in adoration before the god Khepera, beetle-headed, who is seated in the boat of the rising sun (to illustrate lines 116 ff.).

4. Two apes, emblematic of Isis and Nephthys (to illustrate lines 124, 125).

5. The god Tmu, seated within the Sun-disk in the boat of the setting sun, facing a table of offerings.

6. The god Reḥu, in the form of a lion (to illustrate line 133).

7. The serpent Uatchit, the lady of flame, a symbol of the eye of Rā, coiled round a lotus flower. Above is the emblem of fire 𓊮 .

Text: [Chapter XVII.] (1.) Here begin the praises and glorifyings[2] of coming out from and going into (2) the glorious Neter-khert in the beautiful Amenta, of coming out by day[3] in all the forms of existence which

[1] Compare the following variant from a papyrus in Dublin. In the papyrus of Hunefer, before the scene of the Cat cutting off Āpepi's head, is one in which the deceased is represented kneeling in adoration before five ram-headed gods, whose names are Rā, Shu, Tefnut, Seb and Ba-[neb]-Tattu.

[2] Pierret renders, "résurrection des mânes." See *Le Livre des Morts*, p. 53.

[3] Some copies read, "to be with the followers of Osiris, and to feed upon the food of Un-nefer, to come forth by day"; and others, "may I drink water at the sources of the streams, and be among the followers of Un-nefer; may I see the disk every morning." For the texts, see Naville, *Todtenbuch*, Bd. II., Bl. 29.

PLEASE HIM (*i.e.*, THE DECEASED), OF PLAYING AT DRAUGHTS[1] AND SITTING IN THE (3) ṢEH HALL, AND OF COMING FORTH AS A LIVING SOUL. Behold Osiris, the scribe Ani, after (4) he hath come to his haven [of rest]. That which hath been done upon earth [by Ani] being blessed, all (5) the words of the god Tmu come to pass. " I am the god Tmu in [my] rising ;[2] I am the only One. I came " into existence in Nu. (6) I am Rā who rose in the beginning. [He hath " ruled that which he made.][3] "

(7) Who then is this ? It is Rā who rose for the first time in the city of (8) Suten-ḥenen[4] [crowned][5] as a king in [his] rising.[6] The pillars of Shu[7] were not as yet created, when he was upon the (9) high place of him who is in Khemennu.[8]

" I am the great god who gave birth to himself, even Nu, (10) [who] created his name *Paut Neteru*[9] as god."

Who then (11) is this ? It is Rā, the creator of the name[s] of his limbs, which came into being (12) in the form of the gods in the train of Rā.

" I am he who is not driven back among the gods."

[1] For accounts of the way in which draughts were played by the Egyptians, see Birch, in *Revue Archéologique*, 1864, p. 56 ff.; Birch, in *Aeg. Zeitschrift*, 1866, p. 97; Birch, in *Trans. Roy. Soc. Literature*, New Series, vol. ix., p. 256 ; and Falkner, *Oriental Games*, London, 1892. The draught-board of the ancient Egyptians is often a rectangular wooden box, the top divided into squares, containing a drawer in which the men are kept (British Museum, No. 21,576). Draught-boards were also made of blue glazed *faïence*, and bone or ivory (British Museum, No. 21,577). The draughtsmen ⋂ are of wood, bone, ivory, glazed *faïence*, or stone, and have at times the heads of lions ℅ (British Museum, Nos. 13,417, 21,580, 21,581); jackals (British Museum, Nos. 6414*b*, 24,660–66); and of the god Bes (British Museum, Nos. 6413*c*, 24,667–75). No. 6414*a* is inscribed with the prenomen of Necho II.

[2] *I.e.*, the Sun-god when he sets and rises.

[3] Supplied from the Papyrus of Nebseni. See British Museum papyrus No. 9900; Naville, *Todtenbuch*, Bd. II., Pl. xxxi., [hieroglyphs].

[4] See *supra*, p. 273, note 3.

[5] Adding [hieroglyphs], [hieroglyphs], or [hieroglyphs] from the variant readings given by Naville.

[6] Some papyri read [hieroglyphs] *Unnu ;* on this town, see Brugsch, *Dict. Géog.*, p. 146.

[7] Shu was the son of Rā and Hathor and the twin-brother of Tefnut. He typified the sunlight, and separated the earth from the sky, which he established and supported. For a drawing of Shu and his four supports [hieroglyphs], see Lanzone, *Dizionario*, tav. 385.

[8] See Brugsch, *Dict. Géog.*, p. 749.

[9] *I.e.*, "substance of the gods."

(13) Who then is this? It is Tmu in his disk, or (as others say), It is Rā in (14) his rising in the eastern horizon of heaven.

"I am Yesterday; I know (15) Tomorrow."

Who then is this? Yesterday is Osiris, and (16) Tomorrow is Rā, on the day when he shall destroy the (17) enemies of Neb-er-tcher, and when he shall stablish as prince and ruler (18) his son Horus, or (as others say), on the day when we commemorate the festival (19) of the meeting of the dead Osiris with his father Rā, and when the battle of the (20) gods was fought in which Osiris, lord of Amentet, was the leader.

What then is this? (21) It is Amentet, [that is to say] the creation of the souls of the gods when Osiris was leader in Set-Amentet; or (22) (as others say), Amentet is that which Rā hath given unto me; when any god cometh, he doth arise and (23) doeth battle for it.

"I know the god who dwelleth therein."

(24) Who then is this? It is Osiris," or (as others say), Rā is his name, even Rā (25) the self-created.

"I am the *bennu*[1] bird (26) which is in Annu, and I am the keeper of "the volume of the book of things[2] which are and of things which shall be."

Who (27) then is this? It is Osiris, or (as others say), It is his dead body, or (as others say), (28) It is his filth. The things which are are and the things which shall be are his dead body; or (as others say), (29) They are eternity and everlastingness. Eternity is the day, and everlastingness (30) is the night.

"I am the god Amsu[3] in his coming-forth; may his (31) two plumes be set upon my head."

[1] See above, p. 277, note 2.

[2] Or, "I am he that presideth over the arrangement (*or* ordering) of things," etc. Birch renders it, "The Creator of beings and existences," and Pierret, "La loi de l'existence et des êtres." In a hymn Rā is called ⏝ *neb enti*, "lord of things which are," and ⟹ *àri enti*, "maker of things which are," and ⟹ *àri unenet*, "maker of things which shall be." See Grébaut, *Hymne à Ammon-Rā*, pp. 5, 16, 27, who, however, believes ⟿ to mean inanimate objects; see p. 130.

[3] ⟜ The name of this god was first read Khem, and then Min, but it has been proved (*Aeg. Zeitschrift*, 1877, p. 98, and |*Trans. Soc. Bibl. Arch.*, Vol. VIII., p. 204, note 2) that the correct

Who then is this? Amsu is Horus, the (32) avenger of his father, and his coming-forth is his birth. The (33) plumes upon his head are Isis and Nephthys when they go forth to set themselves (34) there, even as his protectors,[1] and they provide that which (35) his head lacketh,[2] or (as others say), They are the two exceeding great uræi which are upon the head of their (36) father Tmu, or (as others say), His two eyes are the two plumes.

(37) "Osiris Ani, the scribe of all the holy offerings, riseth up in his place in triumph ; he cometh into (38) his city."[3]

What then is this? It is the horizon of his father Tmu.

(39) "I have made an end of my shortcomings, and I have put away my faults."

What then (40) is this? It is the cutting off of the corruptible[4] in the body of Osiris, the scribe Ani, (41) triumphant before all the gods; and all his faults are driven out.

(42) What then is this? It is the purification [of Osiris] on the day of his birth.

(43) "I am purified in my exceeding great double nest[5] which is in Suten-"henen, (44) on the day of the offerings of the followers of the great god who "is therein."

(45) What then is this? "Millions of years" is the name of the one

reading is Àmsu (compare the variants in Naville, *Todtenbuch*, Bd. II., Bl. 41). This god was associated with Àmen-Ra, and represented the power of reproduction (see Pierret, *Panthéon*, p. 39 ; and Lanzone, *Dizionario*, p. 935). The seat of his worship was Àpu ⌉□ 🦅⊗, the Panopolis of the Greeks, and the Akhmîm of Arabic writers. For the forms of the name of the town, see Brugsch, *Dict. Géog.*, p. 19. Figures of Àmsu, in bronze and *faïence*, are common, and good examples are Nos. 43, 44, 45, 46 47*a*, and 13,520 in the Third Egyptian Room.

[1] Or "grandmothers." Isis was the "greater tcherti," and Nephthys the "lesser tcherti." On the word, see Brugsch, *Wörterbuch*, Supp., p. 1335.

[2] The chief variant readings are [hieroglyphs] ; [hieroglyphs] [hieroglyphs] ; [hieroglyphs] .

[3] British Museum papyrus No. 9900 has, "I rise up in my land, I come into (*or* from) mine eye." The papyrus of Kenna at Leyden has the same reading as that of Ani.

[4] The papyrus of Kenna has [hieroglyphs], "the hind-parts."

[5] The chief variants are [hieroglyphs] and [hieroglyphs]. See Naville, *Todtenbuch*, Bd. II., Pl. xvii.

[nest], (46) "Green Lake"[1] is the name of the other; a pool of natron, and a pool of nitre (47); or (as others say), "The Traverser of Millions of Years" is the name of the one, "Great Green Lake" (48) is the name of the other; or (as others say), "The Begetter of Millions of Years" is the name of the one, "Green Lake" is (49) the name of the other. Now as concerning the great god who is in it, it is Rā himself. (50)

"I pass over the way, I know the head[2] of the Pool of Maāta."[3]

(51) What then is this? It is Re-stau;[4] that is to say, it is the underworld on the (52) south of Naârut-f,[5] and it is the northern door[6] of the tomb.

Now as concerning (53) She-Maāat,[7] it is Abtu; or (as others say), It is the road by which his (54) father Tmu travelleth when he goeth to Sekhet-Âaru,[8] (55) which bringeth forth the food and nourishment of the gods behind the shrine. (56) Now the Gate of Sert[9] is the gate of the pillars of Shu, (57) the northern gate of the underworld; or (as others say), It is the two leaves of the door through (58) which the god Tmu passeth when he goeth forth in the eastern horizon of heaven.

(59) "O ye gods who are in the presence[10] (of Osiris), grant me your arms, "for I am the god (60) who shall come into being among you."

[1] According to Brugsch (*Dict. Géog.*, p. 179), "Green Lake" is the name of one of the two sacred lakes of Heracleopolis Magna.

[2] Literally "heads."

[3] For the locality of this name in Egypt, see Brugsch, *Dict. Géog.*, p. 248.

[4] *I.e.*, "the door of the passages of the tomb."

[5] The chief variants in Naville are ⟨hieroglyphs⟩, ⟨hieroglyphs⟩.

[6] Variants ⟨hieroglyphs⟩, ⟨hieroglyphs⟩.

[7] *I.e.*, the "Pool of Double Truth."

[8] After the name Sekhet-Âaru, British Museum papyrus No. 9900 has ⟨hieroglyphs⟩, "I come forth to the land of the I come forth from the gate Ser." "What then is this?" The papyrus of Ani omits this passage.

[9] According to Brugsch (*Die biblischen sieben Jahre der Hungersnoth*, p. 13) ⟨hieroglyph⟩ should be read *T'eser* ⟨hieroglyphs⟩. In 1867 Dr. Birch translated, "I go from the Gate of the Taser" (Bunsen, *Egypt's Place*, Vol. V., p. 174).

[10] A variant has ⟨hieroglyphs⟩, "who are in his following." See Naville, *Todtenbuch*, Bd. II., Pl. xlix.

What then is this? It is the drops of blood (61) which fell from Rā when he went forth (62) to cut himself. They sprang into being as the gods Ḥu and Sa, who are in the (63) following of Rā and who accompany Tmu (64) daily and every day.

"I, Osiris, Ani (65) the scribe, triumphant, have filled up for thee the "*utchat*[1] after it was darkened (66)[2] on the day of the combat of the Two "Fighters."[3]

What then (67) is this? It is the day on which Horus fought with (68) Set, who cast filth in the face of Horus, and when Horus destroyed the (69) powers of Set. Thoth did this with his own hand.

(70) "I lift the hair[-cloud][4] when there are storms in the sky."

What then is this? (71) It is the right eye of Rā, which raged against [Set] when (72) he sent it forth. Thoth raiseth up the hair[-cloud], and bringeth the eye (73) alive, and whole, and sound, and without defect to [its] lord; or (as others say), It is the eye of Rā when it is sick and when it (74) weepeth for its fellow eye; then Thoth standeth up to cleanse it.

(75) "I behold Rā who was born yesterday from the (76) buttocks[5] of the "cow Meḥ-urt;[6] his strength is my strength, and my strength is his strength."

What then (77) is this? It is the water of heaven, or (as others say), (78) It is the image of the eye of Rā in the morning at his daily birth. (79) Meḥ-urt is the eye of Rā. Therefore Osiris, the (80) scribe Ani, triumphant, [is] a great one among the gods (81) who are in the train of Horus. The words are] spoken for him that loveth his lord.[7]

I.e., the eye of the Sun.　　　　[2] Some variants give 〔hieroglyphs〕, "pierced."

[3] Rehui was a name given in the first instance to Horus and Set, but subsequently it was applied to any two combatants (see the passages quoted by Brugsch, *Wörterbuch*, Suppl., p. 734). British Museum papyrus No. 10,184 (Sallier IV.), states that the battle between Horus and Set took place on the 26th day of the month of Thoth, *i.e.*, October (see Chabas, *Le Calendrier*, p. 28).

[4] The scribe has omitted the words 〔hieroglyphs〕 *em utchat*, "from the eye of the sun." The word 〔hieroglyphs〕 *shen* is a name for the clouds which cover the eye of the sun, and which in appearance like hair. Brugsch in his *Wörterbuch* (Suppl.), p. 1193, gives the word 〔hieroglyphs〕 as meaning "tempest."

[5] The papyrus has 〔hieroglyphs〕.

[6] For figures of this goddess, see Lanzone, *Dizionario*, plate 131.

[7] The meaning of this passage is doubtful. Birch renders, "one of the gods who belong to Horus, whose words exceed the wish of his Lord"; and Pierret, "un de ces dieux qui suivent Horus, et parlent selon la volonté de leur seigneur."

(82) What then is this? [*i.e.*, who are these gods?] Mesthȧ, Ḥāpi, Tuamāutef, and Qebḥsennuf.

(83) "Homage to you, O ye lords of right and truth, and ye holy ones " who [stand] behind Osiris, who utterly do away with (84) sins and crime, and [ye] " who are in the following of the goddess Ḥetep-se(85)-khus, grant that I " may come unto you. Destroy ye all the faults which (86) are within me, " even as ye did for the seven Shining Ones (87) who are among the followers " of their lord Sepa.[1] (88) Anubis appointed their place on the day [when was " said], 'Come therefore thither.'"

What then (89) is this? These lords of right and truth are Thoth and (90) Astes, lord of Amenta. The holy ones who stand behind Osiris, even Mesthȧ, (91) Ḥāpi, Tuamāutef, and Qebḥsennuf, are they who are (92) behind the Thigh[2] in the northern sky. They who do away with (93) sins and crime and who are in the following of the goddess Ḥetep-se-khus (94) are the god Sebek in the waters. The goddess Ḥetep-se-khus is the eye of (95) Rā, or (as others say), It is the flame which followeth after Osiris to burn up (96) the souls of his foes. As concerning all the faults which are (97) in Osiris, the scribe of the holy offerings of all the gods, Ani, triumphant, [they are all that he hath done against the lords of eternity][3] since he came forth (98) from his mother's womb. As concerning (99) the seven Shining Ones, even Mesthȧ, Ḥāpi, Tuamāutef, Qebḥsennuf, (100) Maa-atef-f, Kheri-beq-f, and Horus-Khenti-maa, Anubis appointed (101) them protectors of the body of Osiris, or (as others say), (102) [set them] behind the place of purification of Osiris; or (as others say), Those seven glorious ones are (103) Netcheh-netcheh, Aqet-qet, An-erta-nef-bes-f-khenti-heh-f,[4] (104) Aq-ḥer-unnut-f,[5] Tesher-maa-ȧmmi (105) -ḥet-Ȧnes,[6]

[1] British Museum papyrus No. 10,477 reads, 𓏤𓏤 ⟍ 〰 ▽ 𓉐 𓅆 𓃻 𓀀, which agrees with many of the variants given in Naville, *Todtenbuch*, Bd. II., Pl. liii. The papyrus of Nebseni agrees with that of Ani ; No. 19,471 has the curious reading, 𓏤𓏤 ⟍ ▽ 𓄿𓈖𓈖.

[2] The Egyptian name for the constellation of the Great Bear. See Brugsch, *Astronomische und Astrologische Inschriften*, p. 123.

[3] Some such words as ▽ 𓈖𓈖 𓅆 𓅆 ▽ 𓁹 𓊹 have been omitted. See Naville, *Todtenbuch*, Bd. II., Pl. lv.

[4] *I.e.*, " He doth not give his flame, he dwelleth in the fire."

[5] *I.e.*, " He goeth in at his hour.'

[6] *I.e.*, " He that hath two red eyes, the dweller in Ḥet-Ȧnes." According to Brugsch (*Dict. Géog.*,). 64), Ḥet-Ȧnes, *i.e.*, the " house of cloth," was a district belonging to the temple of Suten-ḥenen or Ḥeracleopolis in Upper Egypt.

Ubes-hra-per-em-khet khet,[1] and Maa (106) -em-qerh-an-nef-em-hru.[2] The chief
of the holy ones (107) who minister in his chamber is Horus, the avenger of
his father. As to the day (108) [upon which was said] " Come therefore thither,"
it concerneth the words, "Come (109) then thither," which Rā spake unto Osiris.
Lo, may this be decreed for me in Amentet.

" I am the soul which dwelleth in the two (110) *tchafi*."

What then is this ? It is Osiris [when] he goeth into Tattu (111) and
findeth there the soul of Rā; there the one god (112) embraceth the other, and
souls spring into being within the two *tchafi*.[3]

[" I am the Cat which fought (?) by the Persea tree hard by in Annu, on the
" night when the foes of Neb-er-tcher were destroyed."

What then is this ? The male cat is Rā himself, and he is called
Maàu[4] by reason of the speech of the god Sa [who said] concerning him : "He is
like (*maàu*) unto that which he hath made, and his name became Maàu "; or
(as others say), It is Shu who maketh over the possessions of Seb to Osiris.
As to the fight (?) by the Persea tree hard by, in Annu, it concerneth the children
of impotent revolt when justice is wrought on them for what they have done. As
to [the words] " that night of the battle," they concern the inroad [of the children
of impotent revolt] into the eastern part of heaven, whereupon there arose a battle
in heaven and in all the earth.

" O thou who art in the egg (*i.e.*, Rā), who shinest from thy disk and risest
" in thy horizon, and dost shine like gold above the sky, like unto whom there is
" none among the gods, who sailest over the pillars of Shu (*i.e.*, the ether), who
" givest blasts of fire from thy mouth, [who makest the two lands bright with thy
" radiance, deliver] the faithful worshippers from the god whose forms are hidden,
" whose eyebrows are like unto the two arms of the balance on the night of the
" reckoning of destruction."

[1] *I.e.*, " Blazing-face coming forth, going back."

[2] *I.e.*, " The one who seeth by night, and leadeth by day."

[3] This reading differs from that of any other papyrus of this period. After the words, " spring into
being within the two *tchafi*," the papyrus of Nebseni has, " It is Horus. the avenger of his father, and
Horus-khenti-en-maa," or (as others say), " ' the two souls within the *tchafi* ' are the soul of Rā [and]
the soul of Osiris, [or] the soul which is in Shu and the soul which is in Tefnut, that is, the two
souls which are in Tattu." It appears that the scribe of the Ani papyrus has here accidentally
omitted a long section; the text is therefore supplied within brackets from the Nebseni papyrus, plate
xiv., l. 16 ff.

[4] Note the play upon the words *maàu*, " cat," and *maàu*, " like."

Who then is this? It is An-ā-f, the god who bringeth his arm. As concerning [the words] "that night of the reckoning of destruction," it is the night of the burning of the damned, and of the overthrow of the wicked at [the sacred] block, and of the slaughter of souls.

Who then is this? It is Nemu, the headsman of Osiris; or (as others say), It is Āpep when he riseth up with one head bearing *maāt* (*i.e.*, right and truth) [upon it]; or (as others say), It is Horus when he riseth up with two heads, whereof the one beareth *maāt* and the other wickedness. He bestoweth wickedness on him that worketh wickedness, and *maāt* on him that followeth after righteousness and truth; or (as others say), It is the great Horus who dwelleth in [Se]khem; or (as others say), It is Thoth; or (as others say), It is Nefer-Tmu, [or] Sept,[1] who doth thwart the course of the foes of Neb-er-tcher.

"Deliver me from the Watchers who bear slaughtering knives, and who have "cruel fingers,[2] and who slay those who are in the following of Osiris. May they "never overcome me, may I never fall under their knives."

What then is this? It is Anubis, and it is Horus in the form of Khent-en-maa; or (as others say), It is the Divine Rulers who thwart the works of their [weapons]; it is the chiefs of the *sheniu* chamber.

"May their knives never get the mastery over me, may I never fall under "their instruments of cruelty, for I know their names, and I know the being "Mātchet[3] who is among them in the house of Osiris, shooting rays of light from "[his] eye, but he himself is unseen. He goeth round about heaven robed in the "flame of his mouth, commanding Ḥāpi, but remaining himself unseen. May I be "strong upon earth before Rā, may I come happily into haven in the presence of "Osiris. Let not your offerings be hurtful to me, O ye who preside over your "altars, for I am among those who follow after Neb-er-tcher according to the "writings of Kheperà. I fly as a hawk, I cackle as a goose; I ever slay, even as "the serpent goddess Neḥebka."

What then is this? They who preside at the altars are the similitude of the eye of Rā and the similitude of the eye of Horus.

"O Rā-Tmu, lord of the Great House, prince, life, strength and health of all "the gods, deliver thou [me] from the god whose face is like unto that of a dog, "whose brows are as those of a man, and who feedeth upon the dead, who watcheth

[1] Many papyri read, "Nefer-Tmu, son of Bast, and the *tchatcha*."
[2] Or instruments of death. [3] *I.e.*, the "Oppressor."

" at the Bight of the Fiery Lake, and who devoureth the bodies of the dead and
" swalloweth hearts, and who shooteth forth filth, but he himself remaineth unseen."

Who then is this? " Devourer for millions of years " is his name, and he
dwelleth in the Lake of Unt.[1] As concerning the Fiery Lake, it is that which is in
Anrutf, hard by the *Shenit* chamber. The unclean man who would walk thereover
doth fall down among the knives ; or (as others say), His name is " Mathes," [2] and he
is the watcher of the door of Amenta; or (as others say), His name is " Heri-sep-f."

" Hail, Lord of terror, chief of the lands of the North and South, lord of the red
glow, who preparest the slaughter-block, and who dost feed upon the inward parts !"

Who then is this? The guardian of the Bight of Amenta.

What then is this? It is the heart of Osiris, which is the devourer of all
slaughtered things. The *urerit* crown hath been given unto him with swellings of
the heart as lord of Suten-ḥenen.

What then is this? He to whom hath been given the *urerit* crown with
swellings of the heart as lord of Suten-ḥenen is Osiris. He was bidden to rule
among the gods on the day of the union of earth with earth in the presence of
Neb-er-tcher.

What then is this? He that was bidden to rule among the gods is
[Horus] the son of Isis, who was appointed to rule in the place of his father Osiris.
As to the day of the union of earth with earth, it is the mingling of earth with
earth in the coffin of Osiris, the Soul that liveth in Suten-ḥenen, the giver of meat
and drink, the destroyer of wrong, and the guide of the everlasting paths.

Who then is this? It is Rā himself.

" Deliver thou [me] from the great god who carrieth away souls, and who
" devoureth filth and eateth dirt, the guardian of the darkness [who himself
" liveth] in the light. They who are in misery fear him."

As concerning the souls within the (113) *tchafi* [they are those which
are] with the god who carrieth away the soul, who eateth hearts, and who feedeth
(114) upon offal, the guardian of the darkness who is within the *seker* boat ;
they who live in (115) crime fear him.

Who then is this? It is Suti, or (as others say), It is Smam-ur,[3] (116)
the soul of Seb.

" Hail, Kheperā in thy boat, the twofold company of the gods is thy body.
" Deliver thou Osiris (117) Ani, triumphant, from the watchers who give judgment,

[1] Reading ⟨hieroglyphs⟩ *še en Unt*. [2] The one with a knife. [3] *I.e.*, Great Slayer.

" who have been appointed by Neb-er(118)-tcher to protect him and to fasten the
" fetters on his foes, and who slaughter in the shambles (119); there is no escape
" from their grasp. May they never stab me with their knives, (120) may I
" never fall helpless in their chambers of torture. (121) Never have the things
" which the gods hate been done by me, for I am pure within the Mesqet. (122)
" Cakes of saffron have been brought unto him in Tanenet."

Who then is this? (123) It is Kheperà in his boat. It is Rā himself.
The watchers (124) who give judgment are the apes Isis and Nephthys. The
things which the gods hate (125) are wickedness and falsehood; and he who
passeth through the place of purification within the Mesqet is Anubis, who is
(126) behind the chest which holdeth the inward parts of Osiris.

He to whom saffron cakes have been brought in (127) Tanenet is Osiris;
or (as others say), The saffron cakes (128) in Tanenet are heaven and earth,
or (as others say), They are Shu, strengthener of the two lands in (129) Suten-
henen. The saffron cakes are the eye of Horus; and Tanenet is the grave
(130) of Osiris.

Tmu hath built thy house, and the two-fold Lion-god hath founded thy habi-
tation; (131) lo! drugs are brought, and Horus purifieth and Set strengtheneth,
and Set purifieth and Horus strengtheneth.

(132) " The Osiris, the scribe Ani, triumphant before Osiris, hath come into
" the land, and hath possessed it with his feet. He is Tmu, and he is in the city."

(133) " Turn thou back, O Reḥu, whose mouth shineth, whose head moveth,
" turn thou back from before his strength"; or (as others say), Turn thou back
from him who keepeth watch (134) and is unseen. "The Osiris Ani is safely guarded.
" He is Isis, and he is found (135) with [her] hair spread over him. I shake it out
" over his brow. He was conceived in Isis and begotten in (136) Nephthys;
" and they cut off from him the things which should be cut off."

Fear followeth after thee, terror is upon thine (137) arms. Thou art
embraced for millions of years in the arms [of the nations]; mortals go round
about thee. Thou smitest down the mediators of thy (138) foes, and thou seizest
the arms of the powers of darkness. The two sisters (i.e., Isis and Nephthys) are
given to thee for thy delight. (139) Thou hast created that which is in Kherāba,
and that which is in Annu. Every god feareth thee, for thou art exceeding
great and terrible; thou [avengest] every (140) god on the man that curseth him,
and thou shootest out arrows. Thou livest according to thy will;
thou art Uatchit, the Lady of Flame. Evil cometh (141) among those who set
themselves up against thee.

What then is this? The hidden in form, granted of Menḥu, (142) is
the name of the tomb. He seeth [what is] in [his] hand, is the name of the
shrine, or (143) (as others say), the name of the block. Now he whose mouth
shineth and whose head moveth is (144) a limb of Osiris, or (as others say),
of Rā. Thou spreadest thy hair and I shake it out over his brow (145) is
spoken concerning Isis, who hideth in her hair and draweth her hair over her.
Uatchi, the Lady of Flames, is the eye of Rā.[1]

PLATES XI. AND XII.

Vignette I. : Ani and his wife Thuthu approaching the first Ārit,[3] the
cornice of which is ornamented with 〡𝍦〡𝍦〡𝍦 i.e., emblems of power, life, and
stability. At the entrance sit three gods, the first having the head of a hare, the
second the head of a serpent, and the third the head of a crocodile. The first
holds an ear of corn (?), and each of the others a knife.

Text [Chapter CXLVII.]: (1) The First Ārit. The name of the
doorkeeper is Sekhet-hrà-āsht-àru[3]; the name of the (2) watcher is Meti-heh (?)[4];
the name of the herald is Ha-kheru.[5]

[Words to be spoken when Osiris cometh to the First Ārit in Amenta.[6]]
Saith (3) Ani, triumphant, when he cometh to the first Ārit: " I am the mighty one
" who createth his own light. (4) I have come unto thee, O Osiris, and, purified
" from that which defileth thee, I adore thee. Lead on; (5) name not the name

[1] Lepsius (*Todtenbuch*, Bl. XI.) adds, after this : "Now those who rise up against me and among
whom is evil [see above, l. 141] are the powers of darkness of the god Sut, when there is strife among
them, for strife is flame."

 "May it be granted to [the dead] by the decree of [the gods] who are in Tattu to destroy the souls
of his foes ! "

[2] House or mansion. In the upper line of Plates XI. and XII. there is a series of seven *Arits*, or
mansions, through which the deceased is supposed to pass. In the lower line are the ten *Sebkhets*, or
pylon-shaped gateways.

[3] "Reversed of face: of many forms." Var. 〡◉𝍦⚶𓃒🜚🜚𝍦.

[4] Var. ⟶◠𝍦.

[5] "The voice that travelleth." Var. ◁🦁𝍦�. "The high-voiced."

[6] Supplied from Naville, *Todtenbuch*, l. 165.

" of Re-stau unto me. Homage to thee, O Osiris, in thy might and in thy
" strength (6) in Re-stau. Rise up and conquer, O Osiris, in Abtu. Thou
" goest round about heaven, thou sailest in the presence of Rā, (7) thou seest all
" the beings who have knowledge.[1] Hail Rā, who circlest in [the sky]. Verily I
" say [unto thee], O Osiris, I am a (8) godlike ruler. (9) Let me not be driven
" hence [2] (10) nor from the wall of burning coals. [I have] opened the way in
" Re-stau; (11) I have eased the pain of Osiris; [I have] embraced that which
" the balance [3] hath weighed; [I have] made a path for him in the great valley,
" and [he] maketh a path. Osiris shineth (?)."

Vignette II. : The second Ārit, guarded by three gods; the first of whom
has the head of a lion, the second the head of a man, and the third the head of a
dog. Each one holds a knife.

Text : (1) THE SECOND ĀRIT. The name of (2) the doorkeeper is
Un-hat[4]; (3) the name of the watcher is (4) Seqeṭ-ḥrà; the name of the herald
is Uset.[5]

(6) Saith Osiris Ani, when he cometh unto this Ārit; " He sitteth to do his
" heart's desire, and he weigheth (7) words as the second of Thoth. The strength
" of Thoth[6] humbleth the (8) hidden Maāta gods[7] who feed upon Maāt throughout
" the years [of their lives].[8] I make offerings at the (9) moment when [he] passeth
" on his way; I pass on and enter on the way.[9] Grant thou that I may pass through
" and that I may gain sight of Rā together with those who make offerings."

[1] Birch : " Pure Spirits." Pierret : " Intelligents."

[2] *I.e.*, the *Ārit*.

[3] Literally standard or perch. Var. 𓀀𓈖𓏤𓀁 .

[4] Var. 𓈙𓈖𓏤𓂺𓏤 .

[5] Var. 𓂋𓀁𓈖𓏤𓀁𓈖𓏤𓀁 .

[6] Var. 𓀁𓈖𓏤𓀁𓀁 , " the strength of Osiris is the strength of Thoth."

[7] Varr. 𓈖𓀁𓈖𓀁 *Nemasa*, and 𓈖𓀁𓈖𓀁 Saḥ, " Orion." The reading in
Lepsius is 𓈖𓀁𓈖𓀁 *Masti*, " gods of the thigh."

[8] Var. 𓈖𓈖𓈖𓀁 " their years are the years of Osiris."

[9] The text here differs from all others and may be corrupt.

Vignette III. : The third Ārit, guarded by three gods; the first with the head of a jackal, the second the head of a dog, and the third the head of a serpent. The first holds an ear of corn (?), and each of the others a knife.

Text : (1) THE THIRD ĀRIT. The name of the (2) doorkeeper is Qeq-hauau-ent-pehui;[1] the name of the (4) watcher is Se-res-hrá;[2] the name of the herald is Aaa.[3]

Saith Osiris Ani, [when he cometh to this Ārit]: (6) " I am hidden [in] the " great deep, [I am] the judge of the Rehui.[4] I have come and I have done away " with the offences of Osiris. I am building up the standing place (7) which " cometh forth from his *urerit* (?) crown. I have done his business in Abtu, I " have opened the way in Re-stau, I have (8) eased the pain which was in Osiris. " I have made straight his standing place, and I have made [his] path.[5] He " shineth in Re-stau."

Vignette IV. : The fourth Ārit, guarded by three gods; the first with the head of a man, the second the head of a hawk, and the third the head of a lion. The first holds an ear of corn (?), and each of the others a knife.

Text : (1) THE FOURTH ĀRIT. The name of the (2) doorkeeper is Khesef-hrà-āsht- (3) kheru;[6] the name of the (4) watcher is Seres-tepu;[7] (5) the name of the herald is (6) Khesef-Aṭ.[8]

Saith Osiris, the scribe Ani, triumphant, [when he cometh to this Ārit]: " I am " the [mighty] bull, the (7) son of the ancestress of Osiris. O grant ye that his " father, the lord of his godlike (8) companions, may bear witness for him. Here " the guilty are weighed in judgment. I have brought unto (9) his nostrils eternal " life. I am the son of Osiris, I have made the way, I have passed thereover " into Neter-khert."

PLATE XII.—**Vignette V. :** The fifth Ārit, guarded by three gods; the first with the head of a hawk, the second the head of a man, and the third the head of a snake. Each holds a knife.

[1] *I.e.,* " Eater of his own filth."　　　　　[2] *I.e.,* " Making to lift up his face."
[3] *I.e.,* " Great One."　　　　　　　　　　　[4] *I.e.,* Horus and Set.
[5] Var. ⟨hieroglyphs⟩ . See the end of the speech of the Osiris at the first *ārit.*
[6] *I.e.,* " Repulsing the face, great of speech."　　[7] Var. ⟨hieroglyphs⟩ .
[8] *I.e.,* " Repulser of the crocodile."

Text: (1) THE FIFTH ĀRIT. The (2) name of the doorkeeper is Ankh-f-em-fent;[1] the name of the (3) watcher is Shabu; the name of the herald is Ṭeb-ḥrā-keha-kheft.[2]

Saith Osiris, the scribe Ani, triumphant, [when he cometh to this Ārit]: "I "have brought unto thee the bones of thy jaws in Re-stau, I have brought thee "thy backbone in Annu, (7) gathering together all thy members there. (8) I "have driven back Āpep for thee. I have poured water upon the wounds; I have "made a path among you. I am the Ancient One among the gods. I have[3] made "the offering of Osiris, who hath triumphed with victory, gathering his bones and "bringing together all his limbs."

Vignette VI.: The sixth Ārit, guarded by three gods; the first with the head of a jackal, and the second and third the head of a dog. The first holds an ear of corn (?), and each of the others a knife.

Text: (1) THE SIXTH ĀRIT. (2) The name of the doorkeeper is Atek-au-kehaq-kheru;[4] the name of the (4) watcher is Ān-ḥrā; (5) the name of the herald is Aṭes-ḥrā.

Saith Osiris, the scribe Ani, [when he cometh to this Ārit]: "I have come "(7) daily, I have come daily. I have made the way; I have passed along that "which was created by Anubis. I am the lord of the (8) *urerit* crown, "magical words. I, the avenger of right and truth, have avenged his eye. I "have swathed the eye of Osiris, [I have] made the way]; Osiris Ani hath passed "along [it] with you "

Vignette VII.: The seventh Ārit, guarded by three gods; the first with the head of a hare, the second the head of a lion, and the third the head of a man. The first and second hold a knife, and the third an ear of corn (?).

Text: (1) THE SEVENTH ĀRIT. The name of (2) the doorkeeper is Sekhem-Maṭenu-sen;[5] the name of (4) the watcher is Āa-maā-kheru,[6] (5) and the name of the herald is Khesef-khemi.

Saith Osiris, [the scribe] Ani, [when he cometh to this Ārit]: (6) "I have come

[1] *I.e.,* "He liveth upon worms." [2] Var.

[3] For what follows of this speech Naville gives no equivalent.

[4] Var. Seket-tau-keha-kheru.

[5] Var. Aṭes-sen. [6] Var. Āa-kheru.

" unto thee, O Osiris, who art cleansed of [thine] impurities.　Thou goest round
" about heaven, thou seest Rā, thou seest the beings who have knowledge.　Hail
" (7) Only One! behold, thou art in the *sektet* boat,[1] He goeth round the horizon
" of heaven.　I speak what I will unto his[2] body; (8) it waxeth strong and it
" cometh to life, as he spake.　Thou turnest back his face.　Prosper thou for me
" all the ways [which lead] unto thee! "

Vignette I.:　Ani and his wife Thuthu, with hands raised in adoration,
approaching the first *Sebkhet* or Pylon, which is guarded by a bird-headed deity
wearing a disk on his head, and sitting in a shrine the cornice of which is decorated
with *khakeru* ornaments 𓎣𓎣𓎣𓎣𓎣.

Text: [CHAPTER CXLVI.] THE FIRST PYLON. WORDS TO BE SPOKEN
WHEN [ANI] COMETH UNTO THE FIRST PYLON.　Saith Osiris Ani, triumphant:
"Lo, the lady of terrors, with lofty walls, the sovereign lady, the mistress of
" destruction, who uttereth the words which drive back the destroyers, who
" delivereth from destruction him that travelleth along the way.　The name of the
" doorkeeper is Neruit."

Vignette II.:　The second Pylon, which is guarded by a lion-headed deity
seated in a shrine, upon the top of which is a serpent 𓆙.

Text: WORDS TO BE SPOKEN WHEN [ANI] COMETH UNTO THE SECOND PYLON.
Saith Osiris, the scribe Ani, triumphant:　" Lo, the lady of heaven, the mistress of
" the world, who devoureth with fire, the lady of mortals; how much greater is
" she than all men!　The name of the doorkeeper is Mes-Ptaḥ."

Vignette III.:　The third Pylon, which is guarded by a man-headed deity
seated in a shrine, the upper part of which is ornamented with the two *utchats* and
the emblems of the orbit of the sun and of water 𓂀𓈖𓂀.

Text: WORDS TO BE SPOKEN WHEN [ANI] COMETH UNTO THE THIRD PYLON
OF THE HOUSE OF OSIRIS.　Saith the scribe Ani, triumphant: " Lo, the lady of the

[1] Var. 𓏤𓏤... "Thou invokest Rā in the *sektet* boat of
heaven."

[2] Reading with Naville 𓂋𓏤𓎡𓏏𓏥.

" altar, the mighty one to whom offerings are made, the beloved [1] (?) of every god,
" who saileth up to Abtu. The name of the doorkeeper is Sebaq."

Vignette IV. : The fourth Pylon, which is guarded by a cow-headed deity seated in a shrine, the cornice of which is ornamented with uræi wearing disks ⦂⦂⦂ .

Text : WORDS TO BE SPOKEN WHEN [ANI] COMETH UNTO THE FOURTH PYLON. Saith Osiris, the scribe Ani, [triumphant]: " Lo, she who prevaileth with knives, " mistress of the world, destroyer of the foes of the Still-Heart, she who decreeth " the escape of the needy from evil hap. The name of the doorkeeper is Neḳau."

Vignette V. : The fifth Pylon, which is guarded by the hippopotamus deity, with her fore-feet resting upon the buckle, the emblem of protection ⚇, seated in a shrine, the cornice of which is ornamented with 𓉐𓏏𓉐𓏏, emblematic of flames of fire.

Text : WORDS TO BE SPOKEN WHEN [ANI] COMETH UNTO THE FIFTH PYLON. Saith Osiris, the scribe Ani, triumphant : " Lo, the flame, the lady of breath (?) for " the nostrils ; one may not advance to entreat her shall not come into her " presence. The name of the doorkeeper is Ḥentet-Ārqiu."

Vignette VI. : The sixth Pylon, which is guarded by a deity in the form of a man holding a knife and a besom and seated in a shrine, above which is a serpent.

Text : WORDS TO BE SPOKEN WHEN [ANI] COMETH UNTO THE SIXTH PYLON. Saith Osiris, the scribe Ani, triumphant : " Lo, the lady of light, the mighty one, to " whom men cry aloud ; man knoweth neither her breadth nor her height ; there " was never found her like from the beginning (?). There is a serpent thereover " whose size is not known ; it was born in the presence of the Still-Heart. The " name of the doorkeeper is Semati."

Vignette VII. : The seventh Pylon, which is guarded by a ram-headed deity 𓁛 holding a besom and seated in a shrine, the cornice of which is decorated with *khakeru* ornaments.

[1] The principal variants are 𓎡𓅢𓂻𓇋𓃒𓏴𓅢 " every god uniteth with her "; 𓈖𓇋𓅢 𓂋 𓂝 𓄹 𓏏 𓂋 𓅱 𓃒 𓏤 " the heart of every god rejoiceth in her." See Naville, *Todtenbuch*, Bd. II., Bl. 371.

Text: Words to be spoken when [Ani] cometh unto the Seventh Pylon. Saith Osiris, the scribe Ani, triumphant : " Lo, the robe which doth clothe the "feeble one (*i.e.*, the deceased), weeping for what it loveth and shroudeth. " The name of the doorkeeper is Sakti-f."

Vignette VIII. :　The eighth Pylon, which is guarded by a hawk 𓅃 wearing the crowns of the North and South 𓋙 , seated on a sepulchral chest with closed doors ; before him is a besom, and behind him is the *utchat* 𓂀. Above the shrine are two human-headed hawks, emblems of the souls of Rā and Osiris, and two emblems of life 𓅦 𓋹 𓅦 𓋹 .

Text: Words to be spoken when [Ani] cometh unto the Eighth Pylon. Saith Osiris, the scribe Ani, triumphant : " Lo, the blazing fire, the flame whereof "cannot be quenched, with tongues of flame which reach afar, the slaughtering "one, the irresistible, through which one may not pass by reason of the hurt which "it doeth. The name of the doorkeeper is Khu-tchet-f."[1]

Vignette IX. :　The ninth Pylon, which is guarded by a lion-headed deity wearing a disk and holding a besom, seated in a shrine, the cornice of which is ornamented with uræi wearing disks 𓆓𓆓𓆓 .

Text: Words to be spoken when [Ani] cometh unto the Ninth Pylon. Saith Osiris Ani, triumphant : " Lo, she who is chiefest, the lady of strength, who " giveth quiet of heart to her lord. Her girth is three hundred and fifty measures; " she is clothed with mother-of-emerald of the south; and she raiseth up the godlike " form and clotheth the feeble one The name of the doorkeeper is Åri- " su-tchesef."[2]

Vignette X. : The tenth Pylon, which is guarded by a ram-headed deity wearing the *atef* crown 𓋊 and holding a besom, seated in a shrine, upon the top of which are two serpents 𓆙 𓆙 .

Text: Words to be spoken when [Ani] cometh unto the Tenth Pylon. Saith Osiris Ani, [triumphant] : " Lo, she who is loud of voice, she who " causeth those to cry who entreat her, the fearful one who terrifieth, who feareth " none that are therein. The name of the doorkeeper is Sekhen-ur."

[1] *I.e.*, " Protecting his body."　　　　　[2] *I.e.*, " He maketh himself."

Appendix: The several "texts" of the next eleven Pylons are wanting in this papyrus. Translations of them are here given as they are found in a papyrus published by Naville, *Todtenbuch*, Bd. I., Bl. 161, 162. It will be observed that the names of the doorkeepers are wanting, and also that each text, except in the case of the twenty-first Pylon, ends with words which refer to the examination of the dead at each gate.

THE ELEVENTH PYLON. "Lo, she who repeateth slaughter, the burner up of fiends, "she who is terrible at every gateway, who rejoiceth on the day of darkness. She "judgeth the feeble swathed one."

THE TWELFTH PYLON. "Lo, the invoker of the two lands, who destroyeth with "flashings and with fire those who come, the lady of splendour, who obeyeth her lord "daily. She judgeth the feeble swathed one."

THE THIRTEENTH PYLON. "Lo, Isis, who hath stretched forth her hands and arms "over it, and hath made Ḥāpi to shine in his hidden place. She judgeth the feeble "swathed one."

THE FOURTEENTH PYLON. "Lo, the lady of the knife, who danceth in blood; she "maketh [the festival of] the god Hak on the day of judgment. She judgeth the feeble "swathed one."

THE FIFTEENTH PYLON. "Lo, the Bloody Soul, who searcheth out and putteth to "the test, who maketh inquiry and scrutiny, who cometh forth by night, and doth "fetter the Fiend in his lair; may her hands be given to the Still-Heart in his hour, and "may she make him to advance and come forth unto her. She judgeth the feeble "swathed one."

THE SIXTEENTH PYLON. Saith Osiris, when he cometh unto this pylon: "Lo, the "Terrible one, the lady of the rain storm, who planteth ruin in the souls of men, the "devourer of the dead bodies of mankind, the orderer and creator of slaughters, who "cometh forth. She judgeth the feeble swathed one."

THE SEVENTEENTH PYLON. "Lo, the Hewer-in-pieces in blood, the lady of "flame. She judgeth the feeble swathed one."

THE EIGHTEENTH PYLON. "Lo, the Lover of fire, the purifier of sinners (?), the "lover of slaughter, the chief of those who adore, the lady of the temple, the slaughterer "of the fiends in the night. She judgeth the feeble bandaged one."

THE NINETEENTH PYLON. "Lo, the Dispenser of light while she liveth, the "mistress of flames, the lady of the strength and of the writings of Ptaḥ himself. She "maketh trial of the swathings of Pa-an."

THE TWENTIETH PYLON. "Lo, she who is within the cavern of her lord, Clother "is her name; she hideth what she hath made, she carrieth away hearts and greedily "drinketh water. She judgeth the feeble swathed one."

THE TWENTY-FIRST PYLON. "Lo, the knife which cutteth when [its name] is "uttered, and slayeth those who advance towards its flames. It hath secret plots and "counsels."

In the late recensions of the Book of the Dead,[1] the text referring to the twenty-first Pylon reads :—

(71) "Hail," saith Horus, "O twenty-first pylon of the Still-Heart. (72) I have "made the way, I know thee, I know thy name, I know the name of the goddess who "guardeth thee: 'Sword that smiteth at the utterance of its [own] name, the unknown (?) "goddess with back-turned face, the overthrower of those who draw nigh unto her flame' "is her name. Thou keepest the secret things of the avenger of the god whom thou "guardest, and his name is Āmem.[2] (73) He maketh it to come to pass that the persea "trees grow not, that the acacia trees bring not forth, and that copper is not begotten in "the mountain. The godlike beings of this pylon are seven gods. (74) Tchen or Āṭ is "the name of the one at (?) the door; Ḥetep-mes[3] is the name of the second one; "Mes-sep[4] is the name of the third one; Utch-re[5] is the name of the fourth one; "Āp-uat[6] is the name of the fifth one; Beq[7] is the name of the sixth one; Anubis is the "name of the seventh one."

(75) "I have made the way. I am Āmsu-Horus, the avenger of his father, the heir "of his father Un-nefer. I have come and I have overthrown all foes of my father "Osiris. I have come day by day with victory, doing myself the worship of the god, "(76) in the house of his father Tmu, lord of Annu, triumphant in the southern "sky. I have done what is right and true to him that hath made right and truth; I "have made the Haker festival for the lord thereof; I have led the way in the "festival; (77) I have made offerings of cakes to the lords of the altars; and I have "brought offerings and oblations, and cakes and ale, and oxen and ducks, to my father "Osiris Un-nefer. I rise up in order that my soul may be made one wholly; I cause the "bennu bird to come forth at [my] words. I have come daily into the holy house to "make offerings of incense. (78) I have brought garments of byssus. I have set forth "on the lake in the boat. I have made Osiris, the overlord of the netherworld, to be "victorious over his enemies; and I have carried away all his foes to the place of "slaughter in the East; they shall never come forth from the durance of the god Seb "therein. (79) I have made those who stand up against Rā to be still, and [I have] "made him to be victorious. I have come even as a scribe, and I have made all things "plain. I have caused the god to have the power of his legs. I have come into the "house of him that is upon his hill,[8] and I have seen him that is ruler in the sacred hall. "(80) I have gone into Re-stau; I have hidden myself, and I have found out the way; "I have travelled unto An-rutf. I have clothed those who are naked. (81) I have sailed "up to Abtu; I have praised the gods Hu and Sau. (82) I have entered into the house "of Astes, I have made supplication to the gods Khati and Sekhet in the house of Neith," or, as others say, "the rulers. I have entered into Re-stau; I have hidden myself,

[1] See Lepsius, *Todtenbuch*, pl. LXIV.

[3] *I.e.*, "Born of peace."

[5] *I.e.*, "Strong of mouth."

[7] *I.e.*, "Olive tree."

[2] *I.e.*, "Devourer."

[4] *I.e.*, "Who giveth birth to fire."

[6] *I.e.*, "Opener of ways."

[8] *I.e.*, Anubis, the god of the dead.

"and I have found out the way; I have travelled unto An-rutf. (83) I have clothed him
"who was naked. I have sailed up to Abtu ; I have glorified Hu and Sau. (84) I
"have received my crown at my rising, and I have power to sit upon my throne, upon
"the throne of my father and of the great company of the gods. I have adored the
"*meskhen* of Ta-sert. (85) My mouth uttereth words with right and with truth. I have
"drowned the serpent Ākhekh. I have come into the great hall which giveth strength
"unto the limbs ; and it hath been granted to me to sail along in the boat of Hai. The
"fragrance of *ānti* unguent ariseth from the hair of him who hath knowledge. (86) I
"have entered into the house of Astes, and I have made supplication to the gods Khati
"and Sekhet within the House of the Prince. (87) I have arrived as a favoured one in
"Tattu."

Vignette[1] [CHAPTER XVIII.—INTRODUCTION] (Upper register) : The priest
,[2] An-māut-f, who has on the right side of his head the lock of
Heru-pa-khrat, or Horus the Child, and who wears a leopard's skin, introducing
Ani and his wife to the gods whose names are given in Plates XIII. and XIV.

Text: An-māut-f saith: "I have come unto you, O mighty and godlike rulers
"who are in heaven and in earth and under the earth ; (2) and I have brought
"unto you Osiris Ani. He hath not sinned against any of the gods. Grant
"ye that he may be with you for all time."

(1) The adoration of Osiris, lord of Re-stau, and of the great company of the
gods who are in the netherworld beside Osiris, the scribe Ani, who saith : " (2)
" Homage to thee, O ruler of Amenta, Unnefer within Abtu ! I have come unto
" thee, and my heart holdeth right and truth. (3) There is no sin in my body ;
" nor have I lied wilfully, nor have I done aught with a false heart. Grant thou
" to me food in the tomb, (4) and that I may come into [thy] presence at the altar
" of the lords of right and truth, and that I may enter into and come forth from the
" netherworld (my soul not being turned back), and that I may behold the face of
" the Sun, and that I may behold the Moon (5) for ever and ever."

Vignette (Lower register) : The priest Se-mer-f,[3] who has on
the right side of his head the lock of Heru-pa-khrat and wears a leopard's skin,
introducing Ani and his wife to the gods whose names are given in Plates XIII.
and XIV.

[1] This and its companion vignette and the vignettes of Plates XIII.–XIV. form one composition.
[2] Osiris is also called Ån-māut-f ; see Lepsius, *Todtenbuch*, chap. cxlii., l. 7.
[3] For the functions of this priest see above, p. 268.

Text : Se-mer-f saith : " (1) I have come unto you, O godlike rulers who " are in Re-stau, and I have brought unto you Osiris Ani. Grant ye [to him], as " to the followers of Horus, cakes and water, and air, and a homestead in " Sekhet-Hetep."[1]

(1) The adoration of Osiris, the lord of everlastingness, and of all the godlike rulers of Re-stau, by Osiris, [the scribe Ani], who (2) saith : " Homage to thee, " O king of Amenta, prince of Akert, I have come unto thee. I know thy ways, " (3) I am furnished with the forms which thou takest in the underworld. Grant " thou to me a place in the underworld near unto the lords (4) of right and truth. " May my homestead be abiding in Sekhet-ḥetep, and may I receive cakes in thy " presence."

PLATE XIII.

Vignettes (Upper register) : A pylon, or gateway, surmounted by the feathers of Māat and uræi wearing disks. (Lower register) : A pylon, surmounted by Anubis 🐕 and an *utchat* 👁.

Text [Chapter XVIII.]: [" (1) Hail Thoth, who madest Osiris (2) victorious " over his enemies, make thou Osiris [the scribe Ani] to be victorious over " his enemies, as thou didst make Osiris victorious over his enemies, in the " presence of (3) the godlike rulers who are with Rā and Osiris in Annu, on the " night of ' the things for the night,'[2] and on the night of battle, and (4) on the " shackling of the fiends, and on the day of the destruction of Neb-er-tcher."][3]

§ A. **Vignette :** The gods Tmu, Shu, Tefnut, Osiris,[4] and Thoth.

Text : (1) The great godlike rulers in Annu are Tmu, Shu, Tefnut [Osiris, and Thoth], (2) and the shackling of the Sebau signifieth the destruction of the fiends of Set when he worketh evil (3) a second time.

" Hail, Thoth, who madest Osiris victorious over his enemies, make thou the " Osiris (4) Ani to be victorious over his enemies in the presence of the great " divine beings who are in Tattu, on the night of making the Tat to stand up in " Tattu."

[1] *I.e.*, the Fields of Peace.
[2] The words are explained to mean, "the daybreak on the sarcophagus of Osiris."
[3] This section, omitted in the Ani papyrus, is supplied from the papyrus of Nebseni.
[4] This god is omitted from the copy of this chapter given on Plate XXIII.

§ B. **Vignette :** The gods Osiris, Isis, Nephthys, and Horus.

Text : (1) The great godlike rulers in Tattu are Osiris, Isis, Nephthys, and Horus, the avenger of his father. Now the "night of making the Tat to stand (2) up in Tattu" signifieth [the lifting up of] the arm and shoulder of Osiris, lord of Sekhem ; and these gods stand behind Osiris [to protect him] even as the swathings which clothe[1] him.

(3) " Hail, Thoth, who madest Osiris victorious over his enemies, make thou " the Osiris Ani triumphant over his enemies (4) in the presence of the great " godlike rulers who are in Sekhem, on the night of the things of the night " [festival] in Sekhem."

§ C. **Vignette :** The gods Osiris and Horus, two *utchats* upon pylons, and the god Thoth.

Text : (1) The great godlike rulers who are in Sekhem are Horus, who is without sight, and Thoth, who is with the godlike rulers in Naarerutf. (2) Now the " night of the things of the night festival in Sekhem " signifieth the light of the rising sun on the coffin of Osiris.

" Hail, Thoth, who madest Osiris victorious (3) over his enemies, make thou the " Osiris Ani triumphant over his enemies in the presence of the great godlike " rulers in Pe and Tep,[2] on the (4) night of setting up the columns of Horus, and " of making him to be established the heir of the things which belonged to his " father."

§ D. **Vignette :** The gods Horus, Isis, Mesthà and Ḥāpi.

Text : (1) The great divine rulers who are in Pe and Tep are Horus, Isis, Mesthà, and Ḥāpi. Now "setting up the columns (2) of Horus" [signifieth] the command given by Set unto his followers : " Set up columns upon it."

" Hail, Thoth, who madest Osiris victorious over his enemies (3), make thou " the Osiris Ani triumphant over his enemies in the presence of the great godlike

[1] The papyrus of Nebseni reads :— [hieroglyphs] . " Now the setting up of the double Tat signifieth the two shoulders and arms of Horus, lord of Sekhem ; and they stand behind Osiris even as the swathings which clothe him."

[2] See Brugsch, *Dict. Géog.*, p. 213.

"rulers in Rekhit, on the (4) night when Isis lay down to keep watch in
" order to make lamentation for her brother Osiris."

§ E. **Vignette :** (1) The gods Isis, Horus, Anubis,[1] Mesthá, and Thoth.

Text : (1) The great godlike rulers who are in Rekhit are Isis, Horus,
and Mesthá.

" Hail, Thoth, who madest Osiris victorious (2) over his enemies, make thou the
" Osiris, the scribe Ani (triumphant in peace !), to be victorious over his enemies
" in the presence of the great godlike ones (3) who are in Abtu, on the night of
" the god Naker, at the separation of the wicked dead, at the judgment of spirits
" made just, (4) and at the arising of joy in Tenu."[2]

PLATE XIV.

§ F. **Vignette :** The gods Osiris, Isis, and Ap-uat, and the Ṭet.

Text [Chapter XVIII.] : (1) The great godlike rulers who are in Abtu
are Osiris, Isis, and Ap-uat.

" Hail, Thoth, who madest Osiris victorious (2) over his enemies, make thou the
" Osiris Ani, the scribe and teller of the sacred offerings of all the gods, to be
" victorious (3) over his enemies in the presence of the godlike rulers who judge the
" dead, on the night of (4) the condemnation of those who are to be blotted out."

§ G. **Vignette :** The gods Thoth, Osiris, Anubis, and Astennu.[2]

Text : (1) The great godlike rulers in the judgment of the dead are Thoth,
Osiris, Anubis, and Astennu. Now (2) the " condemnation of those who are to be
blotted out " is the withholding of that which is so needful to the souls of the
children of impotent revolt.

" (3) Hail, Thoth, who madest Osiris victorious over his enemies, make thou
" the Osiris, the scribe Ani (triumphant !), to be victorious over his enemies in the

[1] Omitted on Plate XXIV.

[2] ⌂)\\ or ≈ 🦆 𓎡 ⊗, the capital of the eighth nome of Upper Egypt, situated near
Abydos, and probably represented by the modern village of Kûm es-Sulṭân. It is the Θιc of the
Coptic writers. See Brugsch, *Dict. Géog.*, p. 951 ; and Amélineau, *La Géographie de l'Égypte*, p. 500.

"presence of the great godlike rulers, (4) on the festival of the breaking and
"turning up of the earth in Tattu, on the night of the breaking and turning up of
"the earth in their blood and of making Osiris to be victorious over his enemies."

§ H. **Vignette**: The three gods of the festival of breaking up the earth
in Tattu.

Text: (1) When the fiends of Set come and change themselves into beasts,
the great godlike rulers, on the festival of the breaking and turning up of the
earth in Tattu, (2) slay them in the presence of the gods therein, and their blood
floweth among them as they are smitten down. (3) These things are allowed to
be done by them by the judgment of those who are in Tattu.

"Hail, Thoth, who madest Osiris victorious over his enemies, make thou the
"Osiris Ani to be victorious over his enemies in the presence of the godlike rulers
"(4) who are in Naȧruṭef, on the night of him who concealeth himself in divers
"forms, even Osiris."[1]

§ I. **Vignette**: The gods Rā, Osiris, Shu, and Bebi,[2] dog-headed.

Text: (1) The great godlike rulers who are in Naȧruṭef are Rā, Osiris, Shu,
and Bebi.[3] Now the "night of him who concealeth himself in divers forms, even
Osiris," is when the thigh [and the head], and the heel, and the leg, are
brought nigh unto the coffin of Osiris Un-nefer.

"Hail, Thoth, who madest Osiris victorious (3) over his enemies, make thou
"the Osiris Ani (triumphant before Osiris) victorious over his enemies in the
"presence of the great godlike rulers who are in (4) Re-stau, on the night when
"Anubis lay with his arms and his hands over the things behind Osiris, and
"when Horus was made to triumph over his enemies."

§ J. **Vignette**: The gods Horus, Osiris, Isis, and (?)

[1] Var. 〰 ⌷ _en seśeta āā àru_, "of making to be hidden the
one mighty of forms" (_i.e._, Osiris). See Naville, _Todtenbuch_, Bd. II., Bl. 81.

[2] Also written ⌷ = ⌷ = ⌷ ; see Brugsch,
Wörterbuch, p. 387 ; Lanzone, _Dizionario_, p. 197.

[3] Var. ⌷ Ababi.

Text : (1) The great godlike rulers in Re-stau are Horus, Osiris, and Isis. The heart of Osiris rejoiceth, and the heart of Horus (2) is glad ; and therefore are the east and the west at peace.

" Hail Thoth, who madest Osiris victorious over his enemies, (3) make thou the " Osiris Ani, the scribe and teller of the divine offerings of all the gods, to triumph " over his enemies in the presence of the ten (4) companies of great godlike rulers " who are with Rā and with Osiris and with every god and goddess in the " presence of Neb-er-tcher. He hath destroyed his (5) enemies, and he hath " destroyed every evil thing belonging unto him."

Rubric : This chapter being recited, the deceased shall come forth by day, purified after death, and [he shall make all] the forms[1] (or transformations) which his heart shall dictate. Now if this chapter be recited over him, he shall come forth[2] upon earth, he shall escape from every fire ; and none of the foul things which appertain unto him shall encompass him for everlasting[3] and for ever and for ever.

PLATE XV.

Vignette : A seated statue of Ani, the scribe, upon which the ceremony of " opening the mouth "[4] ⸗ *un re*, is being performed by the *sem*[5] priest, clad in a panther's skin and holding in his right hand the instrument *Ur ḥeka*[6] , *i.e.,* " mighty one of enchantments." In front of the statue are : the

[1] Var. ⸗ *àrit χeperuf.*

[2] The Papyrus of Nebseni has the better reading ⸗ *uťa pu ţep ta,* " he shall be in a good state upon earth."

[3] Brugsch renders *em shes maāt* by " sicut æquum et justum est " ; *Wörterbuch* (Supp.), p. 1203.

[4] For a description of this ceremony, see above, pp. 264–270.

[5] Compare ⸗ Naville, *Todtenbuch*, Bd. I., Bl. 34. In British Museum papyrus No. 10,470, sheet 8, the god Horus performs this ceremony upon the deceased, who is seated upon a stool.

[6] See above, p. 264.

sepulchral chest ⊟, the instruments ✕ 🐟 ⌐ Seb-ur, ▭ ⏜ Ṭun-ṭeṭ, and 𓏤 ▭ Temānu, and the object ▭ ∿ 🦆 𝑌 Pesh-en-kef.[1]

Text [CHAPTER XXIII.]: (1) THE CHAPTER OF OPENING THE MOUTH OF OSIRIS, THE SCRIBE ANI. To be said:[2] " May Ptaḥ open my mouth, and may " the god of my town[3] loose the swathings, even the swathings[4] which are over " my mouth (2). Moreover, may Thoth, being filled and furnished with charms, " come and loose the bandages, the bandages of Set which fetter my mouth (3); " and may the god Tmu hurl them[5] at those who would fetter [me] with them, " and drive them back. May my mouth be opened, may my mouth be unclosed " by Shu[6] (4) with his iron[7] knife, wherewith he opened the mouth of the gods. " I am Sekhet,[8] and I sit upon the great western side of heaven. (5) I am the " great goddess Saḥ[9] among the souls of Annu. Now as concerning every charm " and all the words which may be spoken against me (6), may the gods resist " them, and may each and every one of the company of the gods withstand " them."[10]

Text [CHAPTER XXIV.]: (1) THE CHAPTER OF BRINGING CHARMS UNTO OSIRIS ANI [IN NETER-KHERT]. [He saith]: " I am Tmu[11]-Kheperȧ, who gave " birth unto himself upon the thigh of his divine mother.[12] Those who are in Nu[13] " are made wolves, and those who are among the godlike rulers (3) are become

[1] See above, p. 264. [2] Var., 𓆓 ✕⌐ " he saith."

[3] Var., " By Amen, the god of my town"; Lepsius, *Todtenbuch*, Pl. xiv.

[4] Var., ∿ ⌐\\ 𓅓 netiu.

[5] Var., " May Tmu give me my hand to shoot them at those who fetter [me]. May my mouth be given to me, may my mouth be opened."

[6] Var., ▯𓎡 Ptaḥ.

[7] Literally " iron of heaven " (*bàat en pet* = Copt. ⲂⲈⲚⲒⲠⲈ); for discussions on the word, see Dümichen, *Aeg. Zeit.*, 1874, p. 49, and the authorities quoted by Brugsch, *Wörterbuch* (Suppl.), p. 416.

[8] The papyrus of Nebseni adds 𓏤𓏏𓏏⌐𓏏 Uatchit.

[9] Var., 𓏤𓅱𓏏𓏏⌐𓏏✕𓏏 .

[10] Var., " Them may the gods resist, and all the company of my gods, and all the company of their gods."

[11] Many papyri omit Tmu.

[12] Birch, " on the lap of his mother "; Pierret, " en haut de la cuisse de sa mère."

[13] *I.e.*, the sky.

"hyenas.[1]　Behold, I gather together the charm from every place where it is and
"from every man with whom it is,[2] swifter than greyhounds and fleeter than light.
"(4) Hail thou who towest along the *mākhent* boat of Rā, the stays of thy sails
"and of thy rudder are taut in the wind as thou sailest over the Lake of Fire in
"Neter-khert.　Behold, thou gatherest together the charm (5) from every place
"where it is and from every man with whom it is, swifter than greyhounds and
"fleeter than light, [the charm] which createth the forms of existence from the (6)
"mother's thigh (?) and createth the gods from (*or* in) silence, and which giveth
"the heat of life unto the gods.[3]　Behold, the charm is given unto me from
"wheresoever it is [and from him with whom it is], swifter than greyhounds and
"fleeter than light," or, (as others say), "fleeter than a shadow."

Appendix : The following chapter, which generally appears in other early
copies of the Book of the Dead, is closely connected with the preceding chapter.
It is here taken from the Papyrus of Nebseni.

(1) [CHAPTER XXV.] THE CHAPTER OF CAUSING THE DECEASED TO REMEMBER
HIS (2) NAME IN NETER-KHERT.　[He saith]: "May my name be given unto me in
"the great Double House, and may I remember my name in the House of Fire on
"the (3) night of counting the years' and of telling the number of the months.　I am
"with the Holy One, and I sit on the eastern side of heaven.　If any god advanceth unto
"me, (4) forthwith I proclaim his name."

Vignette : The scribe Ani, clothed in white, and with his heart in his right
hand, addressing the god Anubis.[4]　Between them is a necklace of several rows of

[1] Var., ⟨hieroglyphs⟩ *beḥiu*, an animal whic his identified with the *hyaena croenta* by Hart-
mann (see *Aeg. Zeit.*, 1864, p. 12, col. 2).

[2] Reading with the Nebseni papyrus ⟨hieroglyphs⟩.

[3] Here the text is different from any given by Naville.　The chief variants are : ⟨hieroglyphs⟩
⟨hieroglyphs⟩, "which createth the
gods from (*or* in) silence, and which maketh them powerless"; and ⟨hieroglyphs⟩
⟨hieroglyphs⟩, "which maketh the gods to speak [from being] silent,
and which maketh them speechless."

[4] In the vignettes of this chapter published by M. Naville (*Todtenbuch*, Bd. I., Bl. 38) the

coloured beads, the clasp of which is in the shape of a pylon or gateway, and to which is attached a pectoral bearing a representation of the boat of the sun, wherein is set a scarab, emblematic of the sun.[1]

Text [CHAPTER XXVI.] : (1) CHAPTER OF GIVING A HEART UNTO OSIRIS ANI (2) IN THE UNDERWORLD. [Ani saith] : "May my heart be with me in the "House of Hearts.[2] May my heart be with me, and may it rest in [me], or I "shall not eat of the cakes of Osiris on the eastern[3] side of the Lake of "Flowers,[4] (3) [neither shall I have] a boat wherein to go down the Nile, and "another wherein to go up, nor shall I go forward in the boat with thee. May "my mouth be given unto me that I may (4) speak with it, and my two feet to "walk withal, and my two hands and arms to overthrow my foe. May the doors "of heaven be opened unto me5; may Seb, the Prince of the gods, open wide "his two jaws unto me ; may he open my two eyes which are blinded ; may he "cause me to stretch out my (6) feet which are bound together ; and may Anubis "make my legs firm that I may stand upon them. May the goddess Sekhet "make me to rise (7) so that I may ascend unto heaven, and there may that be "done which I command in the House of the *Ka* of Ptaḥ.[6] I know my heart, I "have gotten the mastery over (8) my heart, I have gotten the mastery over "my two hands and arms, I have gotten the mastery over my feet, and I have "gained the power to do whatsoever my *ka* pleaseth. (9) My soul shall not be "shut off from my body at the gates of the underworld ; but I shall enter in "peace, and I shall come forth in peace."

deceased is represented : (1) seated, and addressing his heart, which stands on a support ; (2) standing, holding in his hands a heart, which he offers to three deities. Another vignette represents a priest tying a heart on to a statue of the deceased ; and in the late recension of the Book of the Dead published by Lepsius (Bl. 15) the deceased holds a heart to his left side and addresses a human-headed hawk emblematic of the soul.

[1] A very fine set of examples of blue, green, and yellow glazed *faïence* pectorals inlaid with scarabs is exhibited in the Fourth Egyptian Room.

[2] *I.e.*, the Judgment hall of Osiris, in which hearts were weighed.

[3] Var. "West."

[4] On the word see Brugsch, *Wörterbuch* (Suppl.), p. 1289, and Stern, *Glossarium*, p. 19, col. 2, where the various kinds of this sweet-smelling plant are enumerated.

[5] Var. "May my two hands open [my] mouth in the earth ": Naville, *Todtenbuch*, Bd. II., Bl. 90.

[6] *I.e.*, the heavenly Memphis.

Text: [Chapter XXXb.]. (1) The Chapter[1] of not letting (2) the heart of Osiris, the scribe of the sacred offerings of all the gods, Ani, triumphant, be driven from him in the underworld. Ani saith: "My heart, "my mother; my heart, my mother (3). My heart whereby I come into being. "May there be nothing to withstand me at [my] judgment; may there be no "resistance against me by the Tchatcha; may there be no parting of thee from me "in the presence of him who keepeth the Scales! Thou art my *ka* within (4) "my body, [which] knitteth and strengtheneth my limbs. Mayest thou come "forth in the place of happiness [to which] I advance. May the *Shenit*,[2] who "make men to stand fast, not cause my name to stink."[3]

Vignette: Ani holding his soul in the form of a human-headed bird.

Text: [Chapter LXI.] (1) Chapter of not letting the soul of a man be taken away from him in the underworld. Osiris the scribe Ani saith: "I, "even I, am he (2) who came forth from the water-flood which I make to "overflow and which becometh mighty as the River [Nile]."

Appendix: In many early papyri the text of Chapter LXI. forms part of a longer composition which M. Naville calls Chapters LXI.,[4] LX.,[5] and LXII.,[6] and which reads:—

(1) Chapter of drinking water in the underworld. [He saith]: "I, even I, am he who cometh forth from (2) Seb. The flood hath been given unto him,

[1] This chapter is usually accompanied by a vignette. In that in the papyrus of Nebseni the deceased is being weighed against his own heart; an ape, "Thoth, lord of the Balance," seated on a pedestal, holds the tongue of the balance. In British Museum Papyrus No. 9964 the deceased is also weighed against his own heart, but at the same time a figure of himself is also watching the process. In the papyrus of Sutimes a square weight lies in each pan of the scales. Other vignettes have simply a scarab, or the deceased addressing his heart, which rests on a standard ☥. See Naville, *Todtenbuch*, Bd. I., Bl. 43.

[2] A class of divine beings.

[3] The chapter as here given is incomplete; the missing words are : [hieroglyphs]

[hieroglyphs] "pleasant for us, pleasant is the hearing, and there is gladness of heart at the weighing of words. Let not lies be spoken against me near the god, in the presence of the great god, the lord of Amentet. Verily, how great shalt thou be when thou risest up in triumph!"

[4] The vignette represents the deceased on his knees embracing his soul.

[5] Vignette: a man kneeling and holding a lotus.

[6] Vignettes: the deceased scooping water with his hands out of a tank, [hieroglyph].

" and he hath gotten power over it as Ḥāpi I, even I, open the (3) two doors of
" heaven : and the two doors of the watery abyss have been opened unto me by Thoth
" and by Ḥāpi, the divine twin sons of heaven, (4) who are mighty in splendours.
" O grant ye that I may gain power over the water, even as Set overcame his foes on the
" day(?) (5) when he terrified the world. I have passed by the great ones shoulder
" against shoulder, even as they have passed by that great and splendid god who is (6)
" provided [with all things] and whose name is unknown. I have passed by the mighty
" one of the shoulder. (7) The flood of Osiris hath been passed through by me, and
" Thoth-Ḥāpi-Tmu, the lord of the horizon, hath opened unto me the flood in his name,
" ' Thoth, the cleaver of the earth.' (8) I have gained power over the water, even as Set
" gained power over his foes. I have sailed over heaven. I am Rā. I am the Lion-god.
" I am the young bull (9). I have devoured the Thigh, I have seized the flesh. I have
" gone round about the streams in Seket-Aru. Boundless eternity hath been granted
" unto me, and, behold, (10) I am the heir of eternity ; to me hath been given ever-
" lastingness."

Closely connected with the above chapter are the two following short
chapters :—[1]

Vignette : The deceased drinking water from a running stream.

Text [CHAPTER LXIIIA.]: (1) THE CHAPTER OF DRINKING WATER AND OF NOT
BEING BURNED IN THE FIRE. [The deceased] saith : " Hail, Bull of Amenta. I am
" brought unto thee, I am the oar of Rā (3) wherewith he ferried over the aged ones ; let
" me not be buried nor consumed. I am Beb,[2] (4) the first-born son of Osiris, who doth
" wash every god within his eye in Annu. I am the Heir, (5) the exalted (?), the mighty
" one, the Still [of Heart]. I have made my name to flourish, and I have delivered [it],
" that I may make myself to live [in remembrance] on this day."

Vignette : The deceased standing near flames of fire 𓊹𓊹.

Text [CHAPTER LXIIIB.]: (1) THE CHAPTER OF NOT BEING SCALDED WITH
WATER. [He saith] : " I am the oar (2) made ready for rowing, wherewith Rā ferried
" over the Aged godlike ones. (3) I carry the moistures of Osiris to the lake away from
" the flame which cannot be passed (4) ; he is turned aside from the path thereof and he
" is not burned in the fire. I lie down with the *hamemu* ; (5) I come unto the Lion's
" lair, killing and binding ; and I follow the path by which he came forth."

Vignette : Ani carrying a sail, emblematic of breath and air.

Text [CHAPTER LIV.]: (1) CHAPTER OF GIVING BREATH IN THE UNDERWORLD.
Saith Osiris Ani : " I am the Egg of the Great Cackler, and I watch and guard that

[1] For the texts see Naville, *Todtenbuch*, Bd. I., Bll. 73, 74.

[2] The variants are 𓏱𓅯 𓏱𓅯 𓅆𓏏 𓅆𓏏, and 𓂋𓅆.

"great place[1] (2) which the god Seb hath proclaimed upon earth. I live; and it
"liveth; I grow strong, I live, I sniff the air. I am (3) Utcha-aāb,[2] and I go round
"behind [to protect] his egg. I have thwarted the chance of Set, the mighty one
"of strength. (4) Hail thou who makest pleasant the world with *tchefa* food, and
"who dwellest in the blue [sky]; watch over the babe in his cot when he cometh
"forth unto thee."

Appendix: The two following chapters, which are closely connected with
the preceding chapter, are respectively supplied from Naville, *Todtenbuch*, Bd. I.,
Bl. 67, and the Nebseni Papyrus.

Vignette: Anubis leading the deceased into the presence of Osiris.

Text: [CHAPTER LV.]: (1) ANOTHER CHAPTER OF GIVING BREATH. [He
saith]: "I am Sabsabu. I am Shu. (2) I draw in the air in the presence of the god
"of sunbeams as far as the uttermost ends of heaven, as far as the ends of the earth, as
"far as the bounds of Shu (3); and I give breath unto those who become young [again].
"I open my mouth, and I see with mine eyes."[3]

Vignette: A man holding a sail in his left hand.

Text: [CHAPTER LVI.]: CHAPTER OF SNIFFING THE AIR UPON EARTH. [He
saith]: "(2) Hail, Tmu, grant thou unto me the sweet breath which is in thy two
"nostrils. I embrace the mighty throne which is in Unnu,[4] and I watch and guard the
"Egg of the Great Cackler. I grow, and it groweth; it groweth, and I grow; I live, and
"it liveth; I sniff the air, and it sniffeth the air."

Vignette: Ani standing, with a staff in his left hand.

Text [CHAPTER XXIX.]: (1) THE CHAPTER OF NOT LETTING THE HEART
OF A MAN BE TAKEN AWAY FROM HIM IN THE UNDERWORLD. Saith Osiris Ani,
"triumphant: "Turn thou back, O messenger of all the gods. (2) Is it that thou
"art come to carry away[5] this my heart which liveth? My heart which liveth

[1] The text of Lepsius gives ⟨hieroglyphs⟩ "I guard that great
egg," *etc.*

[2] The variant text given by Naville indicates by ⟨hieroglyph⟩ that these words are the name or title of a god.
Birch translates them by "Discriminator of Purity," and Pierret by "le sauvé dont le nom est pur."

[3] For the texts see Naville, *Todtenbuch*, Bd. I., Bll. 67, 68, 69.

[4] Hermopolis.

[5] In a variant vignette given by Naville the deceased holding his heart in both hands offers it to
three gods; and in another a man is about to fasten a necklace with a pendent heart to the statue of
the deceased.

"shall not be given unto thee. (3) [As I] advance, the gods give ear unto my
"supplications, and they fall down upon their faces wheresoever they be."

PLATE XVI.

Vignette : Ani standing, with both hands raised in prayer, before four gods
who are seated on a pedestal in the form of ⬛, Maāt; before him is his heart
set upon a pedestal ⚱.

Text [CHAPTER XXVII.]: (1) THE CHAPTER OF NOT LETTING THE HEART
OF A MAN BE TAKEN AWAY FROM HIM IN THE UNDERWORLD.[1] Saith Osiris Ani:
"Hail, ye who carry away hearts, [hail] ye who steal hearts! (2) ye have
"done.[2] Homage to you, O ye lords of eternity, ye possessors of everlastingness,
"take ye not away this heart of Osiris Ani (3) in your grasp, this heart of
"Osiris. And cause ye not evil words to spring up against it; because this heart
"of Osiris Ani is the heart of the one of many names, the mighty one whose
"words are his limbs, and who sendeth forth his heart to dwell in (4) his body.
"The heart of Osiris Ani is pleasant unto the gods; he is victorious, he hath
"gotten power over it; he hath not revealed what hath been done unto it. He
"hath gotten power (5) over his own limbs. His heart obeyeth him, he is the
"lord thereof, it is in his body, and it shall never fall away therefrom. I, Osiris,
"the scribe Ani, victorious in peace, and triumphant in the beautiful Amenta and
"on the mountain of eternity, bid thee be obedient unto me in the underworld."

Appendix : The three following chapters, which do not occur in the Ani
papyrus, form part of the group of the chapters relating to the heart. They are
here supplied from Naville, *Todtenbuch*, Bd. I., Pl. xl., xlii., xxxix.

[1] In Naville's edition there follow the words ⟦hieroglyphs⟧ *hab-nef âb-f χenti χat-f temam âb-f er neteru seχem
âm-f*, "his heart goeth to inhabit his body; his heart is perfect before the gods, he gaineth possession
of it."

[2] The reading of Naville's edition is better here. ⟦hieroglyphs⟧ "Ye who steal hearts, and who make
the heart of a man to come into existence according to that which hath been done by him; may it (*i.e.*,
his heart) be made strong by you."

Text [Chapter XXIXa.]:[1] (1) The Chapter of the heart not being carried away in the underworld. He saith: "My heart (2) is with me, and it shall "never come to pass that it shall be carried away. I am the lord of hearts, the slayer of "the heart. (3) I live in right and in truth, and I have my being therein. I am Horus, "a pure heart (4) within a pure body. I live by my word, and my heart doth live. Let "not my heart be taken away (5), let it not be wounded, and may no wounds or gashes "be dealt upon me because it hath been taken away[2] from me. (6) May I exist in the "body of my father Seb, and in the body of my mother Nut. I have not done evil (7) "against the gods; I have not sinned with boasting."

Vignette : The deceased adoring a heart <img_ref id="inline1" />.

Text [Chapter XXXa.]: (1) The Chapter of not (2) letting the heart of a man be driven away from him in the underworld. [He saith]: "My "heart, my mother; my heart, my mother. My heart of my life upon earth. May "naught rise up (3) against me in judgment in the presence of the lord of the trial; "let it not be said concerning me and of that which I have done, 'He hath done deeds "against that which is right and true'; may naught be against me in the presence of "the great god, (4] the lord of Amenta. Homage to thee, O my heart! Homage to "thee, O my heart! Homage to you, O my reins![3] Homage to you, O ye gods who "rule over the divine clouds, and who (5) are exalted by reason of your sceptres; speak "ye comfortably unto Rā, and make me to prosper before Nehebka." And behold him, even though he be joined to the earth in the innermost parts thereof, and though he be laid upon it, he is not dead in Amenta, but is a glorified being therein.

Vignette : The deceased holding his heart to his breast with his left hand, and kneeling before a monster with a knife in its hand.

Text [Chapter XXVIII.]: (1) [The Chapter of] not letting the heart of the deceased be carried away in the underworld. [Saith he]: (2) "Hail, "Lion-god! I am Un.[4] That which I hate is the block of the god. Let not this my "heart be taken away from me by (3) the Fighter[5] in Annu. Hail thou who dost bind "Osiris, and who hast seen Set! Hail thou who returnest after smiting and destroying "him. (4) This heart sitteth and weepeth in the presence of Osiris; it hath with it the staff "for which it entreated him. May there be given unto me for it, may there be decreed "unto me for it the hidden things[6] of the heart in the (5) house of Usekh-ḥrȧ; may

[1] See Naville, *Todtenbuch*, Bd. I., Bl. 40.

Understanding some word like <img_ref id="fn1" /> ; see the text in Lepsius.

[3] Brugsch believes that the word <img_ref id="fn3" /> means the liver or kidneys, or some special organ ; see *Wörterbuch*, p. 421.

[4] Reading <img_ref id="fn4" /> ; another variant has "I am Rā."

[5] *I.e.*, the being represented in the vignette.

[6] Var. <img_ref id="fn6" /> *ta ȧb*, "warmth of heart."

" there be granted unto it food at the bidding of the Eight.[1] Let not this my heart be
" taken from me ! I make thee to dwell in thy place, joining together hearts in (6) Sekhet-
" hetepu, and years of strength in all places of strength, carrying away food (?) at thy
" moment with thy hand according to thy great strength. My heart is placed upon the
" altars of Tmu (7), who leadeth it to the den of Set ; he hath given unto me my heart,
" whose will hath been done by the godlike rulers in Neter-khert. When they find the
" leg[2] and the swathings they bury them."

Vignette : Ani and his wife Thuthu, each holding the emblem of air ⳥
in the left hand, and drinking water with the right from a pool, ▭, on the
borders of which are palm trees laden with fruit.

Text [CHAPTER LVIII.] : (1) THE CHAPTER OF BREATHING THE AIR AND OF
HAVING POWER OVER THE WATER IN THE UNDERWORLD. Saith Osiris Ani : " Open to
" me ! Who art thou then, and whither dost thou fare ? (2) I am one of you. Who is
" with thee ? It is Merti. Separate thou from him, each from each, when thou
" enterest the Mesqen. He letteth me sail to the temple of the divine beings
" who have found their faces (?). (4) The name of the boat is ' Assembler of
" Souls ' ; the name of the oars is ' Making the hair to stand on end ' ; the name
" of the hold is ' Good ' ; (5) and the name of the rudder is ' Making straight for
" the middle '[3] (6) Grant ye to me vessels of milk together
" with cakes, loaves of bread, cups of drink, and flesh in the temple of (7)
" Anubis."

Rubric : If this chapter be known [by Ani] he shall go in after having come
forth from the underworld.

Vignette : Ani kneeling beside a pool of water ▭, where grows a sycamore
tree ; in the tree appears the goddess Nut pouring water into Ani's hands from a
vessel ⳤ.

[1] Var. ⟨hieroglyphs⟩ *Re χemennu*, " Mouth of Hermopolis."

[2] This meaning is indicated by the determinative in the variant given by Naville, *Todtenbuch*,
Bd. II., Bl. 95. The whole sentence may be a rubrical direction.

[3] The text here appears to be corrupt, or at least some words have been omitted, for the equivalent
passage in Lepsius reads ⟨hieroglyphs⟩ ⟨hieroglyphs⟩. The variant reading indicated by ⟨hieroglyph⟩ *ki t'et*
shows that this passage offered difficulties to the ancient Egyptian readers.

Text [Chapter LIX.]: (1) The Chapter of sniffing the air, and of getting power over the waters in the underworld. Saith Osiris Ani: "Hail, " sycamore tree of the goddess Nut! Grant thou to me of the water and the " air which are in (2) thee. I embrace thy throne which is in Unnu,[1] and I watch " and guard (3) the egg of the Great Cackler. It groweth, I grow ; it liveth, I " live ; (4) it sniffeth the air, I sniff the air, I the Osiris Ani, in triumph."

Vignette : Ani seated upon a chair before a table of offerings, ;[2] in his right hand he holds the *kherp* sceptre ,[3] and in his left a staff.

Text [Chapter XLIV] : (1) The Chapter of not dying a second time in the underworld.[4] Saith Osiris Ani : " My place of hiding is opened, my place of " hiding is revealed ! Light hath shone (2) in the darkness. The eye of Horus hath " ordered my coming into being, and the god Apuat hath nursed me. I have " hidden (3) myself with you, O ye stars that never set. My brow is like unto " that of Rā ; my face is open ; (4) my heart is upon its throne ; I utter words, " and I know ; in very truth, I am Rā himself. I am not treated with scorn, " (5) and violence is not done unto me. Thy father, the son of Nut, liveth for " thee. I am thy first-born, (6) and I see thy mysteries. I am crowned like " unto the king of the gods, and I shall not die a second time in the under- " world."

Vignette : The mummy of Ani embraced by Anubis, the god of the dead.

Text [Chapter XLV.]: (1) The Chapter of not corrupting in the underworld. Saith Osiris Ani : " O thou who art without motion like unto " Osiris ! O thou who art without motion like unto Osiris ! (2) O thou whose

[1] *I.e.*, Hermopolis.

[2] For an account of the manner in which altars and other objects were represented on Egyptian monuments, see Borchardt, *Die Darstellung innen verzierter Schalen aus Aegyptischen Denkmälern* (in *Aeg. Zeitschrift*, Bd. XXXI., 1893, p. 1).

[3] For a *kherp* sceptre in bronze, see No. 22,842 in the 2nd Egyptian Room.

[4] Chapters CLXXV. and CLXXVI. bear the same title. For Chapter CLXXV. see Plate XXIX. Chapter CLXXVI. (Naville, *Todtenbuch*, Bd. I., Pl. cc.) reads :—

" What I hate is the land of Abydos. May I never enter into the den, and may there never be " done unto me any of those things which the gods hate, for I am pure within the Mesqet. May " Neb-er-tcher give unto me his splendours on the day of the funeral in the presence of the Lord " of Things."

" If this chapter be known [he] shall be in the condition of one who is acquitted in the under- " world."

" limbs are without motion like unto [those of] Osiris! Let not thy limbs be
" (3) without motion, let them not corrupt, let them not pass away, let them not
" decay; let it be (4) done unto me even as if I were the god Osiris."

Rubric: If this chapter be known by the Osiris Ani, he shall not corrupt in
the underworld.

Vignette: A doorway. By one post stands the soul of Ani in the form of
a human-headed hawk , and by the other the bird .

Text: [CHAPTER XLVI.] (1) THE CHAPTER OF NOT PERISHING AND OF
BECOMING ALIVE IN THE UNDERWORLD. Saith Osiris Ani: " Hail, (2) children of
" Shu! Hail, children of Shu, [children of] the place of the dawn, who as the
" children of light have gained possession of his crown. May I rise up and
" may I fare forth like Osiris."

Vignette: Ani the scribe standing with his back to a block and knife .

Text: [CHAPTER XL.] (1) THE CHAPTER OF NOT ENTERING IN UNTO THE
BLOCK. Saith Osiris Ani: " The four bones[1] of my neck and of my back are
" joined together for me in heaven by Rā, the guardian of the earth. (2) This
" was granted on the day when my rising up out of weakness upon my two
" feet was ordered, on the day (3) when the hair was cut off. The bones of my
" neck and of my back have been joined together by Set and by the company of
" the gods, even as they were (4) in the time that is past; may nothing happen
" to break them apart. Make ye [me] strong against my father's murderer. I
" have gotten power over the two earths. Nut hath joined together my bones,
" and [I] behold [them] as they were in the time that is past [and I] see [them]
" even in the same order as they were [when] the gods had not come into being
" (6) in visible forms.[2] I am Penti, I, Osiris the scribe Ani, triumphant, am the
" heir of the great gods."

PLATE XVII.

Vignette: Ani standing in adoration before three gods, each of whom holds
a sceptre in his left hand, and the symbol of life in his right.

[1] Adding llll *θest ftu*, from the papyrus of Nebseni.

[2] Var. *āχemu*. On this word see Brugsch, *Wörterbuch* (Suppl.), p. 279.

Text [Chapter XCIII.]: (1) The Chapter of not letting a man pass over to the east in the underworld. Saith Osiris Ani: "Hail, manhood of (2) " Rā, which advanceth and beateth down opposition ; things which have been " without movement for millions of years come into being through the god Baba. " Hereby am I made stronger than (3) the strong, and hereby have I more power " than they who are mighty. And therefore neither shall I be borne away nor " carried by force to the East, to take part in the festivals of the fiends ; (4) nor " shall there [be given unto me] cruel gashes with knives, nor shall I be shut in " on every side, nor gored by the horns [of the god Kheperà]"[1]

Vignette : Ani adoring a god in a boat whose head is turned face backwards.

Text [Chapter XCIIIa.]: Another Chapter.[2] [Saith Osiris Ani]: " So " then shall no evil things be done unto me by the fiends, neither shall I (6) be " gored by the horns [of Kheperà]; and the manhood of Rā, which is the head of " Osiris, shall not be swallowed up. Behold me, (7) I enter into my homestead, " and I reap the harvest. The gods speak with me. (8) Gore thou not them, O " Rā-kheperà. In very truth sickness shall not arise in the eye of Tmu nor shall " it (9) be destroyed. Let me be brought to an end, may I not be carried into the " East to take part in the festivals of the fiends who are my enemies (10) ; may no " cruel gashes be made in me. I, Osiris, the scribe Ani, the teller of the divine " offerings of all the gods, triumphant with happy victory, the lord to be revered, " am not carried away into the East."

Text [Chapter XLIII.]: (1) The Chapter of not letting the head of a man be cut off from him in the underworld. Saith Osiris Ani: (2) "I " am the great One, son of the great One ; I am Fire, the son of Fire, to whom " was (3) given his head after it had been cut off. The head of Osiris was not " carried away from him ; let not the head of Osiris Ani (4) be carried away from " him. I have knit together my bones, I have made myself whole and sound ; " I have become young once more ; I am Osiris, the Lord of eternity."

Vignette : The mummy of Ani lying on a bier ; above is his soul in the form of a human-headed bird, holding Ω *shen*, the emblem of eternity, in its claws. At the head and foot stands an incense burner with fire in it.

[1] The text of the rest of this chapter is corrupt.
[2] In other early papyri these two chapters form one ; the division probably arose from a blunder on the part of the scribe.

Text [CHAPTER LXXXIX.]: (1) THE CHAPTER OF CAUSING THE SOUL TO BE UNITED TO ITS BODY IN THE UNDERWORLD. Saith Osiris Ani: " Hail, thou god " Annitu! Hail, O Runner, (2) dwelling in thy hall! O thou great god, grant thou " that my soul may come unto me from wheresoever it may be. If it would tarry, " then bring thou unto me (3) my soul from wheresoever it may be. [If] thou findest " [me], O Eye of Horus, make thou me to stand up like those beings who are like " unto Osiris and who never lie down in death. Let not (4) Osiris Ani, triumphant, " triumphant, lie down in death in Annu, the land wherein souls are joined unto their " bodies, even in thousands. My soul doth bear away with it my victorious spirit " (5) whithersoever it goeth[1] (6) If it would tarry, grant thou that my " soul may look upon my body. [If] thou findest [me], O Eye of Horus, make thou " me to stand up like unto those[1] (7) Hail, ye gods, who row in the boat " of the lord of millions of years, who tow it (8) above the underworld, who make " it to pass over the ways of Nu, who make souls to enter into their glorified " bodies, (9) whose hands are filled with righteousness, and whose fingers grasp your " sceptres, destroy ye (10) the foe. The boat of the Sun rejoiceth, and the great " god advanceth in peace. Behold [ye gods], grant that this soul of Osiris Ani " (11) may come forth triumphant before the gods, and triumphant before you, from " the eastern horizon of heaven, to follow unto the place where it was yesterday, in " peace, in peace, in Amenta. (12) May he behold his body, may he rest in his " glorified frame, may he never perish, and may his body never see corruption."

Rubric : To be said over a golden [figure of a] soul inlaid with precious stones, which is to be placed on the neck of Osiris.

Vignette : Ani's soul, in the form of a human-headed bird, standing in front of a pylon.[2]

[1] Some words are omitted here.

[2] The three following variants show : (1) the soul flying through the door of the tomb to the deceased ; (2) the deceased, accompanied by his soul, standing at the open door of the tomb ; and (3) the deceased, with his soul hovering over him, standing with his back to the door of the tomb, upon which is the disk of the rayed sun.

FIG. 1. FIG. 2. FIG. 3.

Text [Chapter XCI.]: (1) The Chapter of not letting the soul of a man be captive in the underworld. Saith Osiris Ani: "Hail thou who art "exalted, thou who art adored, (2) thou mighty one of souls, thou Ram (or Soul), "possessor of terrible power, who dost put fear of thee into the hearts of the gods, "thou who art crowned upon thy mighty throne! It is he who maketh the path "for the *khu* and for (3) the soul of Osiris Ani. I am furnished [with that which "I need], I am a *khu* furnished [with that which I need], I have made my way "unto the place wherein are Rā and (4) Hathor."

Rubric : If this chapter be known, Ani shall become like unto a shining being fully equipped in the underworld. He shall not be stopped at any door in the underworld from going in and coming out millions of times.

Vignette :[1] Ani standing at the doorway of the tomb ; and Ani's shadow, accompanied by his soul.

Text [Chapter XCII.]: (1) The Chapter of opening the tomb to the soul of the shadow, of coming forth by day, and of getting power over the legs. Saith Osiris, the scribe Ani, triumphant: "(2) The place of bondage is "opened, that which was shut is opened,[2] and; the place of bondage is "opened unto my soul [according to the bidding of][3] the eye of Horus. I have "bound and stablished (3) glories upon the brow of Rā. [My] steps are made "long, [my] thighs are lifted up ; I have passed along the great path, and my "limbs are strong. (4) I am Horus, the avenger of his father, and I bring the "*ureret* crown to rest upon its place. The path of souls is opened [to my soul]."

PLATE XVIII.

"My soul (5) seeth the great god within the boat of Rā on the day of souls. My "soul is (6) in the front among those who tell the years. Come ; the eye of Horus, "which stablisheth glories (7) upon the brow of Rā and rays of light upon the "faces of those who are with the limbs of Osiris, hath delivered my soul. (8) O "shut ye not in my soul, fetter ye not my shade ; (9) may it behold the great god

[1] See Plate XVIII.

[2] The reading of the Nebseni papyrus is

[3] Adding ☐ 𓏺 � from the Nebseni papyrus.

" within the shrine on the day of the judgment of souls, may it repeat the words
" of Osiris. (10) May those beings whose dwelling-places are hidden, who fetter
" the limbs of Osiris, who fetter the souls of the *khu*, who shut in (11) the shade[s]
" of the dead and can do evil unto me—may they do no evil unto me, may they
" turn away their path from me. Thy heart (12) is with thee; may my soul and
" my *khu* be prepared against their attack. May I sit down among the great
" rulers who (13) dwell in their abodes ; may my soul not be set in bondage by
" those who fetter the limbs of Osiris, and who fetter souls, and who shut in (14)
" the shade[s] of the dead. The place which thou possessest, is it not Heaven ? "

Rubric : If this chapter be known, he shall come forth by day and his soul
shall not be shut in.

Vignette : Ani kneeling, with both hands raised in adoration, by the side of
the Seker[1] boat ⚏ placed upon its sledge.

Text [CHAPTER LXXIV.]: (1) THE CHAPTER OF WALKING WITH THE TWO
LEGS, AND OF COMING FORTH UPON EARTH. Saith Osiris Ani : " Thou hast done
" all thy work, O Seker, thou hast done all thy work, O Seker, in thy dwelling-
" place within my legs in the (2) underworld. I shine above the Leg[2] of the Sky,
" I come forth from heaven ; I recline with the glorified (3) spirits. Alas! I am
" weak and feeble ; alas ! I am weak and feeble. I walk. I am weak and feeble
" in the (4) presence of those who gnash with the teeth in the underworld, I
" Osiris, the scribe Ani, triumphant in peace."

Vignette : The emblem of Amenta ⚏ ; and Ani standing with a staff
in his left hand.

Text [CHAPTER VIII.]: (1) THE CHAPTER OF PASSING THROUGH AMENTA,
AND OF COMING FORTH BY DAY. Saith Osiris Ani : " The hour (?) openeth ; (2)
" the head of Thoth is sealed up ; perfect is the eye of Horus. I have delivered
" the eye of Horus which shineth with splendours on the forehead of Rā, (3) the
" father of the gods. I am the same Osiris, dwelling in Amenta. Osiris knoweth
" his day and that he shall not live therein ; nor shall I live therein. (4) I am the
" Moon among the gods ; I shall not come to an end. Stand up, therefore, O
" Horus ; Osiris hath counted thee among the gods."

[1] The god Seker was a form of the night sun, like Ptaḥ, Osiris and Tanen ; see Lanzone, *Dizionario*,
p. 1113.
[2] The name of a constellation.

Text [CHAPTER II.]: (1) THE CHAPTER OF COMING FORTH BY DAY, AND OF LIVING AFTER DEATH. Saith Osiris Ani : " Hail, Only One, shining from the " Moon ! (2) Hail, Only One, shining from the Moon! Grant that this Osiris " Ani may come forth among the multitudes which are round about thee ; (3) let " him be established as a dweller among the shining ones ; and let the under- " world be opened unto him. And behold Osiris, (4) Osiris Ani shall come forth " by day to do his will upon earth among the living."

Vignette : Ani, standing with both hands raised in adoration before a ram crowned with plumes and disk ; in front of the ram is a table, upon which are a libation vase and a lotus flower.

Text [CHAPTER IX.]: (1) THE CHAPTER OF COMING FORTH BY DAY, HAVING PASSED THROUGH THE TOMB. Saith Osiris Ani : "Hail Soul, thou mighty one " of strength ! (2) Verily I am here, I have come, I behold thee. I have passed " through the underworld, I have seen [my] father (3) Osiris, I have scattered the " gloom of night. I am his beloved one. I have come ; I behold my father (4) " Osiris. I have stabbed Set to the heart. I have done the things [needed] by " my father Osiris. (5) I have opened every way in heaven and upon earth. I am " the son beloved of his father Osiris (6). I have become a ruler, I have become " glorious, I am furnished [with what I need]. Hail, all ye gods, and all ye shining " ones, make ye a way for me, the Osiris, the scribe Ani, triumphant."

Vignette : Ani, with a staff in his left hand, standing before a door.

Text [CHAPTER CXXXII.]: THE CHAPTER OF MAKING A MAN TO RETURN TO SEE AGAIN HIS HOME UPON EARTH. Saith Osiris Ani : " I am the Lion-god (2) " coming forth with strides. I have shot forth arrows, I have wounded [the prey], " I have wounded the prey. I am the Eye of Horus ; I have opened the (3) eye of " Horus in his hour. I am come unto the furrows. Let Osiris Ani come in peace."

Vignette : Ani piercing a serpent.

Text [CHAPTER X. [XLVIII.]]: ANOTHER CHAPTER OF ONE WHO COMETH FORTH BY DAY AGAINST HIS FOES IN THE UNDERWORLD. Saith Osiris Ani : " I " have divided the heavens, (2) I have passed through the horizon, I have traversed " the earth, [following] upon his footsteps. I am borne away by the mighty and " shining ones because, behold, (3) I am furnished with millions of years which

" have magic virtues. I eat with my mouth, I chew with my jaws ; and, behold,
" (4) I am the god who is the lord of the underworld.' May there be given unto
" me, Osiris Ani, that which abideth for ever without corruption."

PLATE XIX.

Vignette : Ani standing, with both hands raised in adoration, before Rā,
hawk-headed and seated in a boat floating upon the sky ▭. On the bows sits
Ḥeru-pa-khrat (Harpocrates) or, "Horus the child"; and the side is ornamented
with feathers of Maāt ∬∬, and the *utchat* ☞. The handles of the oars and the
tops of the rowlocks are shaped as hawks' heads, and on the blades of the oars
are ☞☞.

Text [CHAPTER XV.] : (1) A HYMN OF PRAISE TO RĀ WHEN HE RISETH UPON
THE HORIZON, AND WHEN HE SETTETH IN THE [LAND OF] LIFE. Saith Osiris, the
scribe Ani : " Homage to thee, O Rā, (2) when thou risest [as] Tmu-Ḥeru-khuti
" (Harmachis). Thou art adored [by me] when thy beauties are before mine eyes,
" and when thy shining rays (3) [fall] upon my body. Thou goest forth in peace
" in the *Sektet* boat with [fair] winds, and thy heart is glad ; [thou goest forth] in
" the *Ātet* boat, (4) and its heart is glad. Thou stridest over the heavens in peace,
" and thy foes are cast down ; the never-resting stars (5) sing hymns of praise unto
" thee, and the stars which never set glorify thee as thou (6) sinkest in the horizon
" of Manu, O thou who art beautiful in the two parts of heaven, thou lord who livest
" and art established, O my lord ! Homage to thee, O thou who art Rā when
" thou risest, and Tmu (7) when thou settest in beauty. Thou risest and shinest
" upon the back of thy mother [the sky], O thou who art crowned king (8) of the
" gods. Nut doth homage unto thee, and everlasting and never-changing order
" embraceth thee at morn and at eve. Thou stridest over the heaven, being glad
" of heart, and the Lake (9) Testes is at peace. The Fiend hath fallen to the
" ground ; his arms and his hands have been hewn off, and the knife hath severed
" the joints of his body. Rā hath a fair wind (10) ; the *Sektet* boat goeth forth
" and sailing along it cometh into port. The gods of the south and of the north,
" of the west and of the east praise thee, (11) from whom all forms of life came
" into being. Thou sendest forth the word, and the earth is flooded with silence,
" O thou only One, who livedst in heaven before ever the earth and the mountains

" were made. (12) O Runner, Lord, only One, thou maker of things which are,
" thou hast moulded the tongue of the company of the gods, thou hast drawn forth
" whatsoever cometh from the waters, and thou springest up from them over the
" flooded land of the Lake of Horus (13). Make me to sniff the air which cometh
" forth from thy nostrils, and the north wind which cometh forth from thy mother
" [the Sky]. Make thou glorious my shining form, O Osiris, make thou (14)
" strong my soul. Thou art worshipped in peace, O lord of the gods, thou art
" exalted by reason of thy wondrous works. Shine with thy rays of light upon my
" body day by day, upon me, (15) Osiris, the scribe, the teller of the divine offerings
" of all the gods, the overseer of the granary of the lords of Abydos, the royal
" scribe in truth, who loveth him (i.e., Rā) ; Ani, triumphant in peace."

Vignette : Ani, standing with both hands raised in adoration. Behind him
is his wife :

Àusàr	nebt	per	gemātet	en	Àmen	θuθu
Osiris,	the lady	of the house,	priestess	of	Amen,	Thuthu.

Text [CHAPTER XV.]: (1) A HYMN OF PRAISE. "O OSIRIS, lord of eternity,
" Un-nefer, Horus of the two horizons, whose forms are manifold, whose creations
" are without number, (2) Ptaḥ-Seker-Tem in Annu, the lord of the tomb, and the
" creator of Memphis and of the gods, the guide of the underworld, whom [the
" gods] (3) glorify when thou settest in Nut. Isis embraceth thee in peace, and
" she driveth away the fiends from the mouth of (4) thy paths. Thou turnest thy
" face upon Amenta, thou makest the world to shine as with *smu* metal. The
" dead rise up to behold thee, they breathe the (5) air and they look upon thy
" face when the disk shineth on its horizon; their hearts are at peace for that they
" behold thee, O thou who art eternity and everlastingness."

[*Litany*]: (1) "Homage to thee, [O lord of] starry deities in Àn, and of
" heavenly beings in Kher-āba; thou god Unti, who art more glorious than the
" gods who are hidden in Annu.

" (2) Homage to thee, O Àn in Antes (?), Horus, thou dweller in both
" horizons, with long strides thou stridest over heaven, O thou who dwellest in
" both horizons.

" (3) Homage to thee, O soul of everlastingness, thou Soul who dwellest in
" Tattu, Un-nefer, son of Nut ; thou art lord of Akert.

"(4) Homage to thee in thy dominion over Tattu; the *urerit* crown is "established upon thy head; thou art the One whose strength is in himself, and "thou dwellest in peace in Tattu.

"(5) Homage to thee, O lord of the acacia tree, the *Seker* boat is set upon "its sledge; thou turnest back the Fiend, the worker of evil, and thou causest the "*utchat* to rest upon its seat.

"(6) Homage to thee, O thou who art mighty in thine hour, thou great and "mighty god, dweller in An-rut-f, lord of eternity and creator of everlastingness; "thou art the lord of Suten-henen.

"(7) Homage to thee, O thou who restest upon Right and Truth, thou art the "lord of Abtu, and thy limbs are joined unto Ta-sertet; thou art he to whom "fraud and guile are hateful.

"(8) Homage to thee, O thou who art within thy boat, thou bringest Ḥāpi "(*i.e.*, the Nile) forth from his source; the light shineth upon thy body, and thou "art the dweller in Nekhen.

"(9) Homage to thee, O creator of the gods, thou King of the North and of "the South; O Osiris, victorious, ruler of the world in thy gracious seasons; thou "art the lord of the world.

"O grant thou unto me a path whereon I may pass in peace, for I am just "and true; I have not spoken lies wittingly, nor have I done aught with deceit."

PLATE XX.

Vignette : Osiris and Isis in a sepulchral shrine.

Text [CHAPTER XV.]: (1) A HYMN OF PRAISE TO RĀ WHEN HE RISETH IN THE EASTERN PART OF THE HEAVEN. They who are in (2) his train rejoice, and lo! Osiris Ani in triumph saith: "Hail, thou Disk, thou lord of rays, who risest (3) "in the horizon day by day. Shine thou with thy beams of light upon the face of "Osiris Ani, who is victorious; for he singeth hymns of praise unto thee at (4) "dawn, and he maketh thee to set at eventide with words of adoration. May the "soul of Osiris Ani, the triumphant one, come forth with (5) thee from heaven, "may he go forth in the *mātet* boat, may he come into port in the *sektet* boat, "may he cleave his path among the (6) never resting stars in the heavens."

Osiris Ani, being at peace and in triumph, adoreth his lord, the lord of (7) eternity, saying: "Homage to thee, O Horus of the two horizons, who art

" Kheperà, the self-created ; when thou risest on the horizon and (8) sheddest thy
" beams of light upon the lands of the North and the South thou art beautiful, yea
" beautiful, and all the gods rejoice when they behold thee, (9) the King of heaven.
" The goddess Nebt-Unnet is stablished upon thy head ; her portions of the south
" and of the north are upon thy brow (10) ; she taketh her place before thee. The
" god Thoth is stablished in the bows of thy boat to destroy utterly all thy foes.
" (11) Those who dwell in the underworld come forth to meet thee, bowing in
" homage as they come towards thee, and to behold [thy] beautiful (12) Image.
" And I have come before thee that I may be with thee to behold thy Disk every
" day. May I not be shut in the tomb, may I not be turned back (13), may the
" limbs of my body be made new again when I view thy beauties, even as do all
" thy favoured ones, (14) because I am one of those who worshipped thee whilst
" they lived upon earth. May I come in unto the land of eternity, may I come
" even (15) unto the everlasting land, for behold, O my lord, this hast thou
" ordained for me."

And lo, Osiris Ani, triumphant in peace, the triumphant one, saith : " (16)
" Homage to thee, O thou who risest in thy horizon as Rā, thou art stablished by
" a law which changeth not nor can it be altered. Thou passest over the sky, and
" every face watcheth thee (17) and thy course, for thou hast been hidden from
" their gaze. Thou dost show thyself at dawn and at eventide day by day. (18)
" The *Sektet* boat, wherein is thy majesty, goeth forth with might ; thy beams
" shine upon [all] faces ; [the number] of thy yellow rays cannot be known, nor
" can thy bright beams (19) be told. The lands of the gods, and the colours of
" the eastern lands of Punt, must be seen, ere that which is hidden (20) [in thee]
" may be measured [by man]. Alone and by thyself thou dost manifest thyself
" [when] thou comest into being above Nu. May Ani (21) advance, even as thou
" dost advance ; may he never cease [to go forward], even as thy majesty ceaseth
" not [to go forward], even though it be for a moment ; for with strides dost thou
" (22) in one little moment pass over the spaces which would need hundreds of
" thousands and millions of years [for man to pass over ; this] thou doest, and then
" dost thou sink down. Thou (23) puttest an end to the hours of the night, and
" thou dost number them, even thou ; thou endest them in thine own appointed
" season, and the earth becometh light. (24) Thou settest thyself before thy
" handiwork[1] in the likeness of Rā ;[1] thou risest in the horizon."

[1] There is a play on the words and

Osiris, the scribe Ani, triumphant, declareth his (25) praise of thee when thou shinest, and when thou risest at dawn he crieth in his joy at thy birth : (26) " Thou " art crowned with the majesty of thy beauties ; thou mouldest thy limbs as thou " dost advance, and thou bringest them forth without birth-pangs in the form of " Rā (27), as thou dost climb up into the upper air. Grant thou that I may come " unto the heaven which is everlasting, and unto the mountain [where dwell] thy " favoured ones. (28) May I be joined unto those shining beings, holy and " perfect, who are in the underworld ; and may I come forth with them to behold " thy beauties when thou shinest (29) at eventide and goest to thy mother Nut.

PLATE XXI.

" Thou dost place thy disk in the west, and my two hands are [raised] in " adoration [of thee] when thou settest (30) as a living being. Behold, thou art " the maker of eternity, and thou art adored [when] thou settest in the heavens. I " have given my heart unto thee without wavering, (31) O thou who art mightier " than the gods."

Osiris Ani, triumphant, saith : " A hymn of praise to thee, O thou who risest " (32) like unto gold, and who dost flood the world with light on the day of thy " birth. Thy mother giveth thee birth upon [her] hand, and thou dost give light " unto the course of the Disk. (33) O thou mighty Light, who shinest in the heavens, " thou dost strengthen the generations of men with the Nile-flood, and dost cause " gladness in all lands, and in all (34) cities, and in all the temples. Thou art " glorious by reason of thy splendours, and thou makest strong thy *ka* with *hu* and " *tchefau* foods. O thou who art the mighty one of victories, (35) thou who art the " Power of [all] Powers, who dost make strong thy throne against the powers of " wickedness, who art glorious in majesty in the *sektet* boat, and who art exceeding " (36) mighty in the *ātet* boat, make thou glorious Osiris Ani with victory in the " netherworld ; grant thou that in the underworld he may be void of (37) sin. I " pray thee to put away [his] faults behind thee ; grant that he may be one of thy " venerable (38) servants who are with the shining ones ; may he be joined unto " the souls which are in Ta-sertet ; and may he journey into the Sekhet-Aaru (39) " by a prosperous and happy path, he the Osiris, the scribe Ani, triumphant.

" (40) Thou shalt come forth into heaven, thou shalt pass over the sky, thou " shalt be joined unto the starry deities. (41) Praises shall be offered unto thee in " thy boat, thou shalt be hymned in the *ātet* boat, (42) thou shalt behold Rā within

" his shrine, thou shalt set together with his disk day by day, thou shalt see (43)
" the *ant* fish when it springeth into being in the waters of turquoise, and thou shalt
" see (44) the *ābṭu* fish in his hour. May it come to pass that the Evil One shall fall
" when he layeth a snare to destroy me, (45) and may the joints of his neck and of
" his back be cut in sunder."

 " Rā [saileth] with a fair wind, and the *sektet* boat draweth on (46) and cometh
" into port. The mariners of Rā rejoice, and the heart of Nebt-ānkh (47) is glad,
" for the enemy of her lord hath fallen to the ground. Thou shalt behold Horus
" on the watch [in the Boat], and Thoth and Maāt upon either side of him. (48)
" All the gods rejoice when they behold Rā coming in peace (49) to make the
" hearts of the shining ones to live. May Osiris Ani, triumphant, the scribe of the
" divine offerings of the lords of Thebes, be with them."

Vignette : Rā, hawk-headed, with the disk upon his head and the emblem of
life, ♀, upon his knees, seated in the solar bark;[1] before him stands Ani with
both hands raised in adoration.

Text [Chapter CXXXIII.]: (1) To be said on the day of the Month.[2]
(2) Osiris Ani, the scribe, triumphant in peace, triumphant, saith : " Rā riseth (2)
" in his horizon, and the company of his gods follow after the god when he
" appeareth from his secret place, when he showeth strength and bringeth himself
" forth (3) from the eastern horizon of heaven at the word of the goddess Nut.
" They rejoice at the journeyings of Rā, the Ancient One; the Great One (4)
" rolleth along in his course. Thy joints are knitted together,[3] O Rā, within thy
" shrine. Thou breathest the winds, thou drawest in the breezes, (5) thou makest
" thy jaw-bones to eat in thy dwelling on the day when thou dost scent right and
" truth. Thou turnest aside the godlike followers (6) [who] sail after the sacred
" boat, in order that they may return again unto the mighty ones according to thy
" word. Thou numberest thy bones, thou gatherest together thy members; (7)
" thou turnest thy face towards the beautiful Amenta ; thou comest thither renewed

 1 In the Nebseni papyrus the god is seated on a throne, and he holds the sceptre ⌐ in his right
hand ; in the Turin papyrus (Lepsius, Bl. 54) the god is seated within a shrine.
 2 This chapter is generally entitled ⲯ "The Book of making perfect (*or* strong) the *khu* in the netherworld, in the
presence of the great company of the gods."
 3 Or, "thou art exalted."

" day by day. Behold, thou Image of gold, who possessest the splendours (8) of
" the Disk of heaven, thou lord of terror ; thou rollest along and art renewed day by
" day. Hail, there (9) is rejoicing in the heavenly horizon, and shouts of joy are
" raised to the ropes which tow thee along. May the gods who dwell in (10) heaven
" ascribe praises unto Osiris Ani, when they behold him in triumph, as unto Rā.
" May Osiris, the scribe Ani, be a prince (11) who is known by the *ureret* crown;
" and may the meat offerings and the drink offerings of Osiris Ani, triumphant,
" be apportioned unto him ; may he wax exceeding strong in his body ; and may he
" be the (12) chief of those who are in the presence of Rā. May Osiris, the
" scribe Ani, triumphant, be strong upon earth and in the world under the earth ;
" and (13) O Osiris, scribe Ani, triumphant, mayest thou rise up strengthened
" like unto Rā day by day. Osiris Ani, triumphant, shall not tarry, (14) nor shall
" he rest without motion in the earth for ever. Clearly, clearly shall he see with
" his two eyes, and with his two ears shall he hear what is right and true.
" (15) Osiris, the scribe Ani, triumphant, cometh back, cometh back from Annu;
" Osiris Ani, triumphant, is as Rā when he rangeth the oars (16) among the
" followers of Nu.

PLATE XXII.

" Osiris Ani, triumphant, hath not revealed what he hath seen, (17) he hath
" not, he hath not told again what he hath heard in the house which is hidden.
" Hail, there are shouts of joy to Osiris Ani, triumphant, (18) for he is a god and
" the flesh of Rā, he is in the boat of Nu, and his *ka* is well pleased according to
" the will of the god. (19) Osiris Ani, triumphant, is in peace, he is triumphant like
" unto Horus, and he is mighty because he hath divers forms."

Vignette : Rā seated in a boat, sailing across the sky towards the star-
studded heaven.

Rubric : These words shall be recited over a boat (20) seven cubits in length,
and painted green for the godlike rulers. Then shalt thou make a heaven of stars
(21) washed and purified with natron and incense. Behold, thou shalt make an
image (22) of Rā upon a table of stone painted yellow (?), and it shall be placed in
the fore-part of the boat. (23) Behold, thou shalt make an image of the dead
man whom thou wilt make perfect in strength (24) in the boat ; and thou shalt
make it to travel in the divine boat of Rā, (25) and Rā himself will look upon it
therein. Thou shalt show it to no man but thyself, (26) or to thy father or to

thy son ; let them watch with their faces, and he shall be seen in the underworld as a messenger of Rā.

Vignette : Rā, hawk-headed, with a disk upon his head, seated in a boat ; before him is a large disk.

Text [CHAPTER CXXXIV.] : (1) A HYMN OF PRAISE TO RĀ ON THE DAY OF THE MONTH WHEREON HE SAILETH IN THE BOAT. [Osiris, the scribe Ani, saith] : " Homage to thee, O thou who art in thy boat ! Thou risest, thou risest, " (2) thou shinest with thy rays, and thou hast made mankind to rejoice for millions " of years according to thy will. Thou showest thy face unto the beings whom " thou hast created, O Kheperà, (3) in thy boat. Thou hast overthrown Āpepi. " O ye children of Seb, overthrow ye the foes of Osiris (4) Ani, triumphant, destroy " ye the adversaries of righteousness from the boat of Rā. Horus shall cut off " your (5) heads in heaven in the likeness of ducks ; ye shall fall down upon the " earth and become beasts, and into the water in the likeness of fishes. [Osiris, " the scribe Ani,] destroyeth every hostile fiend, male (6) and female, whether he " passeth through heaven, [or] appeareth (7) upon earth, or cometh forth upon " the water, or passeth along before the starry deities ; and Thoth strengtheneth " them (8) coming forth from Anreti. Osiris, the scribe Ani, is silent, " and becometh the second of Rā. Behold thou the god, the great slaughterer, " (9) greatly to be feared, he washeth in your blood, he batheth in your gore ; " Osiris, (10) the scribe Ani, destroyeth them from the boat of his father Rā-Horus. " The mother Isis giveth birth unto Osiris, the scribe (11) Ani, triumphant, whose " heart liveth, and Nephthys nurseth him (12) ; even as they did for Horus, who " drove back the fiends of Sut. They saw (13) the *urertu* crown stablished upon " his head, and they fell down upon their faces. Behold, O ye shining ones, ye " men (14) and gods, ye damned ones, when ye behold Osiris Ani, triumphant " like unto Horus and adored (15) by reason of the *ureret* crown, fall ye down " upon your faces ; for Osiris Ani is victorious (16) over his foes in the heavens " above and [on the earth] beneath, in the presence of the godlike rulers (17) of " all the gods and goddesses."

Rubric : These words shall be recited over a great hawk which hath the white crown set upon his head. Then shall the names of Tmu, (18) Shu, Tefnut, Seb, Nut, Osiris, Isis, Nephthys, be written with green colour upon a (19) new table, anointed with unguents and placed in a boat together with a figure of the dead man (20). Then shall they put incense upon the fire, and set ducks to

be roasted (21). This is a rite of Rā when his boat cometh; and it shall cause the dead man to go with Rā into every place whithersoever he saileth, and the foes of Rā shall be (22) slaughtered in very truth. The Chapter of the *sektet* boat shall be recited on the sixth day of the festival.

Vignette : The ladder by which the soul passes from the underworld to the body.[1]

PLATE XXIII. AND PLATE XXIV. (1).

The whole of Plate XXIII. and part of Plate XXIV. contain a repetition of the XVIIIth Chapter of the " Book of the Dead," which has also been given on Plates XIII. and XIV. The arrangement of the gods in the vignette is, however, slightly different.

PLATE XXIV. (2).

Vignette : Ani and his wife adoring three gods, who are seated on a pylon or door-shaped pedestal.

Text [CHAPTER CXXIV.]: (1) THE CHAPTER OF GOING UNTO THE GOD-LIKE RULERS OF OSIRIS. Osiris, the scribe Ani, triumphant, saith : " My soul hath " builded for me a (2) dwelling-place in Tattu. I have waxed strong in the town " Pe. I have ploughed [my] fields in all my forms, and my palm tree standeth " therein like unto the god Amsu. I eat not that which I abominate, (3) I eat not " that which I loathe; that which I abominate I abominate, and I feed not upon " filth. (4) There are food offerings and meat for those who shall not be destroyed " thereby. I raise not up myself on my two arms unto any abomination, I walk " not thereupon (5) with my shoes, because my bread is [made] from white grain, " and my ale from the red (6) barley of the Nile. The *sektet* boat and the *ātet* " boat bring them unto me, and I feed upon them (7) under the trees, whose " beautiful branches I myself do know. (8) How glorious do I make the white " crown [when] I lift up the uræi! (9) Hail, guardian of the door, who givest peace " unto the two lands, bring thou unto me those who make offerings ! Grant that

[1] In the Appendix to Plates V. and VI. (see above, p. 265), is a reproduction from the papyrus of Neb-set at Paris, of a scene in which the soul of the deceased is represented as descending the ladder with food for the body in the tomb below.

" I may (10) lift up the earth ; that the shining ones may open their arms unto
" me ; that the company of the gods may (11) speak with the words of the
" shining ones unto Osiris Ani ; that the hearts of the gods may direct [him] (12) ; and
" that they may make him powerful in heaven among the gods who have taken
" unto themselves visible forms. (13) Yea, let every god and every goddess whom
" he passeth make Osiris, the scribe Ani, triumphant at the new year. He feedeth
" upon hearts (14) and consumeth them when he cometh forth from the east. He
" hath been judged by the forefather of Light. He is (15) a shining one arrayed
" in heaven among the mighty ones. The food of Osiris, the scribe Ani,
" triumphant, is even (16) the cakes and ale which are made for their mouths. I
" go in through the Disk, I come out through the god Ahui. I speak with the
" followers (17) of the gods, I speak with the Disk, I speak with the shining ones,
" and the Disk granteth me to be victorious in the (18) blackness of night within
" Meḥ-urt near unto his forehead. Behold, I am with Osiris, and I (19) proclaim
" that which he telleth forth among the mighty ones. He speaketh unto me the
" words of men, and I listen and (20) I tell again unto him the words of the gods.
" I, Osiris Ani, triumphant, come even as one who is equipped for the journey.
" Thou raisest up [right and truth] (21) for those who love them. I am a shining
" one clothed in power, mightier than any other shining one."

PLATE XXV.

Vignette : A swallow perched on a conical object painted red and green.

Text [CHAPTER LXXXVI.] : (1) HERE BEGIN THE CHAPTERS OF MAKING
TRANSFORMATIONS. THE CHANGING INTO A SWALLOW. (2) Saith Osiris Ani,
triumphant : " I am the swallow, [I am] the swallow, [I am] the scorpion, the
" daughter of Rā. (3) Hail, ye gods, whose scent is sweet ; hail, ye gods, whose
" scent is sweet ! Hail, thou Flame, which comest forth from (4) the horizon !
" Hail, thou who art in the city. May the Guardian of the Bight lead me on. O
" stretch out up unto me (5) thine hands that I may be able to pass my days in the
" Island of Flame. I have fared forth with my warrant. I have come with the
" power thereof. Let the doors be opened unto me (6). How shall I tell what I
" have seen therein ? Horus was like unto the prince of the sacred bark, and the
" throne of his father was given unto him. Sut, the son of Nut, also hath gotten
" the fall which he (7) wrought for Horus. He who is in Sekhem passed judgment
" upon me. I stretched out my hands and my arms unto Osiris. I have passed on

" to judgment, (8) and I have come that I may speak ; grant that I may pass on
" and deliver my message. I enter in, having been judged ; I come out (9) at
" the door of Neb-er-tcher magnified and glorified. I am found pure at the Great
" place of passage [of souls]. I have put away my faults. (10) I have done away
" mine offences. I have cast out the sins which were a part of me. I, even I, am
" pure, (11) I, even I, am mighty. O ye doorkeepers, I have made my way [unto
" you]. I am like unto you. I have come forth by day. I have walked with my
" legs, and I have gotten the power of the footstep wherewith do walk the shining
" ones of light (12). I, even I, know the hidden ways to the doors of the Field
" of Aaru ; and (13), though my body be buried, yet let me rise up ; and may I
" come forth and overthrow all my foes upon earth."

Appendix[1] : *Rubric.* If this chapter be known [by the deceased], he shall come
forth by day in Neter-khert, and he shall go in again after he hath come forth. If this
chapter be not known, he shall not enter in after he hath come forth, nor shall he come
forth by day.

Vignette : A golden hawk holding a flail ⩘, emblem of rule.

Text [CHAPTER LXXVII.] : (1) CHAPTER OF CHANGING INTO A GOLDEN
HAWK. Saith Osiris Ani : " (2) May I, even I, arise in the *seshet* chamber, like
" unto a hawk of gold (3) coming forth from his egg. May I fly and may I hover
" as a hawk, with a back seven (4) cubits wide, and with wings made of emeralds
" of the South. May I come forth from the *sektet* boat (5), and may my heart be
" brought unto me from the mountain of the east. May I alight on the *ātet* boat,
" and may those who are in (6) their companies be brought unto me, bowing down
" as they come. May I rise, may I gather myself together (7) as the beautiful
" golden hawk [which hath] the head of a *bennu* bird. May I enter into the
" presence of Rā daily to hear his words, and may I sit down among the (8) mighty
" gods of Nut. May a homestead be made ready for me, and may offerings of
" food and drink be put before me therein. May I eat therein ; (9) may I become
" a shining one therein ; may I be filled therein to my heart's fullest desire ; may
" sacred wheat be given unto me to eat. May I, by myself, get power over the
" guardian of my head."

Vignette : A green hawk, holding a flail, and standing upon a pylon-shaped
pedestal.

[1] See Lepsius, *Todtenbuch*, Bl. 32.

Text [Chapter LXXVIII.]: (1) The Chapter of changing into a sacred hawk. Saith Osiris Ani : (2) " Hail, thou mighty one, come unto Tattu.
" Make thou my paths, and let me pass round [to visit] my (3) thrones. Make me
" to renew myself and make me to wax strong. (4) Grant that I may be feared,
" and make me to be a terror. May the gods of the underworld fear me, and
" may they fight for me in their (5) habitations. Let not him that would do harm
" unto me draw nigh unto me. Let me walk through the house of darkness.
" May I (6), the feeble, clothe and cover myself; and may they (*i.e.*, the gods)
" not do the like unto me. Hail, ye gods who hear my speech ! Hail, ye rulers
" who are among the followers of Osiris. Be ye therefore silent, O ye gods,
" [when] the god speaketh with me ; he heareth what is right and (7) true.
" What I speak unto him, do thou also speak, O Osiris. Grant thou that I may
" go round my course according to the order which cometh forth from thy mouth
" concerning me. May I see thy forms ; (8) may I be able to understand thy will.
" Grant that I may come forth, that I may get power over my legs, and that I
" may be like unto Neb-er-tcher (9) upon his throne. May the gods of the
" underworld fear me, and may they fight for me in their habitations. Grant
" thou that I may pass on my way with the godlike ones who rise up (10).
" May I be set up upon my resting-place like unto the Lord of Life ; may I be
" joined unto Isis, the divine Lady. May the gods (11) make me strong against
" him that would do harm unto me, and may no one come to see me fall helpless.
" May I pass over the paths (12), may I come into the furthermost parts of
" heaven. I entreat for speech with Seb, I make supplication unto Hu (13) and
" unto Neb-er-tcher that the gods of the underworld may fear me, and that they
" may fight for me in their habitations, when they see that thou hast (14) provided
" me with the fowl of the air and the fish of the sea.

" I am one of those shining ones who live in rays of light. (15) I have made
" my form like unto the form [of the god] who cometh out and manifesteth himself
" in Tattu ; for I have become worthy of honour by reason of his honour, (16) and
" he hath spoken unto thee of the things which concern me. Surely he hath made
" the fear of me [to go forth], and hath created terror of me ! The gods of the

PLATE XXVI.

" underworld fear me, and they (17) fight for me [in their habitations]. I, in very
" truth I am a shining one and a dweller in light, who hath been created and who
" hath come into being (18) from the body of the god. I am one of the shining

" ones who dwell in light, whom (19) Tmu himself hath created, and who have
" come into being from the eyelashes of his eye. He doth create and glorify
" and make noble the faces of those who live with him. (20) Behold, the only
" One in Nu! They do homage unto him as he cometh forth from the horizon,
" and they strike fear of him into the gods (21) and into the shining ones who
" have come into being with him.

" I am the One among the worms which the eye of the Lord, the only One,
" hath created. And lo! (22) before Isis was, and when Horus was not yet, I
" had waxed strong and flourished. I had grown old, and I had become greater
" (23) than they who were among the shining ones who had come into being with
" him, and I, even I, arose in the form of a sacred hawk (24), and Horus made
" me worthy in the form of his own soul, to take possession of all that belongeth
" unto Osiris in the underworld. The double Lion-god, (25) the warder of the
" things that belong to the house of the *nemmes* crown which is in his hiding
" place, saith unto me: ' Get thee back to the heights of heaven, seeing that
" through Horus (26) thou hast become glorified in thy form; the *nemmes* crown
" is not for thee; thou hast speech even unto the ends (27) of heaven.' I, the
" guardian, take possession of the things which belong to Horus and Osiris in the
" underworld. Horus telleth aloud unto me that which (28) his father had said
" concerning me in years [gone by], on the day of the burial [of Osiris]. I have
" given unto thee the *nemmes* of the double Lion-god which I possess, (29) that
" thou mayest pass onward and mayest travel over the path of heaven, and that
" they who dwell on the confines of the horizon may see thee, and that the gods
" of the underworld may fear thee (30) and may fight for thee in their habitations.
" The god Auhet is of them. The gods, the lords of the boundaries of heaven,
" they who are the warders (31) of the shrine of the lord, the only One, have
" fallen before my words, have fallen down before [my] words. Hail! He that
" is exalted upon his tomb is on my side, and he hath bound upon my head the
" *nemmes* crown. (32) The double Lion-god hath decreed it, the god Auhet
" hath made a way for me. I, even I, am exalted, and the double Lion-god hath
" bound the *nemmes* crown on me, and (33) my head covering hath been given unto
" me. He hath stablished my heart through his strength and through his great might,
" and I shall not (34) fall through Shu. I am Hetep, the lord of the two uræi, the
" being who is adored. I know the shining god, (35) and his breath is in my body. I
" shall not be driven back by the Bull which causeth men to tremble, but I shall come
" daily into the house of the double Lion-god, and I shall come forth therefrom into
" the house of Isis. I shall behold sacred things which are hidden, there shall be

" done unto me holy (37) hidden rites, I shall see what is there ; my words shall
" make full the majesty of Shu, and they shall drive away evil hap. (38) I, even I,
" am Horus who dwell in splendours.　I have gained power over his crown, I have
" gained power over his radiance (39), and I have travelled over the remotest parts
" of heaven.　Horus is upon his throne, Horus is upon his seat.　My (40) face is
" like unto that of a divine hawk.　I am one who hath been armed by his lord.　I
" have come forth from Tattu.　I have seen Osiris, I have risen up on (41) either
" side of him.　Nut [hath shrouded me].　The gods behold me, and I have
" beheld the gods.　The eye of Horus hath consumed me, who dwell in darkness.
" The gods (42) stretch forth their arms unto me.　I rise up, I get the mastery,
" and I drive back evil which opposeth me.　The gods open unto me the holy
" (43) way, they see my form, and they hear my words which I utter in their
" presence.　O ye gods of the underworld, who set yourselves up against me, (44)
" and who resist the mighty ones, the stars which never set have led me on my
" way.　I have passed along the holy paths of the *ḥemtet* chamber unto your
" lord, (45) the exceedingly mighty and terrible Soul.　Horus hath commanded
" that ye lift up your faces to (46) look upon me.　I have risen up in the likeness of
" a divine hawk, and Horus hath set me apart in the likeness of his own soul, to
" take possession of that which belongeth unto Osiris in the underworld.　(47) I
" have passed along the way, I have travelled on and I have come even among those
" who live in their hiding places and who guard the house of Osiris.　(48) I speak
" unto them of his power and I make them to know the terrible power of him that
" is provided with two horns [to fight] against Sut ; and they (49) know who hath
" carried off the sacred food which the power (?) of Tmu had brought for him.
" The gods of the underworld have proclaimed (50) a happy coming for me.　O
" ye who live in your hiding places and who guard the house of Osiris, and who
" have magnified your names, (51) grant ye that I may come unto you.　I bind
" together and I gather up your powers, and I order the strength of the paths of
" those who guard the (52) horizon of the *ḥemtet* of heaven.　I have stablished
" their habitations for Osiris, I have ordered his ways, I have done what hath been
" bidden.　(53) I have come forth from Tattu, I have beheld Osiris, I have spoken
" unto him concerning the things of his son, the divine Prince whom he loveth.
" There is a wound in the heart of Set, (54) and I have seen him who is without

PLATE XXVII.

" life.　O, I have made them to know the plans of the gods which Horus hath
" devised (55) at the bidding of his father Osiris.　Hail, lord, thou most terrible

" and mighty soul! Let me come, even me, (56) let me lift myself up! I have
" opened and passed through the underworld. I have opened the paths of the
" warders (57) of heaven and of the warders of the earth. I have not been driven
" back by them; and I have lifted up thy face, O lord of eternity."

Appendix : The following is the end of the LXXVIIIth chapter according
to the Paris papyrus quoted by Naville (*Todtenbuch,* Bd. I., Bl. 89, ll. 43–48) :—

" Thou art exalted upon thy throne, O Osiris. Thou hearest joyful things, O
" Osiris. Thy strength is vigorous, O Osiris. Thy head is bound to thy body, O
" Osiris. Thy brow is made firm, O Osiris. Thy heart is joyful. O be thou pleased to
" establish gladness for thy servants. Thou art stablished as a bull of Amenta. Thy
" son Horus is crowned king upon thy throne; all life is with him. Unto thy son are
" given millions of years, and the fear of him shall endure for untold ages. The company of
" the gods shall fear him. Unto thy son is given of the company of the gods;
" he changeth not his word. Horus is the food and the altar. I go to unite myself
" unto [my] father; and deliverance cometh from [my] father, from [my] brother, and
" from the friend of Horus. Horus is in the following of his father. He dwelleth amid
" decay. He ruleth Khem. To thy son have the gods given the crown of millions of
" years, and for millions of years it maketh him to live in the eye [of Horus], the single
" eye of the god [which is called] Nebt-er-tcher, the queen of the gods."

Vignette: The deceased kneeling, with both hands raised in adoration, before
three gods.

Text [CHAPTER LXXIX.]: (1) THE CHAPTER OF BEING AMONG THE COMPANY
OF THE GODS AND OF BEING CHANGED INTO THE (2) PRINCE OF THE GODLIKE
RULERS. [The deceased] saith: " Homage to thee, O Tmu, (3) lord of heaven, thou
" creator of things which are and which come forth from the earth; who makest to
" come into being that which is sown, the lord of things which shall be, the begetter
" of the gods, the great god (4) who made himself, the lord of life who maketh mankind
" to flourish. Homage to you, O ye lords of creation, ye pure beings whose abodes
" (5) are hidden. Homage to you, O ye lords of eternity, whose forms are hidden, and
" whose dwelling-places are unknown. (6) Homage to you, O ye gods who dwell in
" the abode(?) of the flooded lands. Homage to you, O ye gods who live in the
" underworld. Homage to you, O ye gods who dwell in heaven. (7) Grant ye that I
" may come [unto you], for I know you. I am pure, I am holy, I am mighty, I have a
" soul, (8) I have become powerful, I am glorious; I have brought unto you perfume,
" and incense, and natron. Blot out from your hearts (9) whatsoever ye have in them
" against me. I have come, having done away all the evil which dwelleth in your hearts
" against me, I have made an end of all the sin which I committed (10) against you;
" I have brought unto you that which is good, I have made to come unto you that which
" is right and true. I, even I, know (11) you, I know your names, I know your forms
" which are not known, which come into being (12) with you. I have come unto you.

"I have risen among men like unto the god, living among the (13) gods. I am strong
"before you like unto the god who is exalted upon his resting-place ; when he cometh
"the gods rejoice, and goddesses and mortal women (14) are glad when they behold him.
"I have come unto you. I have risen (15) upon the throne of Rā, I sit upon my seat
"in the horizon. I receive offerings upon my altar, (16) I drink drink-offerings at
"eventide as one made noble by the lord of mortals. I am exalted (17) even as the holy
"god, the lord of the great House. The gods rejoice when they see him in his (18)
"beautiful manifestation on the body of Nut, who giveth birth unto him daily."

Vignette : The serpent Seta, with human legs.

Text [Chapter LXXXVII.] : (1) The Chapter of changing into Seta.
Osiris Ani, triumphant, saith : " I am the serpent Seta, whose years are many.
" I lie down and I am born day by day. I am (3) the serpent Seta, which
" dwelleth in the limits of the earth. I lie down, I am born, (4) I renew myself,
" I grow young day by day."

Vignette : A crocodile upon a pylon or doorway.

Text [Chapter LXXXVIII.] : (1) The Chapter of changing into a
crocodile. Saith Osiris Ani, triumphant : (2)" I am the crocodile which dwelleth
" in terror, I am the sacred crocodile and I cause destruction. (3) I am the great
" fish in Kamui. I am the lord to whom homage (4) is paid in Sekhem ; and
" Osiris Ani is the lord to whom homage is paid in Sekhem."

Vignette : The god Ptaḥ ⌘ in a shrine, before which is a table of offerings.

Text [Chapter LXXXII.] : (1) The Chapter of changing into Ptaḥ.
Saith Osiris Ani, triumphant : " I eat bread, (2) I drink ale, I put on apparel, (3)
" I fly like a hawk, I cackle like a goose, and I alight upon the path (4) hard
" by the hill of the dead on the festival of the great Being. That which is
" abominable, that which is abominable, have I not eaten ; and that which (5) is
" foul have I not swallowed. That which my *ka* doth abominate hath not entered
" into my body. I have lived according to the (6) knowledge of the glorious gods.
" I live and I get strength from their bread, I get strength when I eat it beneath
" the (7) shade of the tree of Hathor, my lady. I make an offering, and I make
" bread in Tattu, and oblations in (8) Annu. I array myself in the robe of the
" goddess Mātait, and I rise up and I sit me down wheresoever my heart
" desireth (9). My head is like unto the head of Rā ; when my limbs are gathered

" together, I am like unto Tmu. The four regions of Rā are the limits of the
" earth. I come forth ; my tongue (10) is like unto the tongue of Ptaḥ, my throat
" is even as that of Hathor, and I tell forth the words of my father Tmu with
" my lips. He it is who constrained (11) the handmaid, the wife of Seb ; and
" unto him are bowed [all] heads, and there is fear of him. Hymns of praise
" are sung in honour of my mighty deeds (12), and I am accounted the heir of
" Seb, the lord of the earth, the protector. The god Seb giveth cool water, he
" maketh his dawnings to be mine. They who dwell in (13) Annu bow down
" their heads before me, for I am their bull. I grow strong from moment to
" moment ; my loins are made strong for millions of years."

Vignette : A Ram.

Text [CHAPTER LXXXV.]: (1) THE CHAPTER OF CHANGING INTO THE
SOUL OF TMU. Saith Osiris Ani, triumphant : (2) " I have not entered into
" the house of destruction; I have not been brought to naught, I have not known
" decay. I am (3) Rā who come forth from Nu, the divine Soul, the creator of
" his own limbs. Sin is an abomination unto me, (4) and I look not thereon ;
" I cry not out against right and truth, but I have my being (5) therein. I am
" the god Ḥu, and I never die (6) in my name of ' Soul.' I have brought myself
" into being together with Nu in my name of (7) ' Kheperā.' In their forms
" have I come into being in the likeness of Rā. I am the lord of light."

Appendix : In other ancient papyri the LXXXVth Chapter of the Book of
the Dead ends as follows (Naville, *Todtenbuch*, Bd. I., Bl. 97) :—

"What I hate shall be buried (5). Let me not enter into the secret place
"of the god Tuaa. I ascribe glory unto Osiris, and I pacify the heart of those
"who dwell in the god of creation, who love me, who spread (6) abroad fear of
"me, and who strike terror of me into those who dwell in their own places. Behold
"me, for I am exalted upon my resting-place, Nu, (7) upon the place which is
"adjudged unto me. I am Nu, and those who work evil shall not overthrow me.
"I am the eldest and the first-born son of matter ; my (8) soul is the gods, who
"are the eternal souls. I am the creator of darkness who maketh his dwelling-place
"in the limits of the regions of heaven. I come, and my soul advanceth (9) over
"the way of the Ancient Ones. I cause darkness in the limits of the sky, and at
"my will I come unto the boundaries thereof. I walk upon my feet, I am strong
"(10) to pass over the sky, and I fetter with bonds the darkness and the worm
"that hideth therein. I make my steps to advance unto the lord of the two
"hands (?) My soul (11) and the soul of my body are the uræi, and I live for

"ever, the lord of years, and the prince of eternity. I am exalted as lord of the
"earth, I am exalted (?). I grow young in (12) the cities, I grow youthful in my
"homestead, my name is ' My name decayeth not.' I am the Soul, the creator of Nu,
"who maketh his dwelling-place in (13) Neter-khert. My nest is not seen, my egg
"is not broken. I am the lord of millions of years. I make my nest in the limits
"of heaven. I descend unto the earth of Seb (14). I do away with my faults.
"I behold my father, the lord of Māsh; and his body breatheth in Annu. I am
"provided with what I need (15) by Khnemu and Khui in the place of burial
"in Amenta"

Vignette : A *bennu* bird

Text [CHAPTER LXXXIII.]: (1) THE CHAPTER OF CHANGING INTO A *bennu*.
Saith Osiris, the scribe Ani, triumphant in peace : " I came into being from
" unformed matter, (2) I created myself in the image of the god Kheperà, and I
" grew in the form of plants. I am hidden in the likeness of the Tortoise. I
" am formed out of the atoms of all the gods. (3) I am the yesterday of the four
" [quarters of the world], and I am the seven uræi which came into existence in
" the East, the mighty one who illumineth the nations (4) by his body. He is god
" in the likeness of Set; and Thoth dwelleth in the midst of them by (5) judgment
" of the dweller in Sekhem and of the spirits of Annu. I sail (6) among them,
" and I come ; I am crowned, I am become a shining one, (7) I am mighty, I am
" become holy among the gods. I am the god Khonsu who driveth back all that
" opposeth him."

Appendix : The following rubric to this chapter is found in a papyrus at
Paris; see Naville, *Todtenbuch*, Bd. II., Bl. 185 :—

> If this chapter be known, the purified one shall come forth by day after his
> burial, and he shall change his forms at his heart's desire. He shall dwell among
> the servants of Un-nefer, and he shall be satisfied with the food of Osiris, and
> with the meals of the tomb. He shall behold the disk of the Sun, and shall
> travel over the earth with Rā. He shall be triumphant before Osiris, and there
> shall no evil thing get dominion over him for ever and for all eternity and
> for ever.

PLATE XXVIII.

Vignette : A heron.

Text [CHAPTER LXXXIV.]: (1) THE CHAPTER OF CHANGING INTO A HERON.
Saith Osiris, the scribe Ani: (2) " I have gotten dominion over the beasts which
" are brought for sacrifice, with the knife held at their heads and their hair, (3) for

" those who dwell in their emerald [fields], the ancient and the shining ones who
" make ready (4) the hour of Osiris Ani, triumphant in peace. He maketh
" slaughter upon earth, and I make slaughter upon earth. I am strong, and I have
" passed along the (5) lofty path [which leadeth] unto heaven. I have made myself
" pure, with long strides I have gone unto my city, holding on my way to Sepu (?).
" (6) I have stablished [the one who is] in Unnu. I have set the gods upon their
" places, and I have made glorious the temples of those who live in their shrines.
" (7) I know the goddess Nut, I know the god Tatunen, I know Teshert, I have
" brought with me their horns. I know (8) Ḥeka, I have heard his words, I am the
" red calf which is limned with the pen. When they hear [my words], the gods
" say : (9) ' Let us bow down our faces, and let him come unto us ; the light shineth
" beyond you.' My hour is within my body. (10) I have not spoken [evil] in
" the place of right and truth, and each day I advance in right and truth. I am
" shrouded in darkness when I sail up to celebrate the festival of the (11) dead
" one, and to embalm the Aged one, the guardian of the earth—I the Osiris, the
" scribe Ani, triumphant ! I have not entered into (12) the hiding places of the
" starry deities. I have ascribed glory unto Orisis. I have pacified the heart of
" the gods who follow after him. I have not felt fear (13) of those who cause
" terror, even those who dwell in their own lands. Behold, I am exalted (14) upon
" [my] resting place upon my throne. I am Nu, and I shall never be overthrown
" by the Evil-doer. I am the god Shu (15) who sprang from unformed matter.
" My soul is god ; my soul is eternity. I am the creator of darkness, and I (16)
" appoint unto it a resting place in the uttermost parts of heaven. I am the prince
" of eternity, I am the exalted one [in] Nebu. I grow young in [my] city, (17) I
" grow young in my homestead. My name is ' Never-failing.' My name is ' Soul,
" Creator of Nu, who maketh (18) his abode in the underworld.' My nest is not
" seen, and I have not broken my egg. I am lord of millions of years. I have
" made my nest (19) in the uttermost parts of heaven. I have come down unto
" the earth of Seb. I have done away with my faults. I have seen my father
" (20) as the lord of Shāutat. As concerning Osiris Ani, may his body dwell in
" Annu ; may it be manifested unto those who are with the Shining One in the
" place of burial in Amenta. "

Vignette : A human head springing from a lotus in a pool of water ▥▥▥.

Text [CHAPTER LXXXIA.]: (1) [THE CHAPTER OF] CHANGING INTO A
LOTUS. Saith Osiris Ani : " I am the (2) pure lotus which cometh forth from the

" god of light, the guardian of the nostrils of Rā, the guardian (3) of the nose
" of Hathor. I advance and I hasten (4) after him who is Horus. I am the
" pure one who cometh forth from the field."

Vignette : A god with a disk upon his head.

Text [CHAPTER LXXX.] : (1) [THE CHAPTER OF] CHANGING INTO THE GOD
WHO GIVETH LIGHT IN THE DARKNESS. Saith Osiris, the scribe Ani, triumphant :
" I am (2) the girdle of the robe of the god Nu, which shineth and sheddeth
" light, which abideth in his presence and sendeth forth light into the darkness,
" which knitteth together the two fighters (3) who live in my body through the
" mighty spell of the words of my mouth, which raiseth up him that hath fallen—
" for (4) he who was with him in the valley of Abtu hath fallen—and I rest. I
" have remembered him. (5) I have carried away the god Hu from my city
" wherein I found him, (6) and I have led away the darkness captive by my might.
" I have upheld the Eye [of the Sun] when its power waned (7) at the coming of
" the festival of the fifteenth day, and I have weighed Sut in the heavenly
" mansions beside the Aged one who is with him. I have endowed (8) Thoth
" in the House of the Moon-god with all that is needful for the coming of the
" festival of the fifteenth day. I have carried off the *ureret* crown ; right and
" truth are in my body. (9) The months are of emerald and crystal. My
" homestead is among the sapphire furrows. (10) I am the lady who sheddeth
" light in darkness. I have come to give forth light in darkness, and lo ! it is
" lightened and made bright. I have illumined the blackness (11) and I have
" overthrown the destroyers. I have made obeisance unto those who are in
" darkness, and I have raised up (12) those who wept and who had hidden their
" faces and had sunk down. Then did they look upon me. I am the Lady, and
" I will not let you hear concerning me."

PLATES XXIX. AND XXX.

Vignette (PLATE XXIX.) : Ani and his wife standing with hands raised in
adoration before the god Thoth, who has *ānkh*, " life," upon his knees, and is
seated on a pylon-shaped throne.

Text [CHAPTER CLXXV.] : (1) THE CHAPTER OF NOT DYING A SECOND TIME.
Saith Osiris Ani, triumphant : " (2) Hail, Thoth ! What is it that hath happened
" unto the holy children of Nut ? (3) They have done battle, they have upheld

" strife, they have done evil, (4) they have created the fiends, they have made
" slaughter, they have caused (5) trouble ; in truth, in all their doings the mighty
" have worked against the weak. (6) Grant, O might of Thoth, that that which
" the god Tmu hath decreed [may be done] ! And thou regardest not evil, nor
" art thou (7) provoked to anger when they bring their years to confusion and
" throng in and push to disturb their months ; for in all that they have done
" (8) unto thee they have worked iniquity in secret. I am thy writing palette,
" O Thoth, and I have brought unto thee thine ink jar. I am not (9) of those who
" work iniquity in their secret places ; let not evil happen unto me."

Saith Osiris, the scribe Ani : (10) " Hail, Tmu ! What manner [of land] is this
" into which I have come ? It hath not water, it hath not air ; it is deep unfathom-
" able, (11) it is black as the blackest night, and men wander helplessly therein.
" In it a man may not live in quietness of heart ; nor may the longings of love be
" satisfied therein. (12) But let the state of the shining ones be given unto me for
" water and for air and for the satisfying of the longings of love, and let quiet-
" ness of heart be given unto me for bread (13) and for ale. The god Tmu hath
" decreed that I shall see his face, and that I shall not suffer from the things which
" pain him. May the gods hand on (14) their thrones for millions of years.
" Thy throne hath descended unto thy son Horus. The god Tmu hath decreed
" that his course shall be among the holy princes. (15) In truth, he shall rule
" over thy throne, and he shall be heir of the throne of the dweller in the Lake of
" Fire. It hath been decreed that in me he shall see his likeness, and that (16)
" my face shall look upon the lord Tmu. How long then have I to live ? It is
" decreed that thou shalt live for millions of millions of years, a life of millions of
" years. (17) May it be granted that I pass on unto the holy princes, for I am
" doing away with all that I did when this earth came into being from Nu (18), and
" when it sprang from the watery abyss even as it was in the days of old. I
" am Fate (?) and Osiris, and I have changed my form into the likeness of divers
" serpents (19). Man knoweth not, and the gods cannot see, the two-fold beauty
" which I have made for Osiris, who is greater than all the gods. I have granted
" that he [shall rule] in the mount of the dead (20). Verily his son Horus is seated
" upon the throne of the dweller in the double Lake of Fire, as his heir. I have
" set his throne in (21) the boat of millions of years. Horus is established upon
" his throne, amid the friends [of Osiris] and all that belonged unto him. Verily
" the soul of Sut, which (22) is greater than all the gods, hath departed to
" [Amenta]. May it be granted that I bind his soul in the divine boat (23) at my
" will. O my Osiris, thou hast done for me that which thy father

" Rā did for thee. May I abide upon the earth lastingly; (24) may I keep
" possession of my throne; may my heir be strong; may my tomb and my friends
" who are upon earth flourish; (25) may my enemies be given over to destruc-
" tion and to the shackles of the goddess Serq! I am thy son, and Rā is my
" father (26). For me likewise hast thou made life, strength and health. Horus
" is established upon his throne. Grant that the days of my life may come unto
" worship and honour."

Appendix : From the fragmentary copy of this chapter which M. Naville has
published in his *Todtenbuch*, Bd. I., Bll. 198, 199, it is clear that the text given in the
papyrus of Ani forms only about one-half of it, and that its contents refer to the glorious
state of the deceased, who lives again in the form of Horus. He enters among the
revered dead [hieroglyphs]; shouts of joy ascend in Suten-henen,
and gladness reigns in Naârutef [hieroglyphs]
[hieroglyphs]; he hath inherited the throne of Osiris, and ruleth the whole earth,
and the company of the gods are content thereat [hieroglyphs]
[hieroglyphs]; the god Sut feareth him
[hieroglyphs]; all sorts and conditions of men both dead and living
come before him, and bow down in homage when they behold him; the god hath
made all to fear him [hieroglyphs];
Sut cometh unto him with head bent low to the earth [hieroglyphs]
[hieroglyphs]; the deceased breaketh and turneth up the
earth in blood in Suten-henen [hieroglyphs]
(compare Chap. XVIII., § G); his name shall endure for millions of millions of years
[hieroglyphs]; his name shall abide in Suten-henen,
and he shall wear the mighty *atef* crown upon his head for millions, and hundreds
of thousands, and tens of thousands, and thousands, and hundreds, and tens of years
[hieroglyphs]; bread, ale, oxen, wild fowl, all good and pure
things and fresh water from the river shall in abundance be offered unto him, *etc.*
From the concluding lines we find that the chapter was to be recited over a figure
of the god Horus made of lapis-lazuli, which was to be placed near the neck of
the deceased, and which was supposed to give him power upon earth with men,
gods, and the shining spirits; the effect upon him would, moreover, be exceedingly
beneficial if it were recited in the underworld [hieroglyphs]

Vignette I. (PLATE XXX.) : The god Osiris, bearded and wearing the "white" crown, stands in a shrine the roof of which is surmounted by a hawk's head and uræi ; at the back of his neck hangs the *menàt* (see above p. 24 5) and in his hands he holds the crook ⎰, sceptre ⎰, and flail ⋀, emblems of royalty, power, and dominion. Behind him stands the goddess Isis, who rests her right hand upon his right shoulder ; in her left hand she holds the sign of life ⎐. Before Osiris, upon a lotus flower, stand the four children of Horus, the gods of the cardinal points, Mesthà, Hāpi, Ṭuamāutef, and Qebḥsennuf.

Vignette II. (PLATE XXIX.) : Ani and his wife Thuthu standing, with hands raised in adoration to Osiris, before a table of offerings.

Text [CHAPTER CXXV.] : (1) THE CHAPTER OF ENTERING INTO THE HALL OF DOUBLE RIGHT AND TRUTH : A HYMN OF PRAISE TO OSIRIS, THE DWELLER IN AMENTET. Osiris, the scribe Ani, triumphant, saith : (2) " I have come and I " have drawn nigh to see thy beauties ; my two hands are raised in adoration " of thy name Right and Truth. I have drawn nigh unto the place where the " acacia tree groweth not, (3) where the tree thick with leaves existeth not, and " where the ground yieldeth neither herb nor grass. And I have entered in " unto the place of secret and hidden things, (4) I have held converse with the " god Sut Osiris, the scribe Ani, hath entered into the House of " Osiris, and he hath seen the hidden (5) and secret things which are therein. The " holy rulers of the pylons are in the form of shining ones. (6) Anubis spake " unto him with the speech of man when he came from Ta-mera, saying, ' He " knoweth our paths and our cities, I have been pacified, (7) and the smell of him " is to me even as the smell of one of you.' "

Ani saith unto him : " I am Osiris, the scribe Ani, triumphant in peace, " triumphant ! (8) I have drawn nigh to behold the great gods, and I feed upon the " meals of sacrifice whereon their *kas* feed. I have been to the boundaries [of the

" lands] (9) of the Ram, the lord of Tattu, and he hath granted that I may come
" forth as a *bennu* bird and that I may have the power of speech. I have passed
" through the river-flood. I have made (10) offerings with incense. I have made
" my way by the side of the thick-leaved tree of the children (?). I have been in
" Abtu in the House of Satet. (11) I have flooded and I have sunk the boat of my
" enemies. I have sailed forth upon the Lake in the *neshem* boat. I have seen
" the noble (12) ones of Kam-ur. I have been in Tattu, and I have constrained
" myself to silence. I have set the divine Form upon his two feet. (13) I have
" been with the god Pa-tep-tu-f, and I have seen the dweller in the Holy Temple.
" I have entered into the House (14) of Osiris, and I have arrayed myself in the
" apparel of him who is therein. I have entered into Re-stau, and I have beheld
" the hidden things (15) which are therein. I have been swathed, but I found for
" myself a thoroughfare. I have entered into An-aarut-f, and I have clothed my
" body with the apparel (16) which is therein. The *āntu* unguent of women hath
" been given unto me. Verily, Sut spake unto me (17) the things
" which concern himself, and I said, ' Let the thought of the trial of the balance by
" thee be even within our hearts.' "

The majesty of the god Anubis saith : (18) " Dost thou know the name of
" this door to declare it unto me ?" Osiris, the scribe Ani, triumphant, (19)
triumphant in peace, saith : " ' Driven away of Shu ' is the name of this (20) door."
Saith the majesty of the god Anubis : (21) " Dost thou know the name of the
" upper (22) leaf and of the lower leaf thereof ?" [Osiris, the scribe Ani,
triumphant in peace saith] : " ' Lord of right and truth, [standing] (23) upon his
" two feet ' is the name of the upper (24) leaf, and ' Lord of might and power,
" dispenser of (25) cattle ' [is the name of the lower leaf]." [The majesty of the
god Anubis saith]: " Pass thou, for thou knowest [the names] (26), O Osiris, the
" scribe, teller (27) of the divine offerings of all the gods of Thebes, Ani,
" triumphant, lord to be revered."

Appendix : The usual introduction to the CXXVth Chapter reads (see
Naville, *Todtenbuch*, Bd. I., Bl. 133) as follows :—

I. (1) THE FOLLOWING SHALL BE SAID BY A MAN WHEN HE COMETH UNTO THE
HALL OF DOUBLE RIGHT AND TRUTH, WHEREIN HE IS PURGED (2) OF ALL THE SINS
WHICH HE HATH DONE, AND WHEREIN HE SEETH THE FACES OF ALL THE GODS:
" Hail to thee, great god, the lord of Right and Truth ! I have come unto thee, O my lord,
" (3) and I have drawn nigh that I may look upon thy beauties. I know thee, and I know
" the names of the forty-two gods who dwell with thee in this (4) Hall of Double Right
" and Truth, and that they may set the sinners in the gives, who live and who feed upon
" their blood on the day (5) when the natures of men are accounted before Un-neferu.

" In very truth 'Rekhti-merti-f-ent-Maāt' is thy name. Verily (6) I have come unto
" thee, and I bring before thee Right and Truth. For thy sake I have rejected wicked-
" ness. I have done no hurt unto man, nor have I wrought harm unto beasts. I
" have committed no crime (7) in the place of Right and Truth. I have had no know-
" ledge of evil; nor have I acted (8) wickedly. Each day have I laboured more than
" was required of me. (9) My name hath not come forth to the boat of the Prince.
" I have not despised God. (10) I have not caused misery; nor have I worked affliction.
" I have done not (11) that which God doth abominate. I have caused no wrong to be
" done to the servant by his master. I have (12) caused none to feel pain. I have made
" [no man] to weep. (13) I have not committed murder; nor have I ever bidden any man
" to slay on my behalf. I have not wronged the people. I have not filched that which
" hath been offered in (14) the temples; nor have I purloined the cakes of the gods.
" I have not carried away the (15) offerings made unto the blessed dead. I have not
" committed fornication, nor have I defiled my body. (16) I have not added unto nor
" have I minished the offerings which are due. I have not stolen from the orchards;
" nor have I trampled down the fields. I have not added to the weight of the balance;
" (17) nor have I made light the weight in the scales. I have not snatched the milk
" from the mouth of the babe. I have not (18) driven the cattle from their pastures. I
" have not snared the water-fowl of the gods. I have not caught fishes (19) with bait
" of their own bodies. I have not turned back water at its springtide. I have not
" broken the channel of running water. I have not quenched the flame (20) in its
" fulness. I have not disregarded the seasons for the offerings which are appointed ;
" I have not turned away the cattle set apart for sacrifice. I have not thwarted the
" processions of the god. (21) I am pure. I am pure. I am pure. I am pure. I am
" pure with the purity of the great Bennu bird which is in Suten-ḥenen; for, lo! I am
" the nostrils of (22) the lord of the winds who maketh all men to live on the day when
" the eye of the sun becometh full in Annu, in the second month of the season of coming
" forth until the end thereof, (23) in the presence of the lord of this earth. I behold the
" eye of the sun wax full in Annu. May no evil happen unto me in this land in the
" (24) Hall of Double Right and Truth, because I know, even I, the names of the gods
" who live therein and who are the followers of the great god."

PLATES XXXI. AND XXXII.

Vignettes : The Hall of Double Right and Truth, wherein Ani has to address
severally the forty-two gods, who are seated in a row in the middle of the hall.
At each end is a door ▌ ; that on the right is called
" Neb-Maāt-ḥeri-ṭep-reṭui-f," and that on the left ,
" Neb-peḥti-θesu-menment." On the centre o the roof, which is crowned with

a series of uræi and feathers emblematic of Maāt, is a seated deity with hands extended, the right over the eye of Horus 𓂀 and the left over a pool ▦ (see the Vignette of Plate VIII. above, p. 278).[1] On the right, at the end of the hall (Plate XXXII.), are four small vignettes, in which are depicted : (1) Two seated figures of the goddess Maāt, with ∫, emblematic of Right and Truth, on the head, and sceptres ⎸ and emblems of life ☥ in the right and left hands. (2) Osiris, seated, wearing the *atef* crown, and holding in his hands the crook ⌐ and flail ⫽. Before him, by the side of an altar of offerings, stands Ani, with both hands raised in adoration. (3) A balance with the heart, symbolizing the conscience of Ani, in one scale, and ∫, emblematic of Right and Truth, in the other. Beside the balance is the tri-formed monster Amemit. (4) Thoth, ibis-headed, seated on a pylon-shaped pedestal, painting a large feather of Maāt.

Text : [The Negative Confession.]

(1) Ani saith : " Hail, thou whose strides are long, who comest forth from Annu, I have not done iniquity."

(2) " Hail, thou who art embraced by flame, who comest forth from Kher-āba, I have not robbed with violence."

(3) " Hail, Fenṭiu, who comest forth from Khemennu, I have not stolen."

(4) " Hail, Devourer of the Shade, who comest forth from Qernet, I have done no murder ; I have done no harm."

(5) " Hail, Nehau, who comest forth from Re-stau, I have not defrauded offerings."

(6) Hail, god in the form of two lions, who comest forth from heaven, I have not minished oblations."

(7) " Hail, thou whose eyes are of fire, who comest forth from Saut, I have not plundered the god."

(8) " Hail, thou Flame, which comest and goest, I have spoken no lies."

(9) " Hail, Crusher of bones, who comest forth from Suten-ḥenen, I have not snatched away food."

(10) " Hail, thou who shootest forth the Flame, who comest forth from Het-Ptaḥ-ka, I have not caused pain."

[1] In the Nebseni Papyrus a dog-headed ape and a balance are represented on each side of the seated deity, and at each end of the roof; and each uræus wears a disk and horns.

(11) "Hail, Qerer, who comest forth from Amentet, I have not committed fornication."

(12) "Hail, thou whose face is turned back, who comest forth from thy hiding place, I have not caused shedding of tears."

(13) "Hail, Bast, who comest forth from the secret place, I have not dealt deceitfully."

(14) "Hail, thou whose legs are of fire, who comest forth out of the darkness, I have not transgressed."

(15) "Hail, Devourer of Blood, who comest forth from the block of slaughter, I have not acted guilefully."

(16) "Hail, Devourer of the inward parts, who comest forth from Mābet, I have not laid waste the ploughed land."

(17) "Hail, Lord of Right and Truth, who comest forth from the city of Right and Truth, I have not been an eavesdropper."

(18) "Hail, thou who dost stride backwards, who comest forth from the city of Bast, I have not set my lips in motion [against any man]."

(19) "Hail, Sertiu, who comest forth from Annu, I have not been angry and wrathful except for a just cause."

(20) "Hail, thou being of two-fold wickedness, who comest forth from Ati (?), I have not defiled the wife of any man."

(21) "Hail, thou two-headed serpent, who comest forth from the torture-chamber, I have not defiled the wife of any man."

(22) "Hail, thou who dost regard what is brought unto thee, who comest forth from Pa-Amsu, I have not polluted myself."

(23) "Hail, thou Chief of the mighty, who comest forth from Amentet, I have not caused terror."

(24) "Hail, thou Destroyer, who comest forth from Ḳesiu, I have not transgressed."

(25) "Hail, thou who orderest speech, who comest forth from Urit, I have not burned with rage."

(26) "Hail, thou Babe, who comest forth from Uab, I have not stopped my ears against the words of Right and Truth."

(27) "Hail, Kenemti, who comest forth from Kenemet, I have not worked grief."

(28) "Hail, thou who bringest thy offering, I have not acted with insolence."

(29) "Hail, thou who orderest speech, who comest forth from Unaseṭ, I have not stirred up strife."

(30) " Hail, Lord of faces, who comest forth from Netchfet, I have not judged hastily."

(31) " Hail, Sekheriu, who comest forth from Utten, I have not been an eavesdropper."

(32) " Hail, Lord of the two horns, who comest forth from Saïs, I have not multiplied words exceedingly."

(33) " Hail, Nefer-Tmu, who comest forth from Het-Ptaḥ-ka, I have done neither harm nor ill."

PLATE XXXII.

(34) " Hail, Tmu in thine hour, who comest forth from Tattu, I have never cursed the king."

(35) " Hail, thou who workest with thy will, who comest forth from Tebu, I have never fouled the water."

(36) " Hail, thou bearer of the sistrum, who comest forth from Nu, I have not spoken scornfully."

(37) " Hail, thou who makest mankind to flourish, who comest forth from Saïs, I have never cursed God."

(38) " Hail, Neḥeb-ka, who comest forth from thy hiding place, I have not stolen."

(39) " Hail, Neḥeb-nefert, who comest forth from thy hiding place, I have not defrauded the offerings of the gods."

(40) " Hail, thou who dost set in order the head, who comest forth from thy shrine, I have not plundered the offerings to the blessed dead."

(41) " Hail, thou who bringest thy arm, who comest forth from the city of Maāti, I have not filched the food of the infant, neither have I sinned against the god of my native town."

(42) " Hail, thou whose teeth are white, who comest forth from Ta-she, I have not slaughtered with evil intent the cattle of the god."

Appendix : The following version of the Negative Confession is given in the Nebseni Papyrus (Naville, *Todtenbuch*, Bd. I., Bll. 134, 135), showing important variations in the text and in the order in which the gods are addressed.

" (1) Hail, thou whose strides are long, who comest forth from Annu, I have not " done iniquity. (2) Hail, thou who art embraced by flame, who comest forth from " Kher-āba, I have not robbed with violence. (3) Hail Fenti who comest forth from

" Khemennu, I have not made any to suffer pain. (4) Hail, Devourer of Shades, who
" comest forth from [thy] retreat, I have not robbed. (5) Hail, thou whose limbs are
" terrible to look upon, who comest forth from Restau, I have done no murder. (6) Hail,
" thou god who art in the form of two lions, who comest forth from heaven, I have not
" defrauded offerings. (7) Hail, thou god whose two eyes are of fire, who comest forth
" from Sekhem, I have not done harm.[1] (8) Hail, Fiery god, who comest and goest,[2] I
" have not robbed God. (9) Hail, Crusher of Bones, who comest forth from Suten-henen,
" I have told no lies. (10) Hail, thou who shootest thyself forth from the flame, who comest
" forth from Het-Ptah-ka, I have not snatched away food. (11) Hail, Qerti, who comest forth
" from Amentet, I have not worked affliction. (12) Hail, thou whose teeth are white, who
" comest forth from Ta-she, I have not transgressed. (13) Hail, Devourer of blood, who
" comest forth from the block, I have not slaughtered the cattle which are set apart for
" the gods. (14) Hail, Devourer of the inward parts, who comest forth from Mābit, I have
" done no evil. (15) Hail, lord of Right and Truth, who comest forth from Maāti, I have
" not laid waste the ploughed lands. (16) Hail, Strider, who comest forth from Bast, I
" have not been an eavesdropper. (17) Hail, Aaati, who comest forth from Annu, I
" have not set my lips in motion against any man. (18) Hail, thou god of two-fold evil,
" who comest forth from Ati, I have not been angry without a cause. (19) Hail, thou
" god who art in the likeness of a serpent, who comest forth from the torture-chamber,
" I have not committed adultery with the wife of any man. (20) Hail, thou who
" regardest that which is brought before thee, who comest forth from Pa-Amsu, I have
" not polluted myself. (21) Hail, thou mighty Chief, who comest forth from the city of
" acacia trees, I have not caused terror. (22) Hail, Khemi, who comest forth from Kesui,
" I have not done that which is abominable. (23) Hail, thou who orderest speech, who
" comest forth from Urib, I have never uttered fiery words. (24) Hail, thou Babe, who
" comest forth from the Heq-āt nome, I have not stopped my ears against the words of
" Right and Truth. (25) Hail, thou who orderest speech, who comest forth from Unes,
" I have not stirred up strife. (26) Hail, Bast, who comest forth from the secret city, I
" have not caused [any] to weep. (27) Hail, thou whose face is turned behind thee, I
" have not lusted, nor have I committed fornication, nor have I done any other abomin-
" able thing. (28) Hail, Blazing feet, who comest forth from the darkness, I have not
" avenged myself. (29) Hail, Kenemti, who comest forth from Kenemti, I have never
" worked grief. (30) Hail, thou who bringest thy offering, who comest forth from Sau,
" I have not acted insolently. (31) Hail, lord of faces, who comest forth from Tchefet,
" I have never judged hastily. (32) Hail, Sekheriu, who comest forth from Unth, I have
" not transgressed, nor have I vexed or angered God. (33) Hail, lord of the two horns,
" who comest forth from Saui, I have not multiplied my speech overmuch. (34) Hail,
" Nefer-Tmu, who comest forth from Het-Ptah-ka, I have done no harm nor have I done

[1] Var. ⎯ 𓀀𓁐 𓏤 𓅓𓏏𓏌𓏥 𓊵𓏏𓊪 𓊌 "I have not worked deceit in the place of
Right and Truth." See Naville, *Todtenbuch*, Bd. II., p. 292.

[2] One variant has, "who comest forth from Seshet" 𓂋𓊨𓆱, and another, "who comest forth
from Annu"; see Naville, *Todtenbuch*, Bd. II., Bl. 292; Lepsius, *Todtenbuch*, Bl. 47, l. 21.

" evil. (35) Hail, Tmu in thine hour, who comest forth from Tattu, I have not worked
" treason. (36) Hail, thou who workest in thy heart, who comest forth from Tebtu, I
" have never befouled the water. (37) Hail, thou bearer of the sistrum, who comest
" forth from Nu, I have not spoken scornfully. (38) Hail, thou who dost make mankind
" to flourish, who comest forth from thy hall, I have not cursed God. (39) Hail, Neheb-
" nefert, who comest forth from, I have not behaved myself with arrogance (?).
" (40) Hail, Neheb-kau, who comest forth from thy city, I have not been overweeningly
" proud. (41) Hail, Tcheser-tep, who comest forth from thy hiding place, I have
" never magnified my condition beyond what was fitting. (42) Hail, thou who bringest
" thine arm, who comest forth from Aukert, I have never slighted the god in my town."

In the Nebseni papyrus (Naville, *Todtenbuch*, Bd. I., Bll. 137, 138), the CXXVth
Chapter ends as follows :—

 (2) " Homage to you, O ye gods, I know you, (3) and I know your names. Cast
" me not down to your (4) knives of slaughter, and bring not my wickedness into the
" presence of the god whom ye follow, (5) and let not the time of my failings come
" before you. I pray you, declare me right and true in the presence of the (6) universal
" God, because I have done that which is right and true in Ta-mera ; I have not cursed
" the god.
 " Homage to you, O ye gods who live in your hall of (7) Right and Truth, and who
" have no evil in your bodies, who feed on your own substance in (8) the presence of
" Horus who liveth in his disk, deliver ye me from Baabi, who feedeth on the inwards of
" the mighty ones on the day of the great judgment which shall be holden by you. (9)
" I have come unto you ; I have committed no faults ; I have not sinned ; I have done
" no evil ; I have accused no man falsely ; therefore let nothing be done against me. I
" live in right and truth, (10) and I feed my heart upon right and truth. That which
" men have bidden I have done, and the gods are satisfied thereat. I have pacified
" the god, for I have done his (11) will. I have given bread unto the hungry and water
" unto those who thirst, clothing unto the naked, and a boat unto the shipwrecked
" mariner. (12) I have made holy offerings unto the gods ; and I have given meals of
" the tomb to the sainted dead. O, then, deliver ye me, and protect me ; accuse me not
" before the great god. (13) I am pure of mouth, and I am pure of hands. May those who
" see me say, ' Come in peace, come in peace.' For I have heard the speech which the
" Ass held with the Cat in the House of Hept-re. (14) I have borne witness before him
" [the god] and he hath given judgment. I have beheld the dividing of the persea trees
" (15) within Re-stau. I offer up prayers in the presence of the gods, knowing that
" which concerneth them. I have come forward to make a declaration of right and
" truth, and to place (16) the balance upon its supports within the groves of amaranth.
" Hail, thou who art exalted upon thy resting place, thou lord of the *atef* crown, who
" declarest thy name as the lord of the (17) winds, deliver thou me from thine angels of
" destruction, who make dire deeds to happen and calamities to arise, and (18) who have
" no covering upon their faces, because I have done right and truth, O thou Lord of right
" and truth. I am pure, in my fore-parts have I been made clean, and in my hinder
" parts have I (19) been purified ; my reins have been bathed in the Pool of right and

" truth, and no member of my body was wanting. I have been purified in the pool or
" the south. I have rested in Hemet, on the north of the (20) field of the grasshoppers,
" wherein the holy mariners do purify themselves in the night season, that they may
" pacify (?) the heart of the gods after I have passed over it (21) by night and by day.
" May the gods say unto me, 'We let him come,' and they say unto me, 'Who art
" thou, and what is thy name?' My name is 'I grew among (22) the flowers, dwelling
" in the olive tree.' Then shall they say unto me, 'Pass on straightway.' I have passed
" by the city on the north of the groves, and the gods say, 'What didst thou see there?'
" [I saw] the Leg and the Thigh. (23) 'What hadst thou to do with them?' I saw
" rejoicings in the lands of the Fenkhu. 'What did they give thee?' They gave me a
" (24) flame of fire together with a crystal tablet. 'What didst thou therewith?' I
" burned it at the place of Maāti together with the things of the night. 'What didst
" thou (25) find there at the place of Maāti?' A sceptre of flint which maketh a man
" to prevail. 'What then is [the name] of this sceptre of flint?' 'Giver of winds' is its
" name. 'What then didst thou unto the flame of fire with the tablet of (26) crystal
" after thou didst bury it?' I uttered words over it, I made (27) adjuration thereby, I
" quenched the fire, and I used the tablet to create (28) a pool of water. 'Come, then, pass
" through the door of this Hall of two-fold Maāti, for thou (29) knowest us.' 'I will
" not let thee enter in over me,' saith the bolt of the door, (30) 'unless thou tell my
" name.' 'Weight of the place of right and truth' is thy name. 'I will not let thee
" (31) pass in by me,' saith the right post of the door, 'unless thou tell my name.'
" (32) 'Weigher of the labours of right and truth' is thy name. 'I will not let thee
" enter in by me,' saith the left post (33) of the door, 'unless thou tell my name.'
" 'Judge of (34) wine' (?) is thy name. 'I will not let thee pass,' saith the threshold of
" the door, (35) unless thou tell my name.' 'Ox of Seb' is thy name. 'I will not
" open unto thee,' (36) saith the bolt-socket of the door, 'unless thou tell my name.'
" 'Flesh of his (37) mother' is thy name. 'I will not open unto thee,' saith the lock of
" the door, 'unless thou tell my name.' 'The *utchat* of Sebek, the Lord of Bakhan,
" liveth' is thy name. (38) 'I will not open unto thee, and I will not let thee pass
" over me,' saith the dweller at the door, 'unless thou tell my name.' 'Arm of Shu
" that placeth itself to protect Osiris' (39) is thy name. 'We will not let thee pass by
" us,' say the posts of the door, 'unless thou tell our names.' 'Serpent children of
" Rennut' are your names. 'Thou (40) knowest us, pass thou by us.' 'Thou shalt not
" tread upon me,' saith the floor of the hall, 'unless thou tell my name.' 'I am silent, I
" am pure.' 'I know not (41) [the names of] thy two feet with which thou wouldst walk
" upon me; tell them unto me.' '. before Amsu' is the name of my right foot,
" 'Grief of Nephthys' is the name of (42) my left foot. 'Tread thou upon me, for thou
" knowest me.' 'I will not question thee,' saith the warder of the door of the hall,
" 'unless thou tell my name.' 'Discerner of hearts, (43) searcher of reins' is thy name.
" 'I will question thee now. Who is the god that liveth in his hour? Say thou.' The
" teller of the two lands. 'Who then is the teller (44) of the two lands?' It is
" Thoth. 'Come then,' saith Thoth, 'come hither (?).' And I come forward to the test.
" 'What, now, is thy condition?' I am pure from (45) all evil, I am shielded from the
" baleful acts of those who live in their days, and I am not among them. 'I have tried
" thee. (46) Who is he that goeth down into the fire, the walls whereof are [crowned]

" with uræi, and whose paths are in the lake [of fire]?' He who passeth through it (47)
" is Osiris. 'Advance thou, in very truth thou hast been tested. Thy bread is in the
" *utchat*, thine ale is in the *utchat*, and meals of the tomb are brought forth unto thee
" upon earth from the *utchat*. This hath been decreed for thee.'"

PLATE XXXII. (*continued*).

Vignette: The god Nu.

Text: (1) The hair of Osiris Ani, triumphant, is the hair of Nu.

Vignette : Rā, hawk-headed, and wearing a disk.

Text : (2) The face of Osiris, the scribe Ani, is the face of Rā.

Vignette : The goddess Hathor, wearing disk and horns.

Text : (3) The eyes of Osiris Ani, triumphant, are the eyes of Hathor.

Vignette : The god Ap-uat and standard 𓏠 .

Text: (4) The ears of Osiris Ani, triumphant, are the ears of Ap-uat.

Vignette : The god Anpu, jackal-headed 𓀀 .

Text : (5) The lips of Osiris Ani, triumphant, are the lips of Anpu.

Vignette : The scorpion Serqet 𓆲 , holding the *shen* 𓏵 , and *ānkh* 𓋹𓋹 .

Text: (6) The teeth of Osiris Ani, triumphant, are the teeth of Serqet.

Vignette: The goddess Isis 𓁐 .

Text : (7) The neck of Osiris Ani, triumphant, is the neck of Isis.

Vignette: The ram-headed god, with uræus between the horns.

Text : (8) The hands of Osiris Ani, triumphant, are the hands of the Ram,
the lord of Tattu.

Vignette : The god Uatchit, serpent-headed.

Text : (9) The shoulder of Osiris Ani, triumphant, is the shoulder of
Uatchit.

Vignette : The goddess Mert, with outstretched hands, standing upon the emblem of gold ⌐᠊⌐, and having on her head a cluster of plants 🌿.

Text : (10) The throat of Osiris Ani, triumphant, is the blood of Mert.

Vignette : The goddess Neith 𓎛.

Text : (11) The fore-arms of Osiris Ani, triumphant, are the fore-arms of the lady of Saïs.

Vignette : The god Sut.

Text : (12) The backbone of Osiris Ani, triumphant, is the backbone of Sut.

Vignette : A god.

Text : (13) The chest of Osiris Ani, triumphant, is the chest of the lords of Kher-āba.

Vignette : A god.

Text : (14) The flesh of Osiris Ani, triumphant, is the flesh of the Mighty One of terror.

Vignette : The goddess Sekhet, lion-headed, wearing a disk.

Text : (15) The reins and back of Osiris Ani, triumphant, are the reins and back of Sekhet.

Vignette : An *utchat* upon a pylon.

Text : (16) The buttocks of Osiris Ani, triumphant, are the buttocks of the Eye of Horus.

Vignette : Osiris, wearing the *atef* crown and holding the flail and crook.

Text : (17) The privy member of Osiris Ani, triumphant, is the privy member of Osiris.

Vignette : The goddess Nut.

Text : (18) The legs of Osiris Ani, triumphant, are the legs of Nut.

Vignette : The god Ptaḥ .

Text : (19) The feet of Osiris Ani, triumphant, are the feet of Ptaḥ.

Vignette : The star Orion.

Text : (20) The fingers of Osiris Ani, triumphant, are the fingers of Saaḥ (Orion).

Vignette : Three Uræi .

Text : (21) The leg-bones of Osiris Ani, triumphant, are the leg-bones of the living uræi.

Appendix : The complete version of the XLIInd Chapter of the Book of the Dead, referring to the identification of the body of Osiris with those of the gods reads as follows [1] :—

(1) [CHAPTER XLII.] THE CHAPTER OF DRIVING BACK SLAUGHTER IN SUTEN HENEN. Saith Osiris: "O land of the sceptre! (2) O white crown of the divine Form " O holy resting place ! I am the Child. I am the Child. I am the Child. I am the Child " Hail, thou goddess Aburt! Thou sayest daily, ' The slaughter block is (3) made ready " as thou knowest, and thou who wert mighty hast been brought to decay.' I establish " those who praise me. I am the holy knot within the tamarisk tree, more beautiful (4) in " brightness than yesterday." To be said four times. "I am Rā who establish thos " who praise him. I am the knot within the tamarisk (?) tree, more beautiful in bright " ness than the disk of yesterday (5) going forth on this day. My hair i " the hair of Nu. My face is the face of Rā. Mine eyes are the eyes of Hathor. Min " ears are the ears of Ap-uat. (6) My nose is the nose of Khent-sheps.[2] My lips are th " lips of Anpu. My teeth are the teeth of Kheperà. My neck is the neck of Isis, the divin " lady. (7) My hands are the hands of Khnemu, the lord of Tattu. My fore-arms ar " the fore-arms of Neith, the lady of Saïs. My backbone is the backbone of Sut. My " privy member is the privy member of Osiris. My reins (8) are the reins of the lord " of Kher-āba. My breast is the breast of the awful and terrible One. My belly and my " backbone are the belly and backbone of Sekhet. My buttocks (9) are the buttocks o

[1] For the text, see Naville, *Todtenbuch*, Bd. I., Bl. 56.

[2] Varr. , , *Khentet-khas, Khentet-khaset,* and *Khent. sekhem.*

"the eye of Horus. My hips and thighs are the hips and thighs of Nut. My feet are
"the feet of Ptaḥ. My fingers and leg-bones are the fingers and leg-bones of the living
"(10) uræi. There is no member of my body which is not the member of some god.
"Thoth shieldeth my body altogether, and I am [like] unto Rā every day. (11) None
"shall seize me by mine arms; none shall drag me away by my hand. And there shall
"do me hurt neither men, nor gods, nor sainted dead, nor they who have perished, nor
"any one of those of olden times, (12) nor any mortal, nor human being. I come forth
"and advance, and my name is unknown. I am yesterday, and my (13) name is 'Seer
"of millions of years.' I travel, I travel along the path of Horus the Judge. I am
"the lord of eternity; I feel and I have power to perceive. I am the lord of the red
"crown. I am the Sun's eye, yea, (14) I am in my egg, in my egg. It is granted unto
"me to live therewith. I am in the Sun's eye, when it closeth, and I live by the strength
"thereof. I come forth and I shine; (15) I enter in and I come to life. I am in the
"Sun's eye, my seat is on my throne, and I sit thereon within the eye. I am Horus
"who pass through millions of years. (16) I have governed my throne and I rule it
"by the words of my mouth; and whether [I] speak or whether [I] keep silence, I keep
"the balance even. Verily my forms are changed. I am the (17) god Unen, from
"season unto season; what is mine is within me. I am the only One born of an only One,
"who goeth round about in his course; (18) I am within the eye of the Sun. Things are
"not evil nor hostile unto me, nor are they against me. I open the door of heaven. I
"govern my throne, and I give [new] birth to myself on this day. [I am] not the Child
"who trod (19) the path of yesterday, but I am 'To-day' for untold nations. It is I
"who make you strong for millions of years, whether ye be in the heaven, or (20) in the
"earth, or in the south, or in the north, or in the west, or in the east; fear of me is in
"your hearts. I am the pure one who dwell within the sacred eye. I shall not die
"(21) again. My hour resteth with you, but my forms are within my dwelling-place. I
"am he who is unknown, and the gods with rose-bright countenances are (22) with me.
"I am the unveiled one. The season wherein [the god] created heaven for me and
"enlarged the bounds of the earth and made great the progeny thereof cannot be found
"out. (23) My name setteth itself apart aud removeth from all evil things through the
"words which I speak unto you. I am he who riseth and shineth; the wall of walls;
"the only One, [son] of an only One. Rā (24) never lacketh his form, he never passeth
"away, he never passeth away. Verily, I say: I am the plant which cometh forth from
"Nu, and my mother is Nut. Hail, (25) O my Creator, I am he who hath no power to
"walk, the great knot within yesterday. My power is in my hand. I am not known,
"[but] I am he who knoweth (26) thee. I cannot be held with the hand, but I am he
"who can hold thee in his hand. [Hail] O Egg! [Hail] O Egg! I am Horus who
"live for millions of years, whose flame lighteth upon your faces and (27) blazeth in
"your hearts. I have the command of my throne, and I advance in mine hour. I
"have opened the paths, I have turned myself away from all evil. I am (28) the ape of
"gold, three palms and two fingers [high], which is without legs and without arms, and
"which dwelleth in the House of Ptaḥ. I go forth even as goeth forth the ape of (29)
"gold three palms and two fingers [high], which hath neither legs nor arms, and which
"dwelleth in the house of Ptaḥ." When [thou] hast said this chapter thou shalt open a
way and enter thereon.

PLATE XXXIII.

Vignette : A lake of fire, at each corner of which is seated a dog-headed ape.[1]

Rubric : (1) Osiris Ani, triumphant, is girt about with [fine] raiment, he is shod with (2) white sandals, and he is anointed with very precious *ānta* ointment ; and a bull, (3) and herbs, and incense, and ducks, and flowers, and ale, and cakes have been offered unto him. And behold, thou shalt limn upon a clean tile (4) the image of a table of offerings in clean colours, and thou shalt bury it in a field whereon (5) swine have not trampled. If this word then be written upon it, he himself shall rise again, (6) and his children's children shall flourish even as Rā flourisheth without ceasing. He shall dwell in favour (7) in the presence of the king among the chiefs, and cakes and cups of drink and portions of meat shall be given unto him upon the table (8) of the great god. He shall not be thrust from any door in Amentet ; he shall travel on (9) together with the kings of the north and of the south, and he shall abide with the (10) followers of Osiris near unto Un-nefer, for ever, and for ever, and for ever.

Vignette : a Ṭet, ⧊[2]

[1] A somewhat similar scene forms the vignette to Chapter CXXVI., but in addition to the apes there are two uræi at each corner. The text reads : " Hail, ye four apes who sit in the bows of the boat of " Rā, who make the right and truth of Neb-er-tcher to advance, who apportion unto me my weakness " and my strength, who pacify the gods by the flame of your mouths, who give holy offerings unto the " gods, and sepulchral meals of the tomb unto the shining ones, who feed upon right and truth, who are " without falsehood, and who abominate wickedness. Destroy ye the evil which is in me, do away " with mine iniquity, put away the wounds which I had upon earth, and destroy all wickedness which " cleaveth unto me." [The apes say] : " Enter thou in and let nothing whatever oppose thee." " Grant " ye that I may pass through the tomb, and that I may enter into Re-stau, and that I may go in through " the hidden doors of the underworld, and that offerings and other things may be made unto me as " unto those shining ones who pass into and out from the paths of the tomb, and who go through [the " doors thereof].

[2] The ⧊ represents four pillars, *i.e.*, the four quarters of heaven, or the whole universe. As a religious emblem it symbolizes the god Osiris. A fine collection of *ṭets* is exhibited in the Fourth Egyptian Room (Table-Case K, and Wall-Case, No. 114), and among them may be noted : No. 2097, blue glazed *faïence* pendent ṭet, with the horns, disk, and plumes ⧉ ; No. 739, blue glazed *faïence* pendent *ṭet*, with five cross-bars, and ⧉ ; No. 8260, lapis-lazuli pendent *ṭet*, with horns, disk, and plumes ; No. 8275, carnelian *ṭet ;* No. 8270, agate *ṭet ;* No. 20,623, opaque blue glass *ṭet* inscribed with the name of its owner ; No. 20,636, stone *ṭet* inlaid with lapis-lazuli, carnelian, plasma, and mother of emerald.

Text: [CHAPTER CLV.]. (1) THE CHAPTER OF A ṬEṬ OF GOLD: Osiris " Ani, triumphant, saith: Thou risest, O still heart! (2) Thou shinest, O still " heart! Place thou thyself upon my side. I have come and I have brought " unto thee a ṭeṭ of gold; rejoice thou in it."

Appendix: In the late recension of this chapter (Lepsius, *Todtenbuch*, Bl. 75) the rubric is divided into two parts, which read: "To be recited over a Ṭeṭ of gold inlaid (?) " in sycamore wood, and placed on the neck of the shining one; and he shall pass in " through the doors of the underworld by the might of the words here spoken. It shall " set him in his place on the day of the new year among the followers of Osiris.
" If this chapter be known by the deceased he shall become perfect in the underworld. " He shall not be thrust back at the doors of Amentet; cakes and ale and meat offerings " shall be offered unto him upon the altars of Rā, or (as some say) of Osiris Un-nefer; " and he shall triumph over his foes in the underworld for ever and for ever."

Vignette: A buckle, or tie.

Text: [CHAPTER CLVI.]. (1) THE CHAPTER OF A BUCKLE OF CARNELIAN.[1] Saith Osiris Ani, triumphant: "The blood of Isis, the charms of Isis, (2) the " power of Isis, are a protection unto me, the chief, and they crush that which I abhor."

Appendix: *Rubric:*[2] This chapter shall be said over a buckle of red jasper[3] (*or* carnelian) which hath been dipped in water of *ānkham* flowers and inlaid in sycamore wood, and hath been placed on the neck of the shining one. If this chapter be inscribed upon it, it shall become the power of Isis, and it shall protect him; and Horus, the son of Isis, shall rejoice when he seeth it. No way shall be impassable to him, and one hand shall extend unto heaven, and the other unto earth. If this chapter be known [by the

[1] The Nebseni papyrus adds the words ⟨hieroglyphs⟩, "to be placed near the neck of this shining one."

[2] See Maspero, *Mémoire sur Quelques Papyrus du Louvre*, p. 8.

[3] The amulet of the buckle is usually made of carnelian, red jasper, red porphyry, red glass, or red *faïence*, but examples in grey and black stone and wood are also known; at times it was made entirely of gold, but it was frequently set in gold only. Large wooden models of the buckle were placed in the wooden hands which were fastened on the breasts of coffins; they usually lay upon the left breast, and the *ṭeṭ* on the right. In the fine collection of buckles in the British Museum the following are of interest: No. 20,641, pendent buckle of red glass inscribed with the Chapter of the Buckle; No. 20,621, black stone pendent buckle, with hollow loop, inscribed with the Chapter of the Buckle; No. 20,646, grey stone buckle inscribed ⟨hieroglyphs⟩ ⟨hieroglyphs⟩; No. 20,619, red glass (?) buckle set in a gold frame, and inscribed with a few words of the Chapter of the Buckle, and the name of Åāh-mes the scribe; No. 8258, mottled glass buckle having the loop inlaid with blue composition; No. 8259, red *faïence* double buckle, pierced lengthwise for threading in a necklace.

deceased] he shall be among those who follow Osiris Un-nefer, triumphant. The gates of the underworld shall be opened unto him, and a homestead shall be given unto him, together with wheat and barley, in the Sekhet-Aaru ; and the followers of Horus who reap therein shall proclaim his name as one of the gods who are therein.

Vignette : A heart.

Text : [CHAPTER XXIXB.]. (1) THE CHAPTER OF A HEART OF CARNELIAN. Saith Osiris Ani, triumphant : " I am the *Bennu*, the soul of Rā, and the guide of " the gods into (2) the underworld. The souls come forth upon earth to do the " will of their *ka*'s, and the soul of Osiris Ani cometh forth to do the will of his *ka*."

Vignette : A head-rest.

Text : [CHAPTER CLXVI.]. (1) THE CHAPTER OF THE PILLOW WHICH IS PLACED UNDER THE HEAD OF OSIRIS ANI, TRIUMPHANT, TO WARD OFF WOES FROM THE DEAD BODY OF OSIRIS. (2) [Ani saith] : " Lift up thy head to the heavens, " for I have knit thee together triumphantly. Ptaḥ hath overthrown his foes " and thine ; all his enemies have fallen, and they shall never more rise up again, " O Osiris."

PLATES XXXIII AND XXXIV.

Vignette : The mummy-chamber, arranged as a plan, representing the floor and walls laid flat, in fifteen compartments. In the centre, under a canopy, is placed the bier bearing the mummy of Ani, beside which stands the god Anubis,[1]

[1] In the Nebseni papyrus the text referring to Anubis reads : " Anubis, who dwelleth in the region " of the embalmed, the chief of the holy house, layeth his hands upon the lord of life (*i.e.*, the mummy), " and provideth him with all that belongeth unto him, and saith : ' Hail to thee, thou beautiful one, the " lord ! Thou ḥast been gazed upon by the Sun's eye, thou hast been bound up by Ptaḥ-Seker, thou " hast been made whole by Anubis ; breath hath been given unto thee by Shu, and thou hast been " raised up by the fair one, the prince of eternity. Thou hast thine eyes. Thy right eye is in the *sektet* " boat, and thy left eye is in the *ātet* boat. Thine eye-brows appear fair before the company of the gods. " Thy brow is in the charge of Anubis. The back of thy head is in good case in the presence of the " sacred hawk. Thy fingers are stablished by written decree in the presence of the lord of Khemennu, " and Thoth giveth unto thee the speech of the sacred books. Thy hair is in good case in the " presence of Ptaḥ-Seker. Osiris is in bliss, and reverence is done unto him before the company of " the great gods. He looketh upon the great god, he is led on fair paths, he is made strong with " meals of the tomb, and his enemies are cast down beneath him in presence of the company of the " great gods who are in the great house of the aged one in Annu.'"

with hands outstretched over the body. At the foot of the bier kneels the goddess Isis, and at the head the goddess Nephthys, each being accompanied by a flame of fire, which is placed in the compartment immediately behind her. The Ṭeṭ occupies the compartment immediately above the bier, and the jackal— emblematic of Anubis or Ap-uat—couchant on the tomb, with a sceptre having pendent *menats*—occupies the compartment below. The four children of Horus, or gods of the cardinal points—Mesthà, Ḥāpi, Ṭuamautef, and Qebḥsennuf—stand in the corners of the four adjoining compartments. In each of the two upper and outer compartments is the human-headed bird emblematic of the soul, standing on a pylon, the one on the right being turned to the west or 'setting sun, the other on the left facing the east or rising sun. In the right lower compartment stands the figure of the Perfected Soul; in the corresponding compartment on the left is a Ushabti figure.

Text [CHAPTER CLI.]. [Isis saith:] "I have come to be a protector unto " thee. I waft (2) unto thee air for thy nostrils, and the north wind, which cometh " forth from the god Tmu, unto thy nose (3). I have made whole thy lungs. I " have made thee (4) to be like unto a god. Thine enemies have fallen beneath " thy feet. (5, 6) Thou hast been made victorious in (7) Nut, and thou art mighty " to prevail with the gods."

[Nephthys saith:] "(2) I have gone round about to protect thee, brother " Osiris; (3) I have come to be a protector unto thee. [My strength shall be " behind thee, my strength shall be behind thee, for ever. Rā hath heard thy cry, " and the gods have granted that thou shouldst be victorious. Thou art raised " up, and thou art victorious over that which hath been done unto thee. Ptaḥ " hath thrown down thy foes, and thou art Horus, the son of Hathor.]"[1]

[1] In Ani the text is corrupt, and the passage within brackets is translated from the following version (Naville, *Todtenbuch*, Bd. II., Bl. 428):

| māket - à | ḥa - k | sep sen | t'etta | setem | nàs - k | àn | Rā |

| semaāχeru | àn | neteru | θes - tu | semaāχeru - k | her | àrit | erek | χer |

| en | Ptaḥ | χeft - k | entek | Ḥeru | sa | Ḥet-Ḥeru |

[The flame of Isis saith:] " I protect thee with this flame, and I drive away
" him (the foe) from the valley of the tomb, and I drive away the sand from thy
" feet. I embrace Osiris Ani, who is triumphant in peace and in right and
" truth."[1]

[The flame of Nephthys saith :] " I have come to hew in pieces. I am not
" hewn in pieces, nor will I suffer thee to be hewn in pieces. I have come to
" do violence, but I will not let violence be done unto thee, for I am protecting
" thee."

[The Ṭeṭ saith :] " I have come quickly, and I have driven back the footsteps
" of the god whose face is hidden.[2] I have illumined his sanctuary. I stand
" behind the sacred Ṭeṭ on the day of repulsing disaster.[3] I protect thee,
" O Osiris."

[Mesthà saith :] " I am Mesthà, thy son, O Osiris Ani, triumphant. I have
" come to protect thee, and I will make thine abode to flourish everlastingly. I
" have commanded Ptaḥ, even as Rā himself commanded him."

[Ḥāpi saith :] " I am Ḥāpi thy son, O Osiris Ani, triumphant. I have
" come to protect thee. Thy head and thy limbs are knit together; and I have
" smitten down thine enemies beneath thee. I have given unto thee thy head
" for ever and for ever, O Osiris Ani, triumphant in peace."

[Ṭuamāutef saith :] " I am thy beloved son Horus. I have come to avenge
" thee, O my father Osiris, upon him that did evil unto thee ; and I have put him
" under thy feet for ever, and for ever, and for ever, O Osiris Ani, triumphant
" in peace."

[1] The text here is corrupt. Brit. Mus. papyrus, No. 10,010 (Naville, *Todtenbuch*, Bd. II., Bl. 429)
reads :—

nuk àḥu śā er ṭeb àment χesef-ā χesef su er teka set àu seset-nà set àu setenem-nà uat àu-à em sa, " I
" surround with sand the hidden tomb, and drive away the violent one therefrom. I lighten the
" valley of the tomb, I cast light therein, I traverse the ways, and I protect [Osiris]."

[2] Reading

ī - à em ḥeḥ χesef nemmat kep - ḥrà - f seḥet' kep - f

See Naville, *Todtenbuch*, Bd. II., Bl. 428.

[3] Variant *hru χesef śāt,* " day of driving back slaughter."

[Qebḥsennuf saith :] " I am thy son, O Osiris Ani, triumphant. I have come
" to protect thee. I have collected thy bones, and I have gathered together thy
" members. [I have brought thy heart and I have placed it upon its throne
" within thy body. I have made thy house to flourish after thee, O thou who
" livest for ever.]"[1]

[The bird which faceth the setting sun saith]: " Praise be to Rā when he
" setteth in the western part of heaven. Osiris Ani, triumphant in peace in the
" underworld, saith : ' I am a perfected soul.' "

[The bird which faceth the rising sun saith]: " Praise be to Rā when he
" riseth in the eastern part of heaven from Osiris Ani, triumphant."

[The Perfected Soul saith]: " I am a perfected soul in the holy egg of the
" *abtu* fish. I am the great cat which dwelleth in the seat of right and truth
" wherein riseth the god Shu."

[The text near the Ushabti Figure (Chapter VI.) reads]: Osiris Ani, the over-
seer, triumphant, saith : " Hail, *shabti* figure! If it be decreed that Osiris [Ani]
" shall do any of the work which is to be done in the underworld, let all that standeth
" in the way be removed from before him ; whether it be to plough the fields, or
" to fill the channels with water, or to carry sand from [the East to the West]."
The *shabti* figure replies : " I will do [it] ; verily I am here [when] thou callest."

Vignette : Ani, with both hands raised in adoration, standing before a table
of offerings ; behind him is his wife holding lotus and other flowers in her left
hand.

Text : [Chapter CX.] (1) HERE BEGIN THE CHAPTERS OF THE SEKHET-
ḤETEPU, AND THE CHAPTERS OF COMING FORTH BY DAY, AND OF GOING INTO AND
OF COMING OUT FROM THE UNDERWORLD, AND OF ARRIVING IN THE SEKHET-
(2) ÁANRU, AND OF BEING IN PEACE IN THE GREAT CITY WHEREIN ARE FRESH
BREEZES. Let me have power there. Let me become strong to plough there.
(3) Let me reap there. Let me eat there. Let me drink there. [Let me woo
there.][2] And let me do all these things there, even as they are done upon earth.

[1] In the papyrus of Ani the text of the end of the speech of Qebḥsennuf appears to be corrupt ;
the words within brackets are translated from other papyri, and the Egyptian would run as follows :

àn-nà nek àb-k ṭā-à nek su ḥer àuset-f em χat-k seruṭ-nà pa-k emχet-k ānχ-θà t'etta.

[2] Reading, with the Nebseni papyrus, *nehep àm.*

Saith Osiris Ani, triumphant: (4) " Set hath carried away Horus to see what
" is being built in the Field of Peace, and he spreadeth the air over (5) the
" divine soul within the egg in its day.　He hath delivered the innermost part of
" the body of Horus from the holy ones of Akert (?).[1]　Behold I have sailed in
" the mighty boat on the Lake of Peace.[2]　I, even I, have crowned him in the
" House of (6) Shu.　His starry abode reneweth its youth, reneweth its youth.　I
" have sailed on its Lake that I may come unto its cities, and I have drawn nigh
" unto the city Hetep.[3]　For behold, I repose at the seasons [of Horus].　I have
" passed through the region of the company of the gods who are aged and
" venerable.　(7) I have pacified the two holy Fighters[4] who keep ward upon life.
" I have done that which is right and fair, and I have brought an offering and
" have pacified the two holy Fighters.　I have cut off the (9) hairy scalp of their
" adversaries, and I have made an end of the (10) woes which befel [their]
" children; (11) I have done away all the evil which came against their souls; I
" have gotten dominion over it, (12) I have knowledge thereof.　I have sailed
" forth on the waters [of the lake] (13) that I may come unto the cities thereof.
" I have power (14) over my mouth, being furnished [with] charms; let not [the
" fiends] get the mastery over me, (16) let them not have dominion over me.
" May I be equipped in thy Fields of Peace.　What thou wishest that shalt thou
" do, [saith the god]."

Vignette: The Sekhet-hetepet or " Fields of Peace," surrounded and
intersected with streams.　They contain the following:

(*a.*) Thoth, the scribe of the gods, holding pen and palette, introduces Ani,
who is making an offering, and his *ka* to three gods who have the heads of a hare,
serpent, and bull respectively, and are entitled ⊖ *pauti*, " the company of the
gods."　Ani and a table of offerings in a boat.　Ani addressing a hawk standing

[1] Reading, with the Nebseni papyrus, 𓀀 —𓏤𓎺𓏲𓏭 *mā Ȧkeru*.

[2] Adding from the Nebseni papyrus 𓊵𓏏𓊪𓈗𓂺𓃀 *ȧs kuȧ χenen-ȧ uȧa pen āā em Śe-Ḥetep.*

[3] Adding from the Nebseni papyrus 𓏏𓏏𓊪𓈗𓈗𓏏𓊪 *renp-θ renp-θ χen-nȧ em śe-s er sper-ȧ er nut-s χent-ȧ er Ḥetep-sen entet.*

[4] *I.e.,* Horus and Set.

on a pylon-shaped pedestal, before which are an altar and a god. Three ovals.[1] The legend reads : *un em ḥetep seχet nifu er fent,* " Being at peace in the Field [of Peace], and having air for the nostrils."

(*b.*) Ani reaping wheat, with the words *aseχ Ȧusȧr,* " Osiris reaps"; guiding the oxen treading out the corn; standing with hands raised in adoration behind the *bennu* bird , and holding the *kherp* sceptre , and kneeling before two vessels of red barley and wheat. The hieroglyphics seem to mean, " the food of the shining ones." Three ovals.[2]

(*c.*) Ani ploughing[3] with oxen in a part of the Fields of Peace called "Sekhet-ȧanre"; with the word *sekau,* " to plough." The two lines of hieroglyphics read :—

re	*en*	*ḥet'et*	*ȧtru*	1000	*em*	*ȧu - f*
Chapter of the		River-horse.	The river is	one thousand [cubits]	in	its length.

ȧn	*t'eṭ*	*useχ - f*	*ȧn*	*un*	*remu*	*neb*	*ȧm - f*	*ȧn*
Not can be told		its width.	Not	exist	fishes	any	in it,	not [exist]

ḥefȧu	*nebt*	*ȧm - f*
serpents	any	in it.

[1] In the Nebseni papyrus they are called Qetqetmu, Ḥetepmu, and Urmu.

[2] Instead of three, the Nebseni papyrus has four ovals, which are called Hetep, An (?), Uakhakha, and Neb-taui.

[3] In the Turin papyrus, published by Lepsius, the ploughing, sowing, reaping and treading out the corn are all shown in one division, and the deceased stands in adoration before "Ḥāpi, the father of the gods."

In the papyrus of Nebseni the deceased adores the company of the gods who live in the Field of Hetep, saying : "Hail to you, O ye lords of *kas,* I have come in peace into your fields to receive " *tchefau* food. Grant ye that I may come to the great god daily, and that I may have sepulchral " meals, and that my *ka* may be supplied with the meat and drink offered to the dead. May Osiris " and the company of the gods, who dwell in the Field of Hetep, give a royal oblation, may they

(*d.*) A boat bearing a flight of steps 𓊽 and floating on a stream ;[1] above is the legend 𓆓𓄿𓆑𓅱 *tchefau*,[2] (?). A boat of eight oars, each end shaped like a serpent's head, bearing a flight of steps; at the stern is written ⟨⟩, and at the bows ⟨⟩ *neter àm Un-nefer*, "the god therein is Un-nefer." The stream which flows on the convex side of the small island is called ⟨⟩ *àshet pet*, "flood (?) of [heaven]." On the other island is placed a flight of steps, by the side of which is written ⟨⟩.[3] The space to the left represents the abode of the blessed dead, and is described as :—

àuset	*χu*	*àu - sen*	*meh*	*seχef*	*àt*	*meh*	*χemt*	*àn*
The seat	of the shining ones.	Their length is	cubits	seven	the wheat	cubits	three ;	

sāhu	*àqeru*	*aseχet - sen*
the blessed dead	who are perfected	they reap [it].[4]

"grant meat and drink and all good things, and bandages and incense every day. And may I sit "down at the table [of the god] daily to receive bread of his bread, and cakes, and wine, and milk, "and *tchefau* food; and may I follow in the train of the god when he maketh his appearance in his "festivals in Res-tau." (For the text see Naville, *Todtenbuch*, Bd. I., Bl. 123.)

[1] In the Turin papyrus this boat is called

uàa	*en*	*Rā-Ḥeru-χuti*	*χeft*	*t'a - f*	*er*	*Seχet*	*Àanre*
the boat of		Rā-Harmachis	when	he goeth forth	into	the Field	of Aanre.

[2] In the Turin papyrus the words ⟨⟩ *t'efu uru* are written between the boats, the ends of which are shaped like serpents' heads.

[3] In ancient papyri ⟨⟩ *qeqsu* is written, and in the Turin papyrus ⟨⟩. In the Nebseni papyrus four gods dwell on this island, and the accompanying text says that they are "the great company of the gods in Sekhet-ḥetep" ⟨⟩; but in the Turin papyrus three gods only, whose names are Shu, Tefnut, and Seb respectively, are depicted.

[4] A small division called the "birthplace of the gods" is not marked in the Ani papyrus, although it is found in that of Nebseni (see Naville, *Todtenbuch*, Bd. I., Bl. 123).

PLATES XXXV. AND XXXVI.

Vignette : A hall, within which, on the left, Ani stands before two tables of offerings bearing libation water and lotus-flowers, with hands raised, adoring Rā, hawk-headed.[1] Next are ranged seven cows, each one couchant before a table of offerings, and each having a *menàt* attached to the neck ;[2] and a bull standing before a table of offerings. Behind them are four rudders ; and on the extreme right are four triads of gods, each triad having a table of offerings bearing a libation vase and a lotus-flower (?).

Text : [CHAPTER CXLVIII.]. (1) Saith Osiris Ani, triumphant : "Homage " to thee, (2) O thou lord, thou lord of right and truth, the One, the lord of eternity " and creator (3) of everlastingness, I have come unto thee, O my lord Rā. " I have made (4) meat offerings unto the seven kine and unto their bull. O ye " who give (5) cakes and ale to the shining ones, grant ye to my soul to be with

[1] In the Turin papyrus, published by Lepsius, the god wears the triple or *atef* crown instead of a disk and serpent 🜨, and the text describes him as 〔hieroglyphs〕 "Osiris the lord of eternity, the prince, the lord of everlastingness, the great god, the governor of Akertet." Behind the god stands a female figure wearing 〔hieroglyph〕 upon her head, emblematic of "the beautiful Amenta," with both her hands "extended to receive" the deceased. The address to Osiris and Amenta by the deceased reads : "Homage to thee, O thou Bull of Amentet, Prince, lord of everlastingness, the great god, the governor of Akertet, receive thou the Osiris into the beautiful Amentet in peace, and may it stretch forth its hands to receive me."

[2] In other papyri the names of these animals are given as follows :

(1) 〔hieroglyphs〕, *ḥet kau nebt tcher*, "the dwelling of the *kas* of the lord of the universe"; (2) 〔hieroglyphs〕 *šentet uθeset*, "orbit, the raising of the god"; (3) 〔hieroglyphs〕 *àmenit χentet àuset-s*, "the hidden one dwelling in her place"; (4) 〔hieroglyphs〕 *ḥatet sāḥet*, "the divine noble one of the north (?) "; (5) 〔hieroglyphs〕 *urt meru ṭešert*, "the greatly beloved, red of hair"; (6) 〔hieroglyphs〕 *χnemt ānχit*, "the consort of life"; (7) 〔hieroglyphs〕 *seχem ren-s em àbet-s*, "her name prevaileth in her dwelling"; (8) 〔hieroglyphs〕 *ka t'ai kauit*, "Bull, making the kine to be fruitful."

" you. (6) May Osiris Ani, triumphant, be born upon your thighs ; may he be
" like unto one (7) of you for ever and for ever ; and may he become a glorious
" being (8) in the beautiful Amenta."

[*Address to the Rudders*]: "(1) Hail, thou beautiful Power,[1] thou beautiful
" rudder of the northern heaven."

" (2) Hail, thou who goest round about heaven, thou pilot of the world, thou
beautiful rudder of the western heaven."

" (3) Hail, thou shining one, who livest[2] in the temple wherein are the gods
" in visible forms, thou beautiful rudder of the eastern heaven."

" (4) Hail, thou who dwellest in the temple of the bright-faced ones,[3] thou
" beautiful rudder[4] of the southern heaven."

[*Address to the four Triads*[5]]: " (5) Hail, ye gods who are above the earth,
ye pilots of the underworld."

" (6) Hail, ye mother-gods who are above the earth, who are in the under-
" world, and who are in the House of Osiris."

" (7) Hail, ye gods, ye pilots of Tasert, ye who are above the earth, ye pilots
" of the underworld."

" (8) Hail, ye followers of Rā, who are in the train of Osiris."

Vignette : Ani standing before a table of offerings, with both hands raised
in adoration. Behind him is his wife, wearing a lotus-flower and a cone upon her
head, and holding a sistrum and lotus-flower in her left hand.

Text : [Chapter CLXXXV. (?)] (1) A Hymn of Praise to Osiris the
dweller in Amentet, Un-nefer within Abtu. Osiris Ani, triumphant, saith :
" Hail, O my lord, who dost traverse (2) eternity, and whose existence endureth
" for ever. Hail, Lord of Lords, King of Kings, Prince, the God of gods who
" (3) live with Thee, I have come unto Thee Make thou for me a seat
" with those who are in the underworld, and who adore (4) the images of thy *ka*
" (5) and who are among those who [endure] for (6) millions of millions of years

[1] Variant ⊔×—⌐⨯— *ka-f nefer*, "his beautiful *ka*."

[2] Reading �𓈖𓏤 *xenti her àb*.

[3] Reading *her àbu het teser*.

[4] In the Turin and the older papyri each rudder is accompanied by an *utchat* ⟨⟩.

[5] In the Turin papyrus the four children of Horus take the place of these triads.

"......[1] (10) May no delay arise for me in Ta-mera. Grant thou (11) that
" they all may come unto me, great (12) as well as small. Mayest thou grant unto
" the *ka* of Osiris Ani [the power] to go into and to come forth (13) from the
" underworld ; and suffer him not to be driven back at the gates of the *Tuat*."[2]

PLATE XXXVII.

Vignette : A shrine wherein stands

Sekeri-Àusàr	neb	śetait	neter āa	neb	Neter-χert
Seker-Osiris,	lord of	the hidden place,	the great god,	the lord of	the underworld.

He wears the white crown with feathers, and holds in his hands the sceptre
⌐, flail ⋀, and crook.

 The goddess Hathor, in the form of a hippopotamus, wearing upon her head
a disk and horns ; in her right hand she holds an unidentified object, and in her

 [1] The text of all this passage is corrupt, and the version here given is little more than a suggestion.
 [2] The version of the CLXXXVth Chapter given by Naville (*Todtenbuch*, Bd. I., Bl. 211) reads :—

ànet'-ḥrā-k	neter	pen	śeps	āā	menχ	ser	er	neheḥ	χenti
Homage to thee	god	this	sacred	great,	beneficent,	prince	of	eternity,	dweller in

àuset-f	em	sektet	āā	χāāu	em	ātetet	ṭāṭā	nef	hennu
his seat	in	the *Sektet* boat	great,	diademed	in	the *ātet* boat,	are given to him		praises

em	pet	em	ta	seqai	pāt	reχi		āā
in heaven	and in	earth,	exalted by the	ancients	and by mankind,	the greatness		

śefśefet - f	em	àbu	en	reθ	χu	mu	ertāt
of his might is	in	the hearts of	men,	shining spirits,	and the dead,	placing	

left the emblem of life. Before her are tables of meat and drink offerings and flowers. Behind the hippopotamus, the divine cow, Meḥ-urit, symbolizing the same goddess, looks out from the funeral mountain, wearing the *menàt* on her neck. At the foot of the mountain is the tomb ; and in the foreground grows a group of flowering plants.

Text : [Chapter CLXXXVI.] Hathor, lady of Amentet, dweller in the land of Urt, lady of Ta-sert, the Eye of Rā, the dweller in his brow, the beautiful Face in the Boat of Millions of Years.[1]

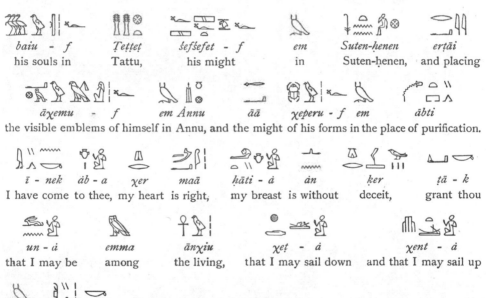

baiu - f	Ṭeṭṭeṭ	šefšefet - f	em	Suten-ḥenen	erṭāi
his souls in	Tattu,	his might	in	Suten-ḥenen,	and placing

āχemu - f	em Ånnu	āā	χeperu - f	em	ābti

the visible emblems of himself in Annu, and the might of his forms in the place of purification.

ī - nek	àb - a	χer	maā	ḥāti - à	àn	ḳer	ṭā - k
I have come	to thee,	my heart	is right,	my breast	is without	deceit,	grant thou

un - à	emma	ānχiu	χeṭ - à	χent - à
that I may be	among	the living,	that I may sail down	and that I may sail up

em	šesiu - k
among	thy followers.

[1] The few remaining words are corrupt.

BIBLIOGRAPHY.

TEXTS.

VTH AND VITH DYNASTIES.

MASPERO, G. La Pyramide du roi Ounas (*Recueil de Travaux*, t. iii., p. 177, Paris, 1882 ; t. iv., p. 41, Paris, 1883).
———————— La Pyramide du roi Teti (*Recueil de Travaux*, t. v., p. 1, Paris, 1884).
———————— La Pyramide du roi Pepi I. (*Recueil de Travaux*, t. v., p. 157, Paris, 1884 ; t. vii., p. 145, Paris, 1886 ; t. viii., p. 87, Paris, 1884).
———————— La Pyramide de Mirinri (*Recueil de Travaux*, t. ix., p. 177, Paris, 1887 ; t. x., p. 1, Paris, 1888 ; t. xi., p. 1, Paris, 1889).
———————— La Pyramide de Pepi II. (*Recueil de Travaux*, t. xii., pp. 53, 139, Paris, 1892 ; t. xiv., p. 125, Paris, 1892).

XITH AND XIITH DYNASTIES.

BIRCH, S. Egyptian Texts of the earliest period, from the coffin of Amamu, London, 1886.
LEPSIUS, R. Aelteste Texte des Todtenbuchs, Berlin, 1867.
MASPERO, G. Trois Années de Fouilles dans les Tombeaux de Thèbes et de Memphis (*Mémoires de la Mission Archéologique*, t. i., pp. 137–80, Paris, 1889).

XVIIITH DYNASTY.

BIRCH, S. The Papyrus of Nebseni (33 photographs), London, 1876.
DEVÉRIA, T. Le Papyrus de Neb-qed, Paris, 1872.
GUIEYESSE, P. Le Papyrus Funéraire de Soutimes, Paris, 1877.
LEEMANS, C. Monuments Égyptiens, Papyrus T. 2, Leyden, 1882. (Contains a facsimile of the Papyrus of Qenna ; see plates 1–27.)
LEFÉBURE, E. Le Papyrus de Soutimes, Paris, 1877.
MARIETTE, A. Les Papyrus Égyptiens du Musée de Boulaq, Paris, 1876. (Contains a facsimile of the Papyrus of Åmen-hetep, a registrary of cattle ; see plates 1–11.)
NAVILLE, É. Das Aegyptische Todtenbuch der XVIII bis XX Dynastie, Berlin, 1886.
PIERRET, P. Le Papyrus de Neb-qed, Paris, 1872.

XXTH, XXIST, AND XXIIND DYNASTIES.

BIRCH, S. Papyri from the Collection of the Earl of Belmore, London, 1843. (Contains a
facsimile of the hieratic papyrus of Tcheṭ-Khensu-àus-ānkh ; see plates 1–4.)
LEPSIUS, R. Denkmäler, Abth. vi. (Contains a facsimile of the hieratic papyrus of Ānkh-f-
en-Khensu ; see Bl. 123.)
MARIETTE, A. Les Papyrus Égyptiens du Musée de Boulaq, Paris, 1876. (Contains a
facsimile of the hieroglyphic papyrus of Queen Ḥent-taui ; see plates 12–21.)
MARUCCHI, O. Il grande papiro Egizio della Biblioteca Vaticana, Roma, 1888.
MASPERO, G. Les Momies Royales de Déir el-Baharî (*Mémoires de la Mission Archéologique*,
t. i., pp. 595–614, Paris, 1889).

XXVITH AND FOLLOWING DYNASTIES.

LEEMANS, C. Les Papyrus Égyptiens du Musée de Boulaq, Leyden, 1867. (Contains a
facsimile of the papyrus of Àuset-urt, see plate 1 ff.)
ROUGÉ, E. de. Rituel Funéraire, Paris, 1861.
———————— Description de l'Égypte, Paris, 1821, t. ii. (Contains a facsimile of the papyrus
of Nes-Ḥeru-p-Rā ; see plate 48 f.)

PTOLEMAIC PERIOD AND LATER.

BIRCH, S. On some Egyptian Rituals of the Roman Period (*P.S.B.A.*,* Vol. VII., p. 49).
———————— Facsimiles of two Papyri found in a Tomb at Thebes, London, 1863.
CADET, J. M. Copie figurée d'un Rouleau de Papyrus trouvé à Thèbes, Paris, 1805. Compare
also *Description de l'Égypte*, Paris, 1821, pl. 72 ff.
FONTANA, D. Copie Figurée d'un Rouleau de Papyrus, publiée par M. Fontana et expliquée
par M. de Hammer, Vienna, 1822.
HAWKINS, E., and S. BIRCH. Papyri from the Collection of the Earl of Belmore, London,
1843. (Contains a facsimile of the papyrus of Peṭā-Ḥeru-p-Rā ; see plates 7, 8).
LEEMANS, C. *Monuments Égyptiens*, Leyden, 1841, 1842. (Contains a facsimile of the
papyrus of Nes-nekht).
LEPSIUS, R. Das Todtenbuch der Aegypten nach dem hieroglyphischen Papyrus im
Turin, Leipzig, 1842).
REVILLOUT, E. Rituel funéraire de Pamauth, Paris, 1880.
WIEDEMANN, A. Hieratische Texte aus den Museen zu Berlin und Paris, Leipzig, 1879.
(Contains the facsimile (MS. Louvre, No. 3283) of a Book of the Dead of the
late Ptolemaïc period, written in hieratic for the lady Àuset-urt, with translation.)

WORKS AKIN TO THE BOOK OF THE DEAD.

BONOMI, J. Alabaster Sarcophagus of Oimenephthah I., London, 1864. (Contains the complete text of the funereal books inscribed on the Sarcophagus of Seti I.)

BRUGSCH, H. Šai an Sinsin sive liber metempsychosis veterum Aegyptorum, Berlin, 1851.

BUDGE, E. A. WALLIS. The Festival Songs of Isis and Nephthys (*Archæologia*, Vol. LII., London, 1891, p. 459).

———— The Litanies of Seker, (*Archæologia*, Vol. LII., London, 1891, p. 491).

———— The Book of the Overthrowing of Āpepi. (*Archæologia*, Vol. LII., London, 1891, p. 502).

DÜMICHEN, J. Der Grabpalast des Patuamenap in der thebanischen Nekropolis. Parts 1–3, Leipzig, 1884–94.

HORRACK, J. de. Les Lamentations d'Isis et de Nephthys, Paris, 1866.

JÉQUIER, G. Le Livre de ce qu'il y a dans l'Hadès (𓊖𓏤𓏏𓅿 ⋆ 𓅿 𓏁), Paris, 1894.

LANZONE, R. V. Le Domicile des Esprits, Paris, 1879.

LEFÉBURE, E. Les Hypogées Royaux de Thèbes (*Mémoires de la Mission Archéologique*, tt. ii., iii., Paris, 1886–89).

LEGRAIN, G. Le Livre des Transformations, Paris, 1890.

NAVILLE, É. La Litanie du Soleil, Leipzig, 1875.

SCHIAPARELLI, E. Il Libro dei funerali degli antichi Egiziani, Rome, 1882, 1890.

VIREY, P. Le Tombeau de Rekhmara (*Mémoires de la Mission Archéologique*, t. v., Paris, 1889).

TRANSLATIONS.

BIRCH, S. Description of the Papyrus of Nas-khem, London, 1863.

———— The Funereal Ritual or Book of the Dead (in Bunsen, *Egypt's Place in Universal History*, Vol. V., pp. 123–333, London, 1867). This translation is made from the text of the Turin papyrus, which is a good example of the version in use during the Ptolemaïc Period.

BRUGSCH, H. A. H. Rhind's zwei bilingue Papyri hieratisch und demotisch, Leipzig, 1865, 4to.

———— Das Todtenbuch der alten Aegypter (*Aeg. Zeit.*, 1872, pp. 65–129). A translation of the first fifteen chapters of the Book of the Dead.

DAVIS, C. H. S. The Egyptian Book of the Dead, New York, 1894.

MASSY, A. Le Papyrus Nebseni, exemplaire hiéroglyphique du Livre des Morts conservé au British Museum, traduit, Gand, 1885.

PIERRET, PAUL. Le Livre des Morts des anciens Égyptiens. Traduction complète d'après le papyrus de Turin et les MSS. du Louvre, Paris, 1882.

PLEYTE, W. Chapitres supplémentaires du Livre des Morts. Traduction et Commentaire, Leyden, 1881, 3 vols.

RENOUF, P. LE P. The Book of the Dead (*P.S.B.A.*, Vols. XIV., XV., XVI., f.).

EDITIONS OF SPECIAL CHAPTERS AND EXTRACTS FROM THE BOOK OF THE DEAD, ARTICLES ON COGNATE TEXTS, Etc.

AMÉLINEAU, E. Un Tombeau Égyptien (*Revue des Religions*, t. xxiii., p. 137, Paris, 1894).

BIRCH, S. On Sepulchral Figures (*Aeg. Zeit.*, 1865, pp. 4–20).

———— On Formulas relating to the Heart (*Aeg. Zeit.*, 1866, p. 89; 1867, pp. 16, 54; 1870, pp. 30, 46, 73).

———— The Chapter of the Pillow (*Aeg. Zeit.*, 1868, p. 52).

———— On the Formulas of the Royal Coffins (*Aeg. Zeit.*, 1869, p. 49).

———— The Amulet of the Tie (*Aeg. Zeit.*, 1871, p. 14).

BRUGSCH, H. Die Kapitel der Verwandlungen im Todtenbuch, 76 bis 88 (*Aeg. Zeit.*, 1867, p. 21 f.).

———— Zwei Pyramiden mit Inschriften, aus den Zeiten der VIe Dynastie (*Aeg. Zeit.*, 1881, p. 1).

CHABAS, F. Notice sur le Pire-em-hrou (*Congrès International des Orientalistes, Compte Rendu*, t. i., Paris, 1876, p. 37 ff.).

DEVÉRIA, T. Lettre sur le Chapitre 1er du Todtenbuch (*Aeg. Zeit.*, 1870, p. 57).

———— Livre de sortir du jour (*Catalogue des Manuscrits Égyptiens écrits sur papyrus, toile, tablettes, et ostraka qui sont conservés au Musée Égyptien du Louvre*, Paris, 1874, pp. 48–129.)

———— L'Expression Mââ-χerou (*Recueil*, t. i., p. 11. Paris, 1880).

EBERS, G. Erklärung eines Abschnittes des XXV. Kapitel des Todtenbuches (*Aeg. Zeit.*, 1871, p. 48).

ERMAN, A. Die Entstehung eines "Todtenbuchtextes" (*Aeg. Zeit.*, 1894, p. 2).

———— Zur Erklärung der Pyramidentexte (*Aeg. Zeit.*, 1891, p. 39; 1894, p. 75).

GOLÉNISCHEFF, W. Eine ältere Redaction des 108 Kapitels des Todtenbuches (*Aeg. Zeit.*, 1874, p. 83).

———— Sur un Ancien Chapitre du Livre des Morts (*Congrès International des Orientalistes, Compte Rendu*, t. ii., Paris, 1878, p. 109 f.).

GOODWIN, C. W. On a text of the Book of the Dead belonging to the Old Kingdom (*Aeg. Zeit.*, 1866, p. 53).

———— On the 112th Chapter of the Ritual (*Aeg. Zeit.*, 1871, p. 144).

———— On the Symbolic Eye (*Aeg. Zeit.*, 1872, p. 124).

———— On Chapter 115 of the Book of the Dead (*Aeg. Zeit.*, 1873, p. 104).

GUIEYESSE, P. Rituel Funéraire Égyptien, Paris, 1876.

HINCKS, E. On the Egyptian Stelè or Tablet (*Transactions of the Royal Irish Academy*, Dublin, 1842, vol. xix, pt. ii.).

———— Catalogue of the Egyptian MSS. in the Library of Trinity College, Dublin, 1843.

LAUTH, J. Eine mystische Stelle des Todtenbuches (*Aeg. Zeit.*, 1866, p. 19).

LEFÉBURE, E. Le Chapitre CXV. du Livre des Morts (*Mélanges d'Archéologie Égyptienne et Assyrienne*, t. i., p. 156).

LIEBLEIN, J. The Title of the Book of the Dead (*P.S.B.A.*, Vol. VII., p. 187).

LIEBLEIN, J. Index de tous les Mots contenus dans le Livre des Morts, Paris, 1875.
——————— On 2 Kings, vii., 6, and the Egyptian Title *per m ḥru* (*P.S.B.A.*, Vol. VIII., p. 74).
LORET, V. Les Statuettes Funéraires du Musée de Boulaq (*Recueil*, t. iv., p. 89, Paris, 1883 ;
t. v., Paris, 1884, p. 70).
MASPERO, G. Mémoire sur Quelques Papyrus du Louvre, Paris, 1875.
——————— Le Livre des Morts (*Revue des Religions*, t. xv., p. 265, Paris, 1887).
——————— Les Hypogées royaux de Thèbes (*Revue des Religions*, t. xvii., p. 253 f., Paris,
1888 ; t. xviii., p. 1 f., Paris, 1889).
——————— Sur une Formule du Livre des Pyramides (*Recueil*, t. xiv., p. 186, Paris, 1892).
NAVILLE, É. Un Chapitre inédit du Livre des Morts (*Aeg. Zeit.*, 1873, pp. 25, 81).
——————— Deux Lignes du Livre des Morts (*Aeg. Zeit.*, 1874, p. 58).
——————— Le Discours d'Horus à Osiris (*Aeg. Zeit.*, 1875, p. 89).
——————— Notes diverses, tirées du Livre des Morts (*Aeg. Zeit.*, 1882, p. 184).
PIEHL, K. Stèle portant une Inscription empruntée au Livre des Morts (*Recueil*,
t. ii., p. 71, Paris, 1880).
PIERRET, P. Traduction de Chapitre 1er du Livre des Morts (*Aeg. Zeit.*, 1869, p. 137 ;
1870, p. 14).
PLEYTE, W. Beiträge zur Kenntniss der Todtenbuchtexte (*Aeg. Zeit.*, 1873, p. 145).
RENOUF, P. LE P. On some Religious Texts of the Early Egyptian Period (*T.S.B.A.*,
Vol. IX., p. 295) ; Egyptian Mythology (*P.S.B.A.*, Vol. VIII., p. 198).
ROSELLINI, J. Breve notizia intorno un frammento di Papiro funebre Egizio essistente nel
ducale Museo di Parma, Parma, 1838.
ROSSI, F. Illustrazione di un Papiro Funerario del Museo Egizio di Torino, Turin, 1879.
ROUGÉ, DE. Études sur le Rituel Funéraire des Anciens Égyptiens (*Revue Archéologique*,
1860, pp. 69, 230, 237, 337).
SCHIAPARELLI, E. Il Libro dei Funerali in Egitto (*Atti del IV. Congresso Inter-
nazionale degli Orientalisti*, Vol. I., Florence, 1880).

MONOGRAPHS, PAPERS, Etc., ON ANCIENT EGYPTIAN RELIGION, MORALITY, AND MYTHOLOGY.

AMÉLINEAU, E. La Morale Égyptienne Quinze Siècles avant notre Ère, Paris, 1892.
BERGMANN, E. Die Osiris-Reliquien in Abydos, Busiris und Mendes (*Aeg. Zeit.*, 1880, p. 87).
——————— Götter-Liste (*Hieratische und Hieratisch-Demotische Texte*, Vienna, 1886,
pp. 13–16).
BIRCH, S. On the Egyptian Belief concerning the Shadow of the Dead (*P.S.B.A.*,
Vol. VII., p. 45 ; *T.S.B.A.*, Vol. VIII., p. 386).
BRUGSCH, H. Die neue Weltordnung nach Vernichtung des sündigen Menschenge-
schlechtes, Berlin, 1881.
——————— Das Osiris-Mysterium von Tentyra (*Aeg. Zeit.*, 1881, p. 77).
——————— Religion und Mythologie der alten Aegypter, Leipzig, 1884.
CHABAS, F. Les Maximes du Scribe Ani (*l'Égyptologie*, Chalons-sur-Saône, 1876).

GOODWIN, C. W. Egyptian Hymn to Amen (*T.S.B.A.*, Vol. II., p. 250).
—————— Egyptian Hymn to Amen (*T.S.B.A.*, Vol. II., p. 353).
GRÉBAUT, E. Hymne à Ammon-Rā, Paris, 1874.
HIRT, A. Über die Bildung der aegyptischen Gottheiten, Berlin, 1821.
JABLONSKI, P. E. Pantheon Aegyptiorum, Frankfort, 1750.
LANZONE, R. V. Dizionario di Mitologia Egiziana, Turin, 1881.
LAUTH, J. Die Siebentägige Trauer um Osiris (*Aeg. Zeit.*, 1886, p. 64).
LEFÉBURE, E. Le Cham et l'Adam Égyptiens (*T.S.B.A.*, Vol. IX., p. 167).
—————— Traduction comparée des Hymnes au Soleil, Paris, 1868.
—————— Le Mythe Osirien, Paris, 1874.
—————— Les Yeux d'Horus, Paris, 1874.
—————— L'Étude de la Religion Égyptienne, son état actuel, et ses conditions (*Revue des Religions*, t. xiv., p. 26 f., Paris, 1885).
—————— L'Œuf dans la Religion Égyptienne (*Revue des Religions*, t. xvi., p. 16 f., Paris, 1887).
LEMM, OSCAR VON. Das Ritualbuch des Ammondienstes, Leipzig, 1882.
LIEBLEIN, J. Étude sur le Nom et le Culte Primitif du Dieu Hébreu Jahvhe (in *Congrès Provincial des Orientalistes, Compte Rendu*, t. i., Paris, 1880, p. 265 f.).
—————— Egyptian Religion, Leipzig, 1884.
LORET, V. Les Fêtes d'Osiris au Mois de Khoiak (*Recueil*, t. iii., p. 43, Paris, 1882 ; t. iv., p. 21, Paris, 1883 ; t. v., p. 85, Paris, 1884).
MALLET, D. Le culte de Neit à Sais, Paris, 1888.
MASPERO, G. Hymne au Nil, Paris, 1868.
—————— The Egyptian Documents relating to the Statues of the Dead (*P.S.B.A.*, 1878–9, p. 44).
—————— *Histoire des Âmes dans l'Égypte Ancienne* (in *Revue Scientifique*, Paris, 1879).
—————— De quelques Cultes et de quelques Croyances Populaires des Égyptiens (*Recueil*, t. ii., pp. 108, 115, 116, Paris, 1880).
—————— Sur l'Ennéade (*Revue des Religions*, t. xxiv., p. 1 f., Paris, 1881).
—————— La Religion égyptienne d'après les pyramides de la Vᵉ et de la VIᵉ dynastie (*Revue des Religions*, t. xii., p. 123 f., Paris, 1885).
—————— Le rituel du sacrifice funéraire (*Revue des Religions*, t. xv., p. 159 f., Paris, 1887).
—————— La Mythologie Égyptienne (*Revue des Religions*, t. xviii., p. 253 f., Paris, 1888 ; t. xix., p. 1 f., Paris, 1889).
—————— Le Nom Antique de la Grande-Oasis et les idées qui s'y rattachent (*Journal Asiatique*, IXᵉ série, t. i., pp. 232–40, Paris, 1893).
NAVILLE, É. La Destruction des Hommes par les Dieux (*T.S.B.A.*, Vol. V., p. 1).
PIERRET, P. Essai sur la mythologie Égyptienne, Paris, 1879.
—————— Le Panthéon Égyptien, Paris, 1881.
—————— Religion et Mythologie des anciens Égyptiens, d'après les Monuments (*Revue Égyptologique*, t. iv., p. 120, Paris, 1885 ; t. v., pp. 9, 128, Paris, 1888).
—————— Le Dogme de la Résurrection chez les anciens Égyptiens, Paris, 4to.
PRICHARD, J. C. An analysis of the Egyptian Mythology, London, 1819.

RAVISI, TEXTOR DE. L'Âme et le Corps d'après la Théogonie Égyptienne (*Congrès International des Orientalistes, Compte Rendu*, t. ii., Paris, 1878, pp. 171–414).

———————— Religions Anciennes de l'Égypte (*Congrès Provincial des Orientalistes, Compte Rendu*, t. i., Paris, 1880, p. 234 ff.)

RENOUF, P. LE P. Lectures on the Origin and Growth of Religion as illustrated by the Religion of Ancient Egypt, London, 1880.

——————— On the true sense of an important Egyptian Word (*T.S.B.A.*, Vol. VI., p. 494).

——————— The Horse in the Book of the Dead (*P.S.B.A.*, Vol. VII., p. 41).

——————— The Title of the Book of the Dead (*P.S.B.A.*, Vol. VII., p. 210).

——————— The Myth of Osiris Unnefer (*T.S.B.A.*, Vol. IX., p. 281).

——————— Two Vignettes of the Book of the Dead (*P.S.B.A.*, Vol. XI., p. 26).

REVILLOUT, E. Les Prières pour les Morts dans l'Épigraphie Égyptienne (*Revue Égyptologique*, t. iv., p. 1, Paris, 1885).

ROBIOU, F. Les Variations de la Doctrine Osiriaque depuis l'âge des pyramides jusqu'à l'époque Romaine (*Actes du Huitième Congrès International des Orientalistes*, Part IV., Leyden, 1892, pp. 71–144).

STRAUSS V. Der altaegyptische Götterglaube, Heidelberg, 1889.

TIELE, C. P. Geschiedenis van den Godsdienst in de Oudheid tot op Alexander den Groote, Amsterdam, 1893.

VIREY, P. Études sur le Papyrus Prisse, Paris, 1887.

WIEDEMANN, A. Une Stèle du Musèe Égyptien de Florence (*Congrès International aes Orientalistes, Compte Rendu*, t. ii., Paris, 1878, p. 146 ff.).

——————— Die Religion der alten Aegypter, Münster, i., W., 1890.

——————— Index der Goetter- und Daemonen-namen, Leipzig, 1892.

COPTIC WORKS BEARING UPON THE RELIGION OF THE CHRISTIAN EGYPTIANS.

AMÉLINEAU, E. Étude sur le Christianisme en Égypte au septième siècle, Paris, 1887.

——————— Étude historique sur Saint Pachome et le Cénobitisme primitif dans la Haute-Égypte d'après les monuments Coptes, Cairo, 1887.

——————— De historia Lausiaca, Paris, 1887.

——————— Essai sur le Gnosticisme Égyptien, Paris, 1887.

——————— La Christianisme chez les anciens Coptes (*Revue de Religions*, t. xiv., p. 308 f., Paris, 1886 ; t. xv., p. 52 f., Paris, 1887.)

——————— Contes et Romans de l'Égypte Chrétienne, Paris, 1888.

——————— Monuments pour servir à l'histoire de l'Égypte Chrétienne au 4e siècle, Paris, 1889.

HYVERNAT. Les Actes des Martyrs de l'Égypte, Paris, 1886.

SCHMIDT, C. Gnostische Schriften in koptischer Sprache aus dem Codex Brucianus, Leipzig, 1892.